"Anything can happen in Grand Prix racing, and it usually does."

Murray Walker

Published by Collins
An imprint of HarperCollins Publishers
Westerhill Road
Bishopbriggs
Glasgow G64 2QT

HarperCollins Publishers
1st Floor, Watermarque Building,
Ringsend Road, Dublin 4, Ireland

www.harpercollins.co.uk

First edition 2015
Reprinted with changes 2016
Second edition 2022

A catalogue record for this book is available from the British Library.

ISBN 978-0-00-855479-8

10 9 8 7 6 5 4 3 2 1

Printed in Bosnia and Herzegovina

If you would like to comment on any aspect of this book, please contact us at the
above address or online.

e-mail: collins.reference@harpercollins.co.uk

collins.co.uk

facebook.com/collinsref
@Collins_Ref
@Collins_Ref

Collins

FORMULA 1 CIRCUITS

MAPS AND STATISTICS FROM EVERY GRAND PRIX TRACK

Maurice Hamilton

Foreword by Sir Jackie Stewart

Contents

Foreword by Sir Jackie Stewart OBE

Seeing the world's Formula 1 race tracks spread across the pages of this book brings home the tremendous colour and variety of our sport as well as documenting the inevitable changes have taken place since the start of the World Championship in 1950. I count myself very fortunate to have raced – and, in some cases, survived - on many of these tracks. Each one had a unique sense of identity as it presented very different challenges.

In many ways, it is appropriate that Monza should appear first because it is the oldest circuit. It was here that I won my first Grand Prix in 1965 before going on to decide two of my three World Championships during typical heady September afternoons at this wonderfully charismatic track.

Apart from Monza's significance in terms of my career, this remains one of the world's most compelling race tracks when it comes to talking about absolute passion for motor sport. From having to hide in the Dunlop truck from invading fans after I had become champion for the first time in 1969, to witnessing the avalanche of exuberant spectators swamping the track beneath the victory rostrum today, Monza retains a tremendous buzz that has to witnessed to be believed.

For that, and many other reasons, it would be a great shame if Monza were to follow the path of the French and German Grands Prix and disappear from the calendar. In my view, F1 must retain 'Classic' events which must also include the British, Belgian and, of course, the Monaco Grands Prix.

All of these great race tracks are included in this book and each in its own way brings special memories. I once referred to the Nürburgring Nordschleife as 'Green Hell' for good reason. In the same way, the original track at Spa-Francorchamps had its inherent dangers but these circuits formed the bedrock of the sport's history. The latest generation of these tracks should continue to have their place when maintaining a sense of tradition.

Not all of the circuits bring a sense of satisfaction. I never got on with Brands Hatch, for example. No matter what car I was driving, I found it to be a difficult track that gave a rough ride and only had one corner, Paddock Hill Bend, that possessed character.

On the other hand, I can relate easily to Silverstone for many reasons. Apart from hosting the very first round of the World Championship in 1950, this was a track with wonderful high-speed corners such as Woodcote, Maggots and Becketts in the circuit's original form. Silverstone has played a major part in ensuring Britain is unique in staging a round of the championship every year while keeping up with the rapid pace of technology to become a world centre of motor sport excellence. It really is the Home of British Motor Sport as far as I'm concerned.

If asked to choose a favourite from the list of 76 venues, I would say Monaco without hesitation. This is a circuit that is distinctive in so many ways. An exceptional discipline is required on a track that punishes the smallest lapse in concentration, the sense of satisfaction that comes with winning being very special indeed. But aside from the challenge of racing, Monaco continues to bring the same sense of colour, flair and excitement it always has done. It's a claim that can not be made for many tracks in these changing times.

Going through the various circuits, some obviously invoke sad memories. Saying that, the sometimes terrible effect of racing when the risks were high does not affect either my respect or sense of enjoyment when reviewing these race tracks.

Every single circuit plays a vital part of motor sport history and I am delighted that Collins and Maurice Hamilton have gathered them together to produce such a memorable record.

Sir Jackie Stewart OBE

Introduction

When I ought to have been studying as a student, I would dream of visiting faraway places; specifically, race tracks with evocative names. Autodromo Nazionale di Monza, Spa-Francorchamps, Rouen-les-Essarts; the very mention would set the adrenalin coursing without so much as having set foot inside these magical scenes of derring-do.

Such visualising from afar was the fault of 'Motor Racing Circuits of Europe', a favourite book by Louis Klemantaski and Michael Frostick; the later a journalist who put words to Klemantaski's equally eloquent photographs. Their work immediately transported me from desk-bound drudgery to trackside bliss and added to the fascination of a sport that already held me in its thrall.

Little did I imagine fifty years ago that my job – if you could call it that – would eventually take me to such places of motor racing legend. The fascination, if anything, accelerated rather than diminished. True, the lure has been anesthetised a little in recent years by a process of standardisation that makes one new circuit look very much like another. And yet, all tracks retain a certain individuality and remain the canvas on which racing drivers exhibit their very special art. I immediately embraced the suggestion by Collins that we should place these F1 circuits between the covers of a book.

Given the variety of racing and liberal use of 'Grand Prix' when naming an event before 1950, the advent of the Formula 1 World Championship that year seemed the only reasonable starting point when listing circuits and formulating the statistics you will find accompanying each.

Sir Jackie Stewart is in the unique position of having raced on many of these tracks. His three World Championships were won during a career that crossed the divide between a cavalier approach to a driver's well-being and the gradual acceptance by those in charge of the need for safety, a cause Stewart pursued with great dignity and vigour. I was delighted and privileged when Sir Jackie agreed to write the Foreword. Only he can begin to understand the true feeling for race tracks that could bring days of great joy and moments of deep personal sadness.

It was surprising to find as many as 76 different tracks in use since 1950. Even more unexpected was the discovery that I had been to 58 of them, either as a working journalist or as a fan visiting the ghosts of circuits past. It is perhaps inevitable that personal preferences might, from time to time, appear between the lines of narrative. Either way, I hope you enjoy this journey and it helps transport you to some truly exceptional places that form the very fabric of the sport.

Maurice Hamilton

Key to text pages

Race name

Year of first Grand Prix

Circuit name

Country

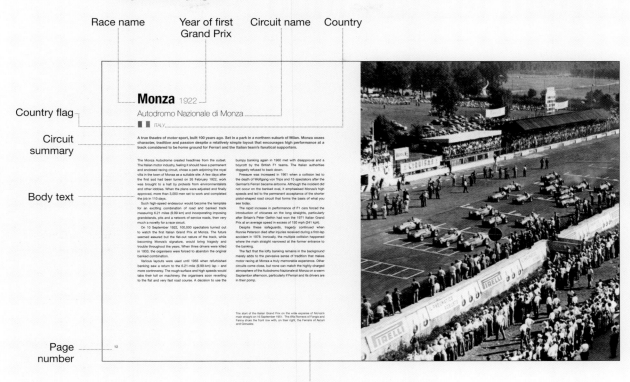

Monza 1922
Autodromo Nazionale di Monza
ITALY

A true theatre of motor sport, built 100 years ago. Set in a park in a northern suburb of Milan. Monza oozes character, tradition and passion despite a relatively simple layout that encourages high performance at a track considered to be home ground for Ferrari and the Italian team's fanatical supporters.

The Monza Autodrome created headlines from the outset. The Italian motor industry, feeling it should have a permanent and enclosed racing circuit, chose a park adjoining the royal villa in the town of Monza as a suitable site. A few days after the first sod had been turned on 26 February 1922, work was brought to a halt by protests from environmentalists and other lobbies. When the plans were adjusted and finally approved, more than 3,000 men set to work and completed the job in 110 days.

Such high-speed endeavour would become the template for an exciting combination of road and banked track measuring 6.21 miles (9.99 km) and incorporating imposing grandstands, pits and a network of service roads, then very much a novelty for a race circuit.

On 10 September 1922, 100,000 spectators turned out to watch the first Italian Grand Prix at Monza. The future seemed assured but the flat-out nature of the track, while becoming Monza's signature, would bring tragedy and trouble throughout the years. When three drivers were killed in 1933, the organisers were forced to abandon the original banked combination.

Various layouts were used until 1955 when refurbished banking saw a return to the 6.21-mile (9.99-km) lap – and more controversy. The rough surface and high speeds would take their toll on machinery, the organisers soon reverting to the flat and very fast road course. A decision to use the

bumpy banking again in 1960 met with disapproval and a boycott by the British F1 teams. The Italian authorities doggedly refused to back down.

Pressure was increased in 1961 when a collision led to the death of Wolfgang von Trips and 15 spectators after the German's Ferrari became airborne. Although the incident did not occur on the banked oval, it emphasised Monza's high speeds and led to the permanent acceptance of the shorter pistol-shaped road circuit that forms the basis of what you see today.

The rapid increase in performance of F1 cars forced the introduction of chicanes on the long straights, particularly after Britain's Peter Gethin had won the 1971 Italian Grand Prix at an average speed in excess of 150 mph (241 kph).

Despite these safeguards, tragedy continued when Ronnie Peterson died after injuries received during a first-lap accident in 1978. Ironically, the multiple collision happened where the main straight narrowed at the former entrance to the banking.

The fact that the lofty banking remains in the background merely adds to the pervasive sense of tradition that makes motor racing at Monza a truly memorable experience. Other circuits come close, but none can match the highly-charged atmosphere of the Autodromo Nazionale di Monza on a warm September afternoon, particularly if Ferrari and its drivers are in their pomp.

The start of the Italian Grand Prix on the wide expanse of Monza's main straight on 16 September 1951. The Alfa Romeos of Fangio and Farina share the front row with, on their right, the Ferraris of Ascari and Gonzalez.

12

Country flag

Circuit summary

Body text

Page number

Image caption

Key to circuit maps

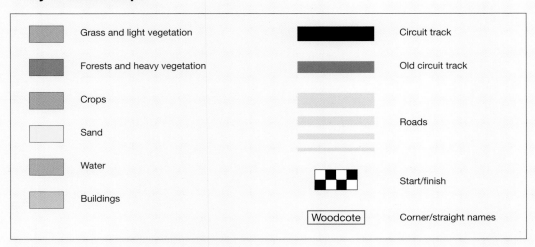

Grass and light vegetation

Forests and heavy vegetation

Crops

Sand

Water

Buildings

Circuit track

Old circuit track

Roads

Start/finish

Woodcote — Corner/straight names

Statistics

Statistics are up to and including the Monaco Grand Prix 2022.

Circuit locator map

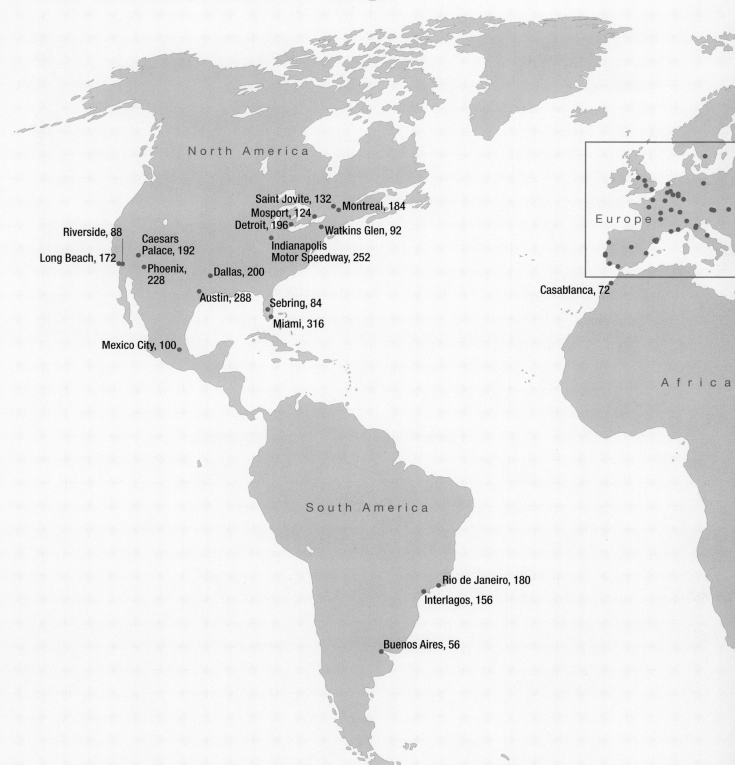

North America

Saint Jovite, 132
Mosport, 124
Montreal, 184
Detroit, 196
Watkins Glen, 92

Riverside, 88
Caesars Palace, 192
Indianapolis Motor Speedway, 252
Long Beach, 172
Phoenix, 228
Dallas, 200
Austin, 288
Sebring, 84
Miami, 316
Mexico City, 100

Europe

Casablanca, 72

Africa

South America

Rio de Janeiro, 180
Interlagos, 156
Buenos Aires, 56

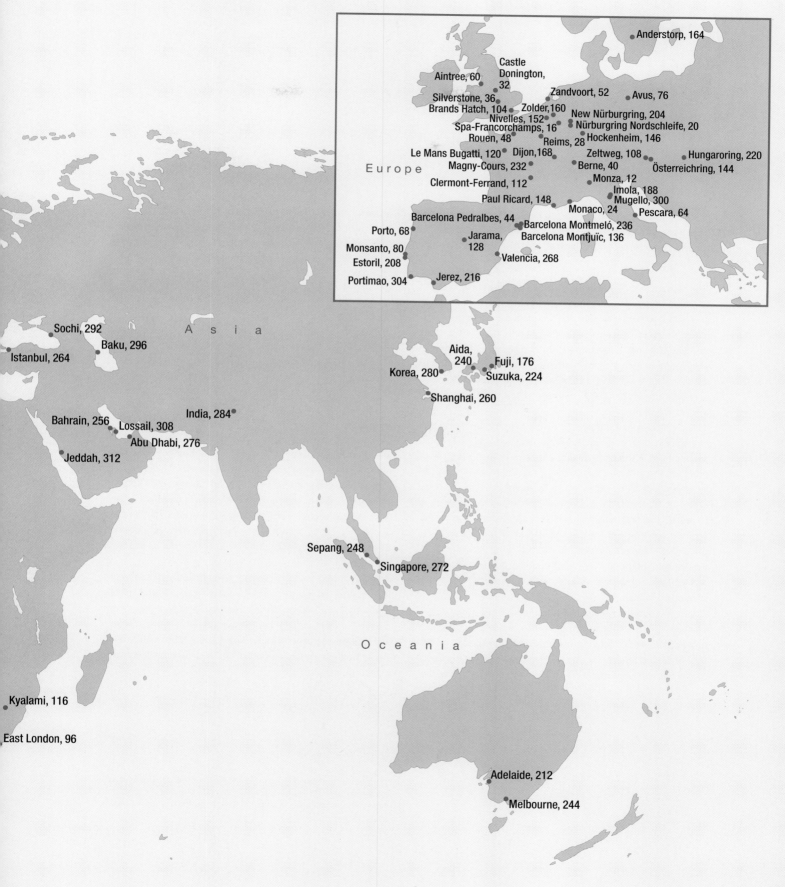

Anderstorp, 164

Castle Donington, 32
Aintree, 60
Silverstone, 36 Zandvoort, 52 Avus, 76
Brands Hatch, 104 Zolder,160
Nivelles, 152 New Nürburgring, 204
Spa-Francorchamps, 16 Nürburgring Nordschleife, 20
Rouen, 48 Reims, 28 Hockenheim, 146
Le Mans Bugatti, 120 Dijon,168 Zeltweg, 108 Hungaroring, 220
Europe Magny-Cours, 232 Berne, 40 Österreichring, 144
Clermont-Ferrand, 112 Monza, 12
Imola, 188
Paul Ricard, 148 Mugello, 300
Monaco, 24 Pescara, 64
Barcelona Pedralbes, 44 Barcelona Montmeló, 236
Porto, 68 Barcelona Montjuïc, 136
Monsanto, 80 Jarama, 128
Estoril, 208 Valencia, 268
Portimao, 304 Jerez, 216

Asia

Sochi, 292
Baku, 296
Istanbul, 264

Aida, 240 Fuji, 176
Korea, 280 Suzuka, 224
Shanghai, 260

Bahrain, 256 India, 284
Lossail, 308
Abu Dhabi, 276
Jeddah, 312

Sepang, 248
Singapore, 272

Oceania

Kyalami, 116

East London, 96

Adelaide, 212

Melbourne, 244

Monza 1922

Autodromo Nazionale di Monza

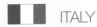 ITALY

A true theatre of motor sport, built 100 years ago. Set in a park in a northern suburb of Milan. Monza oozes character, tradition and passion despite a relatively simple layout that encourages high performance at a track considered to be home ground for Ferrari and the Italian team's fanatical supporters.

The Monza Autodrome created headlines from the outset. The Italian motor industry, feeling it should have a permanent and enclosed racing circuit, chose a park adjoining the royal villa in the town of Monza as a suitable site. A few days after the first sod had been turned on 26 February 1922, work was brought to a halt by protests from environmentalists and other lobbies. When the plans were adjusted and finally approved, more than 3,000 men set to work and completed the job in 110 days.

Such high-speed endeavour would become the template for an exciting combination of road and banked track measuring 6.21 miles (9.99 km) and incorporating imposing grandstands, pits and a network of service roads, then very much a novelty for a race circuit.

On 10 September 1922, 100,000 spectators turned out to watch the first Italian Grand Prix at Monza. The future seemed assured but the flat-out nature of the track, while becoming Monza's signature, would bring tragedy and trouble throughout the years. When three drivers were killed in 1933, the organisers were forced to abandon the original banked combination.

Various layouts were used until 1955 when refurbished banking saw a return to the 6.21-mile (9.99-km) lap – and more controversy. The rough surface and high speeds would take their toll on machinery, the organisers soon reverting to the flat and very fast road course. A decision to use the bumpy banking again in 1960 met with disapproval and a boycott by the British F1 teams. The Italian authorities doggedly refused to back down.

Pressure was increased in 1961 when a collision led to the death of Wolfgang von Trips and 15 spectators after the German's Ferrari became airborne. Although the incident did not occur on the banked oval, it emphasised Monza's high speeds and led to the permanent acceptance of the shorter pistol-shaped road circuit that forms the basis of what you see today.

The rapid increase in performance of F1 cars forced the introduction of chicanes on the long straights, particularly after Britain's Peter Gethin had won the 1971 Italian Grand Prix at an average speed in excess of 150 mph (241 kph).

Despite these safeguards, tragedy continued when Ronnie Peterson died after injuries received during a first-lap accident in 1978. Ironically, the multiple collision happened where the main straight narrowed at the former entrance to the banking.

The fact that the lofty banking remains in the background merely adds to the pervasive sense of tradition that makes motor racing at Monza a truly memorable experience. Other circuits come close, but none can match the highly-charged atmosphere of the Autodromo Nazionale di Monza on a warm September afternoon, particularly if Ferrari and its drivers are in their pomp.

The start of the Italian Grand Prix on the wide expanse of Monza's main straight on 16 September 1951. The Alfa Romeos of Fangio and Farina share the front row with, on their right, the Ferraris of Ascari and Gonzalez.

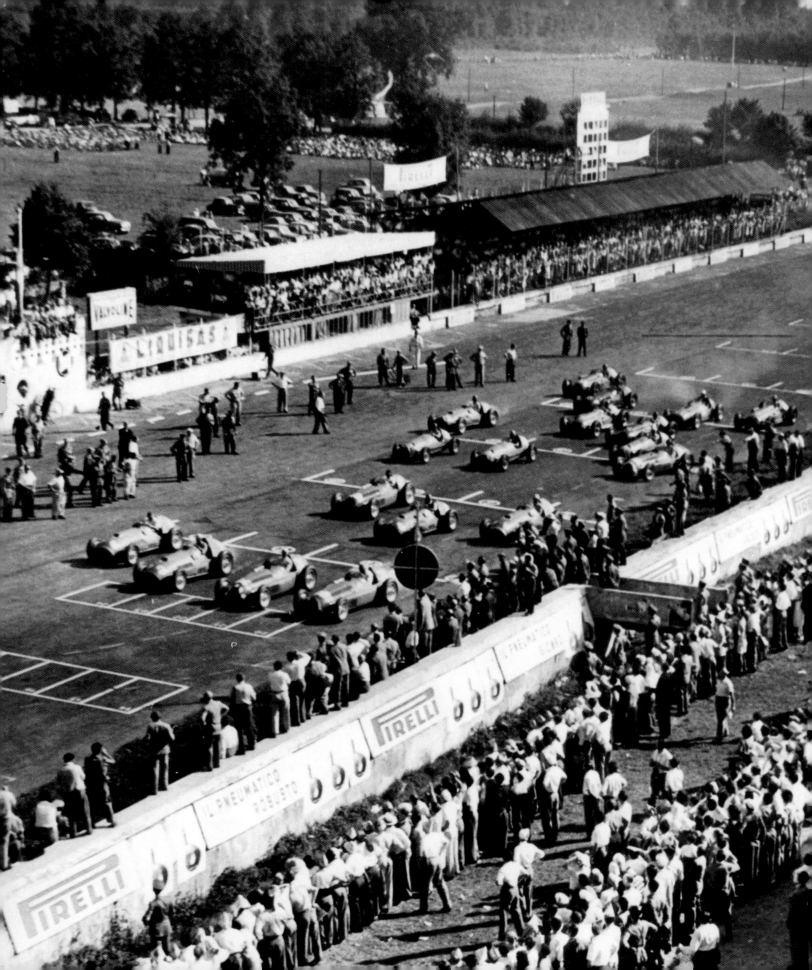

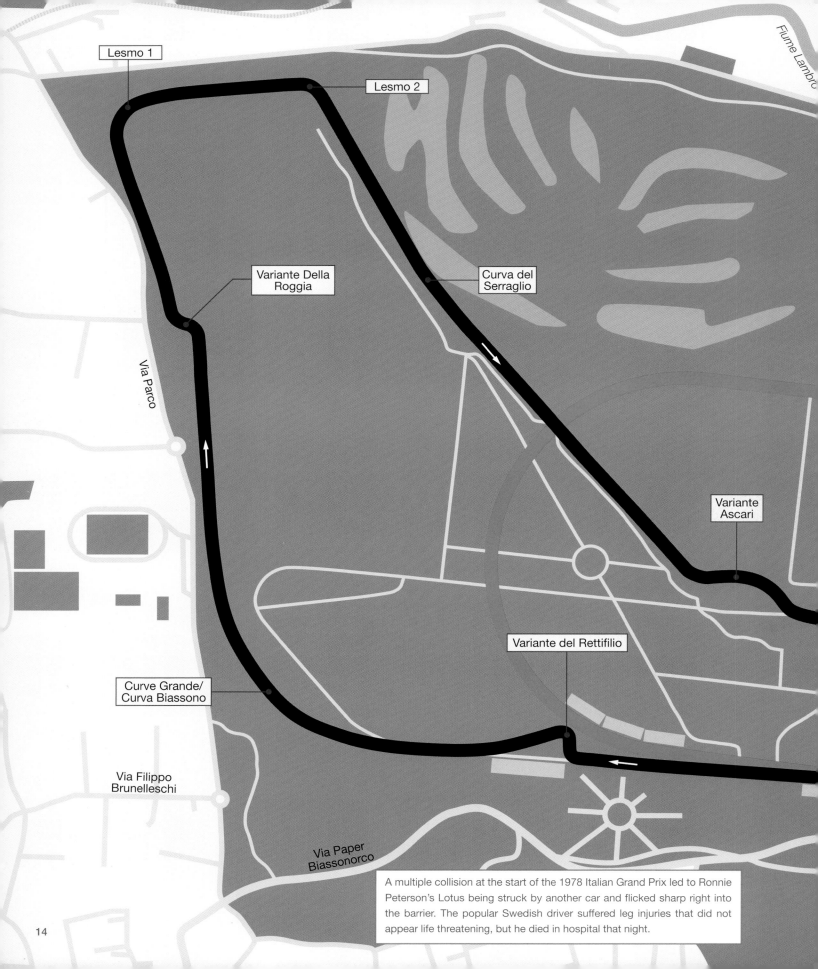

Lesmo 1

Lesmo 2

Variante Della Roggia

Curva del Serraglio

Variante Ascari

Via Parco

Variante del Rettifilio

Curve Grande/ Curva Biassono

Via Filippo Brunelleschi

Via Paper Biassonorco

Fiume Lambro

A multiple collision at the start of the 1978 Italian Grand Prix led to Ronnie Peterson's Lotus being struck by another car and flicked sharp right into the barrier. The popular Swedish driver suffered leg injuries that did not appear life threatening, but he died in hospital that night.

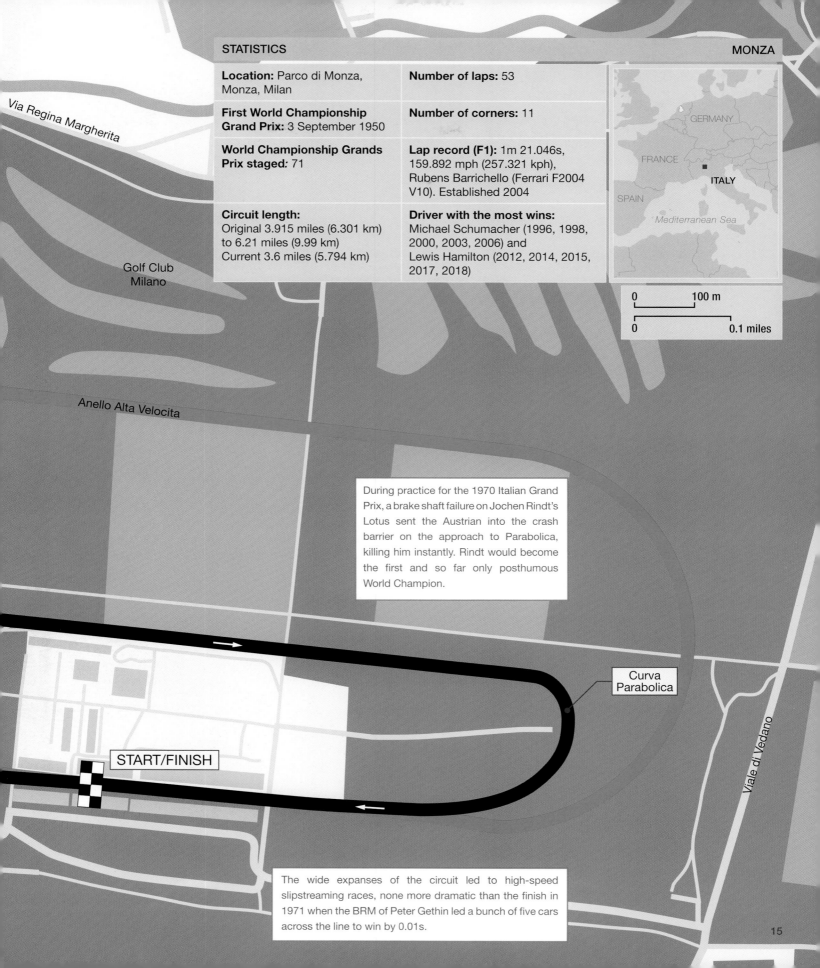

Location: Parco di Monza, Monza, Milan

First World Championship Grand Prix: 3 September 1950

World Championship Grands Prix staged: 71

Circuit length:
Original 3.915 miles (6.301 km) to 6.21 miles (9.99 km)
Current 3.6 miles (5.794 km)

Number of laps: 53

Number of corners: 11

Lap record (F1): 1m 21.046s, 159.892 mph (257.321 kph), Rubens Barrichello (Ferrari F2004 V10). Established 2004

Driver with the most wins: Michael Schumacher (1996, 1998, 2000, 2003, 2006) and Lewis Hamilton (2012, 2014, 2015, 2017, 2018)

GERMANY

FRANCE

ITALY

SPAIN

Mediterranean Sea

0 100 m

0 0.1 miles

Via Regina Margherita

Golf Club Milano

Anello Alta Velocita

During practice for the 1970 Italian Grand Prix, a brake shaft failure on Jochen Rindt's Lotus sent the Austrian into the crash barrier on the approach to Parabolica, killing him instantly. Rindt would become the first and so far only posthumous World Champion.

Curva Parabolica

START/FINISH

Viale di Vedano

The wide expanses of the circuit led to high-speed slipstreaming races, none more dramatic than the finish in 1971 when the BRM of Peter Gethin led a bunch of five cars across the line to win by 0.01s.

15

Spa-Francorchamps 1925

Circuit de Spa-Francorchamps

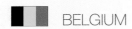 BELGIUM

Shortened and brought up to the required safety standards in 1983, Spa-Francorchamps maintains the challenge and character of the 9-mile (14.5-km) original from nearly 60 years before. A magnificent combination of purpose-built race track and public roads in the Belgian Ardennes. Spa remains a favourite with drivers and spectators alike.

A group of Belgian motor sport enthusiasts dreamed up the idea of holding a race along a series of roads linking the villages of Francorchamps, Malmédy and Stavelot. The town of Spa did not actually figure in the circuit itself but the organising club was based there. Since Francorchamps was nearest to the location of the proposed pits, the name Spa-Francorchamps was adopted when a motor cycle Grand Prix was held in 1921, followed by a touring car event in 1924 and a race for Grand Prix cars a year later.

The original track was roughly triangular in shape and just over 9 miles (14.5 km) long, rising and falling dramatically along sweeping public roads lining either side of a valley. Minor adjustments saw the removal of two tight hairpins, thus adding to the fast nature of a track that thrilled and frightened drivers in equal measure.

The perils of racing at Spa were underlined by several fatalities and exacerbated by rain showers that frequented this corner of the Ardennes. In the 1939 Belgian Grand Prix, Richard Seaman lost control while leading on a damp track, his Mercedes-Benz smashing into a tree and catching fire. The 26-year-old Englishman died of his burns that night.

Twenty years later, Spa-Francorchamps was the fastest road circuit in use but its menacing side continued to be apparent, particularly in 1960 when two British drivers were killed in separate accidents.

It was considered a miracle six years later when no one was fatally injured after several cars crashed on the opening lap of a Grand Prix made treacherous by the first half of the track being bone dry and the second awash in a downpour. Deemed too dangerous with an average speed in the region of 160 mph (257.5 kph); (which included negotiating the 30-mph [48.3-kph] hairpin at La Source), Spa-Francorchamps in its original form was last used for the Grand Prix in 1970.

The attraction of the location lingered long, the Grand Prix returning to Spa in 1983. In a first-rate piece of modernisation, the circuit had virtually been cut in half by a cleverly sculptured link that made full use of the plunging topography between Les Combes and what had been the return leg at Blanchimont. Gone was the run past Malmédy and on towards Stavelot. New pits and amenities had been added but, significantly, none of the challenge and atmosphere had been lost.

Despite alterations to La Source and Eau Rouge, Spa-Francorchamps remains a classic venue in an era of modern race facilities; a circuit that truly challenges and satisfies drivers and delights spectators.

Top: The Ferrari 500 of Alberto Ascari begins the climb from Eau Rouge in 1953, with the pits in the background.

Bottom: Michael Schumacher responds to the crowd after winning in 1996. Ferrari Team Principal, Jean Todt, gathers up the silverware.

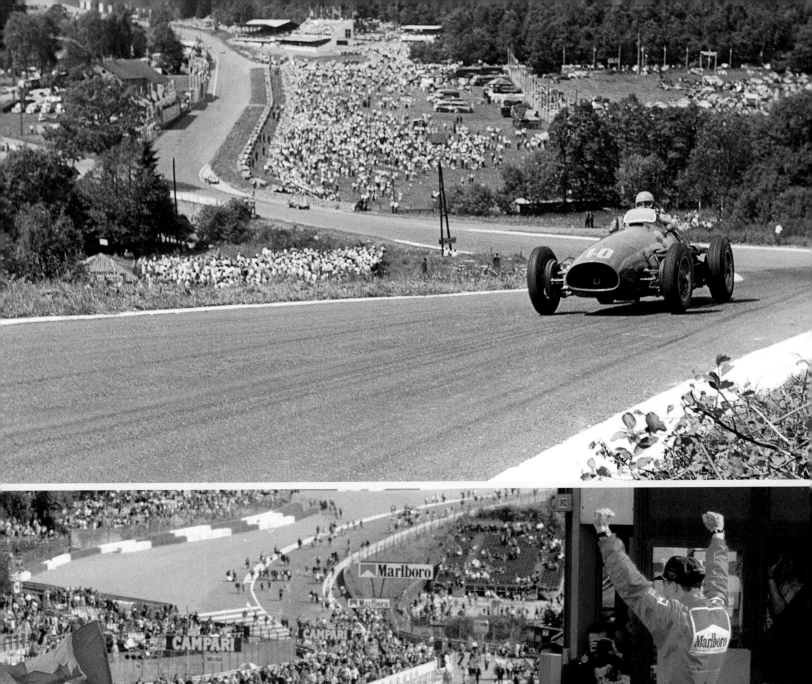

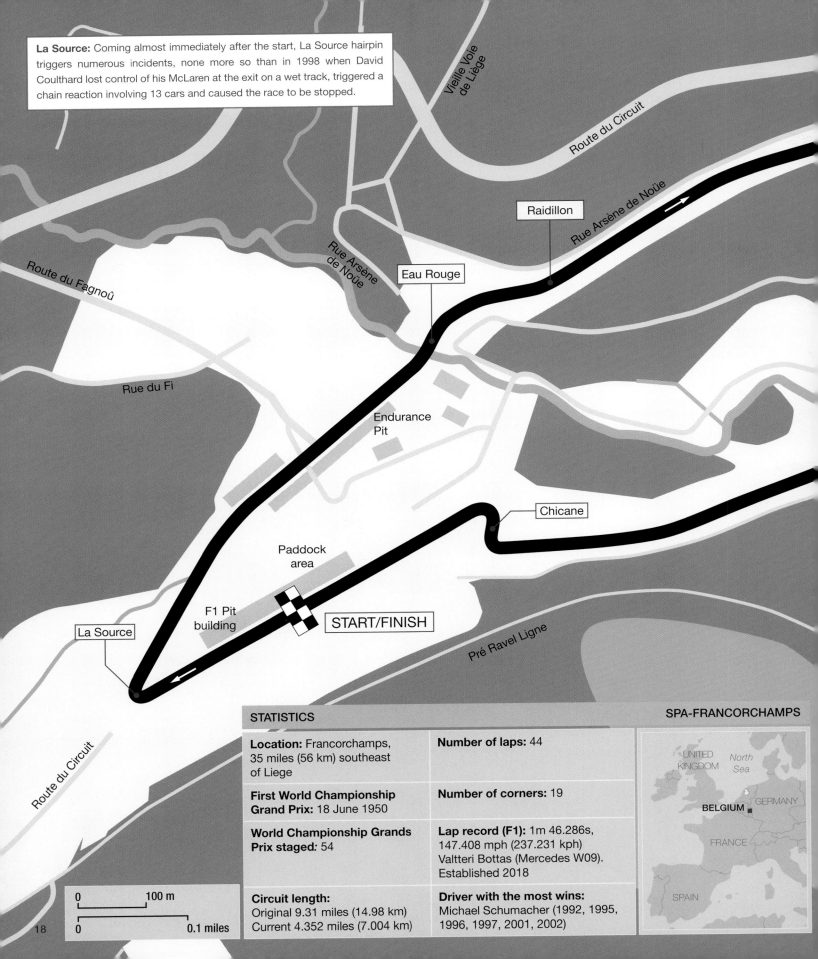

La Source: Coming almost immediately after the start, La Source hairpin triggers numerous incidents, none more so than in 1998 when David Coulthard lost control of his McLaren at the exit on a wet track, triggered a chain reaction involving 13 cars and caused the race to be stopped.

Vieille Voïe de Liège

Route du Circuit

Raidillon

Rue Arsène de Noüe

Rue Arsène de Noüe

Route du Fagnoû

Eau Rouge

Rue du Fi

Endurance Pit

Chicane

Paddock area

La Source

F1 Pit building

START/FINISH

Pré Ravel Ligne

Route du Circuit

0 100 m

0 0.1 miles

18

STATISTICS

SPA-FRANCORCHAMPS

Location: Francorchamps, 35 miles (56 km) southeast of Liege	**Number of laps:** 44
First World Championship Grand Prix: 18 June 1950	**Number of corners:** 19
World Championship Grands Prix staged: 54	**Lap record (F1):** 1m 46.286s, 147.408 mph (237.231 kph) Valtteri Bottas (Mercedes W09). Established 2018
Circuit length: Original 9.31 miles (14.98 km) Current 4.352 miles (7.004 km)	**Driver with the most wins:** Michael Schumacher (1992, 1995, 1996, 1997, 2001, 2002)

UNITED KINGDOM

North Sea

BELGIUM

GERMANY

FRANCE

SPAIN

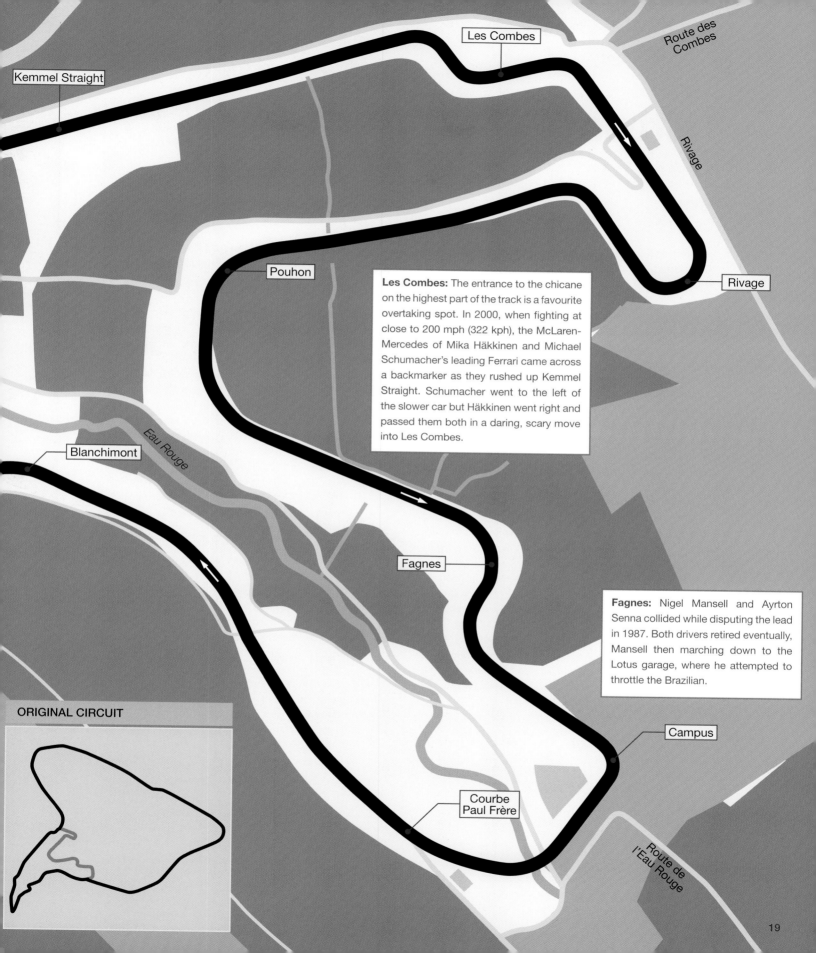

Kemmel Straight

Les Combes

Route des Combes

Rivage

Pouhon

Eau Rouge

Blanchimont

Les Combes: The entrance to the chicane on the highest part of the track is a favourite overtaking spot. In 2000, when fighting at close to 200 mph (322 kph), the McLaren-Mercedes of Mika Häkkinen and Michael Schumacher's leading Ferrari came across a backmarker as they rushed up Kemmel Straight. Schumacher went to the left of the slower car but Häkkinen went right and passed them both in a daring, scary move into Les Combes.

Rivage

Fagnes

Fagnes: Nigel Mansell and Ayrton Senna collided while disputing the lead in 1987. Both drivers retired eventually, Mansell then marching down to the Lotus garage, where he attempted to throttle the Brazilian.

Campus

ORIGINAL CIRCUIT

Courbe Paul Frère

Route de l'Eau Rouge

19

Nürburgring Nordschleife 1926

Nürburg

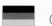 GERMANY

Almost defied description when opened in 1926 to alleviate unemployment and show off the might of the German auto industry in the 1930s. The 14-mile (22.5-km) switch-back ride through the Eifel mountains was ruled out for F1 after Niki Lauda's near-fatal accident in 1976.

The foundation stone for the Nürburgring was laid on 27 September 1925. The project in the Eifel mountains had been instigated to ease unemployment in the Coblenz-Cologne region and would later be seen as the perfect proving ground for the might of a German automobile industry led by Mercedes-Benz and Auto Union.

The Nürburgring in its entirety measured 17.58 miles (28.29 km), made up of two circuits, the South (Sudschleife) and the North (Nordschleife), each using the same start/ finish line and pit and paddock complex. There were more than 130 corners looping around Schloss Nürburg, one of the oldest castles in the Rhineland and overlooking the hamlet of Nürburg from which the circuit derived its name. The relentless succession of twists and turns, plunging and climbing, no two corners the same, would provide a massive and unique challenge as this giant of a track carved its way through the forests.

On 17 July 1927, Otto Merz took almost five hours to complete 18 laps of the combined circuits as he led a clean sweep by Mercedes-Benz in the second German Grand Prix (the first having been held at Avus). The Wall Street Crash and World War II combined to make the Nürburgring largely redundant and it was not ready for Grand Prix racing again until 1951. Using 'only' the 14.17 miles (22.80 km) of the Nordschleife, the Ferrari of Alberto Ascari beat Juan Manuel Fangio's Alfa Romeo by more than half a minute.

The scene was set for the Nürburgring's regular inclusion in the championship, providing the canvas for acts of derring-do (Fangio's legendary comeback from a pit stop in 1957; Jackie Stewart's epic win in fog and rain in 1968) and not altogether unexpected tragedy on such an inherently dangerous race track.

Concerns about safety, sometimes exacerbated by weather of unremitting bleakness, led to a boycott and a switch to Hockenheim in 1970. On their return the following year, drivers found the Nürburgring to be more sanitised and, ironically, much faster after trees and hedges had been removed, rock faces demolished and some of the bumps and crests eased.

Nonetheless it remained a daunting place even though the race was reduced to 12 laps (later extended to 14), a driver's main fear being the slim chance of receiving attention quickly in the event of an accident at one of the many remote locations.

That concern was to be realised in 1976 when Niki Lauda crashed at Bergwerk, his Ferrari catching fire and being rammed by another car. It is one of the miracles of motor sport that the Austrian, trapped in the cockpit, somehow survived. But the Nürburgring did not, its place on the F1 calendar taken by Hockenheim and then, a decade later, by the New Nürburgring, roughly where the Sudschleife used to be.

The Nordschleife, because of its length, could never comply with modern safety and security standards. It remains in all its terrifying majesty, used occasionally for competition and open to the public as a monument to how racing used to be.

Top: An aerial view from 1957 shows the long, dark roof of the Sport Hotel opposite the pits. In the background, the track heads off towards Hatzenbach, the return loop to the pits clearly shown for drivers warming up and not wishing to complete a full 14-mile lap. The enclosed square paddock with lock-up garages – a novelty at the time – can be seen in the foreground.

Bottom: Having descended Ex-Mühle, Jackie Stewart crosses Adenau Bridge during practice in 1971 with the spare Tyrrell (designated by 'T' for training). Stewart went on to win the race.

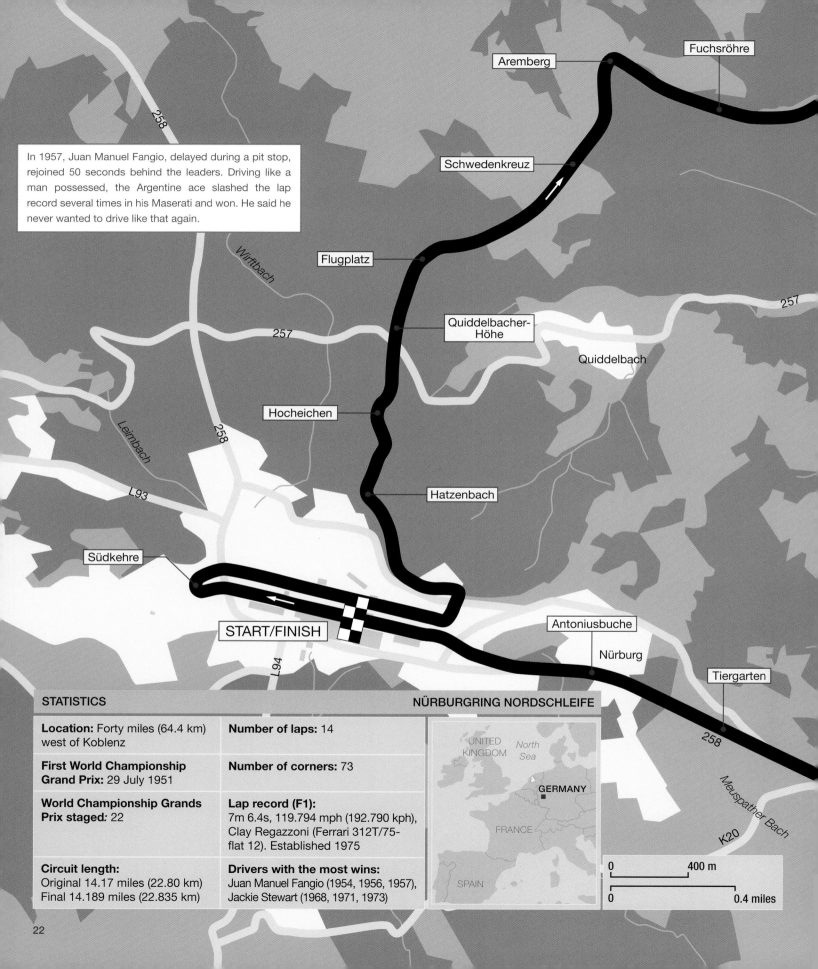

Fuchsröhre

Aremberg

Schwedenkreuz

In 1957, Juan Manuel Fangio, delayed during a pit stop, rejoined 50 seconds behind the leaders. Driving like a man possessed, the Argentine ace slashed the lap record several times in his Maserati and won. He said he never wanted to drive like that again.

Wirftbach

Flugplatz

Quiddelbacher-Höhe

257

Quiddelbach

257

258

Leimbach

Hocheichen

L93

258

Hatzenbach

Südkehre

START/FINISH

Antoniusbuche

Nürburg

Tiergarten

L94

258

Meuspather Bach

K20

STATISTICS

NÜRBURGRING NORDSCHLEIFE

Location: Forty miles (64.4 km) west of Koblenz

Number of laps: 14

First World Championship Grand Prix: 29 July 1951

Number of corners: 73

World Championship Grands Prix staged: 22

Lap record (F1):
7m 6.4s, 119.794 mph (192.790 kph), Clay Regazzoni (Ferrari 312T/75-flat 12). Established 1975

Circuit length:
Original 14.17 miles (22.80 km)
Final 14.189 miles (22.835 km)

Drivers with the most wins:
Juan Manuel Fangio (1954, 1956, 1957), Jackie Stewart (1968, 1971, 1973)

UNITED KINGDOM

North Sea

GERMANY

FRANCE

SPAIN

0 400 m

0 0.4 miles

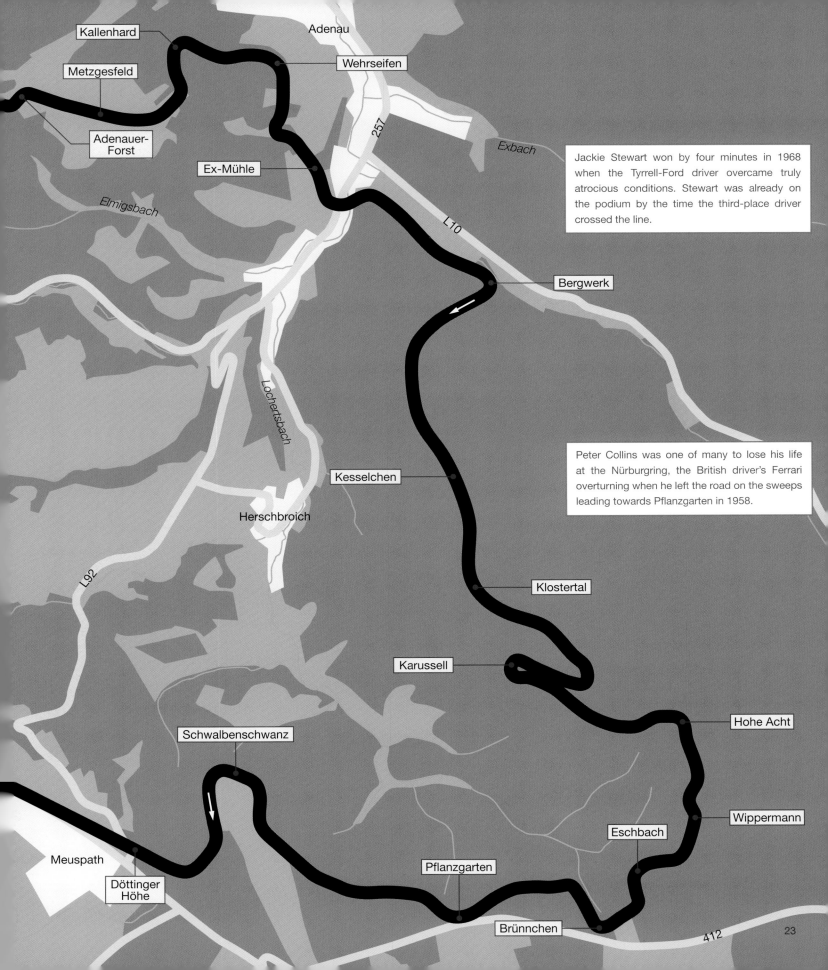

Kallenhard

Metzgesfeld

Adenau

Wehrseifen

Adenauer-
Forst

257

Ex-Mühle

Exbach

Elmigsbach

L10

Jackie Stewart won by four minutes in 1968 when the Tyrrell-Ford driver overcame truly atrocious conditions. Stewart was already on the podium by the time the third-place driver crossed the line.

Bergwerk

Lochertsbach

Kesselchen

Peter Collins was one of many to lose his life at the Nürburgring, the British driver's Ferrari overturning when he left the road on the sweeps leading towards Pflanzgarten in 1958.

Herschbroich

Klostertal

L92

Karussell

Hohe Acht

Schwalbenschwanz

Wippermann

Eschbach

Meuspath

Döttinger
Höhe

Pflanzgarten

Brünnchen

412

23

Monaco 1929

Circuit de Monaco

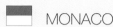 MONACO

One of the best-known events in the world of sport, the glamorous backdrop captures the imagination as readily as it provides a unique challenge for the drivers. Three-quarters of the street circuit remains exactly as it was when first used for the Monaco Grand Prix in 1929.

A decision to run a motor race through the streets had nothing to do with sport as such. It was driven by the need to attract visitors to Monte Carlo and increase Monaco's stature and independence in the eyes of the world.

As luck would have it, the location of the tiny Principality on a rock face overlooking the Mediterranean would provide the perfect venue for a circuit in the days when motor races where held on public roads rather than on closed tracks. The Monaco Grand Prix became the first motor race to be run inside a town.

The circuit rose steeply from sea level to a narrow gap between the Hotel de Paris and the equally imposing casino, before plunging and twisting downhill towards the seafront and the return leg through a tunnel and alongside the harbour. With the bulk of the track, including the start/finish area, overlooked by a royal palace, this unique sporting occasion could not help but intrigue and charm despite concerns over holding a motor race within such narrow confines.

In the event, those natural restrictions would provide a special challenge. The first Grand Prix in 1929 was won by a Bugatti driven by William Grover, an expatriate Englishman known simply as 'Williams' who drove with a peaked cap worn back to front. With only two minor casualties in a race lasting almost four hours, the Grand Prix was adjudged an outstanding success.

After initial reservations, the Monegasques came to accept having daily life totally disrupted once a year as the race became an accepted event on both the Grand Prix schedule and the world's social calendar. The importance of the race grew in commercial terms with the arrival of motor sport sponsorship in the late '60s, Monaco being the place to entertain and do deals, to the point where the noise of the F1 cars practising was sometimes seen as an intrusion.

The one significant change to the layout occurred in 1973 when a loop around the swimming pool was added to lengthen the track and allow necessary expansion of the pits – previously nothing more than a traffic island in the middle of a dual carriageway, with cars racing past either side.

None of this diluted the challenge, Monaco remaining unique in having kerbs, walls, barriers and the difficulties of normal street surfaces waiting to punish the smallest error of judgement. Competing through the streets of Monte Carlo may not be about wheel-to-wheel racing in the accepted sense but it continues to present an extreme test of concentration and precision as drivers attempt to contain powerful machinery caged in by the menacing surroundings.

If the race did not exist and you suggested the idea today, the proposal would be considered unworkable and probably insane. But it exists as a finely-honed occasion that allows the audience to witness the brute power of F1 cars close up in stunning surroundings.

In 1956, the start line was where the pit lane is located today, with the 'pits' being no more than the central reservation beneath the trees to the left of the picture. The Maserati 250F of eventual winner Stirling Moss jumps into the lead as the pack heads towards the Gasworks Hairpin before swinging right onto today's start-finish straight.

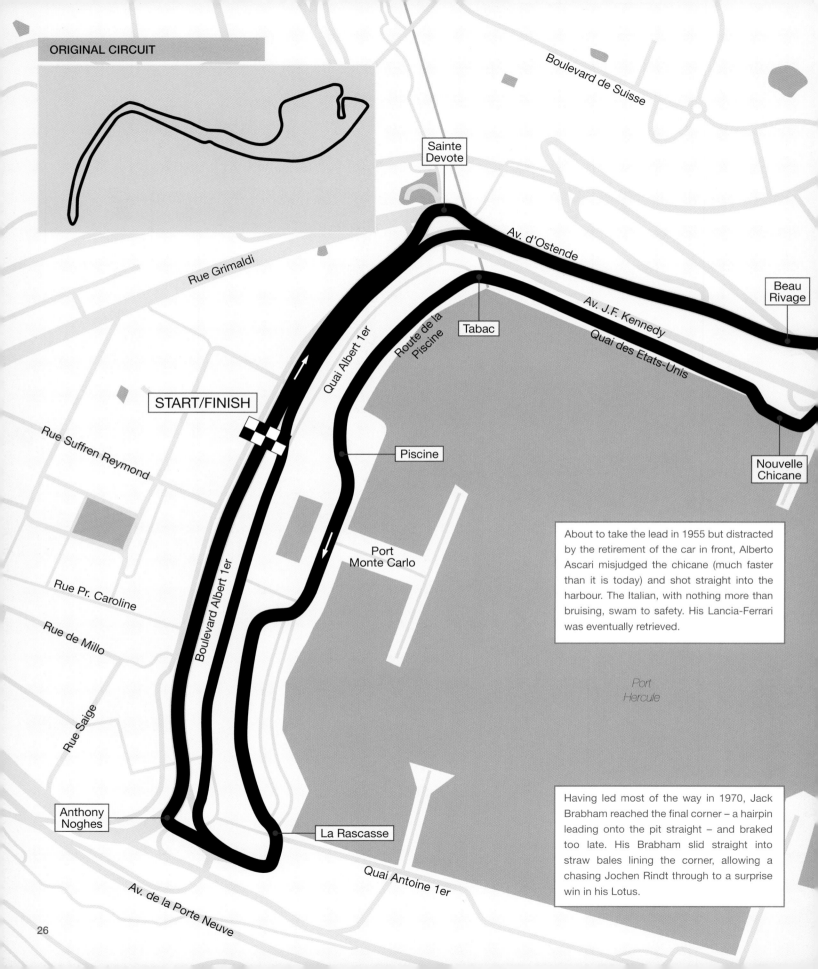

ORIGINAL CIRCUIT

Sainte
Devote

Boulevard de Suisse

Av. d'Ostende

Rue Grimaldi

Av. J.F. Kennedy

Beau
Rivage

Quai Albert 1er

Route de la
Piscine

Tabac

Quai des Etats-Unis

START/FINISH

Rue Suffren Reymond

Piscine

Nouvelle
Chicane

Rue Pr. Caroline

Port
Monte Carlo

Rue de Millo

About to take the lead in 1955 but distracted by the retirement of the car in front, Alberto Ascari misjudged the chicane (much faster than it is today) and shot straight into the harbour. The Italian, with nothing more than bruising, swam to safety. His Lancia-Ferrari was eventually retrieved.

Boulevard Albert 1er

Rue Saige

Port
Hercule

Anthony
Noghes

La Rascasse

Quai Antoine 1er

Av. de la Porte Neuve

Having led most of the way in 1970, Jack Brabham reached the final corner – a hairpin leading onto the pit straight – and braked too late. His Brabham slid straight into straw bales lining the corner, allowing a chasing Jochen Rindt through to a surprise win in his Lotus.

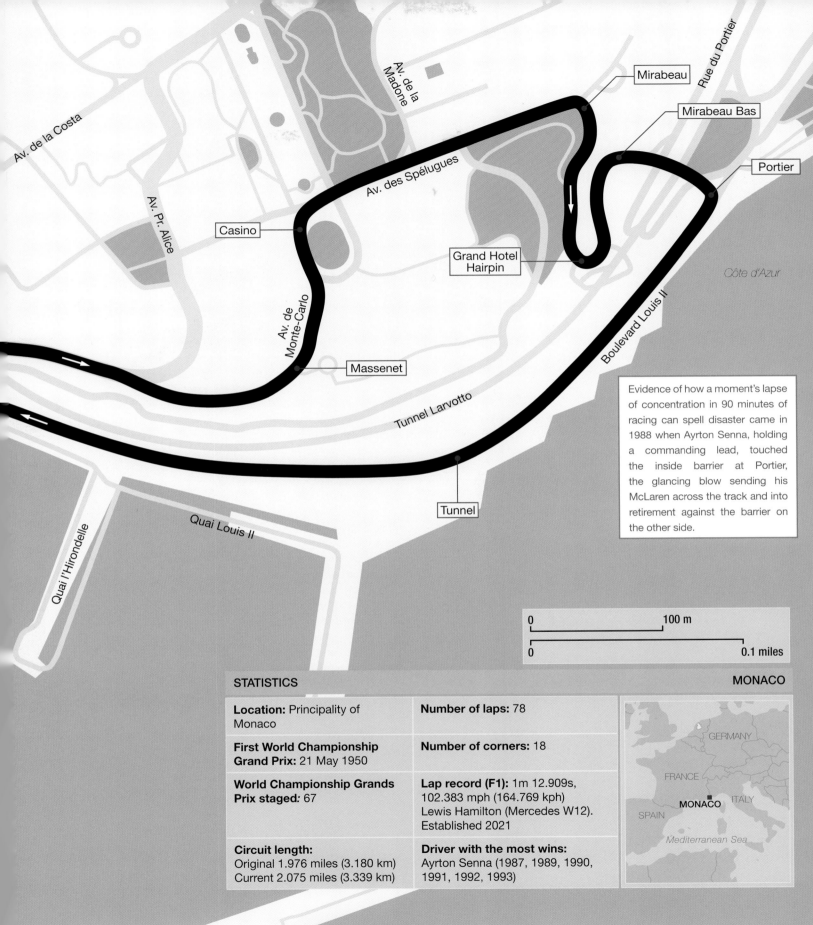

Mirabeau

Rue du Portier

Mirabeau Bas

Portier

Av. de la Madone

Av. de la Costa

Av. des Spélugues

Casino

Av. Pr. Alice

Av. de Monte-Carlo

Grand Hotel Hairpin

Côte d'Azur

Massenet

Boulevard Louis II

Tunnel Larvotto

Tunnel

Quai l'Hirondelle

Quai Louis II

Evidence of how a moment's lapse of concentration in 90 minutes of racing can spell disaster came in 1988 when Ayrton Senna, holding a commanding lead, touched the inside barrier at Portier, the glancing blow sending his McLaren across the track and into retirement against the barrier on the other side.

| 0 | 100 m |
| 0 | 0.1 miles |

STATISTICS

MONACO

Location: Principality of Monaco	**Number of laps:** 78
First World Championship Grand Prix: 21 May 1950	**Number of corners:** 18
World Championship Grands Prix staged: 67	**Lap record (F1):** 1m 12.909s, 102.383 mph (164.769 kph) Lewis Hamilton (Mercedes W12). Established 2021
Circuit length: Original 1.976 miles (3.180 km) Current 2.075 miles (3.339 km)	**Driver with the most wins:** Ayrton Senna (1987, 1989, 1990, 1991, 1992, 1993)

GERMANY

FRANCE

MONACO

ITALY

SPAIN

Mediterranean Sea

27

Reims 1932

Reims-Gueux

 FRANCE

A classic French circuit, triangular in shape, using three main roads near the city of Reims. First used for a Grand Prix in 1932, it may have been very fast and not particularly demanding, but Reims was extremely popular, not least because of the beauty and products of the Champagne region. Last used in 1966.

With France having been the cradle of motor sport since the early 1900s, it was no surprise when a number of Grands Prix were held on a variety of French road circuits while the rest of Europe took longer to re-establish racing following World War I.

In 1925, a circuit was devised following the traditional pattern of using part of a main road, in this case, the RN31 running from Reims to Soissons. Either end of the fast straight between La Garenne and Thillois was linked by lesser roads, the D27 and the D26.

In 1932, the Automobile Club de Champagne proposed a Grand Prix. The pits were located on a long straight running from Thillois to Gueux (hence the venue's title 'Reims-Gueux'). The circuit turned sharp right in the tiny village before heading into open country once more, joining the Reims-Soissons road at La Garenne and rushing flat out towards the hairpin at Thillois.

In the 1950s, modifications saw the introduction of a fast curve after the pits, by-passing Gueux, crossing the original road from Gueux to La Garenne and joining the RN31 further down at Muizon, thus making the straight to Thillois even longer and faster.

The improvements also included impressive permanent grandstands, press box, restaurant and pits, linked by a tunnel and a bridge. To further enhance the growing popularity of this event in the height of summer, the French Grand Prix quickly gained a reputation for thorough organisation, even to the detail of having a flock of sheep constantly cropping the grass in public areas. It was probably no coincidence that a steady flow of Champagne throughout the weekend helped boost the event's popularity.

Much of the order and efficiency was credited to the club's secretary general, Raymond 'Toto' Roche, a rotund man with a reputation, as race starter, for standing in the middle of the road, dropping the flag without warning and making a run for it. The miracle each year was that Roche was not run over – although it was not for the want of trying by drivers exasperated by his antics.

The circuit may have been foot-to-the-floor for almost its entire length but the slipstreaming battles became legendary, none more so than in 1953 when the young Englishman, Mike Hawthorn, raced wheel to wheel with Juan Manual Fangio and beat the Argentine legend by a whisker.

Inevitably, with such high speeds, tragedy was a frequent visitor. The safety work necessary to bring Reims into line with contemporary thinking in 1967 was deemed excessive, even for a wealthy club such as the AC de Champagne, and the French Grand Prix moved on. In some ways, it was good that the essential spirit of racing on this classic track was not tarnished by chicanes and other devices to slow the cars. Reims had enjoyed its days of slipstreaming glory, not to mention memorable hangovers.

Top: Mike Hawthorn (left) looks across at Juan Manuel Fangio while flat out during their epic dual in 1953. Hawthorn's Ferrari beat the maestro's Maserati by a whisker.

Bottom: Classic mid-summer Reims scene of sunshine and cornfields as Jack Brabham, crouching in his Brabham-Repco, heads for victory in 1966. It would be the first win for a driver in a car bearing his own name and the last Grand Prix at Reims.

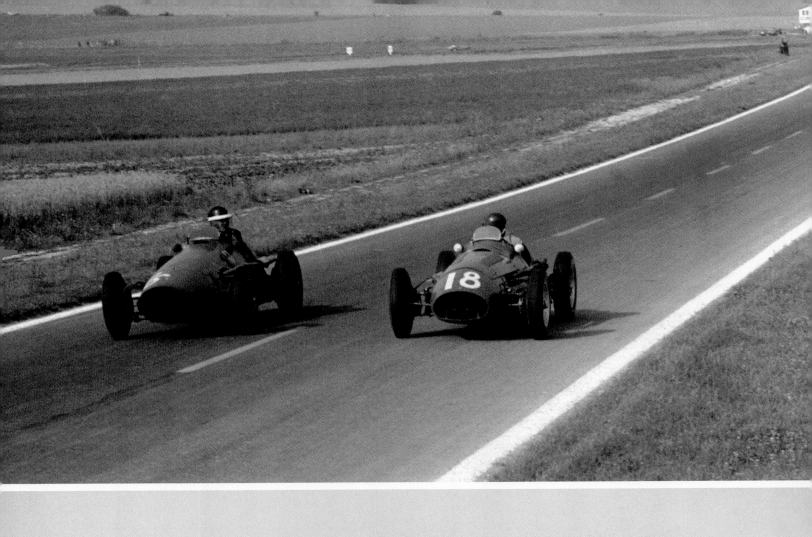
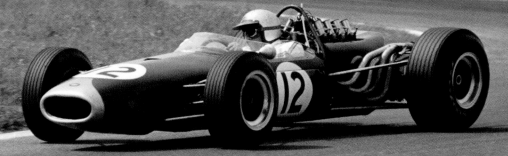

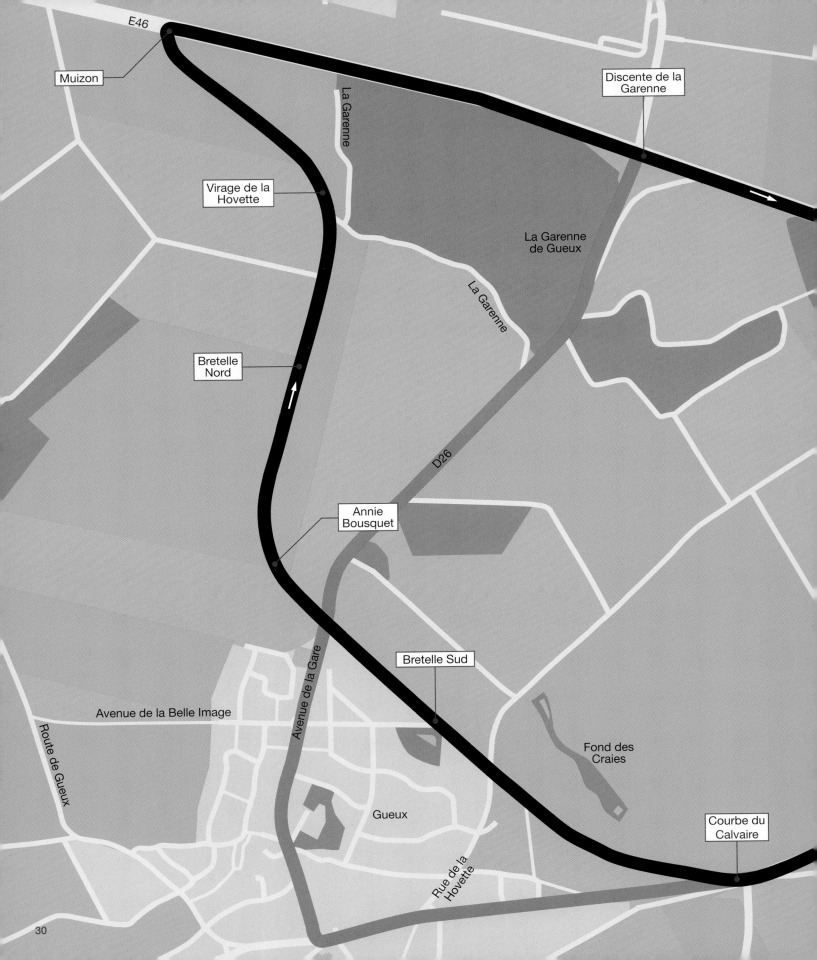

E46

Muizon

Discente de la
Garenne

La Garenne

Virage de la
Hovette

La Garenne
de Gueux

La Garenne

Bretelle
Nord

D26

Annie
Bousquet

Avenue de la Gare

Bretelle Sud

Avenue de la Belle Image

Fond des
Craies

Route de Gueux

Gueux

Courbe du
Calvaire

Rue de la
Hovette

STATISTICS

Location: Five miles (8 km) west of Reims	**Number of laps:** 48
First World Championship Grand Prix: 2 July 1950	**Number of corners:** 5
World Championship Grands Prix staged: 11	**Lap record (F1):** 2m 11.3s, 141.435 mph (227.618 kph), Lorenzo Bandini (Ferrari 312 V12). Established 1966
Circuit length: Original 4.859 miles (7.823 km) Last in use: 5.158 miles (8.301 km)	**Driver with the most wins:** Juan Manuel Fangio (1950, 1951, 1954)

UNITED KINGDOM

North Sea

GERMANY

FRANCE

SPAIN

0 200 m

0 0.2 miles

Route Nationale 31

N31

D227

D227

In preparation for a fast lap during practice in 1958, Stirling Moss pretended he had a problem with his car at Thillois and turned left instead of right. Turning the Vanwall around, Moss made a standing start and a much faster entrance to the pit straight than would have been possible had he taken the corner normally. He therefore crossed the start line much faster to commence what would be his best timed lap.

Virage de Thillois

D27

START/FINISH

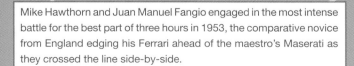

Mike Hawthorn and Juan Manuel Fangio engaged in the most intense battle for the best part of three hours in 1953, the comparative novice from England edging his Ferrari ahead of the maestro's Maserati as they crossed the line side-by-side.

Mike Hawthorn also won in 1958, his championship year, but the day was tainted by the death of his team-mate, Luigi Musso, when the Italian was thrown from the cockpit as his Ferrari left the road in the high-speed right hander after the pits.

Castle Donington 1937

Donington Park

 GREAT BRITAIN

The first licensed road circuit in England opened in 1933 in the grounds of a private estate in the Midlands. Hosted the Donington Grand Prix in 1937 and 1938 for pitched battles between Mercedes and Auto Union. Revived in the 1970s, Donington staged the 1993 European Grand Prix.

Major motor racing in Britain had been confined to Brooklands but, with the purpose-built track near Weybridge going into decline, an alternative was sought as interest in motor sport increased. Fred Craner, a garage owner from Derby and a keen motor cycle racer, persuaded the owner of the Donington Hall estate to allow racing in his parkland.

The unsealed estate roads were used initially, Craner then obtaining permission to use these as a framework for what would become the first permanent park circuit in England. Having previously staged events for bikes, the first car race was held on 25 March 1933, £12,000 having been spent on resurfacing the 2.25-mile (3.62-km) track.

Local drivers won races of increasing length and importance but Donington would gain international significance in 1937 by staging a round of the European Championship (in effect, the World Championship of the era). With the battle for German supremacy at its height, this would be a showdown between Mercedes-Benz and Auto Union, the two mighty marques threatening to blow away puny competition from British privateers. In the absence of a national sporting body of any significance, the race would be known as the Donington Grand Prix rather than incorporating 'British' in the title.

The thought of providing a suitable venue for the immensely powerful cars from Stuttgart and Zwickau had prompted Craner and the Derby and District Motor Club to further improve and lengthen the circuit to 3.125 miles (5.03 km) by adding the so-called Melbourne Loop. On 1 October 1937, the Auto Union of Bernd Rosemeyer beat the Mercedes-Benz of Manfred von Brauchitsch by just 38 seconds. The race, lasting three hours, was such a success that a repeat was planned for October of the following year.

With war clouds on the horizon, the race in October 1938 would be one of the last Grands Prix in Europe and the final major event at Donington. Twelve months later, the site would be requisitioned by the Ministry of Defence and become a military vehicle depot.

Donington remained more or less abandoned until 1971 when Tom Wheatcroft, a wealthy builder and single-seater racing car collector, bought the land, built a museum and set about reviving the track.

The circuit, roughly following the original layout, re-opened for car racing in May 1977 and went from strength to strength. Wheatcroft's private dream to host a World Championship F1 event was fulfilled in 1993 when the late cancellation of a race in Japan allowed the staging of the European Grand Prix on 11 April. Despite appalling weather throughout the Easter weekend, the race is fondly remembered for a truly mesmeric performance by Ayrton Senna in the winning McLaren-Ford.

Despite occasional optimistic plans, there would be no further F1 Grands Prix at Donington, the future and reputation of the circuit suffering from many damaging legal disputes. The history of Donington Park as a F1 venue has been brief but extremely spectacular.

Top: The one and only World Championship Grand Prix at Donington coincided with gloomy Easter weather in April 1993.

Bottom: Ayrton Senna produced one of his greatest drives when he dominated the European Grand Prix in his McLaren MP4/8-Ford.

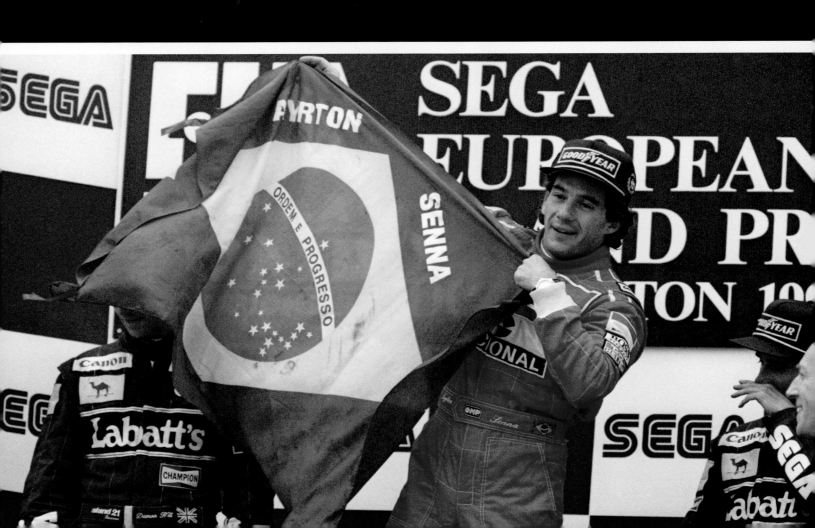

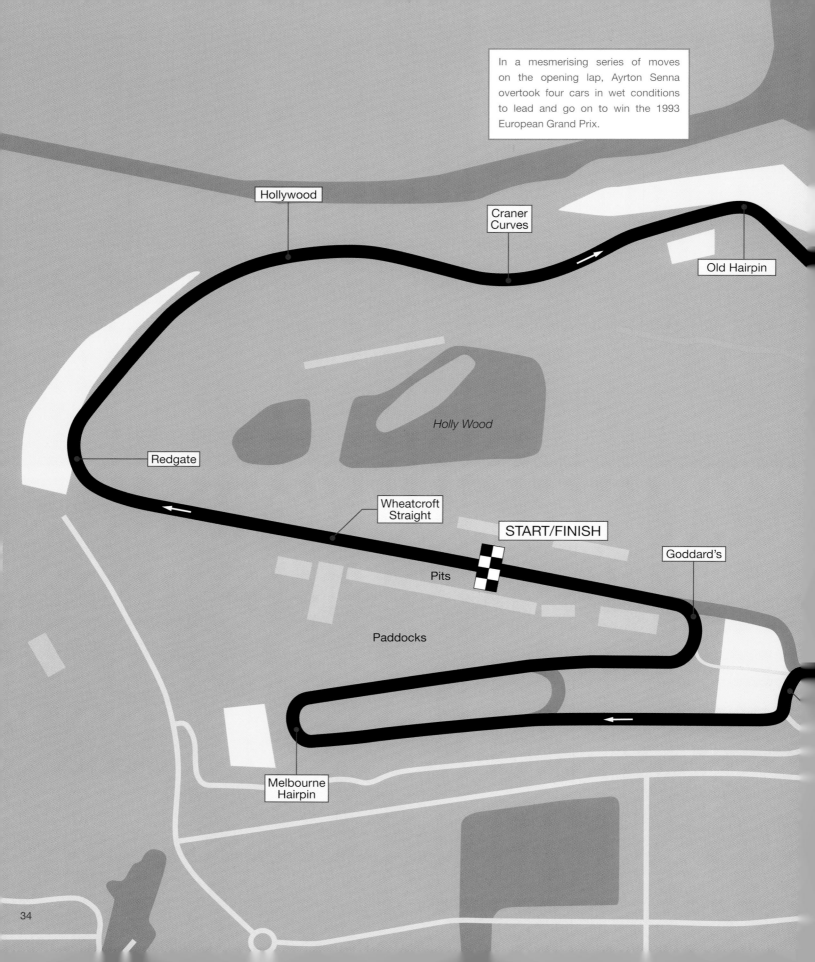

In a mesmerising series of moves on the opening lap, Ayrton Senna overtook four cars in wet conditions to lead and go on to win the 1993 European Grand Prix.

Hollywood

Craner Curves

Old Hairpin

Holly Wood

Redgate

Wheatcroft Straight

START/FINISH

Goddard's

Pits

Paddocks

Melbourne Hairpin

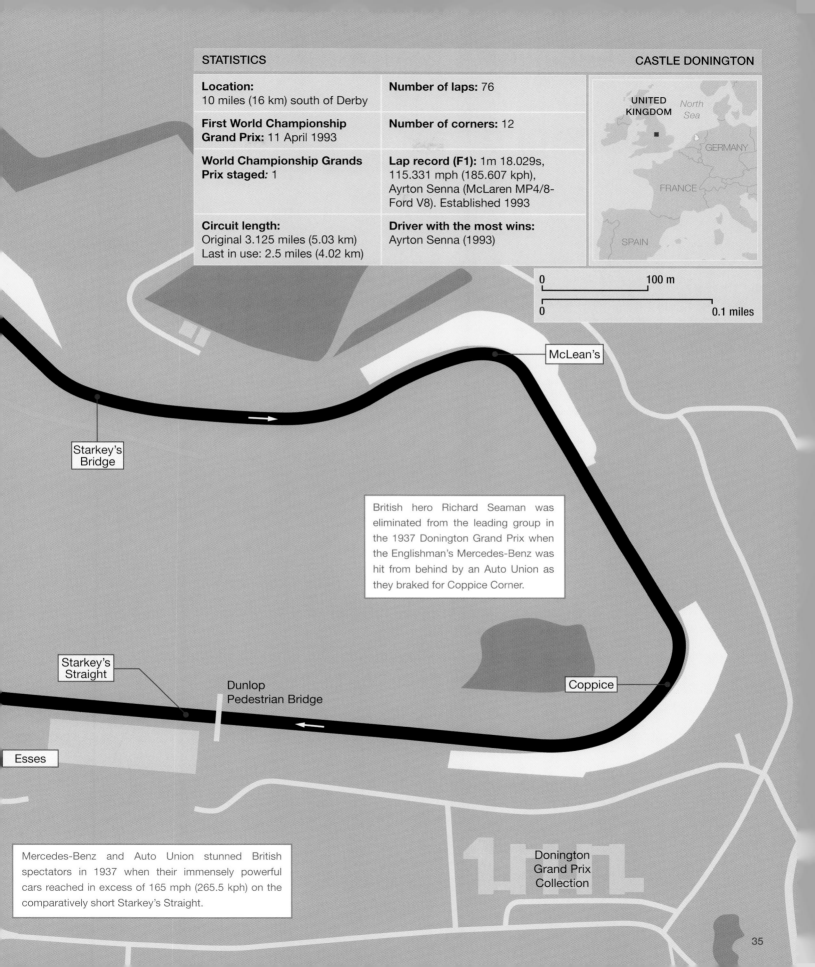

Location:
10 miles (16 km) south of Derby

Number of laps: 76

First World Championship Grand Prix: 11 April 1993

Number of corners: 12

World Championship Grands Prix staged: 1

Lap record (F1): 1m 18.029s, 115.331 mph (185.607 kph), Ayrton Senna (McLaren MP4/8-Ford V8). Established 1993

Circuit length:
Original 3.125 miles (5.03 km)
Last in use: 2.5 miles (4.02 km)

Driver with the most wins:
Ayrton Senna (1993)

UNITED KINGDOM
North Sea
GERMANY
FRANCE
SPAIN

0 100 m

0 0.1 miles

McLean's

Starkey's Bridge

British hero Richard Seaman was eliminated from the leading group in the 1937 Donington Grand Prix when the Englishman's Mercedes-Benz was hit from behind by an Auto Union as they braked for Coppice Corner.

Starkey's Straight

Dunlop Pedestrian Bridge

Coppice

Esses

Mercedes-Benz and Auto Union stunned British spectators in 1937 when their immensely powerful cars reached in excess of 165 mph (265.5 kph) on the comparatively short Starkey's Straight.

Donington Grand Prix Collection

Silverstone 1948

Silverstone Circuit

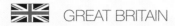 GREAT BRITAIN

Rightly called 'The Home of British Motor Racing', Silverstone's title could extend globally since this is the track where the very first round of the Formula 1 World Championship was held in 1950. The former wartime aerodrome has changed beyond recognition as the British Grand Prix continues to be one of the most respected on the F1 calendar.

Silverstone was built in 1943 for the purpose of training wartime bomber crews. When the airfield became redundant at the end of World War II and British motor sport enthusiasts were looking for a suitable venue to resume racing, the abandoned runways and perimeter road were an obvious choice.

After hosting two international races in 1948 and 1949, Silverstone was chosen as the venue for the first round of the newly constituted F1 World Championship in May 1950. The runways were abandoned in favour of the perimeter road, making Silverstone a high-speed track with a fastest lap average of 94 mph (151.3 kph).

Corners were named after local landmarks and locations associated with the Royal Automobile Club, organiser of the early Grands Prix: Stowe (Stowe School, to the south of the circuit); Hangar Straight (running past two large aircraft hangers, since demolished); Becketts and Chapel (adjacent to the ancient Chapel of St Thomas á Becket) and Club and Woodcote (after the RAC's premises in London's Pall Mall and Surrey). Silverstone continued to host the British Grand Prix, occasionally alternating with Aintree (on the roads around the Grand National horse racing course) and, in 1964, a new venue at Brands Hatch.

As technical developments on the cars saw speeds rise at Silverstone (Ronnie Peterson's Lotus-Ford setting the fastest lap in 1973 at an average of 135 mph [217.3 kph]), a chicane was introduced in 1975 at Woodcote, previously a sweeping right-hander just before the pits.

The chicane did its job for several years but further steps needed to be taken in the interest of safety when Keke Rosberg's turbocharged Williams-Honda claimed pole for the 1985 British Grand Prix at an average of 160 mph (257.5 kph). A dogleg left before Woodcote (and the removal of the chicane) marked the first major change since 1949.

The stepping up of standards worldwide meant Silverstone followed suit by demolishing and replacing the old pits in 1988. For 1992, major revisions altered the track layout and yet retained the essential character with a high-speed sequence of bends at Becketts and an infield loop at Priory, the circuit length stretching to 3.2 miles (5.15 km).

The most substantial reworking of the track layout and facilities came in 2011 with a large inner loop extending the length to 3.6 miles (5.79 km) and the addition of the Wing pit and paddock complex costing £27 million.

The shape of Silverstone may have changed over 60 years but the challenge and unique atmosphere associated with one of the world's greatest race tracks has remained.

Top: Memorable moment in 1991 as Ayrton Senna, his McLaren out of fuel, hitches a ride back to the pits on Nigel Mansell's victorious Williams-Renault.

Bottom: The most recent development of an ever-changing scene came in 2011 with the building of the Silverstone Wing pit and paddock complex at Club Corner. Part of one of the former airfield's runways (and part of the original race track) can be seen behind the paddock.

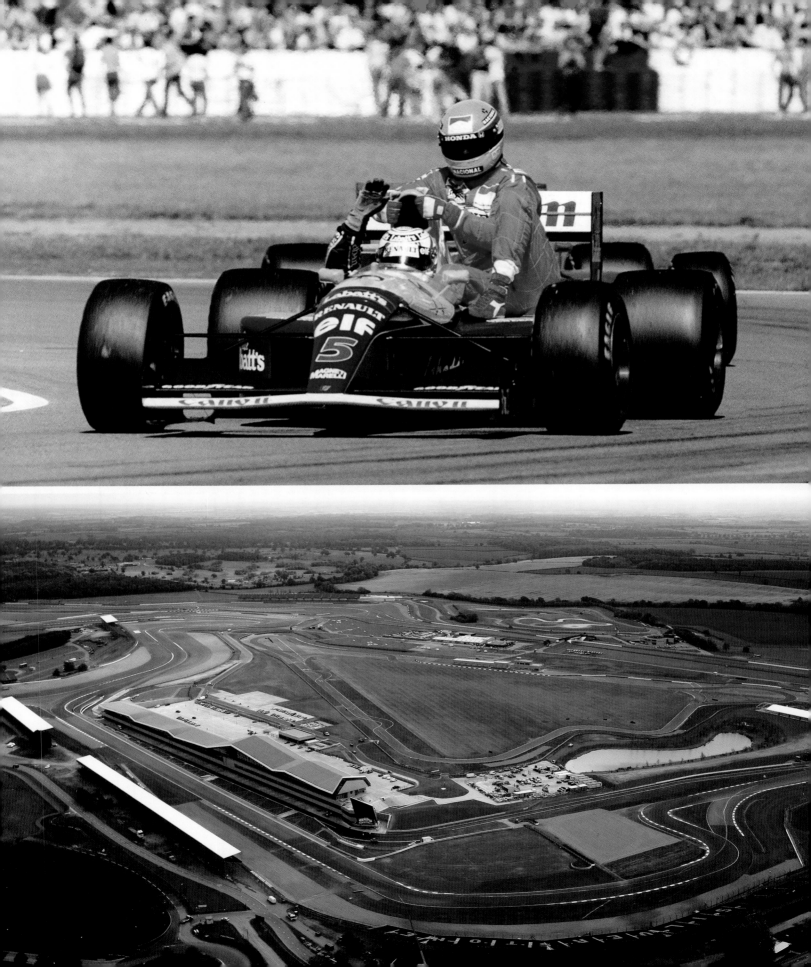

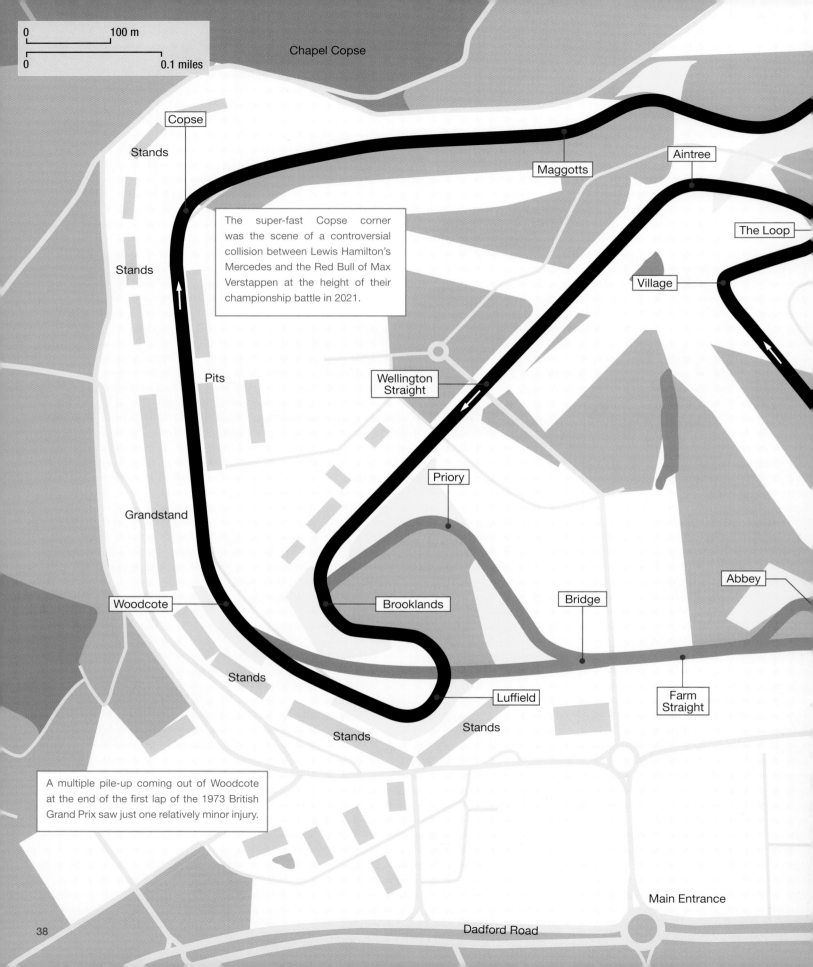

Chapel Copse

0 100 m

0 0.1 miles

Copse

Stands

Maggotts

Aintree

The Loop

Stands

The super-fast Copse corner was the scene of a controversial collision between Lewis Hamilton's Mercedes and the Red Bull of Max Verstappen at the height of their championship battle in 2021.

Village

Pits

Wellington Straight

Priory

Grandstand

Abbey

Woodcote

Brooklands

Bridge

Luffield

Farm Straight

Stands

Stands

A multiple pile-up coming out of Woodcote at the end of the first lap of the 1973 British Grand Prix saw just one relatively minor injury.

Stands

Main Entrance

Dadford Road

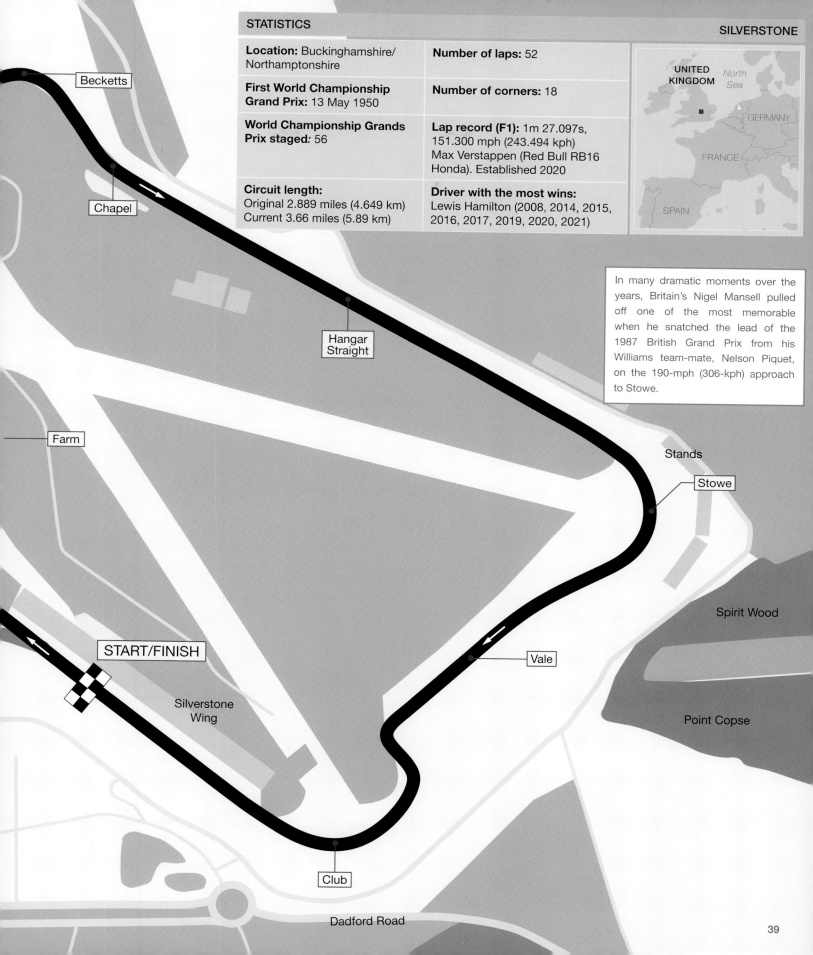

STATISTICS

Location: Buckinghamshire/ Northamptonshire

First World Championship Grand Prix: 13 May 1950

World Championship Grands Prix staged: 56

Circuit length:
Original 2.889 miles (4.649 km)
Current 3.66 miles (5.89 km)

Number of laps: 52

Number of corners: 18

Lap record (F1): 1m 27.097s, 151.300 mph (243.494 kph) Max Verstappen (Red Bull RB16 Honda). Established 2020

Driver with the most wins: Lewis Hamilton (2008, 2014, 2015, 2016, 2017, 2019, 2020, 2021)

UNITED KINGDOM

North Sea

GERMANY

FRANCE

SPAIN

In many dramatic moments over the years, Britain's Nigel Mansell pulled off one of the most memorable when he snatched the lead of the 1987 British Grand Prix from his Williams team-mate, Nelson Piquet, on the 190-mph (306-kph) approach to Stowe.

Becketts

Chapel

Hangar Straight

Farm

Stands

Stowe

Spirit Wood

START/FINISH

Vale

Silverstone Wing

Point Copse

Club

Dadford Road

Berne 1950

Circuit Bremgarten

 SWITZERLAND

A true road course, fast and dangerous, sweeping through the Bremgarten forest on the outskirts of Berne. Used initially for motor cycle racing, Bremgarten staged the inaugural Swiss Grand Prix in 1934. Remained in regular use until 1955, when motor racing was banned in Switzerland.

For a country that would ultimately ban motor racing on the grounds of safety, Switzerland offered a massive contradiction in the shape of Bremgarten, considered to be extremely dangerous, even in more cavalier days several decades ago.

When motor sport on closed public roads was at its height in the 1930s, Switzerland joined neighbouring countries in the rush to host a race by earmarking a circuit looping through *Bremgartenwald*, a forest on the northern edge of Berne.

Having no straights to speak of, the 4.52-mile (7.27-km) track was formed by a relentless series of curves and high-speed corners. With the close proximity of trees restricting light, natural hazards were exacerbated by constant changes in road surface that became even more lethal in the wet. Thanks to an average speed of around 100 mph (161 kph), accidents were inevitable.

Introduced originally as a motor cycle racing circuit in 1931, Bremgarten hosted its first car race three years later and claimed the life of British privateer Hugh Hamilton when his Maserati crashed into the trees. The fact that the Ulsterman had suffered a tyre failure (and a post mortem allegedly declared his heart had stopped before the incident) did nothing to detract from the circuit's ever-present danger.

The risk element would be confirmed during practice for the 1948 Swiss Grand Prix when Achille Varzi, a legendary figure, lost control on a wet surface, the Italian's Alfa Romeo flipping over and crushing him to death. The sombre mood was heightened when the Swiss privateer, Christian Kautz, was killed during the race.

Bremgarten had been used regularly until the outbreak of World War II, Auto Union and Mercedes-Benz battling it out with great names such as Rudolph Caracciola and Bernd Rosemeyer claiming victory. When racing returned in 1947, Alberto Ascari and Juan Manuel Fangio were among the brave men adding their names to the roll of honour.

Fangio's win for Mercedes-Benz in 1954 would be the last at Bremgarten, the following year's Swiss Grand Prix being cancelled in the highly-charged political atmosphere following the death of more than 80 spectators during the Le Mans 24-Hour race the previous June. Bremgarten was never used again, not that it was likely to survive into a more safety conscious era.

Alberto Ascari grits his teeth as he tackles the many hazards of the Bremgarten road circuit on his way to one of five victories with the Ferrari 500 during the Italian's championship year in 1953.

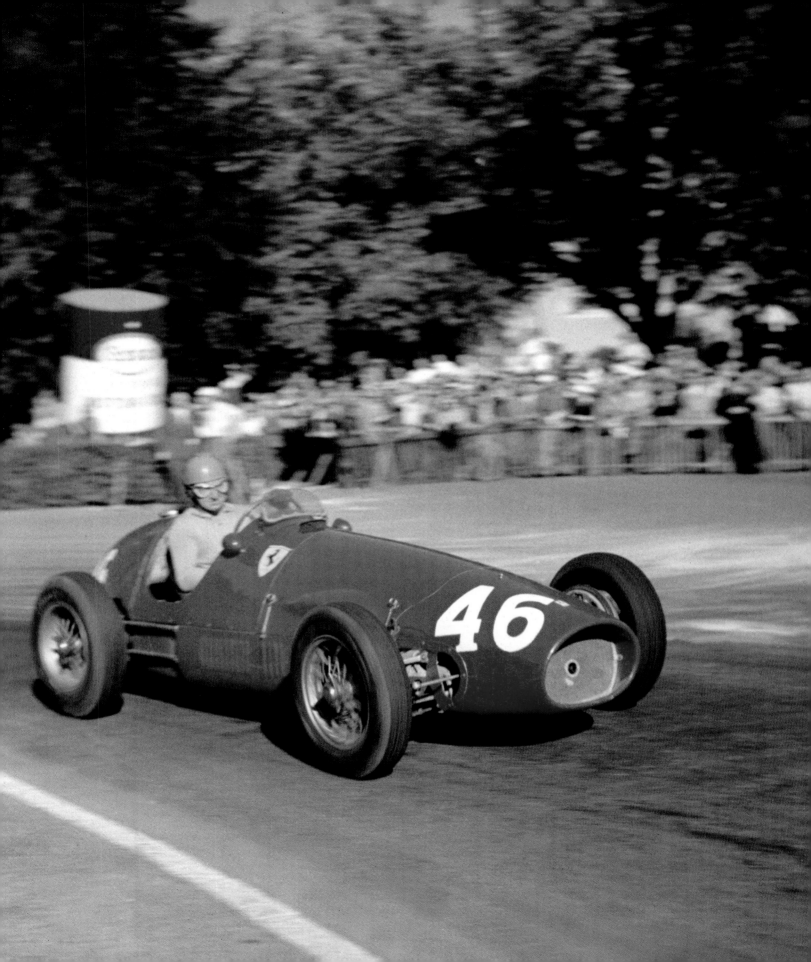

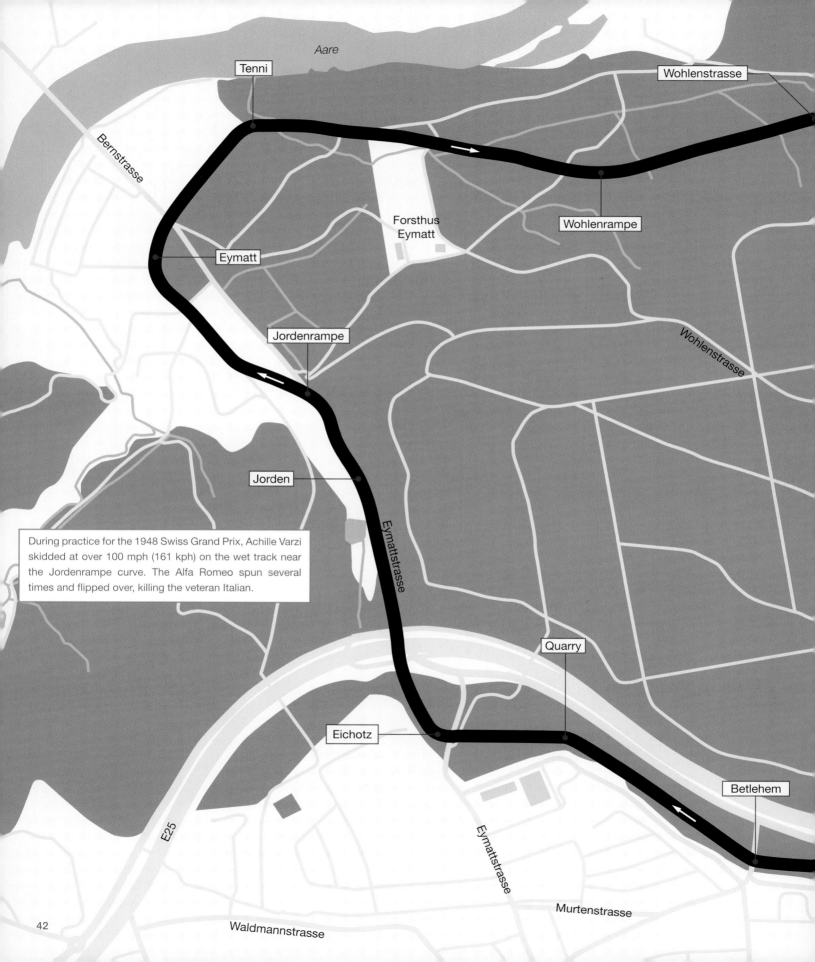

During practice for the 1948 Swiss Grand Prix, Achille Varzi skidded at over 100 mph (161 kph) on the wet track near the Jordenrampe curve. The Alfa Romeo spun several times and flipped over, killing the veteran Italian.

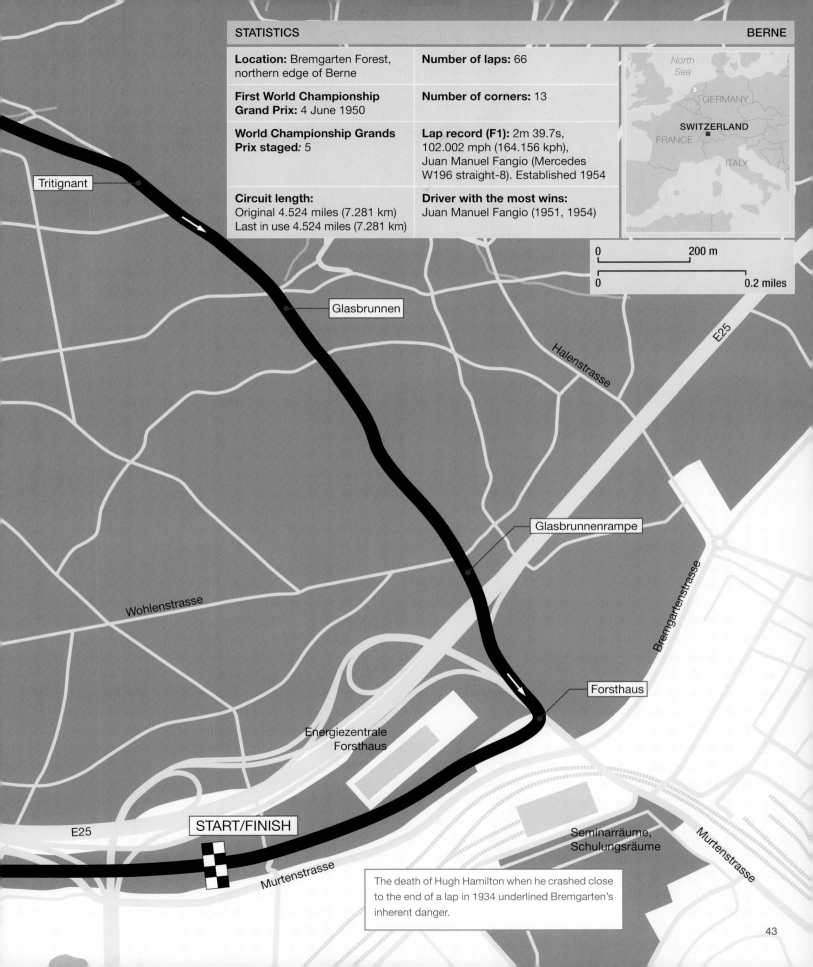

STATISTICS

Location: Bremgarten Forest, northern edge of Berne

First World Championship Grand Prix: 4 June 1950

World Championship Grands Prix staged: 5

Circuit length:
Original 4.524 miles (7.281 km)
Last in use 4.524 miles (7.281 km)

Number of laps: 66

Number of corners: 13

Lap record (F1): 2m 39.7s, 102.002 mph (164.156 kph), Juan Manuel Fangio (Mercedes W196 straight-8). Established 1954

Driver with the most wins: Juan Manuel Fangio (1951, 1954)

North Sea

GERMANY

SWITZERLAND

FRANCE

ITALY

0 200 m

0 0.2 miles

Tritignant

Glasbrunnen

Halenstrasse

E25

Glasbrunnenrampe

Wohlenstrasse

Bremgartenstrasse

Forsthaus

Energiezentrale Forsthaus

START/FINISH

E25

Murtenstrasse

Seminarräume, Schulungsräume

Murtenstrasse

The death of Hugh Hamilton when he crashed close to the end of a lap in 1934 underlined Bremgarten's inherent danger.

43

Barcelona Pedralbes 1951

Pedralbes Circuit

SPAIN

A 2.8-mile (4.5-km) combination of streets in a central suburb of Barcelona, roughly triangular in shape and hosting rounds of the F1 World Championship in the early 1950s. The fast, wide and relatively straightforward circuit was used to settle the championship in 1951.

Spain's lengthy and varied history of motor races included the Penya Rhin Grand Prix. Established as a private society in Barcelona to encourage motor sport in Catalonia, Penya Rhin had been running their own Grand Prix, starting in 1921 at Vilafranca del Penedés, a triangular series of roads 25 miles from Barcelona, and moving 12 years later to Montjuïc in the city.

When racing was resumed after World War II, the club chose to run their 1946 Grand Prix on the streets of Pedralbes in what was then the outskirts to the west of the city.

The circuit, measuring 2.79 miles (4.49 km), was formed by the streets of *Avenida del Generalisimo Franco* (now *Avinguda Diagonal*), *Carretera de Cornella a Focas de Toreda* (now *Avinguda d'Esplugues*) and *Avenida de la Victoria* (now *Avinguda de Pedralbes*). Only the short middle sector contained any fast curves, the rest being the angular corners of junctions connecting these very wide streets.

Despite top speeds in excess of 175 mph (282 kph), Pedralbes was scarcely a serious challenge but nevertheless considered worthy of inclusion in the World Championship in 1951. To meet the occasion, the organisers had already extended the track by including parts of *Passeig de Manuel Girona* and *Carrera de Numància* to increase the length to 3.925 miles (6.317 km). The significance of what was now known as the Spanish Grand Prix was increased further when Pedralbes would decide the outcome of a championship being fought between Juan Manuel Fangio, Alberto Ascari and Froilan Gonzales.

Ascari, winner of the non-championship Grand Prix at Pedralbes the previous year, used his experience to take pole. The race should have belonged to the Italian but a tactical error saw Ferrari fit smaller wheels in the interest of performance: this did not take into account an average speed of over 100 mph (161 kph). The subsequent unscheduled tyre changes played into the hands of Alfa Romeo, giving Fangio the race and, with it, the championship.

After a brief absence, the race returned to the championship calendar in 1954, Britain's Mike Hawthorn winning for Ferrari in what would be the last Grand Prix at Pedralbes. The circuit would be consigned to history the following year following unease over the tragedy at Le Mans and spectator safety.

Mechanics and a man from Pirelli lovingly prepare Mike Hawthorn's winning Ferrari 553 for what would be the second and final World Championship Grand Prix at Pedralbes in 1954.

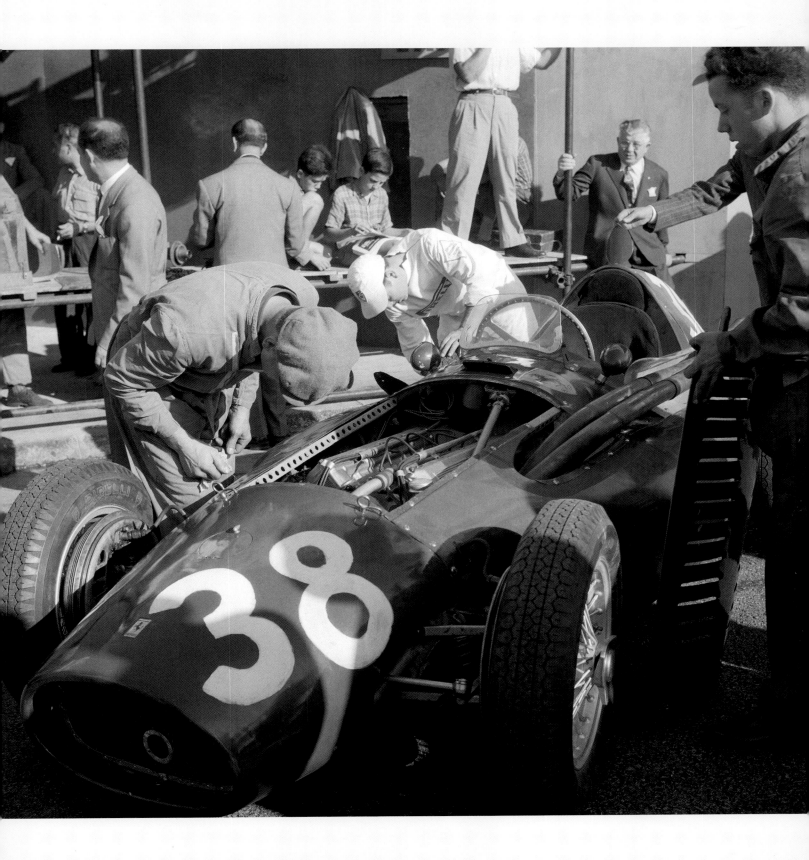

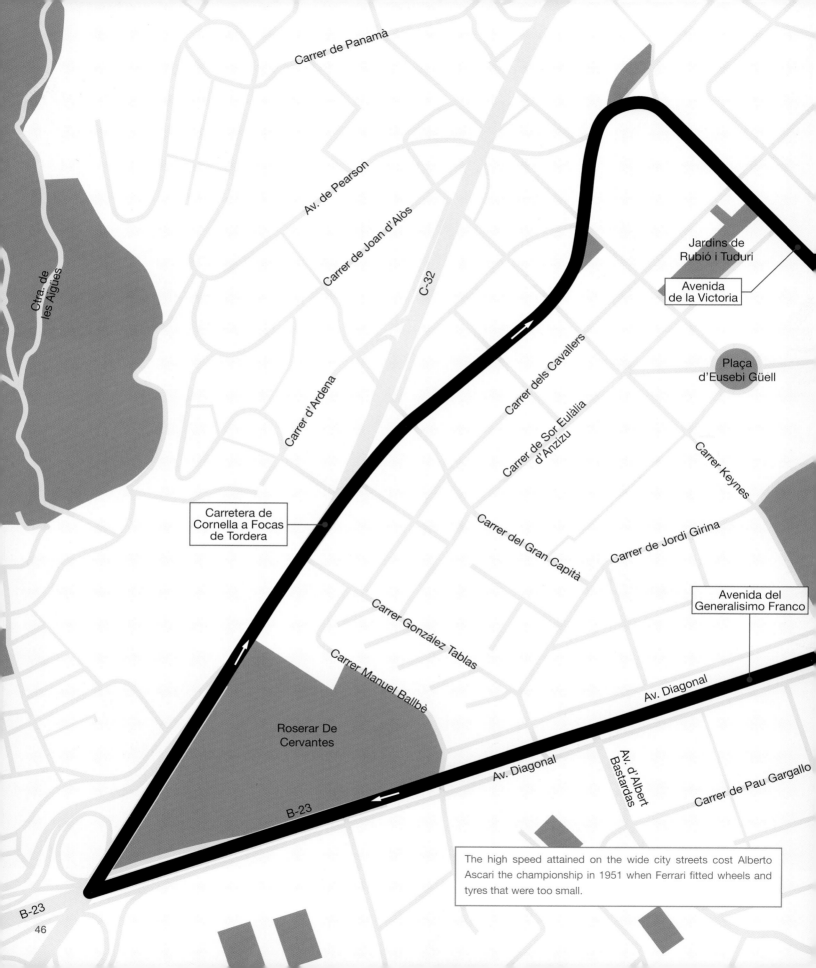

Carrer de Panamà

Av. de Pearson

Carrer de Joan d'Alòs

C-32

Carrer d'Ardena

Carrer dels Cavallers

Carrer de Sor Eulàlia d'Anzizu

Jardins de Rubió i Tuduri

Avenida de la Victoria

Plaça d'Eusebi Güell

Carrer Keynes

Ctra. de les Aigües

Carretera de Cornella a Focas de Tordera

Carrer del Gran Capità

Carrer de Jordi Girina

Carrer González Tablas

Carrer Manuel Ballbè

Avenida del Generalisimo Franco

Roserar De Cervantes

Av. Diagonal

Av. d'Albert Bastardas

Carrer de Pau Gargallo

Av. Diagonal

B-23

The high speed attained on the wide city streets cost Alberto Ascari the championship in 1951 when Ferrari fitted wheels and tyres that were too small.

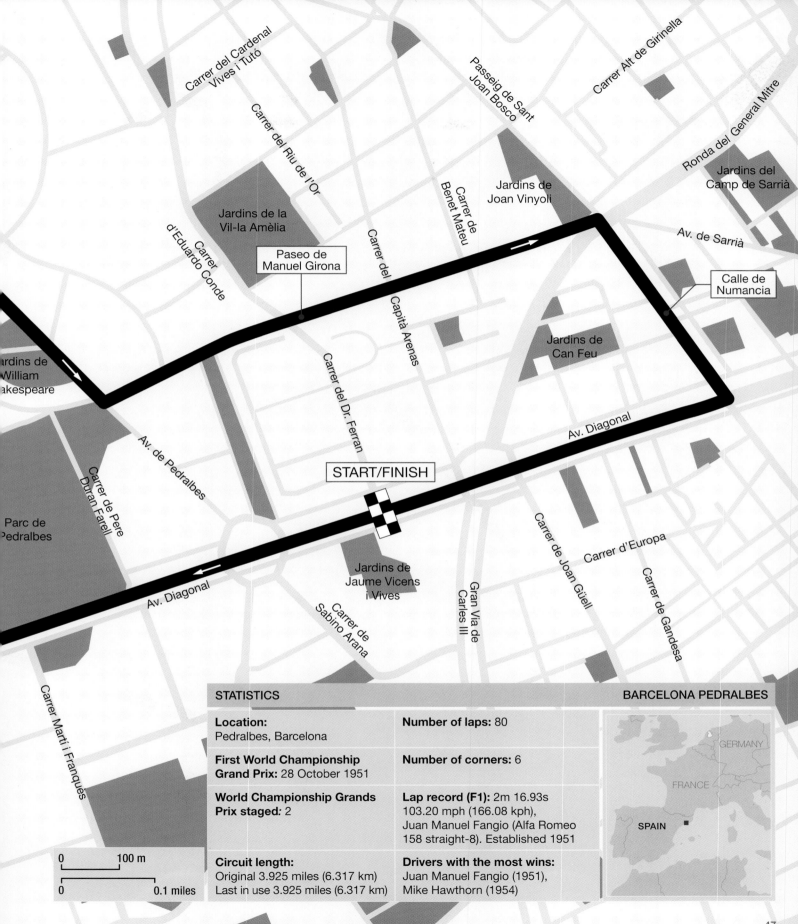

Carrer del Cardenal Vives i Tutó

Carrer del Riu de l'Or

Passeig de Sant Joan Bosco

Carrer Alt de Girinella

Ronda del General Mitre

Carrer de Benet Mateu

Jardins de Joan Vinyoli

Jardins del Camp de Sarrià

Av. de Sarrià

Carrer d'Eduardo Conde

Jardins de la Vil-la Amèlia

Paseo de Manuel Girona

Carrer del

Calle de Numancia

Capità Arenas

Jardins de Can Feu

Jardins de William akespeare

Carrer del Dr. Ferran

ardins de William akespeare

Av. de Pedralbes

Carrer de Pere Duran Farell

START/FINISH

Av. Diagonal

Parc de Pedralbes

Av. Diagonal

Carrer de Joan Güell

Carrer d'Europa

Carrer de Gandesa

Jardins de Jaume Vicens i Vives

Carrer de Sabino Arana

Gran Via de Carles III

Carrer Martí i Franquès

STATISTICS		BARCELONA PEDRALBES
Location: Pedralbes, Barcelona	**Number of laps:** 80	
First World Championship Grand Prix: 28 October 1951	**Number of corners:** 6	
World Championship Grands Prix staged: 2	**Lap record (F1):** 2m 16.93s 103.20 mph (166.08 kph), Juan Manuel Fangio (Alfa Romeo 158 straight-8). Established 1951	GERMANY FRANCE SPAIN
Circuit length: Original 3.925 miles (6.317 km) Last in use 3.925 miles (6.317 km)	**Drivers with the most wins:** Juan Manuel Fangio (1951), Mike Hawthorn (1954)	

0 100 m

0 0.1 miles

Rouen 1952

Rouen-Les-Essarts

 FRANCE

A truly stunning road circuit in a wooded valley southwest of Rouen. Used five times for championship Grands Prix before a fatal crash in 1968 spelled the demise of the venue with a very fast downhill section and a cobbled hairpin at the bottom.

A short circuit, previously used for club racing in a wooded area southwest of Rouen, formed the basis of a Grand Prix track run by the Automobile Club Normand for the first time in 1950. One leg ran down the side of a valley before a right-hand hairpin led to the uphill climb on the opposite side, the two legs linked across the top by a comparatively level road.

This 3.17-mile (5.10-km) track staged the French Grand Prix for the first time in 1952 (won by Alberto Ascari's Ferrari) before an extension loop at the top end, which took competitors along the RN138, was made ready in time for the Grand Prix to return in 1957.

This 4.065-mile (6.542-km) configuration found favour with drivers, particularly the downhill run which began just after the pits. A series of four bends - none acute, no two identical – favoured the brave and the skilful. *Nouveau Monde*, the lowest point on the course, was part-cobbled in contrast to the smooth surface elsewhere.

The return leg, climbing uphill, passed the entrance to the original link across the top and led to a right-hander at *Virage de Grésil,* and the only substantial straight, running for less than a mile along the RN138. A ninety-right at *Virage de la Scierie* marked the beginning of the return towards the pits, drivers bracing themselves for the start of the downhill section. An attractive setting was enhanced by high grass banks lining most of the circuit's lower part, making Rouen-Les-Essarts (Les Essarts being a local commune) very popular among competitors and spectators alike.

It was perfect territory for Juan Manuel Fangio to exhibit consummate car control as he powered his Maserati to victory in 1957. The American, Dan Gurney, won in 1962 and 1964, the Grand Prix returning for a fifth and final time in 1968. In a race run in streaming wet conditions, 22-year-old Jacky Ickx drove away from the opposition in his Ferrari. That event, however, is remembered just as readily for the death of Jo Schlesser, the Frenchman crashing heavily in an air-cooled Honda, a new car which many believed was not yet ready to race.

The stigma of this fiery accident was attached to Rouen thereafter and the Grand Prix never returned. The circuit, reduced in length because of motorway construction, continued to be used for racing but a number of fatal crashes in junior categories brought its permanent closure in 1994.

The Maserati of Jean Behra, having jumped the start, leads the field in 1957 through the first of the awesome downhill sweeps.

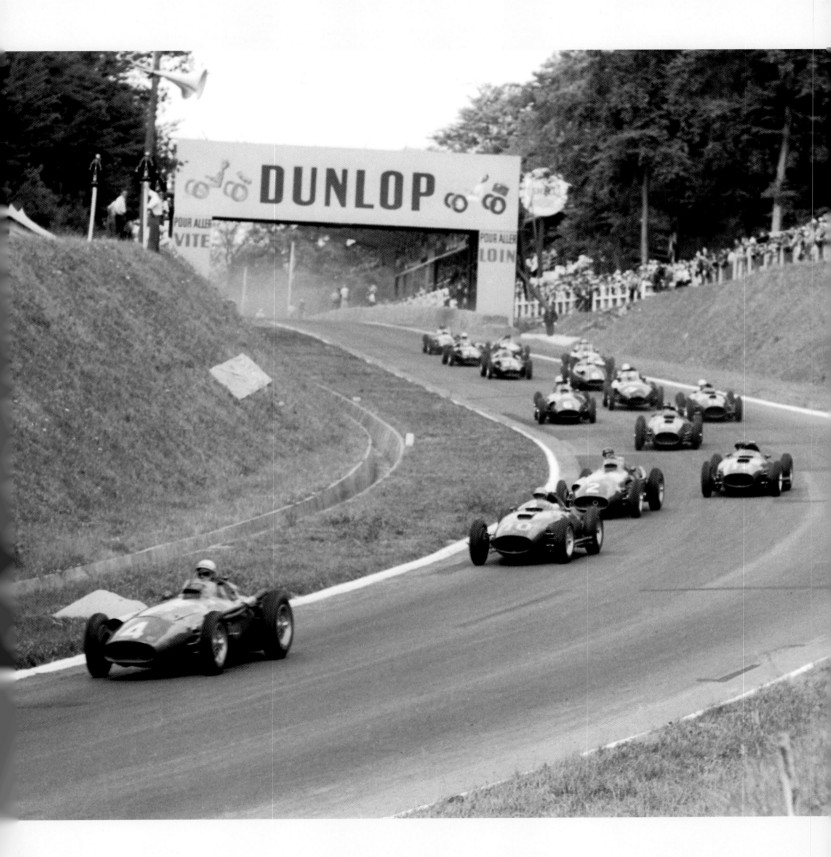

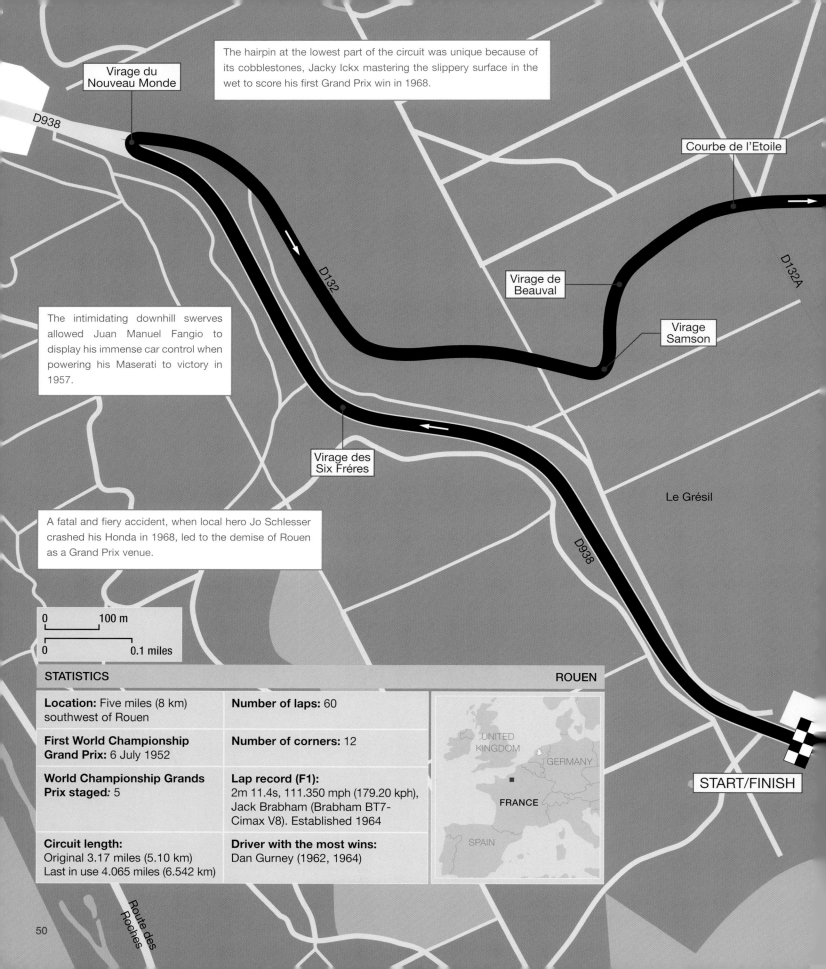

Virage du
Nouveau Monde

D938

The hairpin at the lowest part of the circuit was unique because of
its cobblestones, Jacky Ickx mastering the slippery surface in the
wet to score his first Grand Prix win in 1968.

Courbe de l'Etoile

D132

D132A

Virage de
Beauval

Virage
Samson

The intimidating downhill swerves
allowed Juan Manuel Fangio to
display his immense car control when
powering his Maserati to victory in
1957.

Virage des
Six Fréres

Le Grésil

A fatal and fiery accident, when local hero Jo Schlesser
crashed his Honda in 1968, led to the demise of Rouen
as a Grand Prix venue.

D938

0	100 m
0	0.1 miles

ROUEN

STATISTICS

Location: Five miles (8 km) southwest of Rouen	**Number of laps:** 60
First World Championship Grand Prix: 6 July 1952	**Number of corners:** 12
World Championship Grands Prix staged: 5	**Lap record (F1):** 2m 11.4s, 111.350 mph (179.20 kph), Jack Brabham (Brabham BT7-Cimax V8). Established 1964
Circuit length: Original 3.17 miles (5.10 km) Last in use 4.065 miles (6.542 km)	**Driver with the most wins:** Dan Gurney (1962, 1964)

UNITED
KINGDOM

GERMANY

FRANCE

SPAIN

START/FINISH

Route des
Roches

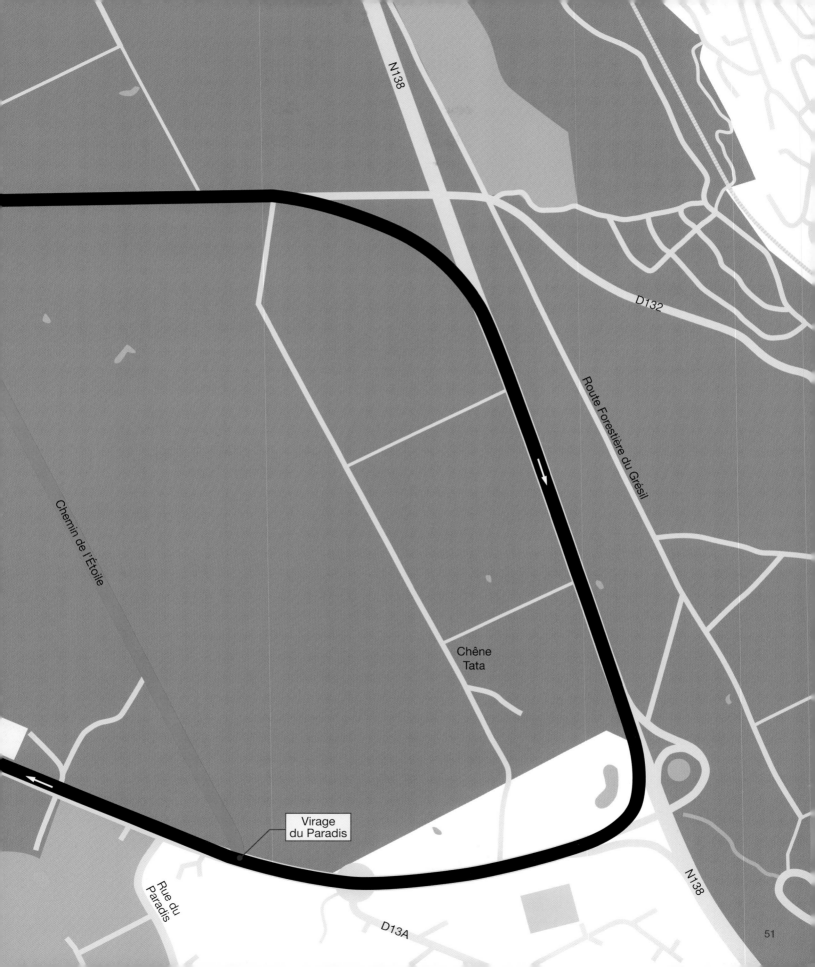

N138

D132

Route Forestière du Grésil

Chemin de l'Étoile

Chêne
Tata

Virage
du Paradis

Rue du
Paradis

D13A

N138

Zandvoort 1952

Circuit Park Zandvoort

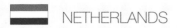 NETHERLANDS

Uniquely positioned among sand dunes on the North Sea coast, Zandvoort remained a much-appreciated venue when hosting Grands Prix between 1952 and 1985. A combination of fast curves frequently produced eventful racing, which continued when a shortened version of the track was introduced in 2021.

John Hugenholtz, one of the very few specialists in circuit design in the 1940s and a keen sporting motorist, knew exactly what was required to make a race track successful from a driver's point of view. Choosing a location in the sand dunes close by the town of Haarlem, the Dutchman laid out a circuit that had a bit of everything.

A long pit straight with a gently banked hairpin at its end guaranteed drivers would attempt to overtake when braking from high speed. From there, they faced a fast left and a tight but fairly quick right at *Gerlachbocht*, before jumping on the brakes for a 180-degree left-hander. This was directly behind the pits and therefore a popular vantage point before the cars would power through another left-hander and away towards the dunes. There followed a glorious succession of sweeping bends, rising and falling before gradually turning inland and heading into an open right giving a fast entry onto the main straight.

The 2.6-mile (4.2-km) track was built in the years immediately after World War II. After hosting major races known as the Netherlands Grand Prix, Zandvoort was recognised as a round of the World Championship in 1952, a race won by the Ferrari of Alberto Ascari.

The Italian returned to repeat his success the following year but Zandvoort itself was unable to show the same consistency, a sequence of financial and political problems leading to intermittent appearances on the F1 calendar before truly establishing itself in the 1960s.

Jim Clark won four times. Niki Lauda and James Hunt would win their first-ever Grands Prix in 1974 and 1975 respectively but the jubilation and pleasure over the years had been tinged with bouts of shocking sadness.

In 1970, the Englishman Piers Courage died when his de Tomaso, entered and run by Frank Williams, crashed and caught fire. Three years later, Zandvoort would come under even greater scrutiny followed the death of Roger Williamson, the young Briton trapped beneath his burning March.

Located a 30-minute train ride from vibrant Amsterdam, Zandvoort remained popular, particularly among British enthusiasts making the short sea trip. However, financial strain and problems with noise pollution meant the Grand Prix in 1985 was the last to be held on the original circuit.

Plans for a more compact club circuit eventually reached fruition in 1989, before being expanded to international standards 12 years later. By 2019, further modifications, including a banked curve at Turns 13 and 14, had been approved for F1 use, plans for a Grand Prix in 2020 being shelved due to Covid-19. The Dutch Grand Prix eventually made a successful and welcome return in September 2021.

Top: The sand dunes made an excellent natural vantage point. Jackie Stewart's BRM leads the Cooper-Maserati of Jo Bonnier into Hugenholtzbocht in 1966. Stewart finished fourth. Bonnier was seventh, six laps down on the winner, Jack Brabham.

Bottom: Max Verstappen gave his fans all they could wish for with a commanding win on the return of the Dutch GP to Zandvoort in 2021.

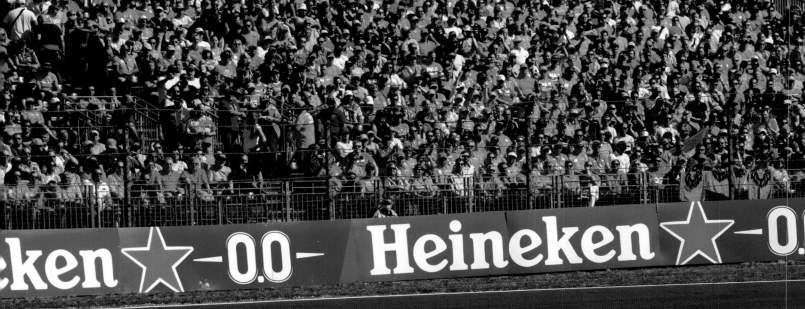

North
Sea

The 1961 Dutch Grand Prix became the first championship race in which every starter finished, none of the 15 drivers even making a pit stop. This was highly unusual in the days of chronic mechanical unreliability. The 75-lap race, lasting for two hours, was won by the Ferrari of Wolfgang von Trips.

Tarzanbocht

Pits

Gerlachboc

Hunseru

START/FINISH

Hans Ernst Bocht

Hugenholtzbocht

Boulevard Barnaart

Arie Luyendyk Bocht

Kumhobocht

Grand Prix racing suffered one of its most appalling safety-related moments in 1973 when Roger Williamson perished. The Englishman was trapped beneath his overturned March, the trackside officials ill-equipped to either revert the car or stop a fire from taking hold. The race continued throughout.

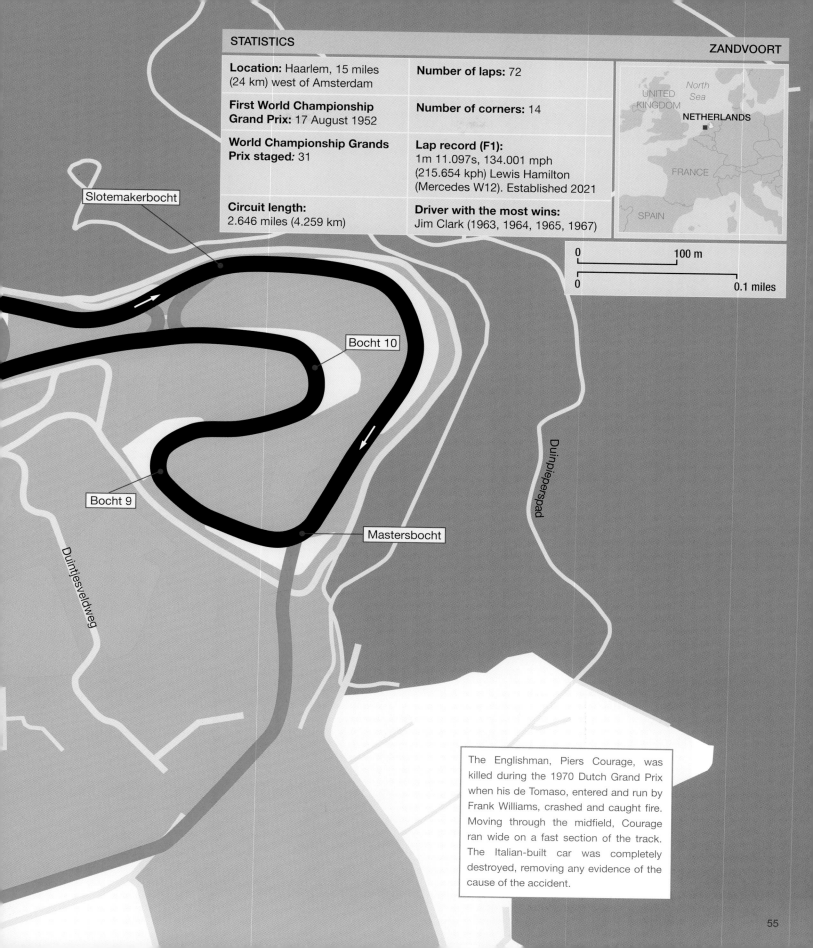

STATISTICS

Location: Haarlem, 15 miles (24 km) west of Amsterdam

First World Championship Grand Prix: 17 August 1952

World Championship Grands Prix staged: 31

Circuit length: 2.646 miles (4.259 km)

Number of laps: 72

Number of corners: 14

Lap record (F1): 1m 11.097s, 134.001 mph (215.654 kph) Lewis Hamilton (Mercedes W12). Established 2021

Driver with the most wins: Jim Clark (1963, 1964, 1965, 1967)

North Sea

UNITED KINGDOM

NETHERLANDS

FRANCE

SPAIN

0 100 m

0 0.1 miles

Slotemakerbocht

Bocht 10

Bocht 9

Mastersbocht

Duinpieperspad

Duintjesveldweg

The Englishman, Piers Courage, was killed during the 1970 Dutch Grand Prix when his de Tomaso, entered and run by Frank Williams, crashed and caught fire. Moving through the midfield, Courage ran wide on a fast section of the track. The Italian-built car was completely destroyed, removing any evidence of the cause of the accident.

Buenos Aires 1953

Autódromo Juan y Oscar Galvez

 ARGENTINA

Held intermittently across five decades, the Argentine Grand Prix's popularity never waned. The Buenos Aires autodrome, with a variety of tracks, was ahead of its time in 1952 but the race would always be a victim of regular political turmoil in such a vibrant country.

Argentina was not immune from South America's passion for motor sport, the country's enthusiasm knowing no bounds when their home hero, Juan Manual Fangio, became World Champion for the first time in 1951.

Seizing the moment, President Juan Perón consulted with Fangio and other drivers to discover what could be done to boost racing in Argentina and in the eyes of the world. There had been a series of nationwide races across closed public roads but it was clear that a permanent circuit would go a long way to answering the country's needs.

Perón immediately earmarked an area of swampland in the Lugano district of Buenos Aires, close to airports and with the city's advancing skyline as a backdrop. The autodrome set new standards with as many as 12 possible layouts served by large grandstands and permanent pit buildings. Known as Parc Almirante Brown, the entrance had an imposing white arch as another tribute to Brown, founder of the Argentine navy.

Completed in rapid time, the autodrome hosted its first motor race on 9 March 1952. With Fangio as reigning champion, and given Perón's presence, it was almost a matter of course when Argentina was granted the opening race of the 1953 season, the first time a World Championship Grand Prix had been held outside Europe (ignoring the strange anomaly of the Indianapolis 500-mile race being considered part of the championship at the time).

In the oppressive heat of race day, a massive crowd was swept along on a wave of emotion that took them beyond overcrowded enclosures and onto the race track. President Perón, showing a worrying grasp of reality, encouraged mayhem by saying: 'My children, my children! Let them in!'

By the time the drivers went to the grid late in the afternoon, the track was lined by a solid wall of humanity. Facing the alternative of a riot, officials started the race. When the crowd obscured marker boards and, eventually, the corners themselves, the inevitable happened. A spectator ran across the track in front of Giuseppe Farina, the Italian swerved, lost control of his Ferrari and ploughed broadside into the crowd. Nine people died and 40 were injured.

Yet the race survived, Fangio winning four in succession before retiring in 1958. Three years later, the race had disappeared from the international calendar, a return in 1972 coinciding with the arrival of Carlos Reutemann, who thrilled the locals by claiming pole on his F1 debut. Two years later, Reutemann was heading for a highly emotional victory until part of his Brabham came adrift and he eventually ran out of fuel.

The Falklands War put paid to the Grand Prix for most of the 1980s, only for a welcome return to be made in the 1990s. The track had been changed with the removal of a long loop around a lake and the insertion of infield loops, comparatively dull races seeming to reflect that. The 1998 Argentine Grand Prix would be the last. The circuit, having had a number of titles, was finally named after Juan and Oscar Galvez, two Argentine brothers who had raced internationally in the 1950s and 1960s.

After two hours and 20 minutes of racing in the heat, Stirling Moss takes the chequered flag 2.7 seconds ahead of Luigi Musso in 1958. With rear tyres down to the canvas, Moss had duped the Ferrari team into thinking Rob Walker's privately entered Cooper-Climax would have to stop for tyres. Crowd control appears to be as minimal as ever.

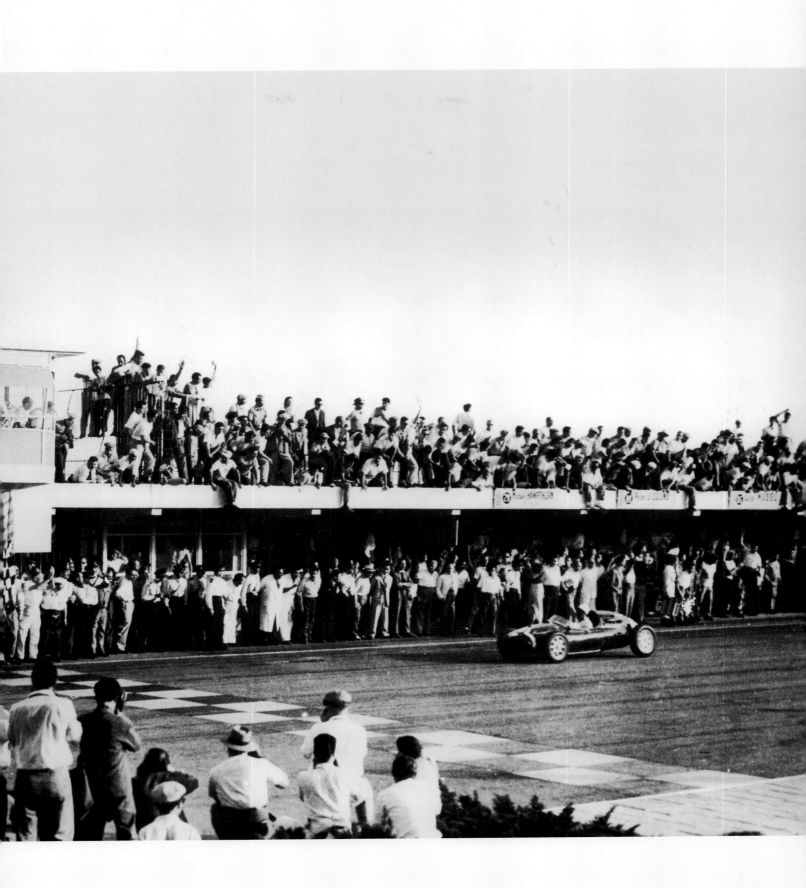

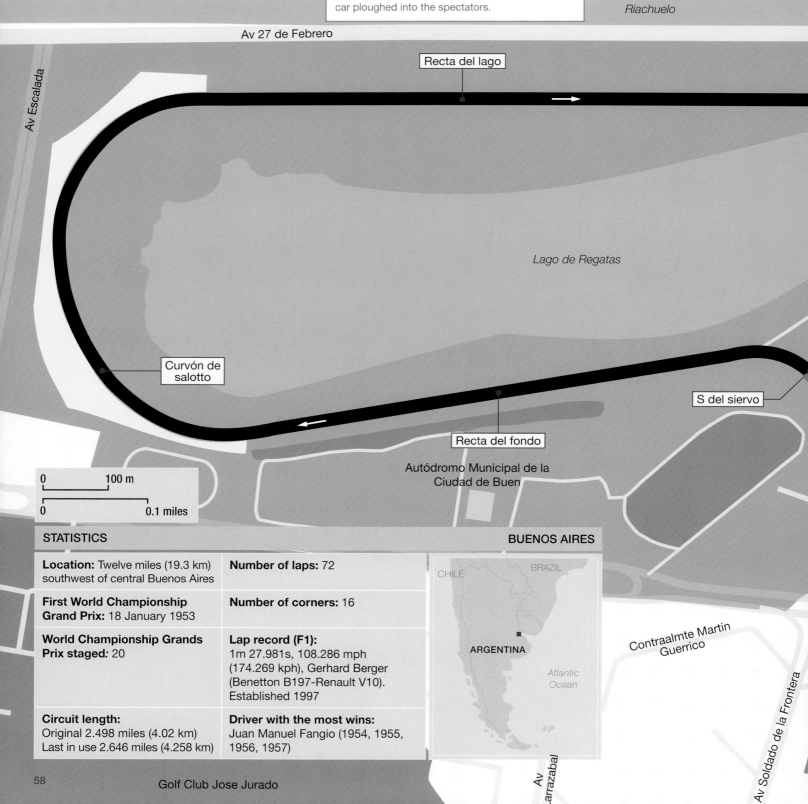

Camino de la Rivera Sud

Gral Hornos

Larrazabal

Arroyo

The inaugural Grand Prix in 1953 was a shambles as an over-enthusiastic crowd got out of control. There were nine fatalities and many injuries when a car ploughed into the spectators.

Riachuelo

Av 27 de Febrero

Recta del lago

Av Escalada

Lago de Regatas

Curvón de salotto

S del siervo

Recta del fondo

Autódromo Municipal de la Ciudad de Buen

0 100 m

0 0.1 miles

STATISTICS

BUENOS AIRES

Location: Twelve miles (19.3 km) southwest of central Buenos Aires

Number of laps: 72

First World Championship Grand Prix: 18 January 1953

Number of corners: 16

World Championship Grands Prix staged: 20

Lap record (F1):
1m 27.981s, 108.286 mph (174.269 kph), Gerhard Berger (Benetton B197-Renault V10). Established 1997

CHILE BRAZIL

ARGENTINA

Atlantic Ocean

Contraalmte Martin Guerrico

Circuit length:
Original 2.498 miles (4.02 km)
Last in use 2.646 miles (4.258 km)

Driver with the most wins:
Juan Manuel Fangio (1954, 1955, 1956, 1957)

Av Larrazabal

Av Soldado de la Frontera

Camino de la Rivera Sud

Av 27 de Febrero

Carlos Reutemann and, it seemed, most of Argentina were heart-broken in 1974 when the local hero's Brabham ran out of fuel while in the lead.

Chicana de Ascari

Stands

Ombú

Vivorita

Cajon

Entrada a los mixtos

Tobogán

Helipuerto Autódromo

Pits

Curva de Parga

Stands

Stands

START/FINISH

Curva N°1

Cto Autódromo

Stands

Acceso Autódromo

Acceso Autódromo

e. Gral Eduardo Racedo

Av Cnel. Roca

Stirling Moss pulled off a remarkable win in a privately-entered Cooper in 1958 when he ran non-stop, duping the Ferrari team into thinking he would need to change tyres. Moss finished with the canvas showing on a rear tyre.

Av Lisandro de la Torre

Timoteo Gordillo

Canadá de Gómez

Ferre

Cosquin

Av Piedra Buena

Berón de Astrada

Aintree 1955

Aintree

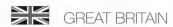 GREAT BRITAIN

The perimeter roads around the Grand National horse race course were used to stage the British Grand Prix five times, the imposing and permanent amenities being a cut above the temporary facilities at other circuits. 1957 produced the first win for a British driver/car combination.

It was thanks to the foresight and energy of Mirabel Topham that Aintree was converted to use for horsepower of a different kind. The owner of the famous Grand National steeplechase course worked for more than a year on various problems with licences, roads, footpaths and parish councils in order to stage a motor race.

Once under way, contractors completed the 3-mile (4.83-km) circuit in as many months for around £100,000. Although flat in nature because of the surroundings, Aintree was a reasonable mix of long straights and medium-speed corners, Melling Crossing – one of two points where the track crossed the Grand National course – being a tricky left and right flick.

The project was well received. This was a purpose-built race track (as opposed to a converted airfield; the usual choice at the time) but a major bonus came with the existing grandstands and facilities automatically becoming available for motor sport. This was a huge step from the scaffolding and tents found elsewhere.

The first race was held on 29 May 1954, the cars running anti-clockwise. The direction of travel was reversed for a non-championship F1 race in the autumn, a prelude to a successful bid to host the 1955 British Grand Prix on 16 July when home hero, Stirling Moss, would be driving for Mercedes.

As expected, the German team laid on a demonstration, filling the first four places. An estimated 150,000 spectators went home happy when Moss won, although it remains a matter of conjecture whether the maestro Fangio allowed the British driver to win at home after a close fight.

When the Grand Prix returned two years later, Mercedes had withdrawn and Moss was driving for Vanwall. Starting from pole position once again, Moss led until his car developed a misfire. In the 1950s, drivers could swap cars during a race. Tony Brooks, recovering from injuries received in an accident at Le Mans, was called in to hand over his Vanwall. Moss rejoined in ninth place and gave chase. With less than 20 laps to go, he was in the lead, the fear being that this car would also prove fragile. The Vanwall held together, Brooks joining Moss to receive a tumultuous welcome for the first British drivers to win a championship Grand Prix in a British car.

Two years later, Britain had taken a stronger hold of the F1 scene thanks to the arrival of Cooper with cars featuring the engine at the rear. Jack Brabham used one of these to dominate the 1959 British Grand Prix, Moss giving vain chase around Aintree at the wheel of a front-engine BRM.

It was the turn of Italy in 1961, Wolfgang von Trips heading a trio of red cars in the pouring rain as Ferrari made the most of a major change in the technical regulations. By the time the F1 cars had returned to Aintree for a final time a year later, the Brits had caught up handsomely, as demonstrated by Jim Clark dominating the weekend in his Lotus-Climax.

The Grand Prix circuit continued to be used for non-championship F1 races until 1964, after which a shortened version hosted a variety of club events.

Top: Spectators make the most of Aintree's splendid facilities as they watch the start of the 1955 British Grand Prix, the Mercedes-Benz duo of Stirling Moss (12) and Juan Manuel Fangio leading Jean Behra's Maserati off the line.

Bottom: History in the making in 1957 as Stirling Moss becomes the first British driver to win a championship Grand Prix at the wheel of a British car, the Vanwall he shared with Tony Brooks.

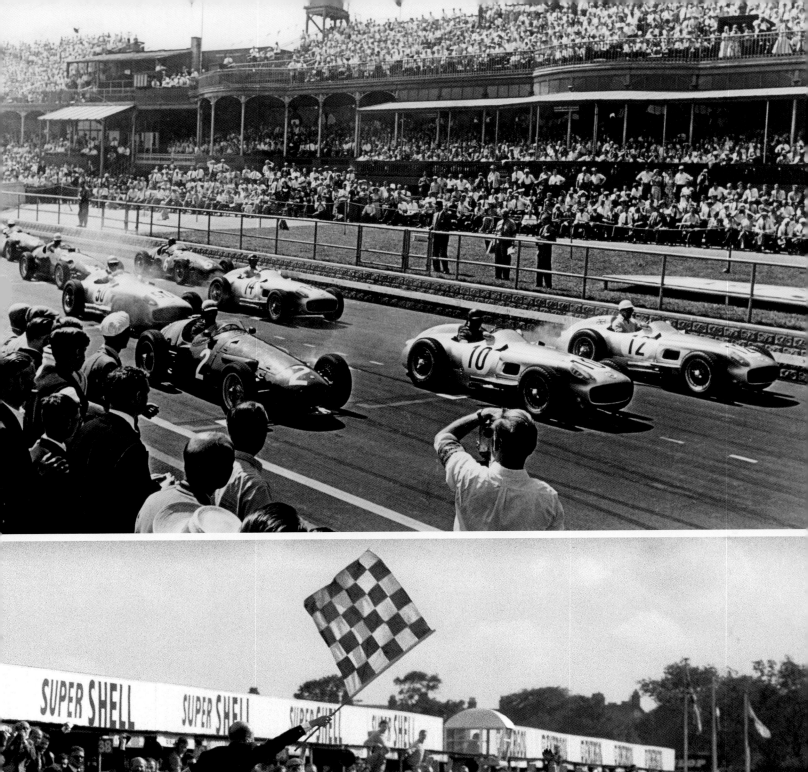

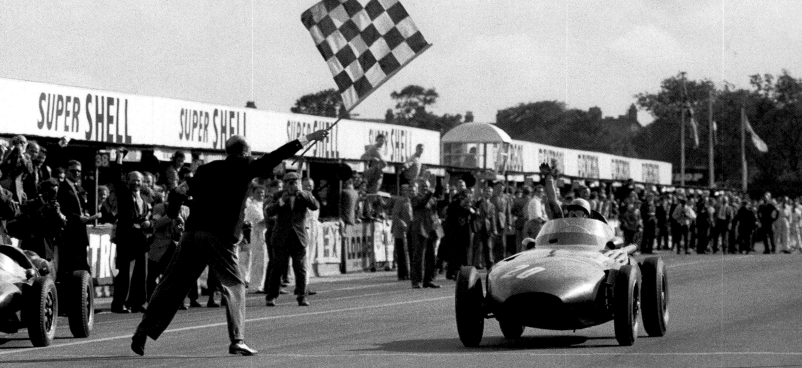

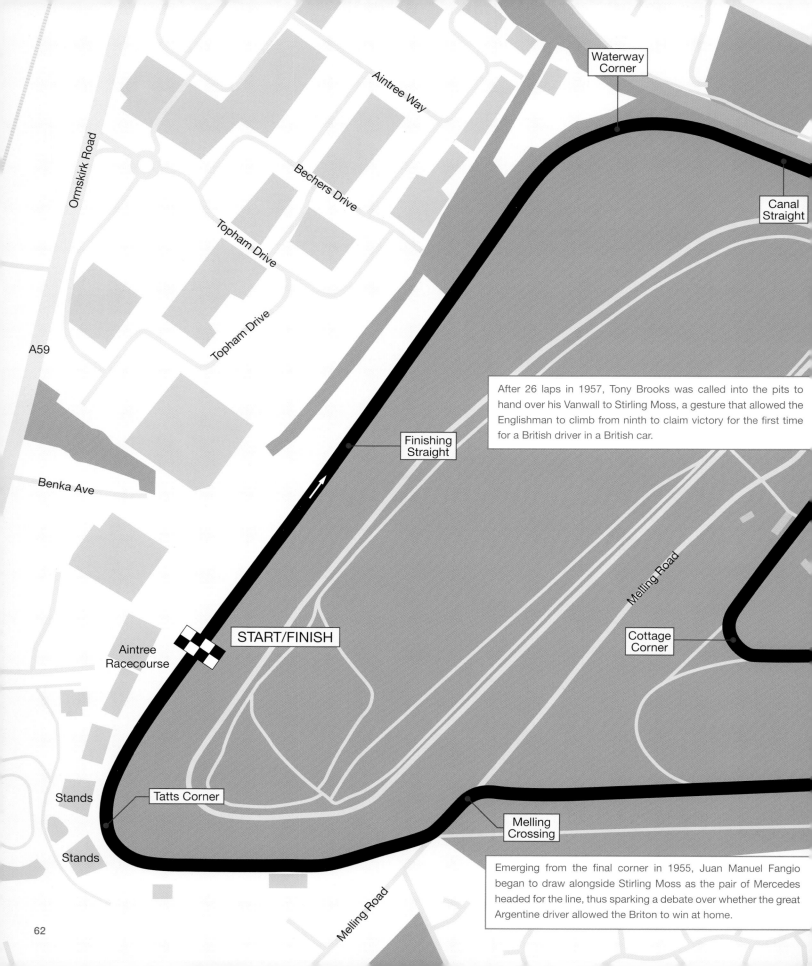

Waterway
Corner

Canal
Straight

Aintree Way

Bechers Drive

Topham Drive

Topham Drive

Ormskirk Road

A59

Benka Ave

Finishing
Straight

After 26 laps in 1957, Tony Brooks was called into the pits to hand over his Vanwall to Stirling Moss, a gesture that allowed the Englishman to climb from ninth to claim victory for the first time for a British driver in a British car.

Melling Road

Cottage
Corner

START/FINISH

Aintree
Racecourse

Stands

Tatts Corner

Melling
Crossing

Stands

Emerging from the final corner in 1955, Juan Manuel Fangio began to draw alongside Stirling Moss as the pair of Mercedes headed for the line, thus sparking a debate over whether the great Argentine driver allowed the Briton to win at home.

Melling Road

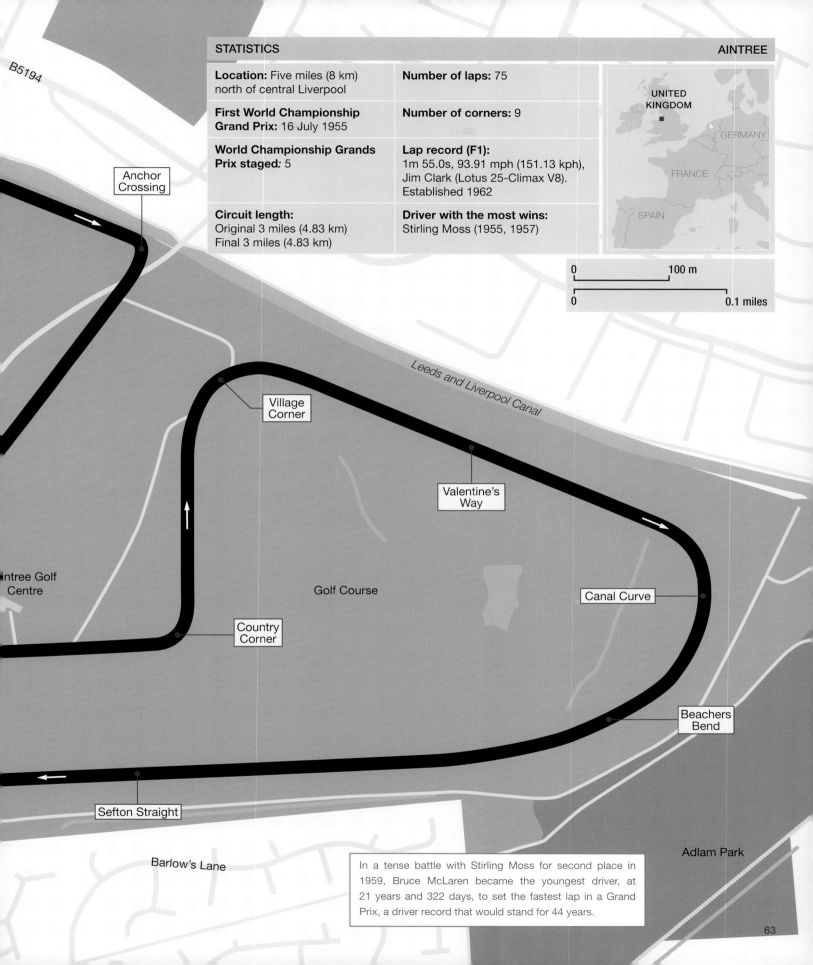

B5194

STATISTICS

AINTREE

Location: Five miles (8 km) north of central Liverpool

First World Championship Grand Prix: 16 July 1955

World Championship Grands Prix staged: 5

Circuit length:
Original 3 miles (4.83 km)
Final 3 miles (4.83 km)

Number of laps: 75

Number of corners: 9

Lap record (F1):
1m 55.0s, 93.91 mph (151.13 kph), Jim Clark (Lotus 25-Climax V8). Established 1962

Driver with the most wins:
Stirling Moss (1955, 1957)

UNITED KINGDOM
GERMANY
FRANCE
SPAIN

0 100 m
0 0.1 miles

Anchor Crossing

Village Corner

Leeds and Liverpool Canal

Valentine's Way

Aintree Golf Centre

Golf Course

Canal Curve

Country Corner

Beachers Bend

Sefton Straight

Barlow's Lane

Adlam Park

In a tense battle with Stirling Moss for second place in 1959, Bruce McLaren became the youngest driver, at 21 years and 322 days, to set the fastest lap in a Grand Prix, a driver record that would stand for 44 years.

Pescara 1957

Pescara Circuit

 ITALY

A magnificent road circuit, roughly triangular in shape, running from the town of Pescara, heading into the hills of Abruzzo before returning for a fast, straight run along the Adriatic coast. The longest track in F1 history was only used once for a championship Grand Prix.

The circuit began in the centre of Pescara, a bustling town on the Adriatic coast, before turning right after half a mile and heading inland through the suburbs of Montani and Villa Raspa. Then began a climb through open country to the village of Spoltore and on, even higher, to the hamlets of Pornace and Villa St Maria. A steep descent through a 180-degree hairpin brought competitors onto a level road, running more or less straight for 5 miles (8 km) through Mulino and towards the sea. In the centre of Montesilvano, the course turned sharp right onto the coast road and another 5-mile blast along Via Adriatica towards the start/finish in Pescara. At 16.05 miles (25.83 km) it was, and remains, the longest circuit ever used for a World Championship Grand Prix.

The race was originally known as the *Coppa Acerbo*, a trophy named after Tito Acerbo, born locally and a hero from World War I. Enzo Ferrari, a name later to become more famous as the maker of fine sports cars than a competent racing driver, won the first race, held on 13 July 1924. The race was such a success that it became an annual event, drawing in major players such as Mercedes-Benz and Auto Union in the 1930s.

When racing returned following hostilities in Europe, the shift in government and politics also saw a change in the name of the event to *Gran Premio di Pescara*, initially for sports cars and then Formula 1. Finally, and at short notice in 1957, the 25th running of the Grand Prix of Pescara would become a round of the F1 World Championship.

A modest entry of 16 cars was not helped by Ferrari taking umbrage over outrage when one of his sports cars had crashed and killed nine spectators during the *Mille Miglia*, run across 1000 miles (1609 km) of Italian public roads. Only after a plea from his Italian driver, Luigi Musso, did Ferrari agree to send one car with a skeleton crew as a semi-works entry, leaving regular drivers Mike Hawthorn and Peter Collins unemployed that weekend.

In the end, British presence was upheld by Stirling Moss, who started his Vanwall from the front row, inbetween Musso and the pole position Maserati of Juan Manuel Fangio. It had taken the five-time World Champion just under 10 minutes to complete the lap but Fangio was beaten off the start line by both the Ferrari and the Vanwall.

Musso thrilled an estimated 200,000 spectators enjoying the rising heat of the August morning as he led the first lap. But their joy was to be short-lived, Moss edging ahead of the Ferrari as they reached 175 mph (282 kph) on the straight leading to Montesilvano. The green car would remain in front for the remaining 16 laps, beating the best the Italians had to offer. By lunchtime, the one and only World Championship round on this truly magnificent road circuit was over.

The essence of Pescara as a relaxed Fangio takes his Maserati 250F through one of the many villages in 1957. He would finish second to the Vanwall of Stirling Moss in what would be the only championship Grand Prix on the longest circuit ever used for F1.

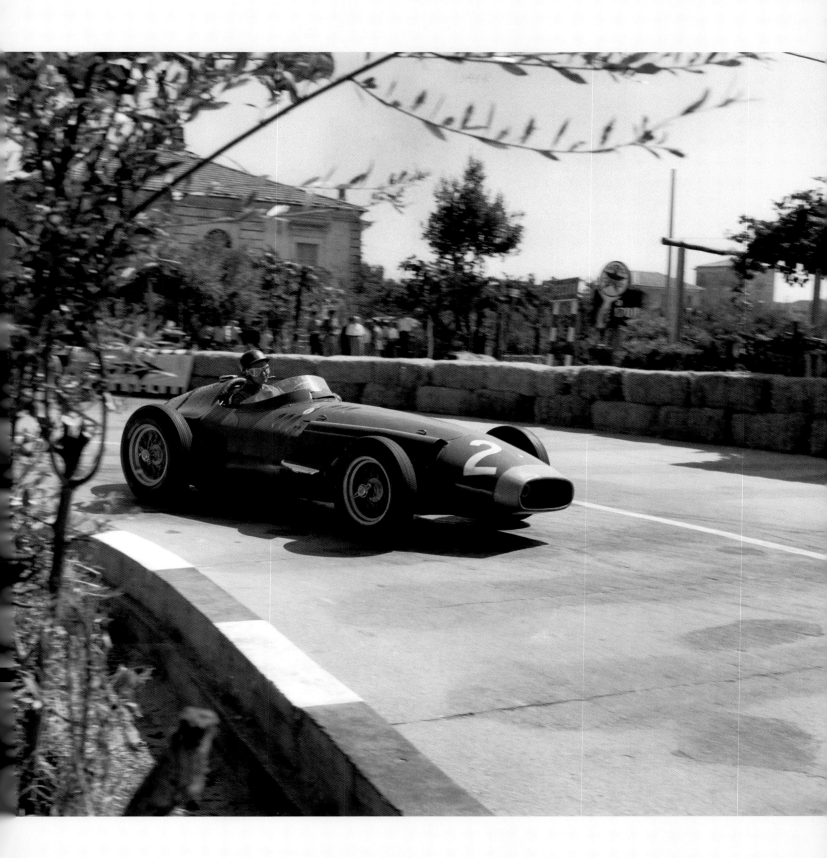

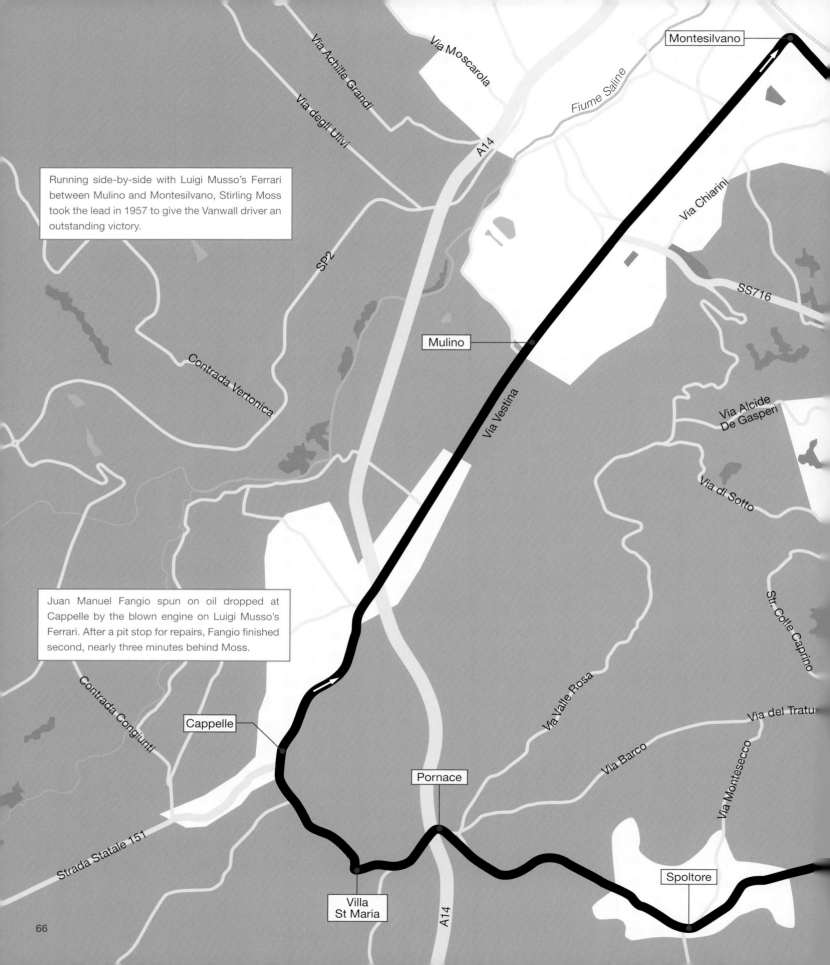

Running side-by-side with Luigi Musso's Ferrari between Mulino and Montesilvano, Stirling Moss took the lead in 1957 to give the Vanwall driver an outstanding victory.

Juan Manuel Fangio spun on oil dropped at Cappelle by the blown engine on Luigi Musso's Ferrari. After a pit stop for repairs, Fangio finished second, nearly three minutes behind Moss.

Montesilvano

Via Moscarola

Via Achille Grandi

Via degli Ulivi

Fiume Saline

A14

Via Chiarini

SS716

SP2

Mulino

Via Alcide
De Gasperi

Contrada Vertonica

Via Vestina

Via di Sotto

Str. Colle Caprino

Via Valle Rosa

Via del Tratu

Cappelle

Contrada Congiunti

Pornace

Via Barco

Via Montesecco

Strada Statale 151

A14

Spoltore

Villa
St Maria

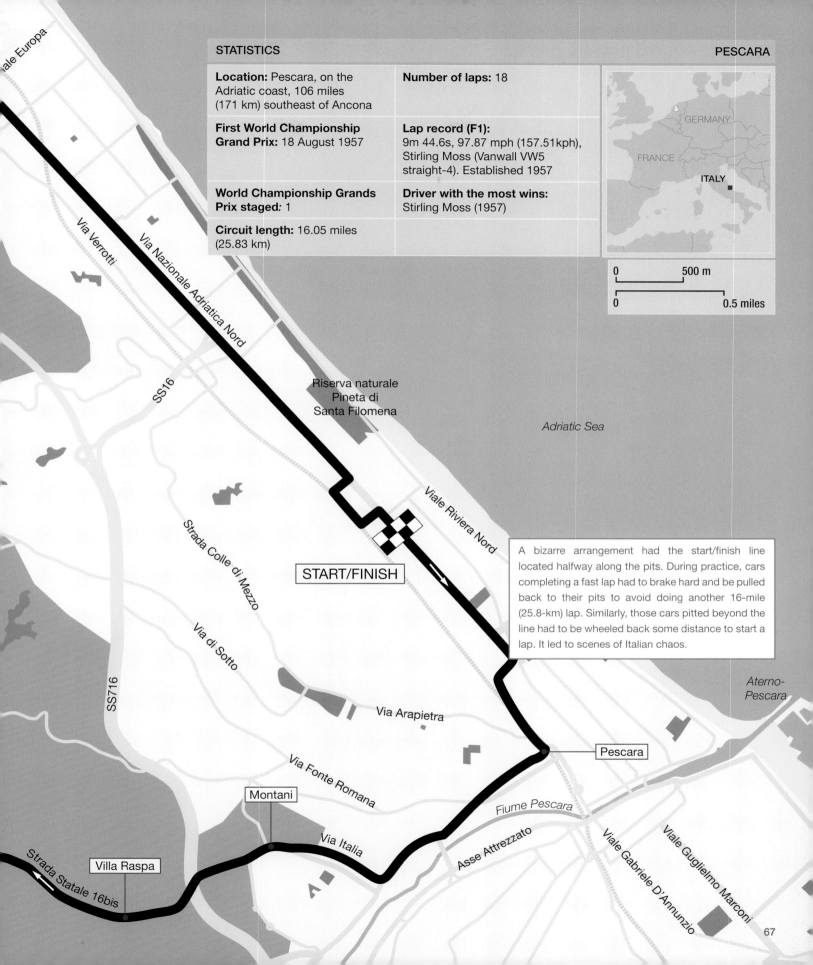

STATISTICS

Location: Pescara, on the Adriatic coast, 106 miles (171 km) southeast of Ancona

First World Championship Grand Prix: 18 August 1957

World Championship Grands Prix staged: 1

Circuit length: 16.05 miles (25.83 km)

Number of laps: 18

Lap record (F1): 9m 44.6s, 97.87 mph (157.51kph), Stirling Moss (Vanwall VW5 straight-4). Established 1957

Driver with the most wins: Stirling Moss (1957)

Viale Europa

Via Verrotti

Via Nazionale Adriatica Nord

SS16

Strada Colle di Mezzo

Via di Sotto

SS716

Riserva naturale Pineta di Santa Filomena

Adriatic Sea

Viale Riviera Nord

START/FINISH

A bizarre arrangement had the start/finish line located halfway along the pits. During practice, cars completing a fast lap had to brake hard and be pulled back to their pits to avoid doing another 16-mile (25.8-km) lap. Similarly, those cars pitted beyond the line had to be wheeled back some distance to start a lap. It led to scenes of Italian chaos.

Aterno-Pescara

Via Arapietra

Pescara

Via Fonte Romana

Montani

Via Italia

Villa Raspa

Strada Statale 16bis

Fiume Pescara

Asse Attrezzato

Viale Gabriele D'Annunzio

Viale Guglielmo Marconi

GERMANY

FRANCE

ITALY

0 500 m

0 0.5 miles

Porto 1958

Circuito da Boavista

 PORTUGAL

A 4.6-mile (7.4-km) combination of roads and streets in Porto, wide in parts, tight in others but made even more treacherous by cobblestones and tramlines. Used twice to stage rounds of the F1 World Championship and the scene of a fine act of sportsmanship by Stirling Moss in 1958.

Racing through streets to the west of Porto city centre was first mooted in the 1930s and really took hold two decades later. But even in 1958, when the *Automovel Club de Portugal* successfully applied for a round of the World Championship, the circuit was considered to be 'Old School', such were the numerous hazards around its 4.66-mile (7.5-km) length.

The start/finish area was located on the wide expanse of a harbour-front esplanade, the track immediately turning left onto the longest straight using part of *Avenida da Boavista*, from which the circuit derived its name.

Another 90-degree left took competitors down *Avenida do Doutor Antunes Guimarães*, the last quick section before another left into *Rua do Lidador*. Now began a tight and twisting run through narrow streets before returning to the fast, curving approach to the finish line. The anti-clockwise layout was tricky enough, given the presence of kerbs, telegraph posts, yew trees and walls, but the fast sections in particular were made extremely hazardous by the presence of tramlines criss-crossing a cobblestone surface.

The F1 teams, even by the standard of the day, were mildly shocked by the conditions when they arrived for the ninth round of the championship in late August 1958. But, as ever, there was never any question of the drivers refusing to race. There was, after all, a championship at stake as Stirling Moss and Mike Hawthorn fought to become the first British driver to claim the title.

Moss took pole position in his Vanwall with Hawthorn's Ferrari alongside, just 0.05 seconds slower. Such an exceptionally close margin helped draw 120,000 spectators, the tension being ratcheted up even further when rain fell on race morning. The thought of wet cobblestones did not bear thinking about.

Fortunately, the rain had eased just before the start, Moss jumping into the lead, only to be overtaken by Hawthorn on the second lap. Five laps later, Moss was back in front and pulling away as Hawthorn began to experience brake trouble that would eventually prompt a pit stop. Rejoining, Hawthorn smashed the lap record as he moved back to second place, but Moss was too far ahead.

On the final lap, Hawthorn spun and stalled. Using a slight downhill slope, but facing the wrong way, the Englishman coaxed the V6 into life and continued to finish second. When officials attempted to disqualify Hawthorn for going against race traffic, Moss came to his defence by pointing out that the Ferrari had been on the pavement at the time and therefore not officially on the race track. Hawthorn kept his six points, plus one for fastest lap. Two races later, Moss would lose the title by a single point.

The F1 cars returned to Porto two years later, the circuit remaining exactly as before – and extracting its dues as drivers either hit hard objects or the rough surface shook their cars to bits. Only five of the 14 starters were running at the finish, a fifth win in succession for Jack Brabham giving the Cooper driver his second World Championship.

No major racing took place in Porto until 2005 when a shortened version of the track was used for historic racing cars.

Tramlines and cobblestones abound as Mike Hawthorn hustles his Ferrari 246 through the start/finish area in 1958.

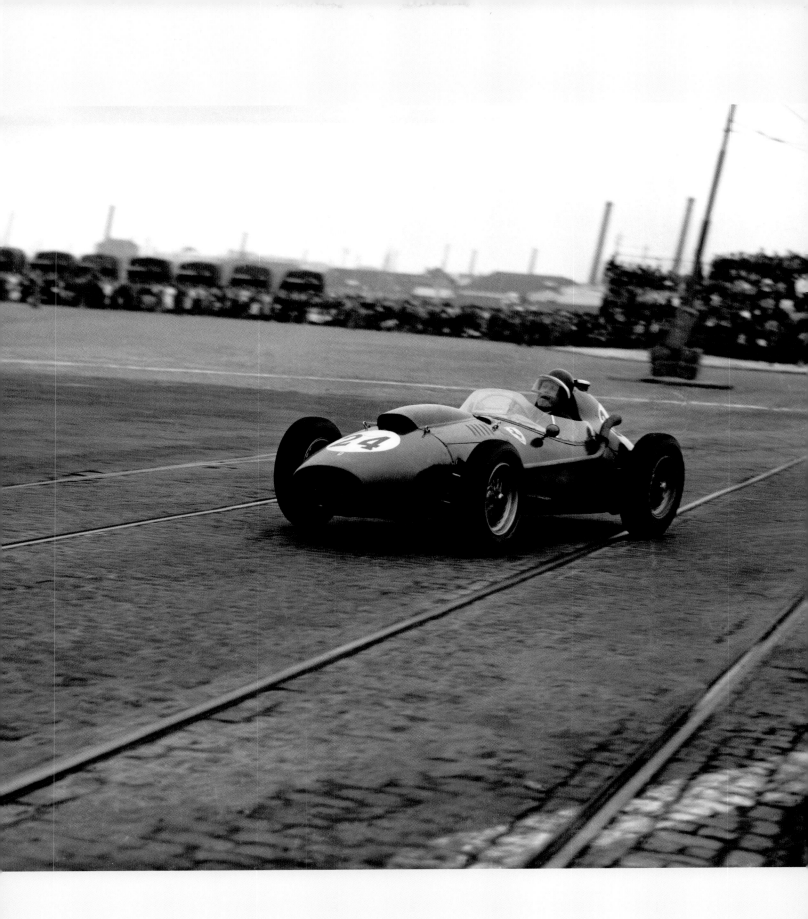

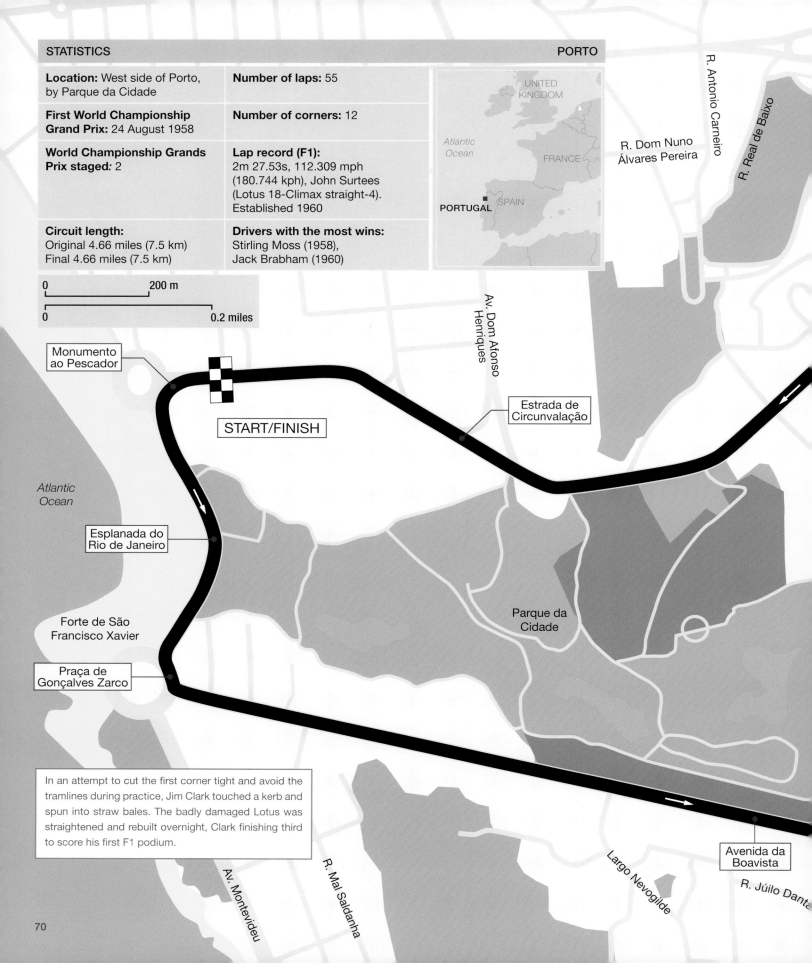

STATISTICS

PORTO

Location: West side of Porto, by Parque da Cidade

First World Championship Grand Prix: 24 August 1958

World Championship Grands Prix staged: 2

Circuit length:
Original 4.66 miles (7.5 km)
Final 4.66 miles (7.5 km)

Number of laps: 55

Number of corners: 12

Lap record (F1):
2m 27.53s, 112.309 mph (180.744 kph), John Surtees (Lotus 18-Climax straight-4). Established 1960

Drivers with the most wins:
Stirling Moss (1958), Jack Brabham (1960)

UNITED KINGDOM

Atlantic Ocean

FRANCE

PORTUGAL SPAIN

R. Antonio Carneiro

R. Dom Nuno Álvares Pereira

R. Real de Baixo

0 — 200 m
0 — 0.2 miles

Monumento ao Pescador

START/FINISH

Av. Dom Afonso Henriques

Estrada de Circunvalação

Atlantic Ocean

Esplanada do Rio de Janeiro

Forte de São Francisco Xavier

Praça de Gonçalves Zarco

Parque da Cidade

In an attempt to cut the first corner tight and avoid the tramlines during practice, Jim Clark touched a kerb and spun into straw bales. The badly damaged Lotus was straightened and rebuilt overnight, Clark finishing third to score his first F1 podium.

Av. Montevideu

R. Mal Saldanha

Largo Nevogilde

Avenida da Boavista

R. Júilo Danta

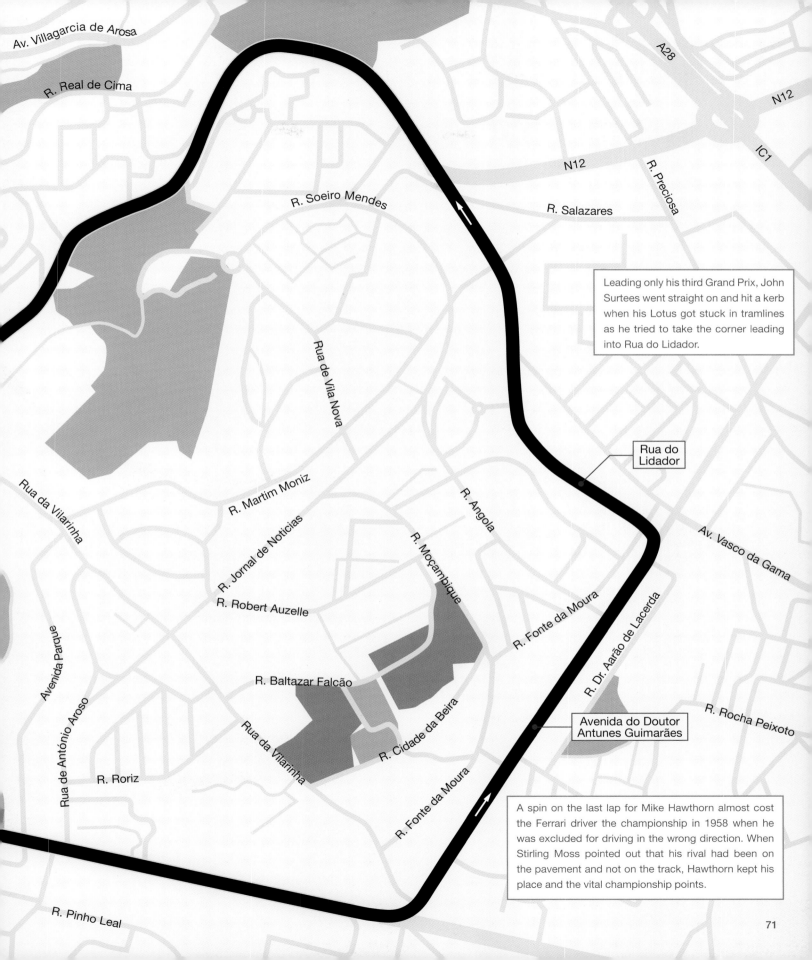

Av. Villagarcia de Arosa

R. Real de Cima

R. Soeiro Mendes

Rua de Vila Nova

Rua da Vilarinha

R. Martim Moniz

R. Jornal de Noticias

R. Robert Auzelle

Avenida Parque

Rua de António Aroso

R. Roriz

R. Baltazar Falcão

Rua da Vilarinha

R. Moçambique

R. Angola

R. Cidade da Beira

R. Fonte da Moura

R. Fonte da Moura

R. Pinho Leal

A28

N12

IC1

N12

R. Salazares

R. Preciosa

Av. Vasco da Gama

R. Dr. Aarão de Lacerda

R. Fonte da Moura

R. Rocha Peixoto

Leading only his third Grand Prix, John Surtees went straight on and hit a kerb when his Lotus got stuck in tramlines as he tried to take the corner leading into Rua do Lidador.

Rua do Lidador

Avenida do Doutor Antunes Guimarães

A spin on the last lap for Mike Hawthorn almost cost the Ferrari driver the championship in 1958 when he was excluded for driving in the wrong direction. When Stirling Moss pointed out that his rival had been on the pavement and not on the track, Hawthorn kept his place and the vital championship points.

Casablanca 1958

Ain-Diab

 MOROCCO

A fast, rectangular 4.7-mile (7.6-km) course on the south western edge of Ain-Diab, using a coastal road and part of the main route from Casablanca to Azemmour. Settled the 1958 world title during the only year the Grand Prix of Morocco was part of the championship.

Keen to promote his country after recent independence, the King of Morocco put his weight behind a drive to bring Grand Prix racing to the region even though the idea of travelling so far at the end of the season was not immediately welcomed by the Formula 1 teams. A non-championship race in 1957 was successful enough to have oil companies in Morocco offer financial support for an application to run a round of the F1 World Championship.

When a date was granted for October 1958, the organisers were to receive an additional bonus when it became clear the 10th and final Grand Prix of the season would settle the championship fight between Mike Hawthorn (Ferrari) and Stirling Moss (Vanwall). Both Englishmen were aiming for their first title, Moss needing to win the race (worth eight points) and set fastest lap (one point) while second place (six points) would be sufficient for Hawthorn, regardless of Moss's score.

Hawthorn took pole position, a tenth of a second ahead of Moss at the end of the 4.724-mile (7.602-km) lap. Despite its simple appearance, the circuit presented a considerable challenge. The well-surfaced undulating road was bordered throughout by straw bales, making corners tricky to identify and the featureless circuit difficult to learn. The 170-mph (274-kph) back-leg had a left-hand kink and cars reached 150 mph (241 kph) on the shorter straight running past the pits on the coast road. Only the first corner, a right-hander, called for severe braking.

While Hawthorn looked for support from team-mates Phil Hill and Olivier Gendebien, Moss relied on Stuart Lewis-Evans (the young Englishman qualifying on the outside of the front row) and Tony Brooks. In reality, though, Moss knew he had no option but to go flat out and let the rest sort themselves out.

Following a reception the previous evening in the British Consul's residence in Casablanca, race day got off to a regal start when the King arrived and was introduced to the 25 drivers, the field having been bolstered by Formula 2 cars.

Moss jumped into an immediate lead and defended his position from a vigorous attack by Hill, who led only briefly before taking to an escape road on the third lap. Brooks moved into second place to support his team-mate but, when the Vanwall blew up, the recovering Hill let Hawthorn into the second place he needed.

Moss did all he could by setting the fastest lap on the way to his fourth win of the season but his disappointment was to be put in stark perspective six days later when Lewis-Evans died of burns received after his engine had seized and the Vanwall crashed and caught fire. It was a terrible footnote for a circuit that would never host another championship Grand Prix.

A championship Grand Prix disrupted the way of life just once in Morocco, Stirling Moss winning on the roads of Ain-Diab with Mike Hawthorn finishing second to clinch the 1958 World Championship.

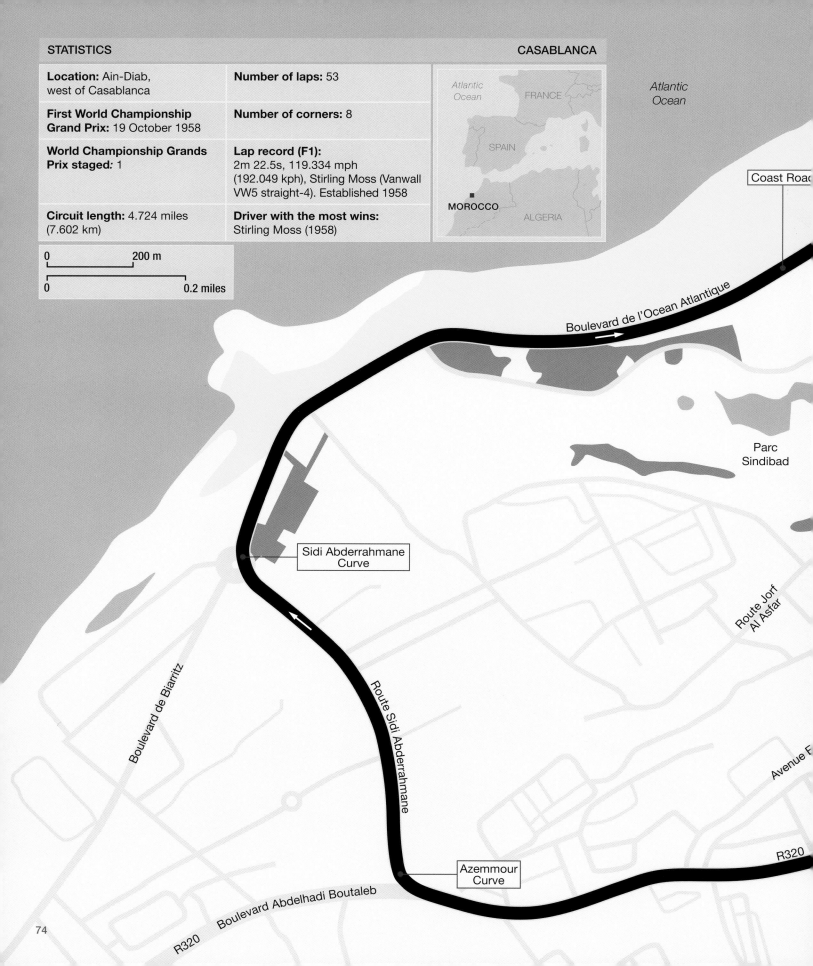

STATISTICS

Location: Ain-Diab,
west of Casablanca

**First World Championship
Grand Prix:** 19 October 1958

**World Championship Grands
Prix staged:** 1

Circuit length: 4.724 miles
(7.602 km)

Number of laps: 53

Number of corners: 8

Lap record (F1):
2m 22.5s, 119.334 mph
(192.049 kph), Stirling Moss (Vanwall
VW5 straight-4). Established 1958

Driver with the most wins:
Stirling Moss (1958)

CASABLANCA

*Atlantic
Ocean*

FRANCE

*Atlantic
Ocean*

SPAIN

MOROCCO

ALGERIA

0 200 m

0 0.2 miles

Coast Road

Boulevard de l'Ocean Atlantique

Parc
Sindibad

Sidi Abderrahmane
Curve

Route Jorf
Al Asfar

Boulevard de Biarritz

Route Sidi Abderrahmane

Avenue E

R320

Azemmour
Curve

Boulevard Abdelhadi Boutaleb

R320

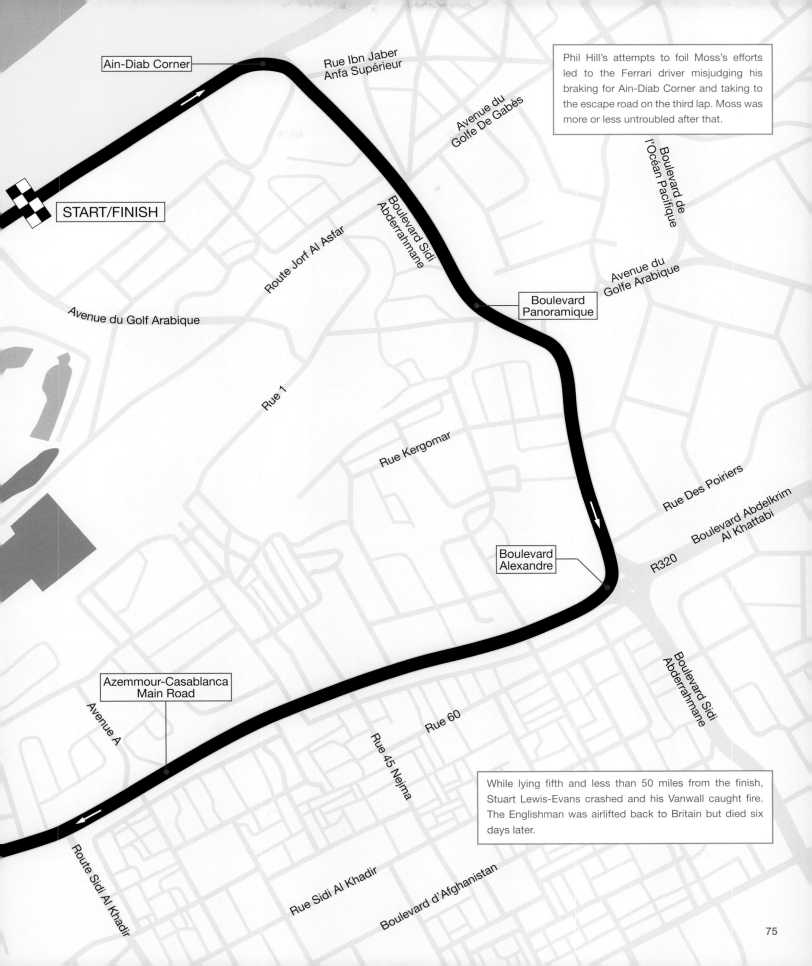

Ain-Diab Corner

Rue Ibn Jaber
Anfa Supérieur

START/FINISH

Avenue du
Golfe De Gabès

Boulevard Sidi
Abderrahmane

Boulevard de
l'Océan Pacifique

Phil Hill's attempts to foil Moss's efforts led to the Ferrari driver misjudging his braking for Ain-Diab Corner and taking to the escape road on the third lap. Moss was more or less untroubled after that.

Route Jorf Al Asfar

Avenue du Golf Arabique

Avenue du
Golfe Arabique

Boulevard
Panoramique

Rue 1

Rue Kergomar

Rue Des Poiriers

Boulevard Abdelkrim
Al Khattabi

R320

Boulevard
Alexandre

Azemmour-Casablanca
Main Road

Avenue A

Rue 60

Boulevard Sidi
Abderrahmane

Rue 45 Nejma

While lying fifth and less than 50 miles from the finish, Stuart Lewis-Evans crashed and his Vanwall caught fire. The Englishman was airlifted back to Britain but died six days later.

Route Sidi Al Khadir

Rue Sidi Al Khadir

Boulevard d'Afghanistan

Avus 1959

Avus

 GERMANY

In the southwest district of Berlin. Used just once to stage a round of the World Championship in 1959. A very simple layout dictated by two sides of an almost straight dual carriageway, linked at one end by a flat 180-degree turn and a banked brick-built curve at the other.

Devised as a test facility for the German motor industry and as a race track, Avus was opened in 1921. Approximately 12 miles (19.3 km) long, the circuit consisted of nothing more than parallel straights linked at each end by flat, large radius curves. Looking to increase the challenge in 1936 and lay claim to the title 'The World's Fastest Race Track', the authorities converted the north curve into a steeply banked turn made of bricks. Similar banking planned for the south curve was never built and the straights became part of the growing autobahn network.

Following World War II, the straights were shortened, a new south curve reducing the length to just over 5 miles (8 km). The so-called *Avusrennen* events became part of the international racing scene, although not a round of the World Championship. That honour finally fell to Avus for the running of the 21st German Grand Prix in August 1959, the organisers staging the race in two one-hour heats to overcome fears of tyre problems at an average of 150 mph (241 kph).

Competitors new to the circuit found it not quite as straightforward as it looked. Where the large loop at the southern end crossed the central reservation, grass had been replaced by concrete, as had extensions to the outer edges of the dual carriageway, in order to open the corner and allow greater speed. With the autobahn itself covered with asphalt, drivers had to deal with the surface changes as they ran across concrete three times. In addition, the large radius turn called for a gentle right-hand curve on the approach, at the very point when braking from 175 mph

(282 kph) to 50 mph (80 kph). Similarly, the entry to the banked north curve was fed by a right-hand curve, although the entry speed was higher at 110–120 mph (177–193 kph).

Once on the 43-degree banking, drivers discovered that very little science had been applied to the design and the cars did not find a natural line, as they would on the banking at Monza, making it necessary to physically steer as if round a normal corner. At the top, the bricks rose vertically for two or three feet before forming a wide ledge.

Unspoken fears about safety were realised during a sports car race, held inbetween F1 practice sessions on the Friday. Jean Behra, a talented and popular member of the F1 circus, lost control of his Porsche on banking made ever more treacherous by earlier rain. The car flew over the top, hit a building and flung Behra from the cockpit, the Frenchman killed instantly when he struck a flag pole.

There would be a miraculous escape in the Grand Prix when Hans Herrmann suffered a brake failure approaching the south turn. The BRM was launched by straw bales, the German being thrown clear and unhurt as his car went on to destroy itself in a series of barrel rolls.

The race itself turned out to be a Ferrari demonstration, Britain's Tony Brooks winning both heats. Of the original fifteen starters, only seven were left at the end, nine having got as far as the start of the second heat.

National racing would continue at Avus but the banking was dismantled in 1967, the track later being reduced in length before a farewell event was held in 1999.

Top: Hans Herrmann looks on in disbelief as he escapes injury after being flung from his cavorting BRM in the escape road on the approach to the Sudkurve.

The Ferrari of eventual winner, Tony Brooks, leads the field off the banking in 1959 on the sole occasion Avus was used to stage a championship Grand Prix.

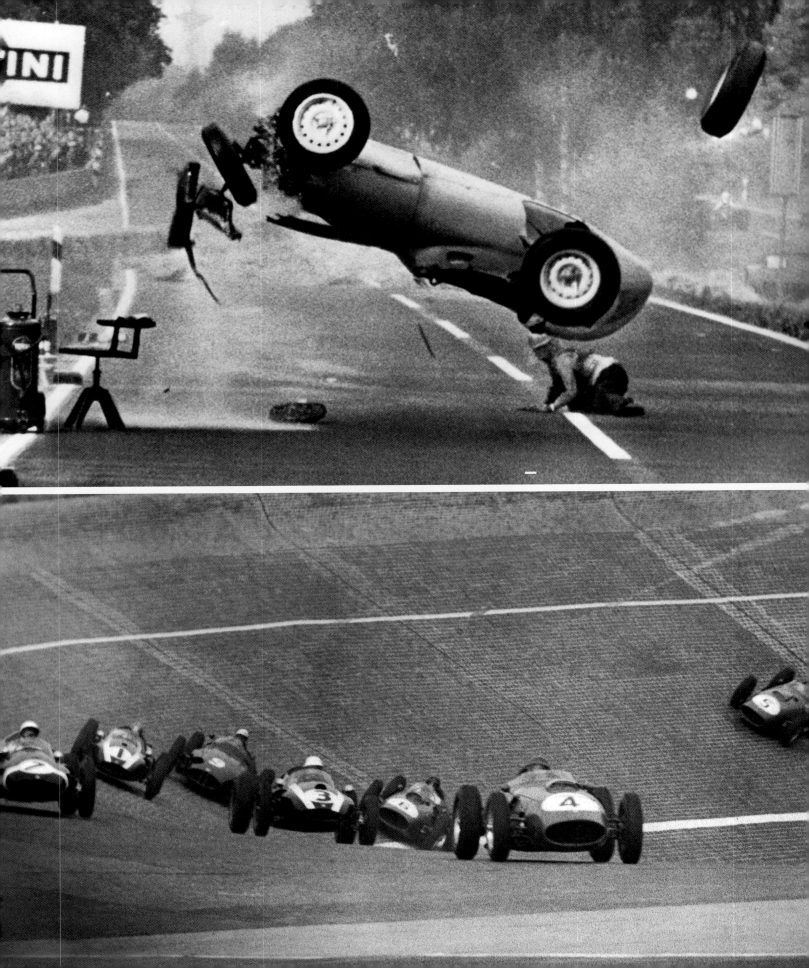

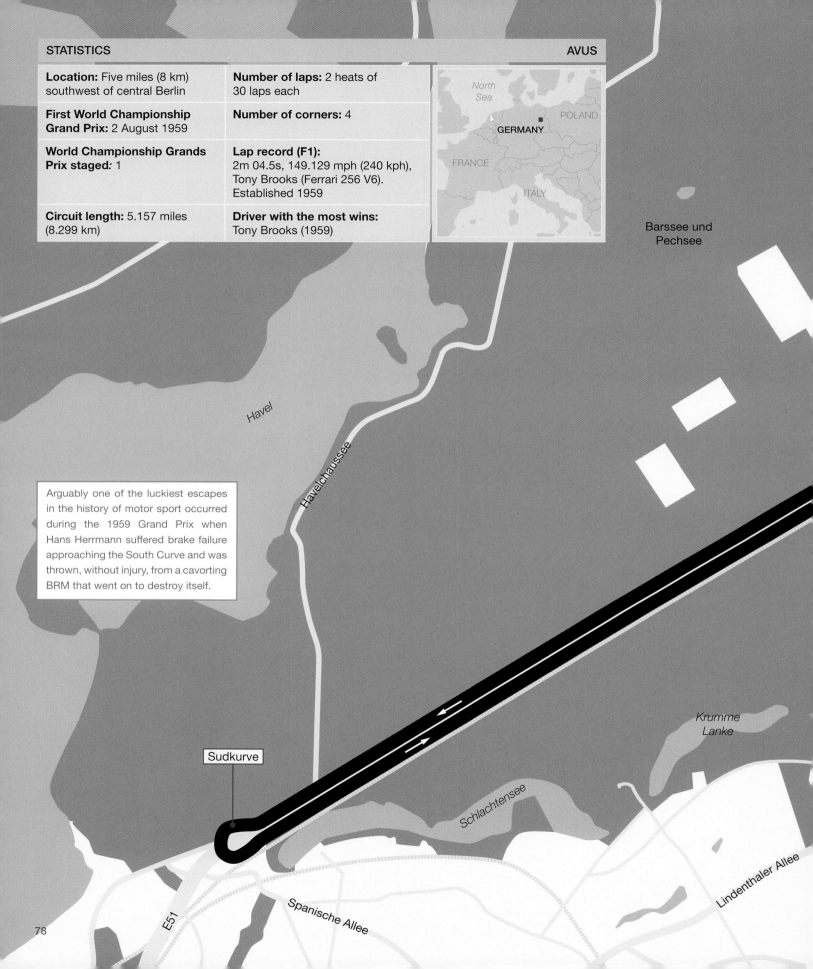

Location: Five miles (8 km) southwest of central Berlin

First World Championship Grand Prix: 2 August 1959

World Championship Grands Prix staged: 1

Circuit length: 5.157 miles (8.299 km)

Number of laps: 2 heats of 30 laps each

Number of corners: 4

Lap record (F1): 2m 04.5s, 149.129 mph (240 kph), Tony Brooks (Ferrari 256 V6). Established 1959

Driver with the most wins: Tony Brooks (1959)

Arguably one of the luckiest escapes in the history of motor sport occurred during the 1959 Grand Prix when Hans Herrmann suffered brake failure approaching the South Curve and was thrown, without injury, from a cavorting BRM that went on to destroy itself.

North Sea

GERMANY

POLAND

FRANCE

ITALY

Barssee und Pechsee

Havel

Havelchaussee

Krumme Lanke

Sudkurve

Schlachtensee

Lindenthaler Allee

Spanische Allee

E51

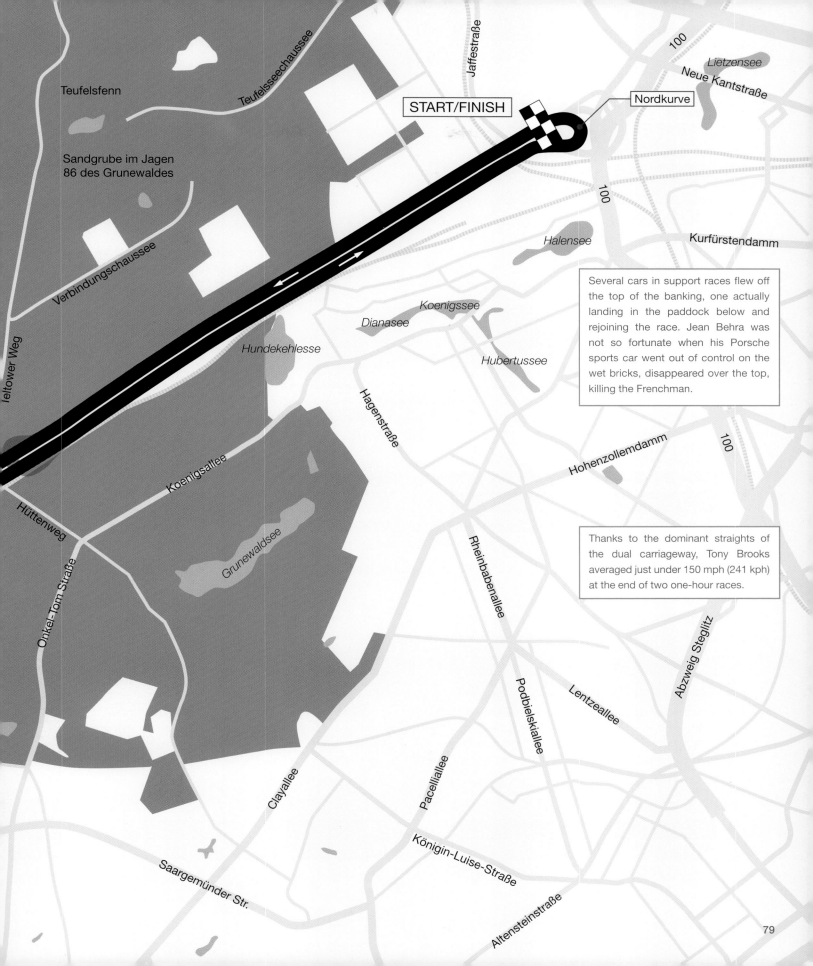

Teufelsfenn

Sandgrube im Jagen
86 des Grunewaldes

Teufelsseechaussee

Jaffestraße

START/FINISH

Nordkurve

Lietzensee

Neue Kantstraße

100

100

Verbindungschaussee

Ieltower Weg

Hundekehlesse

Dianasee

Koenigssee

Halensee

Hubertussee

Kurfürstendamm

Koenigsallee

Hagenstraße

Hohenzollemdamm

100

Hüttenweg

Grunewaldsee

Onkel-Tom Straße

Rheinbabenallee

Podbielskiallee

Lentzeallee

Abzweig Steglitz

Clayallee

Paceliallee

Königin-Luise-Straße

Saargemünder Str.

Altensteinstraße

Several cars in support races flew off
the top of the banking, one actually
landing in the paddock below and
rejoining the race. Jean Behra was
not so fortunate when his Porsche
sports car went out of control on the
wet bricks, disappeared over the top,
killing the Frenchman.

Thanks to the dominant straights of
the dual carriageway, Tony Brooks
averaged just under 150 mph (241 kph)
at the end of two one-hour races.

Monsanto 1959

Circuito de Monsanto

 PORTUGAL

A tricky combination of roads, rising and falling through 3.3 miles (5.3 km) of parkland in the western suburbs of Lisbon. Occasional racing in the 1950s led to a reconfiguration of the perimeter roads to host Monsanto's only World Championship Grand Prix in 1959, won easily by Stirling Moss.

The seed for a motor racing venue was literally sown in 1934 when the Portuguese Secretary of State for Public Works laid out plans for the reforestation of Serra de Monsanto, an area on the western fringe of Lisbon. Apart from the obvious natural and social objectives, the scheme also embraced the possibility of motor racing thanks to the area having run a hillclimb as early as 1910. It was, admittedly, a tenuous reason since there had been just two more hillclimbs in 1913 and 1922.

In 1953, the Automovel Club de Portugal took a closer look at the roads within and close to Monsanto Park and laid out a course suitable for their Jubilee Grand Prix in 1953. The track would prove popular enough to attract strong entries for sports car races, but the move by Porto to stage a championship Grand Prix in 1958 prompted the national automobile club to consider Monsanto. A round of the championship was secured for August 1959 on a slightly revised layout declared by drivers at the time to represent a true road racing circuit. That feeling was evident right from the start of the 3.371-mile (5.425-km) lap.

A slight uphill straight from the start led to a brow and a steep descent that had a step in the middle. Waiting at the bottom, a left turn with adverse camber crossed a cobbled main road and fed into a long right-hand hairpin joining one side of a concrete dual carriageway. Running uphill and measuring roughly one mile, this was the only straight which ended when competitors went into a slip road on the right. The climb continued through a cutting, the circuit crossing a minor road and levelling out before starting a long sweeping right-hand curve that gradually tightened into a sharp right-hand bend.

Running through woods, the circuit dipped into a fast right-hand curve before climbing to a sharp left-hander, running level through another fast right and descending again to a slow left-hand bend on a crossroads. A short, level straight allowed drivers to brace themselves for the final downhill run, through a fast left-hander with adverse camber and into a double-right climbing curve that led to the finish line. With the numerous curves, blind corners and off-camber braking, this was hard work with little room for error; a driver's circuit.

It was no surprise, therefore, when Stirling Moss dominated the two practice sessions (held early each evening), his nimble Rob Walker Cooper-Climax proving a perfect match for the driver's skill. Moss was two seconds clear of Jack Brabham's works Cooper. The Ferraris, winners at Avus three weeks before, were five seconds off the pace and clearly not at home in such contrasting surroundings.

With the start taking place at 5 p.m. Moss simply raced into the early evening, lapping the entire field in 66 laps and two hours of racing. His performance was so dominant that he could afford to almost come to a standstill at the Cooper pit and inform them that Brabham, Moss's only rival of note, was perfectly okay after being thrown from his car when he ran wide and hit a telegraph pole.

The race may have been processional but the praise heaped on the circuit and the slick organisation was not enough to have the Grand Prix return, or racing continue at Monsanto.

With Monsanto's challenging and picturesque elevation above Lisbon in evidence, Dan Gurney heads for third in his Ferrari 246 in 1959.

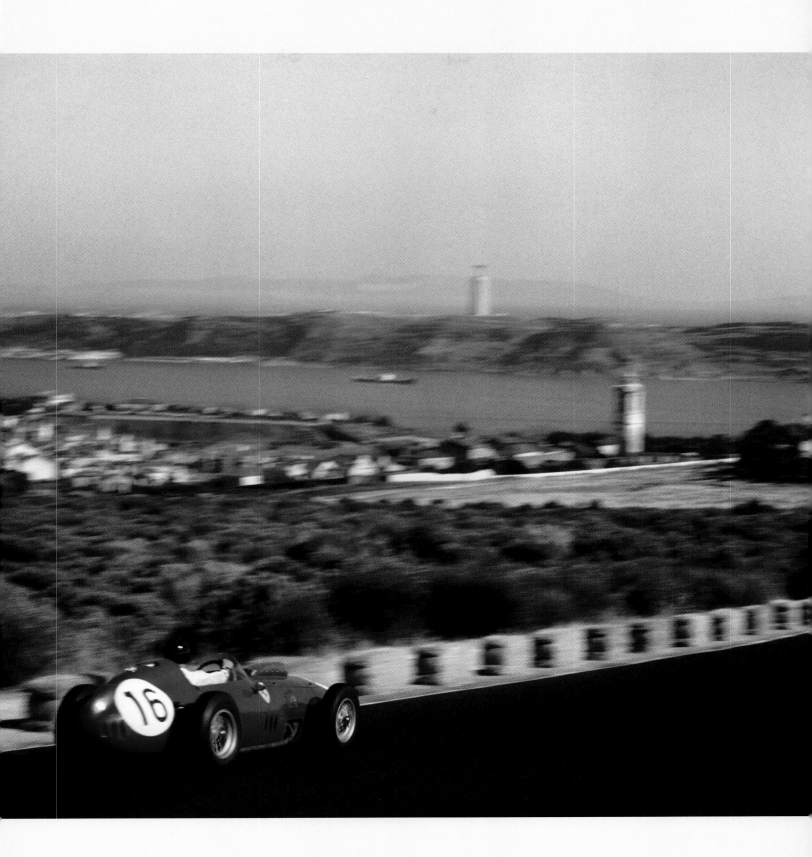

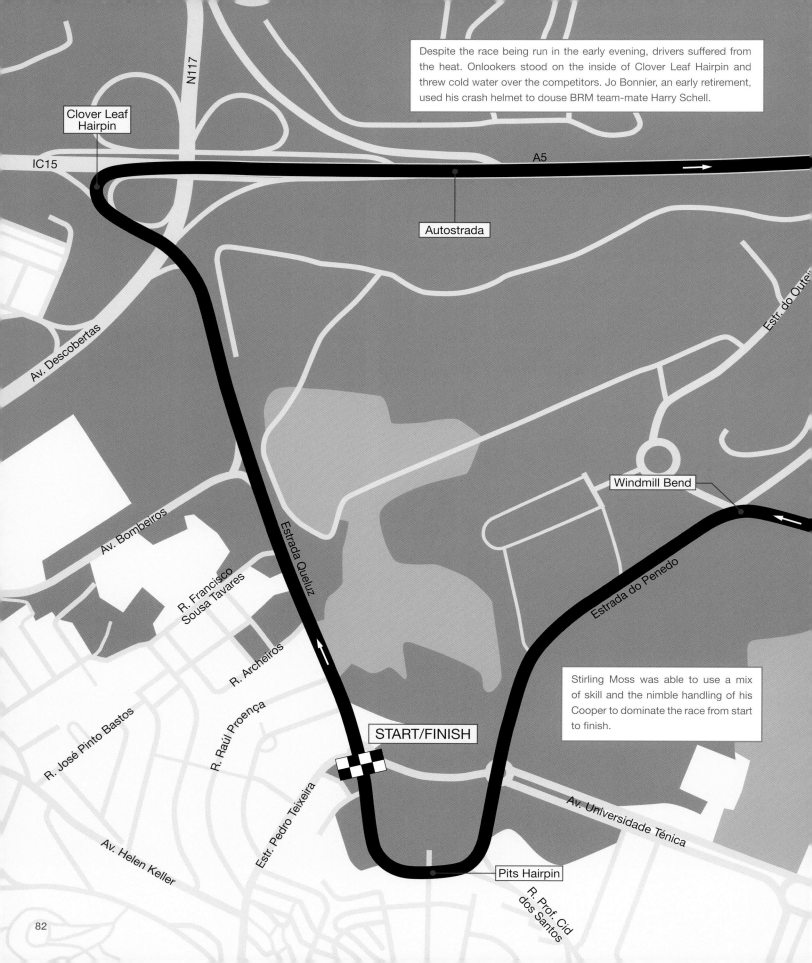

Despite the race being run in the early evening, drivers suffered from the heat. Onlookers stood on the inside of Clover Leaf Hairpin and threw cold water over the competitors. Jo Bonnier, an early retirement, used his crash helmet to douse BRM team-mate Harry Schell.

Clover Leaf Hairpin

IC15

A5

Autostrada

Av. Descobertas

N117

Estr. do Oute...

Windmill Bend

Av. Bombeiros

R. Francisco Sousa Tavares

Estrada Queluz

Estrada do Penedo

R. Archeiros

R. José Pinto Bastos

R. Raúl Proença

Stirling Moss was able to use a mix of skill and the nimble handling of his Cooper to dominate the race from start to finish.

START/FINISH

Av. Universidade Ténica

Av. Helen Keller

Estr. Pedro Teixeira

Pits Hairpin

R. Prof. Cid dos Santos

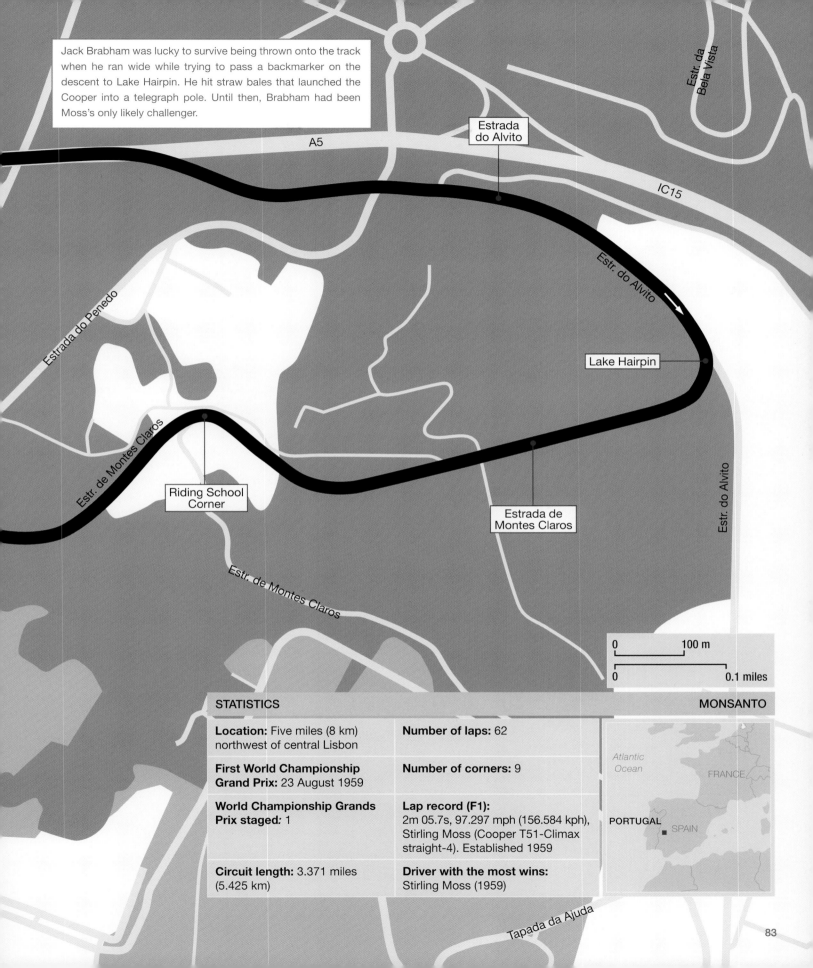

Jack Brabham was lucky to survive being thrown onto the track when he ran wide while trying to pass a backmarker on the descent to Lake Hairpin. He hit straw bales that launched the Cooper into a telegraph pole. Until then, Brabham had been Moss's only likely challenger.

A5

Estrada do Alvito

IC15

Estr. da Bela Vista

Estr. do Alvito

Estrada do Penedo

Lake Hairpin

Estr. de Montes Claros

Riding School Corner

Estrada de Montes Claros

Estr. do Alvito

Estr. de Montes Claros

0		100 m
0		0.1 miles

STATISTICS

MONSANTO

Location: Five miles (8 km) northwest of central Lisbon	**Number of laps:** 62
First World Championship Grand Prix: 23 August 1959	**Number of corners:** 9
World Championship Grands Prix staged: 1	**Lap record (F1):** 2m 05.7s, 97.297 mph (156.584 kph), Stirling Moss (Cooper T51-Climax straight-4). Established 1959
Circuit length: 3.371 miles (5.425 km)	**Driver with the most wins:** Stirling Moss (1959)

Atlantic Ocean

FRANCE

PORTUGAL SPAIN

Tapada da Ajuda

Sebring 1959

Sebring International Raceway

 UNITED STATES OF AMERICA

Used to stage the United States Grand Prix in 1959. Laid out on the runways of a former US Air Force training base near the town of Sebring, the Florida track has been the home for an annual sports car classic but was only used once for F1.

Built in 1941, Hendricks Field was a training base for the US Army Air Force before being deactivated four years later to become Sebring Airport.

Alec Ulmann had been inspired by a visit to the 1950 Le Mans 24-Hour race, the Russian-born graduate of the Massachusetts Institute of Technology deciding to run something similar in the USA. Ulmann, a stalwart of the Automobile Racing Club of America, saw the runways of the Sebring airfield as a ready-made venue and quickly organised a six-hour endurance race for sports cars on 31 December of the same year.

By 1952, the event had been expanded to 12 hours and, a year later, became a round of the Sports Car World Championship. Leading teams and drivers were therefore familiar with Sebring when the circuit was put forward as host for the first-ever United States Grand Prix in 1959. Run on 12 December, this would be the final race and the championship decider between Jack Brabham, Stirling Moss and Tony Brooks.

By using the wide expanse of runways, the track was predominantly fast, straight and bumpy thanks to the use of concrete with wide joints. The transitions between the runways were very rough, the corners being designated by nothing more than tubs. Apart from the infield loop incorporating the pits, a major problem for drivers unfamiliar with the flat and featureless track was determining its actual boundaries. Some compared it unfavourably with a driving test course at a British club meeting.

Typically, Moss found his way round the 5.4-mile (8.7-km) track faster than anyone else to claim pole in the Cooper-Climax entered by Rob Walker. Brabham parked his works

Cooper alongside, in the middle of a three-car front row that had the Ferrari of Brooks on the outside. However, the championship front-row synergy was to be disrupted shortly before the start.

As majorettes marched, prayers said and the anthem sung with due solemnity, a fierce row raged on the grid. Harry Schell claimed he had recorded a time good enough for the front row but the organisers had failed to recognise his lap, set at the end of qualifying under controversial circumstances. Schell won the argument, his Cooper was pushed onto the front row and the hapless Brooks relegated to row two.

Moss took the lead but, not far into the first lap, Wolfgang von Trips misjudged his braking and hit the rear of team-mate Brooks. Following a private principle not to take unnecessary risks with his machinery, Brooks called into the pits to have his Ferrari checked over. Apart from a dent at the rear, nothing was amiss and he rejoined in 15th place.

Moss retired with broken transmission, leaving Brabham untroubled at the front and en route to the title. Then, on the last lap, Brabham ran out of fuel, leaving his young team-mate Bruce McLaren to score his first Grand Prix win. Jack pushed his car 400 metres, slightly uphill, and collapsed when he crossed the line. He was classified fourth and claimed his first World Championship. Brooks finished third. But for the pit stop he might have won the race and, with it, the title.

The race had not been a financial success. And neither, according to F1 people, had it been well organised. There were few tears shed when Riverside in California was announced as host for the 1960 US Grand Prix, shortened versions of Sebring meanwhile going on to be a regular part of international sports car racing.

Jack Brabham tackles the narrower link roads away from the vast expanses of runway before running out of fuel. The Australian pushed his Cooper-Climax across the line to claim fourth place and his first world title.

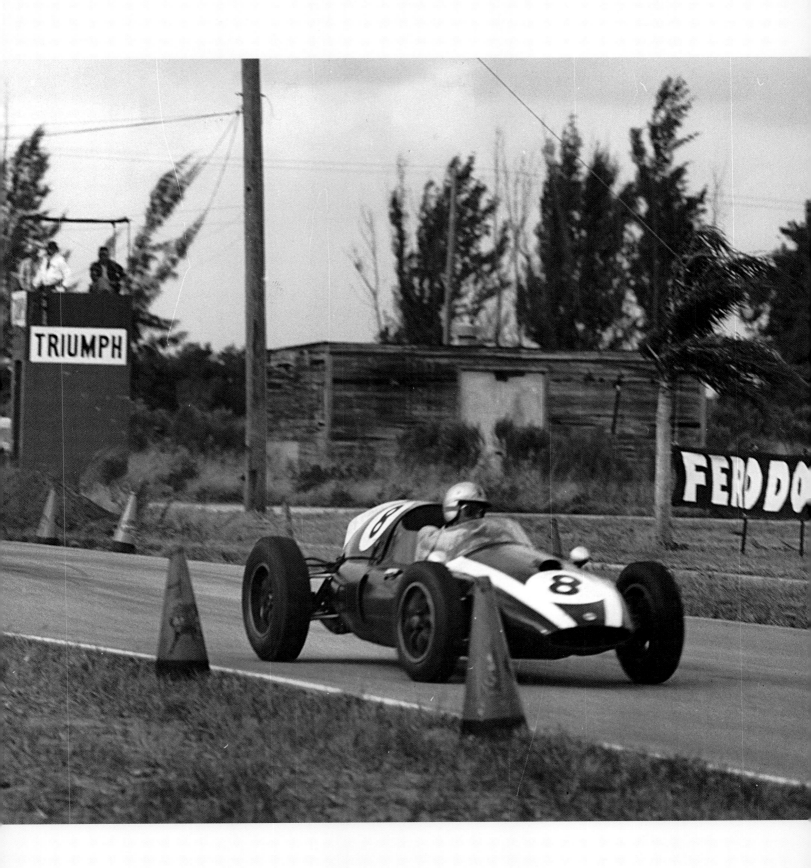

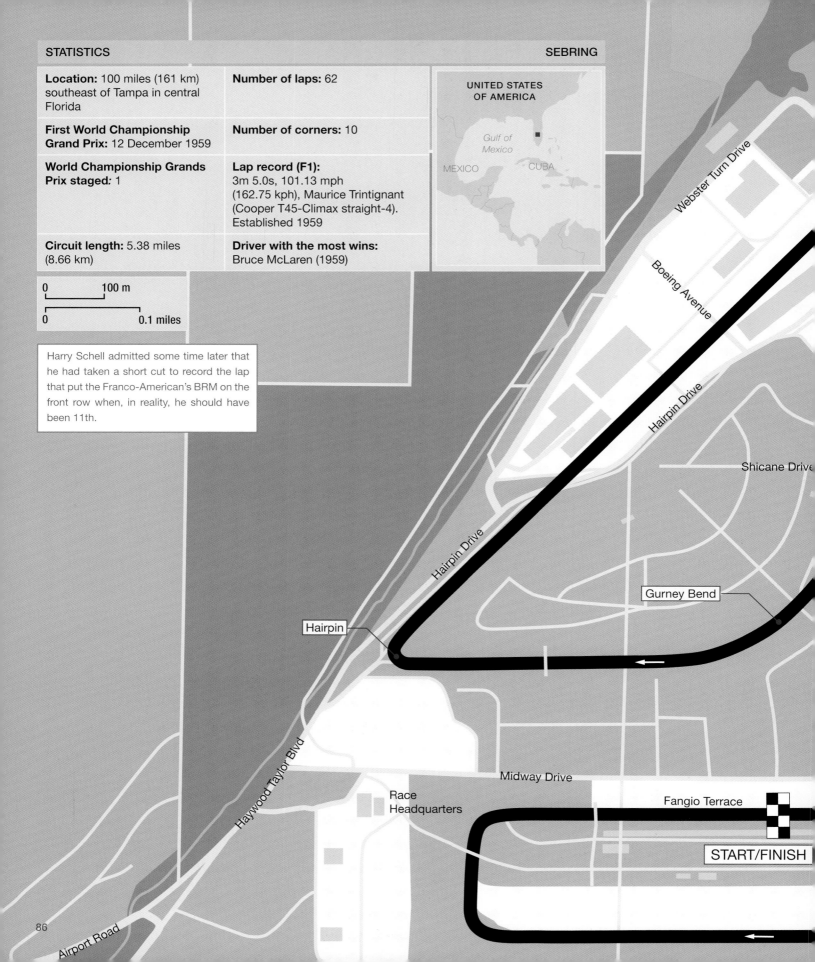

Location: 100 miles (161 km) southeast of Tampa in central Florida

Number of laps: 62

First World Championship Grand Prix: 12 December 1959

Number of corners: 10

World Championship Grands Prix staged: 1

Lap record (F1):
3m 5.0s, 101.13 mph (162.75 kph), Maurice Trintignant (Cooper T45-Climax straight-4). Established 1959

Circuit length: 5.38 miles (8.66 km)

Driver with the most wins:
Bruce McLaren (1959)

UNITED STATES OF AMERICA

Gulf of Mexico

MEXICO

CUBA

0 100 m

0 0.1 miles

Harry Schell admitted some time later that he had taken a short cut to record the lap that put the Franco-American's BRM on the front row when, in reality, he should have been 11th.

Webster Turn Drive

Boeing Avenue

Hairpin Drive

Shicane Drive

Hairpin Drive

Gurney Bend

Hairpin

Haywood Taylor Blvd

Midway Drive

Race Headquarters

Fangio Terrace

START/FINISH

Airport Road

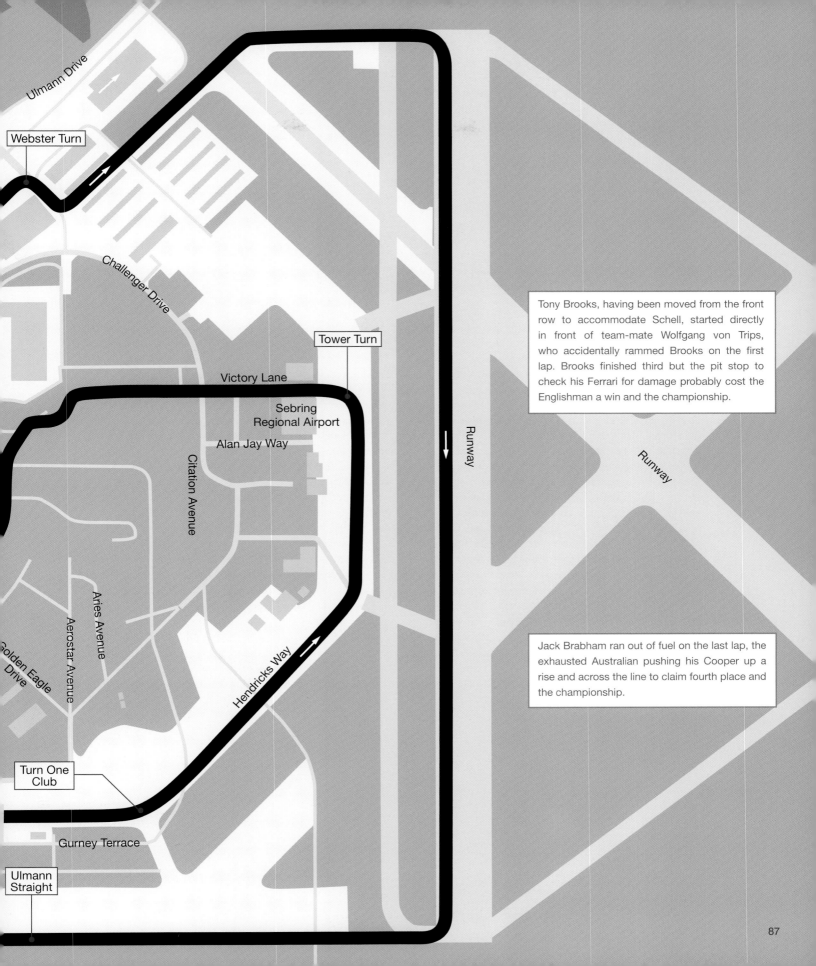

Ulmann Drive

Webster Turn

Challenger Drive

Tower Turn

Victory Lane

Sebring
Regional Airport

Alan Jay Way

Citation Avenue

Runway

Runway

Tony Brooks, having been moved from the front row to accommodate Schell, started directly in front of team-mate Wolfgang von Trips, who accidentally rammed Brooks on the first lap. Brooks finished third but the pit stop to check his Ferrari for damage probably cost the Englishman a win and the championship.

Aries Avenue

Aerostar Avenue

Golden Eagle Drive

Hendricks Way

Jack Brabham ran out of fuel on the last lap, the exhausted Australian pushing his Cooper up a rise and across the line to claim fourth place and the championship.

Turn One
Club

Gurney Terrace

Ulmann
Straight

Riverside 1960

Riverside International Raceway

 UNITED STATES OF AMERICA

Situated on the edge of the desert. A combination of layouts catered for drag racing, sports cars and NASCAR. The Grand Prix in 1960 did not attract enough spectators from nearby Los Angeles to make F1 viable. Closed in 1989; now the site of a shopping mall.

Opened in 1957, a 1.1-mile (1.77-km) straight used for drag racing formed the mainstay of a variety of layouts known collectively as Riverside International Raceway. Despite the downhill straight with a slow 180-degree turn at the end being considered dangerous, the longest combination at 3.275 miles (5.271 km) was put forward by the Automobile Racing Club of California as a venue for the 1960 United States Grand Prix.

The idea had been prompted by the failure of Sebring the year before and a 70,000 crowd turning out to watch the United States Grand Prix for sports cars in 1958. Enthusiasm was heightend further by an even bigger crowd attending the sports car event in the autumn of 1960 but, at the same time, the writing was on the wall in Portugal when Jack Brabham settled the championship, making the trip to California seem a long way to travel for the final race of the F1 season.

Added to which the *Los Angeles Times*, having heavily promoted the sports car race run under the newspaper's title sponsorship, did not show the same eagerness to support the 'foreigners' with their funny little F1 cars. (One European journal reported that the organisers 'made one or two mistakes which were not appreciated by the local newspapers and [motor] clubs')

No more than 25,000 spectators made the 50-mile (80-km) trip east from Los Angeles to witness the second United States Grand Prix. They didn't miss much on the barren desert circuit, even though the drivers enjoyed the challenge of a track some compared with Zandvoort in Holland.

Stirling Moss and Jack Brabham fought it out during practice with the Lotus proving 0.6 seconds faster than the champion's similarly Climax-powered Cooper. Brabham took off into the lead but his race was to be compromised in an unusual way.

Anxious to avoid the last-lap drama of the previous year's race at Sebring, the Cooper crew had filled Brabham's tanks to the brim. Under braking and acceleration, fuel was gushing from the breather, hitting the hot exhaust and causing a flash fire. Brabham could see the occasional eruption of flame in his mirror, accompanied by a 'whoompf' noise, but each time he stopped at his pit to investigate, the mechanics could find nothing wrong. By the time the fuel level had dropped and the pyrotechnics were over, Brabham had lost too much ground, leaving Moss in total control and on his way to another victory.

However, F1 was destined never to return to Riverside, the track would undergo various modifications and host many races over the years before finally being sold in 1989 as valuable land for housing and supermarket development.

Although drivers compared Riverside favourably with Zandvoort, spectators were not so enthusiastic and a poor attendance in 1960 meant this would be the first and last championship F1 race at the track situated on the edge of a desert.

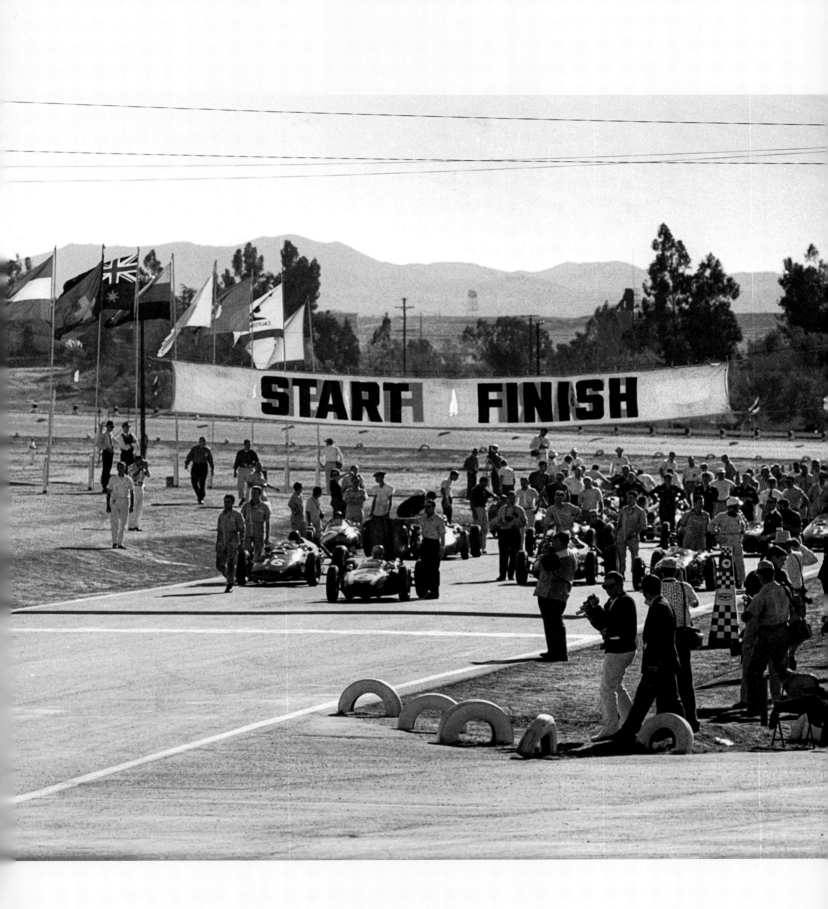

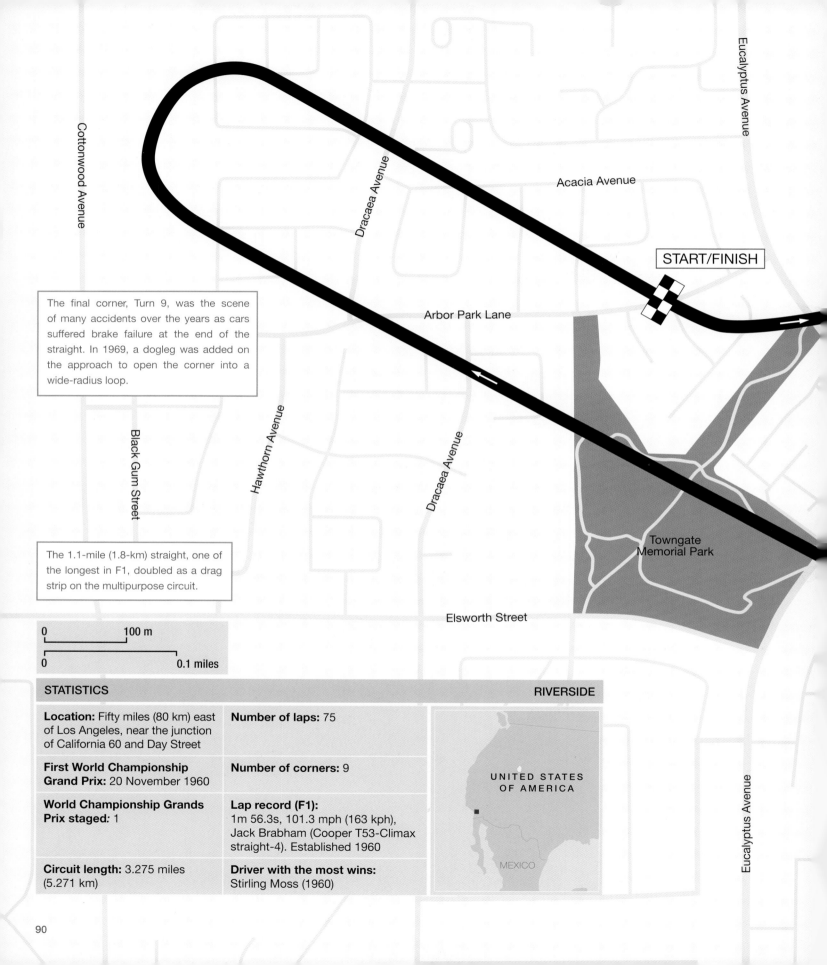

Cottonwood Avenue

Eucalyptus Avenue

Dracaea Avenue

Acacia Avenue

START/FINISH

The final corner, Turn 9, was the scene of many accidents over the years as cars suffered brake failure at the end of the straight. In 1969, a dogleg was added on the approach to open the corner into a wide-radius loop.

Arbor Park Lane

Black Gum Street

Hawthorn Avenue

Dracaea Avenue

The 1.1-mile (1.8-km) straight, one of the longest in F1, doubled as a drag strip on the multipurpose circuit.

Towngate
Memorial Park

Elsworth Street

| 0 | 100 m |
| 0 | 0.1 miles |

STATISTICS

RIVERSIDE

Location: Fifty miles (80 km) east of Los Angeles, near the junction of California 60 and Day Street

Number of laps: 75

First World Championship Grand Prix: 20 November 1960

Number of corners: 9

World Championship Grands Prix staged: 1

Lap record (F1):
1m 56.3s, 101.3 mph (163 kph), Jack Brabham (Cooper T53-Climax straight-4). Established 1960

Circuit length: 3.275 miles (5.271 km)

Driver with the most wins: Stirling Moss (1960)

UNITED STATES
OF AMERICA

MEXICO

Eucalyptus Avenue

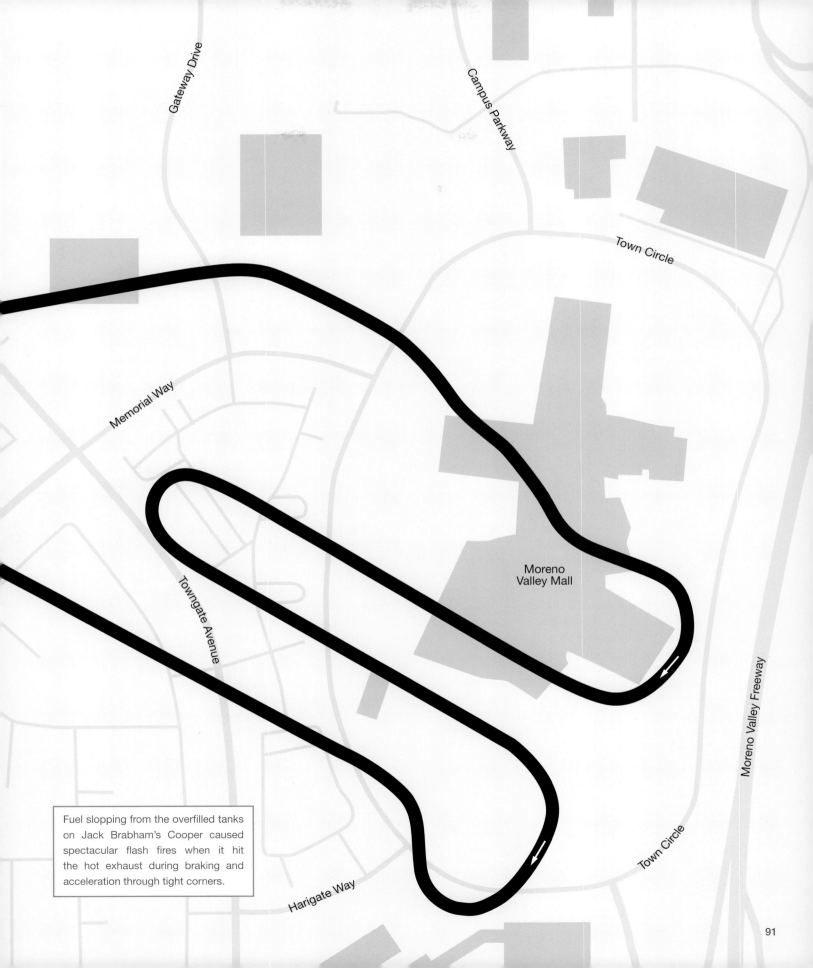

Fuel slopping from the overfilled tanks on Jack Brabham's Cooper caused spectacular flash fires when it hit the hot exhaust during braking and acceleration through tight corners.

Gateway Drive

Campus Parkway

Town Circle

Memorial Way

Towngate Avenue

Moreno Valley Mall

Moreno Valley Freeway

Town Circle

Harigate Way

91

Watkins Glen 1961

Watkins Glen

 UNITED STATES OF AMERICA

Home of the United States Grand Prix for two decades. Established a fine reputation as a challenging and attractive race track set in the beautiful Finger Lakes region of New York State. The permanent circuit, unable to afford the necessary updates to safety and facilities, was dropped from the F1 calendar in 1981.

The first post-war road races in the United States were held in 1948 across 6 miles (9.7 km) of public roads through and around the village of Watkins Glen in New York State. When a car left the road, killing and injuring spectators in 1952, the course was abandoned.

In 1956 a 2.3-mile (3.7-km) track was constructed as a community project in the rolling countryside above the town. Since the site was only 200 miles (322 km) northwest of Manhattan, it was reasoned there were adequate population centres to draw from if Watkins Glen was to host a successful United States Grand Prix in 1961.

Formula 1 was new to the region – indeed, to North America as a whole since this would be only the third running of the US Grand Prix (the previous two having been at Sebring in Florida and Riverside in California).

There should have been the added bonus of having Phil Hill on the entry list but America's first World Champion had won the title under tragic circumstances following the death of his team-mate and championship leader, Wolfgang von Trips, during the preceding Italian Grand Prix at Monza. With the championship decided in this way, Ferrari chose not to travel to North America, leaving Hill as a disappointed spectator for his home Grand Prix.

That did not prevent the F1 teams from being impressed with both the track layout and the hospitality of the locals. The teams and drivers were more than happy to return in 1962, along with enough spectators to make the race a paying proposition.

An investment in track facilities led to construction of the Technical Centre, a unique (at the time) central workspace to house all the F1 teams under one roof. There were other attractions, not least the biggest prize fund on the F1 calendar and stunning scenery accompanying what would become a traditional autumn date. In 1968, there was the added benefit of having Mario Andretti claim pole position for Lotus in what would be the American's first Grand Prix.

The US Grand Prix had become an accepted part of the North American social calendar with up to 90,000 spectators, many crossing the Canadian border, a three-hour drive to the northwest. The organisers responded by adding a new loop (known as 'The Boot') to extend the track length to 3.37 miles (5.42 km) in 1971, with the $50,000 first prize that year going to Jackie Stewart. In 1975, the Esses was added to reduce speed onto Back Straight.

By 1980, much had changed in the world of F1. Watkins Glen, for all its genuine warmth and endeavour, had not kept pace. The Technical Centre, once the ultimate in working conditions, was no longer adequate and neither were the pits. The circuit itself was deemed to be too bumpy and the spectator enclosures a quagmire at the merest hint of rain.

Over the years, 'The Bog' had become an infamous area to be avoided within the spectator enclosure, the crazed denizens' usual prize being the burning of a commandeered car, none of which improved the event's declining image. The 1980 US Grand Prix would be the last at Watkins Glen.

The lavender-suited Tex Hopkins gives an exuberant welcome to Jim Clark after a surprise win for the Lotus-BRM in 1966.

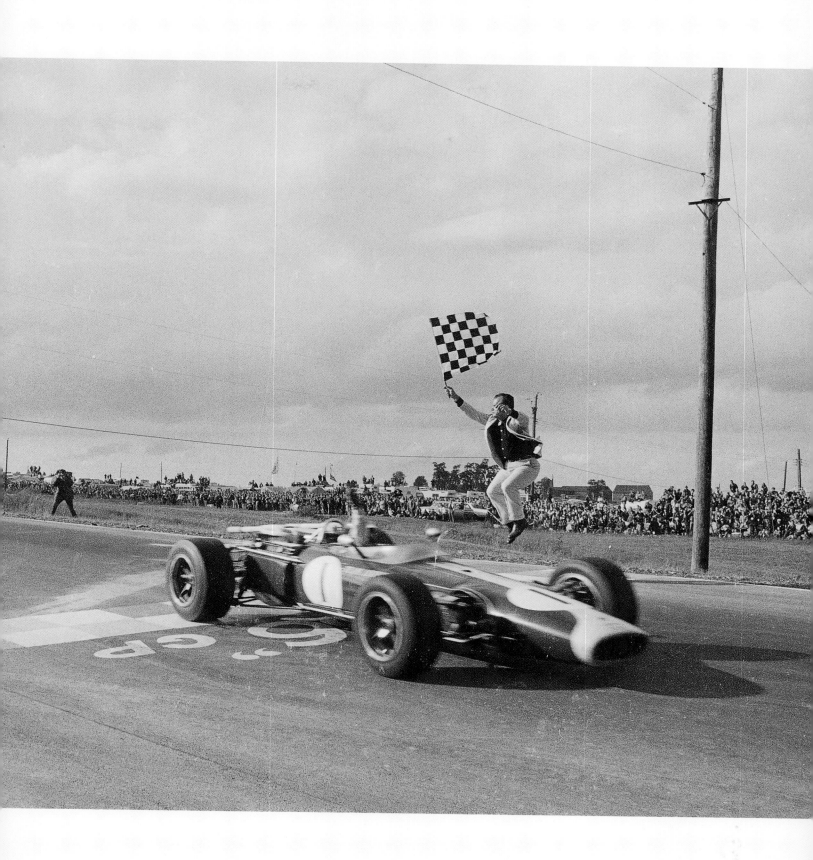

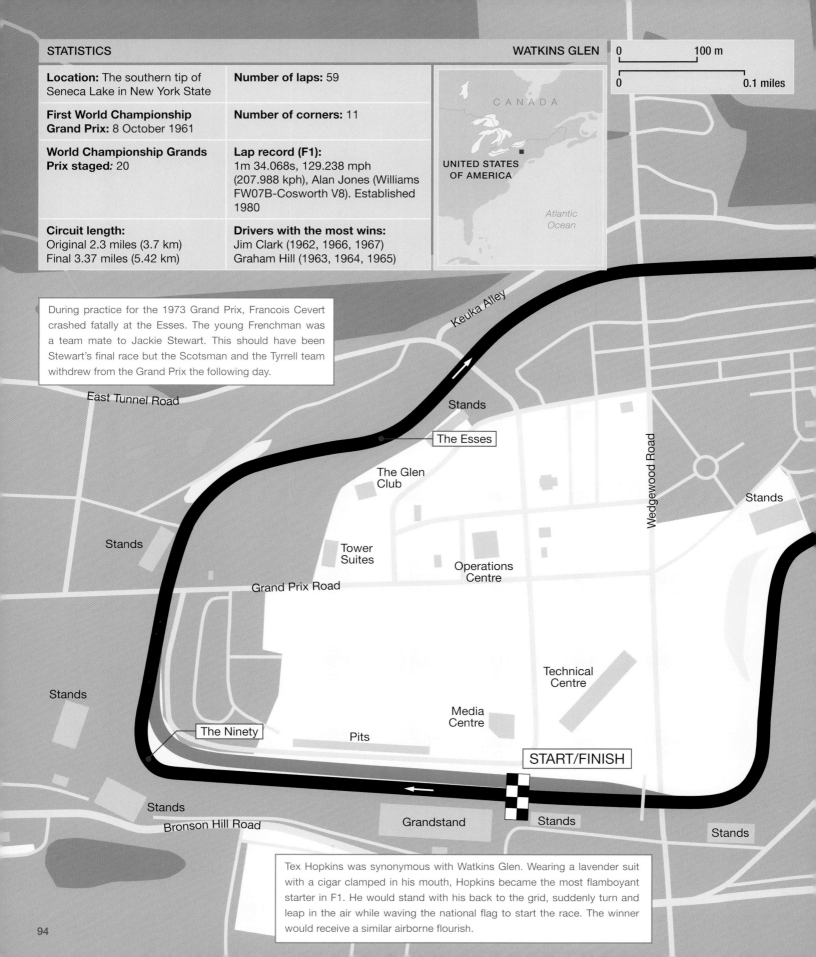

STATISTICS

Location: The southern tip of Seneca Lake in New York State

First World Championship Grand Prix: 8 October 1961

World Championship Grands Prix staged: 20

Circuit length:
Original 2.3 miles (3.7 km)
Final 3.37 miles (5.42 km)

Number of laps: 59

Number of corners: 11

Lap record (F1):
1m 34.068s, 129.238 mph (207.988 kph), Alan Jones (Williams FW07B-Cosworth V8). Established 1980

Drivers with the most wins:
Jim Clark (1962, 1966, 1967)
Graham Hill (1963, 1964, 1965)

CANADA

UNITED STATES OF AMERICA

Atlantic Ocean

0 100 m
0 0.1 miles

During practice for the 1973 Grand Prix, Francois Cevert crashed fatally at the Esses. The young Frenchman was a team mate to Jackie Stewart. This should have been Stewart's final race but the Scotsman and the Tyrrell team withdrew from the Grand Prix the following day.

East Tunnel Road

Keuka Alley

Stands

The Esses

The Glen Club

Stands

Wedgewood Road

Stands

Stands

Tower Suites

Grand Prix Road

Operations Centre

Stands

Technical Centre

Stands

The Ninety

Pits

Media Centre

START/FINISH

Stands

Stands

Bronson Hill Road

Grandstand

Stands

Stands

Tex Hopkins was synonymous with Watkins Glen. Wearing a lavender suit with a cigar clamped in his mouth, Hopkins became the most flamboyant starter in F1. He would stand with his back to the grid, suddenly turn and leap in the air while waving the national flag to start the race. The winner would receive a similar airborne flourish.

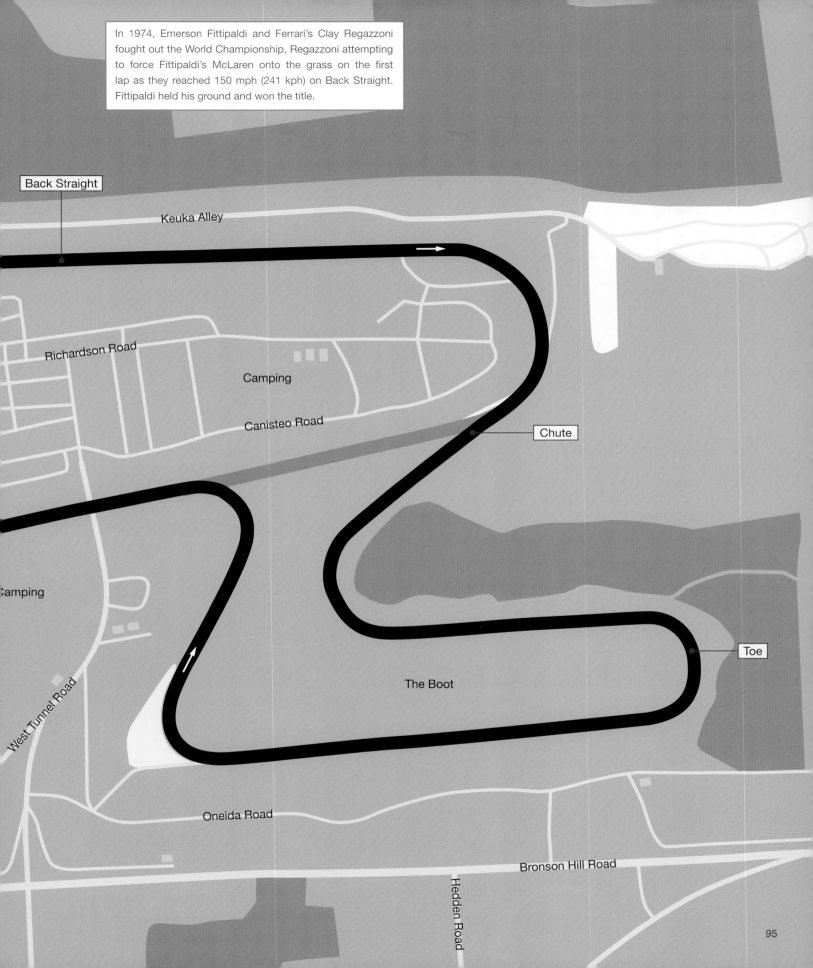

In 1974, Emerson Fittipaldi and Ferrari's Clay Regazzoni fought out the World Championship, Regazzoni attempting to force Fittipaldi's McLaren onto the grass on the first lap as they reached 150 mph (241 kph) on Back Straight. Fittipaldi held his ground and won the title.

Back Straight

Keuka Alley

Richardson Road

Camping

Canisteo Road

Chute

Camping

West Tunnel Road

The Boot

Toe

Oneida Road

Bronson Hill Road

Hedden Road

East London 1962

Prince George Circuit

 SOUTH AFRICA

Originally a 15-mile (24-km) road course used for the South African Grand Prix in the 1930s. Shortened to 2.44 miles (3.93 km) in 1960. The most significant initially of a number of tracks re-establishing South Africa internationally. A round of the F1 World Championship three times, settling the title in 1962.

South Africa had been thinking big from the outset. The first Grand Prix in 1934 used 15 miles (24 km) of fast roads on the southwest fringe of East London and attracted an impressive international entry. The Prince George circuit – so-called because it used part of Prince George Road skirting the Indian Ocean – was reduced to 11.7 miles (18.8 km) for the running of the Grand Prix in 1936, victory for Luigi Villoresi's Maserati three years later marking the final South African Grand Prix before the outbreak of World War II.

It was not until 1 January 1960 that international racing made a comeback, the Prince George Circuit being reduced further to 2.4 miles (3.9 km). Incorporating a small part of Prince George Road and Molteno Drive (used on the original 15-mile (24-km) circuit) as two sides of a triangle, the latest version then looped through a rifle range and parkland bordering the ocean before returning via a right-hand hairpin ('Beacon Bend') to Prince George Road, where the pits and main grandstand were located.

The Cooper-Borgward of Stirling Moss led a sparse international entry for a Formula Libre event, the field consisting of a weird assortment of single seaters, sports cars and one-off specials. Moss led until a misfire forced a pit stop and handed an easy victory to the Cooper-Climax of Belgian journalist/driver Paul Frere. Moss made up for the disappointment in December when he returned to win at the wheel of a works Porsche, the quality of the field still wanting as Moss lapped one particular homespun car no less than ten times.

Twelve months later, the 1961 South African Grand Prix at East London was part of a four-race Springbok series using the Killarney, Westmead and Kyalami tracks. All four were won by Jim Clark, then in the ascendancy with Lotus. The Scotsman described the East London track as 'a jolly good mixture. There are two fast right-hand bends after the start-finish straight, two slow hairpins and some tricky Esses in a section that is a bit narrow and could do with widening.'

The race on Boxing Day was seen as good practice for the following year when, finally, the 1962 South African Grand Prix on 29 December would be granted World Championship status. Clark, in a two-way fight for the title, was considered the favourite after winning the Rand Grand Prix at Killarney and finishing second in the Natal Grand Prix at Westmead.

He backed that up by taking pole and an immediate lead at East London in front of 90,000 spectators, the second largest crowd to have attended a sporting fixture in South Africa. Clark was on course for his first championship until lap 59 when wisps of blue smoke appeared from the back of his Lotus. A bolt had dropped out, eventually allowing all of the Climax V8's oil onto the exhaust. Hill's BRM emerged through what had become a smokescreen to take the race and the championship.

Clark won the next two championship Grands Prix at East London, the first being at the end of an all-conquering year in 1963 and the second, on 1 January, marking the start of his second championship in 1965.

Noting the success of East London, the owners of Kyalami were keen to stage the Grand Prix, a move that met little resistance from the F1 teams as the Prince George Circuit, for all its attractive location and efficient organisation, was now considered too narrow. The Grand Prix never returned.

Jim Clark winning the race in 1963, having lost the World Championship here the previous year when a bolt dropped out and drained the oil from the Climax engine.

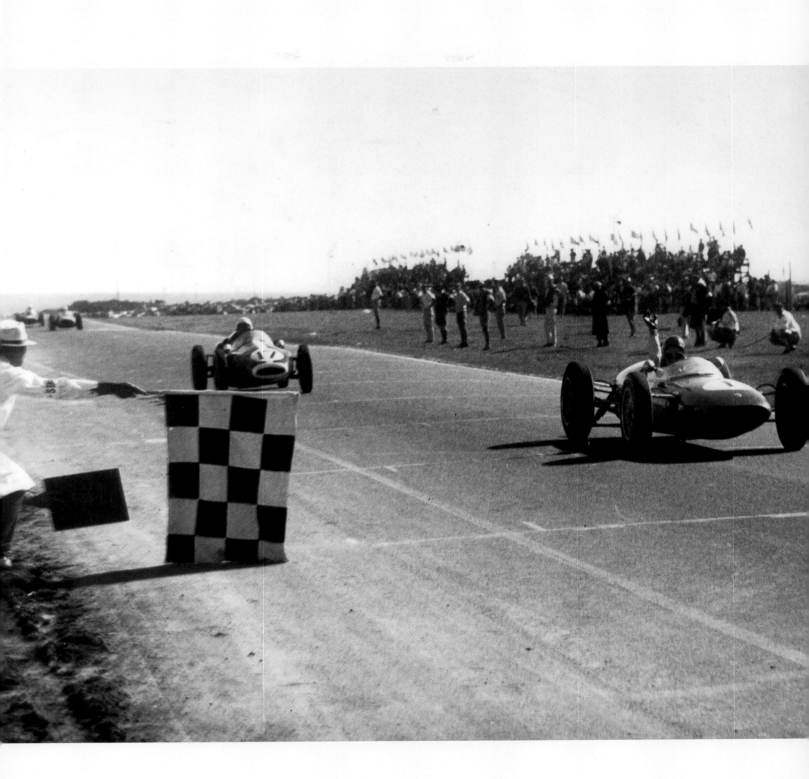

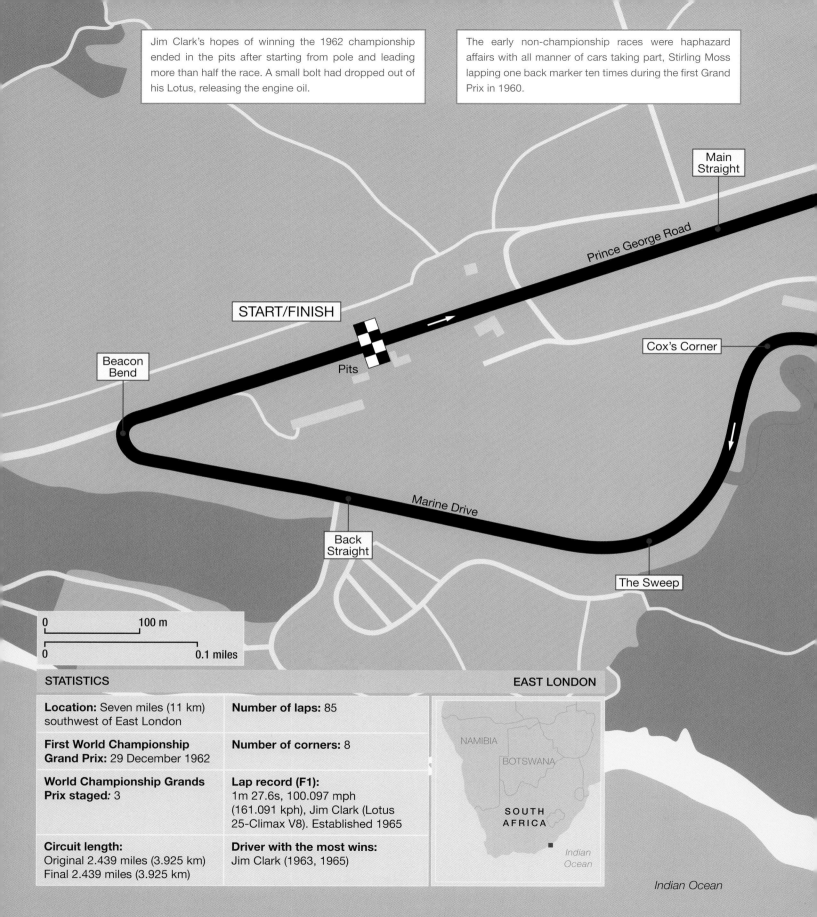

Jim Clark's hopes of winning the 1962 championship ended in the pits after starting from pole and leading more than half the race. A small bolt had dropped out of his Lotus, releasing the engine oil.

The early non-championship races were haphazard affairs with all manner of cars taking part, Stirling Moss lapping one back marker ten times during the first Grand Prix in 1960.

Main Straight

Prince George Road

START/FINISH

Cox's Corner

Beacon Bend

Pits

Marine Drive

Back Straight

The Sweep

0 100 m
0 0.1 miles

STATISTICS

EAST LONDON

Location: Seven miles (11 km) southwest of East London

Number of laps: 85

First World Championship Grand Prix: 29 December 1962

Number of corners: 8

World Championship Grands Prix staged: 3

Lap record (F1):
1m 27.6s, 100.097 mph (161.091 kph), Jim Clark (Lotus 25-Climax V8). Established 1965

Circuit length:
Original 2.439 miles (3.925 km)
Final 2.439 miles (3.925 km)

Driver with the most wins:
Jim Clark (1963, 1965)

NAMIBIA

BOTSWANA

SOUTH AFRICA

Indian Ocean

Indian Ocean

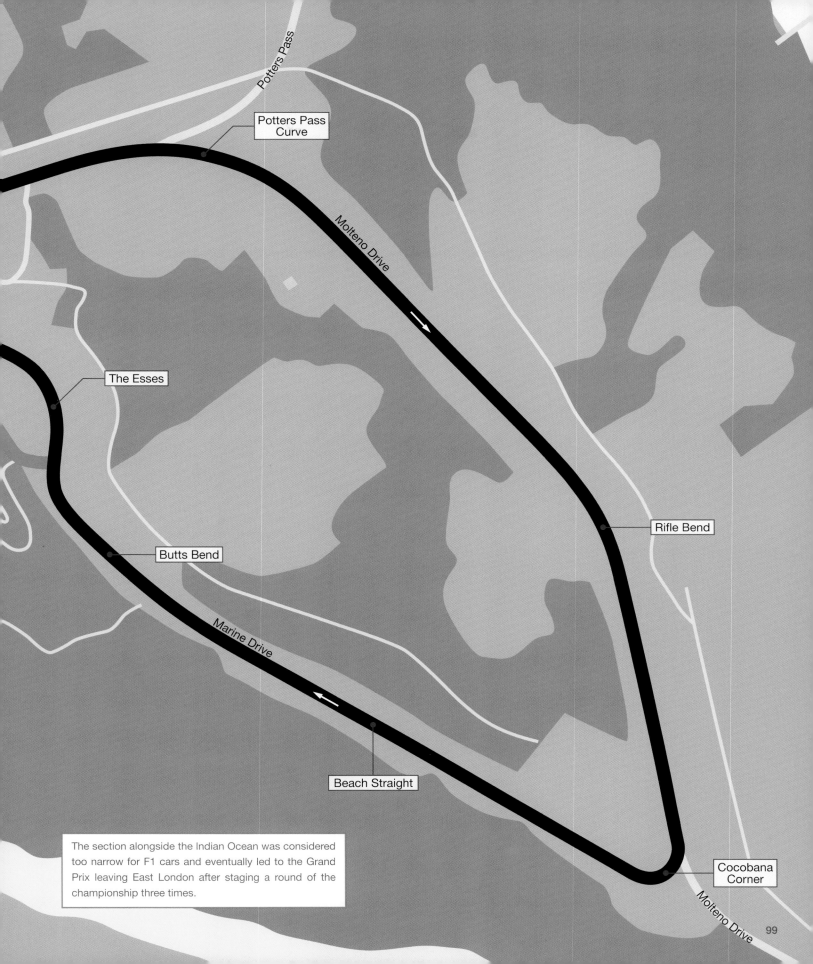

Potters Pass

Potters Pass
Curve

Molteno Drive

The Esses

Rifle Bend

Butts Bend

Marine Drive

Beach Straight

Cocobana
Corner

Molteno Drive

The section alongside the Indian Ocean was considered too narrow for F1 cars and eventually led to the Grand Prix leaving East London after staging a round of the championship three times.

Mexico City 1963

Autódromo Hermanos Rodriguez

 MEXICO

Challenging track within a park not far from the centre of Mexico City. Colourful and controversial from the first Grand Prix in 1963 to the last of that era in 1970. Revived on a shorter version between 1986 and 1992. Returned with more revisions in 2015.

Mexico has never been short of controversy and drama when it comes to motor racing. The Carrera Panamericana road races in the early 1950s ran from town to town and from potential crisis to potential crisis. The Mexican government did not support motor sport until the early 1960s when the new president, Adolfo Lopez Mateos, turned out to be an *aficionado*. It was the work of a moment to grant permission for the construction of a track on roads within Magdalena Mixhuca, a municipal park within the suburbs of Mexico City.

Racing began in January 1961 but an expansion to international status got off to a terrible start during the first day of practice for a non-championship Grand Prix in November 1962. The circuit received a mixed reaction from the F1 teams. Flat in profile with a long straight and an interesting series of curves that increased in speed, the track's main criticism was a banked 180-degree turn leading onto the pit straight. The drivers considered the bumpy banking, known as Peraltada, too dangerous. Their fears were to be proved right in the most tragic circumstances.

Ricardo Rodriguez, the younger of two talented Mexican brothers, was attempting to take Peraltada flat out when he lost control and hit the guardrail at the top. The 20-year-old was thrown from the Lotus and died from his injuries in front of his family and an adoring public.

The start of the race three days later was chaotic as no less than three officials, none communicating with each other, took it upon themselves to get things going while one car was actually on fire. Jim Clark, who had stalled, was black-flagged for a push start, the Scotsman taking over the Lotus of his team-mate, Trevor Taylor, and going on to retake the lead.

Clark would win under less controversial circumstances when the race became a round of the championship in 1963, the Mexican Grand Prix quickly establishing itself as a welcome part of the calendar. The organisers rebuilt Peraltada, making it smoother and faster, and added permanent pit buildings at the autodrome, now named in memory of Ricardo Rodriguez.

Ricardo's elder brother, Pedro, had begun to make his name, finishing seventh in his home race in 1964 (when John Surtees won the championship for Ferrari) and fourth in 1968, another year in which Mexico settled the title, this time in favour of Graham Hill and Lotus. By which time, the Mexican organisation had become lax and the track itself frayed round the edges. The end would come during a disastrous weekend in October 1970.

Hyped by a win for Rodriguez in the Belgian Grand Prix, a massive crowd encroached beyond flimsy fencing and onto the edge of the track. Despite pleas from their hero and from Jackie Stewart, the spectators stayed put, leaving the organisers with the option of either going ahead or facing a riot. They chose the former. Miraculously, no one was killed, the only causality being a large dog that had been fatally hit by Stewart's Tyrrell. There was no question of the Grand Prix returning in 1971.

When a consortium of businessmen invested $10 million in 1986, the improved Autodromo Hermanos Rodrigues (renamed after Pedro had been killed in Germany in 1971) staged the first of seven Grands Prix. Eventually, problems with pollution and the economy would see the race removed from the F1 calendar once more. Racing continued on a track with heavy revisions, including cutting Peraltada in half, further major surgery and rebuilding being seen as good enough to have the Mexican Grand Prix make a very popular return in 2015.

Despite staging the Grand Prix in three separate phases since 1963, Mexico was always viewed as a colourful addition to the F1 calendar. Max Verstappen heads for victory in his Red Bull in 2021.

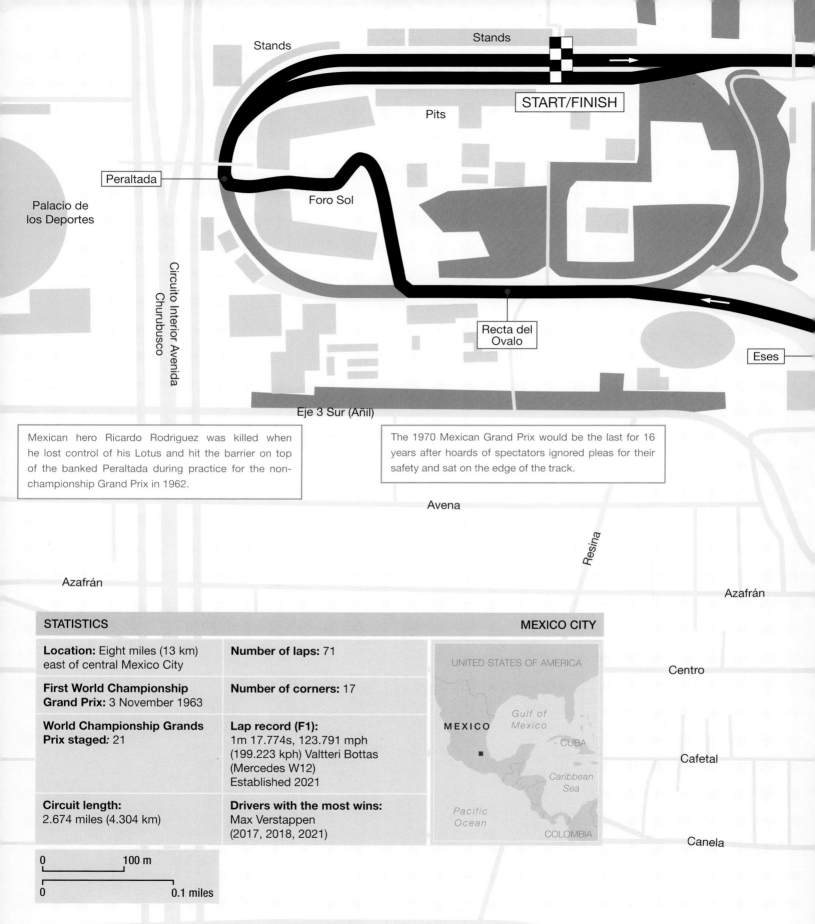

Stands

Stands

⬜◼⬜
◼⬜◼
⬜◼⬜

START/FINISH →

Pits

Peraltada

Foro Sol

Palacio de
los Deportes

Circuito Interior Avenida
Churubusco

Recta del
Ovalo ←

Eses

Eje 3 Sur (Añil)

Mexican hero Ricardo Rodriguez was killed when he lost control of his Lotus and hit the barrier on top of the banked Peraltada during practice for the non-championship Grand Prix in 1962.

The 1970 Mexican Grand Prix would be the last for 16 years after hoards of spectators ignored pleas for their safety and sat on the edge of the track.

Avena

Resina

Azafrán

Azafrán

Centro

STATISTICS

MEXICO CITY

Location: Eight miles (13 km) east of central Mexico City

Number of laps: 71

First World Championship Grand Prix: 3 November 1963

Number of corners: 17

World Championship Grands Prix staged: 21

Lap record (F1):
1m 17.774s, 123.791 mph (199.223 kph) Valtteri Bottas (Mercedes W12)
Established 2021

Circuit length:
2.674 miles (4.304 km)

Drivers with the most wins:
Max Verstappen (2017, 2018, 2021)

UNITED STATES OF AMERICA

Gulf of
Mexico

MEXICO

CUBA

Caribbean
Sea

Pacific
Ocean

COLOMBIA

Cafetal

Canela

0 100 m

0 0.1 miles

Eje 4 Sur Avenida Té

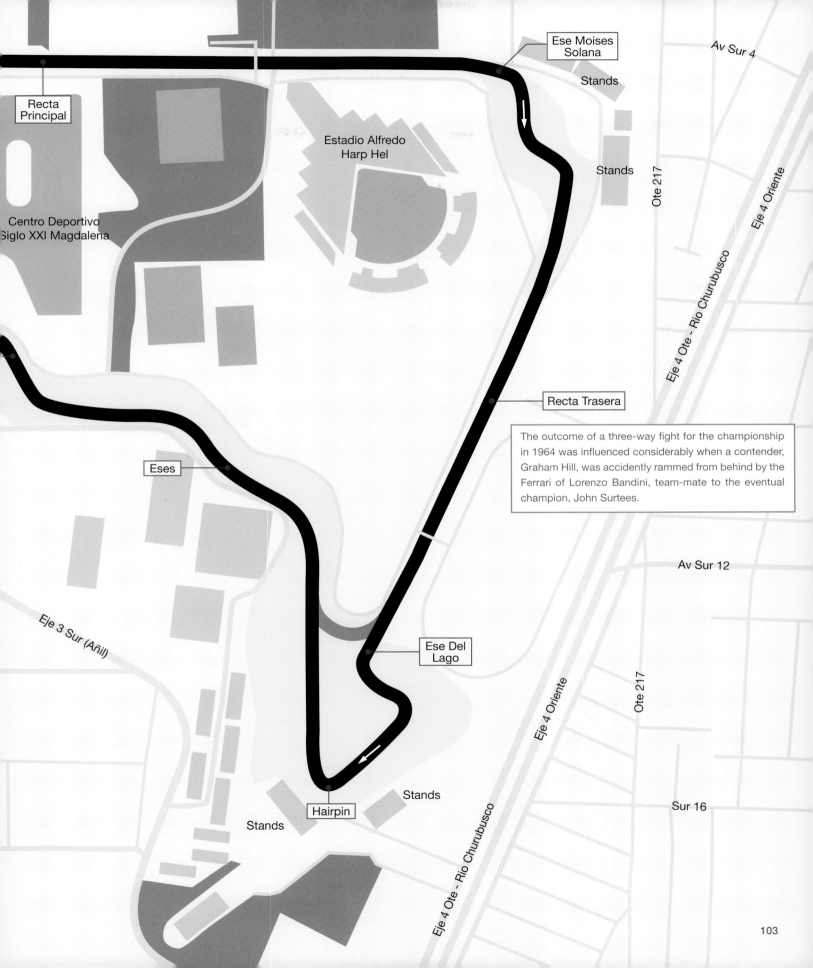

Recta Principal

Ese Moises Solana

Stands

Stands

Estadio Alfredo Harp Hel

Centro Deportivo Siglo XXI Magdalena

Recta Trasera

Eses

Av Sur 4

Ote 217

Eje 4 Oriente

Eje 4 Ote - Río Churubusco

The outcome of a three-way fight for the championship in 1964 was influenced considerably when a contender, Graham Hill, was accidently rammed from behind by the Ferrari of Lorenzo Bandini, team-mate to the eventual champion, John Surtees.

Av Sur 12

Eje 3 Sur (Añil)

Ese Del Lago

Eje 4 Oriente

Ote 217

Sur 16

Stands

Hairpin

Stands

Eje 4 Ote - Río Churubusco

Brands Hatch 1964

Brands Hatch Grand Prix Circuit

 GREAT BRITAIN

A classic track in an undulating setting by the A20, south of London. Originally for bike racers in the 1950s. Gradually extended until suitable for the British Grand Prix in 1964 and on alternate years until 1986. Always popular with drivers and spectators.

With Silverstone recognised as the only venue for the British Grand Prix, Brands Hatch was seen as a welcome and very different alternative. Established in the late 1940s as a grass track venue, the motor cycle racers used a natural bowl just off the A20 London-Maidstone road in Kent. This led to a cinder track along the kidney-shaped line and drew the attention of the 500 Club, so-called because of the spindly little cars powered by 500cc motor bike engines. The sum of £17,000 was invested in cutting down surrounding trees and laying tarmac along the one-mile length. The first motor race, run in an anticlockwise direction, was held on Sunday, 16 April 1950.

Four years later, an extension up the hill to Druids Bend added 0.24 miles (0.39 km) to a track now being used in a clockwise direction. But it was not until 1960 that a more serious and lengthy addition took competitors away from the original at Kidney Bend, dipping into the woods, sweeping through Hawthorn and Westfield bends, plunging down Dingle Dell, rising quickly to meet Dingle Dell Corner, followed almost immediately by Stirling's Bend, the new loop rejoining at Clearways. At 2.65 miles (4.26 km), Brands Hatch was now almost ready for Grand Prix racing.

In April 1961, Grovewood Securities announced their controlling interest in Brands Hatch Circuit Limited and began a £100,000 investment programme that included restaurants, bars, grandstands and toilet blocks. All 12,400 seats had been sold within seven weeks of the commencement of booking for the 1964 British Grand Prix, added impetus coming from the bestowal of *Grand Prix d'Europe*, an honorary title handed out at the whim of the FIA, motor sport's governing body.

Jim Clark won a race that would set a standard for organisation and preliminary parades and entertainment for which Brands Hatch would become justifiably famous thanks to the boundless energy of circuit director John Webb. The racing would be good, too, the 1970 Grand Prix being lost by Jack Brabham to Jochen Rindt when Brabham ran out of fuel on the last lap. While someone within the Brabham team was at fault, on two subsequent occasions, it was the organisers who would take a hammering.

With one lap remaining in 1974, Niki Lauda stopped his leading Ferrari in the pits to replace a punctured tyre – only to find the pit exit blocked by hangers-on and a course car. Two years later, trouble would erupt not long after the start when a collision caused the race to be stopped. James Hunt, the darling of the crowd, had been caught up in the chaos. When it was announced that the Briton would not be allowed to take the restart in the spare McLaren, 70,000 fans, sweltering in the heat of a tropical summer, gave vent, beer cans clattering onto the track to a backdrop of vocal disapproval. Hunt was eventually able to start in his repaired car. When he took the lead from arch-rival Lauda going into Druids, school was out. (A disqualification would come later in court.)

Such an emotional victory was equalled in 1985 when the astute Webb, sensing there might be a cancellation on the calendar, applied to host a Grand Prix in a year the British round alternated with Silverstone (as had been the case since 1964). Webb was granted the European Grand Prix in October, Nigel Mansell making the day for himself and his faithful followers by winning his first Grand Prix in superb style. Mansell and Williams would be back to win the British Grand Prix the following July but, sadly, this would be the last, Silverstone having secured a long-term deal.

Brands Hatch remains a hub of British motor racing, well-organised events giving drivers the rich experience of racing on the former Grand Prix track and the short but busy Indy circuit.

Top: Jochen Rindt shares with his wife Nina one of the 100 bottles of champagne for fastest lap on the fi rst day of practice in 1970. The Lotus driver would receive a traditional horn-blowing reception from the South Bank car park in the background when he won the British Grand Prix two days later. The area would eventually become car-free, as the photo below testifies.

Bottom: Officials and medical teams attend Jacques Laffite after a multiple collision just after the start in 1986 had forced the Frenchman's Ligier into the barrier on the approach to Paddock Hill Bend. Run before a packed house, this would be the last British Grand Prix at Brands Hatch.

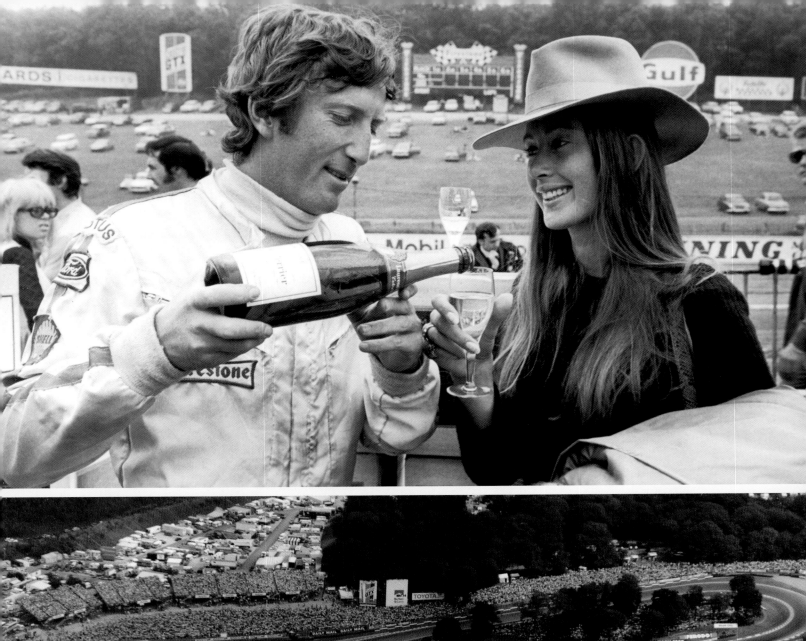

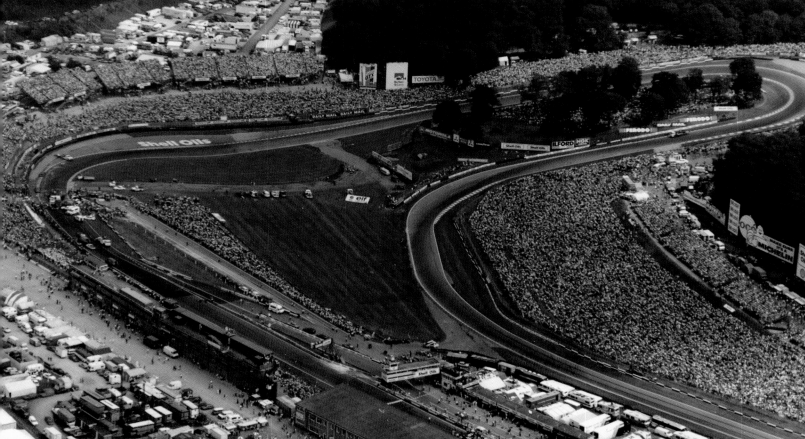

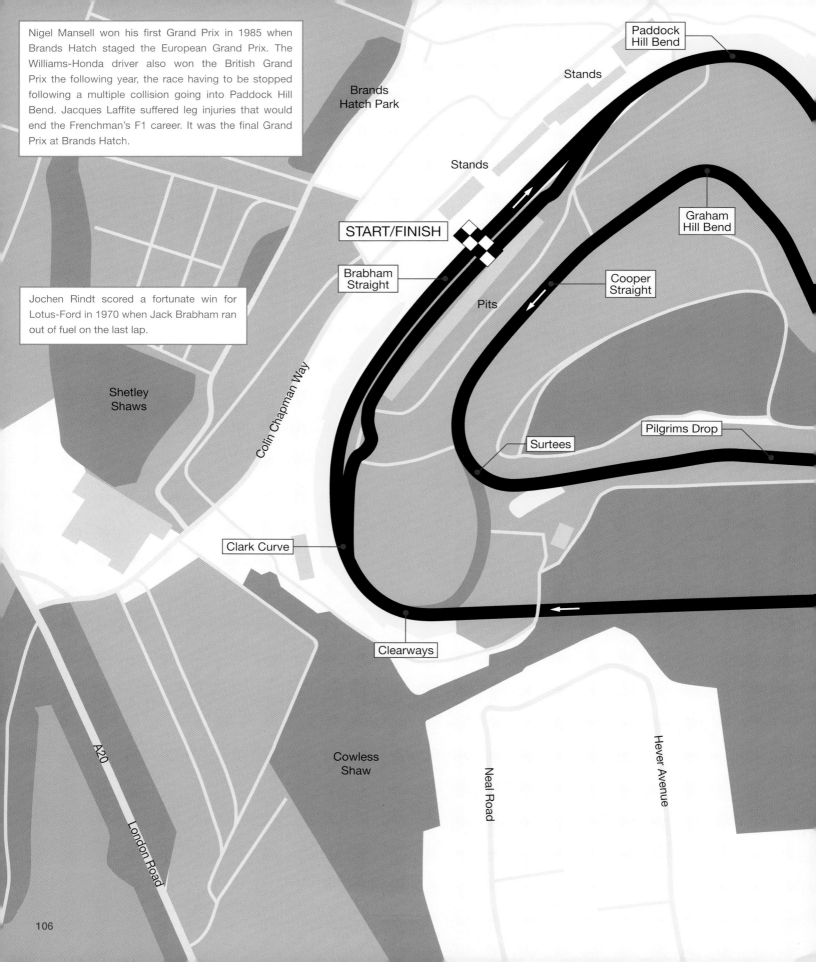

Nigel Mansell won his first Grand Prix in 1985 when Brands Hatch staged the European Grand Prix. The Williams-Honda driver also won the British Grand Prix the following year, the race having to be stopped following a multiple collision going into Paddock Hill Bend. Jacques Laffite suffered leg injuries that would end the Frenchman's F1 career. It was the final Grand Prix at Brands Hatch.

Jochen Rindt scored a fortunate win for Lotus-Ford in 1970 when Jack Brabham ran out of fuel on the last lap.

Brands Hatch Park

Stands

Stands

Paddock Hill Bend

START/FINISH

Graham Hill Bend

Brabham Straight

Cooper Straight

Pits

Surtees

Pilgrims Drop

Shetley Shaws

Colin Chapman Way

Clark Curve

Clearways

A20

London Road

Cowless Shaw

Neal Road

Hever Avenue

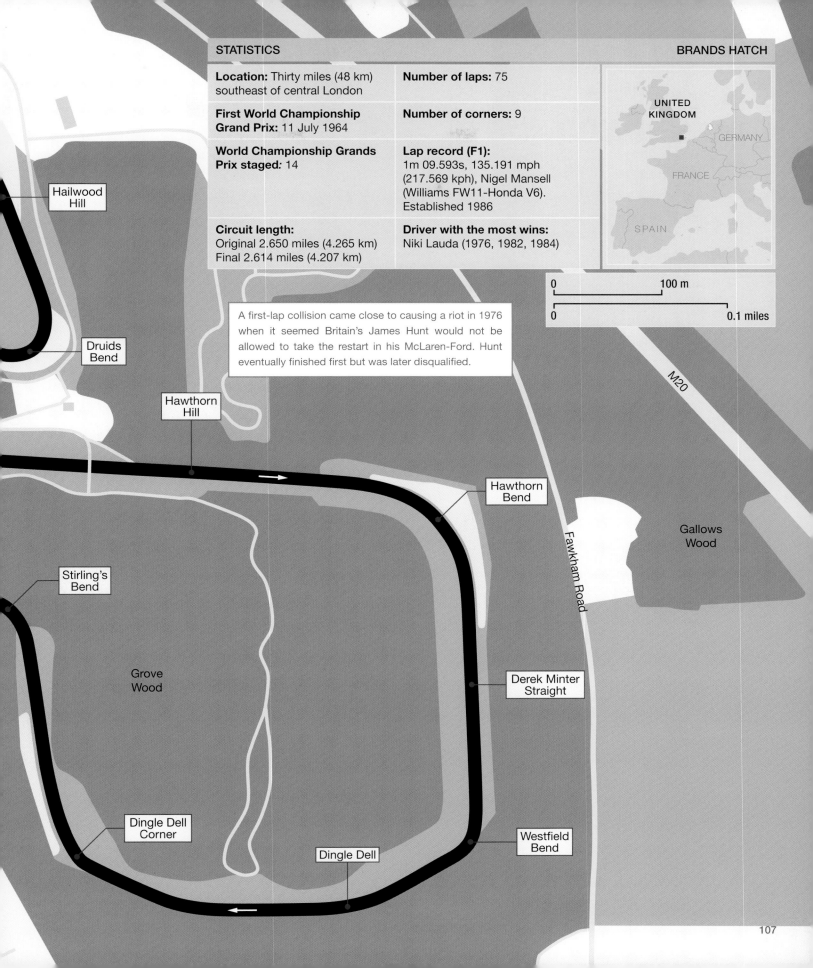

Location: Thirty miles (48 km) southeast of central London

First World Championship Grand Prix: 11 July 1964

World Championship Grands Prix staged: 14

Circuit length:
Original 2.650 miles (4.265 km)
Final 2.614 miles (4.207 km)

Number of laps: 75

Number of corners: 9

Lap record (F1):
1m 09.593s, 135.191 mph (217.569 kph), Nigel Mansell (Williams FW11-Honda V6). Established 1986

Driver with the most wins:
Niki Lauda (1976, 1982, 1984)

UNITED
KINGDOM
GERMANY
FRANCE
SPAIN

0 100 m

0 0.1 miles

A first-lap collision came close to causing a riot in 1976 when it seemed Britain's James Hunt would not be allowed to take the restart in his McLaren-Ford. Hunt eventually finished first but was later disqualified.

Hailwood Hill

Druids Bend

Hawthorn Hill

Hawthorn Bend

M20

Gallows Wood

Fawkham Road

Stirling's Bend

Grove Wood

Derek Minter Straight

Dingle Dell Corner

Dingle Dell

Westfield Bend

Zeltweg 1964

Zeltweg Airfield

 AUSTRIA

An unprepossessing 1.9-mile (3.1-km) track using the main runway with a loop onto a taxiway at Zeltweg airfield. Staged the 1964 Austrian Grand Prix but never likely to be used again because of the bumps and the temporary nature of the bland L-shaped track.

During the 1950s, circuit racing was rare in Austria. Hill climbing was more popular, if only because of the plentiful supply of suitable venues. But when a motor race attracted more than 30,000 spectators to the 1.69-mile (2.72-km) track on Aspern airfield near Vienna, the automobile club thought they might be on to something. Plans were accelerated to run races on a military airfield at Zeltweg, located in the flat valley of the River Mur, just below where the Österreichring would later be built.

The track did not match the lofty ambitions of organisers keen to stage the Austrian Grand Prix for the first time. L-shaped and running up and down the main runway with a short loop onto a taxiway and around a grass island, the track measured a very bumpy 1.9 miles (3.1 km). Zeltweg would stage sports car races in 1957 and 1958 and Formula 2 events, along with two non-championship F1 races, during the next five years. After initial rejection to run a round of the World Championship in 1963, permission was granted for the following year. It was to be memorable for nothing more than a catalogue of problems.

The timing beam failed and a typing error meant none of the team passes were recognised by the police controlling access. The paddock was housed in an aircraft hanger which was not only noisy when engines were running but also some way from the pits located in the middle of the runway with the main straights running either side. It was necessary, therefore, to shuttle back and forth and have everything in place before track activity could begin.

When they got going, the drivers were shaken to bits, as was their machinery as steering arms, suspensions and transmissions took a terrible pounding. Graham Hill claimed pole position, the BRM driver joined on the front row by John Surtees (Ferrari), Jim Clark (Lotus-Climax) and Dan Gurney (Brabham-Climax). Not one of them would finish.

There would be just nine of the 20 starters running at the end of 105 laps, the final three being between nine and 29 laps behind Lorenzo Bandini's winning Ferrari. The Italian would be one of the few wishing to remember the race since this would be his only Grand Prix win.

For Phil Hill, it was a race to forget. Having crashed his Cooper during practice, a spare car, more than a year old, was made ready for the race. Hill got caught out by a gutter running across the apex of the left-hander leading onto the main straight. He went off at the same spot during the race, the Cooper ending its journey – and what would turn out to be its life – against the straw bales at the exit, where it caught fire. The complete absence of marshals able to assist meant the car was soon ablaze, Hill being fortunate enough to have emerged from the cockpit uninjured.

There was talk of resurfacing the track but no one in F1 was keen to return. The airfield track would be a complete contrast to the magnificent circuit due to be built six years later on the hillside overlooking this doomed venue.

The Ferrari of Lorenzo Bandini heads for his one and only championship win on the airfield at Zeltweg in 1964.

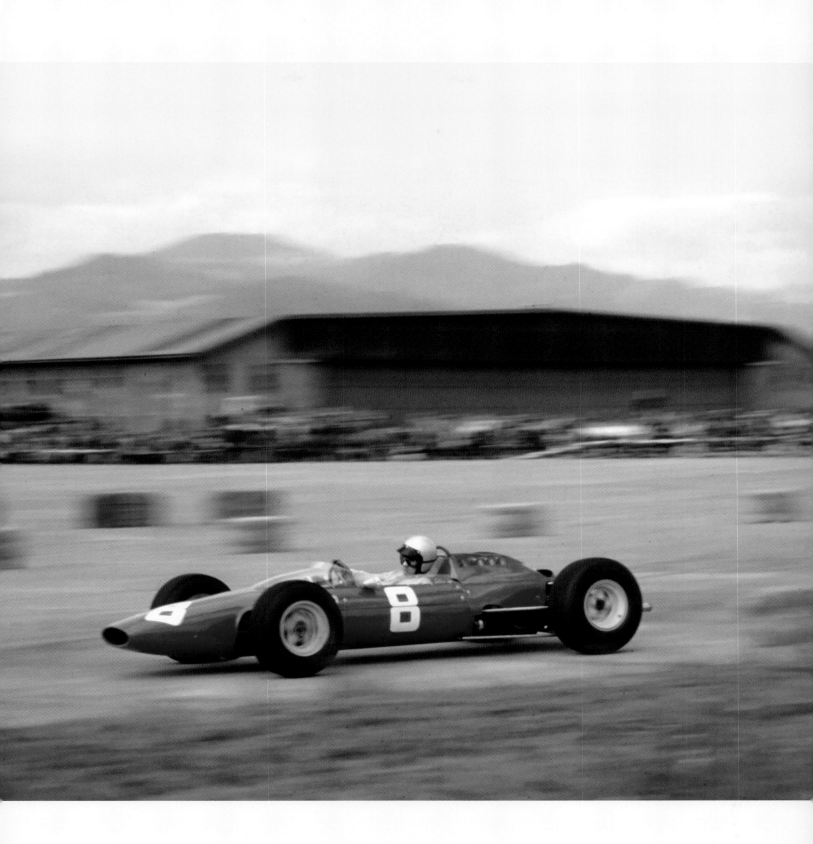

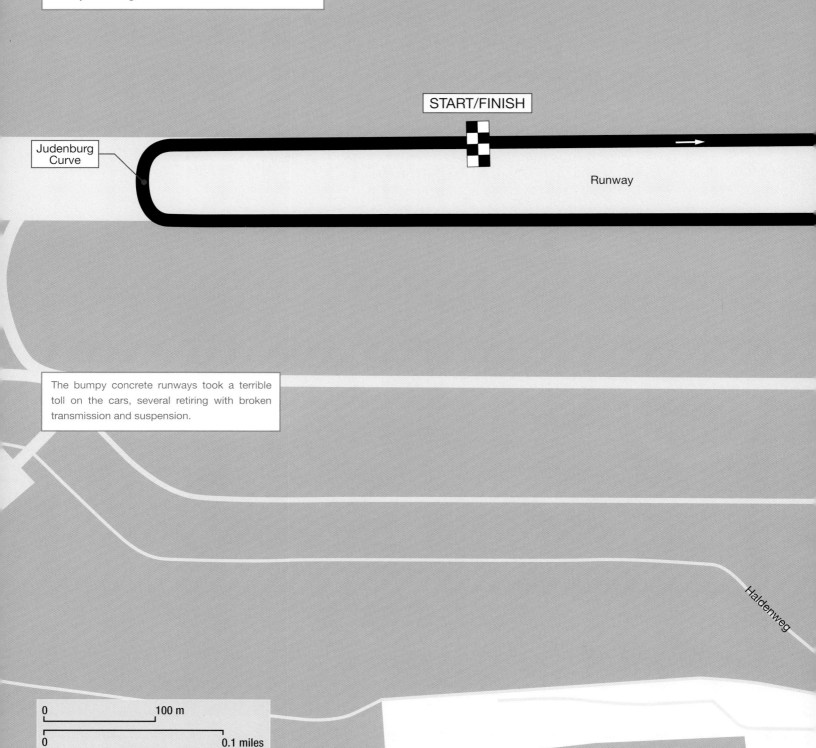

Having the pits located in the middle of the two straights meant the shuttling of equipment to and from the paddock. Personnel had to be in place before track activity could begin.

START/FINISH

Judenburg Curve

Runway

The bumpy concrete runways took a terrible toll on the cars, several retiring with broken transmission and suspension.

Haldenweg

0 100 m

0 0.1 miles

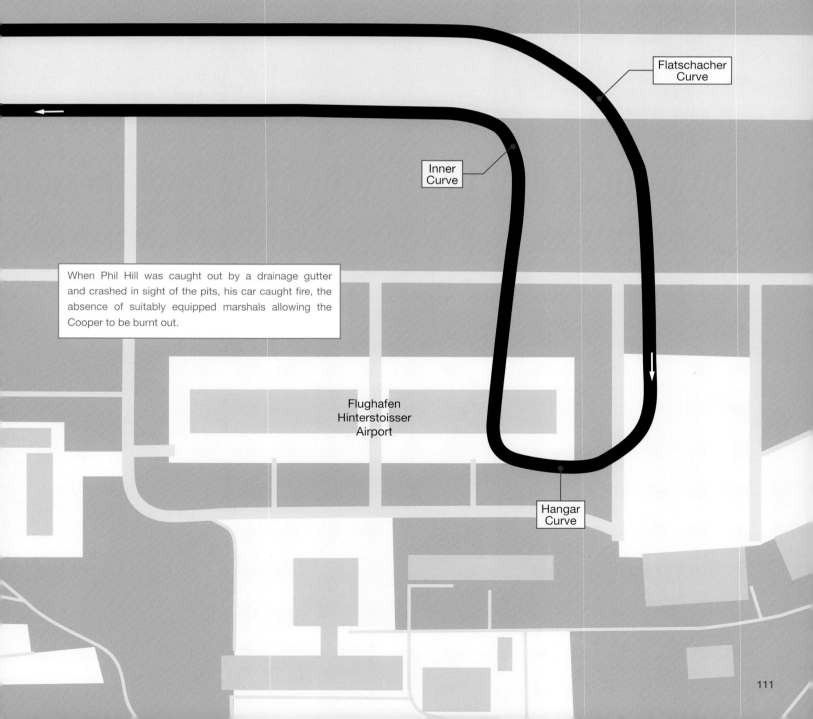

STATISTICS

Location: West of the town of Zeltweg in Styria

First World Championship Grand Prix: 23 August 1964

World Championship Grands Prix staged: 1

Circuit length: 1.988 miles (3.199 km)

Number of laps: 105

Number of corners: 4

Lap record (F1): 1m 10.56s, 101.532 mph (163.40 kph), Dan Gurney (Brabham BT7-Climax V8). Established 1964

Driver with the most wins: Lorenzo Bandini (1964)

Flatschacher Curve

Inner Curve

When Phil Hill was caught out by a drainage gutter and crashed in sight of the pits, his car caught fire, the absence of suitably equipped marshals allowing the Cooper to be burnt out.

Flughafen Hinterstoisser Airport

Hangar Curve

Clermont-Ferrand 1965

Charade Circuit

 FRANCE

A magnificent road circuit around extinct volcanic mountains above Clermont-Ferrand. Five miles (8 km) of twists and turns, rising and falling. Described as a mini-Nürburgring when first used for the French Grand Prix in 1965. Considered too dangerous after the fourth Grand Prix in 1972.

The *Automobile Club d'Auvergne* planned this circuit using just over a mile of purpose-built track to link four miles of public roads climbing around the *Puy de Charade* (from which the circuit gets its name) and the *Puy de Gravenoire*. The two long-extinct volcanic mountains formed the picturesque backdrop to a track of one short straight and more than fifty varied corners that drew favourable comparison as a smaller version of the Nürburgring Nordschleife.

Leaving a short pit straight, a medium speed left led to a climbing three-quarter of a mile straight which fed into a right and on to the highest point near the village of Charade. A tortuous descent passed through corners with either a rock face or a drop on one side. After rounding the Puy de Gravenoire, the return leg eventually reached the Petit Pont hairpin. The final brief climb over a shoulder was in view of the main grandstand some distance away on the pit straight. The final corner, a tight right, was named after Louis Rosier, a native of nearby Clermont-Ferrand and an energetic sponsor and supporter of the circuit.

It was a circuit with everything but decent facilities. The pits were crammed on the side of a hill and were considered woefully inadequate, even in the 1960s. The first races had been for GT and F2 cars on 27 July 1958. The 60th anniversary of the last of the famed Gordon Bennett Cup races (established for the benefit of a fledgling world-wide motor industry and run, in 1905, in the Auvergne region) was seen as a good excuse to draw the French Grand Prix away from Rouen and Reims to Clermont-Ferrand and the Charade circuit, or *Circuit de Montagne d'Avergne*, to give the full but not often used title.

The irony was that the entry for the 1965 French Grand Prix would not have a Frenchman racing at home for the first time in decades. Not that anyone seemed to notice as the championship was in full swing for this fourth round on 27 June. Jim Clark, who had won two of the previous three, took pole, his Lotus just half a second ahead of Jackie Stewart's BRM at the end of the 5.005-mile (8.055-km) lap.

Clark immediately set a new lap record – on his standing lap! - as he streaked into a lead he would never lose. With Stewart following his fellow Scot home half a minute behind, the race did not match the stunning surroundings. The Grand Prix would not return until 1969 when Stewart would dominate the weekend in his Matra-Ford.

Given that this was a driver's circuit of the highest quality, it is fitting that the list of winners should consist solely of Clark, Stewart and Jochen Rindt. While drivers enjoyed the twisting, dipping nature of the circuit (despite Rindt having to overcome nausea in 1969), a regular complaint was the presence of sharp volcanic stones lining the edge of the track. One of these did for Chris Amon when the subsequent puncture robbed the Matra driver of a certain and well-deserved win in 1972.

By which time, more serious concerns were affecting the future of the race, the establishment of the Charade circuit coinciding with a new awareness of safety. With it being impossible to incorporate the required standards into the natural surroundings, the 1972 Grand Prix would be the last.

The track in its original form would continue until considered too dangerous in 1988, an abbreviated 2.4-mile (3.9-km) version now holding national events.

Top: Jackie Stewart takes the plaudits as he crosses the line in the winning Matra-Ford in 1969.

Bottom: The rural nature of the paddock meant mechanics had to carry equipment to the pits via steep steps.

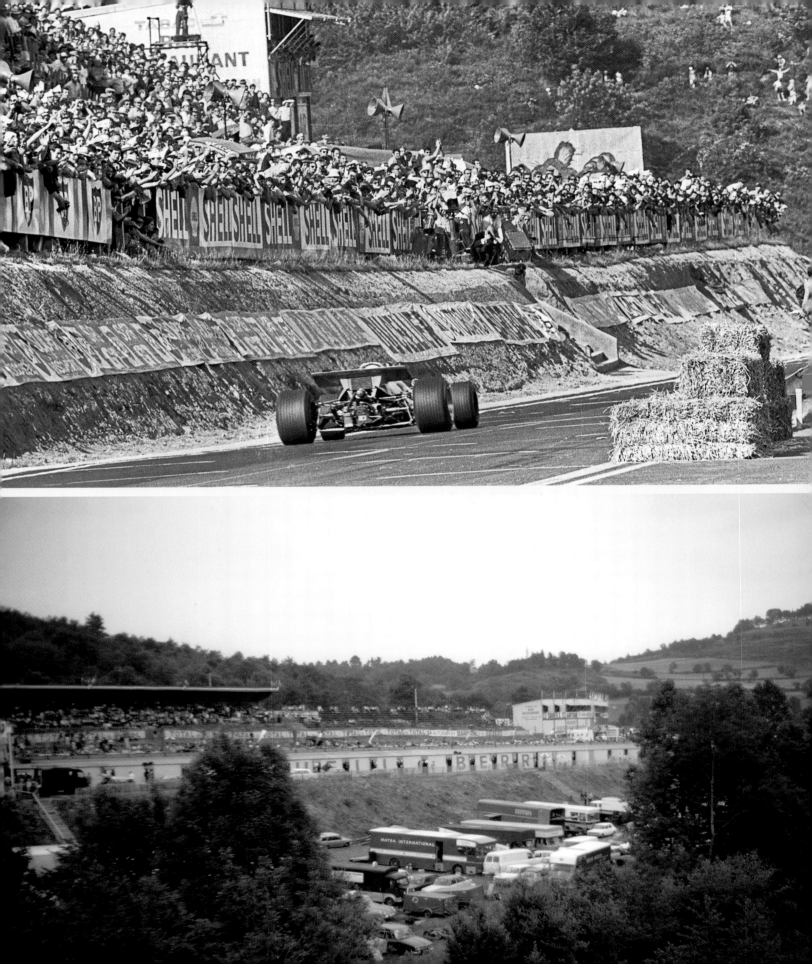

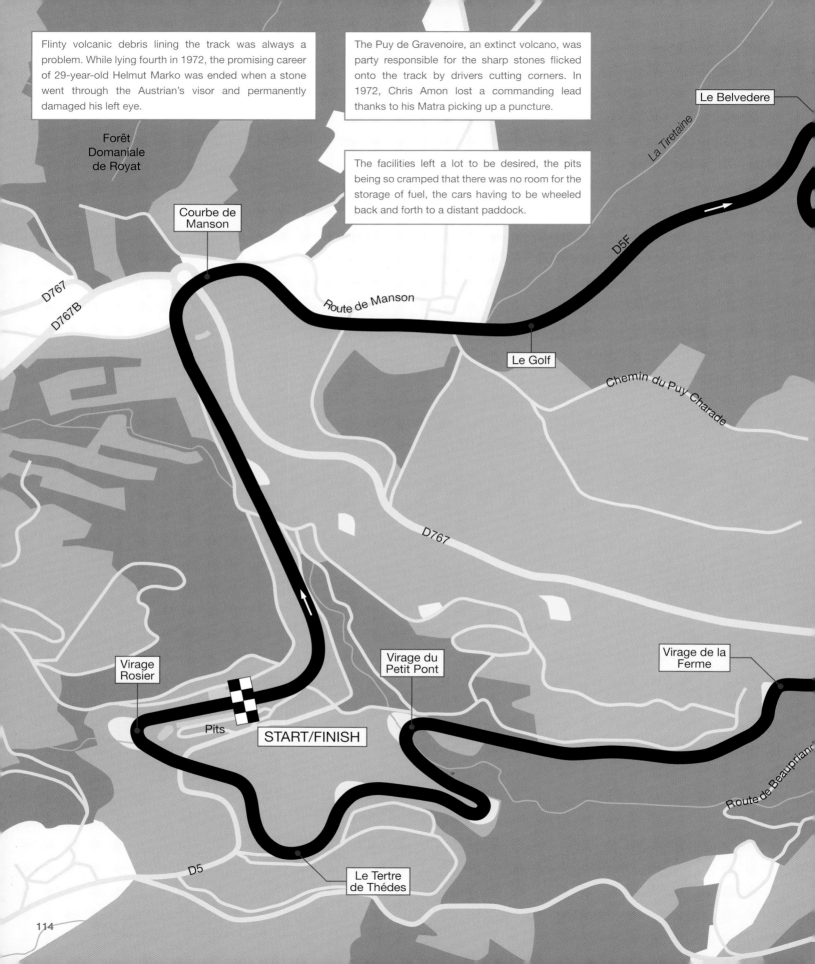

Flinty volcanic debris lining the track was always a problem. While lying fourth in 1972, the promising career of 29-year-old Helmut Marko was ended when a stone went through the Austrian's visor and permanently damaged his left eye.

The Puy de Gravenoire, an extinct volcano, was party responsible for the sharp stones flicked onto the track by drivers cutting corners. In 1972, Chris Amon lost a commanding lead thanks to his Matra picking up a puncture.

The facilities left a lot to be desired, the pits being so cramped that there was no room for the storage of fuel, the cars having to be wheeled back and forth to a distant paddock.

Le Belvedere

La Tiretaine

D5F

Forêt Domaniale de Royat

Courbe de Manson

Route de Manson

Le Golf

Chemin du Puy Charade

D767

D767B

D767

Virage de la Ferme

Virage Rosier

Virage du Petit Pont

Pits

START/FINISH

Route de Beauptrand

D5

Le Tertre de Thédes

114

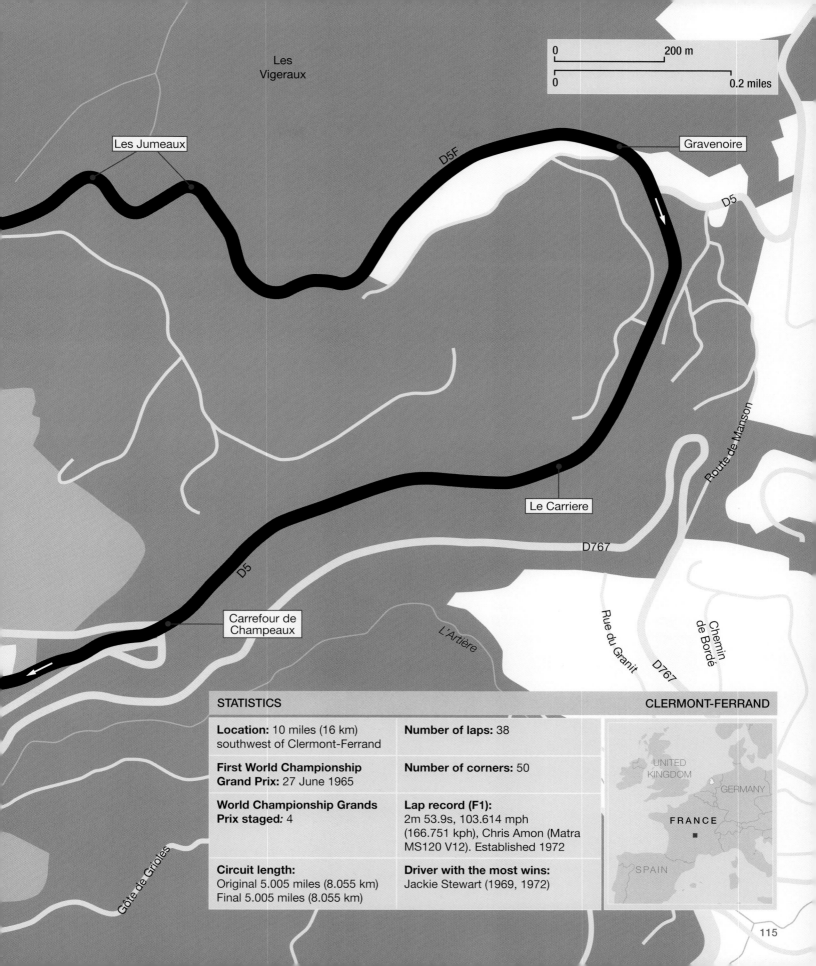

Les
Vigeraux

Les Jumeaux

D5F

Gravenoire

D5

Le Carriere

Route de Manson

D767

D5

Carrefour de
Champeaux

L'Artière

Côte de Grioles

Rue du Granit

D767

Chemin
de Bordé

STATISTICS

CLERMONT-FERRAND

Location: 10 miles (16 km) southwest of Clermont-Ferrand	**Number of laps:** 38
First World Championship Grand Prix: 27 June 1965	**Number of corners:** 50
World Championship Grands Prix staged: 4	**Lap record (F1):** 2m 53.9s, 103.614 mph (166.751 kph), Chris Amon (Matra MS120 V12). Established 1972
Circuit length: Original 5.005 miles (8.055 km) Final 5.005 miles (8.055 km)	**Driver with the most wins:** Jackie Stewart (1969, 1972)

UNITED
KINGDOM

GERMANY

FRANCE

SPAIN

Kyalami 1967

Kyalami Grand Prix Circuit

 SOUTH AFRICA

In its original form, home of the South African Grand Prix from 1967–1985. A revised layout used in 1992 and 1993. North of Johannesburg. Popular for winter testing and well liked despite two tragedies. Hampered in latter years by financial difficulties.

Noting the popularity of Grand Prix racing at East London, the Mayor of Johannesburg worked with the South African Motor Racing Club to search for a suitable site. Sixteen miles (25.7 km) north of the city, on the road to Pretoria, they found an ideal location for a permanent circuit to be known as Kyalami, from the Zulu words *kaya lami*, meaning 'my home'.

When the Rand Grand Prix on 9 December 1961 marked the first major meeting, Kyalami was enthusiastically received by a healthy entry of European teams. A long wide straight ran gently downhill towards Crowthorne, a medium-speed right that immediately dropped away towards a quick right at Barbecue. A gradual climb through Jukskei Sweep led to hard braking for a right at Sunset, followed soon after by a tight left at Clubhouse. A short straight led to the Esses and a steep climb to a rising right-hander at Leeukop. From there it was flat out through the Kink and over a slight crest in front of the pits.

Nominated to stage the opening round of the 1967 F1 World Championship on 2 January, Kyalami drew a crowd reported to be in excess of 100,000 (but perhaps closer to 60,000). The organisers came close to a dream result when the Rhodesian driver and local hero, John Love, led the final stages until his elderly and privately entered Cooper-Climax ran out of fuel. An unexpected win for the heavy and unfancied Cooper-Maserati of Pedro Rodriguez presented officials with a dilemma when they could not find a copy of the Mexican national anthem. A rendition of 'South of the Border' seemed to suffice.

The race was eventually moved to March, making Kyalami and its agreeable climate popular for testing. It was during such a session in 1974 that Peter Revson was killed when the front suspension on his Shadow-Ford broke going into Barbecue.

Worse was to follow during the Grand Prix three years later. Tom Pryce crested the rise on the main straight at 170 mph (274 kph) to find a marshal running across the track to attend to a car on fire. Both were killed instantly, the Welshman taking a grievous blow to the head from the marshal's fire extinguisher.

On a happier note, Mike Hailwood received the George Medal for rescuing Clay Regazzoni from the blazing wreck of his crashed BRM during the 1973 Grand Prix. Two years later, fans were thrilled when South Africa's Jody Scheckter won in a Tyrrell-Ford, Kyalami making the headlines for different reasons in 1982 when the drivers held a strike and refused to take part in the first day of practice. In 1983, with the date moved to October, the South African race settled the championship in favour of Nelson Piquet's Brabham-BMW.

Three years later, there was no racing at all, financial difficulties having forced the sale of part of the land, the circuit being virtually cut in two. A revised track, using the lower portion through Sunset and Clubhouse before swinging left at Leeukop into a new loop, staged the Grand Prix in 1992 and 1993. F1 did not return, the latest version being seen as a shadow of the former. Racing and changes of ownership continued until the track was sold in 2014.

Patrick Tambay's Ferrari leads the Brabham-BMW of champion-elect Nelson Piquet in 1983.

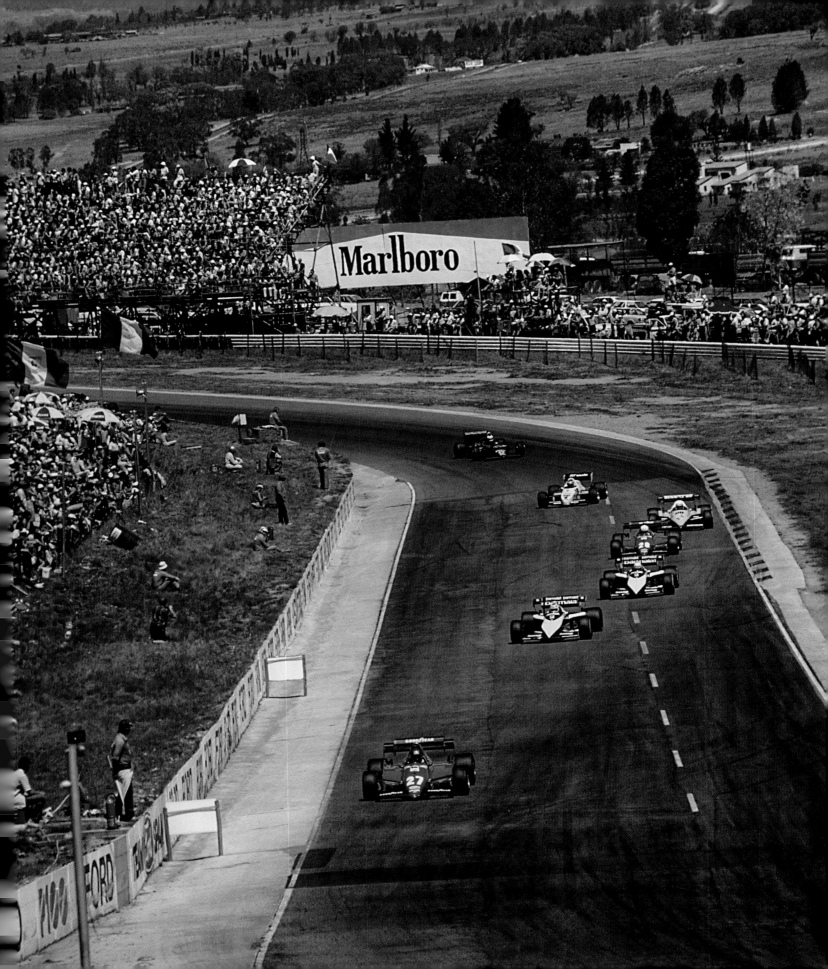

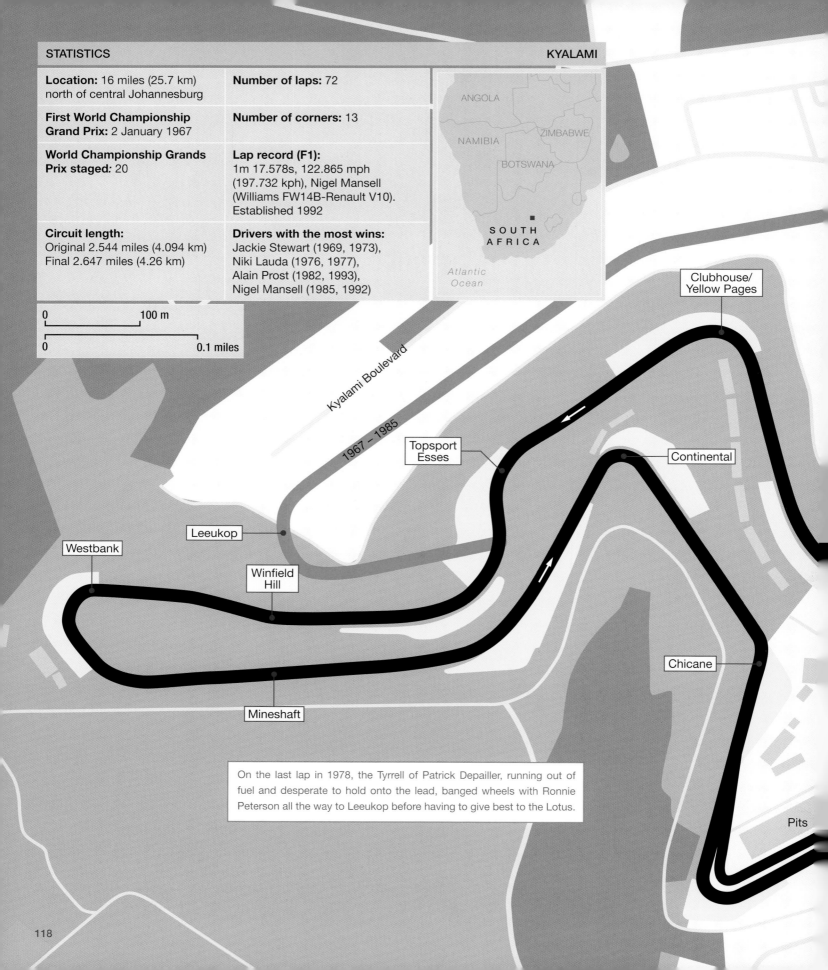

STATISTICS

Location: 16 miles (25.7 km) north of central Johannesburg

First World Championship Grand Prix: 2 January 1967

World Championship Grands Prix staged: 20

Circuit length:
Original 2.544 miles (4.094 km)
Final 2.647 miles (4.26 km)

Number of laps: 72

Number of corners: 13

Lap record (F1):
1m 17.578s, 122.865 mph (197.732 kph), Nigel Mansell (Williams FW14B-Renault V10). Established 1992

Drivers with the most wins:
Jackie Stewart (1969, 1973),
Niki Lauda (1976, 1977),
Alain Prost (1982, 1993),
Nigel Mansell (1985, 1992)

ANGOLA

ZIMBABWE

NAMIBIA

BOTSWANA

SOUTH
AFRICA

*Atlantic
Ocean*

0		100 m

0		0.1 miles

Kyalami Boulevard

1967 – 1985

Clubhouse/
Yellow Pages

Topsport
Esses

Continental

Leeukop

Westbank

Winfield
Hill

Chicane

Mineshaft

On the last lap in 1978, the Tyrrell of Patrick Depailler, running out of fuel and desperate to hold onto the lead, banged wheels with Ronnie Peterson all the way to Leeukop before having to give best to the Lotus.

Pits

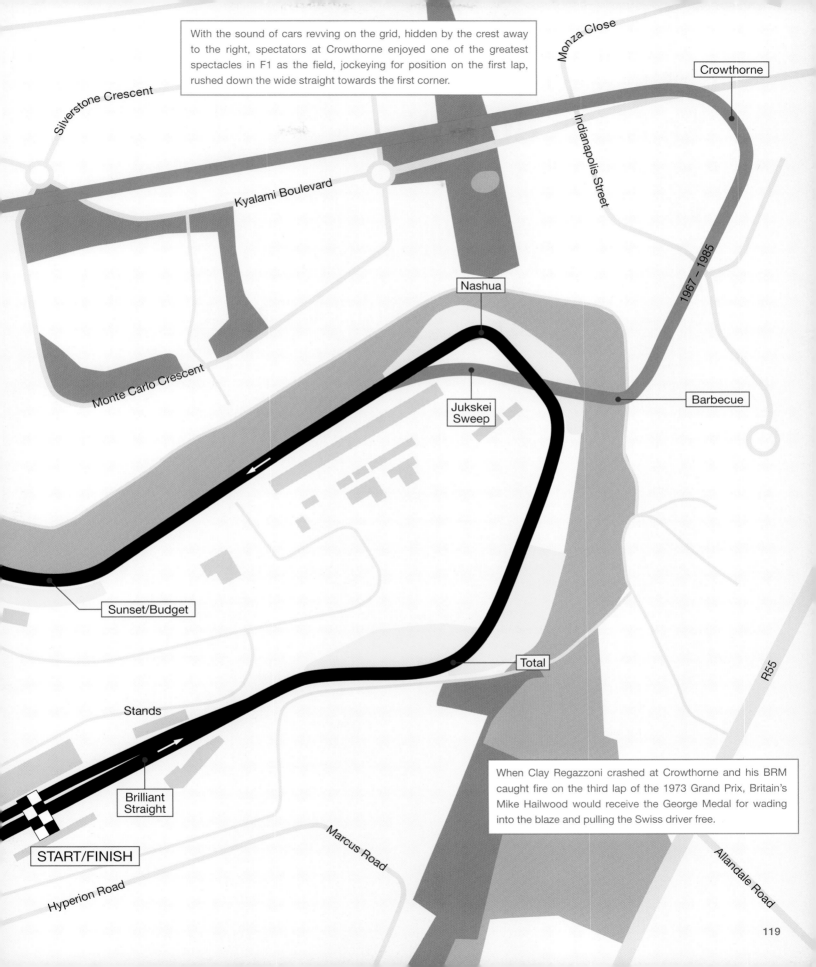

With the sound of cars revving on the grid, hidden by the crest away to the right, spectators at Crowthorne enjoyed one of the greatest spectacles in F1 as the field, jockeying for position on the first lap, rushed down the wide straight towards the first corner.

Monza Close

Crowthorne

Silverstone Crescent

Indianapolis Street

Kyalami Boulevard

1967 – 1985

Nashua

Monte Carlo Crescent

Jukskei Sweep

Barbecue

Sunset/Budget

Total

R55

Stands

Brilliant Straight

When Clay Regazzoni crashed at Crowthorne and his BRM caught fire on the third lap of the 1973 Grand Prix, Britain's Mike Hailwood would receive the George Medal for wading into the blaze and pulling the Swiss driver free.

START/FINISH

Marcus Road

Allandale Road

Hyperion Road

Le Mans Bugatti 1967

Bugatti Circuit

 FRANCE

Used the pits and a very small section at the start of the Le Mans 24-Hour *Circuit de la Sarthe*. Improvised by a section through car parks. Considered dull for drivers and spectators alike. Only used once for the French Grand Prix.

L'Automobile Club de l'Ouest, organisers of the Le Mans 24-Hour race, managed to persuade the *Automobile Club de France* to stage the 1967 French Grand Prix on what amounted to a racing drivers' school using the pits and car park area of the famous *Circuit de la Sarthe*. It was an entirely inappropriate choice for such a prestigious race, particularly with Reims, Rouen and the Charade Circuit being available.

Named the Bugatti Circuit in honour of the famous French motor manufacturer, the track used the start of the 24-Hour circuit through the long right-hand bend, rising under the Dunlop bridge and down to the Esses (this was long before the introduction of the Dunlop Chicane) before making a hairpin right leading from the traditional track into a vast car park. Three straights linked by two more hairpins led to another car park, where artificial ess-bends brought competitors back to the main straight, just before the pit buildings. The track may have had a good surface but, in the car parks, it was edged with sand, the corners marked by old tyres sunk into the ground.

The Bugatti Circuit may have been perfect for a driving school but it was not of the standard expected for a championship Grand Prix. Allowing use of the imposing permanent facilities built for the 24-Hour extravaganza prompted one seasoned F1 journalist to liken the situation to 'putting the whole mechanism of London [Heathrow] airport into operation in order that someone could land a Piper Cub aircraft'.

The feeling of extreme anti-climax was exacerbated by an entry of just 17 cars – two of which would be non-starters – the F1 teams looking lost in a long pit lane designed to cater for 55 cars. Even worse, crowd estimates on race day varied between 7,000 and 15,000. Either way, it was less than the attendance at a test day for the 24-Hour race, blame being laid at the close proximity to the French classic a few weeks before, the start of the summer holiday season and minimal publicity for the running of the 53rd Grand Prix of France. The entire three days completely lacked atmosphere.

Graham Hill took pole position, the green Lotus with the yellow stripe joined on the front row by Jack Brabham's Brabham-Repco and the Eagle-Westlake of Dan Gurney. The first few laps were lively enough thanks to Jim Clark, troubled by an engine misfire throughout practice, coming from fourth on the grid to take the lead from Hill on the fifth lap. As the British pair disputed the lead, they left the rest standing but the learning curve with the Lotus 49 (this was only the third race for the elegant car and its Ford DFV engine) would continue as Hill retired with broken transmission, Clark going out with a similar problem nine laps later.

At the end of a tedious race lasting for more than two hours, Brabham led home a mere six cars still running at the end of 80 laps. Small wonder headline writers referred to the Grand Prix as a French Farce and the Bugatti Circuit was never again considered for F1. It remains in use for national racing and MotoGP.

In front of the imposing Le Mans 24-Hours pits in 1967, the pole position Lotus-Ford of Graham Hill is already out of the picture as his team-mate, Jim Clark (6), Jack Brabham's Brabham-Repco (3) and the Eagle-Weslake (9) of Dan Gurney give chase.

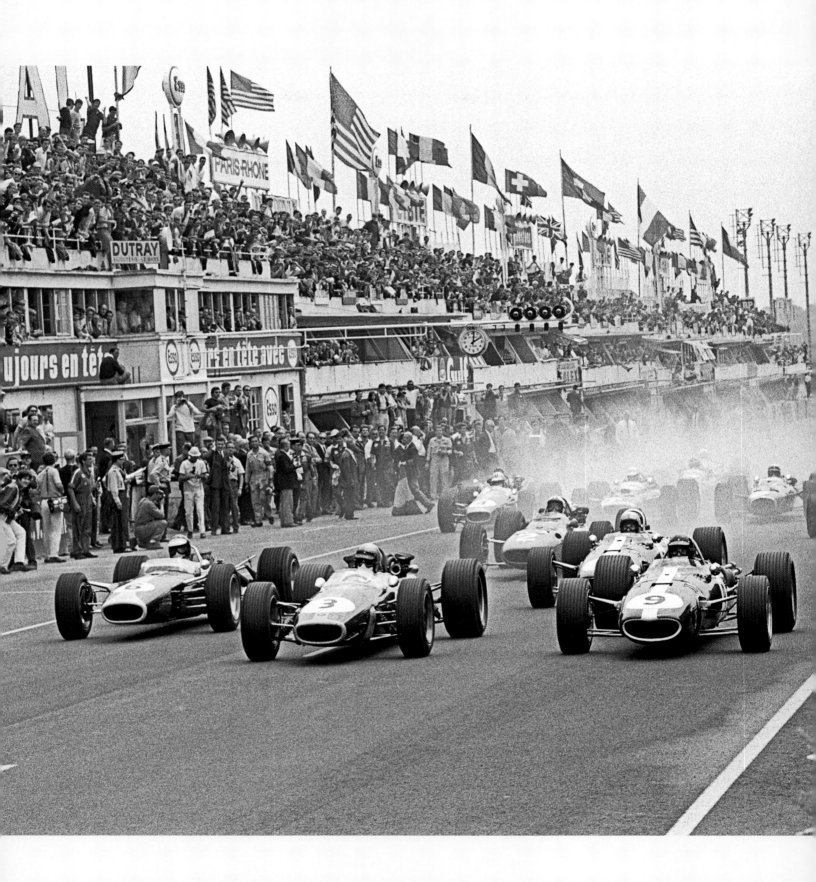

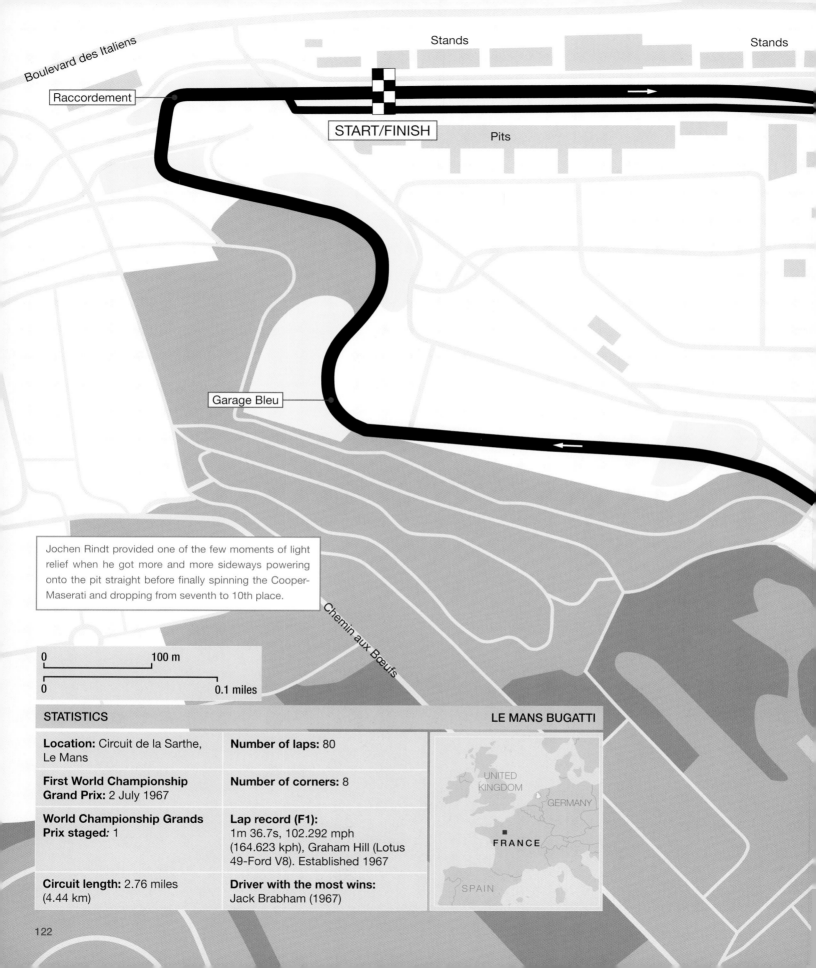

Boulevard des Italiens

Raccordement

Stands

Stands

START/FINISH

Pits

Garage Bleu

Jochen Rindt provided one of the few moments of light
relief when he got more and more sideways powering
onto the pit straight before finally spinning the Cooper-
Maserati and dropping from seventh to 10th place.

Chemin aux Bœufs

0	100 m
0	0.1 miles

STATISTICS

LE MANS BUGATTI

Location: Circuit de la Sarthe,
Le Mans

**First World Championship
Grand Prix:** 2 July 1967

**World Championship Grands
Prix staged:** 1

Circuit length: 2.76 miles
(4.44 km)

Number of laps: 80

Number of corners: 8

Lap record (F1):
1m 36.7s, 102.292 mph
(164.623 kph), Graham Hill (Lotus
49-Ford V8). Established 1967

Driver with the most wins:
Jack Brabham (1967)

UNITED
KINGDOM
GERMANY
FRANCE
SPAIN

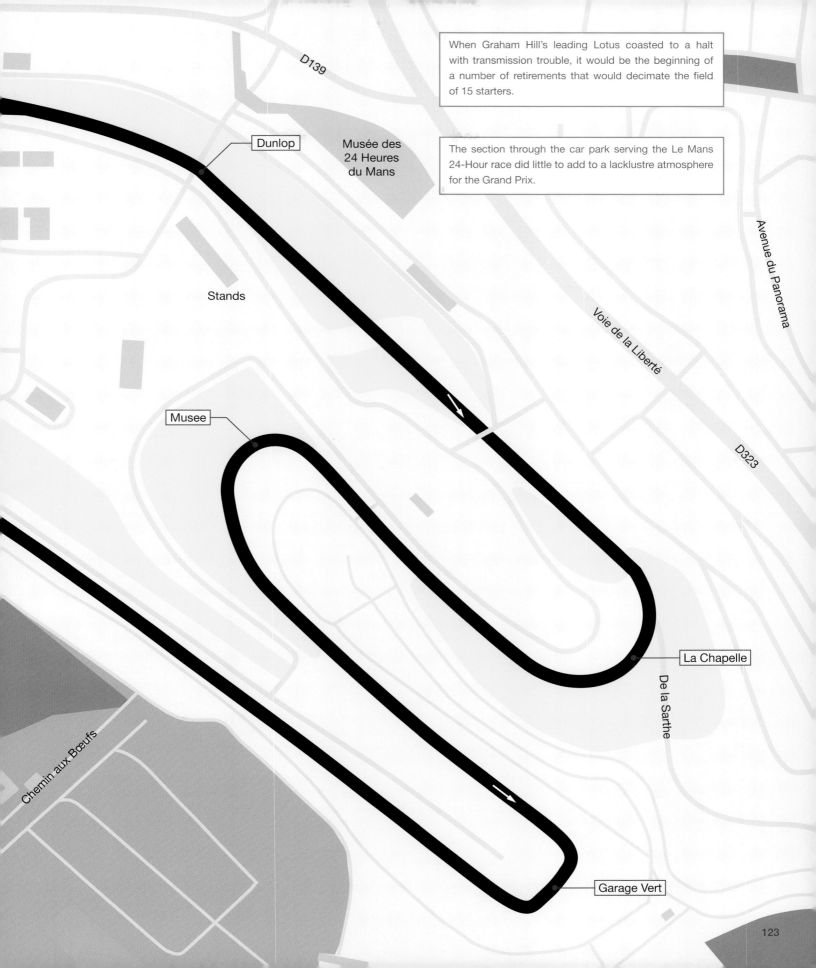

D139

Dunlop

Musée des
24 Heures
du Mans

Stands

Musee

Voie de la Liberté

Avenue du Panorama

D323

When Graham Hill's leading Lotus coasted to a halt with transmission trouble, it would be the beginning of a number of retirements that would decimate the field of 15 starters.

The section through the car park serving the Le Mans 24-Hour race did little to add to a lacklustre atmosphere for the Grand Prix.

La Chapelle

De la Sarthe

Chemin aux Bœufs

Garage Vert

Mosport 1967

Mosport Park

 CANADA

A challenging 2.5-mile (4.02-km) track through rolling countryside 70 miles (113 km) east of Toronto. Hosted eight Canadian Grands Prix between 1967 and 1977, each having a share of drama, adding to the circuit's popularity with drivers and North American race fans.

Set in 450 acres of rolling terrain near the town of Bowmanville and using design input from Stirling Moss (after whom Moss Corner was named), Mosport was considered to be top quality when used for sports car racing in 1961. The approach of Canada's centennial year in 1967 spurred the Canadian Automobile Sports Club to successfully bid for a round of the World Championship on 27 August.

An estimated 55,000 people, drawn mainly from Toronto to the west and across the Canadian/American border, arrived to see the first-ever Canadian Grand Prix. The F1 teams followed suit with virtually a full turnout even through the race was awkwardly placed between the German and Italian Grands Prix.

The journey was made worthwhile by an undulating course, beginning with a fast downhill right-hander. A blind and difficult left was followed soon after by a tight right-hander. This led to a downhill chute going left and ending with hard braking uphill for Moss Corner, a tightening right in two parts, going downhill at the exit. Hard acceleration uphill had the cars becoming light over a crest and sweeping right and left before sliding through a medium-speed right leading to the pit straight. All in all, a busy 2.459 miles (3.957 km) in a most attractive setting.

The same could not be said for race day when persistent rain would have a major bearing, Jim Clark's leading Lotus sputtering to a halt with drowned electrics, Denny Hulme having previously lost the lead through a pit stop for clean goggles. The New Zealander's difficulties allowed his boss and team-mate, Jack Brabham, to slither into the lead of a race that would last for 2 hours and 40 minutes.

Brabhams finished first and second once again when the Grand Prix returned in 1969, the winner Jacky Ickx having muscled his way to the front by accidentally tapping a rear wheel on Jackie Stewart's Matra-Ford and sending the furious Scotsman into a ditch.

Stewart would make amends by winning the next two Grands Prix at Mosport, each one visited by rain. The first, in 1971, was stopped short because of the misty conditions but the second, a year later, ran the full distance.

So would the 1973 Canadian Grand Prix although, at the end of another rain-affected race, no one was sure who had won. When an accident had partly blocked the track, a pace car appeared in a Grand Prix for the first time and added to the chaos by holding position in front of the wrong car. Meanwhile, a multitude of pit stops threw lap charts into complete confusion. After much deliberation, McLaren's Peter Revson was declared the winner.

With the date having been moved to October, the Canadian race was seen as having an important bearing on the championship, none more so than in 1976 when James Hunt produced arguably one of his greatest drives to win and keep his title hopes alive.

A year later, the McLaren driver would be at the centre of one of several controversial incidents filling the final Grand Prix at Mosport. While fighting for the lead and, at the same time, attempting to lap his team-mate, Hunt crashed and was later fined for thumping a marshal who had come to his aid. When the leading Lotus of Mario Andretti blew up and deposited oil on the track, several cars spun off, but not Jody Scheckter, leading in a Wolf owned by Canadian oil baron Walter Wolf.

That would be the final happy story for F1 at Mosport, the track unable to keep pace with the required safety developments.

Top: Denny Hulme's McLaren-Chevrolet (5) leads Jackie Stewart's Lola-Chevrolet through Turn 1 on the first lap of a CanAm race in 1971.

Bottom: A wide-eyed response to an unexpected home win in 1977 when Jody Scheckter was one of the few not to spin off a treacherous track in a Wolf-Ford owned by Canadian oil baron Walter Wolf.

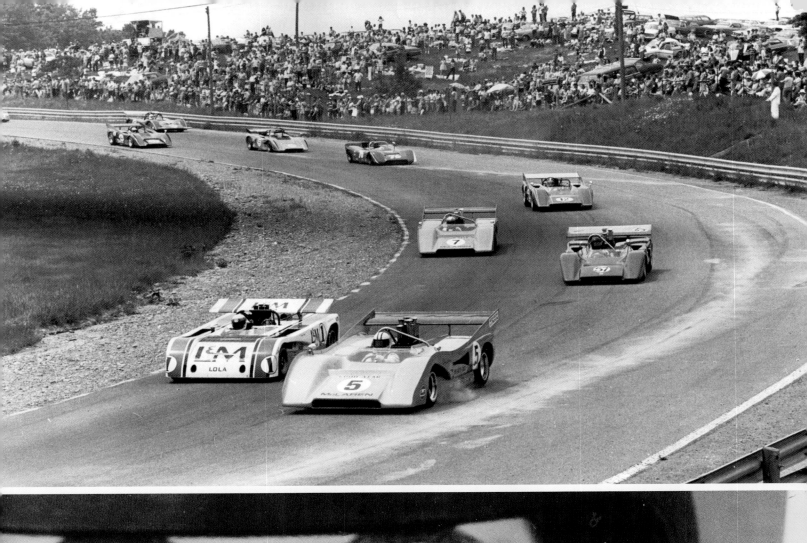

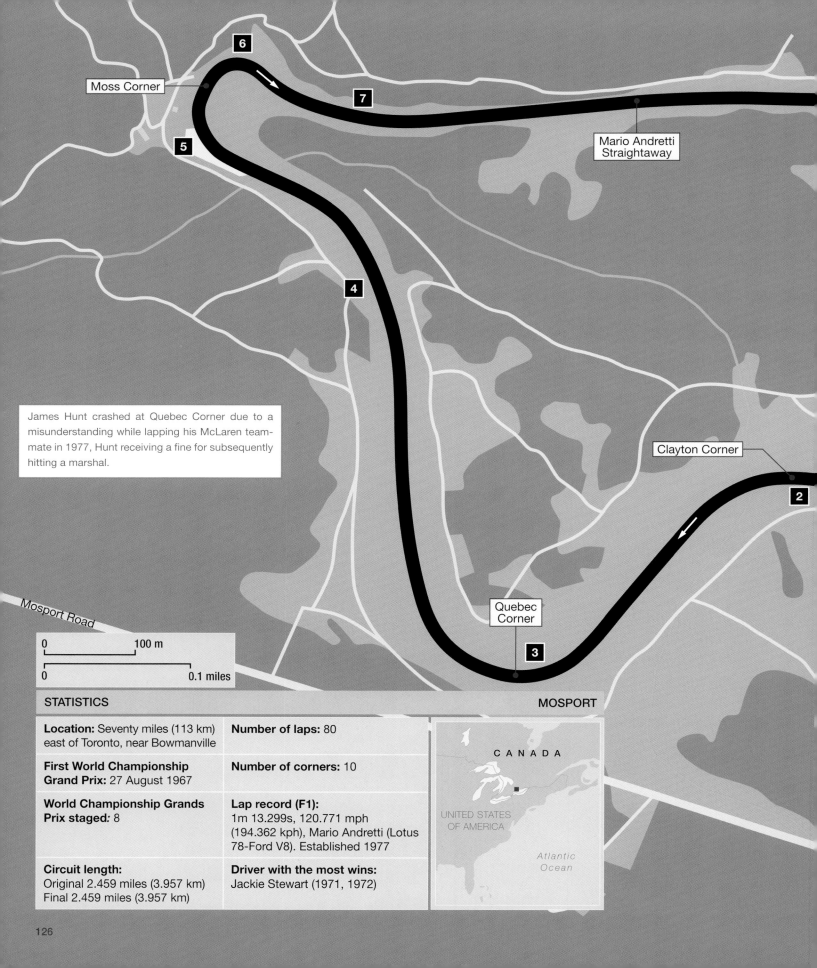

Moss Corner

6

7

Mario Andretti
Straightaway

5

4

James Hunt crashed at Quebec Corner due to a misunderstanding while lapping his McLaren team-mate in 1977, Hunt receiving a fine for subsequently hitting a marshal.

Clayton Corner

2

Quebec
Corner

3

Mosport Road

0	100 m
0	0.1 miles

STATISTICS

MOSPORT

Location: Seventy miles (113 km) east of Toronto, near Bowmanville

Number of laps: 80

First World Championship Grand Prix: 27 August 1967

Number of corners: 10

World Championship Grands Prix staged: 8

Lap record (F1):
1m 13.299s, 120.771 mph (194.362 kph), Mario Andretti (Lotus 78-Ford V8). Established 1977

Circuit length:
Original 2.459 miles (3.957 km)
Final 2.459 miles (3.957 km)

Driver with the most wins:
Jackie Stewart (1971, 1972)

CANADA

UNITED STATES
OF AMERICA

*Atlantic
Ocean*

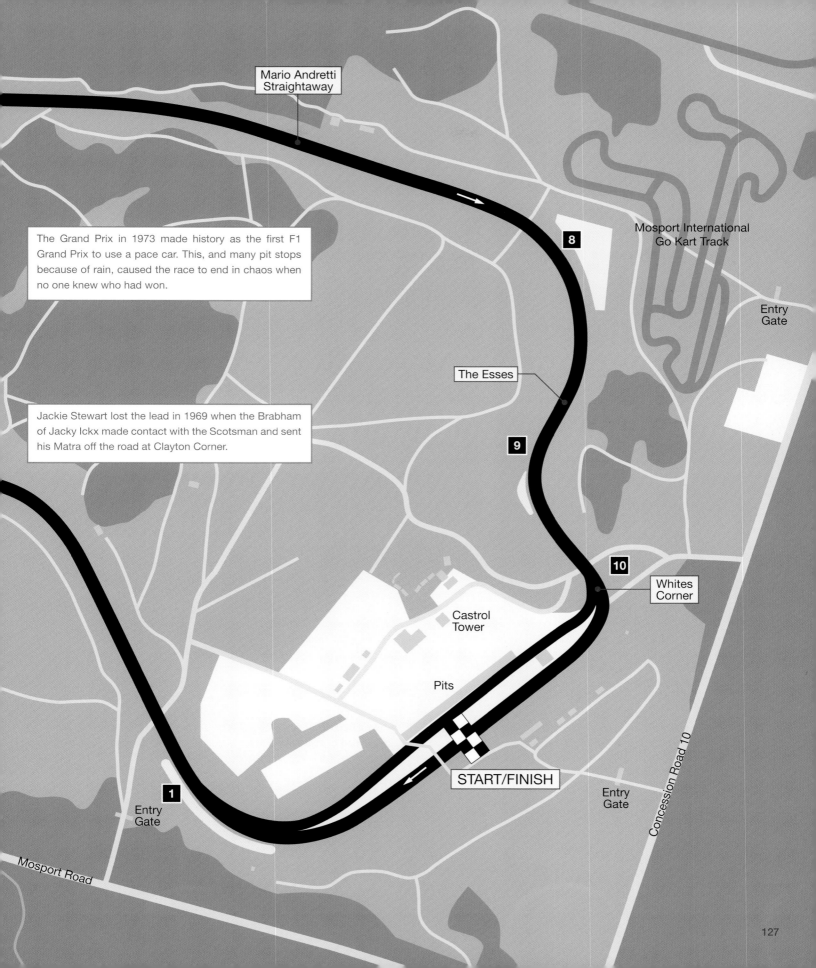

Mario Andretti
Straightaway

The Grand Prix in 1973 made history as the first F1 Grand Prix to use a pace car. This, and many pit stops because of rain, caused the race to end in chaos when no one knew who had won.

Jackie Stewart lost the lead in 1969 when the Brabham of Jacky Ickx made contact with the Scotsman and sent his Matra off the road at Clayton Corner.

Mosport International
Go Kart Track

Entry
Gate

8

The Esses

9

10

Whites
Corner

Castrol
Tower

Pits

1

Entry
Gate

START/FINISH

Entry
Gate

Concession Road 10

Mosport Road

Jarama 1968

Circuito del Jarama

 SPAIN

Hosted eight World Championship Grands Prix, the last in 1981. A purpose-built track on arid scrubland north of Madrid, already deemed too tight and twisty on its debut in 1968. The scene of political drama in 1980 and an intriguing race in 1981.

At the request of the Royal Automobile Club of Spain, John Hugenholtz, the designer of Zandvoort and Suzuka, was asked to examine a dusty piece of land bordering the main road between Madrid and Burgos. The initial plan was to build a sporting complex, with a permanent track as the focal point, within range of the club's headquarters in Madrid.

The scheme was changed almost from the start, the area devoted to the circuit being less than envisaged and compromising the layout. Known as Jarama (after the nearby town), the 2.115-mile (3.404-km) track was immediately considered to be too tight and too slow.

By staging a Formula 2 and a non-championship Formula 1 Grand Prix (both won by Jim Clark) in 1967, the automobile club successfully pushed to have a round of the championship the following year. This did not go down well with the drivers, who asked for additional catch fencing and other modifications in the interests of safety. When two local drivers were added to the entry list, there was serious talk of a boycott. The race did take place on 12 May but few turned out to watch Graham Hill score a morale-boosting win for Lotus just over a month after the death of Jim Clark.

The Grand Prix returned in 1970, a flag-to-flag victory for Jackie Stewart's March-Ford (entered by Tyrrell Racing) proving to be the least complicated part of the weekend. The organisation was chaotic thanks to confusion over new rules governing qualifying procedures. When the stewards revoked an earlier agreement to let everyone start, qualified or not, there were ugly scenes when officials attempted to remove cars and drivers from the grid.

The field would be reduced further on the first lap when brake failure on Jackie Oliver's BRM led to the Englishman T-boning Jacky Ickx as the Ferrari driver accelerated out of a hairpin. Neither driver was seriously hurt but both cars were destroyed in a fire officials seemed unable to do anything about. Only five cars finished.

The organisation had improved marginally when Emerson Fittipaldi won for Lotus in 1972 and Niki Lauda scored his first victory for Ferrari two years later, the Grand Prix alternating with Montjuïc in Barcelona. When it was Jarama's turn in 1976, a fine battle between Lauda and James Hunt ended in dispute after the Englishman's McLaren-Ford was deemed to be 1.8 cm too wide (the win being reinstated later in a court room).

A win for Patrick Depailler and Ligier-Ford in 1979 was straightforward compared to a weekend of turmoil in 1980. Jarama was unwittingly caught up in a mounting dispute between the teams and the governing body over control of the sport and its finances. Alan Jones was recorded as the winner of a Grand Prix that was declared illegal and thrown out of the championship.

Sport reigned supreme the following year as Gilles Villeneuve scored an exceptional win in a cumbersome Ferrari turbo which was not, by any stretch of the imagination, the most competitive car in the field. For 67 of the race's 80 laps, the French-Canadian resisted attack from a frustrated mob of pursuers, the first five finishers covered by 1.24 seconds.

Apart from demonstrating Villeneuve's car control and tenacity, this race had also underlined how Jarama was too narrow and tight for a decent Grand Prix. In addition, the track had become down at heel and no one in F1 was sorry when the Spanish Grand Prix moved away for good.

Jarama, modern but uninspiring, made its championship debut in 1968, the Honda of John Surtees leading the McLaren-Ford of Bruce McLaren and Graham Hill in the winning Lotus-Ford.

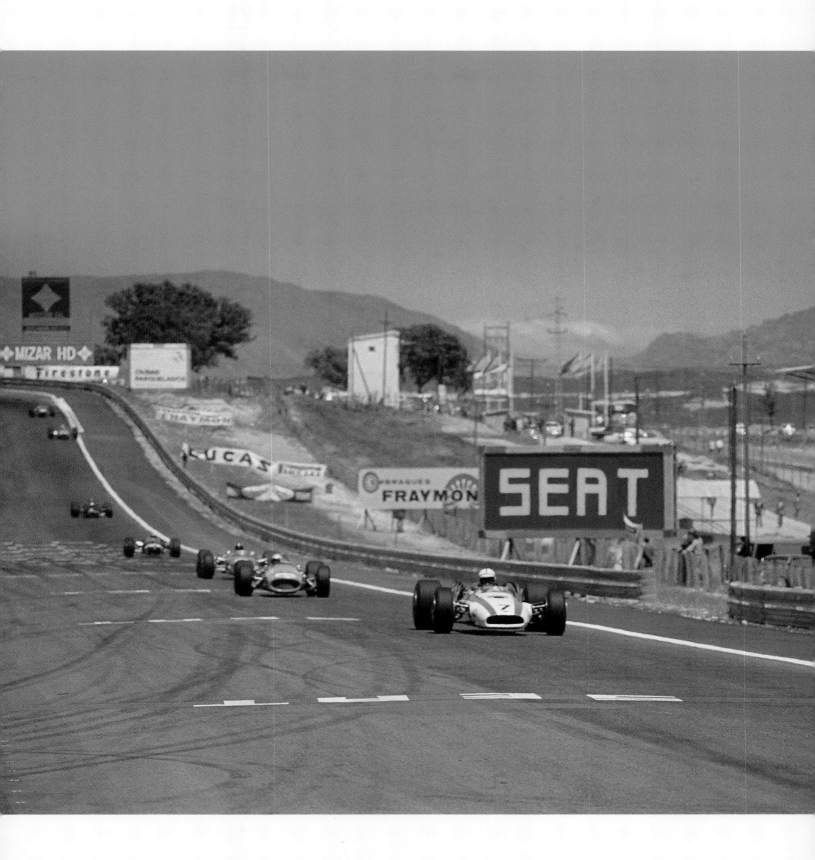

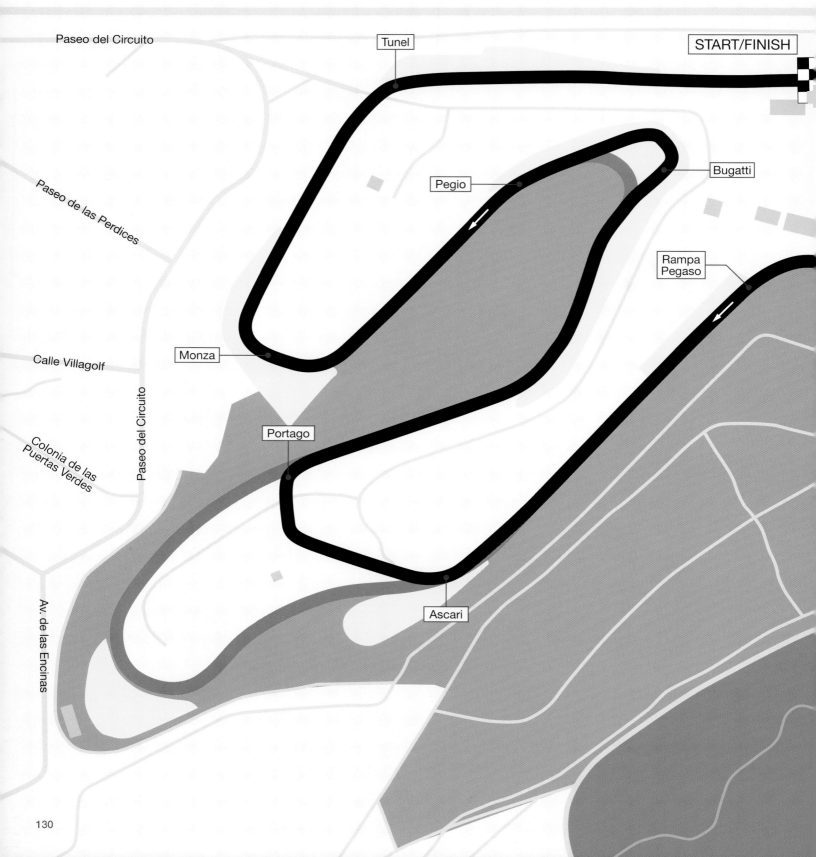

Gilles Villeneuve used the tight confines to hold back four cars for 67 laps as he won in the unfancied Ferrari turbo in 1981.

Paseo del Circuito

Tunel

START/FINISH

Paseo de las Perdices

Pegio

Bugatti

Monza

Rampa Pegaso

Calle Villagolf

Paseo del Circuito

Colonia de las Puertas Verdes

Portago

Ascari

Av. de las Encinas

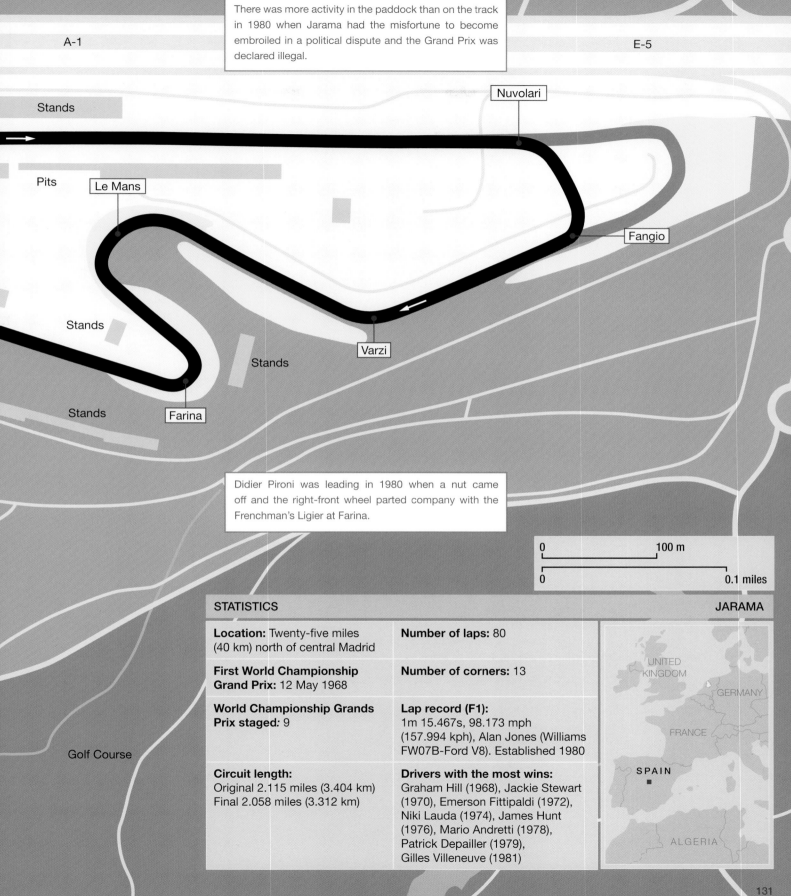

A-1

E-5

Stands

There was more activity in the paddock than on the track in 1980 when Jarama had the misfortune to become embroiled in a political dispute and the Grand Prix was declared illegal.

Nuvolari

Pits

Le Mans

Fangio

Stands

Varzi

Stands

Stands

Farina

Didier Pironi was leading in 1980 when a nut came off and the right-front wheel parted company with the Frenchman's Ligier at Farina.

| 0 | | 100 m |
| 0 | | 0.1 miles |

Golf Course

STATISTICS

JARAMA

Location: Twenty-five miles (40 km) north of central Madrid	**Number of laps:** 80
First World Championship Grand Prix: 12 May 1968	**Number of corners:** 13
World Championship Grands Prix staged: 9	**Lap record (F1):** 1m 15.467s, 98.173 mph (157.994 kph), Alan Jones (Williams FW07B-Ford V8). Established 1980
Circuit length: Original 2.115 miles (3.404 km) Final 2.058 miles (3.312 km)	**Drivers with the most wins:** Graham Hill (1968), Jackie Stewart (1970), Emerson Fittipaldi (1972), Niki Lauda (1974), James Hunt (1976), Mario Andretti (1978), Patrick Depailler (1979), Gilles Villeneuve (1981)

UNITED KINGDOM

GERMANY

FRANCE

SPAIN

ALGERIA

Saint Jovite 1968

Le Circuit Mont-Tremblant

 CANADA

Set in a stunning location outside Saint Jovite in the Laurentians. A fast, demanding track used twice for the Canadian Grand Prix before falling foul of political disagreements and becoming a much-loved national course.

The success generated by the first Canadian Grand Prix at Mosport in 1967 prompted a call to share the event between the track in Ontario and arguably an even more attractive venue in the province of Quebec.

A 2.6-mile (4.2-km) undulating track had been carved from wooded and fairly rugged terrain in the shadow of Mont Tremblant, from which it would derive its name even though the circuit was often known as Saint Jovite with reference to the nearby town.

Whatever the nomenclature, the appeal was enhanced by the Laurentians in the autumn, a date chosen to facilitate travel arrangements with the United States Grand Prix. The F1 teams loved the location and the track, once certain safety improvements had been put in place. These would be necessary given the natural hazards on a circuit described by 'Motor Sport' magazine's F1 correspondent as a cross between Brands Hatch and Oulton Park; praise indeed and an indicator of the challenge.

The potential hazards would be graphically demonstrated on the first day of practice when the throttle of Jacky Ickx's Ferrari jammed open at Connor Corner, a fast and fierce downhill right-hander immediately after the pits. The Ferrari had gone straight into an earth bank, which acted as a launch ramp and hurled the red car towards the trees before wire mesh safety fences brought it to rest just before reaching a creek. Two wheels were torn off, Ickx being extracted from the wreckage with a broken leg and facial bruises.

An estimated 40,000 spectators packed the hillsides and waited for Prime Minister, Pierre Elliott Trudeau, to drop the Canadian flag and unleash 21 cars, led by Jochen Rindt's Repco-Brabham and the Ferrari of Chris Amon.

This track was perfect territory for Amon, a driver with a natural gift to match the surroundings. He led for 72 laps and then, as would happen many times, the chance of winning a Grand Prix would be wrenched from his grasp, this time by broken transmission after the New Zealander's clutch had failed at the start. It took almost a minute for Denny Hulme to appear and assume the lead in his McLaren-Ford.

Ickx, on crutches and the first to commiserate with Amon, would have the satisfaction of winning when the Grand Prix returned to Saint Jovite two years later. The Belgian, now driving for Brabham, was no match for Jackie Stewart in the early stages as the Scotsman gave the Tyrrell Grand Prix car a sensational debut before a front stub axle failed to take the stresses imposed by the switch-back track.

Stresses of a more political kind would get in the way of future Grands Prix at Saint Jovite but the circuit, much modified over the years, would survive as one of the truly great race tracks of the world.

The magnificent surroundings of the Laurentians in the autumn are evident as the Ferrari of Jacky Ickx heads for victory in 1970.

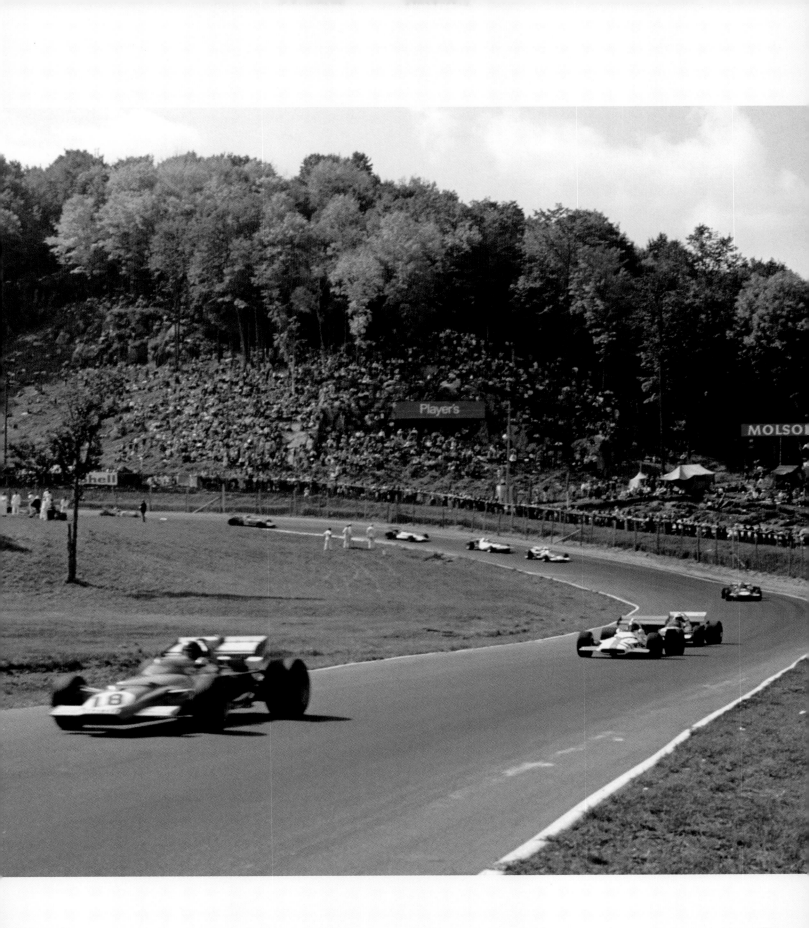

Location: Ninety miles (145 km) northwest of Montreal	**Number of laps:** 90
First World Championship Grand Prix: 22 September 1968	**Number of corners:** 15
World Championship Grands Prix staged: 2	**Lap record (F1):** 1m 32.2s, 103.47 mph (166.52 kph), Clay Regazzoni (Ferrari 312B/70 flat 12). Established 1970
Circuit length: Original 2.65 miles (4.26 km) Final 2.65 miles (4.26 km)	**Drivers with the most wins:** Denny Hulme (1968), Jacky Ickx (1970)

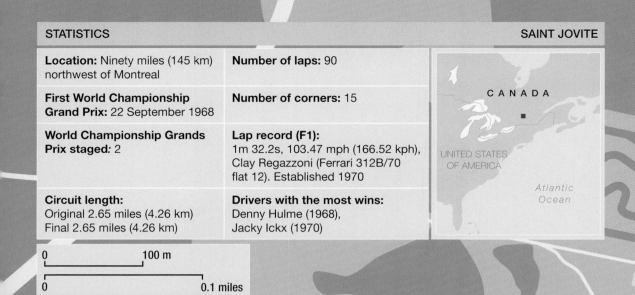

0 ——— 100 m

0 ——— 0.1 miles

Hump

South Loop

Rivière du Diable

With only 18 of the 90 laps remaining in 1968, Chris Amon's chances of winning his first Grand Prix were yet again denied, this time by broken transmission on his Ferrari.

Jackie Stewart gave the first Tyrrell F1 car a sensational debut in 1970 when he led from pole position until a stub axle broke.

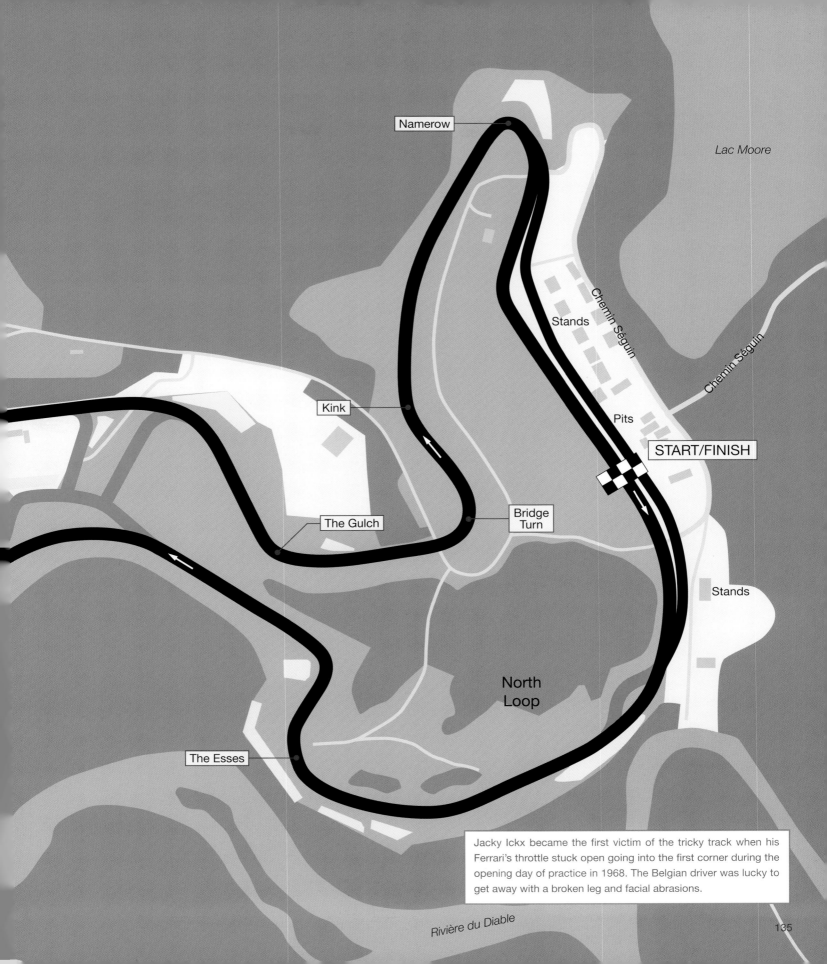

Namerow

Lac Moore

Stands

Chemin Séguin

Chemin Séguin

Kink

Pits

START/FINISH

The Gulch

Bridge Turn

Stands

North Loop

The Esses

Jacky Ickx became the first victim of the tricky track when his Ferrari's throttle stuck open going into the first corner during the opening day of practice in 1968. The Belgian driver was lucky to get away with a broken leg and facial abrasions.

Rivière du Diable

Barcelona Montjuïc 1969

Circuito de Montjuïc

 SPAIN

A breathtaking road circuit through a park on a steep hillside overlooking Barcelona. Very fast in places and causing concern over safety from the first Grand Prix in 1969. Never used again after a car cleared the barrier and killed a fireman plus three onlookers in 1975.

Public roads through Montjuïc Park had been used for racing in 1933. The intervention of the Spanish Civil War and the war in Europe contributed to a lapse in activity, the *Real Automovil de Cataluña* (RAC) waiting until 1966 before reviving motor sport at Montjuïc despite the Spanish Grand Prix having been staged through the streets of Barcelona's Pedralbes district a decade before. Formula 2 races at Montjuïc were so successful that the negative reviews of Jarama as host for the Spanish Grand Prix prompted the RAC to make a bid for 1969.

The drivers were as much impressed by the extent of the challenge as they were by the sight of Barcelona stretched out below. From the start-line at the top of the circuit, the track rose gently to a crest before plunging downhill to a hairpin left. The descent continued through a couple of tricky curves towards a hairpin right and into more difficult corners leading to the city's street level at the bottom of the park. A quick burst past a palace was followed by the beginning of the return climb, a fast left and right followed by a long left-hand curve leading to the top of the hill and a final right kink onto the finishing straight. Two layers of barriers were added either side for much of the 2.355 miles (3.79 km); a sensible investment, as things would turn out.

F1 aerodynamics were in their infancy in 1969, the cars sprouting wings to such an absurd degree that each one of the 14 starters had aerofoils mounted high above the rear wheels (and some above the front axle as well). On lap nine (of 90), the theory began to fall apart in every sense.

The rear wing on the Lotus was among the largest and the highest. Graham Hill had just taken third place when, cresting the rise beyond the pits, the wing buckled and sent the Lotus into the barrier. Miraculously, Hill was able to step unharmed from the wreckage.

His team-mate, Jochen Rindt, had been leading since the start. Hill suspected the rear wing as being the cause of the accident, particularly when Rindt's appeared to be bending under identical circumstances. Hill immediately sent a message to the Lotus pit, advising them to call in his team-mate. But it was too late. On lap 20, Rindt's wing failed at exactly the same point only, this time, the result was much worse. The Lotus went out of control, hit the barrier and smashed into Hill's abandoned car before overturning and trapping Rindt beneath. Hill was quickly on the scene, turning off the electrics and helping the Austrian scramble free with blood streaming from his face.

By comparison, the Grands Prix in 1971 and 1973 were fairly uneventful. But not in 1975. There was trouble from the outset when drivers refused to take part in first practice because the safety barriers (now with a third tier) had not been installed properly. But, since a former Olympic stadium was being used for the paddock, it would have been the work of a moment to have the teams impounded for breach of contract.

The race did take place and a tense weekend reached an awful climax, Rolf Stommelen's leading Hill-Lola losing its rear wing as the German approached the crest after the pits at more than 150 mph (241 kph). Without rear downforce, the Lola bounced off the barrier to the left, took flight and scraped across the top of the barrier on the right, breaking in two as it hit a lamp post. A fire marshal and three onlookers in this prohibited area were killed; dozens were injured by flying debris.

The race was stopped, the Grand Prix never to return to Montjuïc Park. The irony was that the barrier, cause of the initial controversy and subsequent emotional criticism, had actually done its job.

Jochen Rindt leads the downhill charge on the first lap in 1969. Twenty laps later, at more or less the same spot, the high rear wing on the Austrian's Lotus-Ford would buckle and break, causing Rindt to crash heavily.

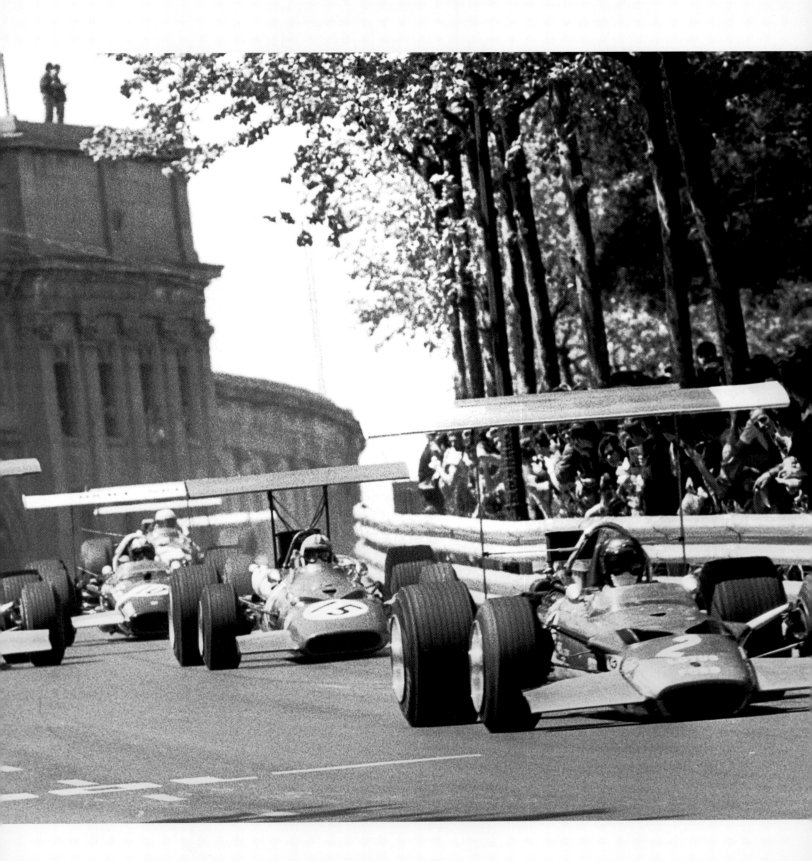

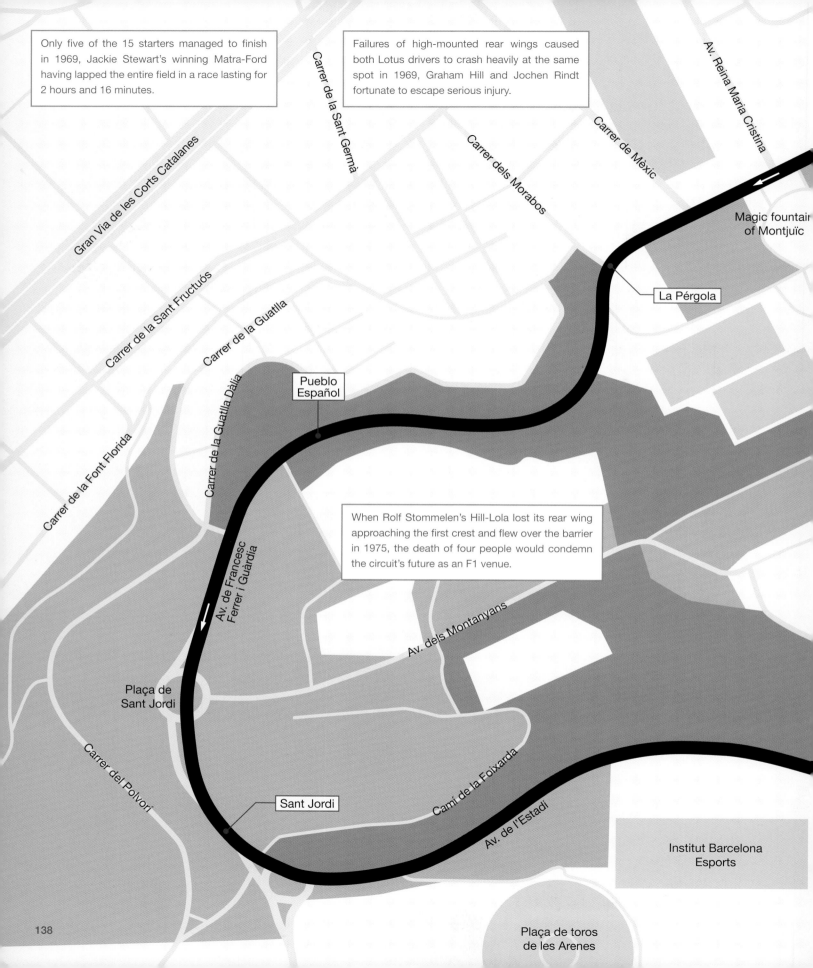

Only five of the 15 starters managed to finish in 1969, Jackie Stewart's winning Matra-Ford having lapped the entire field in a race lasting for 2 hours and 16 minutes.

Failures of high-mounted rear wings caused both Lotus drivers to crash heavily at the same spot in 1969, Graham Hill and Jochen Rindt fortunate to escape serious injury.

When Rolf Stommelen's Hill-Lola lost its rear wing approaching the first crest and flew over the barrier in 1975, the death of four people would condemn the circuit's future as an F1 venue.

Av. Reina Maria Cristina

Carrer de la Sant Germà

Carrer de Mèxic

Carrer dels Morabos

Carrer de la Sant Fructuós

Gran Via de les Corts Catalanes

Magic fountain of Montjuïc

La Pérgola

Carrer de la Guatlla

Carrer de la Font Florida

Carrer de la Guatlla Dàlia

Pueblo Español

Av. de Francesc Ferrer i Guàrdia

Av. dels Montanyans

Plaça de Sant Jordi

Carrer del Polvorí

Camí de la Foixarda

Sant Jordi

Av. de l'Estadi

Institut Barcelona Esports

Plaça de toros de les Arenes

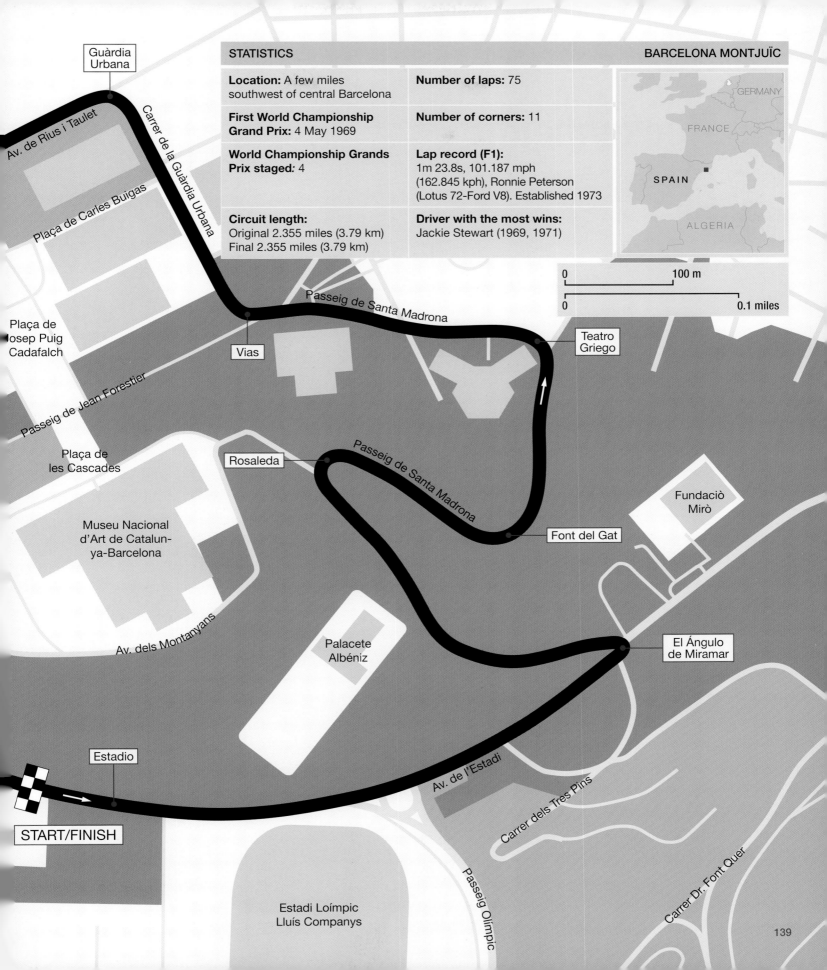

STATISTICS

Location: A few miles southwest of central Barcelona

First World Championship Grand Prix: 4 May 1969

World Championship Grands Prix staged: 4

Circuit length:
Original 2.355 miles (3.79 km)
Final 2.355 miles (3.79 km)

Number of laps: 75

Number of corners: 11

Lap record (F1):
1m 23.8s, 101.187 mph (162.845 kph), Ronnie Peterson (Lotus 72-Ford V8). Established 1973

Driver with the most wins:
Jackie Stewart (1969, 1971)

GERMANY

FRANCE

SPAIN

ALGERIA

0 100 m

0 0.1 miles

Guàrdia Urbana

Av. de Rius i Taulet

Carrer de la Guàrdia Urbana

Plaça de Carles Buigas

Plaça de Josep Puig Cadafalch

Passeig de Santa Madrona

Vias

Teatro Griego

Passeig de Jean Forestier

Plaça de les Cascades

Rosaleda

Passeig de Santa Madrona

Font del Gat

Fundaciò Mirò

Museu Nacional d'Art de Catalun- ya-Barcelona

Av. dels Montanyans

Palacete Albéniz

El Ángulo de Miramar

Estadio

Av. de l'Estadi

Carrer dels Tres Pins

START/FINISH

Estadi Loímpic Lluís Companys

Passeig Olímpic

Carrer Dr. Font Quer

139

Hockenheim 1970

Hockenheimring

 GERMANY

Originally, a flat-out banana-shaped track with a vast stadium at one end. First used for the German Grand Prix in 1970. The long straights were abandoned but the stadium remained during a major redesign in 2002 that removed Hockenheim's essential, if not particularly popular, character.

The original Hockenheimring, built in 1932, was nothing more than a straightforward charge up and down straights running from the edge of the small town, into a woodland, and back again. Hockenheim lies to the south of Mannheim and the growth of industry in the region led to the construction of motorways, one of which, joining Mannheim with Heilbronn, cut across the old circuit, close by the town.

The Hockenheim-Ring company, in association with the local and national automobile clubs, used compensation from the Autobahn department to spend £1 million on reshaping the track and adding the stadium, which included a pit and paddock complex.

Racing resumed on the truncated circuit in 1966 and hit the headlines for all the wrong reasons two years later when the legendary Jim Clark was killed instantly when his Formula 2 Lotus spun into trees on the edge of a gentle curve on the outbound leg. This tragedy notwithstanding, the irony was that Hockenheim should be chosen to stage the 1970 German Grand Prix because the Nürburgring Nordschleife was thought to be too dangerous.

It was with reluctance that the F1 teams travelled to what was considered an unattractive circuit in this region of the Rhine Valley but they were to be surprised by a sell-out crowd drawn from Frankfurt, Karlsruhe, Heidelberg and Mainz. The spectators in turn were to be rewarded by a gripping contest between the Ferrari of Jacky Ickx and the Lotus-Ford of eventual winner, Jochen Rindt.

In the meantime, a token safety upgrade at the Nürburgring saw the Grand Prix go back to the Eifel Mountains until the almost inevitable near-tragedy of Niki Lauda's fiery accident in 1976. A return to Hockenheim in 1977 saw the addition of a chicane on each of the two long straights, a third being deemed necessary at the Ostkurve in 1980 after Patrick Depailler had been killed while testing his Alfa Romeo.

Racing in the rain had always been even more risky than usual at Hockenheim because the close proximity of the trees did not allow the spray to disperse. The problem was to be highlighted during a wet practice session in 1982 when Didier Pironi, having overtaken one car, did not realise there was another hidden by the spray. The Frenchman slammed into the back of Alain Prost's Renault, Pironi's Ferrari becoming airborne and landing with a terrible force on its nose. Pironi suffered serious foot and ankle injuries and never raced again.

As the years went by and new circuits of a uniform design began to fill the calendar, that paradox was that Hockenheim, with its long straights and special technical challenge, was being seen as increasingly unique as the previous ambivalence towards the venue began to decline.

But all that was to change in 2002 when a major design retained the stadium but replaced the straights with a dramatically shorter section. When the long runs through the forest were later torn up and replaced with trees, Hockenheim's distinctive profile had gone forever.

Top: The streamlined shape of Jochen Rindt's winning Lotus 72 was ideally suited to the long straights in 1970.

Bottom: Despite a gradual drop in attendance over recent years, the stadium section continued to provide its unique atmosphere in 2018.

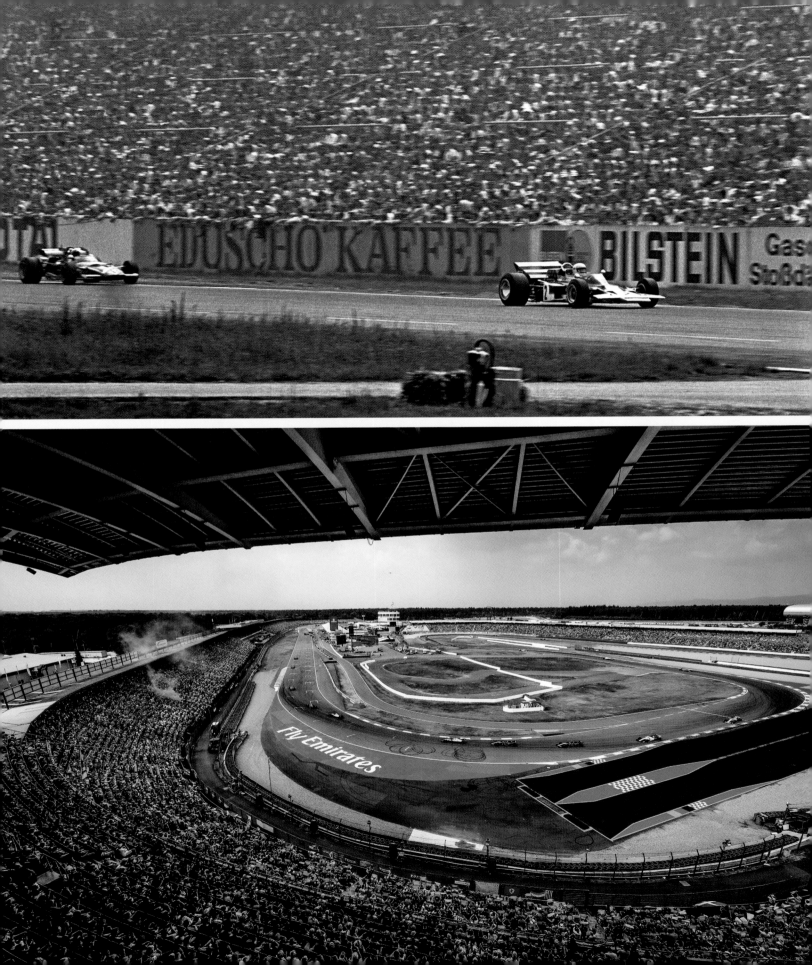

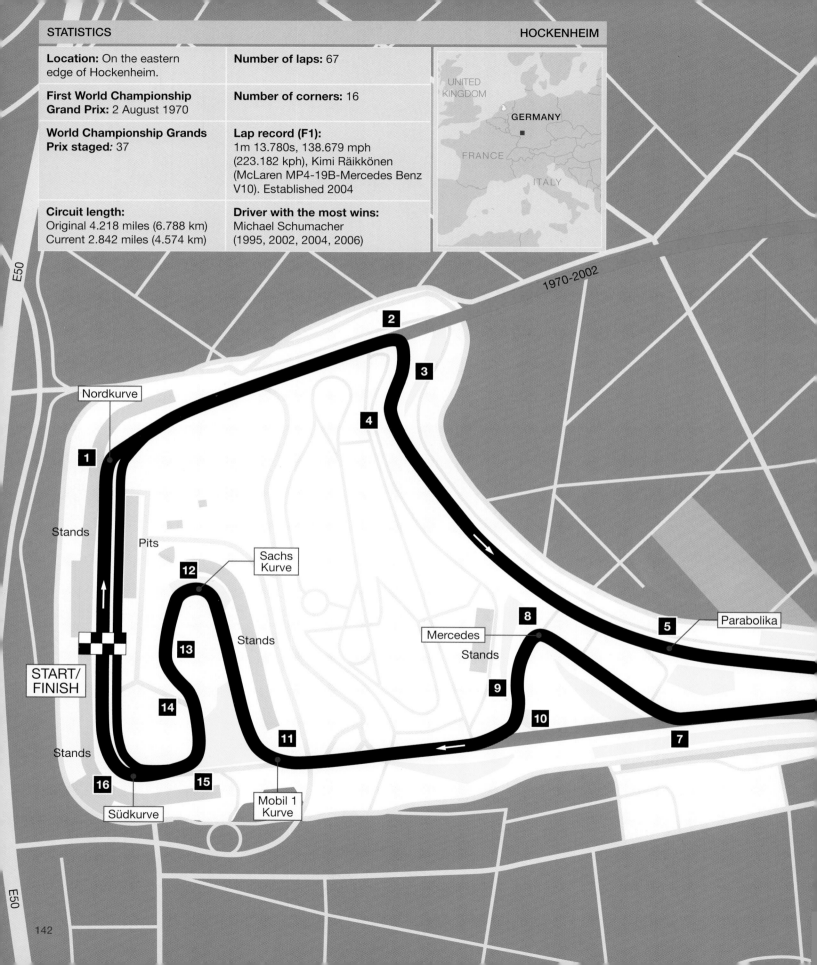

Location: On the eastern edge of Hockenheim.

First World Championship Grand Prix: 2 August 1970

World Championship Grands Prix staged: 37

Circuit length:
Original 4.218 miles (6.788 km)
Current 2.842 miles (4.574 km)

Number of laps: 67

Number of corners: 16

Lap record (F1):
1m 13.780s, 138.679 mph (223.182 kph), Kimi Räikkönen (McLaren MP4-19B-Mercedes Benz V10). Established 2004

Driver with the most wins:
Michael Schumacher (1995, 2002, 2004, 2006)

UNITED KINGDOM

GERMANY

FRANCE

ITALY

E50

1970-2002

2

3

4

Nordkurve

1

Stands

Pits

Sachs Kurve

12

5

Parabolika

8

Mercedes

Stands

13

Stands

9

14

10

11

7

Stands

START/ FINISH

16

15

Südkurve

Mobil 1 Kurve

E50

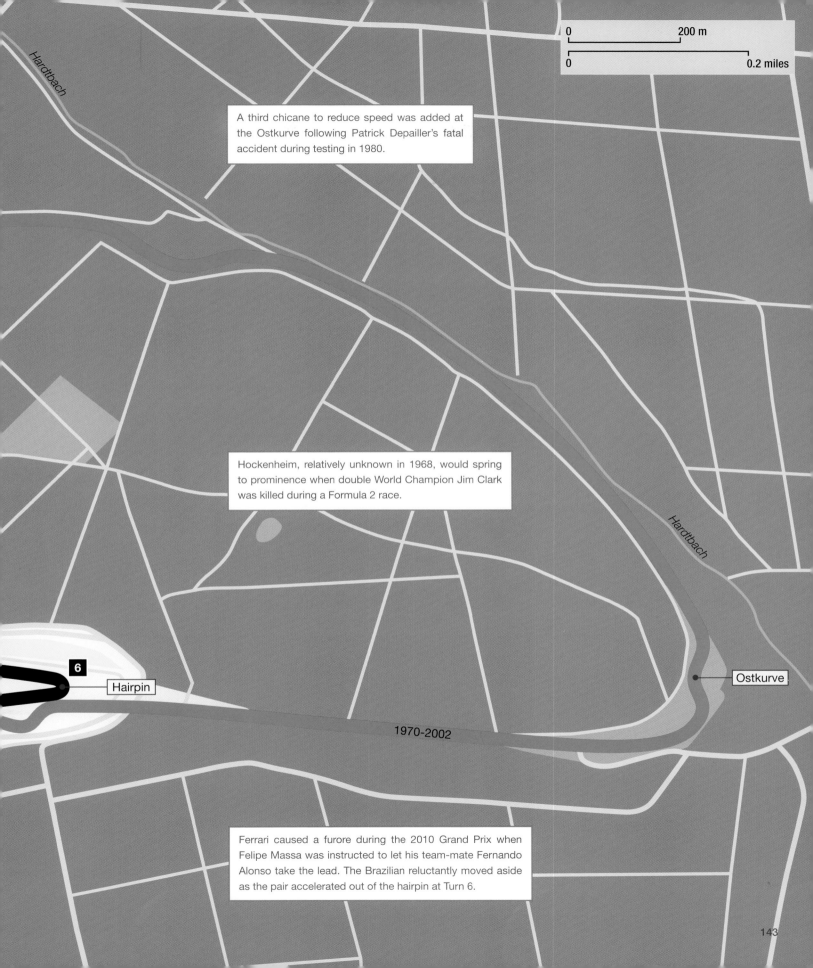

A third chicane to reduce speed was added at the Ostkurve following Patrick Depailler's fatal accident during testing in 1980.

Hockenheim, relatively unknown in 1968, would spring to prominence when double World Champion Jim Clark was killed during a Formula 2 race.

Ferrari caused a furore during the 2010 Grand Prix when Felipe Massa was instructed to let his team-mate Fernando Alonso take the lead. The Brazilian reluctantly moved aside as the pair accelerated out of the hairpin at Turn 6.

Hardtbach

Hardtbach

6

Hairpin

Ostkurve

1970-2002

0 200 m

0 0.2 miles

Österreichring 1970

Red Bull Ring

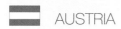 AUSTRIA

Built for the 1970 Austrian Grand Prix. The challenge and majesty enhanced by the surroundings in Styria. Staged 18 Grands Prix but considered out of step with commercial requirements in 1987. Known as A1-Ring and reduced in length for 1997–2003. Renamed Red Bull Ring for 2014.

Unperturbed by their disastrous race at Zeltweg in 1964 and spurred on by the rise of local hero Jochen Rindt, the Austrians laid plans for a track in the hills overlooking the former airfield circuit. The 3.7-mile (5.95-km) Österreichring possessed an immediate sense of maturity and permanence when opened in 1969. The corners were immense in every respect, the Boschkurve being a prime example as this perfectly cambered downhill right-hander required drivers to run as close as they dared to the barrier at the exit.

Approval for a Grand Prix the following year was soon forthcoming; a timely move since Rindt was in the running for the championship. If he won at home, the title would be his. The Austrians were to be disappointed when Rindt's Lotus blew up as he gave chase to Jacky Ickx and Clay Regazzoni, this overdue one-two for Ferrari causing the track and paddock to be mobbed by fans who had flocked across the Italian border.

That first race would set in motion some unexpected and poignant results. Barely a month after the death of their driver, Pedro Rodriguez, in July 1971, the devastated BRM team arrived in Austria to score their first win in over a year thanks to a dominant weekend for the Swiss driver, Jo Siffert.

The record book shows that Vittorio Brambilla won in 1975. The bare facts, however, give no hint of the conditions that day as a thunderstorm visited the circuit. The fearless Italian, who had never won a Grand Prix, was in the lead when the race was stopped. Such was his delight and surprise that the March-Ford skated nose-first into the crash barrier as Brambilla waved with unconfined joy. It was the one bright moment in an otherwise desperate day.

During the warm-up on race morning, a deflating tyre had sent Mark Donohue off the road at the very fast Hella Licht Kurve. The wayward March severely injured two marshals before slamming into an advertising hoarding supported by stout poles. One of the poles caught the American a sharp blow on the head. He died two days later.

This tragedy knocked the stuffing from the Penske team. Their sense of quiet satisfaction a year later can be imagined when John Watson drove a Penske-Ford to a maiden F1 win for both driver and team. Another duck was broken in 1977 when Alan Jones scored a surprise win, his uncompetitive Shadow-Ford being perfect for the changeable conditions. When it comes to close wins, there was none better than the first victory for Elio de Angelis as the Italian's Lotus-Ford crossed the line side-by-side with the Williams-Ford of Keke Rosberg in 1982.

As the average speed rose to more than 150 mph (241 kph) despite the introduction of a chicane at Hella Licht, concern grew over the absence of run-off areas in certain places. This, linked with a narrow pit straight causing a ten-car pile-up in 1987, added to dissatisfaction with such a remote area being unsuitable for the needs of an increasingly corporate sport.

The Grand Prix returned ten years later to a rebuilt and shortened track known as the A1-Ring in deference to the mobile phone company footing most of the bill. With the fast sweeping corners having been mainly replaced by tight right-handers, none of the spine-tingling challenge remained.

The race stayed on the calendar for another seven years before much discussion over future plans eventually saw the site purchased by Red Bull. After several false starts, the existing track and facilities were upgraded in readiness for a round of the championship in June 2014. The Red Bull Ring received critical acclaim for the standard of finish and, of course, the imposing surroundings. The majesty of the original track had long since been forgotten.

Top: Jacky Ickx and Clay Regazzoni gave Ferrari a well-received one-two finish when the Österreichring staged its first Austrian Grand Prix in 1970.

Bottom: Max Verstappen won for Red Bull on their circuit in 2019.

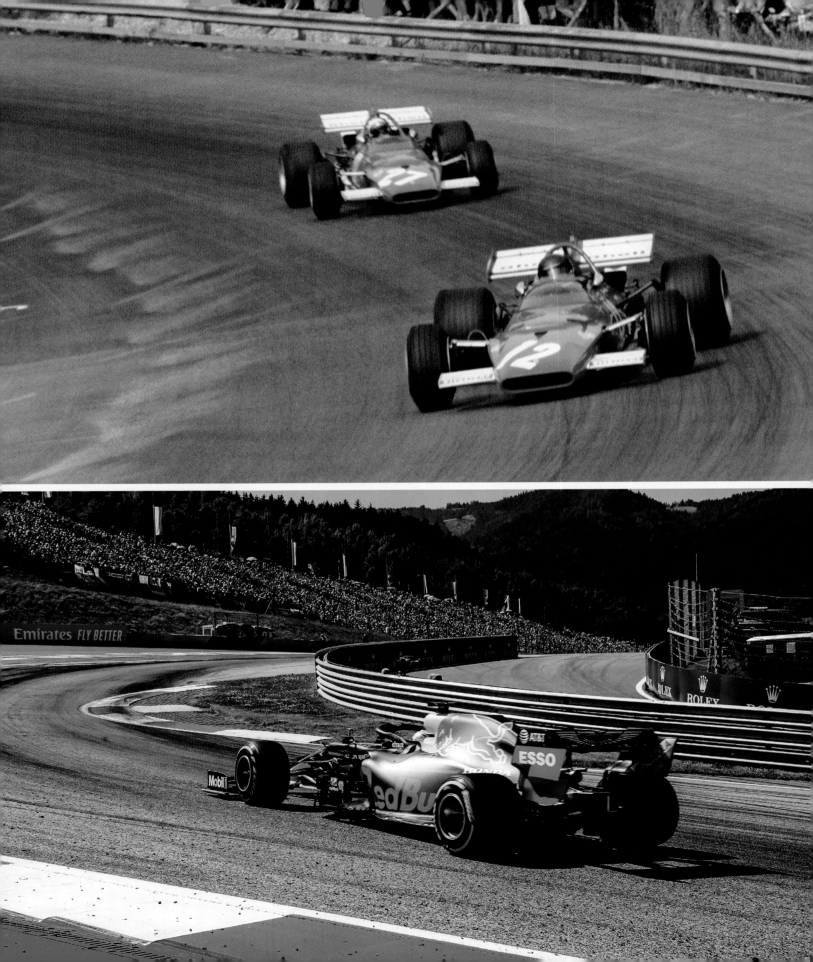

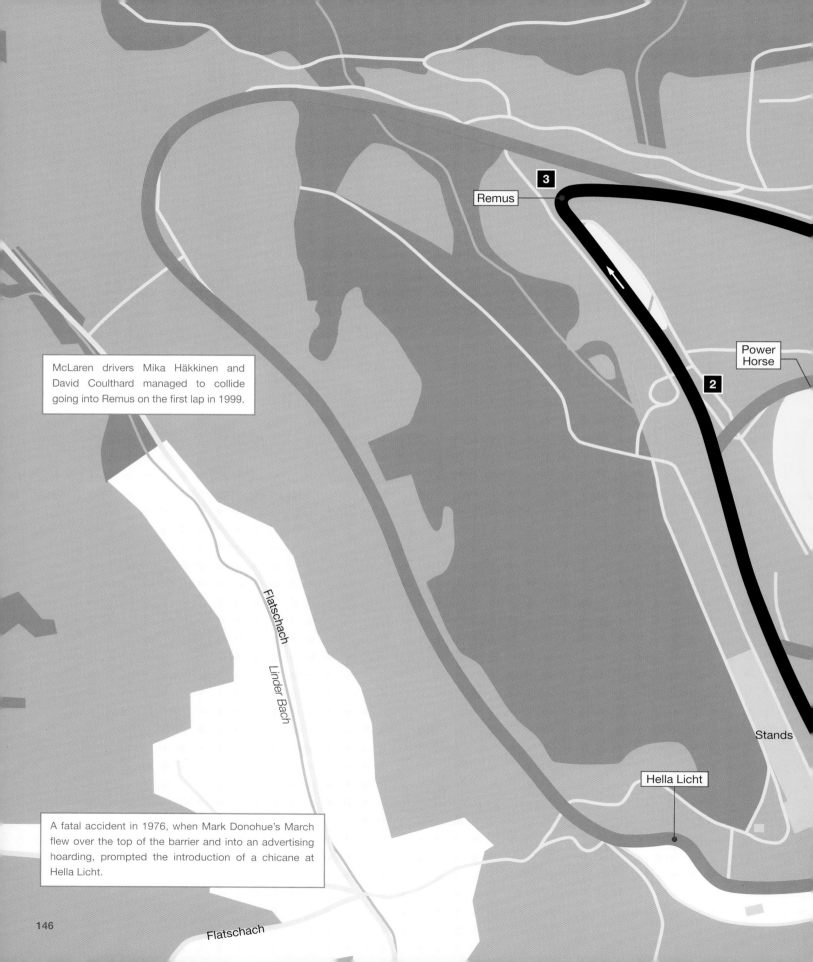

McLaren drivers Mika Häkkinen and David Coulthard managed to collide going into Remus on the first lap in 1999.

A fatal accident in 1976, when Mark Donohue's March flew over the top of the barrier and into an advertising hoarding, prompted the introduction of a chicane at Hella Licht.

Remus **3**

Power Horse

2

Stands

Hella Licht

Flatschach

Linder Bach

Flatschach

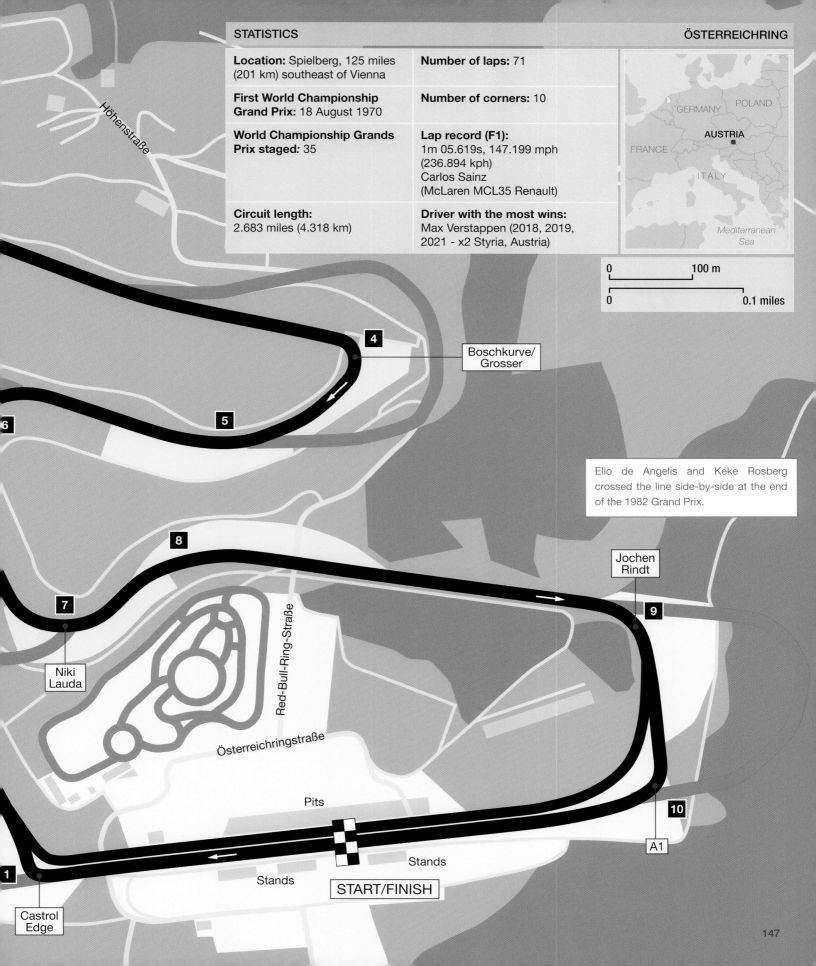

STATISTICS

Location: Spielberg, 125 miles (201 km) southeast of Vienna

First World Championship Grand Prix: 18 August 1970

World Championship Grands Prix staged: 35

Circuit length: 2.683 miles (4.318 km)

Number of laps: 71

Number of corners: 10

Lap record (F1): 1m 05.619s, 147.199 mph (236.894 kph) Carlos Sainz (McLaren MCL35 Renault)

Driver with the most wins: Max Verstappen (2018, 2019, 2021 - x2 Styria, Austria)

GERMANY

POLAND

AUSTRIA

FRANCE

ITALY

Mediterranean Sea

0 100 m

0 0.1 miles

Höhenstraße

4

Boschkurve/ Grosser

5

6

Elio de Angelis and Keke Rosberg crossed the line side-by-side at the end of the 1982 Grand Prix.

8

Jochen Rindt

7

9

Niki Lauda

Red-Bull-Ring-Straße

Österreichringstraße

10

Pits

A1

1

Stands

Stands

START/FINISH

Castrol Edge

147

Paul Ricard 1971

Circuit Paul Ricard, Le Castellet

 FRANCE

A flat, elongated track considered modern and safe on its opening in 1969. Scene of French Grand Prix in 1971. The full track used until Elio de Angelis's fatal accident during testing in 1986, a shorter 2.37-mile (3.81-km) version favoured for five Grands Prix. A revised version of the long track used when F1 returned in 2018.

When Paul Ricard, the drinks magnate and inventor of Pastis, decided to build a Grand Prix circuit in 1969, he chose a flat, dusty plateau – the only such place in otherwise rugged terrain – at Le Castellet, east of Marseille. The track had three possible layouts, the longest being favoured for the staging of the first World Championship Grand Prix in 1971. The 3.61-mile (5.81-km) circuit may have been featureless but, at the time, it boasted run-off areas as well as excellent facilities, air-conditioned offices, an extensive tree-fringed paddock and the convenience of a small airport suitable for F1's high flyers.

One of Circuit Paul Ricard's most attractive qualities was its location, high above the Mediterranean coastal town of Bandol and within reach of Cassis and La Ciotat. For the first year, however, most of the locals preferred to stay on the beach rather than make the climb to see Jackie Stewart win a fairly straightforward race for Tyrrell.

With the track dominated by the Mistral Straight measuring more than a mile, Circuit Paul Ricard (often referred to by the French simply as Le Castellet) presented the drivers with little in the way of a challenge. That would change through the years as speeds continued to rise and the *S de la Verrière*, a left-right sweep after the pits, became a daunting combination. In 1986, that sequence would contribute to tragedy and a major re-think.

During a mid-week test session on 14 May, the rear wing on Elio de Angelis's Brabham-BMW came off as he went through *S de la Verrière*. The car finished upside down on the other side of the right-hand barrier. The chassis withstood the impact, de Angelis's injuries limited to a broken collarbone.

But he was trapped in the cockpit as the car caught fire. The first marshal on the scene was wearing tee-shirt and shorts, his dress proving as inadequate as a single fire extinguisher, the fumes from which would actually contribute to a shortage of oxygen in the cockpit area. Drivers who had stopped to see what they could do felt completely helpless. After an interminable delay, de Angelis was airlifted to hospital, where he died the following day.

In response to heavy criticism, the circuit length was slashed, the cars turning right before *S de la Verrière* and joining the Mistral Straight halfway along its length. Apart from the almost flat-out Signes corner at the end of the straight, there was nothing to tax the drivers – a situation that was often reflected in dull races.

In 1991, French politics were behind a move to Magny-Cours in the centre of the country. Paul Ricard continued to host motorcycle and national races until M. Ricard's death prompted the sale of the facility to a company owned by Bernie Ecclestone. The F1 boss removed the grandstands and remodelled the circuit into a first class test facility.

When Magny-Cours ran into difficulties in 2008, Paul Ricard had already undergone a series of changes. Further tweaks to the layout (including La Verrière, Virage du Camp at the far end of the original circuit, and a chicane on the Mistral Straight) received full F1 approval. A cap on spectator numbers in 2019 and 2021 (and cancellation of the 2020 French Grand Prix) due to Covid-19 avoided the chaotic scenes in 2018 when the roads and organisation failed to cope with the return of a popular venue.

Top: The Paul Ricard circuit has been through several make-overs, including the introduction of a chicane on the Mistral Straight leading to Signes and Beausset in the foreground.

Bottom: A home win for Alain Prost in 1988 as he leads his McLaren-Honda team-mate, Ayrton Senna.

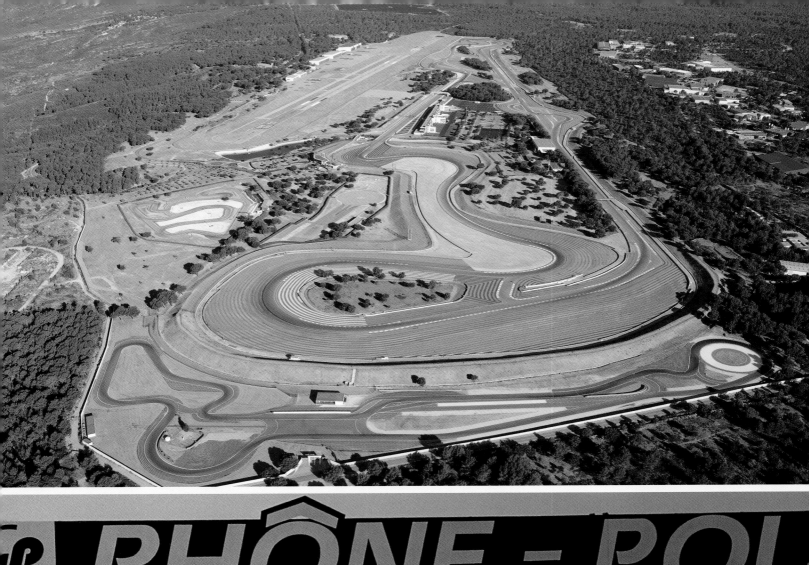

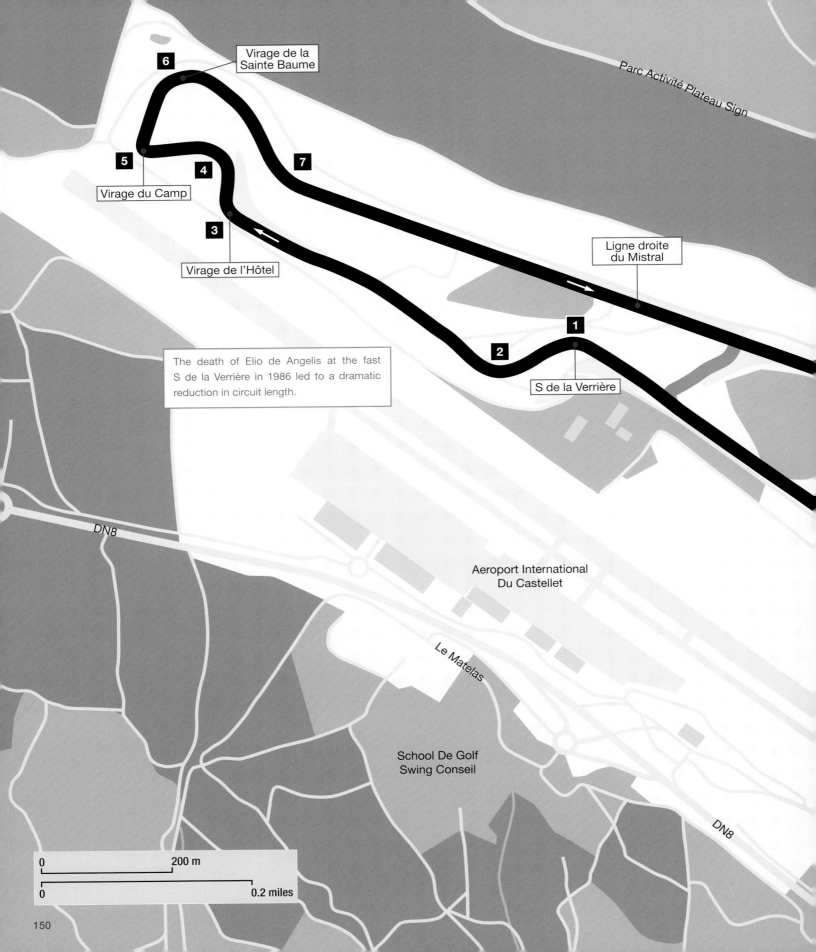

6 Virage de la Sainte Baume

7

5 Virage du Camp

4

3 Virage de l'Hôtel

Ligne droite du Mistral

1 S de la Verrière

2

The death of Elio de Angelis at the fast S de la Verrière in 1986 led to a dramatic reduction in circuit length.

Parc Activité Plateau Sign

DN8

Aeroport International Du Castellet

Le Matelas

School De Golf Swing Conseil

DN8

0 200 m

0 0.2 miles

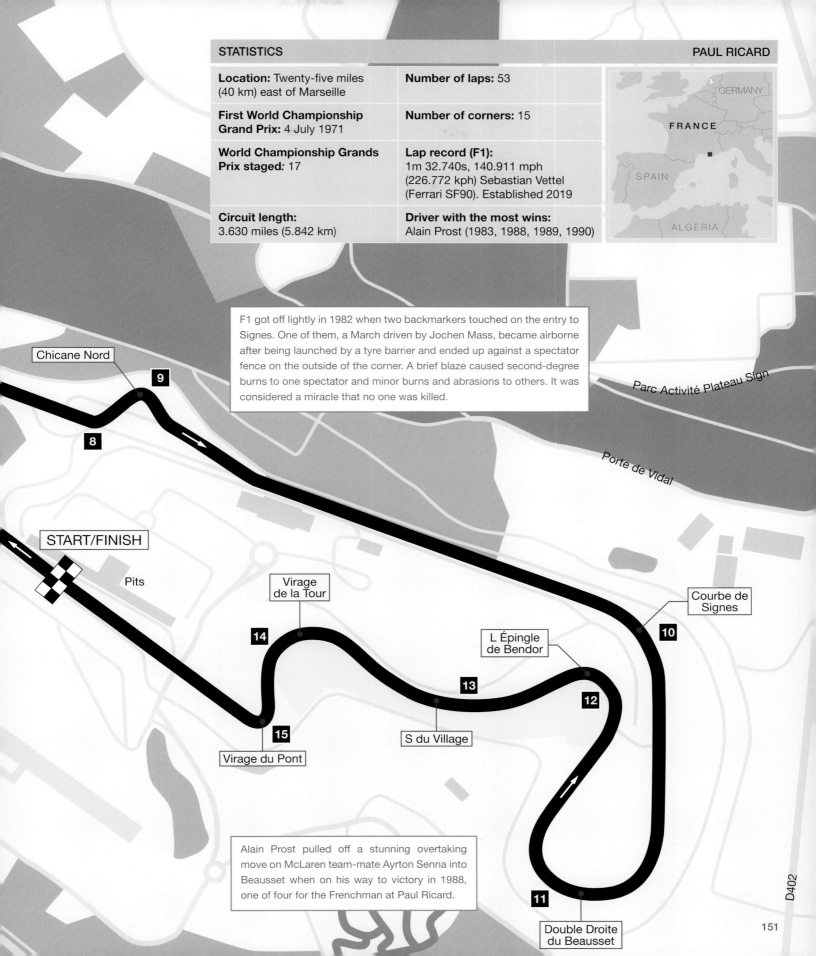

STATISTICS

Location: Twenty-five miles (40 km) east of Marseille

First World Championship Grand Prix: 4 July 1971

World Championship Grands Prix staged: 17

Circuit length: 3.630 miles (5.842 km)

Number of laps: 53

Number of corners: 15

Lap record (F1): 1m 32.740s, 140.911 mph (226.772 kph) Sebastian Vettel (Ferrari SF90). Established 2019

Driver with the most wins: Alain Prost (1983, 1988, 1989, 1990)

GERMANY

FRANCE

SPAIN

ALGERIA

F1 got off lightly in 1982 when two backmarkers touched on the entry to Signes. One of them, a March driven by Jochen Mass, became airborne after being launched by a tyre barrier and ended up against a spectator fence on the outside of the corner. A brief blaze caused second-degree burns to one spectator and minor burns and abrasions to others. It was considered a miracle that no one was killed.

Parc Activité Plateau Sign

Porte de Vidal

Chicane Nord

9

8

START/FINISH

Pits

Virage de la Tour

14

Courbe de Signes

10

L Épingle de Bendor

12

13

S du Village

15

Virage du Pont

Alain Prost pulled off a stunning overtaking move on McLaren team-mate Ayrton Senna into Beausset when on his way to victory in 1988, one of four for the Frenchman at Paul Ricard.

11

Double Droite du Beausset

D402

151

Nivelles 1972

Complex Européen de Nivelles-Baulers

 BELGIUM

An almost flat and featureless purpose-built track, south of Brussels. Used only twice for the Belgian Grand Prix in the 1970s due to a lack of interest and commitment in a 2.3-mile (3.7-km) circuit that was thought to be almost too safe. Both Grands Prix were won by Emerson Fittipaldi.

With the original Spa-Francorchamps circuit considered too dangerous for F1, two new tracks – Nivelles and Zolder – attempted the impossible by trying to fill the vacuum created by the absence of the giant in the Ardennes. If Zolder was marginally successful, then Nivelles was almost a non-starter.

The two substitutes typified the political play within Belgian motor sport as the Flemish and Walloon territories demanded to be satisfied. Nivelles represented the best efforts of the French-speaking region through a group of businessmen keen to build a safe race track located between the town of Nivelles and the village of Baulers, some 20 miles (32 km) south of Brussels. The grand title given to the project was 'Complex Européen de Nivelles-Baulers', although the circuit would generally be known simply as Nivelles.

With design input from John Hugenholtz, Nivelles would not be regarded as the Dutchman's best work when compared to gems such as Suzuka and Zandvoort. To be fair to Hugenholtz, the original project envisaged a circuit of about 3.5 miles (5.6 km). When the developers were unable to purchase all of the required land in time, the 2.3-mile (3.7-km) compromise fell short in every department, not least the rush to get started prompting the owner of the second parcel of land to increase his price to a level that would never be met.

The pit straight, running slightly uphill, ended in a fast right leading into a much shorter straight. Competitors then looped through 180-degrees courtesy of two long right-handers before a tight left and another short straight heading behind the pits. An elongated chicane left-right, gently running downhill to a right-left, led to the final corner, a slow hairpin and the brief climb towards the finish line. With a maximum speed just short of 160 mph (257 kph), this was not a circuit to quicken the pulse.

It kept the drivers busy, however, Emerson Fittipaldi's pole position lap in 1972 being completed in 1 minute 11.43 seconds, 0.15 seconds quicker than Clay Regazzoni's Ferrari. The Swiss got the jump on Fittipaldi at the start, but, with a clever move on the ninth lap, the Lotus driver managed to take the lead from the wide Ferrari. And that was it for the remaining 76 laps. Some 65,000 spectators had turned up but few were impressed by wide run-offs forcing them to watch some distance from what little track action there was.

There were fewer complaints when the Grand Prix returned two years later in 1974, Fittipaldi (now with McLaren) winning again, but only by the narrowest of margins from the Ferrari of rising star, Niki Lauda. There were 17 finishers from a massive field of 31 cars but the numbers on the organiser's balance sheet were not so healthy, the first incumbent having gone bankrupt before the Grand Prix; the second not long after.

With the track needing resurfacing and no one to pay for it, Nivelles had to forgo its scheduled biennial slot in 1976. Racing of sorts would continue at Nivelles-Baulers until 1981, when it was closed for good, small sections remaining in what has become a business park.

The McLaren-Ford of eventual winner, Emerson Fittipaldi, chases Clay Regazzoni's Ferrari during the opening stages in 1974, the last time the Grand Prix would be held at Nivelles.

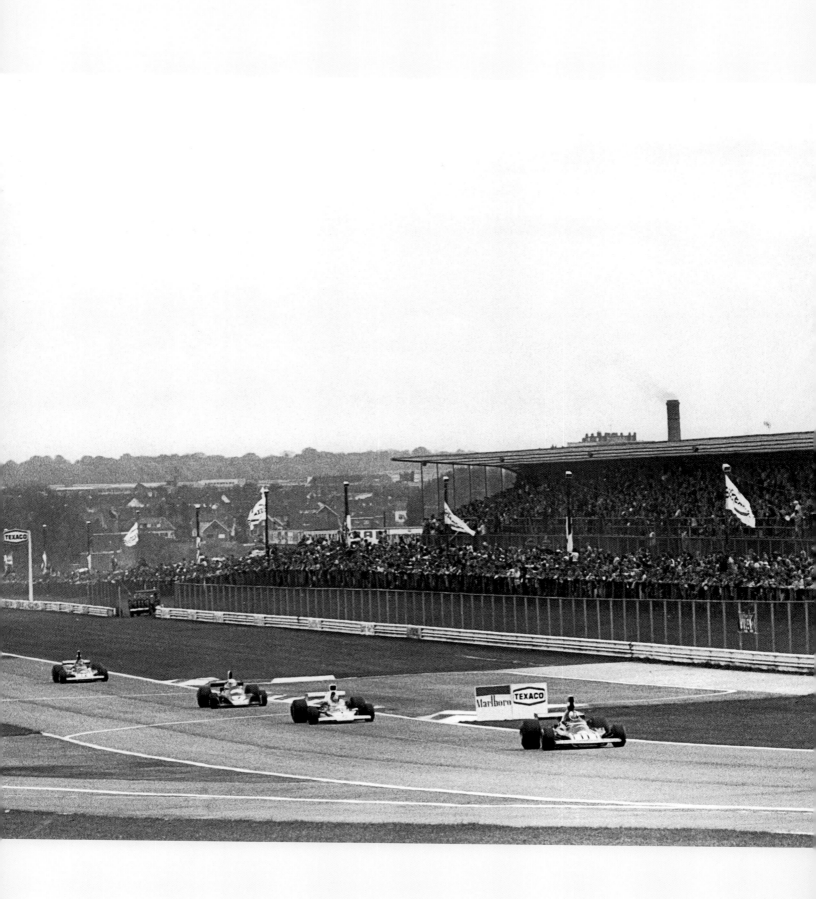

Emerson Fittipaldi considered himself fortunate to win for a second time in 1974, a wheel balance weight having flown off a car in front and taken a chunk from the Brazilian's windscreen before flying over the top of the McLaren.

Avenue Robert Schuman

3

2

Rue Joseph Luns

Nivelles, with its wide run-off areas, was considered boring and was bound to suffer in comparison with Spa-Francorchamps.

Av. Konrad Adenauer

5

4

Rue Maurice Faure

N28

1

Avenue Robert Schuman

Chaussée de Hal

Avenue de l'Europe

N252

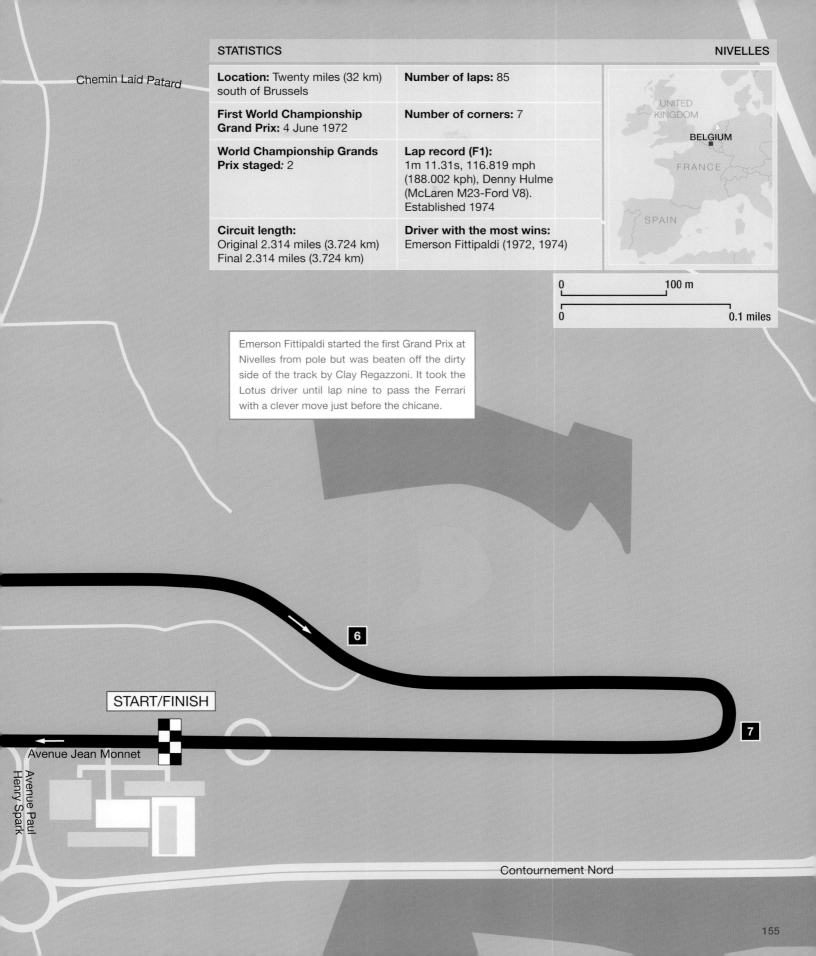

Location: Twenty miles (32 km) south of Brussels	**Number of laps:** 85
First World Championship Grand Prix: 4 June 1972	**Number of corners:** 7
World Championship Grands Prix staged: 2	**Lap record (F1):** 1m 11.31s, 116.819 mph (188.002 kph), Denny Hulme (McLaren M23-Ford V8). Established 1974
Circuit length: Original 2.314 miles (3.724 km) Final 2.314 miles (3.724 km)	**Driver with the most wins:** Emerson Fittipaldi (1972, 1974)

UNITED KINGDOM

BELGIUM

FRANCE

SPAIN

0 100 m

0 0.1 miles

Chemin Laid Patard

Emerson Fittipaldi started the first Grand Prix at Nivelles from pole but was beaten off the dirty side of the track by Clay Regazzoni. It took the Lotus driver until lap nine to pass the Ferrari with a clever move just before the chicane.

6

7

START/FINISH

Avenue Jean Monnet

Avenue Paul Henry Spark

Contournement Nord

Interlagos 1973

Autódromo José Carlos Pace

 BRAZIL

Apart from a break in the 1980s, regular host to the Brazilian Grand Prix since 1973. Located in the sprawling suburbs of São Paulo, the 5-mile (8-km) track, twisting and turning within itself, was shortened to 2.7 miles (4.3 km) in 1990. Often a dramatic championship decider.

Earmarked originally for housing in a suburb to the southwest of São Paulo, the land was given over to the construction of a race track that opened in May 1940. Located in the neighbourhood of Interlagos (so-called because of its position between two large artificial lakes), the 4.946-mile (7.96-km) circuit made the most of a natural amphitheatre with the pits on a plateau and the rest of the track weaving back and forth across the plain beneath.

When Emerson Fittipaldi, a native of São Paulo, accelerated local interest in F1 by winning his first Grand Prix in 1970, it was only a matter of time before a non-championship race in 1972 would be the prelude to the first Brazilian Grand Prix the following year – which was duly won by Fittipaldi, now the reigning champion.

Fittipaldi won again the following year and, in 1975, it was the turn of Carlos Pace at the wheel of a Brabham. When the Brazilian was killed in a plane crash in 1977, the circuit was officially renamed in his honour. But little else changed as the number of complaints rose over the track's inherent dangers, inadequate barriers and increasingly bumpy surface.

The Jacarepaguá track near Rio de Janeiro was favoured from 1981 until the rise in F1 stature of São Paulo-born Ayrton Senna prompted a $15 million facelift for Interlagos and a return in 1990. The circuit length had been cut by almost half thanks to clever use of parts of the old layout.

Instead of sweeping past the pits into a very long and fast left-hander, the track suddenly dived downhill into the Senna S and began its progress on the flat land beneath the escarpment, rising and falling through two tight right-handers at Laranja and Bico de Pato, as used on the original layout.

The essential challenge and character remained, not least the vibrant atmosphere created by the colourful motor sport mad Brazilians. Their reaction is not difficult to imagine when Senna finally won his home Grand Prix in 1991, and again in 1993, one year before his death at Imola on 1 May 1994.

With the race being switched from the start of the season to the end in 2004, Brazil has frequently decided the championship, none more dramatic than in 2008 when Lewis Hamilton of McLaren took the title from Ferrari's Felipe Massa at the last corner of the last lap.

Racing at Interlagos has always been tough thanks to the track's anti-clockwise direction testing a driver's neck muscles while the bumps and heat sap his strength over 71 laps of twisting and turning. And if high temperatures do not present a challenge then rain, a frequent visitor to this high ground, can make the track surface even more hazardous.

Despite promises of rebuilding, the cramped garages and paddock remain and probably would have been rejected as totally unacceptable had they been anywhere other than Interlagos. The start line, set in a dip and overlooked by towering grandstands humming with energy, gives the grid an electric atmosphere that has no equal.

Top: Emerson Fittipaldi continued the surge in F1's popularity in Brazil by winning for Lotus-Ford at Interlagos in 1973.

Bottom: Ayrton Senna (seen leading Michael Schumacher's Benetton-Ford) was adored at Interlagos, particularly when he won for McLaren-Ford in 1993.

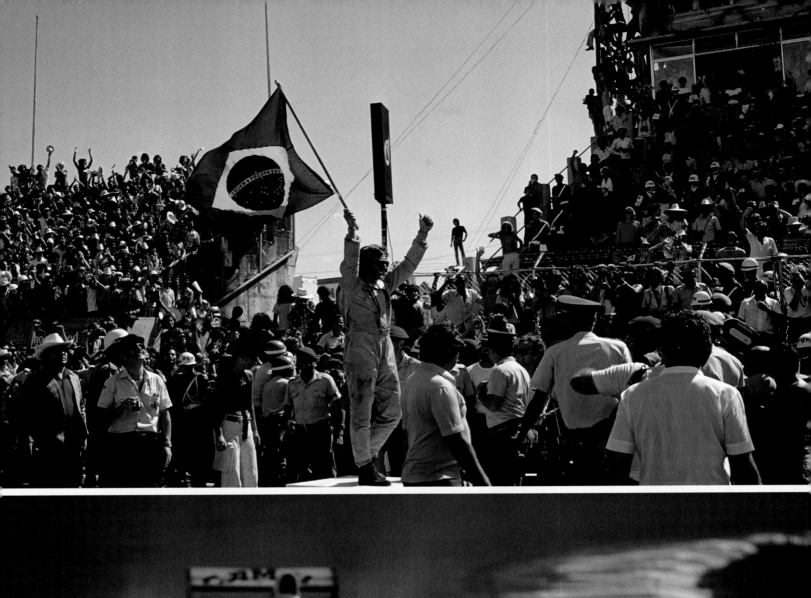
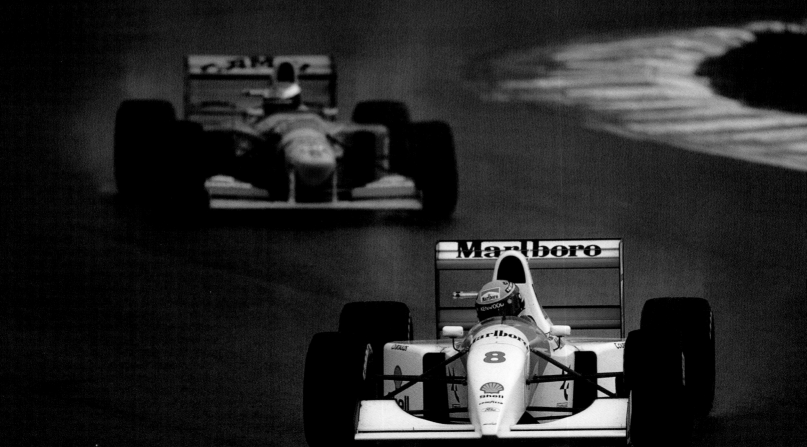

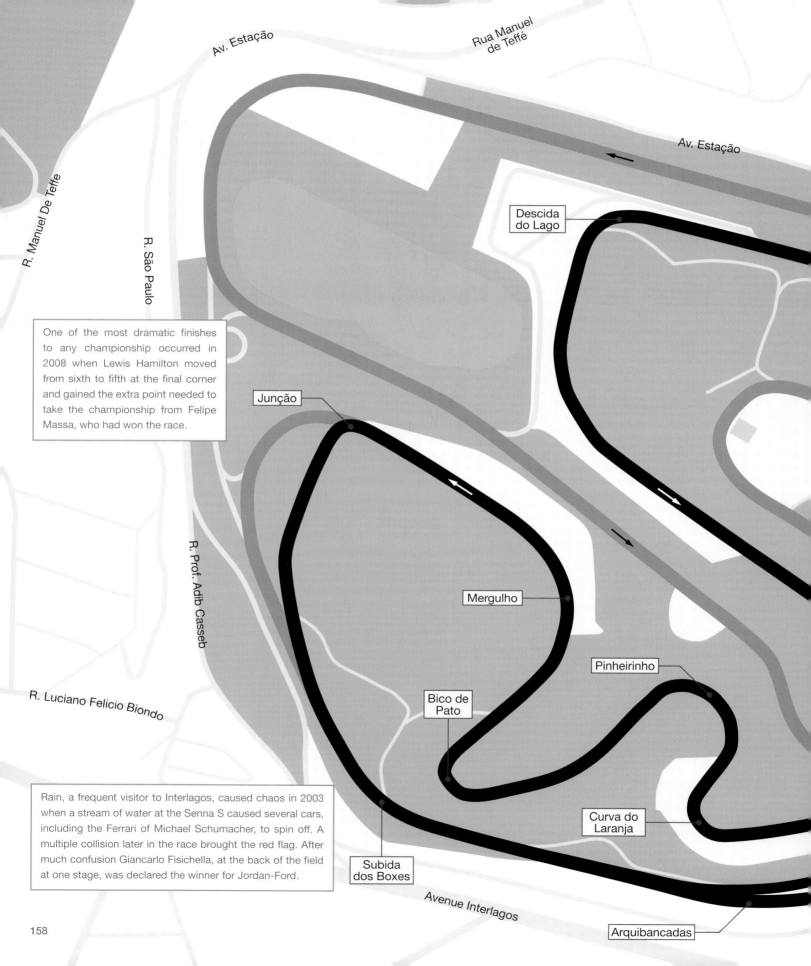

Av. Estação

Rua Manuel
de Teffé

R. Manuel De Teffe

R. São Paulo

Av. Estação

Descida
do Lago

One of the most dramatic finishes to any championship occurred in 2008 when Lewis Hamilton moved from sixth to fifth at the final corner and gained the extra point needed to take the championship from Felipe Massa, who had won the race.

Junção

R. Prof. Adib Casseb

Mergulho

Pinheirinho

R. Luciano Felicio Biondo

Bico de
Pato

Curva do
Laranja

Rain, a frequent visitor to Interlagos, caused chaos in 2003 when a stream of water at the Senna S caused several cars, including the Ferrari of Michael Schumacher, to spin off. A multiple collision later in the race brought the red flag. After much confusion Giancarlo Fisichella, at the back of the field at one stage, was declared the winner for Jordan-Ford.

Subida
dos Boxes

Avenue Interlagos

Arquibancadas

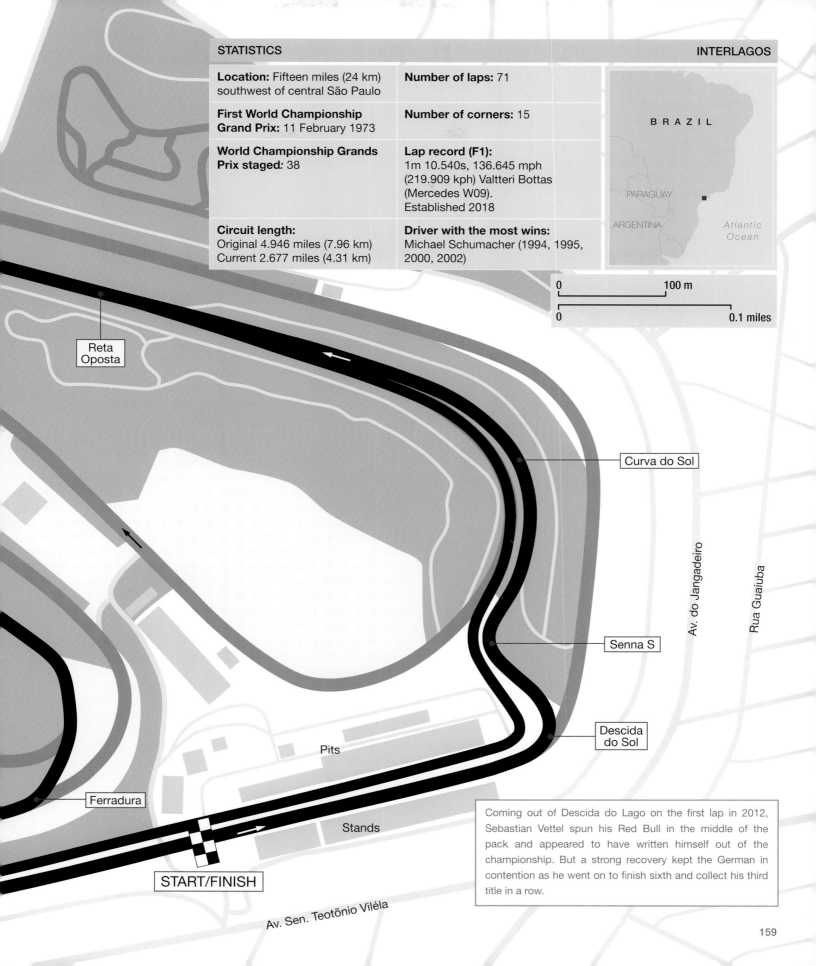

Location: Fifteen miles (24 km) southwest of central São Paulo

Number of laps: 71

First World Championship Grand Prix: 11 February 1973

Number of corners: 15

World Championship Grands Prix staged: 38

Lap record (F1):
1m 10.540s, 136.645 mph (219.909 kph) Valtteri Bottas (Mercedes W09). Established 2018

Circuit length:
Original 4.946 miles (7.96 km)
Current 2.677 miles (4.31 km)

Driver with the most wins:
Michael Schumacher (1994, 1995, 2000, 2002)

BRAZIL

PARAGUAY

ARGENTINA

Atlantic
Ocean

0 100 m

0 0.1 miles

Reta
Oposta

Curva do Sol

Av. do Jangadeiro

Rua Guaiuba

Senna S

Descida
do Sol

Ferradura

Pits

Stands

START/FINISH

Coming out of Descida do Lago on the first lap in 2012, Sebastian Vettel spun his Red Bull in the middle of the pack and appeared to have written himself out of the championship. But a strong recovery kept the German in contention as he went on to finish sixth and collect his third title in a row.

Av. Sen. Teotõnio Viléla

159

Zolder 1973

Omloop Terlaemen Zolder

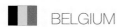 BELGIUM

Built in the Flemish-speaking region of Belgium in 1963. Hosted 10 World Championship Grands Prix between 1973 and 1984. A reasonably tricky circuit but forever associated with death of Gilles Villeneuve during qualifying in 1982, and with various controversies.

The search for alternatives to Spa-Francorchamps saw the Flemish division of Belgian motor sport put forward Zolder, a purpose-built 2.5-mile (4-km) track built in 1963 near the town of Hasselt and close by the village of Zolder. The land originally belonged to Antoine Palmers de Terlaemen, whose name was incorporated in the title of a circuit that had been extended from the original fairly primitive 1.5-mile (2.4-km) layout first used in 1961.

Situated on sandy heathland amid pine trees, Omloop Terlaemen Zolder successfully hosted an international F2 race in 1966 and became an obvious choice for the home Grand Prix, particularly when the move to Nivelles-Baulers was not well received. But this more attractive alternative in a thickly wooded area would be in trouble from the minute the F1 teams arrived for the first Grand Prix in May 1973.

Despite the Royal Automobile Club of Belgium's best efforts to support the local club, Zolder was far from ready. The track surface in particular caused great concern when it began to break up one hour into the first practice session. Despite threats of strike action, the drivers raced on a track that, for more than half of the race distance, had an extremely narrow racing line fringed by grit and gravel, not to mention abandoned cars that had spun off the treacherous surface. The Tyrrell-Ford of Jackie Stewart was not among them, this win contributing to the Scotsman's third and final title.

Following a second visit to Nivelles, the teams returned to Zolder in 1975 to find that the surface was no longer a problem and the addition of chicanes had brought the required reduction in speed. With the demise of Nivelles, Zolder became the Grand Prix's permanent home, albeit not a satisfactory one for mechanics dealing with cramped working conditions.

The absurdly narrow pit lane would be highlighted during practice in 1981 when an Osella mechanic slipped from the signalling ledge and died of injuries received when clipped by the hapless Carlos Reutemann as the Williams driver edged his way down the pit lane. An ill-advised protest on the grid led to a shambolic start in which an Arrows mechanic, attending to a stalled car, was extremely lucky not to be killed when struck by, of all people, the unsighted driver of the second Arrows.

That race was won by Reutemann who, understandably, was in no mood to celebrate. The following year, John Watson would take victory for McLaren under similar circumstances, the joy of the moment being overtaken by the lingering effects of a terrible accident the previous day. Going for a quick lap in his Ferrari at the end of qualifying, Gilles Villeneuve had come across a slow car in the middle of the track. At the precise moment Villeneuve had chosen to go right, the other driver had done likewise. The Ferrari became airborne, flinging the driver, seatbelts and all, from the cockpit. Villeneuve died of neck injuries that night, Zolder being forever tainted with the loss of the popular French-Canadian.

With the return of Spa-Francorchamps in 1983, Zolder would have one last shout the following year when, almost too late, the race ran without incident. In subsequent years, the circuit would undergo changes of ownership and major revisions to ensure Zolder remains a stalwart of the European racing calendar.

The Ligier-Ford of Patrick Depailler leads into the first corner in 1979.

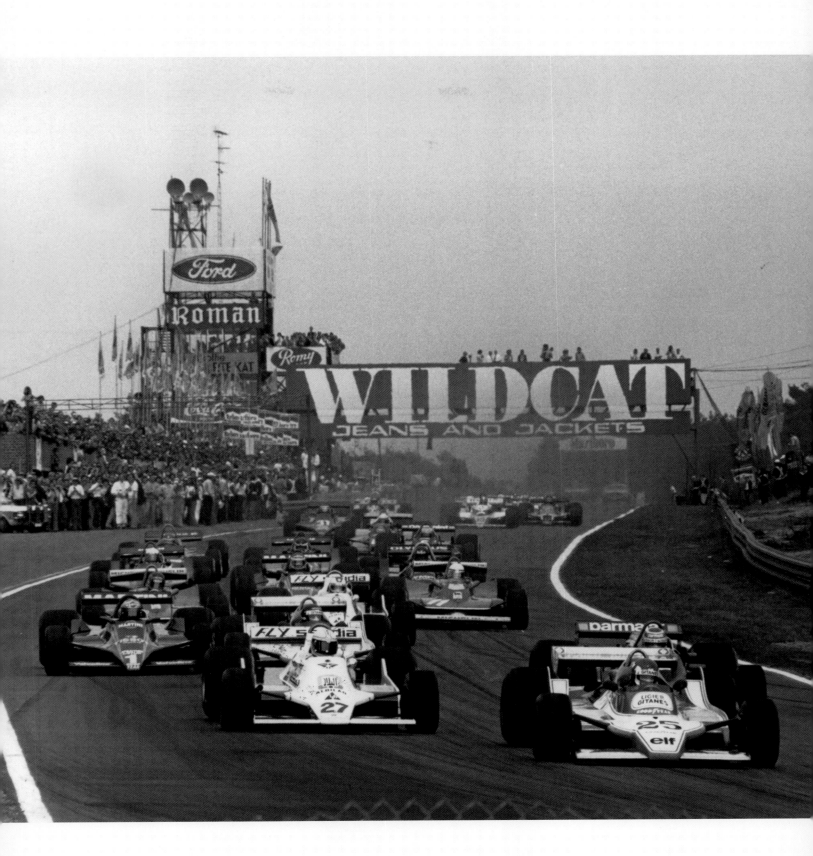

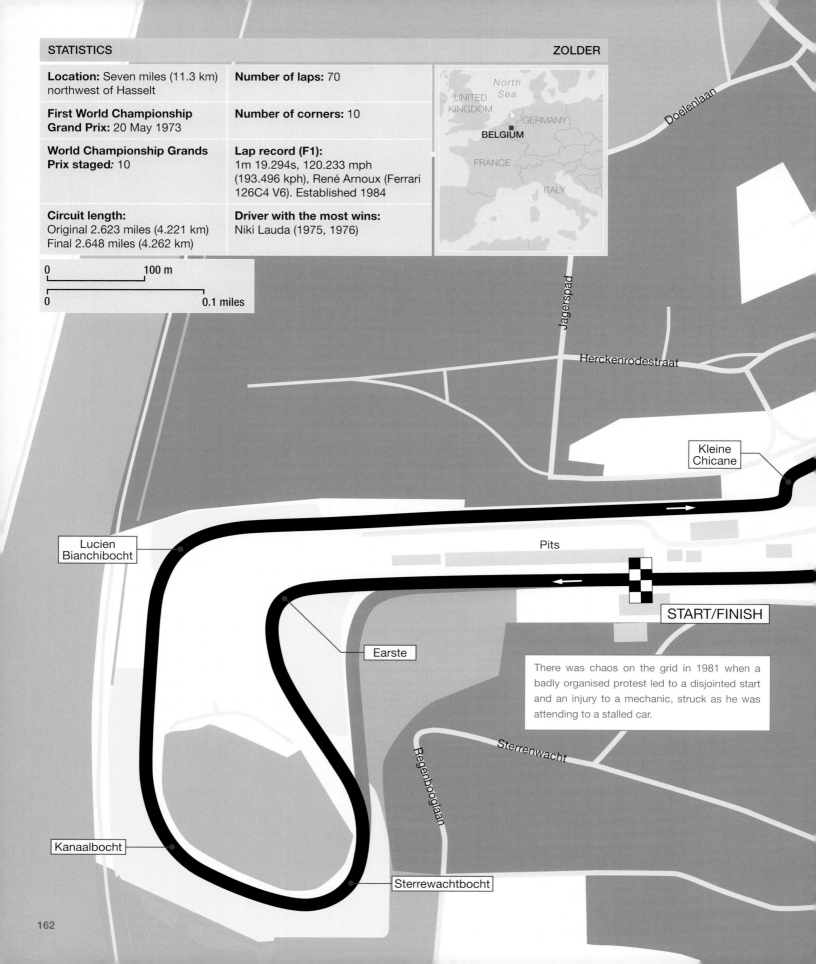

STATISTICS

Location: Seven miles (11.3 km) northwest of Hasselt

First World Championship Grand Prix: 20 May 1973

World Championship Grands Prix staged: 10

Circuit length:
Original 2.623 miles (4.221 km)
Final 2.648 miles (4.262 km)

Number of laps: 70

Number of corners: 10

Lap record (F1):
1m 19.294s, 120.233 mph (193.496 kph), René Arnoux (Ferrari 126C4 V6). Established 1984

Driver with the most wins:
Niki Lauda (1975, 1976)

0 100 m

0 0.1 miles

Doelenlaan

Jagerspad

Herckenrodestraat

Kleine Chicane

Lucien Bianchibocht

Pits

START/FINISH

Earste

There was chaos on the grid in 1981 when a badly organised protest led to a disjointed start and an injury to a mechanic, struck as he was attending to a stalled car.

Sterrenwacht

Regenbooglaan

Kanaalbocht

Sterrewachtbocht

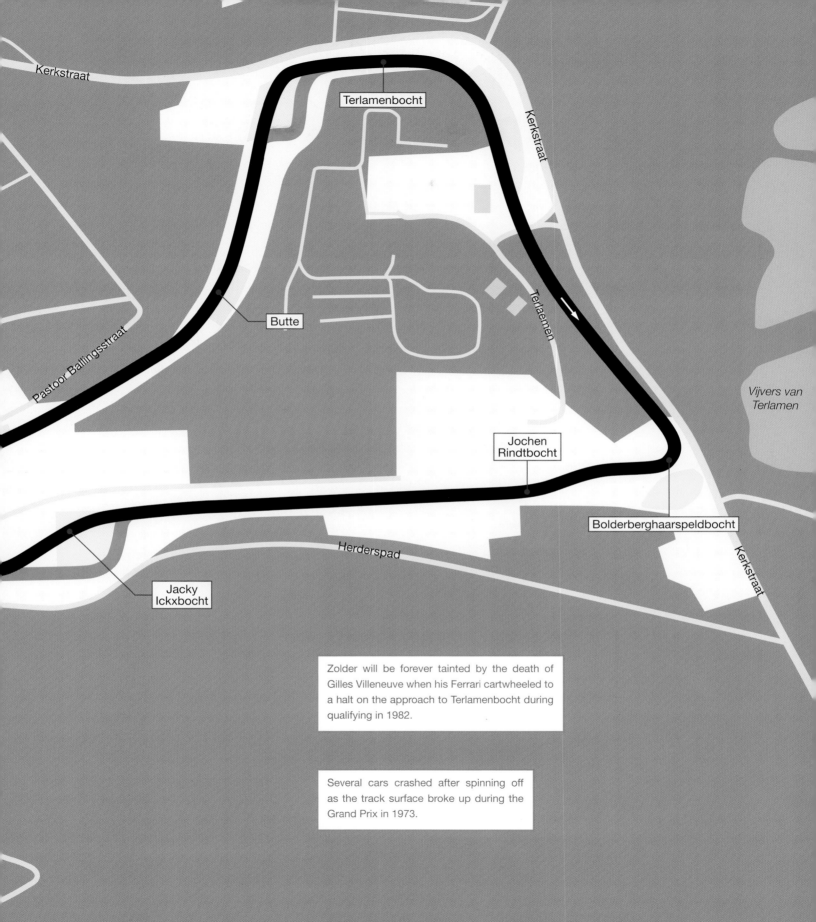

Kerkstraat

Terlamenbocht

Kerkstraat

Butte

Terlaemen

Pastoor Ballingsstraat

Jochen
Rindtbocht

Vijvers van
Terlamen

Bolderberghaarspeldbocht

Jacky
Ickxbocht

Herderspad

Kerkstraat

Zolder will be forever tainted by the death of
Gilles Villeneuve when his Ferrari cartwheeled to
a halt on the approach to Terlamenbocht during
qualifying in 1982.

Several cars crashed after spinning off
as the track surface broke up during the
Grand Prix in 1973.

Anderstorp 1973

Scandanavian Raceway

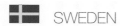 SWEDEN

Staged six Swedish Grands Prix in the 1970s, twice with victories for unconventional cars. Completely flat, in scrubland near the small town of Anderstorp and incorporating the main runway of an airfield. Unusual in having the pits some distance from the start/finish line.

Built on marshland in Gislaved Municipality, 85 miles (137 km) southeast of Gothenburg, the Scandinavian Raceway was also known simply as Anderstorp after the nearby country town. Completely flat with only sandy scrub and distant pine trees to be seen, the 2.5-mile (4-km) track was based around the single runway (known for racing as Flight Straight) of the local airfield and a series of right-angled corners and hairpins.

Ronnie Peterson's arrival in F1 in 1970 prompted an application to stage the first Swedish Grand Prix at Anderstorp. The only obstacle was an administrative one, the original circuit inspection having taken place immediately after construction in 1968. When final approval was sought for the Grand Prix five years later, the pits and paddock had been built on a small straight just before the hairpin leading to the runway. The governing body felt the straight was too short for the start line and grid, demanding that they be placed on the longer straight on the far side of the circuit. Despite the inconvenience, the separation of the timing beam and race control from the pits would work without a hitch when the Grand Prix came to town on 17 June 1973.

Prince Bertil of Sweden was among 55,000 spectators expecting great things on race day after Peterson had put his Lotus 72 on pole. All seemed set for a storybook finish when the man from Örebro led from the start only to bring heartbreak on the last of 80 laps when a slow puncture meant he lost out to the McLaren-Ford of Denny Hulme.

Jody Scheckter won his first Grand Prix the following year, the South African heading a one-two for Tyrrell-Ford. When Scheckter and Patrick Depailler repeated the result in 1976, there was to be a significant difference as they scored a landmark result for a six-wheel F1 car.

While there was nothing controversial about the Tyrrell P34-Ford with its four small front wheels, the same could not be said for the Brabham-Alfa Romeo used by Niki Lauda to win for a second time in Sweden in 1978 (his first having been for Ferrari in 1975). This was the first race for a car using a large fan at the rear, ostensibly to cool the engine but, in reality, to also create suction and pull the car closer to the track.

There was uproar and protests when the so-called 'fan car' walked off with the race. The Brabham BT46B was subsequently proved legal even if it was beyond the spirit of the rules but, for the sake of harmony within teams needing to unite to do battle with the sport's governing body, the fan car did not race again.

And neither was there another Grand Prix in Sweden, the loss of Peterson in a fatal accident at Monza later that year, and the death of rising star Gunnar Nilsson due to cancer, sapping the race of support and momentum. Anderstorp continued to host national and international races for cars and motor bikes.

Top and Bottom: Brabham-Alfa Romeo caused a stir at Anderstorp in 1978 by introducing the BT46B with a fan on the rear, Niki Lauda taking the so-called 'Fan Car' to an easy win.

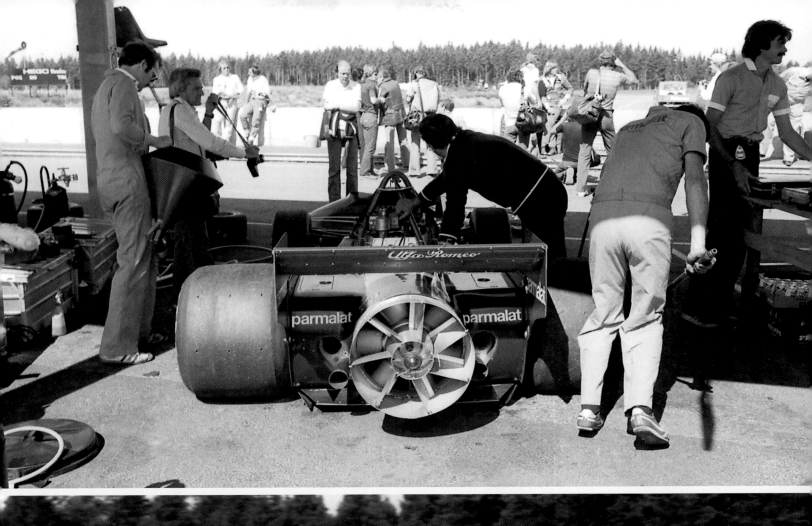

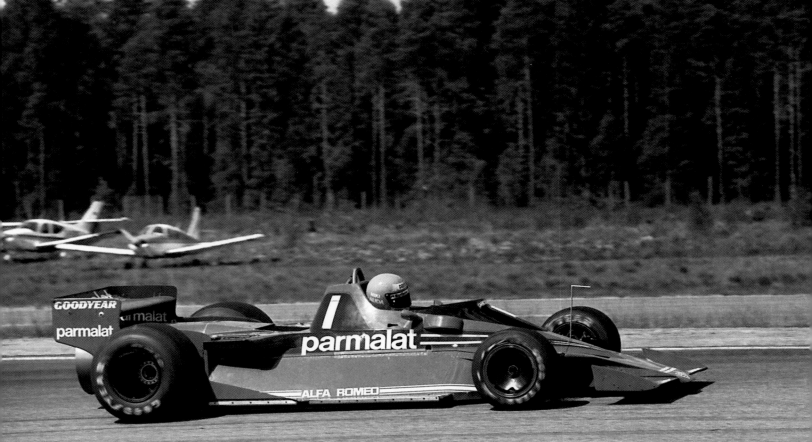

A slow puncture on the left-rear tyre of his Lotus-Ford meant Ronnie Peterson struggled through the predominant right-hand bends and lost a lead he had held from the start on the very last lap of his home Grand Prix in 1973.

Denny Hulme thought he was out of the race in 1973 when the car ahead showered Hulme with stones, one of which jammed the throttle. Miraculously, the throttle slide cleared itself and Hulme recovered from fifth place to take the lead on the last lap.

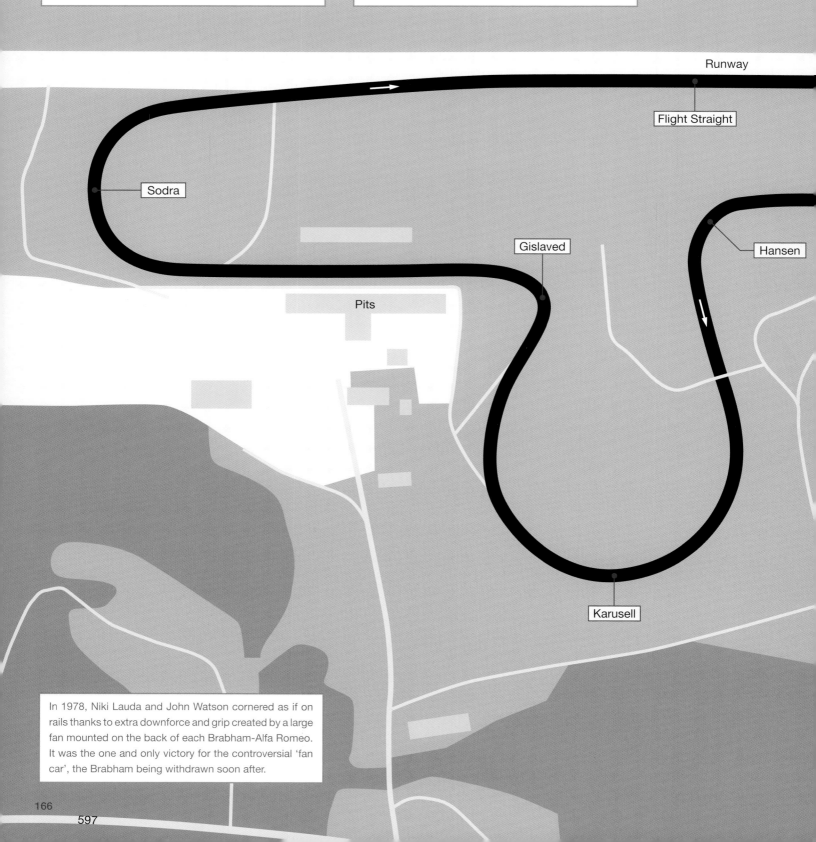

Runway

Flight Straight

Sodra

Gislaved

Hansen

Pits

Karusell

In 1978, Niki Lauda and John Watson cornered as if on rails thanks to extra downforce and grip created by a large fan mounted on the back of each Brabham-Alfa Romeo. It was the one and only victory for the controversial 'fan car', the Brabham being withdrawn soon after.

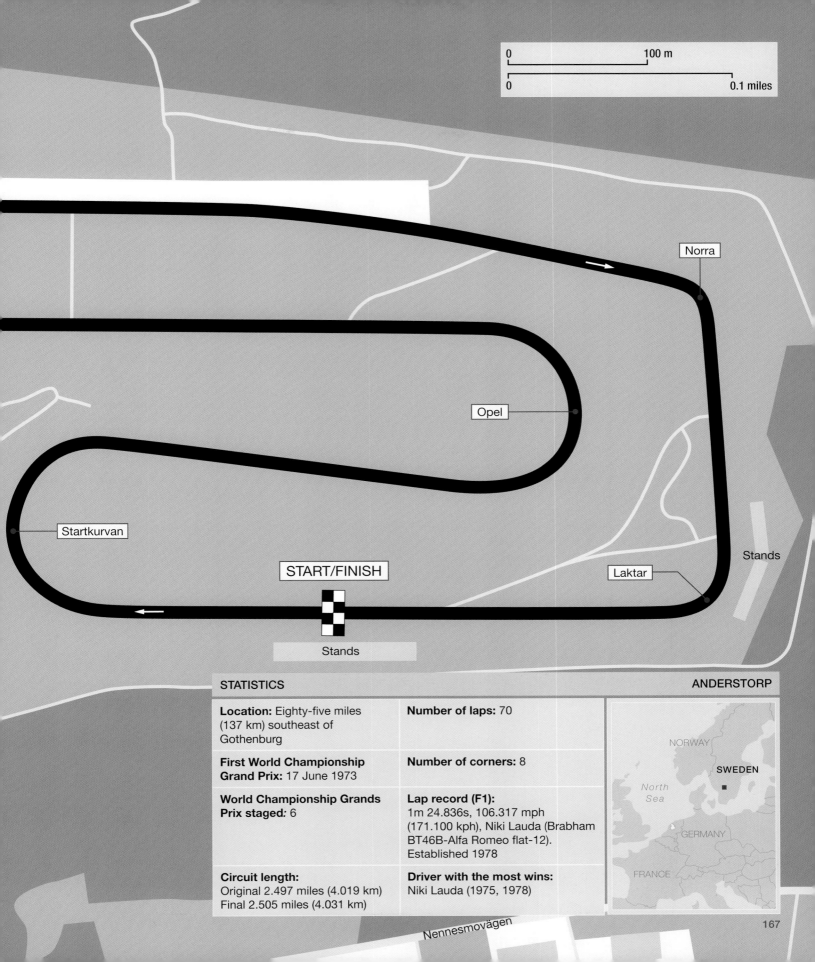

Norra

Opel

Startkurvan

START/FINISH

Laktar

Stands

Stands

STATISTICS

ANDERSTORP

Location: Eighty-five miles (137 km) southeast of Gothenburg	**Number of laps:** 70
First World Championship Grand Prix: 17 June 1973	**Number of corners:** 8
World Championship Grands Prix staged: 6	**Lap record (F1):** 1m 24.836s, 106.317 mph (171.100 kph), Niki Lauda (Brabham BT46B-Alfa Romeo flat-12). Established 1978
Circuit length: Original 2.497 miles (4.019 km) Final 2.505 miles (4.031 km)	**Driver with the most wins:** Niki Lauda (1975, 1978)

NORWAY

SWEDEN

North Sea

GERMANY

FRANCE

Nennesmovägen

Dijon 1974

Dijon-Prenois

 FRANCE

An undulating track enhanced by glorious surroundings in Burgundy. The layout, first used for the Grand Prix in 1974, was considered too short. A loop was added for the final five occasions F1 visited Dijon, the most memorable being a wheel-banging duel for second place in 1979.

French F1 drivers Jean-Pierre Beltoise and François Cevert had a hand in the design of a track in rolling wooded countryside close to Prenois, a village to the west of Dijon. The main straight was the only reasonably flat section of a circuit that plunged and rose through the natural terrain although, at 2.044 miles (3.289 km), it was considered to be too short when the French Grand Prix first came to visit in 1974.

The owner, François Chambelland, had no government support but nevertheless found sufficient funding to add a rising loop to the back section. With the length extended to 2.361 miles (3.8 km), the problem of an over-crowded track and a lap time of less than a minute had been largely overcome in time for the next Grand Prix in 1977. After leading most of the way, John Watson's Brabham-Alfa Romeo stuttered on low fuel and was overtaken by Mario Andretti's Lotus halfway round the last of 80 laps.

Two years later, the winner was more clear-cut as Jean-Pierre Jabouille scored his, and Renault's, first win in an emotional day for France. But the talk was not of the ground-breaking result for a turbo engine but a titanic battle for second place as Gilles Villeneuve and René Arnoux passed and repassed, sometimes on the track, sometimes off it and frequently banging wheels during the final memorable laps. The Ferrari driver eventually edged out Arnoux to prevent a Renault one-two.

Renault won again when the Grand Prix returned in 1981, Alain Prost bringing added significance for himself and France by scoring his first F1 victory. The result had not come without mild controversy. A decision to stop the race because of rain and restart it for the final 22 laps had allowed Prost to streak into an untouchable lead by using softer Michelin qualifying tyres on his Renault. Until the restart, the race had belonged to Nelson Piquet, Brabham-Ford and Goodyear.

In 1975, Dijon had hosted a non-championship Swiss Grand Prix and the title was revived again in 1982, this time as a round of the championship. Keke Rosberg would score his only victory in a year of many winners, the nine points contributing towards the Williams driver's world title. Similarly, when Niki Lauda won two years later, it would come halfway through a season in which the Austrian would win the championship by just half a point from his McLaren-TAG team-mate, Prost.

Despite the challenge and beauty of the circuit, not to mention the attraction of the local grape, Dijon was never a particularly happy place to go racing. A single access road created massive traffic problems and, once inside, team members were confronted by zealous officials performing their duties in a manner that was out of keeping with the region. When the Grand Prix moved to the featureless Paul Ricard circuit on a more regular basis in 1985, the feeling was that a stimulating and appealing venue in Burgundy was being completely wasted.

Top: Mario Andretti's Lotus-Ford took victory on the last lap in 1977.

Bottom: The Williams-Ford of Carlos Reutemann tackles the downhill Gauche de la Bretelle in 1981.

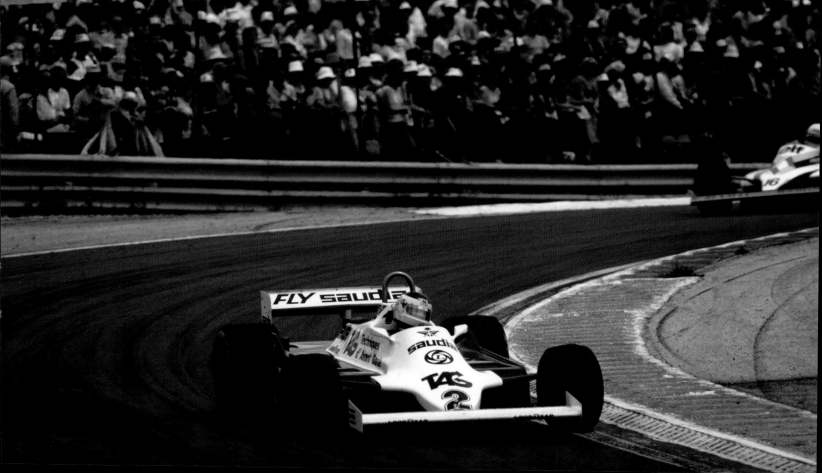

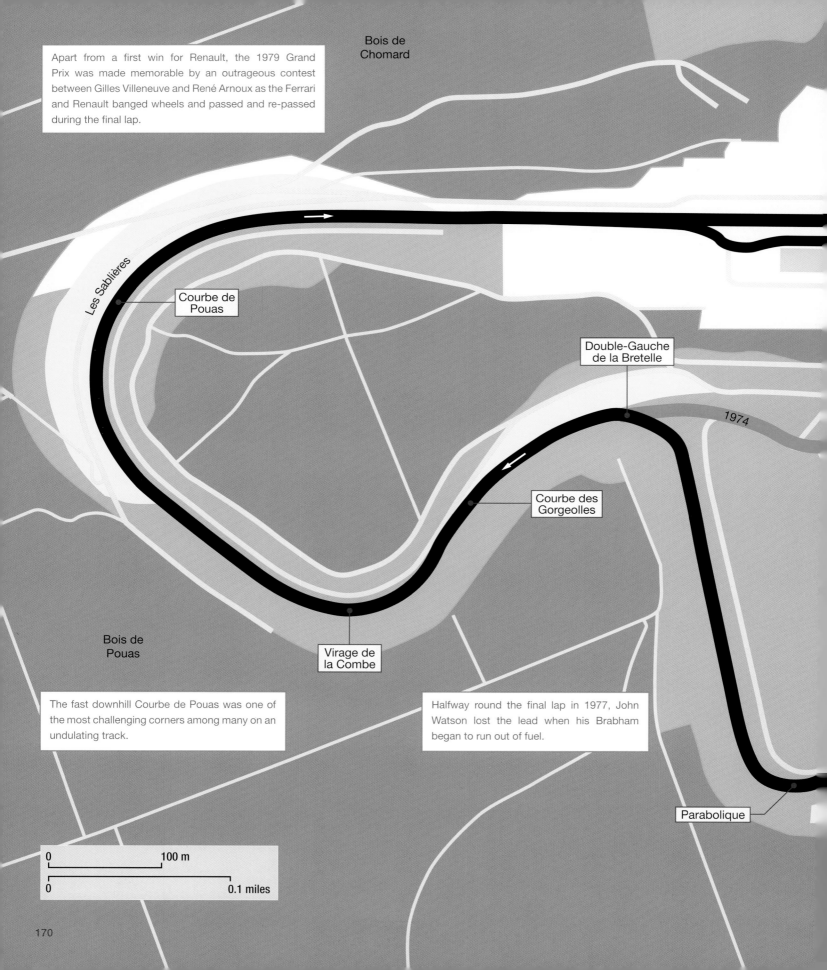

Apart from a first win for Renault, the 1979 Grand Prix was made memorable by an outrageous contest between Gilles Villeneuve and René Arnoux as the Ferrari and Renault banged wheels and passed and re-passed during the final lap.

Bois de Chomard

Les Sablières

Courbe de Pouas

Double-Gauche de la Bretelle

1974

Courbe des Gorgeolles

Bois de Pouas

Virage de la Combe

The fast downhill Courbe de Pouas was one of the most challenging corners among many on an undulating track.

Halfway round the final lap in 1977, John Watson lost the lead when his Brabham began to run out of fuel.

Parabolique

0	100 m
0	0.1 miles

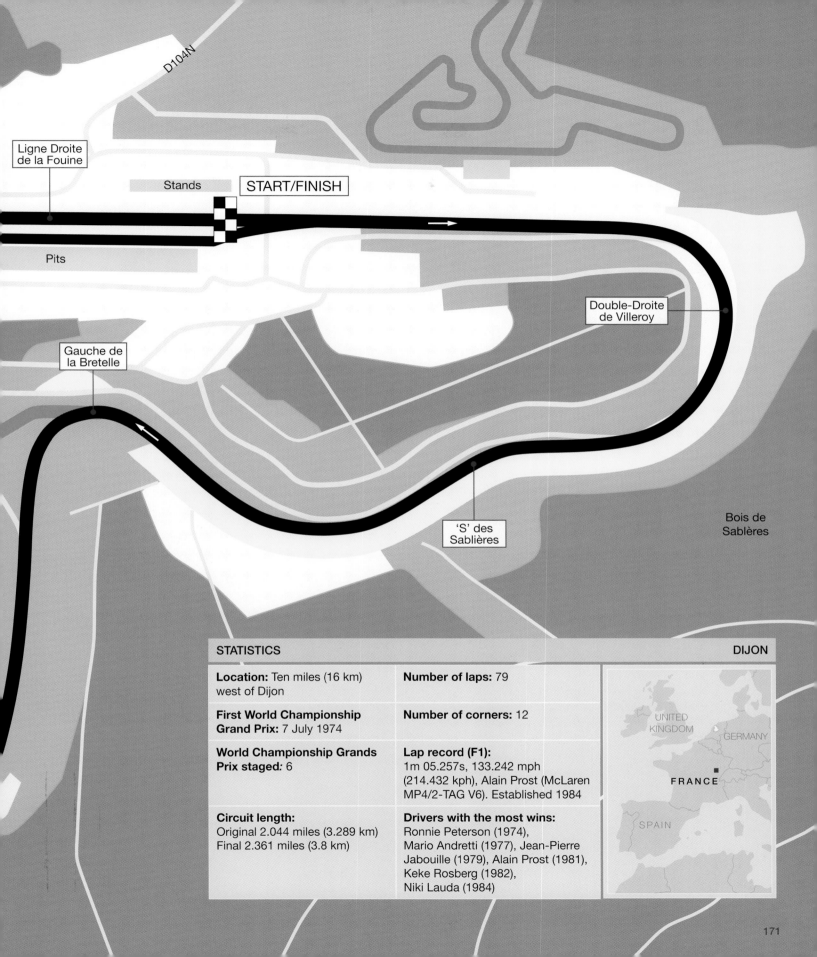

D104N

Ligne Droite
de la Fouine

Stands

START/FINISH

Pits

Gauche de
la Bretelle

Double-Droite
de Villeroy

'S' des
Sablières

Bois de
Sablières

STATISTICS

DIJON

Location: Ten miles (16 km) west of Dijon

First World Championship Grand Prix: 7 July 1974

World Championship Grands Prix staged: 6

Circuit length:
Original 2.044 miles (3.289 km)
Final 2.361 miles (3.8 km)

Number of laps: 79

Number of corners: 12

Lap record (F1):
1m 05.257s, 133.242 mph (214.432 kph), Alain Prost (McLaren MP4/2-TAG V6). Established 1984

Drivers with the most wins:
Ronnie Peterson (1974), Mario Andretti (1977), Jean-Pierre Jabouille (1979), Alain Prost (1981), Keke Rosberg (1982), Niki Lauda (1984)

UNITED KINGDOM

GERMANY

FRANCE

SPAIN

Long Beach 1976

Long Beach Street Circuit

 UNITED STATES OF AMERICA

A well organised and highly regarded circuit through downtown Long Beach. The original layout, first used for a championship race in 1976, featured a dramatic rise and fall to and from the pit straight. A reduced version lost a little of the character, the cost of staging F1 eventually proving prohibitive.

The Grand Prix of Long Beach was the brainchild of Chris Pook, an ex-patriot Englishman working as a travel agent in what was a drab seaport with an elderly population. Seeking to raise the image, the City bought into Pook's vision to run a motor race on the streets.

Starting on Ocean Boulevard (with a shabby cinema located opposite the pits), the track turned sharp right, plunged downhill to a left and a right before an arcing left led to a hairpin onto Shoreline Drive. The fastest part of the track gradually curved right as cars reached 180 mph (290 kph) before braking very hard for Queens Hairpin. The return towards the start/finish involved four 90-degree turns before a steep climb to the final right rejoining Ocean Boulevard. It was a tough and mechanically demanding track lined both sides by unyielding concrete walls.

In true American racing style, the pits were open, defined only by concrete blocks, but this temporary working environment was compensated by the paddock being located within a vast Convention Centre in the middle of the circuit.

A Formula 5000 race in September 1975 was a huge success and adequate preparation for the United States Grand Prix (West), won with ease by Ferrari's Clay Regazzoni in March of the following year. The stature of the event grew annually, helped enormously in 1977 when the American driver, Mario Andretti, won a race-long battle for Lotus.

To avoid first-lap incidents caused by the bottleneck corners within the first mile, the start was moved to Shoreline Drive in 1978, a location that was to cause confusion the following year when no one stopped the field after cars had rolled in formation from the dummy grid on Ocean Drive, pole man Gilles Villeneuve leading his puzzled colleagues back to the pits.

The retirement list at each Grand Prix was littered with collisions with the concrete but the most serious by far would occur in 1980 when a broken brake pedal caused Regazzoni to crash at high speed into a retaining wall in the escape road at the end of Shoreline Drive. The front of his Ensign was bent double, Regazzoni suffering severe spinal injuries.

Small modifications to the turns in Pine Avenue in 1981 led to more substantial changes that would rid the track in subsequent years of Queens Hairpin and the climb to and from Ocean Boulevard, as well as switching the pits to Shoreline Drive.

The racing proved as dramatic as ever, capacity crowds drawn from the vast population centres all around enjoying the temperate climate. In 1983 they witnessed John Watson pull off an extraordinary win as the McLaren driver, with team-mate Niki Lauda in tow, came from the back of the grid to win what would be the final Grand Prix at Long Beach.

With F1 considered too expensive to run, Pook and his team switched to IndyCar racing, the event remaining one of the most popular on the US racing calendar.

With the familiar Long Beach profile of 'Queen Mary' across the bay, Clay Regazzoni points his Ferrari into the left-hander leading to Le Gasomet hairpin and the flat-out blast along Shoreline Drive in the background. The Swiss led the inaugural event all the way in 1976 but ended his career with a severe accident at the end of the straight in 1980.

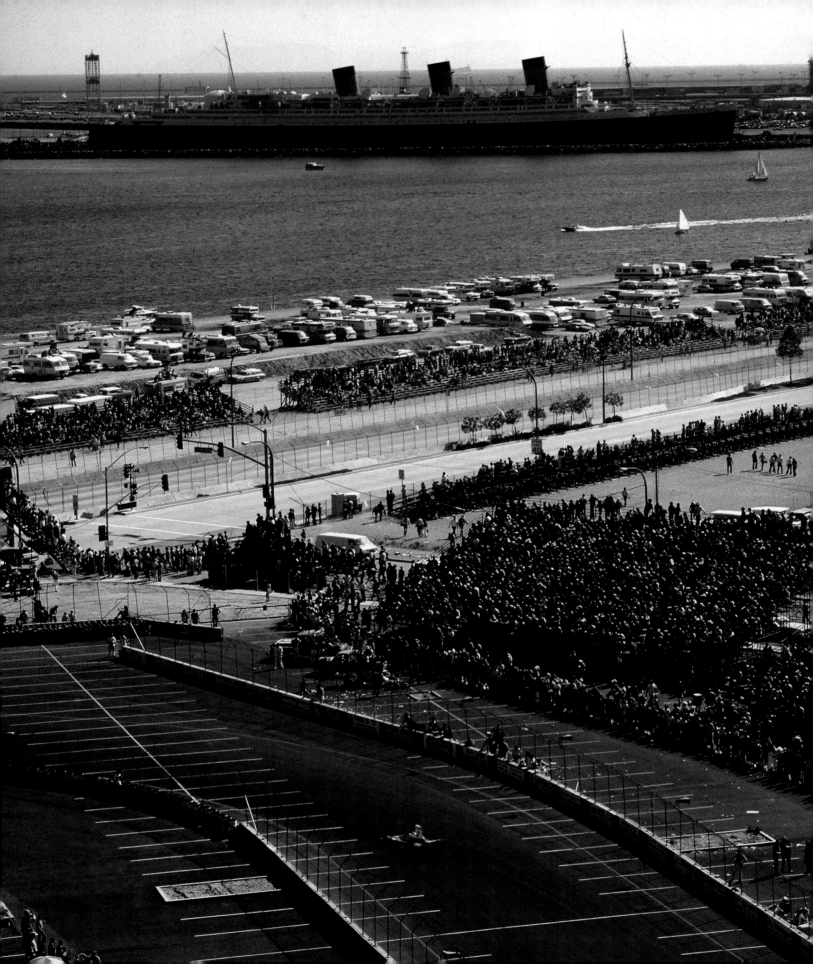

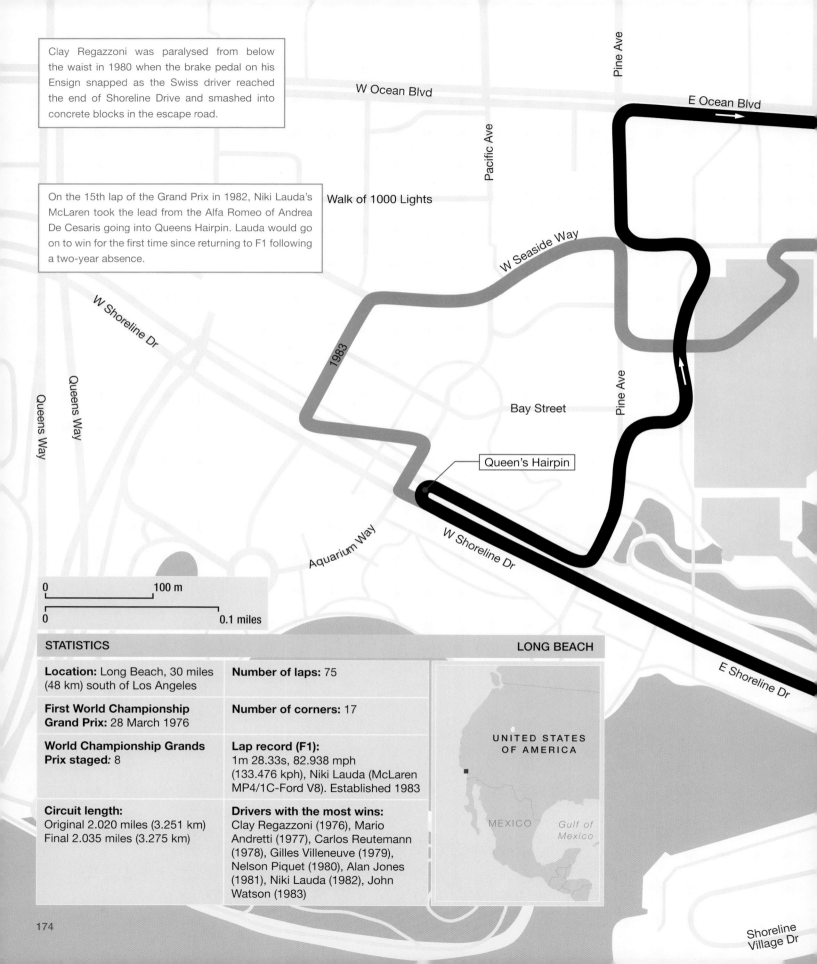

Clay Regazzoni was paralysed from below the waist in 1980 when the brake pedal on his Ensign snapped as the Swiss driver reached the end of Shoreline Drive and smashed into concrete blocks in the escape road.

On the 15th lap of the Grand Prix in 1982, Niki Lauda's McLaren took the lead from the Alfa Romeo of Andrea De Cesaris going into Queens Hairpin. Lauda would go on to win for the first time since returning to F1 following a two-year absence.

Pine Ave

W Ocean Blvd

E Ocean Blvd

Pacific Ave

Walk of 1000 Lights

W Seaside Way

W Shoreline Dr

1983

Queens Way

Queens Way

Pine Ave

Bay Street

Queen's Hairpin

Aquarium Way

W Shoreline Dr

E Shoreline Dr

0 100 m

0 0.1 miles

STATISTICS

LONG BEACH

Location: Long Beach, 30 miles (48 km) south of Los Angeles

First World Championship Grand Prix: 28 March 1976

World Championship Grands Prix staged: 8

Circuit length:
Original 2.020 miles (3.251 km)
Final 2.035 miles (3.275 km)

Number of laps: 75

Number of corners: 17

Lap record (F1):
1m 28.33s, 82.938 mph (133.476 kph), Niki Lauda (McLaren MP4/1C-Ford V8). Established 1983

Drivers with the most wins:
Clay Regazzoni (1976), Mario Andretti (1977), Carlos Reutemann (1978), Gilles Villeneuve (1979), Nelson Piquet (1980), Alan Jones (1981), Niki Lauda (1982), John Watson (1983)

UNITED STATES OF AMERICA

MEXICO

Gulf of Mexico

Shoreline Village Dr

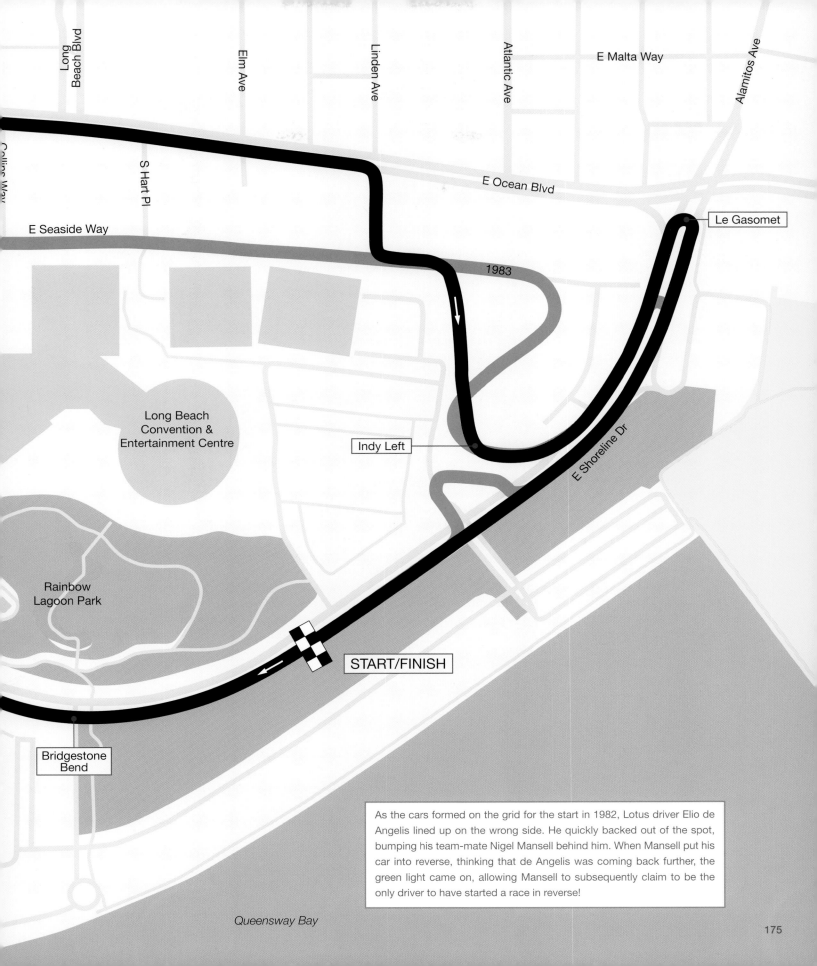

Long Beach Blvd

Elm Ave

Linden Ave

Atlantic Ave

E Malta Way

Alamitos Ave

Colline Way

S Hart Pl

E Ocean Blvd

Le Gasomet

E Seaside Way

1983

Long Beach
Convention &
Entertainment Centre

Indy Left

E Shoreline Dr

Rainbow
Lagoon Park

START/FINISH

Bridgestone
Bend

As the cars formed on the grid for the start in 1982, Lotus driver Elio de Angelis lined up on the wrong side. He quickly backed out of the spot, bumping his team-mate Nigel Mansell behind him. When Mansell put his car into reverse, thinking that de Angelis was coming back further, the green light came on, allowing Mansell to subsequently claim to be the only driver to have started a race in reverse!

Queensway Bay

Fuji 1976

Fuji International Speedway

 JAPAN

Planned as an oval beneath Mount Fuji but completed as an undulating circuit. Hosted dramatic finale to 1976 championship and used again in 1977. Revamped under new ownership for two more Grands Prix in 2007 and 2008 before dropping out due to global recession.

Hoping to run NASCAR-style races in Japan, the Fuji Speedway Corporation was established in 1963 to build a 2.5-mile (4.02-km) high-banked superspeedway in the shadow of Mount Fuji. A shortage of funds meant the original project was never fulfilled but the one completed banked curve became part of a road course opened in December 1965.

The high-speed banked corner caused so many accidents – some of them fatal – that a major revision in 1965 was necessary if Fuji wished to bid for a round of the F1 World Championship at the end of 1976.

A highly dramatic season would continue to the end thanks to heavy rain putting the race in doubt. James Hunt and Niki Lauda were fighting tooth and nail for the championship but, when Lauda pulled out citing dangerous conditions, the title went to Hunt as the McLaren driver eventually finished third following a comeback drive as the result of having to change a punctured tyre.

Hunt won the Japanese Grand Prix on the return to Fuji 12 months later but the race was clouded in controversy following a collision between Gilles Villeneuve and Ronnie Peterson's Tyrrell-Ford, the Ferrari crashing into a group of marshals and photographers, killing two of them.

The Japanese race was removed from the calendar. When it returned in 1986, Fuji was never in the reckoning as Suzuka, owned by Honda, became the permanent home.

Toyota's purchase of Fuji in 2000 prompted a major reprofiling of the track (keeping one of the longest straights in F1) and a much-needed rebuild of the facilities in order to allow the return of the Grand Prix. This was granted for 2007 but, as with Fuji's debut 31 years before, incessant rain put the race in doubt, the first 19 laps being run under the Safety Car. There were several incidents – none serious – with Lewis Hamilton running out the winner to strengthen a championship challenge that would ultimately be frittered away.

Hamilton was in the thick of the title fight once more when the Grand Prix returned in October 2008 but the McLaren-Mercedes driver did his chances no good at all when, starting from pole, he locked his brakes and caused a collision at the first corner. When Hamilton was hit by his championship rival Felipe Massa a lap later, this, and a drive-through penalty for causing the first collision, dropped the Englishman to the back. He eventually finished out of the points in a race won by the Renault of Fernando Alonso.

Fuji was supposed to enter an alternate year plan with Suzuka for hosting Japan's round of the championship but a combination of factors, led mainly by the world-wide recession and poor ticket sales, prompted Fuji's withdrawal after a brief but colourful F1 history.

Top: Fuji is best remembered for the dramatic finale to the 1976 drivers' championship when James Hunt finished third and won the title after Niki Lauda had pulled out, citing the dangerous conditions. Hunt leads his McLaren team-mate, Jochen Mass, with the foot of Mount Fuji in the background.

Bottom: The Fuji International Speedway had a brief but colourful history in F1.

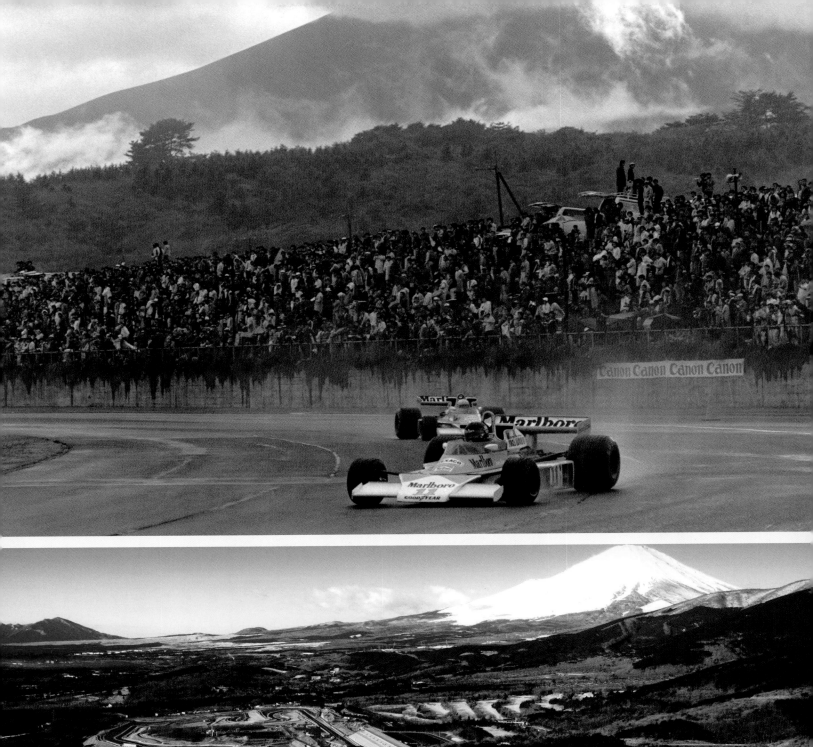
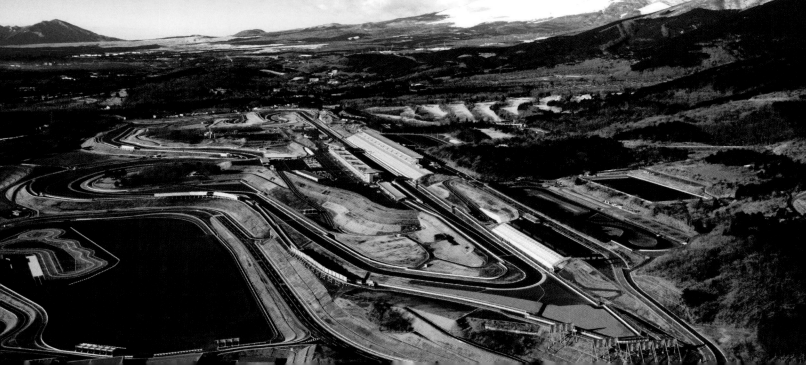

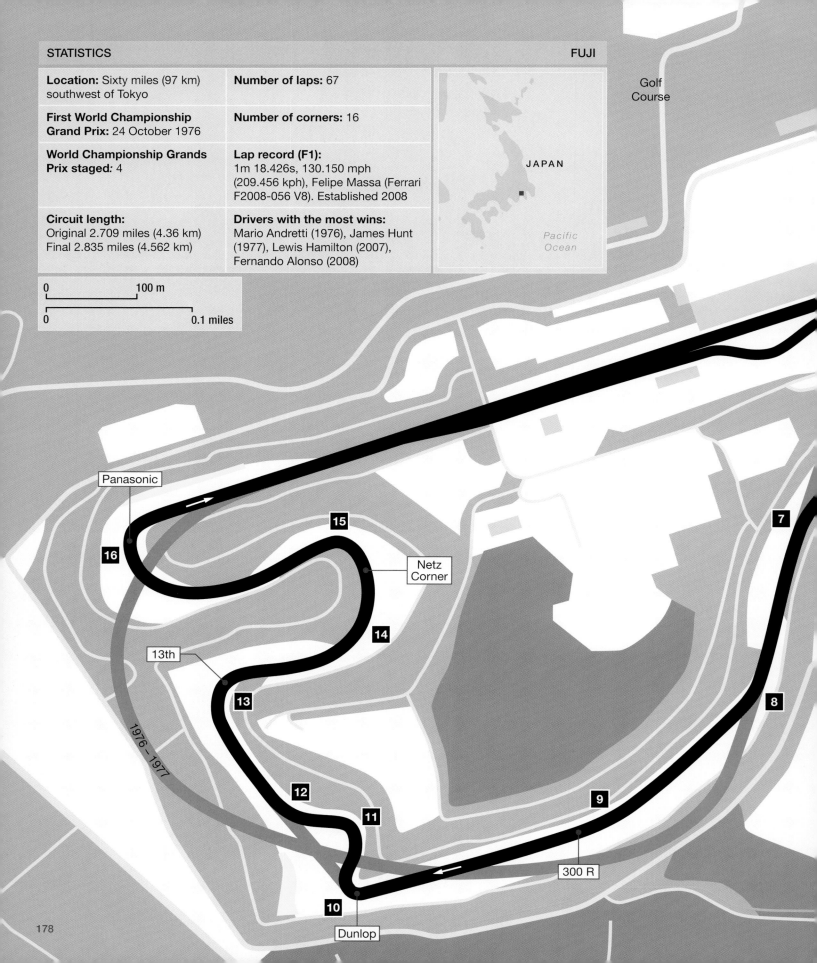

STATISTICS

FUJI

Golf Course

Location: Sixty miles (97 km) southwest of Tokyo	**Number of laps:** 67
First World Championship Grand Prix: 24 October 1976	**Number of corners:** 16
World Championship Grands Prix staged: 4	**Lap record (F1):** 1m 18.426s, 130.150 mph (209.456 kph), Felipe Massa (Ferrari F2008-056 V8). Established 2008
Circuit length: Original 2.709 miles (4.36 km) Final 2.835 miles (4.562 km)	**Drivers with the most wins:** Mario Andretti (1976), James Hunt (1977), Lewis Hamilton (2007), Fernando Alonso (2008)

JAPAN

Pacific Ocean

0 — 100 m

0 — 0.1 miles

Panasonic

16

15

Netz Corner

7

14

13th

13

8

12

9

11

300 R

1976–1977

10

Dunlop

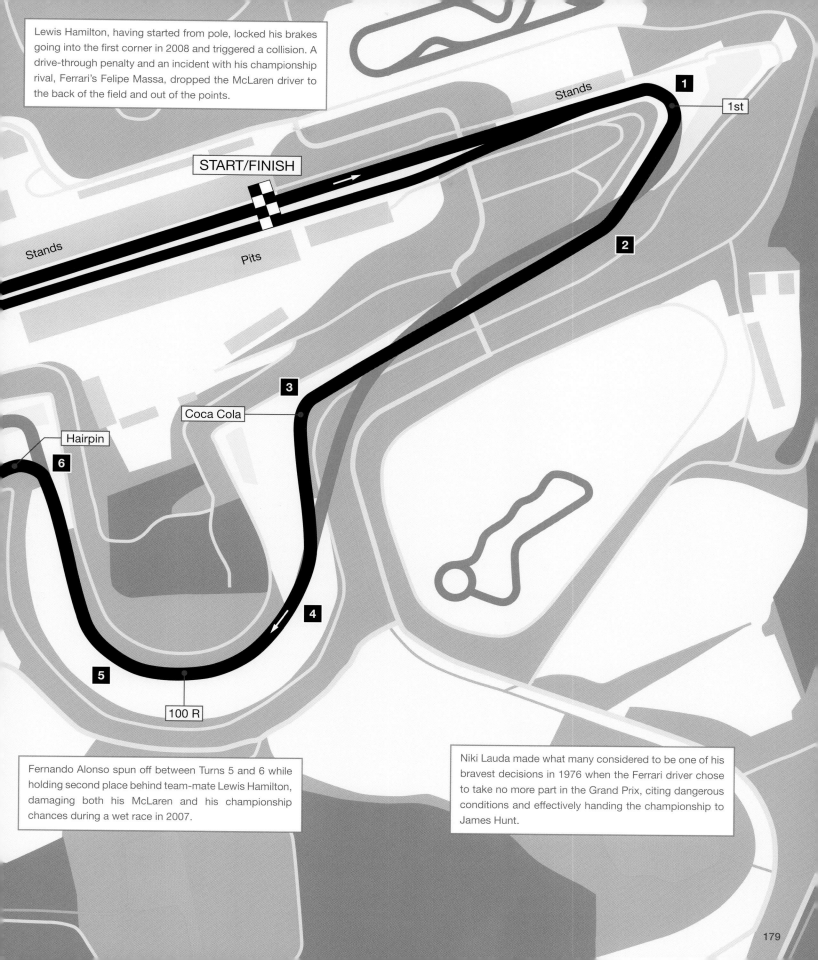

Lewis Hamilton, having started from pole, locked his brakes going into the first corner in 2008 and triggered a collision. A drive-through penalty and an incident with his championship rival, Ferrari's Felipe Massa, dropped the McLaren driver to the back of the field and out of the points.

Stands

1

1st

Stands

START/FINISH

Pits

Stands

2

3

Coca Cola

Hairpin

6

4

5

100 R

Fernando Alonso spun off between Turns 5 and 6 while holding second place behind team-mate Lewis Hamilton, damaging both his McLaren and his championship chances during a wet race in 2007.

Niki Lauda made what many considered to be one of his bravest decisions in 1976 when the Ferrari driver chose to take no more part in the Grand Prix, citing dangerous conditions and effectively handing the championship to James Hunt.

Rio de Janeiro 1978

Autodrómo Internacional Nelson Piquet, Jacarepaguá

 BRAZIL

An agreeable climate, good for extensive pre-season testing in the 1980s. A flat and not particularly demanding track, located near a rubbish tip at the end of a bumpy and hazardous drive from central Rio. A colourful event, often opening the season when playing Brazilian host 10 times.

Built on marshland to the southwest of Rio de Janeiro, the Jacarepaguá race track (named after the local neighbourhood) was never going to be particularly inspiring. Flat, and with a long pit straight, the main feature was a massive grandstand overlooking an even longer back straight.

This structure would contain the majority of the 90,000 spectators making the hazardous run along pot-holed roads from Rio when the first Grand Prix was staged in 1978. Argentina's Carlos Reutemann won the race but there was consolation for the locals when Emerson Fittipaldi brought Brazil's F1 car, the Fittipaldi-Ford, into second place, albeit almost a minute behind the Ferrari.

Despite starting from the second row, Reutemann had assumed an immediate lead and raced into the distance thanks, in part, to his Michelin tyres being better suited to the searing heat than the Goodyears used by every other team bar one. The South American sun was generally not a problem for the race fans but a fire truck spraying the grandstand had added to a carnival atmosphere before the start.

There would be no need for such measures in 1981, race day being notable for two things: incessant rain and Reutemann (now with Williams) refusing to obey team orders and winning at the expense of a disgruntled Alan Jones.

Having been to São Paulo for two years, the Grand Prix would remain at Jacarepaguá for the remainder of the 1980s. There would be drama aplenty, ranging from rows over the legality of the first two finishers in 1982 to Nelson Piquet, the latest Brazilian hero, collapsing with exhaustion as he stood on top of the podium at the end of the same race.

Ayrton Senna's F1 debut at Jacarepaguá in 1984 ended with mechanical trouble on his Toleman-Hart, a switch to Lotus-Renault promising better things the following year. Senna would retire in 1985 with more car problems in a race won by Alain Prost's McLaren-TAG. Prost, in fact, would dominate the podium in Rio by winning five times, often through stealth as he nursed either his car or its tyres in the tricky conditions so often thrown up by this track and its torpid environment.

For that reason, Jacarepaguá had become a popular test track, F1 teams spending much of the off-season in Brazil. It was a balmy alternative to the European winter even if, when the wind was blowing in the wrong direction, an aroma from the local rubbish tip would replace the more soothing breeze fresh from the South Atlantic.

Prost's final win came in 1988, the year the circuit was renamed in honour of Piquet's third World Championship the season before. The victory for Prost in Brazil was almost expected but the same could not be said for Nigel Mansell's win in 1989, the Englishman having booked himself an early flight home, such was his belief that the all-new Ferrari, with its revolutionary paddle-shift gearbox, would not last the distance. Just to round off a slightly bizarre race, Mansell cut his fingers on the sharp edges of the winner's trophy.

It would be the last F1 celebration in Rio, a revamped Interlagos assuming ownership of the Grand Prix once more. The circuit would be used for national racing while its conversion into a speedway of sorts hosted American Indy Cars.

In 2012, the various tracks and ageing facilities were demolished to make way for structures to accommodate the 2016 Olympic Games. It was the end of a Grand Prix track treated with an ambivalence largely massaged by a wonderful climate and buzzy atmosphere.

Top: Alain Prost opened the 1988 season with a win for McLaren-Honda.

Bottom: Elio de Angelis limps past the packed grandstand on the back straight in 1986 after a front wheel had come off his Brabham-BMW following a pit stop. The Italian driver managed to return to the race and finish eighth.

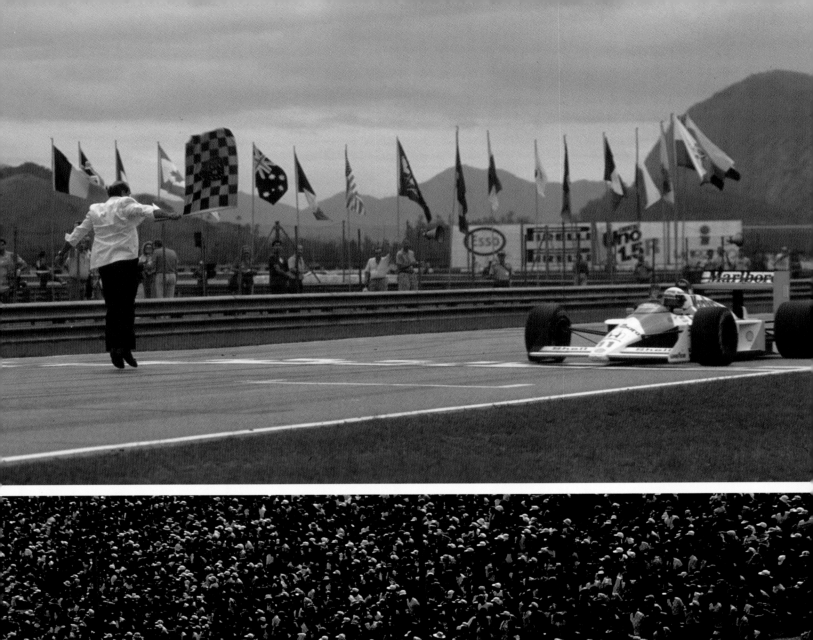

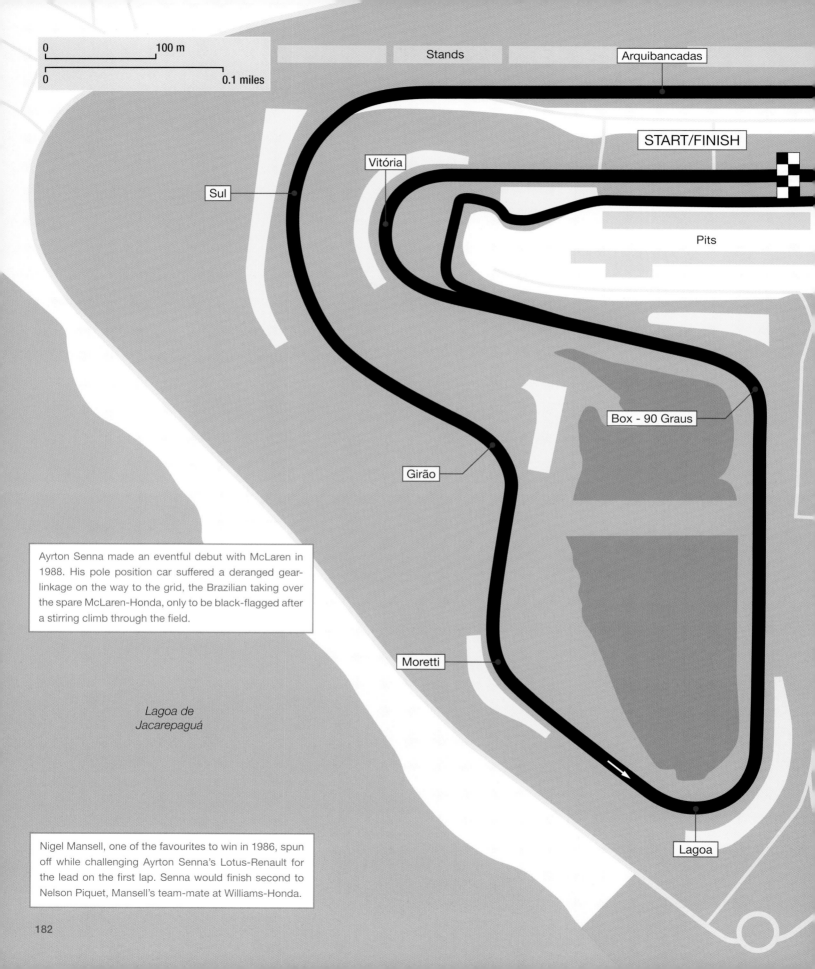

0

100 m

0

0.1 miles

Stands

Arquibancadas

START/FINISH

Vitória

Sul

Pits

Box - 90 Graus

Girão

Ayrton Senna made an eventful debut with McLaren in 1988. His pole position car suffered a deranged gear-linkage on the way to the grid, the Brazilian taking over the spare McLaren-Honda, only to be black-flagged after a stirring climb through the field.

Moretti

Lagoa de Jacarepaguá

Lagoa

Nigel Mansell, one of the favourites to win in 1986, spun off while challenging Ayrton Senna's Lotus-Renault for the lead on the first lap. Senna would finish second to Nelson Piquet, Mansell's team-mate at Williams-Honda.

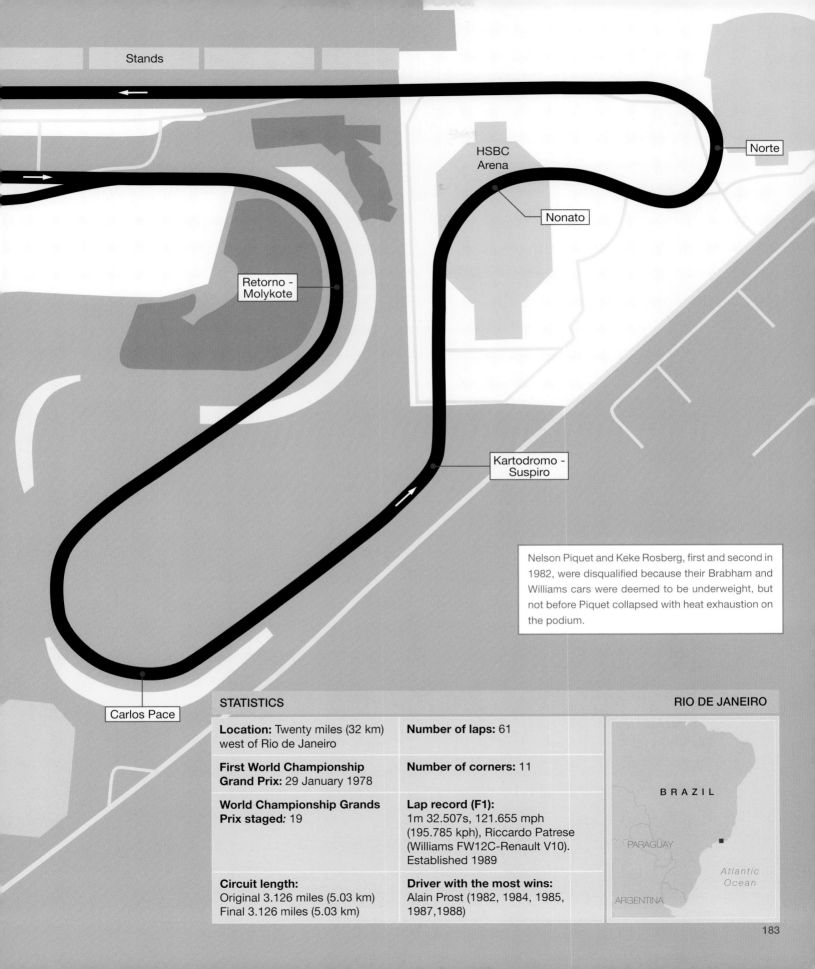

Stands

Norte

HSBC
Arena

Nonato

Retorno -
Molykote

Kartodromo -
Suspiro

Carlos Pace

Nelson Piquet and Keke Rosberg, first and second in
1982, were disqualified because their Brabham and
Williams cars were deemed to be underweight, but
not before Piquet collapsed with heat exhaustion on
the podium.

STATISTICS

RIO DE JANEIRO

Location: Twenty miles (32 km) west of Rio de Janeiro	**Number of laps:** 61
First World Championship Grand Prix: 29 January 1978	**Number of corners:** 11
World Championship Grands Prix staged: 19	**Lap record (F1):** 1m 32.507s, 121.655 mph (195.785 kph), Riccardo Patrese (Williams FW12C-Renault V10). Established 1989
Circuit length: Original 3.126 miles (5.03 km) Final 3.126 miles (5.03 km)	**Driver with the most wins:** Alain Prost (1982, 1984, 1985, 1987,1988)

BRAZIL

PARAGUAY

Atlantic
Ocean

ARGENTINA

Montreal 1978

Circuit Gilles Villeneuve

 CANADA

Introduced in 1978. Despite a flat and straightforward profile, a track well liked by teams, drivers and race fans. Unique location on an island in the Saint Lawrence, a quick ride by Metro from central Montreal. Tough on brakes and demanding on drivers thanks to tight chicanes and ever-present walls.

With Mosport and Saint Jovite no longer considered suitable for F1, plans were quickly drawn up for a track on Île Notre-Dame in the Saint Lawrence River. This man-made island had been put in place for Expo 67, the circuit using much of the perimeter road serving futuristic pavilions. Half of the track ran alongside *Bassin Olympique*, created for rowing events in Montreal's 1976 Olympic Games and providing former boathouses that would be used to garage the F1 teams. All in all, a unique location served by the city's efficient Metro system.

The 2.9-mile (4.7-km) venue was made ready for the 1978 Canadian Grand Prix and in time for a dream result when the race was won by the Ferrari of Gilles Villeneuve. The French-Canadian's first Grand Prix victory helped ensure the circuit's immediate future despite its comparatively desolate look on that cold October afternoon.

A year later, Montreal would decide Niki Lauda's future when he suddenly quit F1 halfway through the first day's practice. In 1980, the Canadian Grand Prix would settle the championship after the two contenders, Alan Jones and Nelson Piquet, collided and triggered a pile-up. Jones returned the following September as reigning World Champion and took part in a race notable for 11 drivers either having accidents or spinning off in appalling conditions.

The one complaint about Montreal had been the chilly, unpredictable weather at that time of year. When the US Grand Prix was moved to Detroit in June and linked with the Canadian race, a solution seemed to have been found. As luck would have it, the weather on 13 June 1982 was unseasonably cold. But that would be a minor issue.

Villeneuve had been killed the previous month. Despite his absence and a transport strike in the city, a vast crowd turned up to watch Didier Pironi start his Ferrari from pole. Seconds before the green light, the Frenchman stalled and was struck from behind by Ricardo Paletti, the Osella driver travelling at speed and completely unsighted after starting from the back of the grid. The Italian novice died from massive chest injuries.

After a year's break in 1987, the Grand Prix returned to find new pits at what had been the bottom end of a track now renamed Circuit Gilles Villeneuve. Ayrton Senna won for McLaren in two out of the next three years but retired while lying third in 1991. That race should have belonged to a dominant Nigel Mansell, only for the Williams-Honda driver to roll to a halt less than a mile from home.

During the following years, Michael Schumacher would win seven times, although the German was not immune to coming to grief against what became known as the 'Wall of Champions' on the outside of the exit from the final chicane. In 1999, three champions – Schumacher, Damon Hill and Jacques Villeneuve (son of Gilles) – ended their race there.

Jenson Button would also suffer the embarrassment of crashing out in full view of the pits in 2005 but he made up for it six years later when he pulled off a memorable win by coming from the back of the field to take the lead on the final lap.

Despite its bland layout, Circuit Gilles Villeneuve has provided many dramatic races and, just as frequently, fallen into dispute with F1 boss Bernie Ecclestone over finance, as evidenced by an occasional absence from the calendar. If the race were ever to be removed permanently, it would be much missed by F1 and an enthusiastic home crowd. There are few better places to hold a motor race on a perfect summer's day.

Fairy tale beginning. Gilles Villeneuve and Ferrari scored an emotional win in 1978 when Montreal staged the Canadian Grand Prix for the first time.

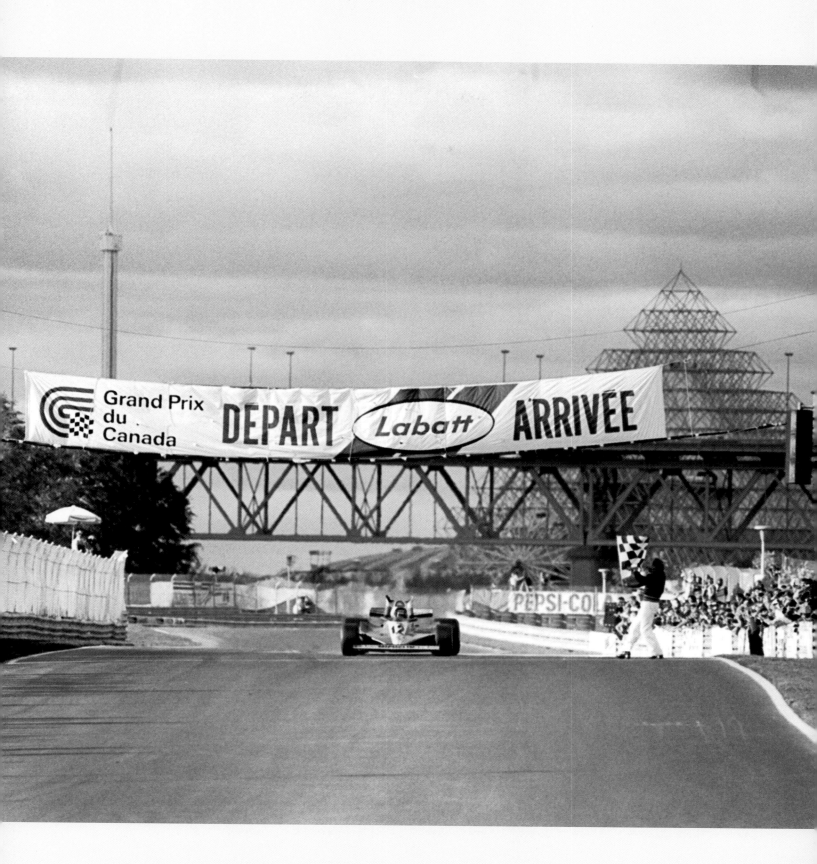

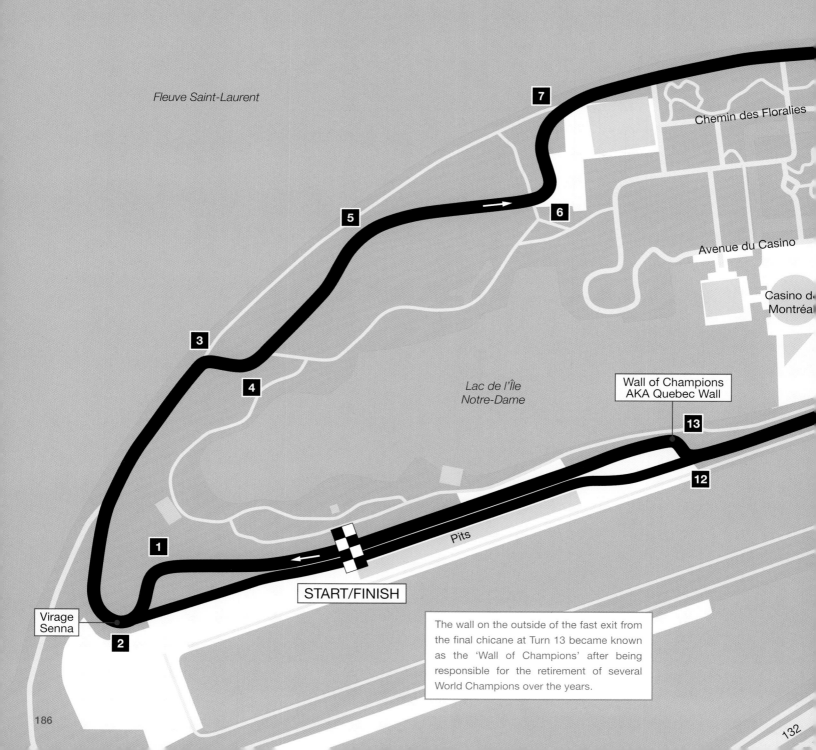

Having started from seventh on the grid in 2011, collided with his McLaren team-mate, received a drive-through penalty for speeding in the pit lane, dropped to the back of the field and collided with a Ferrari, Jenson Button came through to take the lead halfway round the last lap when Sebastian Vettel ran wide under pressure.

Fleuve Saint-Laurent

7

Chemin des Floralies

5

6

Avenue du Casino

3

Casino de Montréal

4

Lac de l'Île Notre-Dame

Wall of Champions AKA Quebec Wall

13

12

1

Pits

START/FINISH

Virage Senna

2

The wall on the outside of the fast exit from the final chicane at Turn 13 became known as the 'Wall of Champions' after being responsible for the retirement of several World Champions over the years.

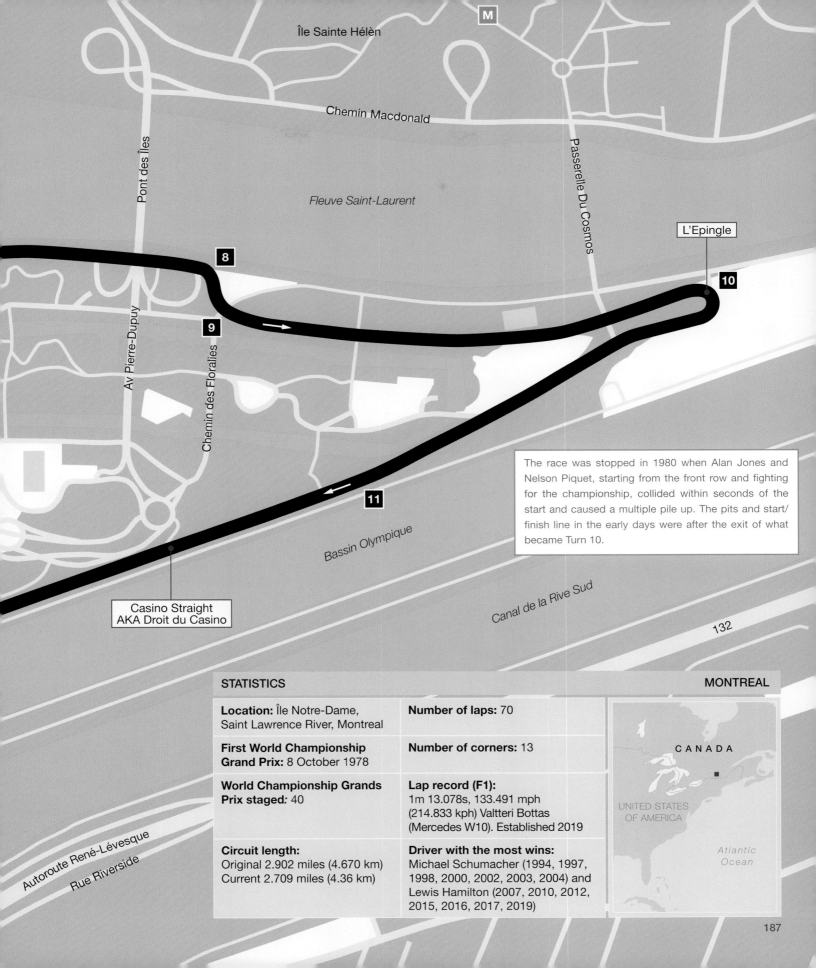

M

Île Sainte Hélèn

Chemin Macdonald

Fleuve Saint-Laurent

Passerelle Du Cosmos

Pont des Îles

L'Epingle

8

10

Av Pierre-Dupuy

9

Chemin des Floralies

The race was stopped in 1980 when Alan Jones and Nelson Piquet, starting from the front row and fighting for the championship, collided within seconds of the start and caused a multiple pile up. The pits and start/finish line in the early days were after the exit of what became Turn 10.

11

Bassin Olympique

Canal de la Rive Sud

Casino Straight
AKA Droit du Casino

132

Autoroute René-Lévesque

Rue Riverside

STATISTICS

MONTREAL

Location: Île Notre-Dame, Saint Lawrence River, Montreal

Number of laps: 70

First World Championship Grand Prix: 8 October 1978

Number of corners: 13

World Championship Grands Prix staged: 40

Lap record (F1):
1m 13.078s, 133.491 mph (214.833 kph) Valtteri Bottas (Mercedes W10). Established 2019

Circuit length:
Original 2.902 miles (4.670 km)
Current 2.709 miles (4.36 km)

Driver with the most wins:
Michael Schumacher (1994, 1997, 1998, 2000, 2002, 2003, 2004) and Lewis Hamilton (2007, 2010, 2012, 2015, 2016, 2017, 2019)

CANADA

UNITED STATES OF AMERICA

Atlantic Ocean

Imola 1980

Autodromo Enzo e Dino Ferrari

 ITALY

Quickly became popular in the 1980s thanks to straddling rolling hills on the edge of Imola and a spring date that opened the European season. Forever associated with the deaths of Roland Ratzenberger and Ayrton Senna during a desperate weekend in 1994. Only used twice after that, returning in 2020.

Given Monza's tradition and history, it was always going to be difficult establishing another Italian circuit as a F1 venue. But Imola, built in 1950, had a lot going for it.

Laid out in rolling parkland around and over a hillside on the edge of the ancient town, Imola presented a circuit the drivers would love while providing excellent natural vantage points for spectators. It was used for a non-championship F1 race in 1963 but a reasonable claim to host a Grand Prix was limited by poor facilities and Monza's stranglehold.

The addition of a three-story pit complex in the 1970s was a step in the right direction while, not long after, a political opportunity arose in the wake of criticism following the death of Ronnie Peterson as the result of an accident at Monza in 1978. When Imola hosted a non-championship race in September 1979, the F1 teams were quick to appreciate its attributes and backed a call to have the Italian Grand Prix switched to the circuit in the Emilia-Romagna region for 1980.

When Monza regained the Italian Grand Prix rights the following year, Imola cleverly side-stepped an inconsistently applied regulation ruling that each country could stage just one Grand Prix. By offering to run a round of the championship for the principality of San Marino, Imola made light of the fact that the tiny country was 50 miles (80 km) away.

Whereas Monza possessed a sense of cheerful menace and traditional obstinacy, the more gentle surroundings of Imola encouraged a sense of relaxation that was nevertheless charged with the country's absolute passion for Ferrari and all things racing. With Maranello less than an hour away, Imola made a shrewd move by naming their circuit Autodromo Dino Ferrari in honour of Enzo's pre-deceased son.

Typically, the Grands Prix at Imola would be notable for incidents, both political and physical. In 1981, Gilles Villeneuve somehow survived a massive shunt on a high-speed curve approaching Tosa, the scene of the accident subsequently being named after the Ferrari driver. Villeneuve's name would make headlines for different reasons in 1982 when he

believed he had been duped by Didier Pironi, who broke an agreement by winning at his Ferrari team-mate's expense.

Villeneuve would be killed two weeks later at Zolder in Belgium. When the Grand Prix returned to Imola the following year, there was scarcely a dry eye in the house when Patrick Tambay, a good friend of Gilles and driving a Ferrari bearing Villeneuve's number 27, scored an emotional win.

Imola, traditionally the opening round of the European season, had become popular for its ambience, food and wine in Spring. But the track's lurking hazards would be exposed in 1989 when Gerhard Berger was lucky to escape from his blazing Ferrari after hitting the wall on the outside of the very fast Tamburello curve. The same corner six years later would tarnish the circuit's image forever.

On a bleak weekend, the Austrian novice Roland Ratzenberger was killed when his Simtek-Ford suffered a failure and crashed heavily at Villeneuve during qualifying. On race day, 1 May 1994, F1 and the sporting world in general went into deep shock when Ayrton Senna's Williams-Renault left the road at Tamburello and wiped off the front-right wheel, a suspension arm fatally penetrating the Brazilian's helmet.

The double tragedy triggered a series of changes, most notably the insertion of a chicane before Tamburello. The character of the track was deemed to be different for a number of reasons, not least the lasting memory of Senna's death. Imola, in any case, was no longer considered adequate, particularly a narrow paddock that was too cramped to cope with the increasing number of trucks and motorhomes necessary to service F1's expanding needs.

Following the last Grand Prix in 2006, the pits were razed and substantial remodelling carried out, including the removal of a chicane before the start-finish straight. When the Covid-19 pandemic struck and decimated the F1 calendar, Imola stepped in to stage the Emilia Romagna Grand Prix in 2020.

Top: An emotional win for Patrick Tambay and Ferrari in 1983.

Bottom: Delight for the passionate home fans as Michael Schumacher brings his winning Ferrari into the pit lane in 2006.

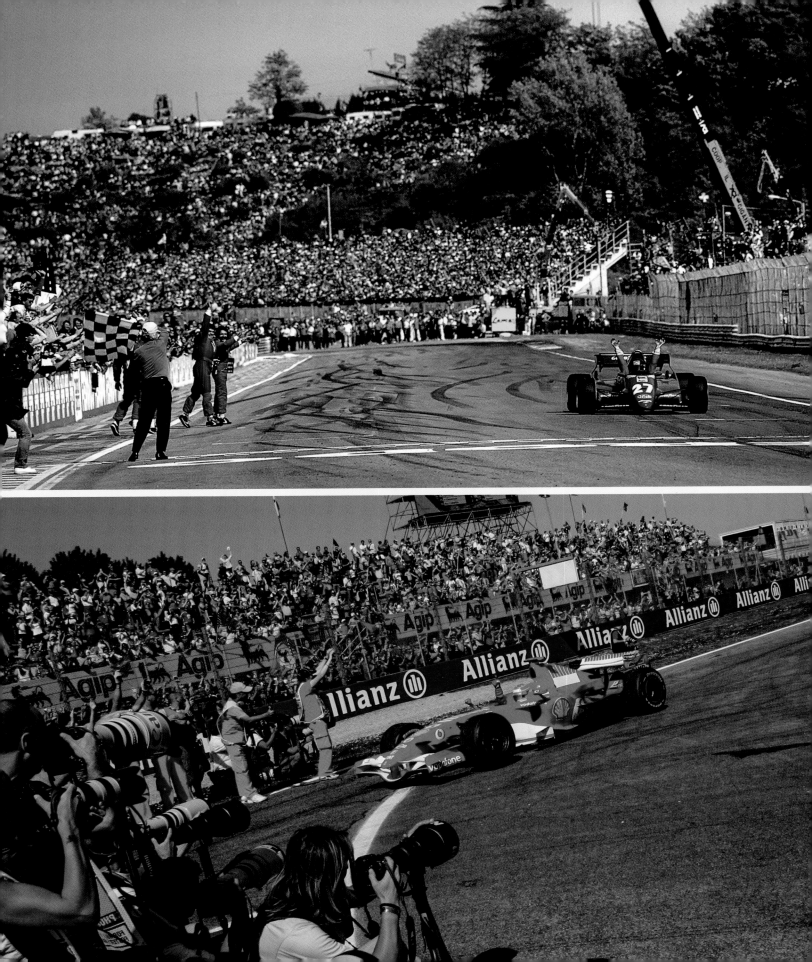

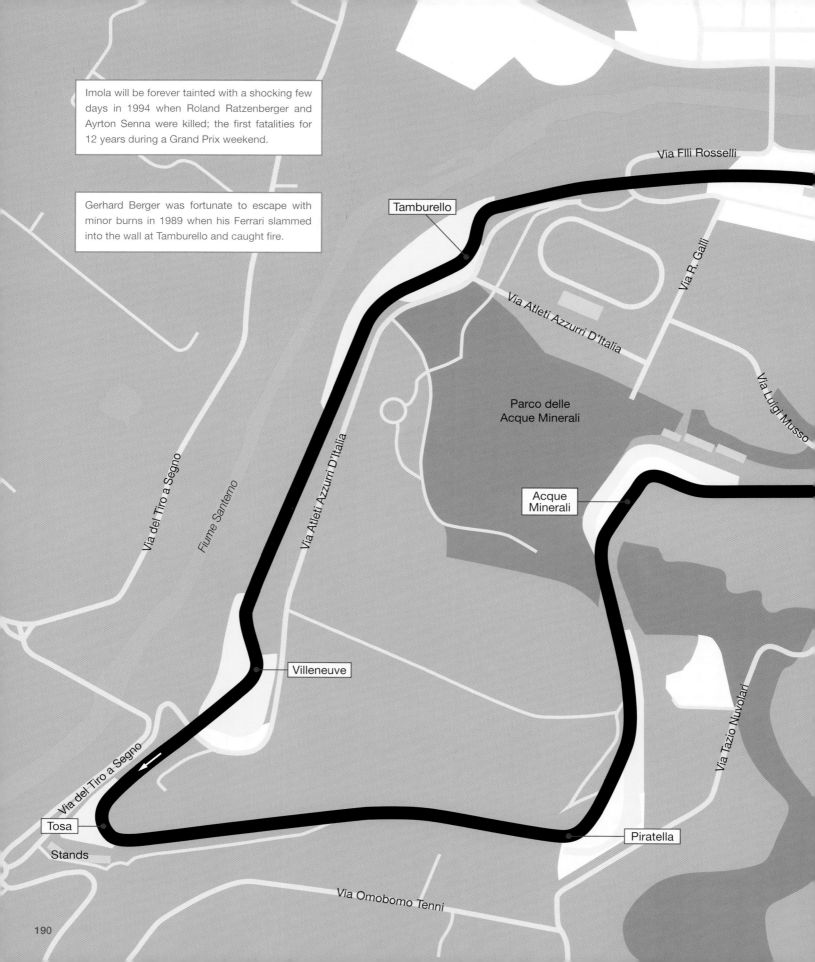

Imola will be forever tainted with a shocking few days in 1994 when Roland Ratzenberger and Ayrton Senna were killed; the first fatalities for 12 years during a Grand Prix weekend.

Gerhard Berger was fortunate to escape with minor burns in 1989 when his Ferrari slammed into the wall at Tamburello and caught fire.

Via Flli Rosselli

Tamburello

Via R. Galli

Via Atleti Azzurri D'Italia

Via Luigi Musso

Parco delle Acque Minerali

Via del Tiro a Segno

Fiume Santerno

Via Atleti Azzurri D'Italia

Acque Minerali

Villeneuve

Via Tazio Nuvolari

Via del Tiro a Segno

Tosa

Piratella

Stands

Via Omobomo Tenni

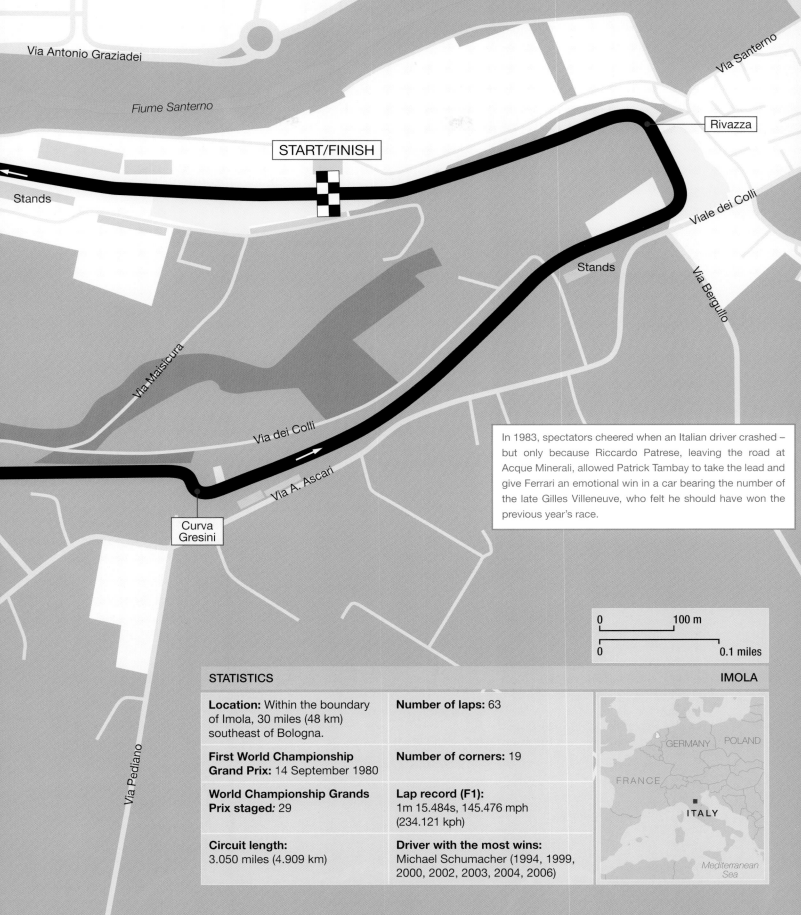

Via Antonio Graziadei

Fiume Santerno

Via Santerno

START/FINISH

Rivazza

Stands

Viale dei Colli

Via Bergullo

Stands

Via Maisicura

Via dei Colli

In 1983, spectators cheered when an Italian driver crashed –
but only because Riccardo Patrese, leaving the road at
Acque Minerali, allowed Patrick Tambay to take the lead and
give Ferrari an emotional win in a car bearing the number of
the late Gilles Villeneuve, who felt he should have won the
previous year's race.

Via A. Ascari

Curva
Gresini

Via Pediano

| 0 | 100 m |
| 0 | 0.1 miles |

STATISTICS

IMOLA

Location: Within the boundary of Imola, 30 miles (48 km) southeast of Bologna.	**Number of laps:** 63
First World Championship Grand Prix: 14 September 1980	**Number of corners:** 19
World Championship Grands Prix staged: 29	**Lap record (F1):** 1m 15.484s, 145.476 mph (234.121 kph)
Circuit length: 3.050 miles (4.909 km)	**Driver with the most wins:** Michael Schumacher (1994, 1999, 2000, 2002, 2003, 2004, 2006)

GERMANY POLAND

FRANCE

ITALY

*Mediterranean
Sea*

Caesars Palace 1981

Las Vegas

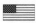 UNITED STATES OF AMERICA

A bizarre race track defined by concrete blocks laid out in a car park at the back of Caesars Palace Hotel. Only used twice but the end of season date meant the championship was settled both times. Proved difficult to draw gamblers from the tables to spectate under a blazing sun.

The removal of Watkins Glen from the F1 schedule prompted the acceptance of a proposal to run a Grand Prix in Las Vegas at the end of the 1981 season. The gambling capital of the west coast had built a reputation for promoting boxing matches and tennis tournaments; a Grand Prix was envisaged as another means of drawing big players from Los Angeles to the gambling tables. It didn't quite work out that way.

The 2.268-mile (3.65-km) track was defined by concrete blocks laid out in a zigzag pattern within a vast cark park at the back of Caesars Palace Hotel. It had little to offer but novelty value, and that would quickly wear off.

The organisers did their best with what they'd got. The track surface appeared smooth but the series of tight left and right-hand corners within a jumble of concrete proved to be nothing more than a test of stamina in the desert heat. Lower backs and neck muscles would take a hammering when stiff suspensions sought out previously unseen ripples on a track that presented the added difficulty of being run anti-clockwise.

The irony was that, being the final round, this race would settle a three-way fight for the championship between Carlos Reutemann (Williams-Ford), Nelson Piquet (Brabham-Ford) and Jacques Laffite (Ligier-Matra). With Laffite being the outsider, in simple terms Reutemann had to finish in front of Piquet.

Reutemann started off on the right note by producing a single pole position lap, seemingly from nowhere, one that left the opposition reeling. But that would be the sum of his brilliance. By the end of the opening lap he was fifth, destined to slide further behind with a car that was not to his liking. When Reutemann fell to seventh and out of the points, all Piquet had to do was finish fifth. He just about made it, the Brazilian utterly spent and taking 15 minutes to climb from his car as World Champion.

There was a repeat scenario the following September when 30 drivers turned up for the final race with two of them in with a serious shout of the championship. Keke Rosberg (Williams-Ford) led the points table and the betting for the title, his main rival, John Watson (McLaren-Ford), being nine points behind and in need of a win. Rosberg simply had to score two points by finishing fifth, which is precisely what he did at the end of a measured 75 laps lasting an hour and 42 minutes. The fact that very few spectators had braved the heat to see him do it mattered little to the team but a great deal to the promoters who, once again, had taken a financial hit.

There were few tears within F1 when Las Vegas did not appear on the schedule again. That said, teams would miss the opportunity to back their drivers with favourable odds. Bookies, unfamiliar with the sport, had posted Michele Alboreto at 20-1 prior to the Tyrrell driver's win, his only victory in 1982. It had been that sort of year: Las Vegas had been that sort of place.

The circuit layout was adapted to form a distorted oval for Indycar racing in 1983 and 1984 before finally being put out of its misery by being given over to urban development.

Top: The Renaults of Alain Prost and René Arnoux lead the field at the start of the 1982 Caesars Palace Grand Prix.

Bottom: FISA president Jean-Marie Balestre holds centre stage as he welcomes the 1981 World Champion to the podium. Nelson Piquet, barely able to stand after 75 laps in the dry heat, joins Renault's Alain Prost (left) and the winner Alan Jones, hidden behind Bruno Giacomelli who finished third for Alfa Romeo. Giacomelli's Roman headgear, presented to each driver, was but a small part of a bizarre event.

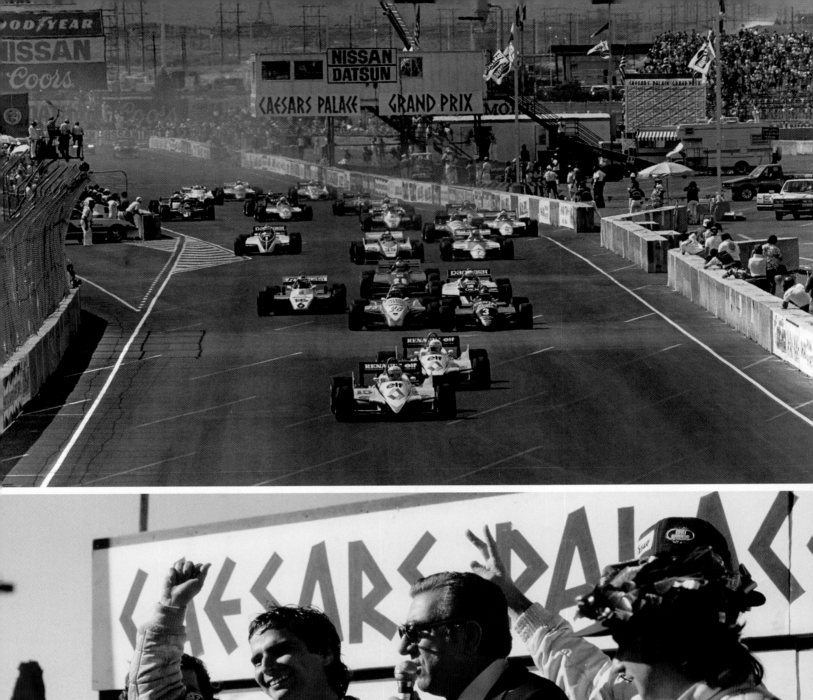

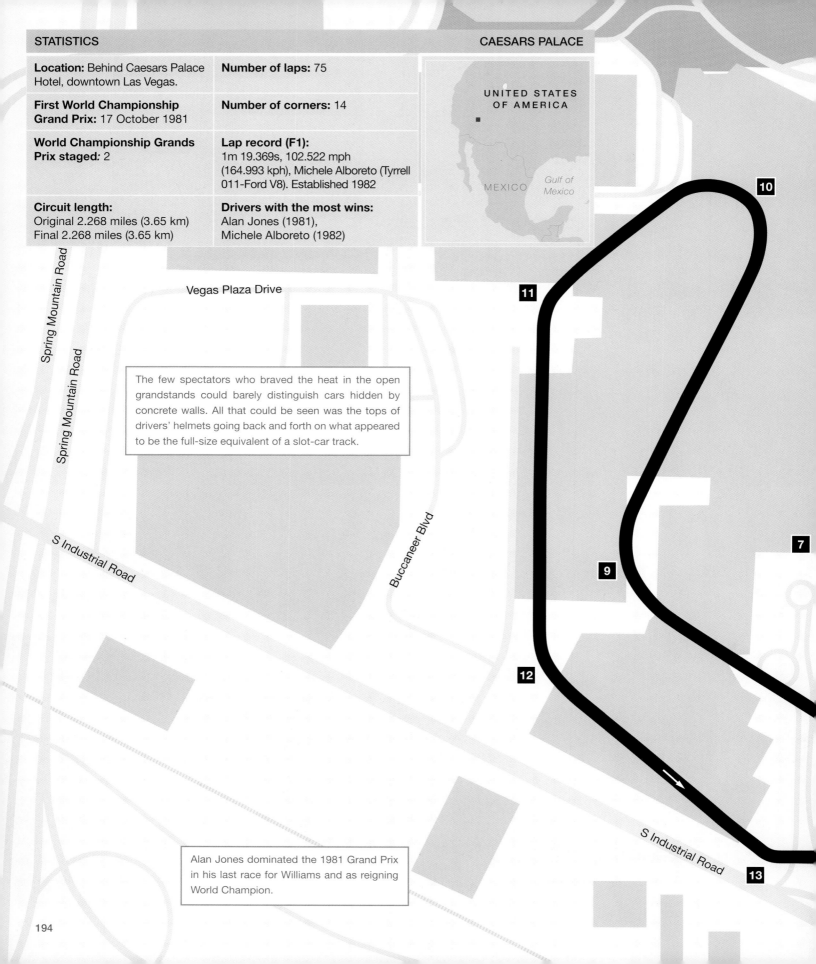

Location: Behind Caesars Palace Hotel, downtown Las Vegas.

First World Championship Grand Prix: 17 October 1981

World Championship Grands Prix staged: 2

Circuit length:
Original 2.268 miles (3.65 km)
Final 2.268 miles (3.65 km)

Number of laps: 75

Number of corners: 14

Lap record (F1):
1m 19.369s, 102.522 mph (164.993 kph), Michele Alboreto (Tyrrell 011-Ford V8). Established 1982

Drivers with the most wins:
Alan Jones (1981),
Michele Alboreto (1982)

UNITED STATES OF AMERICA

MEXICO

Gulf of Mexico

Vegas Plaza Drive

Spring Mountain Road

Spring Mountain Road

S Industrial Road

Buccaneer Blvd

S Industrial Road

The few spectators who braved the heat in the open grandstands could barely distinguish cars hidden by concrete walls. All that could be seen was the tops of drivers' helmets going back and forth on what appeared to be the full-size equivalent of a slot-car track.

Alan Jones dominated the 1981 Grand Prix in his last race for Williams and as reigning World Champion.

10

11

7

9

12

13

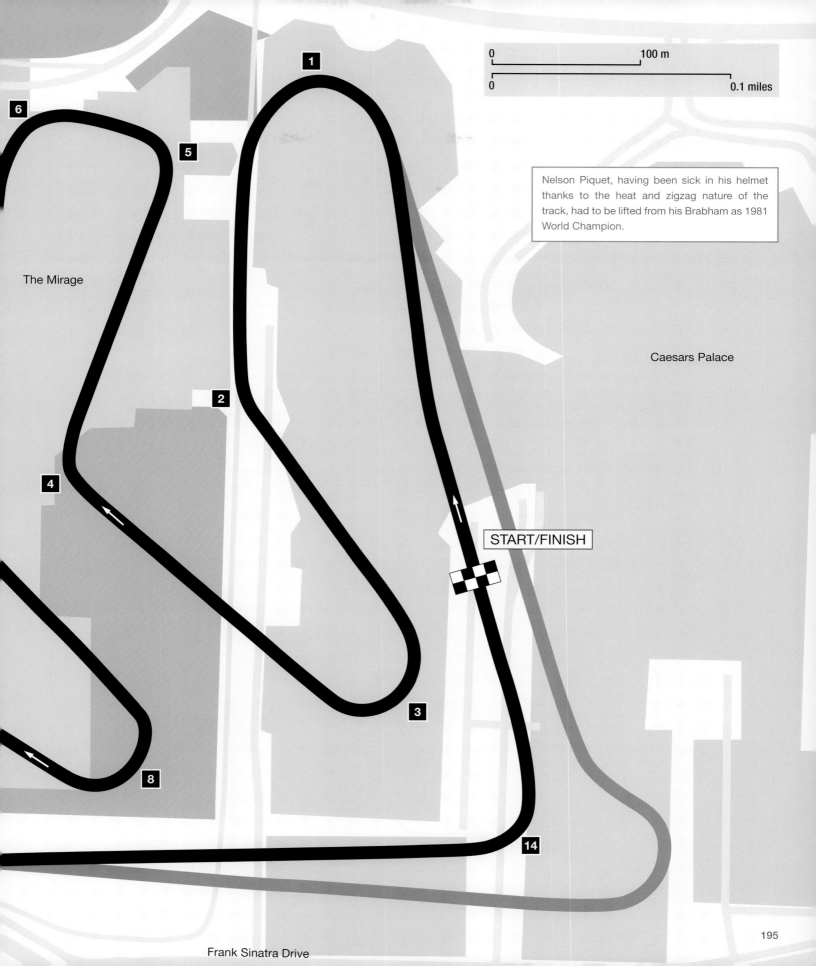

1

6

5

The Mirage

2

4

Nelson Piquet, having been sick in his helmet thanks to the heat and zigzag nature of the track, had to be lifted from his Brabham as 1981 World Champion.

Caesars Palace

START/FINISH

3

8

14

Frank Sinatra Drive

Detroit 1982

Detroit Street Circuit

 UNITED STATES OF AMERICA

The street circuit in downtown Detroit was either loved or loathed. Embraced by the US automobile industry headquartered nearby and party-going fans using the hotels and offices overlooking a difficult and bumpy track. Eventually, F1's demands for better facilities and safety could not be met.

Formula 1 had never been so popular in the United States than in 1982. Starting with Long Beach in April and finishing in Las Vegas in September, the country hosted a third race in June, the Detroit Grand Prix (also known as the United States Grand Prix East) through the city's streets.

Anxious to polish the tarnished image of a once-great metropolis, Detroit Renaissance Grand Prix Inc. pushed forward the idea of running a race with, at his heart, the 72-storey Renaissance Centre, a glass ziggurat rising from a former run-down area as a sign of the city's new image

It was a brave venture that did not receive immediate approval from either the locals or the drivers. The 2.59-mile (4.17-km) track, running along the riverfront and through the fringe of downtown Detroit, was slow, stilted and very bumpy as it dealt with the grid-pattern streets, a railway crossing and the usual obstacles accompanying thoroughfares ravaged by severe winters.

As ever, the layout was defined by concrete blocks. Unfortunately, poor liaison with the many local businesses overlooking the circuit meant widespread outrage as employees found their daily commute severely disrupted. Complicating matters further, the F1 teams demanded several changes to the tyre barriers and escape roads simply to make the track reasonably safe.

An acclimatisation session on the Thursday was cancelled, practice the following day seriously delayed, the entire programme then enduring the additional difficulty of heavy rain during lunch time on Saturday, which meant times set in the morning had to be used to determine the grid. And so it went on.

Come Sunday, however, the Americans (and the Canadians from across the Detroit River) embraced the Grand Prix as only they can. The nearby automotive industry, although in decline, grabbed the opportunity to entertain and party, the lifts in the Renaissance Centre working flat out from an early hour.

The atmosphere was electric and the F1 teams responded with an eventful race, including a stoppage of an hour to deal with the damage caused by a collision and minor fire. After 62 laps, only 11 of the 26 starters were running, John Watson working his way past damaged and wrecked cars to come from 17th on the grid to a popular win for McLaren.

Despite the initial complaints, the Grand Prix continued in successive years as the community either ignored the noisy inconvenience or embraced the occasion. The circuit received a few improvements such as ruling out a very tight hairpin but, overall, the drivers did not particularly enjoy the challenge. Ayrton Senna mastered it better than most, the Brazilian using the active suspension on his Lotus-Honda to good effect in 1987 by scoring the second of three wins.

Then, just as the event seemed to be getting into its stride, the organisers could not find the necessary cash to carry out modifications, particularly to the basic open pits some distance from the paddock inside Cobo Hall. The 1988 Detroit Grand Prix would be the last. Some within F1 would miss this unique event; others would be glad to see the back of it.

Ayrton Senna led from pole in his Lotus-Honda in 1987.

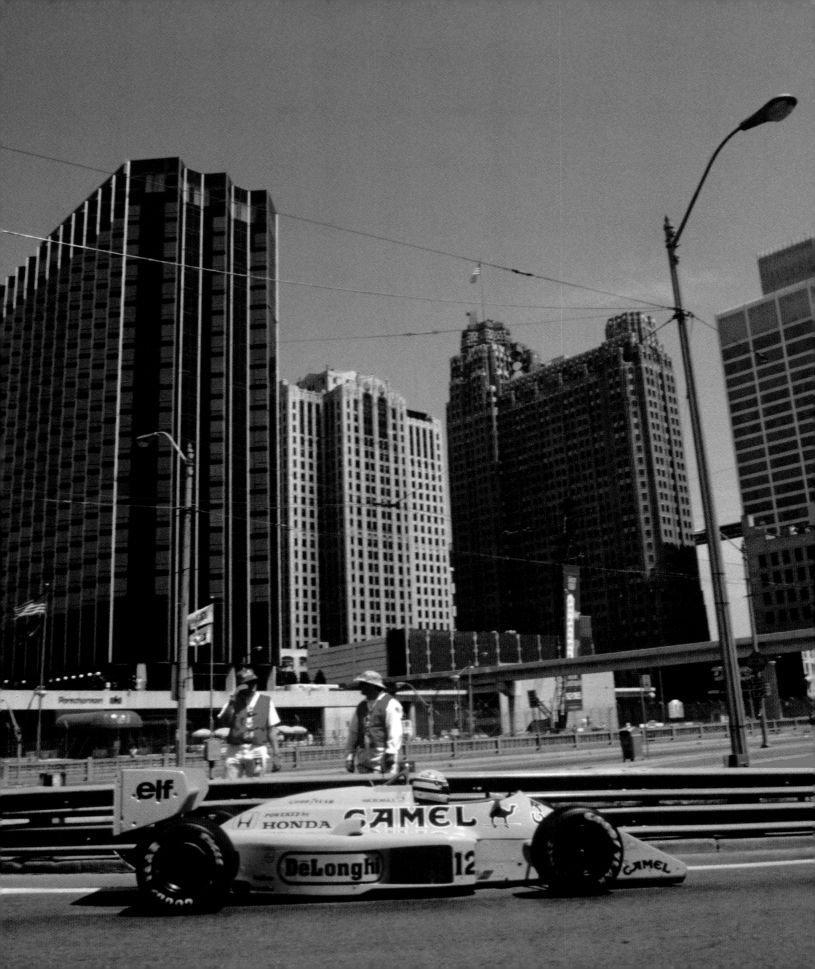

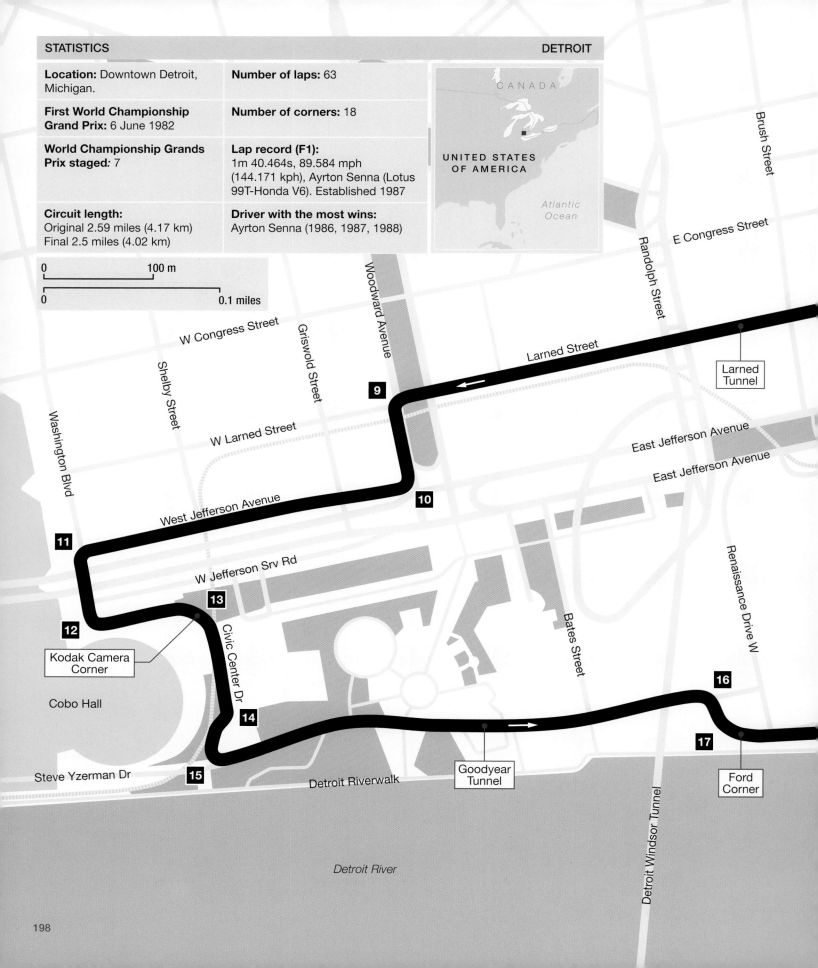

Location: Downtown Detroit, Michigan.

First World Championship Grand Prix: 6 June 1982

World Championship Grands Prix staged: 7

Circuit length:
Original 2.59 miles (4.17 km)
Final 2.5 miles (4.02 km)

Number of laps: 63

Number of corners: 18

Lap record (F1):
1m 40.464s, 89.584 mph (144.171 kph), Ayrton Senna (Lotus 99T-Honda V6). Established 1987

Driver with the most wins:
Ayrton Senna (1986, 1987, 1988)

CANADA

UNITED STATES
OF AMERICA

Atlantic
Ocean

0 100 m

0 0.1 miles

Brush Street

E Congress Street

Randolph Street

Larned Street

Larned Tunnel

W Congress Street

Woodward Avenue

Griswold Street

Shelby Street

East Jefferson Avenue

East Jefferson Avenue

W Larned Street

9

10

Washington Blvd

West Jefferson Avenue

11

W Jefferson Srv Rd

Renaissance Drive W

Bates Street

13

12

Civic Center Dr

Kodak Camera Corner

16

Cobo Hall

14

17

Steve Yzerman Dr

15

Detroit Riverwalk

Goodyear Tunnel

Ford Corner

Detroit Windsor Tunnel

Detroit River

Martin Brundle finished a brilliant second as he used the nimble normally-aspirated Tyrrell-Ford to chase Nelson Piquet's turbo Brabham-BMW across the line in 1984. The Tyrrell was later excluded on a controversial technicality.

Chrysler Freeway

Larned Street

6

E Congress Street

Chrysler Drive

7

St Antoine Street

Larned Street

East Jefferson Avenue

5

8

1982

Woodbridge Street

Rivard Street

4

3

East Jefferson Avenue

Franklin Street

St Antoine Street

Schweizer Place

Beaubien Street

Beaubien Street

Atwater Street

New Street

1

2

Atwater Street

START/FINISH

18

Detroit River

The Grand Prix in 1984 had to be stopped within seconds of the start when Nigel Mansell aimed his Lotus for a gap in the front row that was destined to close. Several cars were involved in the resulting collision.

The uneven surface was tailor-made for the active suspension on Ayrton Senna's Lotus-Honda in 1987, the Brazilian taking the second of three wins at Detroit.

Dallas 1984

Fair Park

 UNITED STATES OF AMERICA

Had potential for a decent street circuit. Destined to be used just once when the Dallas Grand Prix in 1984 was defined by cars crashing on a track surface that broke up in blistering heat and the promoter absconding with the funds when a colourful weekend was over.

The idea was right but the timing and execution were poor. By choosing a July date, the Dallas organisers were at the mercy of an ambient temperature hitting 100°F and a track surface that had not been laid properly in the first place. The actual layout would have been acceptable were it not for being narrow in places and the ends of concrete walls butting onto the racing line.

That was a problem for the drivers to deal with; meanwhile, the rest of F1 enjoyed a warm welcome from the people of Dallas and made visits to 'Southfork', scene of the popular TV soap at the time. No amount of cosmetic treatment, however, could overcome the gradual disintegration of the track surface. The situation became so serious that there was talk of the race being cancelled, the problem seemingly getting even worse after the warm-up at 7am on race morning when quick-drying cement was applied to holes at the apex and exit of corners savaged by fat rear tyres. Sixty-seven laps and a track temperature of 150°F did not bear thinking about.

The race got under way just eleven minutes behind schedule – which was just as well because a large crowd, the majority unfamiliar with the sport, might not have understood had the F1 stars failed to perform. It was always likely to be a race of attrition, and so it proved, the circuit increasingly lined with cars abandoned either through mechanical failure or broken wheels and suspension, all caused by the demands of a bumpy and crumbling track.

Nigel Mansell led for 35 laps until the Lotus-Renault driver brushed a wall. Derek Warwick, trying to wrest the lead from his fellow countryman, had spun his Renault into the tyre barrier. Alain Prost, in charge for eight laps, clipped a wall and damaged the front suspension of his McLaren-TAG. Steering through the carnage and biding his time, Keke Rosberg brought his Williams-Honda from seventh on the grid to lead at half distance and then the final 11 laps following Prost's indiscretion, the Finn having kept a cool head in every sense thanks to a chilled skull cap. Then, just for good measure in front of the TV soap stars, Mansell collapsed in a heap while trying to physically push his hobbled car across the line.

The fact that the race, lasting two hours, had been completed was considered a minor miracle. But it would be all for nothing as far as the organisers were concerned when one of their number absconded with the cash box a few days later, thus ruling out what had become a very slim chance of a second Dallas Grand Prix. Which was a pity. Given proper planning and the adoption of lessons learned, the Texas venue would have been a decent addition.

Alain Prost was one of several drivers to fall foul of the track surface when his McLaren-TAG hit the wall.

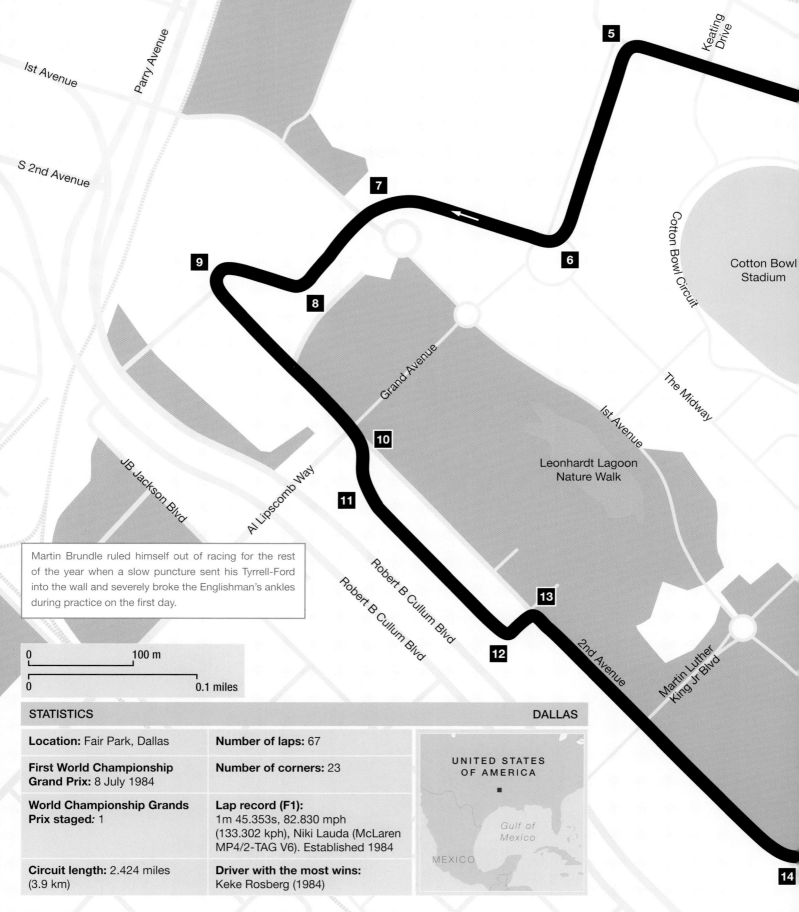

Martin Brundle ruled himself out of racing for the rest of the year when a slow puncture sent his Tyrrell-Ford into the wall and severely broke the Englishman's ankles during practice on the first day.

0 100 m

0 0.1 miles

STATISTICS

DALLAS

Location: Fair Park, Dallas

First World Championship Grand Prix: 8 July 1984

World Championship Grands Prix staged: 1

Circuit length: 2.424 miles (3.9 km)

Number of laps: 67

Number of corners: 23

Lap record (F1):
1m 45.353s, 82.830 mph (133.302 kph), Niki Lauda (McLaren MP4/2-TAG V6). Established 1984

Driver with the most wins: Keke Rosberg (1984)

UNITED STATES OF AMERICA

Gulf of Mexico

MEXICO

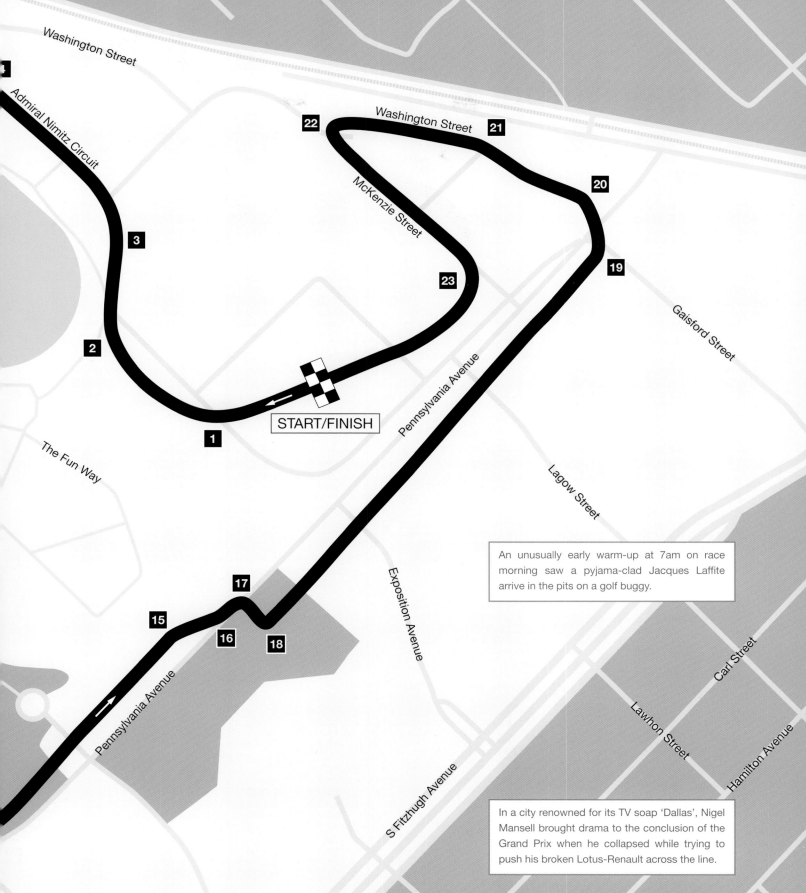

Washington Street

Admiral Nimitz Circuit

Washington Street

McKenzie Street

22

21

20

3

23

19

Gaisford Street

2

START/FINISH

1

The Fun Way

Pennsylvania Avenue

Lagow Street

An unusually early warm-up at 7am on race morning saw a pyjama-clad Jacques Laffite arrive in the pits on a golf buggy.

17

Exposition Avenue

Carl Street

15

16

18

Lawhon Street

Pennsylvania Avenue

S Fitzhugh Avenue

Hamilton Avenue

In a city renowned for its TV soap 'Dallas', Nigel Mansell brought drama to the conclusion of the Grand Prix when he collapsed while trying to push his broken Lotus-Renault across the line.

New Nürburgring 1984

Nürburg

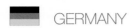 GERMANY

The New Nürburgring, kissing the edge of the old, was seen as a modern, safe and not very exciting facility when opened in 1984, hosting not only the German Grand Prix but also the European and Luxembourg GPs in years when Hockenheim staged the national race.

With the Nordschleife ruled out for F1 and the Sudschleife more or less abandoned, £18 million was spent on the construction of the so-called New Nürburgring. Located at the top of the former Sudschleife, bulldozing of the natural terrain ensured the new track was the model of efficiency and safety, but totally without soul; an unfair comparison, perhaps, given that the Nordschleife remained glowering in the background, the pits on the new circuit occupying the former location of the old.

The New Nürburgring had plenty of elevation and excellent viewing but there was not much to see thanks to constant radius corners promoting tedious and processional racing. The accompanying change in culture also proved difficult to accept.

Previously, racing at the Nürburgring had been a major recreational and social event. Spectators, camping in the woods around the entire length of the old circuit, would be in holiday mood, barbecues, bockwurst and beer being interrupted occasionally by watching racing cars go by. If they were lucky, spectators would have a car in view for a maximum of ten seconds and not see it again for several minutes. It was a curious part of the charm.

With the New Nürburgring, fans had full view of large chunks of the circuit. Judging by the sparsely populated grandstands at the early races, few felt the need to pay handsomely for the experience at what became known unofficially and unkindly as the Ersatzring.

The Grosser Preis von Europa was run there in 1984, the Nürburgring's turn for the Grosser Preis von Deutschland title coming the following year. Aware that overtaking was difficult, the organisers added a loop with a wide first corner in 2002, but too late to save embarrassment in the Schumacher family in 1997 when Ralf hit Michael going into the original first corner and possibly cost his brother the championship.

The Nürburgring's difficulty in meeting the cost of staging a Grand Prix increased further in 2009 when the opening of a commercial area, including shops, fun park and hotel, led to bankruptcy three years later. The future of the track as a F1 venue has been in doubt ever since, highlighted by a late withdrawal of the traditional early August date from the 2015 calendar.

Top: The addition of a loop after the first corner improved the challenge in 2002, but not by enough to save the venue from further financial difficulties.

Bottom: Embarrassment all round in 1997 as the yellow Jordan-Peugeots of Ralf Schumacher and Giancarlo Fisichella collide going into the fi rst corner, Schumacher eliminating the Ferrari of his brother, Michael, in the process.

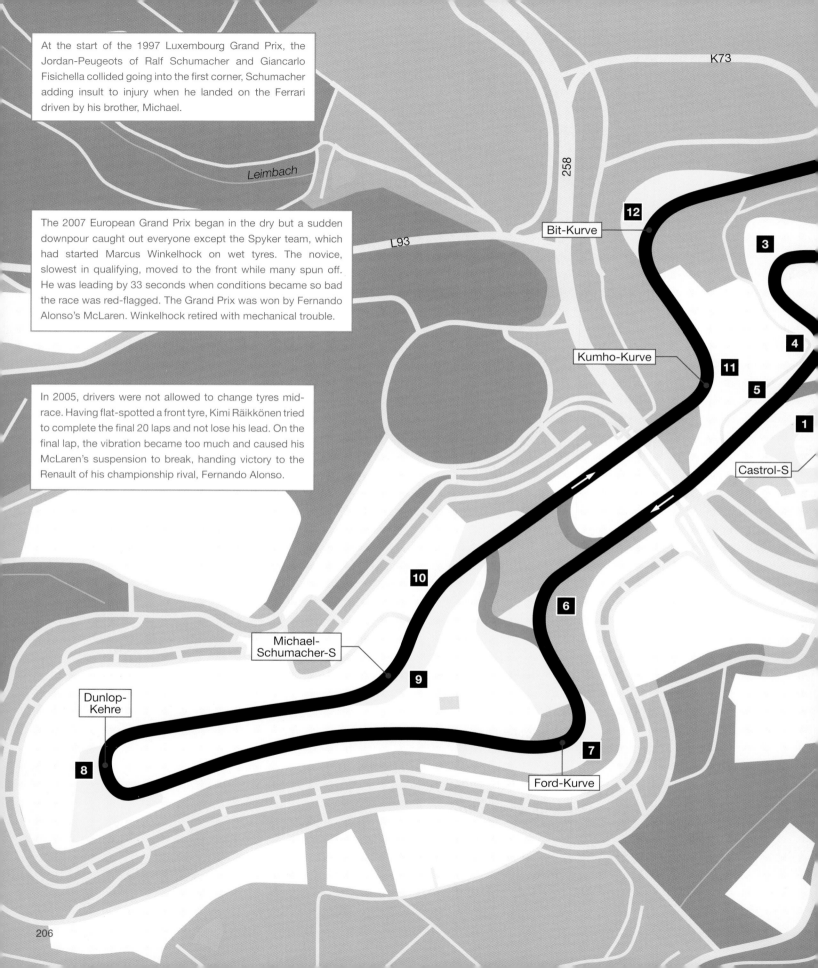

At the start of the 1997 Luxembourg Grand Prix, the Jordan-Peugeots of Ralf Schumacher and Giancarlo Fisichella collided going into the first corner, Schumacher adding insult to injury when he landed on the Ferrari driven by his brother, Michael.

The 2007 European Grand Prix began in the dry but a sudden downpour caught out everyone except the Spyker team, which had started Marcus Winkelhock on wet tyres. The novice, slowest in qualifying, moved to the front while many spun off. He was leading by 33 seconds when conditions became so bad the race was red-flagged. The Grand Prix was won by Fernando Alonso's McLaren. Winkelhock retired with mechanical trouble.

In 2005, drivers were not allowed to change tyres mid-race. Having flat-spotted a front tyre, Kimi Räikkönen tried to complete the final 20 laps and not lose his lead. On the final lap, the vibration became too much and caused his McLaren's suspension to break, handing victory to the Renault of his championship rival, Fernando Alonso.

Leimbach

K73

258

L93

12 Bit-Kurve

3

Kumho-Kurve

11

4

5

1

Castrol-S

10

6

Michael-Schumacher-S

9

Dunlop-Kehre

8

7

Ford-Kurve

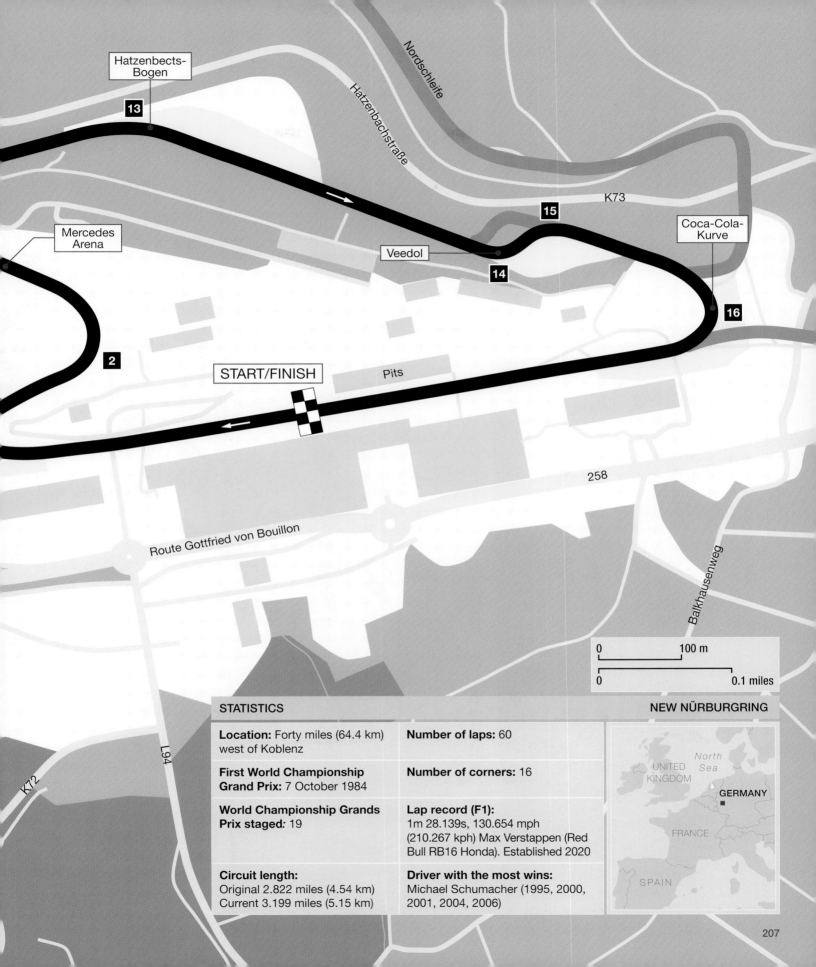

Hatzenbects-
Bogen

13

Nordschleife

Hatzenbachstraße

K73

15

Mercedes
Arena

Veedol

Coca-Cola-
Kurve

14

2

16

START/FINISH

Pits

258

Route Gottfried von Bouillon

Balkhausenweg

0	100 m
0	0.1 miles

L94

K72

STATISTICS

NEW NÜRBURGRING

Location: Forty miles (64.4 km)
west of Koblenz

Number of laps: 60

**First World Championship
Grand Prix:** 7 October 1984

Number of corners: 16

**World Championship Grands
Prix staged:** 19

Lap record (F1):
1m 28.139s, 130.654 mph
(210.267 kph) Max Verstappen (Red
Bull RB16 Honda). Established 2020

Circuit length:
Original 2.822 miles (4.54 km)
Current 3.199 miles (5.15 km)

Driver with the most wins:
Michael Schumacher (1995, 2000,
2001, 2004, 2006)

North
Sea

UNITED
KINGDOM

GERMANY

FRANCE

SPAIN

Estoril 1984

Autódromo do Estoril

 PORTUGAL

A popular venue between 1984 and 1996, located not far from the Atlantic coast. Used extensively for winter testing. Settled the championship in 1984 and staged several eventful Portuguese Grands Prix before falling behind in terms of safety and facilities.

Following the brief flurry at Oporto and Monsanto in the 1950s, there was a lull in Portugal's championship interest until the country's first permanent track was constructed on a rocky plateau, close by the coastal town of Estoril.

Opened in 1972, Estoril earned its reputation as a worthwhile track by staging rounds of the European F2 Championship. The long pit straight fed into two very quick right-handers on a downhill plunge to a hairpin right. A short climb led to the back straight with a flat-out right and slight downhill run to a tight left. Continuing to fall, the track reached a right-hander and the beginning of the climb towards the main straight, culminating in a very long right-hander. Only the first two corners – with very little run-off – were truly challenging but the narrow, bumpy track kept drivers busy.

Despite falling into disrepair, Estoril was considered potentially good enough to stage the final round of the 1984 World Championship. And, as luck would have it, the Portuguese found themselves with the added cache of settling the title between the McLaren-TAG drivers, Niki Lauda and Alain Prost. The paint had barely dried on the revamped facilities and the organisation may have been dominated by officious police officers but the race made history when Lauda won the championship by half a point.

Despite incessant rain, the next Grand Prix will be best remembered for a mesmeric performance from Ayrton Senna in April 1985 as the Lotus-Renault driver scored his first Grand Prix victory. Apart from anything else, Senna's performance and presence encouraged the local populace to make the short drive from Lisbon and its surroundings despite the absence of a Portuguese driver of note.

There would be equally eventful races to follow, with Nigel Mansell usually playing a leading role. In 1989, the Williams driver overshot his pit and was disqualified for being pushed backwards in the pit lane – but not before he had been involved in a collision with Senna. Two years later, Mansell was in trouble again when a wheel came loose as he left the pits, the Williams team breaking the rules by refitting the wheel in the pit lane.

In terms of action actually on the track, Senna upset Prost in 1988 when he squeezed his McLaren team-mate against the pit wall at 180 mph (290 kph) and Jacques Villeneuve pulled off a stunning move when disputing the lead in 1996, the Williams-Renault driver running round the outside of Michael Schumacher's Ferrari coming through the final fast right-hander.

By then, Estoril was thought to be no longer suitable for F1 and the Portuguese Grand Prix disappeared from the calendar as suddenly as it had arrived. Estoril, meanwhile, would continue to stage international car and motor bike racing, the track being altered significantly in places in line with safety requirements.

Historic moments at Estoril as (top) Niki Lauda beats his McLaren team-mate Alain Prost (right) by half a point to win the 1984 championship. A year later, Ayrton Senna (bottom) scored his first Grand Prix win with a mesmeric drive in the Lotus-Renault under atrocious conditions.

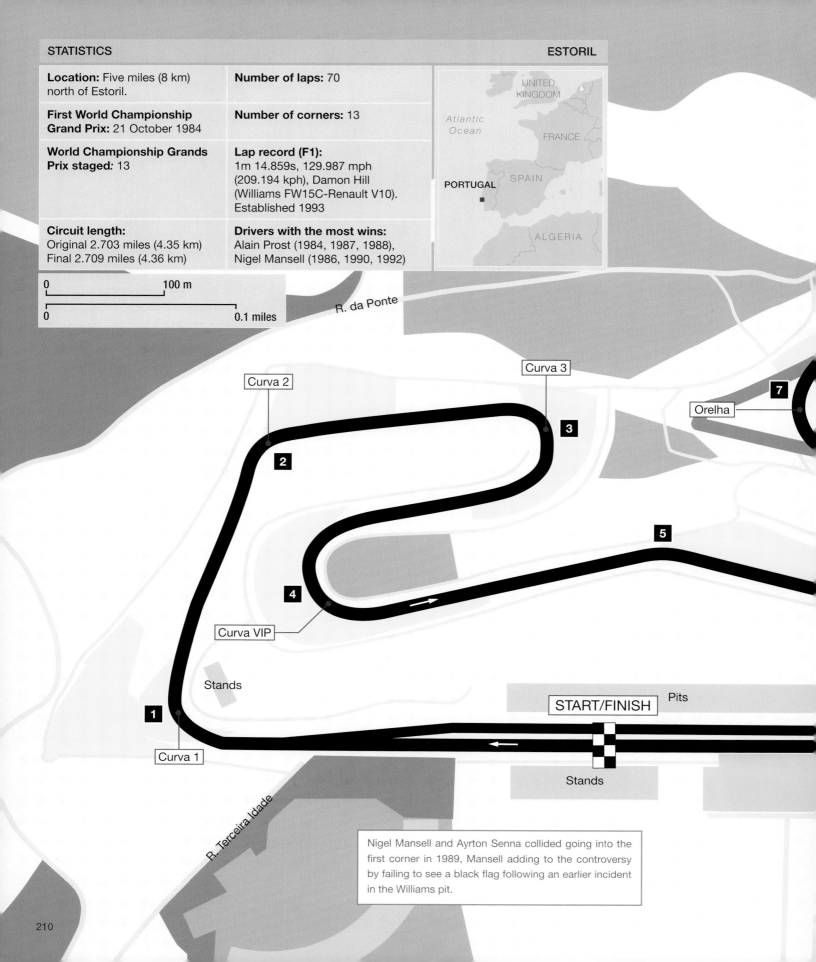

STATISTICS

ESTORIL

Location: Five miles (8 km) north of Estoril.

First World Championship Grand Prix: 21 October 1984

World Championship Grands Prix staged: 13

Circuit length:
Original 2.703 miles (4.35 km)
Final 2.709 miles (4.36 km)

Number of laps: 70

Number of corners: 13

Lap record (F1):
1m 14.859s, 129.987 mph (209.194 kph), Damon Hill (Williams FW15C-Renault V10). Established 1993

Drivers with the most wins: Alain Prost (1984, 1987, 1988), Nigel Mansell (1986, 1990, 1992)

0 100 m

0 0.1 miles

R. da Ponte

Curva 2

Curva 3

2

3

7

Orelha

5

4

Curva VIP

1

Curva 1

Stands

START/FINISH

Pits

Stands

R. Terceira Idade

Nigel Mansell and Ayrton Senna collided going into the first corner in 1989, Mansell adding to the controversy by failing to see a black flag following an earlier incident in the Williams pit.

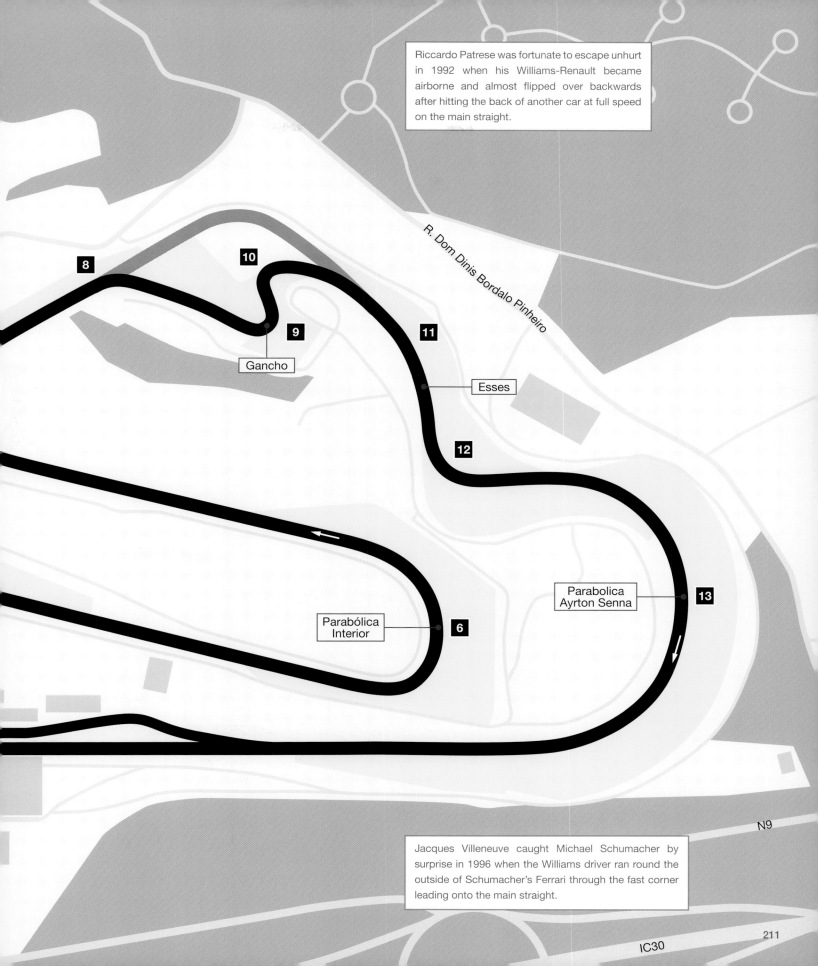

Riccardo Patrese was fortunate to escape unhurt in 1992 when his Williams-Renault became airborne and almost flipped over backwards after hitting the back of another car at full speed on the main straight.

R. Dom Dinis Bordalo Pinheiro

8

10

9
Gancho

11

Esses

12

6
Parabólica
Interior

Parabolica
Ayrton Senna

13

N9

Jacques Villeneuve caught Michael Schumacher by surprise in 1996 when the Williams driver ran round the outside of Schumacher's Ferrari through the fast corner leading onto the main straight.

Adelaide 1985

Adelaide Street Circuit

 AUSTRALIA

An immediate hit. Excellent combination on streets and inside a horse racecourse. Well organised. Close to a small city that threw itself behind their Grand Prix. A demonstration of how street racing should be done; the temporary facilities second to none. Eventually lost out to the power of Melbourne and Victoria.

For a country with a fine history of motor sport and home-grown world champions, Australia had been remarkably slow in coming forward with a track suitable for a championship Grand Prix. An Adelaide businessman, Bill O'Gorman, came up with the idea of using streets in a suburb of the city and won the support of South Australia's Premier, John Bannon. Here was a perfect way for Adelaide (known as the City of Churches) to put one across Australia's main sporting players, Sydney and Melbourne. A seven-year deal was done, starting with the final race of the 1985 season.

With the championship having been settled, the F1 teams arrived in the parkland city in a relaxed frame of mind and were impressed by what they found. The pits and paddock were located inside the Victoria Park Racecourse. The Tarmac loop crossed the racing turf in two places within these idyllic surroundings before heading, via a chicane, into the streets of what was essentially a residential and shopping neighbourhood. A series of right-angle corners led to Rundle Road, where a fast right fed cars onto Dequetteville Terrace, a long and wide straight. The tight right at the end, apart from calling for heavy braking, marked the start of a curving return beneath the trees and into Victoria Park once more.

If the track was impressive for a street circuit, then so were the facilities. The pit buildings may have been temporary but they outclassed many permanent circuits back in Europe. And driving the entire event was an infectious enthusiasm throughout a city thoroughly enjoying the novelty of a Grand Prix, and keen to see it succeed. The slogan 'Adelaide Alive' could not have been more appropriate.

The first Grand Prix was adjudged a success, Keke Rosberg winning for Williams-Honda after an at times tense struggle with the Lotus-Renault of Ayrton Senna. The spotlight on Adelaide would increase massively in 1986 as three drivers arrived in town with a chance of winning the championship.

It was to be an extraordinary Grand Prix, all three drivers at some stage poised to take the title if the positions remained exactly as they were. But the shifting story led to a spectacular retirement for Nigel Mansell when his left-rear tyre failed as he reached 180 mph (290 kph) on Dequetteville Terrace (aka Brabham Straight). Somehow, Mansell wrestled the Williams-Honda to a halt in the escape road, Nelson Piquet then carrying hopes for Williams until called in for a precautionary tyre change. Which left Alain Prost, the outsider, to bring his McLaren-TAG, on the verge of running out of fuel, across the line to win the race and his second championship.

One way or another, Adelaide would have its fair share of drama. Heavy rain and a crash caused the race to be stopped in 1989; Senna scored what would be his final Grand Prix win in 1993; Michael Schumacher ended an epic battle with Damon Hill by colliding with the Williams-Renault driver to take the 1994 title; Mika Häkkinen had a life threatening crash during qualifying in 1995, the same year David Coulthard's leading Williams hit the wall entering the pits and Hill went on to win.

That was to be the last F1 race in Adelaide, the promoters winning the award for the best organised Grand Prix for a third time but losing the financial fight with Melbourne. Adelaide remains alive in motor sport terms by staging an annual and well-supported race for Australian V8 touring cars.

An epic battle on a circuit to match. Damon Hill's Williams-Renault chases the Benetton-Ford of Michael Schumacher for the lead and the championship in 1994 as they reach the end of Brabham Straight and swing onto Wakefield Road.

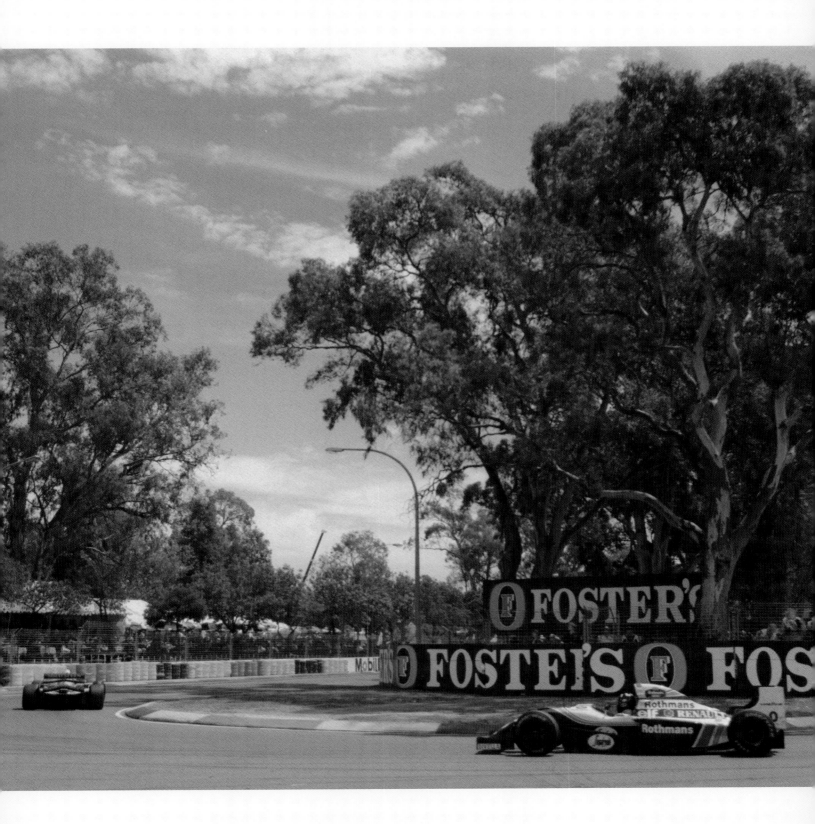

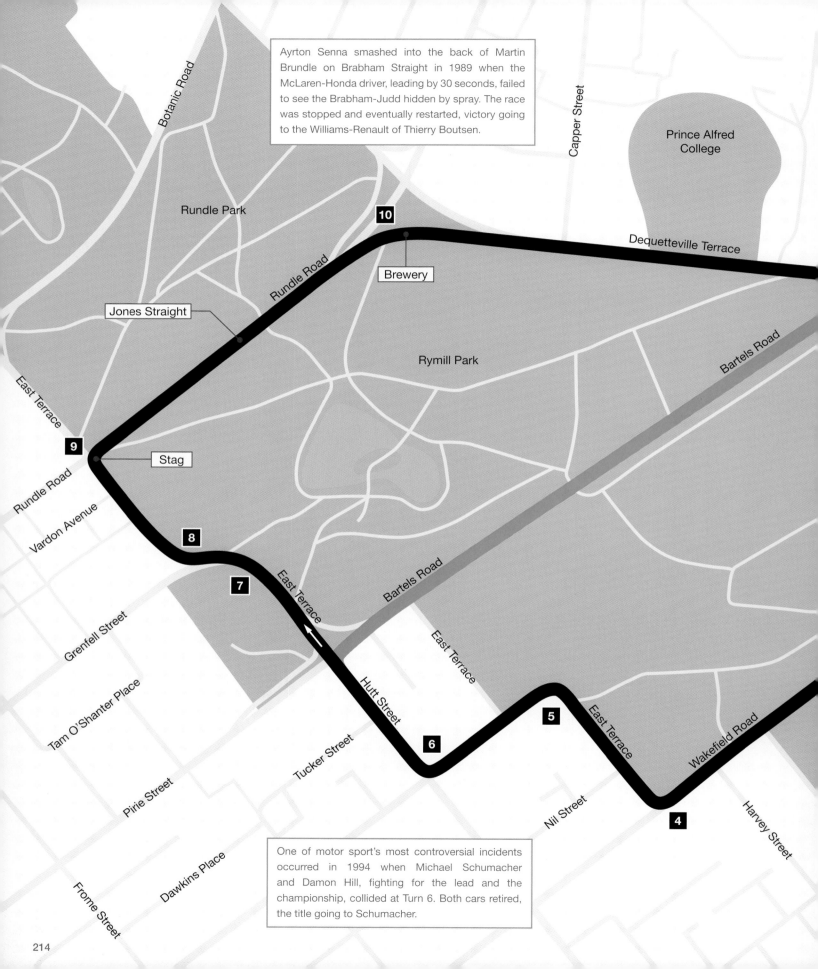

Ayrton Senna smashed into the back of Martin Brundle on Brabham Straight in 1989 when the McLaren-Honda driver, leading by 30 seconds, failed to see the Brabham-Judd hidden by spray. The race was stopped and eventually restarted, victory going to the Williams-Renault of Thierry Boutsen.

Prince Alfred College

Botanic Road

Capper Street

Dequetteville Terrace

Rundle Park

10

Brewery

Rundle Road

Jones Straight

Rymill Park

Bartels Road

East Terrace

9

Stag

Rundle Road

Vardon Avenue

8

7

East Terrace

Bartels Road

East Terrace

Grenfell Street

Tam O'Shanter Place

Hutt Street

East Terrace

5

6

Wakefield Road

Pirie Street

Tucker Street

Nil Street

4

Harvey Street

Frome Street

Dawkins Place

One of motor sport's most controversial incidents occurred in 1994 when Michael Schumacher and Damon Hill, fighting for the lead and the championship, collided at Turn 6. Both cars retired, the title going to Schumacher.

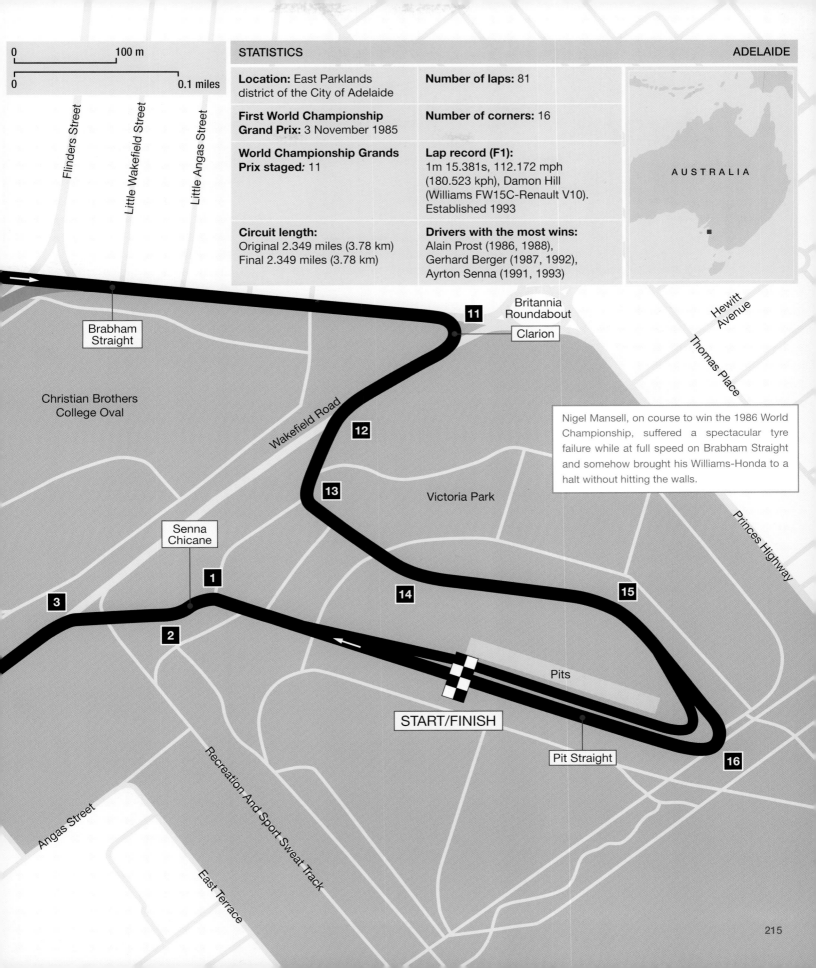

0 100 m

0 0.1 miles

Flinders Street

Little Wakefield Street

Little Angas Street

STATISTICS

Location: East Parklands district of the City of Adelaide

First World Championship Grand Prix: 3 November 1985

World Championship Grands Prix staged: 11

Circuit length:
Original 2.349 miles (3.78 km)
Final 2.349 miles (3.78 km)

Number of laps: 81

Number of corners: 16

Lap record (F1):
1m 15.381s, 112.172 mph (180.523 kph), Damon Hill (Williams FW15C-Renault V10). Established 1993

Drivers with the most wins:
Alain Prost (1986, 1988), Gerhard Berger (1987, 1992), Ayrton Senna (1991, 1993)

AUSTRALIA

Brabham Straight

Christian Brothers College Oval

Britannia Roundabout

11

Clarion

Wakefield Road

Hewitt Avenue

Thomas Place

12

13

Victoria Park

Nigel Mansell, on course to win the 1986 World Championship, suffered a spectacular tyre failure while at full speed on Brabham Straight and somehow brought his Williams-Honda to a halt without hitting the walls.

Senna Chicane

1

3

2

14

15

Princes Highway

Pits

START/FINISH

Pit Straight

16

Angas Street

Recreation And Sport Sweat Track

East Terrace

Jerez 1986

Circuito de Jerez

 SPAIN

A reasonable permanent circuit in a natural amphitheatre that failed to attract spectators in anything like the numbers drawn to MotoGP. Produced good racing and settled the 1997 championship. Popular for winter testing. Staged seven GPs but ousted by Barcelona Montmeló.

During a lull in Spain's F1 history following Montjuïc Park and Jarama falling from favour, the Mayor of Jerez de la Frontera decided to sanction the building of a circuit close to his city. The aim was to promote the famous sherry region, a reasonable ambition based on first acquaintance with the 2.621-mile (4.22-km) permanent track.

Nestling in a natural amphitheatre, not far from the small local airport, the Circuito Permanente de Jerez (as it was called initially) provided a reasonable mix of corners and just one chicane. The 2.742-mile (4.41-km) circuit was made ready in time for the second race of the season in April 1986. Ayrton Senna and Nigel Mansell gave the revived Spanish Grand Prix a perfect introduction when the Lotus-Renault and the Williams-Honda crossed the line side-by-side to record one of the closest finishes in F1, Senna's Lotus beating Mansell by 0.014 seconds after an hour and 49 minutes of racing.

Although not far from the population centres of Seville and Cadiz, the circuit – and F1 – failed to attract the anticipated 125,000 spectators, the sort of numbers that would regularly attend subsequent rounds of the MotoGP motor cycle world championship.

The F1 Grand Prix continued through to 1990, the year Jerez hit the headlines for the wrong reasons when Martin Donnelly suffered an appalling accident. The front suspension failed on the Ulsterman's Lotus-Lamborghini as he entered a very fast right-hander behind the pits. The car disintegrated and Donnelly was flung onto the track. He was fortunate to survive severe leg injuries and would never race in F1 again.

The venue appeared to be doomed, particularly with the rise of an alternative at Barcelona Montmeló, but Jerez was used to stage the European Grand Prix in 1994 and 1997, the latter causing controversy on several fronts as it settled the championship.

Michael Schumacher was stripped of his second place finish in the championship after he was deemed to have deliberately collided with his rival Jacques Villeneuve as the Williams-Renault tried to take the lead. With the championship in his pocket, Villeneuve allowed Mika Häkkinen and David Coulthard to overtake, Williams and McLaren later being accused of colluding to determine the finishing order, a claim that was found to be without foundation.

Meanwhile, the circuit was in trouble for allowing the Mayor of Jerez to disrupt the carefully managed podium procedure. Angered over the embarrassment caused to dignitaries who were supposed to present the trophies, the sport's governing body announced that no further rounds of the FIA F1 World Championship would be held at the Jerez circuit. The track (now with a chicane before the site of Donnelly's accident) continues to be used for F1 testing and other forms of racing.

Despite its location and layout, the Jerez track and F1 failed to attract the vast crowds drawn by motor bike racing.

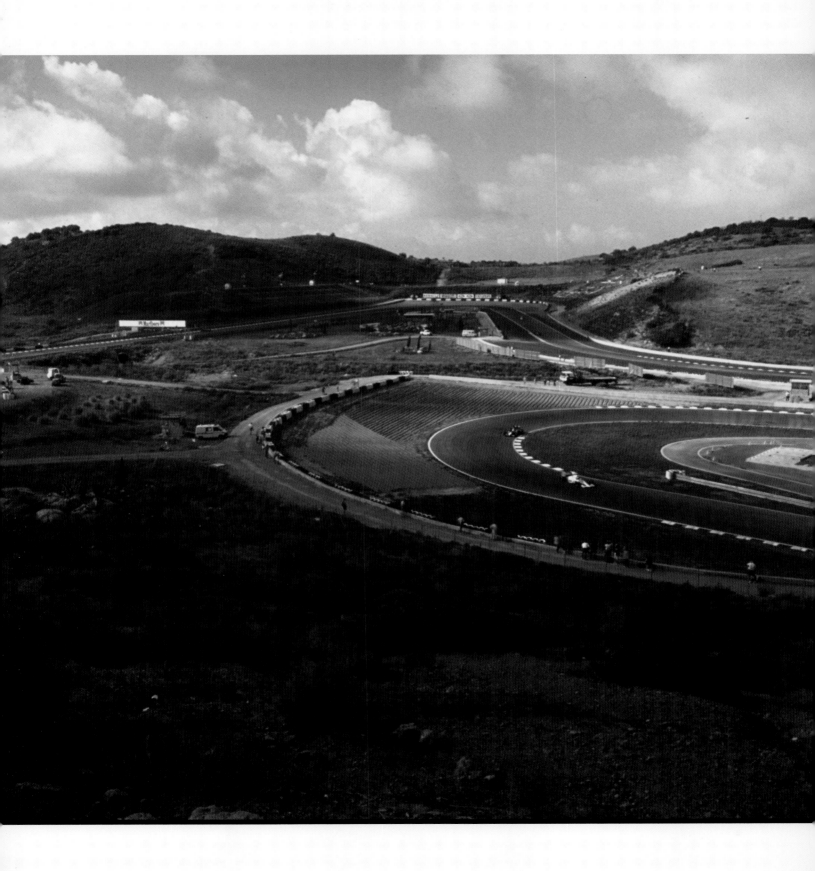

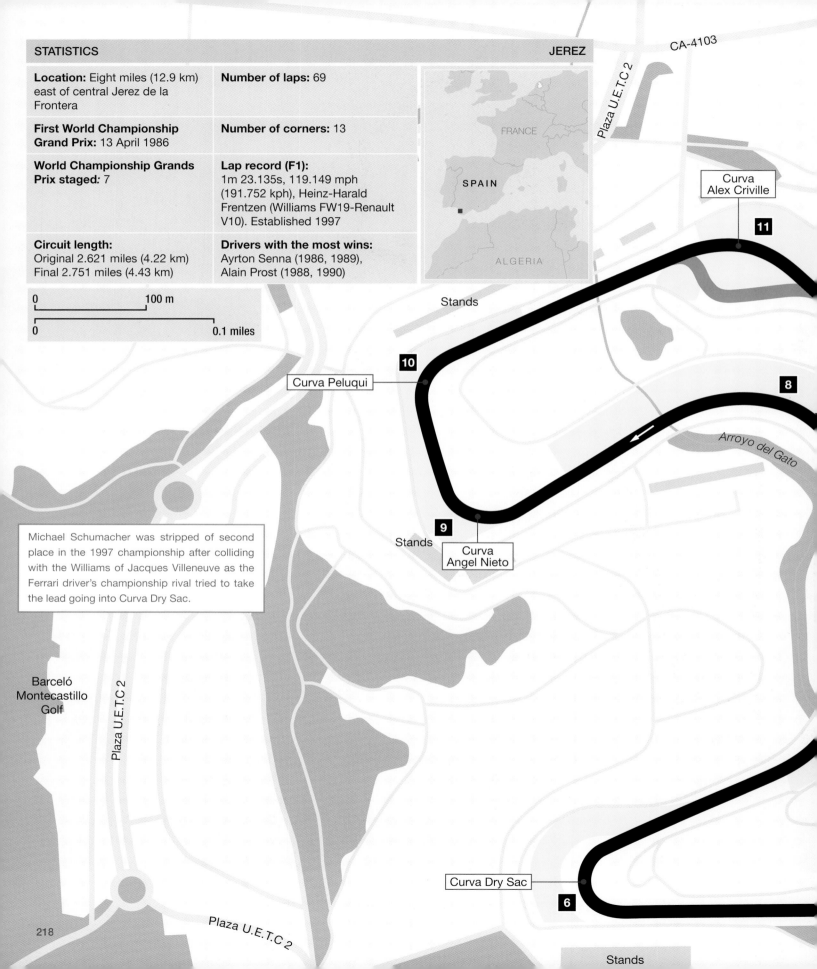

STATISTICS

Location: Eight miles (12.9 km) east of central Jerez de la Frontera

First World Championship Grand Prix: 13 April 1986

World Championship Grands Prix staged: 7

Circuit length:
Original 2.621 miles (4.22 km)
Final 2.751 miles (4.43 km)

Number of laps: 69

Number of corners: 13

Lap record (F1):
1m 23.135s, 119.149 mph (191.752 kph), Heinz-Harald Frentzen (Williams FW19-Renault V10). Established 1997

Drivers with the most wins:
Ayrton Senna (1986, 1989),
Alain Prost (1988, 1990)

FRANCE

SPAIN

ALGERIA

0 100 m

0 0.1 miles

CA-4103

Plaza U.E.T.C 2

Curva
Alex Criville

11

Stands

10

Curva Peluqui

8

Arroyo del Gato

Stands

9

Curva
Angel Nieto

Michael Schumacher was stripped of second place in the 1997 championship after colliding with the Williams of Jacques Villeneuve as the Ferrari driver's championship rival tried to take the lead going into Curva Dry Sac.

Barceló
Montecastillo
Golf

Plaza U.E.T.C 2

Curva Dry Sac

6

Plaza U.E.T.C 2

Stands

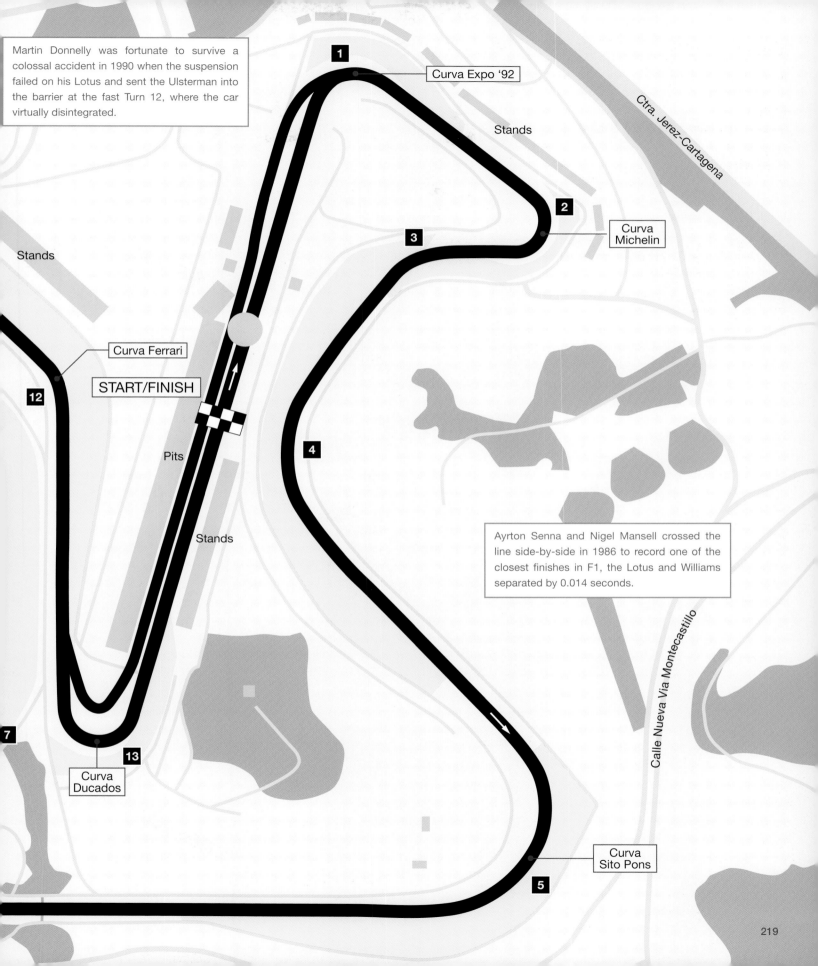

Martin Donnelly was fortunate to survive a colossal accident in 1990 when the suspension failed on his Lotus and sent the Ulsterman into the barrier at the fast Turn 12, where the car virtually disintegrated.

1 Curva Expo '92

Stands

2 Curva Michelin

3

Stands

Curva Ferrari

12

START/FINISH

Pits

4

Stands

Ayrton Senna and Nigel Mansell crossed the line side-by-side in 1986 to record one of the closest finishes in F1, the Lotus and Williams separated by 0.014 seconds.

7

13

Curva Ducados

Curva Sito Pons

5

Ctra. Jerez-Cartagena

Calle Nueva Via Montecastillo

219

Hungaroring 1986

Hungaroring

 HUNGARY

F1's first venture into an Eastern Bloc country took a bit of getting used to for inhabitants and teams alike. The Hungarians, and neighbouring countries, flocked to a purpose-built track tightly laid out in a dust bowl. Survived despite itself and now an established part of the calendar, helped by the faded splendour of Budapest.

Despite its fairly recent arrival on the F1 calendar, Hungary could claim valid and interesting connections with the sport's history. The winner of the first-ever Grand Prix in 1906 was Ferenc Szisz, born in 1873 in Szeghalom, then in the Hungarian part of the former Austro-Hungarian Empire. Szisz, an engineer, drove for Renault and he would doubtless have shown interest in the staging of the first Hungarian Grand Prix in Népliget, a 270-acre park in a south eastern suburb of Budapest.

The 3.1-mile (4.99-km) tight and twisting track provided victory in 1936 for the legendary Tazio Nuvolari's Alfa Romeo (entered by Ferrari) over the might of Mercedes-Benz. The intervention of World War II ended plans for further Grands Prix. The chances of staging such an increasingly capitalist pursuit seemed even more remote decades later as Hungary lay behind the Iron Curtain.

Bernie Ecclestone was the first to explore the possibility of F1 breaking new ground when plans for a Russian Grand Prix stalled and the de facto boss of F1 turned his attention to Hungary. Environmentalists halted a proposal to return to Népliget but the Hungarian government showed support for the idea by approving the construction of a permanent track near Mogyoród, a village 15 miles (24 km) northeast of the capital city.

The site chosen was a natural bowl, the pits located on one side with the track dipping down and crossing the valley to the opposite high ground before returning via a series of tight turns. Apart from the main straight leading to a 180-degree first corner, there was nowhere for the cars to stretch their legs, the rise and fall through a relentless series of corners being compared in some ways to Monaco, but without the imposing surroundings.

A dusty, arid location it may have been but the Hungaroring presented its challenges, particularly in the heat of August on a track made slippery by fine grit migrating from the edges. The tricky surface would be made even more hazardous because of its lack of serious use between each Grand Prix.

A crowd of close to 200,000 people attended the maiden international event, one that would set an inevitable pattern for processional races lasting the best part of two hours. Ferrari's Nigel Mansell would buck the trend in 1989 when he came from 12th on the grid to take the lead from Ayrton Senna with a typically bold move as the McLaren-Honda was briefly boxed in by a back-marker.

Senna would be even more frustrated the following year when he spent most of the race unable to pass the slower Williams-Renault of an unruffled Thierry Boutsen; a scenario which was more in keeping with a track that would receive just one change of note, in 2003, when the main straight was extended. Neither this nor the tightening of the first corner would do little for the track's reputation as a place where it was difficult to overtake.

Nonetheless, the Hungaroring remains popular with fans from across Europe – particularly Finland. The race has made its statistical mark by settling the championship (Mansell in 1992 and Michael Schumacher in 2001) and listing first time F1 winners with Damon Hill (Williams-Renault 1993), Fernando Alonso (Renault 2003), Jenson Button (BAR-Honda 2006), Heikki Kovalainen (McLaren-Mercedes 2008) and Esteban Ocon (Alpine-Renault 2021). The overall winner has been Hungary itself for establishing a niche for a well-organised Grand Prix.

Top: The purpose-built track carved a niche for Hungary in F1 history.

Bottom: Mercedes and Lewis Hamilton on their way to victory in 2020.

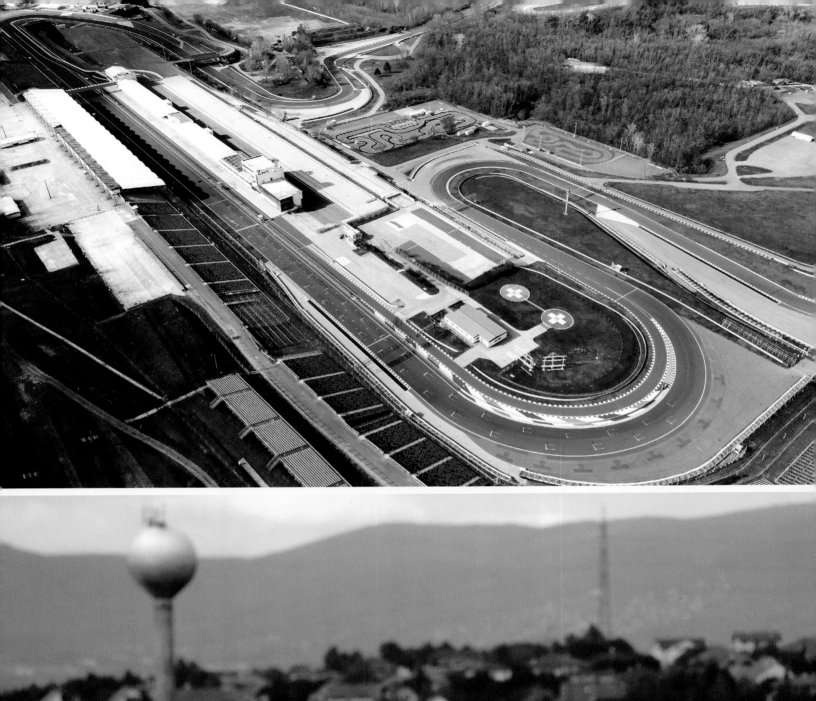
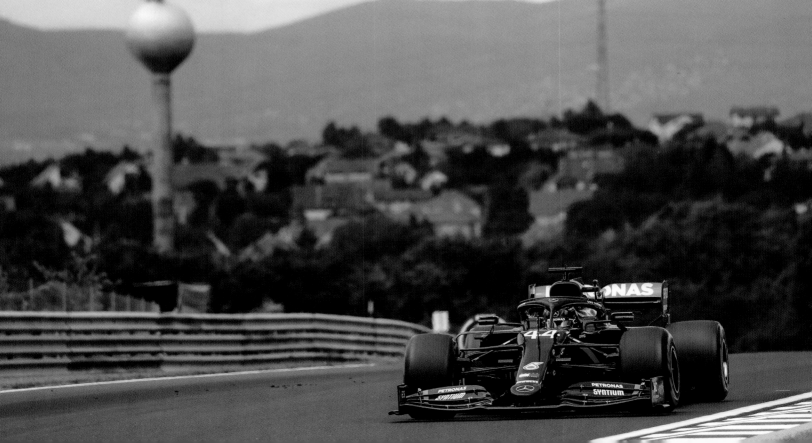

Michael Schumacher was reprimanded in 2010 when the Mercedes driver pushed the Williams-Cosworth of Rubens Barrichello dangerously close to the pit wall.

Felipe Massa was knocked unconscious when the Ferrari driver was struck by a spring that had broken free from the suspension of the Brawn-Mercedes driven by Rubens Barrichello during qualifying for the 2009 Hungarian Grand Prix.

START/FINISH

Stands

14

13

12

Stands

11

10

0 100 m

0 0.1 miles

STATISTICS

HUNGARORING

Location: Fifteen miles (24 km) northeast of Budapest

Number of laps: 70

First World Championship Grand Prix: 10 August 1986

Number of corners: 14

World Championship Grands Prix staged: 36

Lap record (F1):
1m 16.627s, 127.892 mph (205.823 kph) Lewis Hamilton (Mercedes W11). Established 2020

Circuit length:
Original 2.494 miles (4.01 km)
Current 2.722 miles (4.38 km)

Driver with the most wins:
Lewis Hamilton (2007, 2009, 2012, 2013, 2016, 2018, 2019, 2020)

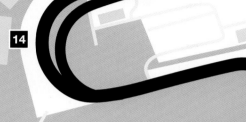

GERMANY POLAND

UKRAINE

HUNGARY

ITALY

Vizi-park út

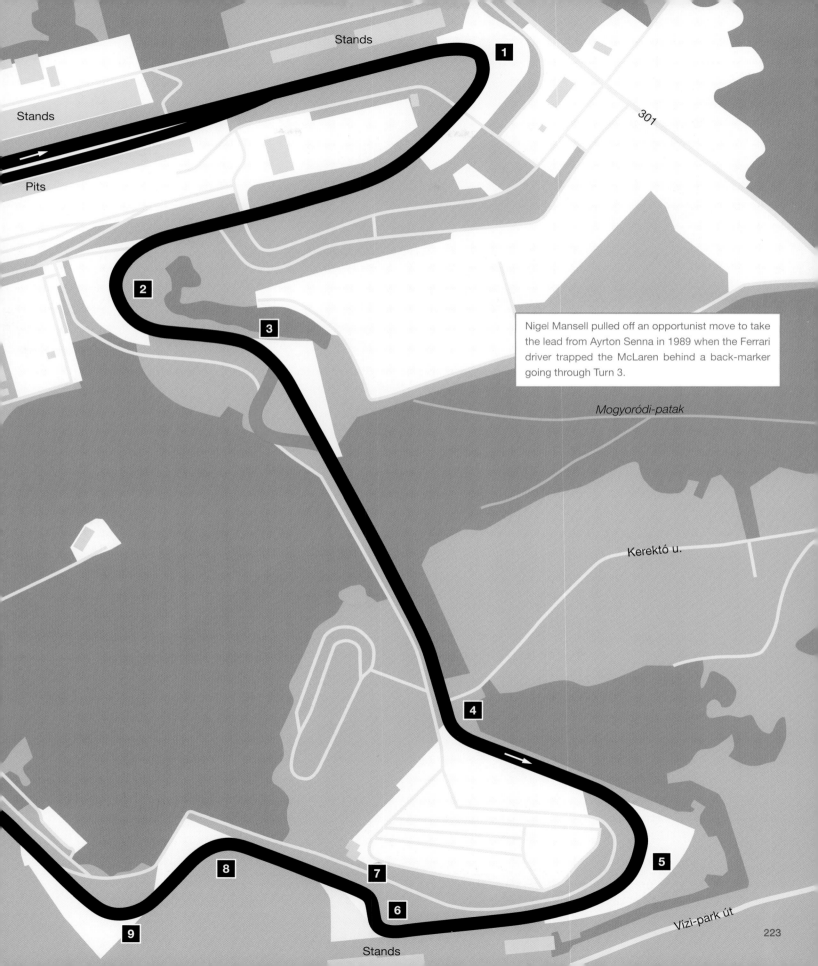

Stands

Stands

Pits

1

301

2

3

Nigel Mansell pulled off an opportunist move to take the lead from Ayrton Senna in 1989 when the Ferrari driver trapped the McLaren behind a back-marker going through Turn 3.

Mogyoródi-patak

Kerektó u.

4

5

8

7

6

9

Vízi-park út

223

Stands

Suzuka 1987

Suzuka International Racing Course

 JAPAN

A design dating back to the early 1960s helps Suzuka stand alone as a fascinating and difficult track in the modern era. Challenging combination of every type of corner, gradient and camber. The only figure-of-eight layout in F1. Remains hugely popular among drivers and the quietly passionate Japanese fans.

Soichiro Honda, founder of the car and motor cycle company, chose a wooded valley alongside rice fields near Suzuka City to build a test track. Designed by John Hugenholtz, the Dutchman responsible for Zandvoort, Suzuka cleverly incorporated every type of corner in a 3.6-mile (5.8-km) figure-of-eight layout. The circuit was opened in September 1962. One of the first races was a sports car 'Grand Prix', won by a Lotus 23 driven by Peter Warr, the Englishman who would later return to Suzuka as boss of the Lotus F1 team.

During one of the first motor cycle events, Ernst Degner was badly injured at the fast corner leading to the bridge underpass. When the East German rider recovered from serious burns, the long curve, later to be split into two tricky right-handers, was named after him.

Suzuka was used extensively but the staging of the Japanese Grand Prix at Mount Fuji in 1976 and 1977 prompted Honda to push for F1. Upgrades included the introduction of a chicane before the downhill plunge past the pits, the realignment of Spoon Curve to create a large run-off area and rebuilding of the pits and paddock, plus the addition of an upgraded medical centre.

When the F1 teams arrived for the first Grand Prix in November 1987, they were struck by not only the circuit's variety but also the unique ambience created by quietly passionate fans and an impressive permanent funfair alongside. The drivers immediately relished a track that presented a wonderful blend of corners, starting with a downhill swoop to never-ending Esses that rose to a blind and fast left-hander before the seemingly innocuous Degner corners. And so it continued, running beneath a return leg boasting the awesome 130R, a very quick left-hander that was not quite flat-out.

Enthusiasm for the arrival of a Grand Prix was so great that the grandstand tickets had to be allocated by lottery and fans slept on the entrance roads overnight in order to be sure of general admission.

They were to be mildly disappointed when a much trumpeted title fight was actually settled during qualifying. The battle between Williams-Honda drivers Nigel Mansell and Nelson Piquet ended abruptly when Mansell crashed. His Brazilian team-mate became 1987 World Champion as he stood in the garage and watched Mansell being lifted from the car and taken to hospital with a back injury.

Being at or near the end of the season, the Japanese Grand Prix would see the crowning of several champions, usually under dramatic circumstances, none more so than in 1989 and 1990 when Alain Prost and Ayrton Senna managed to collide on both occasions, the title going to Prost and then, twelve months later, to Senna.

In 1991, the chicane was moved closer to the final corner to allow an earlier entry to the pit lane. Ten years later, the pit entry would be returned close to its original position as part of a £18 million package of improvements covering new run-off areas, repositioned walls and a reprofiling of the Esses and Dunlop corner sections.

The most controversial change followed in the wake of a huge crash for Allan McNish in 2002, the Toyota driver spearing through the crash barrier – fortunately without serious injury to himself – after trying to take 130R flat. The previously daunting left-hander was eased to become safer and, in the view of some, a dilution of Suzuka's unique test of skill and bravery.

When Fuji appeared to be queering Suzuka's pitch in 2007 and 2008, a further programme of much-needed redevelopment led to new pits and paddock. The degree of difficulty remained, as proved in the worst possible way when Jules Bianchi spun off a wet track in fading light and suffered grievous injury as his Marussia-Ferrari hit a rescue vehicle in 2014. The fact that Suzuka should survive the subsequent controversy was seen as a further indication of its place among the great racetracks of the world.

One of the many novelties at Suzuka is a first-class fairground close by a challenging circuit. Mark Webber's Red Bull-Renault tackles the Casio Triangle chicane in 2013.

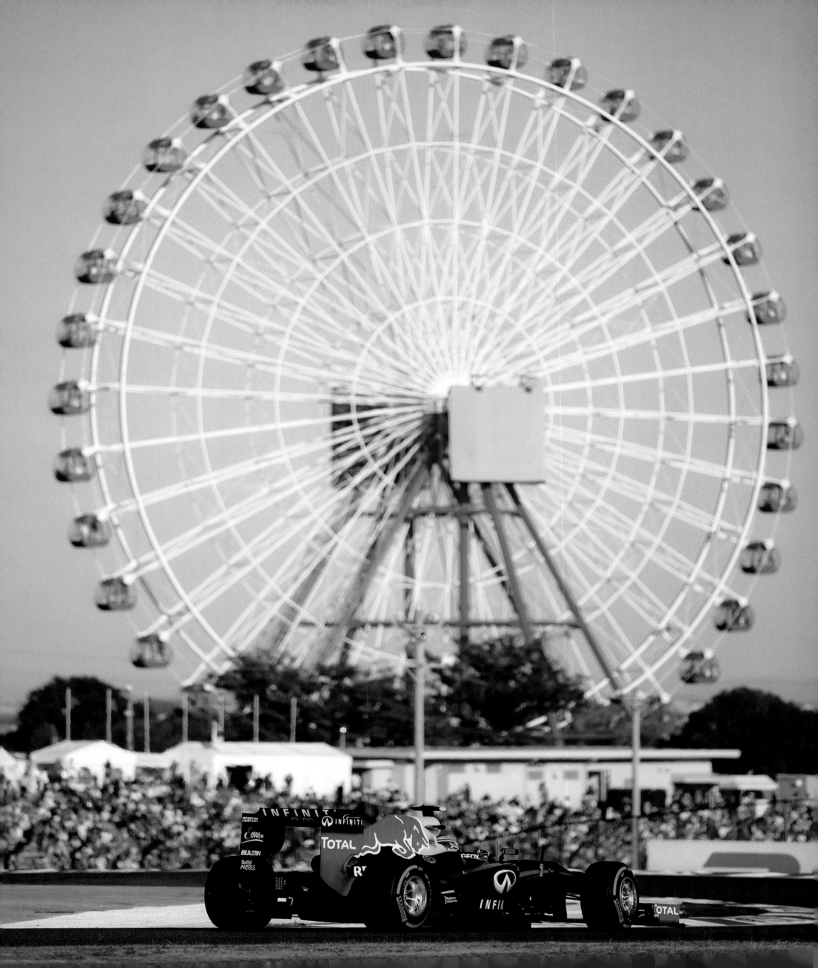

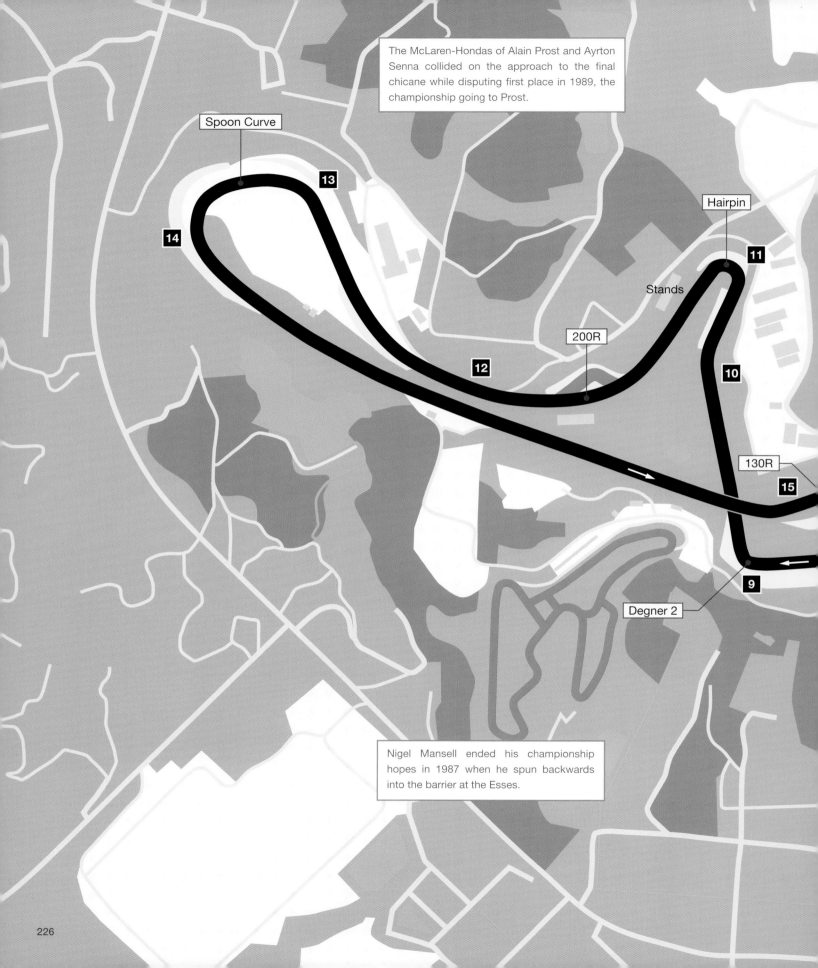

The McLaren-Hondas of Alain Prost and Ayrton Senna collided on the approach to the final chicane while disputing first place in 1989, the championship going to Prost.

Spoon Curve

13

14

Hairpin

11

Stands

200R

12

10

130R

15

Degner 2

9

Nigel Mansell ended his championship hopes in 1987 when he spun backwards into the barrier at the Esses.

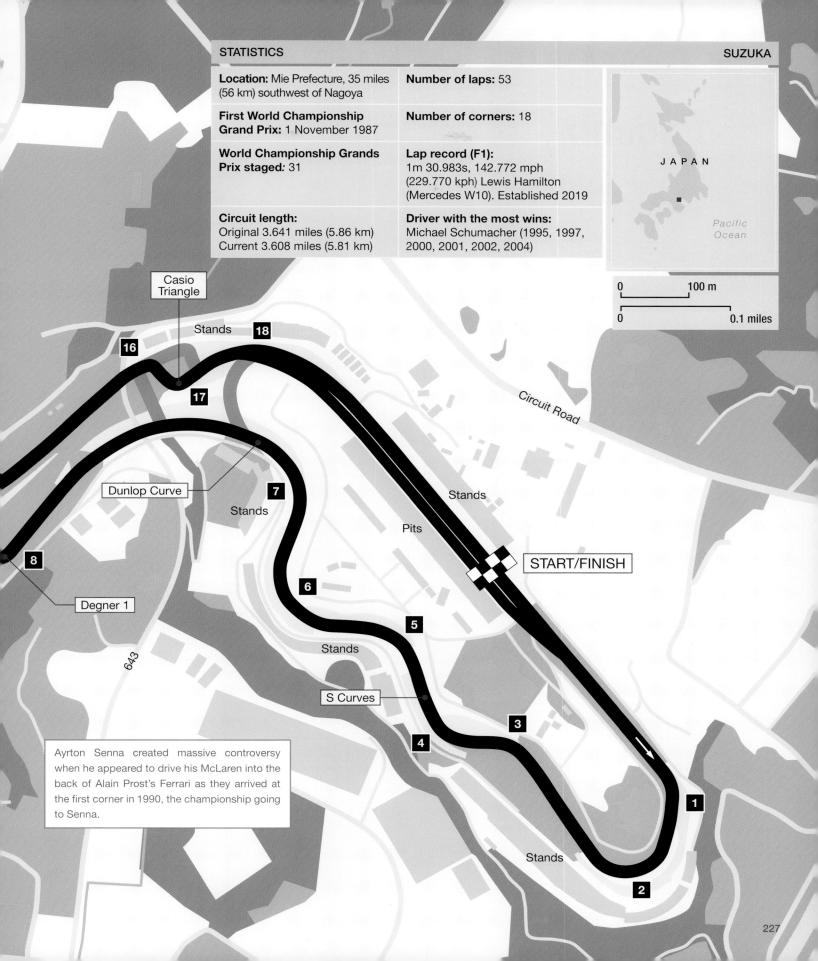

STATISTICS

Location: Mie Prefecture, 35 miles (56 km) southwest of Nagoya

First World Championship Grand Prix: 1 November 1987

World Championship Grands Prix staged: 31

Circuit length:
Original 3.641 miles (5.86 km)
Current 3.608 miles (5.81 km)

Number of laps: 53

Number of corners: 18

Lap record (F1):
1m 30.983s, 142.772 mph (229.770 kph) Lewis Hamilton (Mercedes W10). Established 2019

Driver with the most wins: Michael Schumacher (1995, 1997, 2000, 2001, 2002, 2004)

JAPAN

Pacific Ocean

0 100 m

0 0.1 miles

Casio Triangle

Stands

16

18

17

Circuit Road

Dunlop Curve

7

Stands

Stands

8

Degner 1

6

Pits

START/FINISH

643

Stands

5

S Curves

3

4

Stands

Ayrton Senna created massive controversy when he appeared to drive his McLaren into the back of Alain Prost's Ferrari as they arrived at the first corner in 1990, the championship going to Senna.

1

2

Stands

227

Phoenix 1989

Phoenix Street Circuit

 UNITED STATES OF AMERICA

Failed to click from the outset. A dull and level combination of streets did nothing for the drivers and failed to attract spectators. Opened the season twice but an absence of charisma and promotion led to its demise after just three races.

Detroit's failure to come up to scratch led to F1 looking for yet another venue in the United States for 1989. The answer – for the time being – was a five-year deal to run a race through the streets of downtown Phoenix in Arizona.

Predictably, there were detractors, one disgruntled resident writing to the *Phoenix Gazette* to complain about the $8 million so-called 'investment' by the city fathers. 'Phoenix does not need such an event,' wrote Marvin A Pringle. 'Most people would not consider sitting in temperatures over 100°F for two or three hours to view a basically boring event.'

Mr. Pringle made a couple of valid points. The positioning of the race in the calendar may have made logistical sense, coming as it did between Mexico and Canada, but a date in early June was asking for trouble in the desert heat. The timing was also unfortunate because the Grand Prix would be at the end of the Memorial Day week, bringing an inevitable comparison with a sensational finish to the Indianapolis 500 in which Emerson Fittipaldi had edged Al Unser Junior into the wall with just over a lap to go. F1, meanwhile, was coming off the back of a series of races dominated by Ayrton Senna and McLaren-Honda.

On the plus side, the disruption to the comparatively easy-going way of life in Phoenix was minimal compared to Detroit where angry office workers had found their routes to work barred by concrete barriers. According to the *Phoenix Gazette*, the major issue had been the re-siting of a bus stop for the service to the local zoo.

The careful planning had nevertheless been unable to overcome the restrictions imposed by the right-angle corners endemic to American cities and which, coincidentally, were ideal for the punchy acceleration of the McLaren-Honda.

Compared to Detroit, however, the streets were wide and less claustrophobic when viewed from the cockpit of a racing car. The 2.36-mile (3.8-km) track had two straights running either side of the majestic City Courthouse and linked by a loop around Civic Plaza, a modern complex which, like the rest of the city, was both spotless and soulless at the same time. The final half-mile included a dogleg along Third and Fifth Avenues, which had the unfortunate effect of bringing drivers face-to-face with the bright lights of Moore's Mortuary on the corner of West Adams Street. As ever, the streets were bumpy but, overall, drivers considered this an improvement over Detroit – which, according to McLaren's Alain Prost, was not too difficult.

Prost had never hidden his dislike of Motor City. His feelings for Phoenix can only have been improved by a victory that eased him to the top of the championship following Senna's retirement from the lead with an electrical problem. The pity was that a mere 31,411 spectators had paid to watch a race lasting two hours.

Senna made up for it by winning in 1990. The switch to a date in March brought the anticipated fall in temperature and, surprisingly, enough rain to rule out qualifying on the second day. But the spectators continued to stay away. The eastern end of the circuit was moved a few blocks to provide a slightly more flowing profile that raised the average speed by a modest 3 mph (4.8 kph) in 1991. When Senna completely dominated the weekend once more, the end of Phoenix as a Grand Prix venue was in sight, the final word perhaps being news in the *Gazette* that an Ostrich Festival on the same day had attracted a bigger crowd.

This picture sums up motor racing on the streets of Phoenix, the locals preferring to play tennis rather than watch F1.

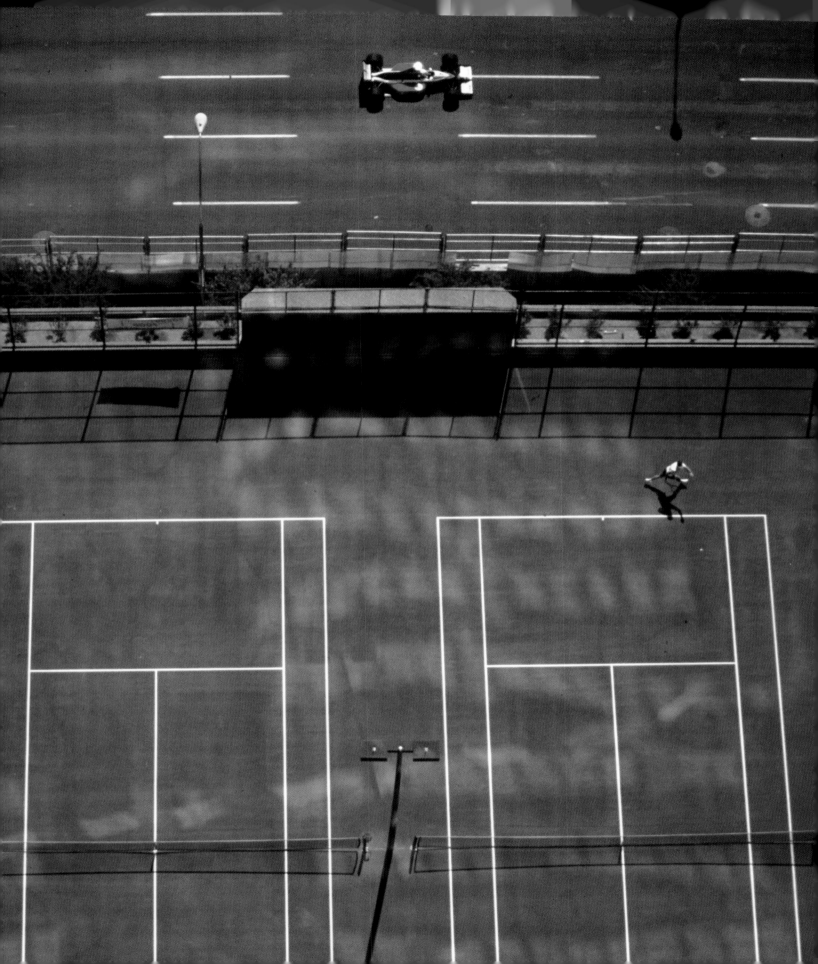

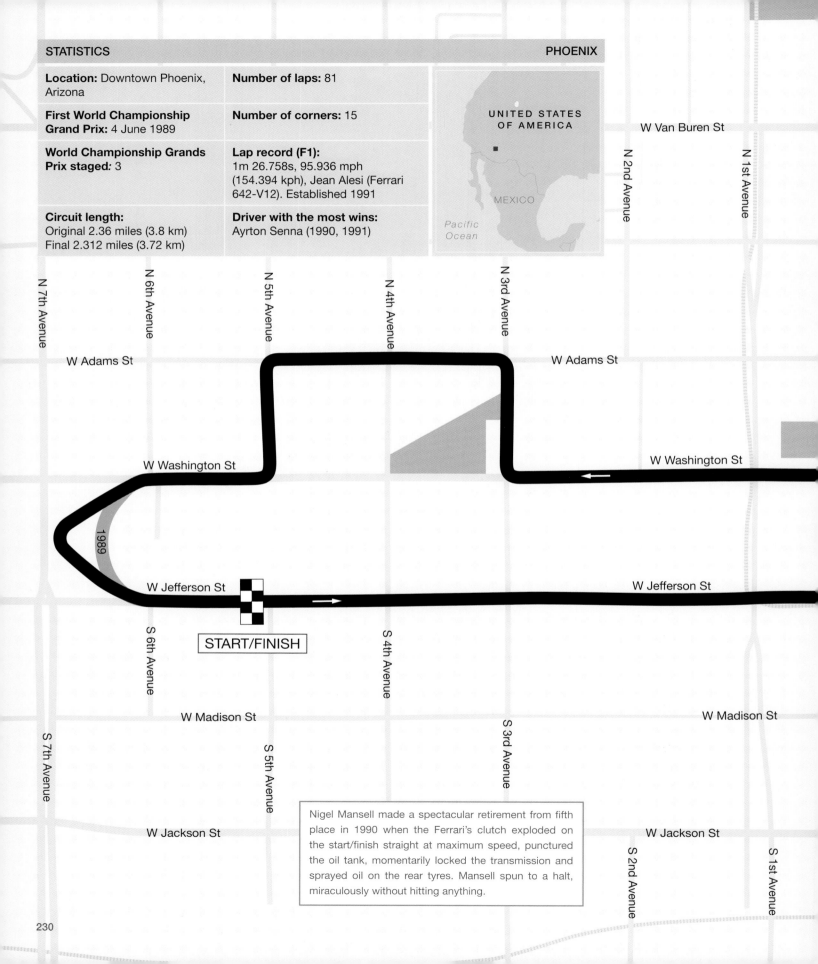

STATISTICS

PHOENIX

Location: Downtown Phoenix, Arizona

First World Championship Grand Prix: 4 June 1989

World Championship Grands Prix staged: 3

Circuit length:
Original 2.36 miles (3.8 km)
Final 2.312 miles (3.72 km)

Number of laps: 81

Number of corners: 15

Lap record (F1):
1m 26.758s, 95.936 mph
(154.394 kph), Jean Alesi (Ferrari
642-V12). Established 1991

Driver with the most wins:
Ayrton Senna (1990, 1991)

UNITED STATES
OF AMERICA

MEXICO

Pacific
Ocean

W Van Buren St

N 2nd Avenue

N 1st Avenue

N 7th Avenue

N 6th Avenue

N 5th Avenue

N 4th Avenue

N 3rd Avenue

W Adams St

W Adams St

W Washington St

W Washington St

1989

W Jefferson St

W Jefferson St

START/FINISH

S 6th Avenue

S 4th Avenue

S 3rd Avenue

S 7th Avenue

S 5th Avenue

S 2nd Avenue

S 1st Avenue

W Madison St

W Madison St

W Jackson St

W Jackson St

Nigel Mansell made a spectacular retirement from fifth place in 1990 when the Ferrari's clutch exploded on the start/finish straight at maximum speed, punctured the oil tank, momentarily locked the transmission and sprayed oil on the rear tyres. Mansell spun to a halt, miraculously without hitting anything.

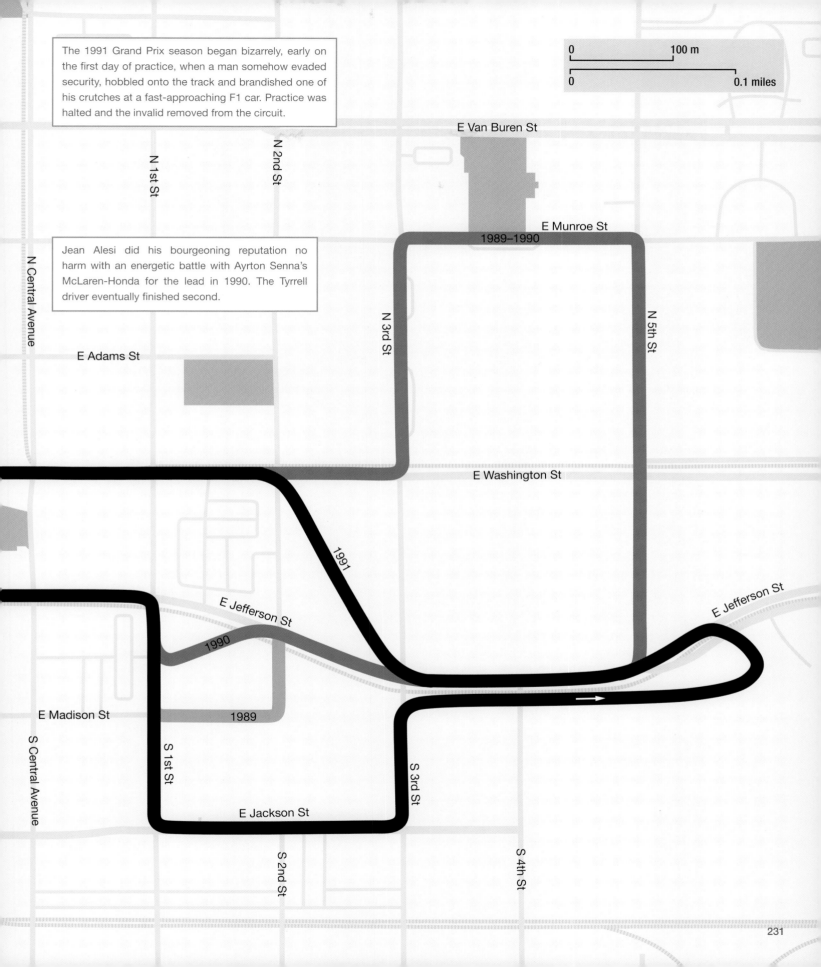

The 1991 Grand Prix season began bizarrely, early on the first day of practice, when a man somehow evaded security, hobbled onto the track and brandished one of his crutches at a fast-approaching F1 car. Practice was halted and the invalid removed from the circuit.

Jean Alesi did his bourgeoning reputation no harm with an energetic battle with Ayrton Senna's McLaren-Honda for the lead in 1990. The Tyrrell driver eventually finished second.

0 100 m
0 0.1 miles

E Van Buren St

N 1st St

N 2nd St

E Munroe St

1989–1990

N 3rd St

N 5th St

E Adams St

E Washington St

1991

E Jefferson St

E Jefferson St

1990

E Madison St

1989

N Central Avenue

S Central Avenue

S 1st St

S 2nd St

S 3rd St

S 4th St

E Jackson St

Magny-Cours 1991

Circuit de Nevers Magny-Cours

 FRANCE

A former club circuit. Received an extension and major update as a political move to bring interest and industry to rural France. Super-smooth surface but not considered hugely challenging when hosting F1 for 18 years before lack of interest spelled the end of the F1 venue and, with it, the world's oldest Grand Prix.

As an indication of its modest beginning, the track was conceived in 1960 by a farmer on land next to his home on the RN7, close to the village of Magny-Cours. A mere 1.21 miles (1.95 km) in length, the track received a boost with the establishment of the Winfield Racing School, which would go on to produce a string of Grand Prix winners for France.

The length was doubled in 1971 thanks to the addition of a loop but it was not taken seriously on an international basis until the mid 1980s when the regional government saw the track as an investment and promotional tool. Magny-Cours, near the town of Nevers in central France, 160 miles (257.5 km) south of Paris and 150 miles (241.4 km) northwest of Lyon, was in danger of becoming an industrial backwater, not helped by the race track having deteriorated to the point of closure.

President Mitterrand, a former deputy for the local region, put his political weight behind developing the Nevers area ahead of re-election. His plans included a major revamp of the Magny-Cours circuit in the hope of wresting the French Grand Prix from Paul Ricard.

Close to $25 million was spent as the pits and paddock, formerly on the descent from Château d'Eau, were moved to the outside of the track, making Lycée the final corner. Beyond that, the expansion of an industrial complex succeeded in attracting leading racing teams and manufacturers, including Ligier and Martini. The track, incorporating new corners that were facsimiles of others from existing race venues such as Imola and the Nürburgring, was opened in 1989 and hosted its first French Grand Prix two years later.

Reactions were mixed. While few could fault the facilities, some drivers thought the 2.654-mile (4.27-km) track was too tight and lacked a decent straight while others felt it was well-surfaced and better than Paul Ricard. Either way, race fans, relishing the thought of no longer having to travel to the south of France, came in their thousands – and found access to be woefully inadequate, so much so that the local gendarmerie had their work cut out turning away irate ticket holders. Even the disappointment of seeing the Ferrari of local hero Alain Prost being denied the lead by Nigel Mansell's Williams-Renault would have been worth experiencing, if only they could have got in.

In 2003, in the hope of improving overtaking opportunities, a new complex was added at the final corner. It made little obvious difference, the one unexpected advantage coming from a shorter pit lane. With pit visits taking less time, Michael Schumacher managed to win in 2004 by stopping no less than four times. In many ways, Schumacher was making Magny-Cours his own as he went on to set a record by winning eight times at the same circuit.

By the time of his final victory in 2006, complaints were growing about a narrow pit lane and facilities considered no longer up to the mark. Financial problems were mounting and, after much toing and froing, the Grand Prix in 2008 would be the last. Apart from the regrettable loss of the French Grand Prix itself, there was a notable ambivalence within F1 about no longer having to return to the flat expanses of Magny-Cours.

Top: A smart facility, with a smooth surface, built with government assistance to help foot the $25 million bill.

Bottom: Michael Schumacher made no less than four pit stops on his way to victory in 2004.

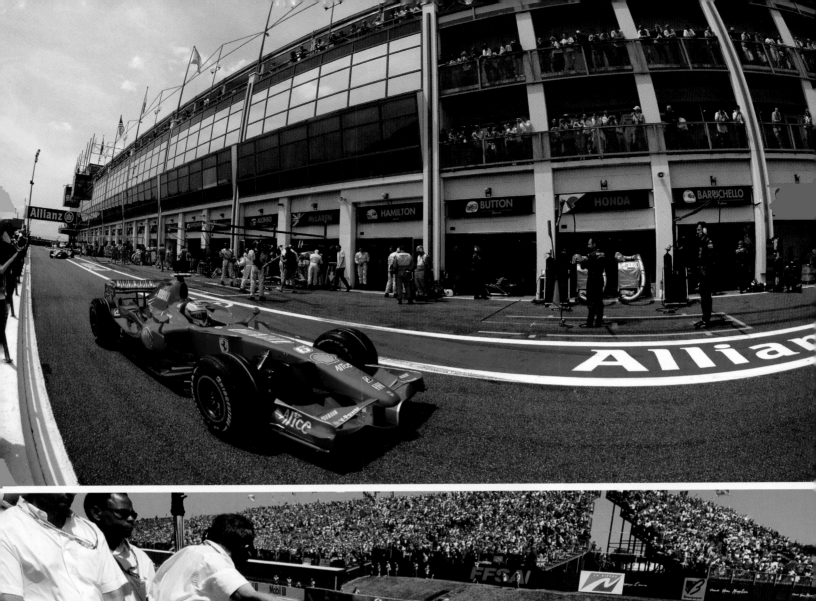

The original Lycée corner was a tight right-hander, followed immediately by the finishing line. In 1991, on F1's first visit to the track, Ayrton Senna took the corner faster than he normally would at the end of his qualifying lap, knowing that even if he lost control – which he did – he would still trigger the timing beam and the lap would count. The time was only good enough for third on the grid.

0 100 m

0 0.1 miles

D58

15

Lycée

16

Stands

17

Les Grandes Gayères

Stands

Route du Circuit

Stands

13

14

Châteaux d'Eau

Imola

12

Stands

6

Adelaide

5

Golf

4

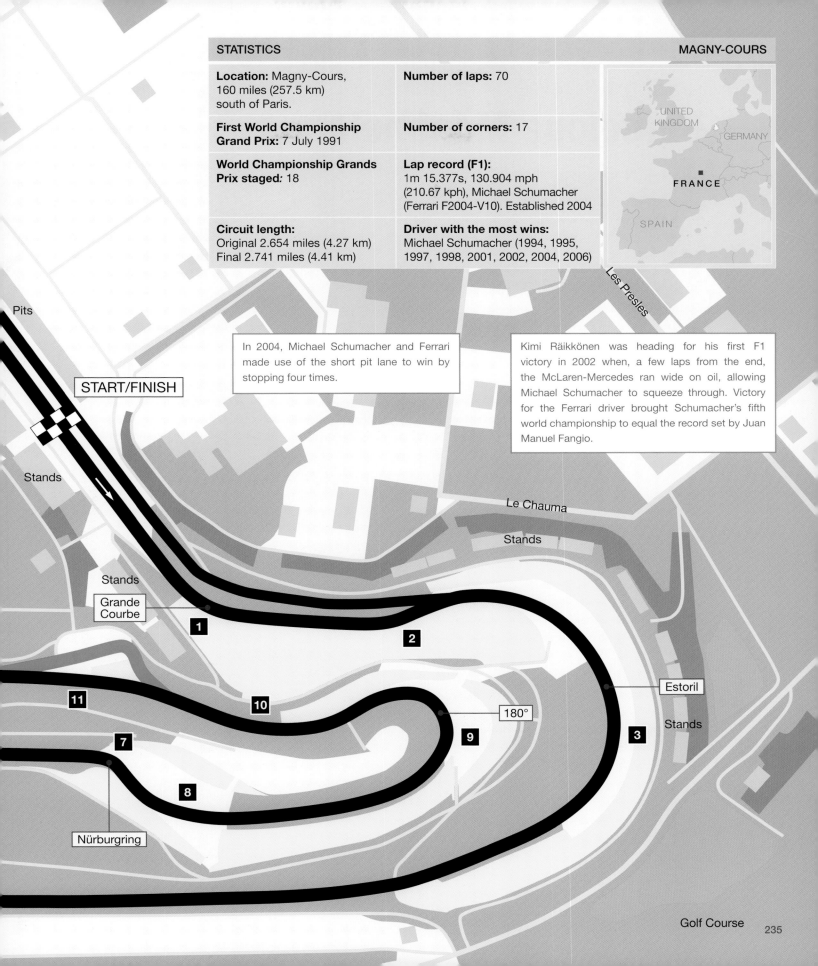

Location: Magny-Cours, 160 miles (257.5 km) south of Paris.

Number of laps: 70

First World Championship Grand Prix: 7 July 1991

Number of corners: 17

World Championship Grands Prix staged: 18

Lap record (F1): 1m 15.377s, 130.904 mph (210.67 kph), Michael Schumacher (Ferrari F2004-V10). Established 2004

Circuit length: Original 2.654 miles (4.27 km) Final 2.741 miles (4.41 km)

Driver with the most wins: Michael Schumacher (1994, 1995, 1997, 1998, 2001, 2002, 2004, 2006)

UNITED KINGDOM
GERMANY
FRANCE
SPAIN

Les Presles

In 2004, Michael Schumacher and Ferrari made use of the short pit lane to win by stopping four times.

Kimi Räikkönen was heading for his first F1 victory in 2002 when, a few laps from the end, the McLaren-Mercedes ran wide on oil, allowing Michael Schumacher to squeeze through. Victory for the Ferrari driver brought Schumacher's fifth world championship to equal the record set by Juan Manuel Fangio.

Pits

START/FINISH

Stands

Le Chauma

Stands

Stands

Stands

Grande Courbe

1

2

Estoril

11

10

180°

3

Stands

7

9

8

Nürburgring

Golf Course

235

Barcelona Montmeló 1991

Circuit de Barcelona-Cataluña

 SPAIN

Well thought out in every respect. A reasonable layout with good spectator viewing, facilities and a direct rail link to nearby Barcelona. Poor initial attendances, boosted to sell-out by the rise of Fernando Alonso in the 1990s. Used frequently for testing when it was allowed between races.

Spain was thought to be taking a gamble when plans were rushed through to have a new track made ready in time for the 1991 season. The original intention had been to introduce the Circuit de Cataluña at Montmeló 12 months later during Barcelona's Olympic year: forcing an early completion seemed to be inviting further trouble in a country where few would be bothered to attend in the first place. The worst fears appeared to be confirmed when word came through of hopeless communications, poor access and unfinished facilities, a picture of gloom exacerbated by severe thunderstorms early in race week adding additional mud to the potential chaos.

Cometh the hour, cometh the sunshine and a race track that surprised everyone with its interesting design. Laid out on the side of a hill, the circuit had undulations and a variety of corners, the final one – a fast downhill right – feeding a long, wide straight and the need for overtaking at the end of it. The location close by an industrial estate was not promising but the key would be Montmeló's proximity to central Barcelona and a direct rail link adding to the access provided by the nearby motorway network.

With a date in September and three races to run in the season, the Spanish Grand Prix was seen as Nigel Mansell's last chance to stay in touch with Ayrton Senna at the top of the championship. Mansell had to win, which is exactly what he did as he took the fight to Senna, the Williams-Renault and McLaren-Honda, sparks flying as they ran wheel-to-wheel for some distance at 190 mph (306 kph), becoming one of the most iconic sights in motor sport. The Circuit de Cataluña had begun to establish itself, and would continue to do so despite the lack of enthusiasm among Spaniards for F1.

That began to change in 2003 when Fernando Alonso, having spent two seasons on the fringe with Minardi and then as a test driver, became part of the Renault race team and started to claim pole positions and won his first Grand Prix in Hungary in August. With the Spanish race having switched to May, the fans would have to wait until 2004 before welcoming the new national hero, Alonso then ensuring a 140,000 capacity crowd by becoming champion in 2005 and winning at home the following year.

By now, the rise in importance of a car's aerodynamics meant that overtaking had become more difficult and cornering speeds higher. For 2007, a chicane was inserted on the approach to the final corner but it did little for the racing (the same being said for the tightening of La Caixa a few years before – although this would be remodelled yet again in 2021). Barcelona was also suffering because extensive testing at the track meant cars were as close to a competitive set up as they were ever likely to be, a familiarity that led to a lack of on-track action during practice until the ban on testing between races.

Nonetheless, the Circuit de Barcelona-Cataluña (the track name was changed in 2013 in recognition of a sponsorship deal with Barcelona City Council) remains popular because of its excellent spectating points and location close to a colourful city well served by an international airport.

The Williams-Renault (5) of Nigel Mansell and Ayrton Senna's McLaren-Honda gave the track a thrilling introduction to F1 in 1991 when they raced wheel-to-wheel on the main straight.

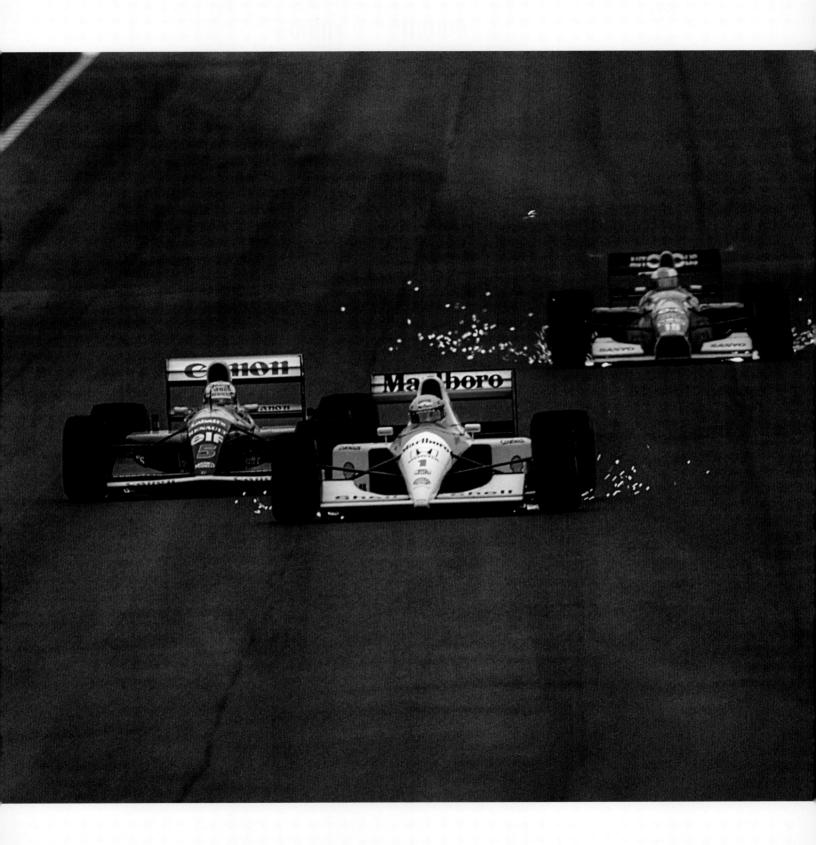

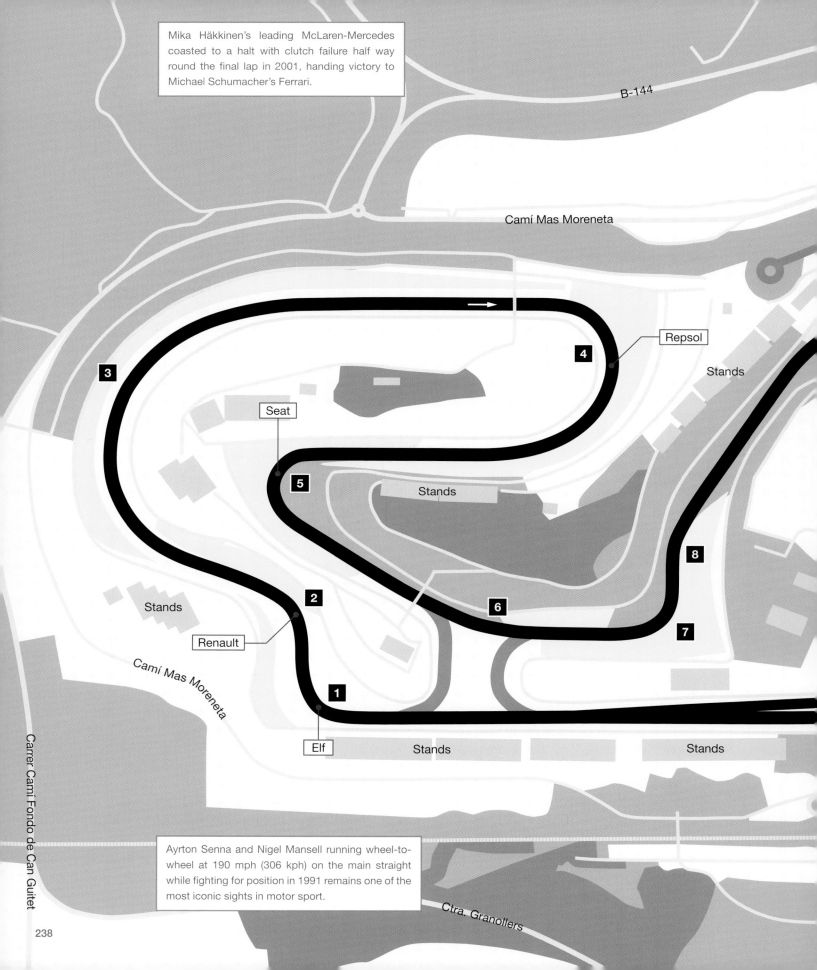

Mika Häkkinen's leading McLaren-Mercedes coasted to a halt with clutch failure half way round the final lap in 2001, handing victory to Michael Schumacher's Ferrari.

B-144

Camí Mas Moreneta

Repsol

Stands

4

3

Seat

5

Stands

8

2

Stands

6

7

Renault

Camí Mas Moreneta

1

Stands

Elf

Stands

Stands

Carrer Camí Fondo de Can Guitet

Ayrton Senna and Nigel Mansell running wheel-to-wheel at 190 mph (306 kph) on the main straight while fighting for position in 1991 remains one of the most iconic sights in motor sport.

Ctra. Granollers

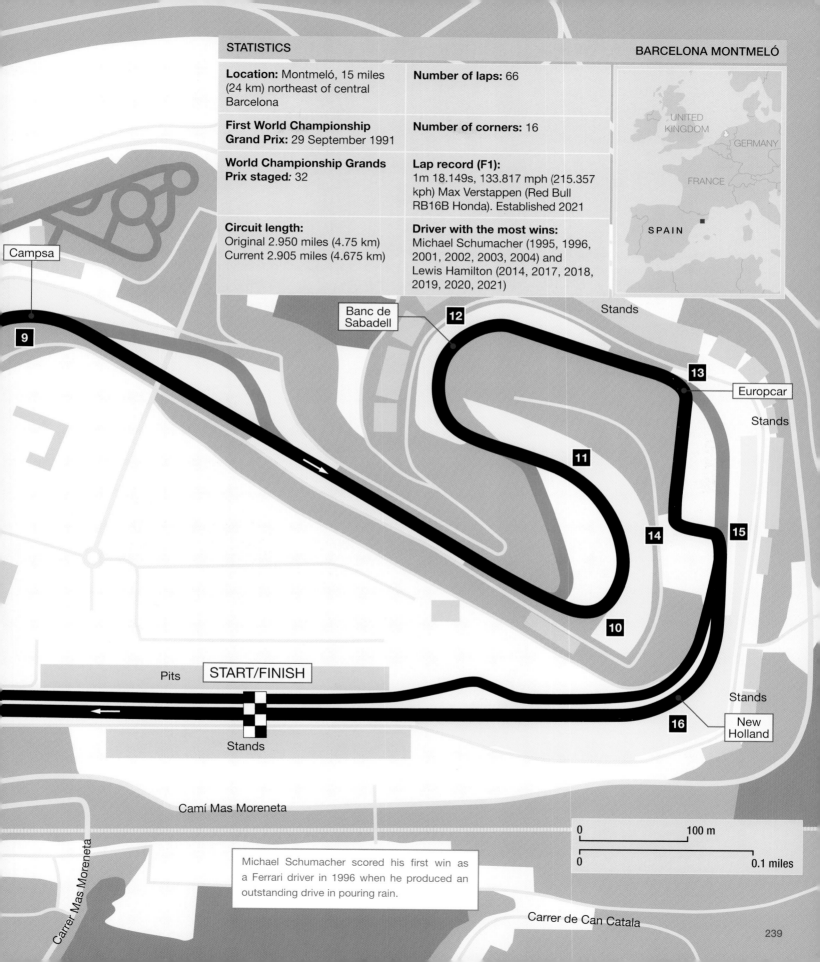

STATISTICS

BARCELONA MONTMELÓ

Location: Montmeló, 15 miles (24 km) northeast of central Barcelona

First World Championship Grand Prix: 29 September 1991

World Championship Grands Prix staged: 32

Circuit length:
Original 2.950 miles (4.75 km)
Current 2.905 miles (4.675 km)

Number of laps: 66

Number of corners: 16

Lap record (F1):
1m 18.149s, 133.817 mph (215.357 kph) Max Verstappen (Red Bull RB16B Honda). Established 2021

Driver with the most wins:
Michael Schumacher (1995, 1996, 2001, 2002, 2003, 2004) and Lewis Hamilton (2014, 2017, 2018, 2019, 2020, 2021)

Campsa

9

Banc de Sabadell

12

13

Europcar

Stands

Stands

11

14

15

10

START/FINISH

Pits

Stands

16

New Holland

Stands

Stands

Camí Mas Moreneta

Carrer Mas Moreneta

Carrer de Can Catala

0 100 m

0 0.1 miles

Michael Schumacher scored his first win as a Ferrari driver in 1996 when he produced an outstanding drive in pouring rain.

Aida 1994

Tanaka International Circuit Aida

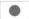 JAPAN

Originally, a private club and race track for wealthy car owners. Hosted the Pacific Grands Prix in 1994 and 1995. Not particularly demanding. Discontinued as a F1 venue because of the location in a remote area of Japan. Spectators and F1 personnel had to be bussed in and out.

Golf club magnate Hajime Tanaka owned more than 50 courses in Japan and had the idea of applying the same model for wealthy motor enthusiasts. Tanaka bought land in Mimasaka, a remote and hilly area of the Okayama Prefecture, and built a race track, club house and hotel, part-funding the project with $120,000 for life membership of this exclusive venture. More than 300 of Japan's motoring elite, plus motor manufacturers such as Nissan and Toyota, invested in the idea. The circuit, opened in November 1990, was known as TI Circuit Aida (TI referring to Tanaka International; Aida being the closest town).

Measuring 2.3 miles (3.7 km) and restricted somewhat by the mountainous terrain, the track had a reasonable straight and some elevation but was predominantly compact with a tight infield section. By 1992, the TI circuit was being used for national touring car racing.

Tanaka had grander ideas even though he knew Suzuka possessed a monopoly on the Japanese Grand Prix. Nonetheless, his timing was fortuitous since Bernie Ecclestone was looking to expand F1 in the Far East. With support from Okayama Prefecture, a deal was done to host the Pacific Grand Prix, the second round of the 1994 championship. It seemed to matter little that running a major international race in this lofty location would be a logistical nightmare.

A single narrow road, climbing at least 10 miles (16 km) through this remote area, served the circuit. With no room for parking and just one hotel at the track itself, all of the spectators and a large proportion of F1 personnel had to be brought in each day by fleets of coaches and minibuses from various overcrowded towns, the major cities and hotels being more than 100 miles (161 km) away. The novelty value quickly wore off thanks to seemingly endless traffic queues.

The race was won by the Benetton-Ford of Michael Schumacher, much of the potential interest having been eliminated at the first corner when another competitor took out Ayrton Senna's pole position Williams-Renault.

The race was earmarked for the same month in 1995 but had to be rescheduled for later in the year following an earthquake 70 miles (113 km) away in Kobe. The result was another win for Schumacher, although this time the Benetton-Renault driver had to work hard after a tough battle with the Williams-Renaults of Damon Hill and David Coulthard.

There were few regrets when a decline in enthusiasm on all sides meant the Grand Prix would not return. The circuit has since changed hands and been renamed Okayama International Circuit for the staging of occasional national races.

Top: Out of the way and out of the ordinary, Aida failed as a Grand Prix venue.

Bottom: Michael Schumacher won both Grands Prix. This is his first in the Benetton-Ford in 1994.

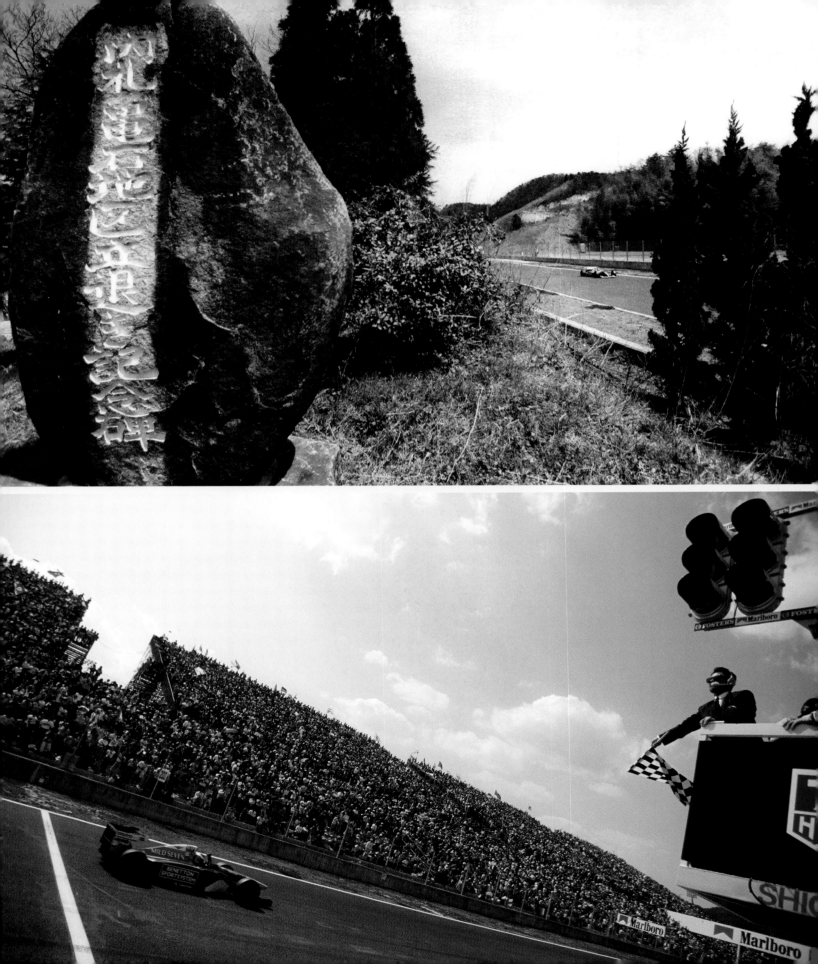

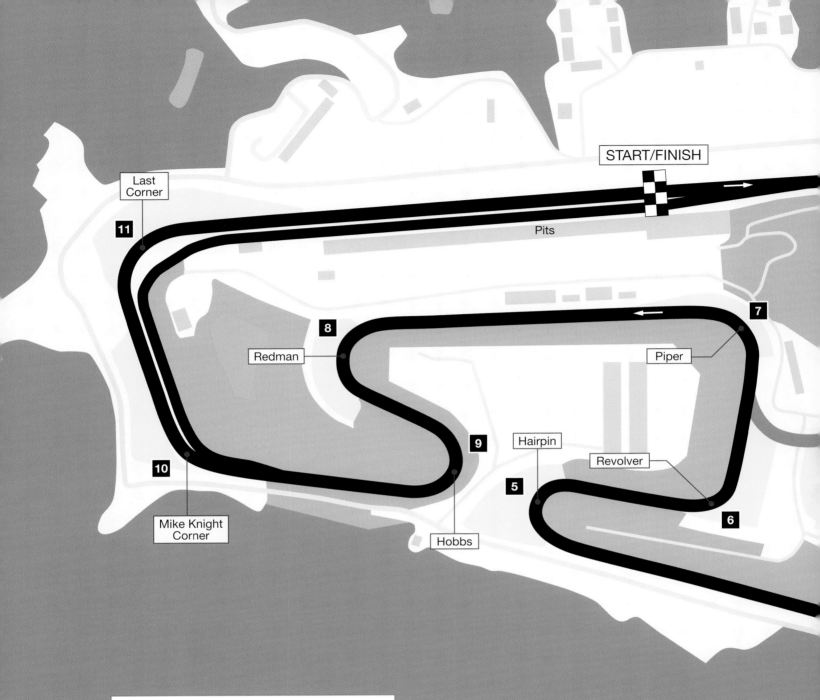

START/FINISH

Pits

Last Corner

11

8

Redman

7

Piper

9

Hairpin

5

Revolver

10

6

Mike Knight Corner

Hobbs

Michael Schumacher clinched his second title by winning the final Grand Prix at TI Aida in 1995. When Damon Hill, a close rival in this race, went to congratulate Schumacher on the podium, the World Champion complained about Hill's driving.

On the first-ever racing lap in 1994, the McLaren-Peugeot of Mika Häkkinen tapped the back of Ayrton Senna's car and sent the Williams-Renault into a spin at the first corner, where it was hit by another car.

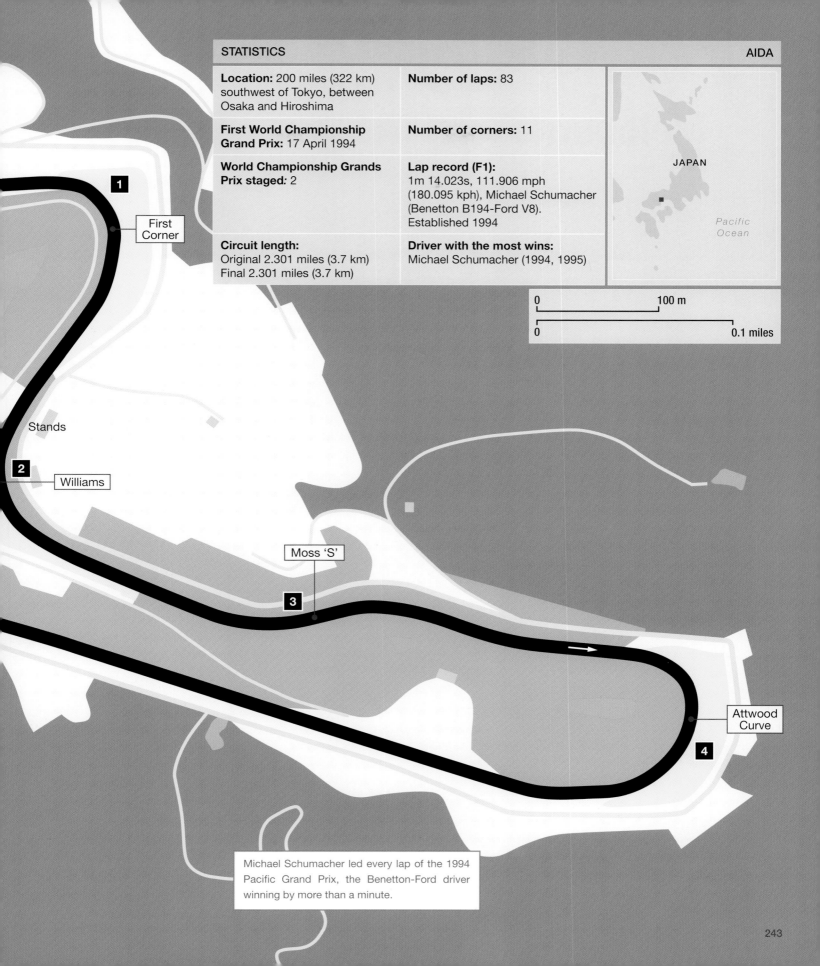

STATISTICS

Location: 200 miles (322 km) southwest of Tokyo, between Osaka and Hiroshima

Number of laps: 83

First World Championship Grand Prix: 17 April 1994

Number of corners: 11

World Championship Grands Prix staged: 2

Lap record (F1): 1m 14.023s, 111.906 mph (180.095 kph), Michael Schumacher (Benetton B194-Ford V8). Established 1994

Circuit length: Original 2.301 miles (3.7 km) Final 2.301 miles (3.7 km)

Driver with the most wins: Michael Schumacher (1994, 1995)

JAPAN

Pacific Ocean

0 100 m

0 0.1 miles

1

First Corner

Stands

2

Williams

Moss 'S'

3

Attwood Curve

4

Michael Schumacher led every lap of the 1994 Pacific Grand Prix, the Benetton-Ford driver winning by more than a minute.

243

Melbourne 1996

Albert Park

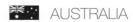 AUSTRALIA

More than adequate successor to Adelaide as host of Australia's Grand Prix. Located in Albert Park, a tram ride from Melbourne city centre. Instant hit thanks to efficient organisation, lively atmosphere and a reasonable track with a good flow. For many years, an ideal place to start the season.

Melbourne's Albert Park hosted the first of the current run of World Championship races in 1996 but the municipal park had actually staged the Australian Grand Prix before. It may have been a non-championship event but it was significant enough in 1956 to attract Stirling Moss and the works Maserati team. Using parkland roads around a lake, the race was run in an anti-clockwise direction but there would eventually be no running at all thanks to local opposition.

The thought of racing in Albert Park was not raised again until Jeff Kennett, Premier of Victoria, noted the success of the Australian Grand Prix in Adelaide and backed a plan, instigated by prominent businessman Ron Walker, to have it staged in Melbourne.

Albert Park, a tram ride from the heart of Melbourne, seemed a perfect site even though it had gradually become run down during the previous decades. This was a good excuse to drag the lake, plant trees and help bring the parkland into line with the sought-after dynamic image for the city. Using a car park and some of the original internal roads, but resurfaced and run in the opposite direction, the Albert Park circuit was reborn. New sections were added, along with permanent garages backing on to a grass paddock, one that would become arguably the most popular on the calendar as soon as the F1 teams arrived in March 1996. The circuit may have been flat and offering just one fast section on the far side of the lake, but it had a good flow.

All in all, it was seen as the perfect place to start the season thanks to the agreeable climate (compared to Europe at that time of year), a wide choice of hotels and cuisine and easy access thanks to an efficient transport system delivering an enthusiastic crowd besotted with sport and intent on having a good time. There had been much speculation beforehand about the effect of protests but, in the event, the only incident of note amounted to no more than a banner-waving party of four in the grandstand opposite the impressive pit complex. The only complaint from the drivers concerned a track that was dusty and initially without grip.

That would become a perennial problem which the teams learned to deal with just as readily as the circuit management polished an already slick organisation into one that was regarded as truly top rate, Australia winning the Best Organised Grand Prix award in 1996 and 1997.

Melbourne had been rewarded – if that's the right word – with drama from the start. Three corners into the first Grand Prix, Britain's Martin Brundle escaped unhurt from an enormous accident when his Jordan-Peugeot ran into the back of another car and cart-wheeled before landing upside down in an escape road.

The outcome of another incident close by the same spot would be tragic in 2001 when the BAR-Honda of Jacques Villeneuve also became airborne. A rear wheel, ripped from the car by a fence post, somehow got through a gap barely its own size and killed a volunteer marshal in a horrifyingly freak accident.

There would be harmless incidents aplenty, often at the first corner where, in 2002, 11 of the 22 starters were eliminated. With the Australian Grand Prix usually – but not always – being the first race of the season, Melbourne would be frequently responsible for setting records such as 'Youngest F1 starter' or 'Best Rookie Performance'. Overall, though, it continued to be regarded as one of the best Grands Prix of the season.

In March 2020, the Australian Grand Prix was an early casualty of the Covid-19 pandemic, the race being cancelled after the teams had arrived. Racing returned in 2022, by which time adjustments had been made to the circuit; principally getting rid of the chicane just after the start of the back straight.

The Ferrari of Charles Leclerc on its winning way as Melbourne welcomed the return of F1 in 2022 following the Covid-19 hiatus.

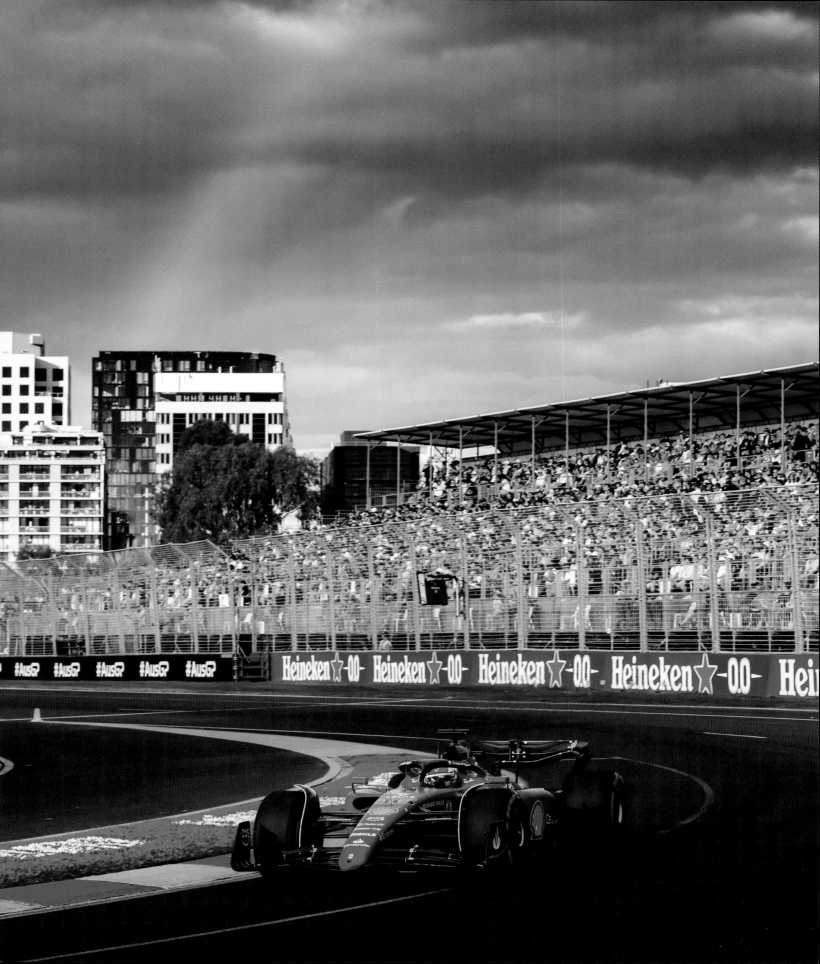

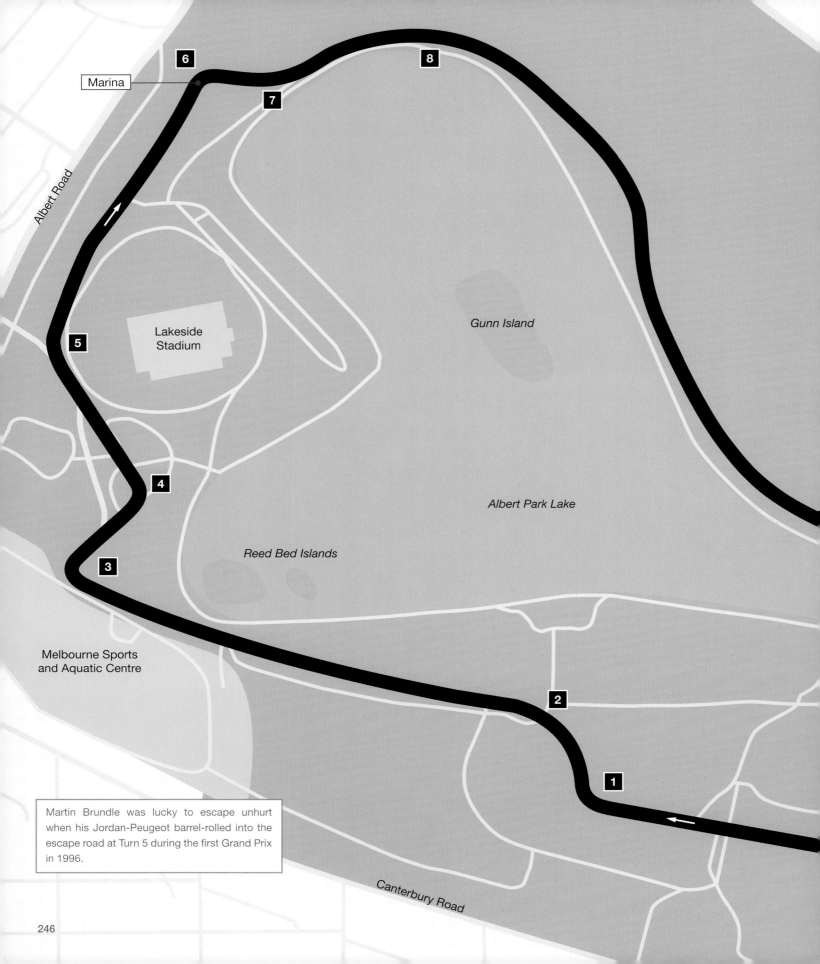

Marina

Albert Road

Gunn Island

Lakeside
Stadium

Albert Park Lake

Reed Bed Islands

Melbourne Sports
and Aquatic Centre

Martin Brundle was lucky to escape unhurt
when his Jordan-Peugeot barrel-rolled into the
escape road at Turn 5 during the first Grand Prix
in 1996.

Canterbury Road

0 100 m

0 0.1 miles

Queens Road

STATISTICS

Location: Albert Park, two miles (3.2 km) southeast of central Melbourne

First World Championship Grand Prix: 10 March 1996

World Championship Grands Prix staged: 26

Circuit length:
Original 3.295 miles (5.3 km)
Current 3.279 miles (5.278 km)

Number of laps: 58

Number of corners: 16

Lap record (F1): 1m 20.260s, 141.010 mph (226.933 kph), Charles Leclerc (Ferrari F1-75). Established 2022

Driver with the most wins: Michael Schumacher (2000, 2001, 2002, 2004)

AUSTRALIA

Tasman Sea

Albert Park
Golf Course

In 2009 Jenson Button led home his Brawn-Mercedes team-mate Rubens Barrichello in a truly unexpected one-two for the former Honda team which, a few months before, had been on the point of closure.

Australian Mark Webber, driving for Minardi in his first Grand Prix, finished fifth in 2002 and stepped onto the podium to receive an emotional reception after the official presentation had finished.

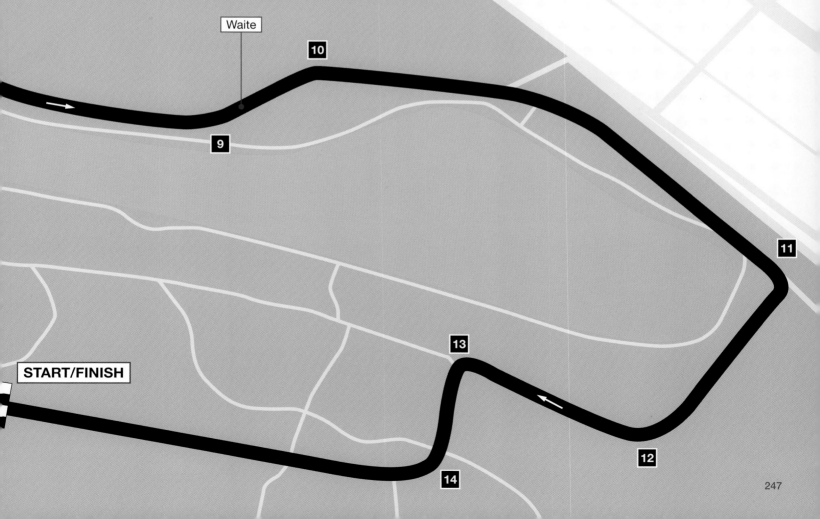

Waite

10

9

11

13

START/FINISH

12

14

247

Sepang 1999

Sepang International Circuit

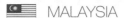 MALAYSIA

Excellent combination of corners and a wide track to encourage overtaking. Located in a wide dip not far from the international airport and close enough to Kuala Lumpur to draw a modest crowd to the first rate facilities. Humidity and high G-forces made it one of the most physically demanding before Sepang held its 19th and last Grand Prix in 2017.

Malaysia's motor sport roots stretch back to road races in the 1960s and a permanent track (Shah Alam) used for the World Sportscar Championship 1985. But it was not until the next decade that the country truly arrived on the international scene thanks to the foresight of the Prime Minister of the day. Keen to advance Malaysia as a cutting edge industrial nation in the early 1990s, Dr Mahathir Bin Mohamad included plans for a Grand Prix track, close by a shining new international airport and part of a so-called 'Multimedia Super Corridor' leading to the capital, Kuala Lumpur.

Circuit consultant Hermann Tilke was called upon to draw up plans for what would arguably be one of his best designs. Using the vast space available as well as a rolling landscape, Tilke laid out a flowing 3.4-mile (5.47-km) track that included two long straights ending with wide entries to tight hairpins to encourage overtaking. The first corner, initially turning in on itself, offered different lines and set drivers up for a variety of medium speed corners and fast curves. Apart from the G-forces generated by several of the corners, drivers would have to cope with levels of humidity not experienced anywhere else on the F1 calendar at the time.

Work began in December 1996. When the F1 teams arrived for the first Malaysian Grand Prix in October 1999, the estimated $12 million was thought to have been well spent, the excellent circuit enhanced by state of the art facilities and a massive double-sided grandstand topped by huge canopies shaped like Hibiscus, Malaysia's national flower.

The circuit invited overtaking but the first Grand Prix would be remembered for controversy away from the track. This was the penultimate race of the season, Mika Häkkinen of McLaren-Mercedes holding a slender two-point lead over Ferrari's Eddie Irvine. Having missed several races because of a broken leg, Michael Schumacher returned to support his Ferrari team-mate, duly leading from pole, allowing Irvine through and then keeping Häkkinen in third place. The Ferrari one-two was then ruled out because the cars' bargeboards were deemed to exceed the regulatory limits – only for Ferrari to later win an appeal in a Paris courtroom.

Schumacher's team-work was rewarded the following year by the first of three wins for the German, his brother Ralf taking the honours for Williams-BMW in 2002. At these and subsequent races, tyre performance has been paramount when dealing with track temperatures that can reach 60°C. Rain – often of tropical proportions – can also be a problem, Jenson Button dealing with both in 2009 as he coped with a dry track and was in front when rain became so heavy that the race had to be stopped, never to be restarted because of fading light.

The following year, there were suggestions that the track and facilities were beginning to show signs of a decade's use. The necessary touching up took place but, in the end, dwindling ticket sales made the 2017 Grand Prix the last for the time being.

Top: The signature and distinctive Hibiscus-shaped canopies over the massive grandstand.

Bottom: Eddie Irvine heads a controversial Ferrari one-two during the first Grand Prix at Sepang in 1999.

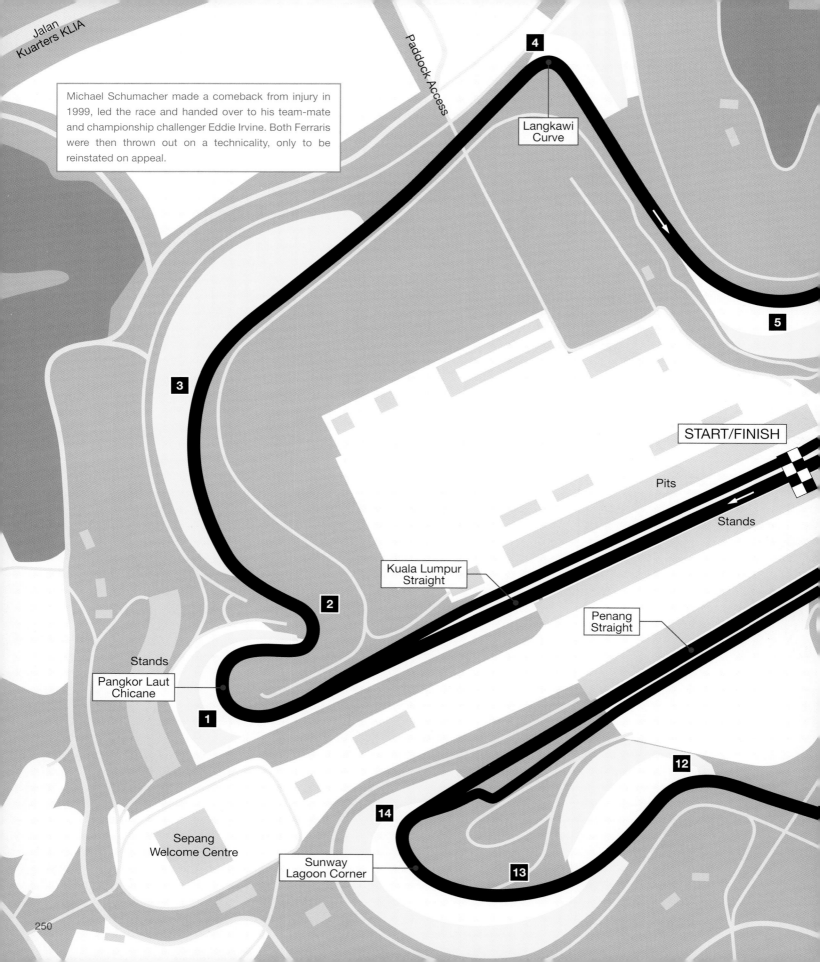

Michael Schumacher made a comeback from injury in 1999, led the race and handed over to his team-mate and championship challenger Eddie Irvine. Both Ferraris were then thrown out on a technicality, only to be reinstated on appeal.

Paddock Access

4

Langkawi
Curve

5

3

START/FINISH

Pits

Stands

Kuala Lumpur
Straight

Penang
Straight

2

12

Stands

Pangkor Laut
Chicane

1

14

Sepang
Welcome Centre

Sunway
Lagoon Corner

13

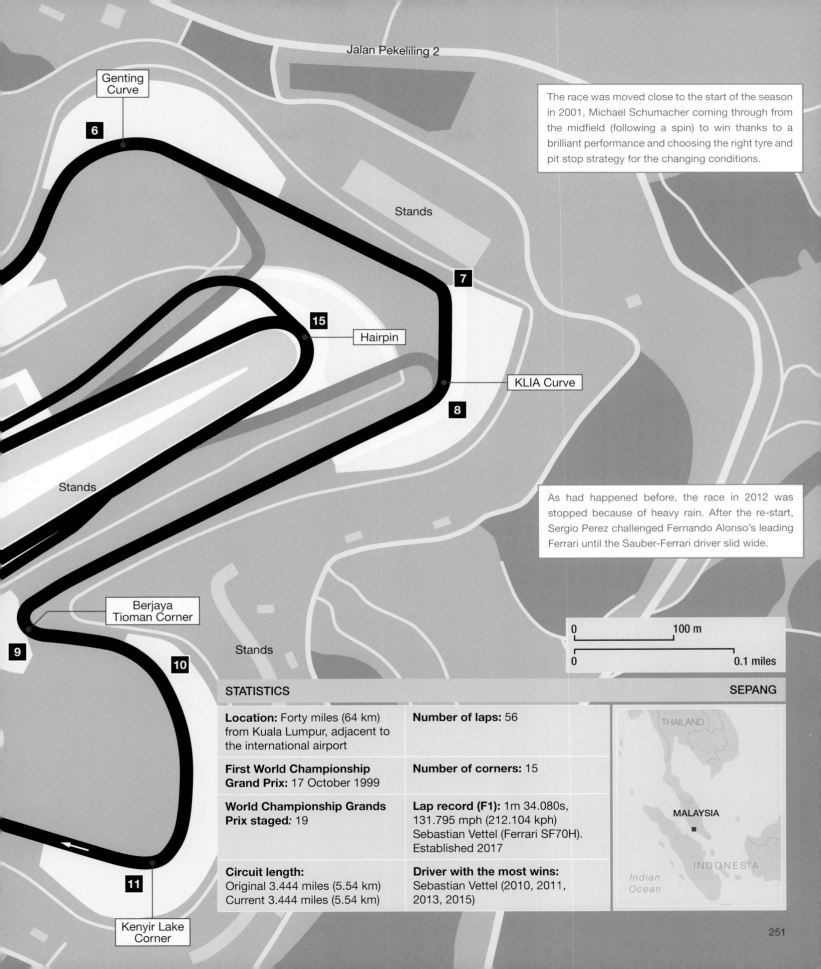

Jalan Pekeliling 2

Genting
Curve

6

7

Stands

15

Hairpin

KLIA Curve

8

Stands

Berjaya
Tioman Corner

9

10

Stands

Kenyir Lake
Corner

11

The race was moved close to the start of the season in 2001, Michael Schumacher coming through from the midfield (following a spin) to win thanks to a brilliant performance and choosing the right tyre and pit stop strategy for the changing conditions.

As had happened before, the race in 2012 was stopped because of heavy rain. After the re-start, Sergio Perez challenged Fernando Alonso's leading Ferrari until the Sauber-Ferrari driver slid wide.

0 100 m

0 0.1 miles

STATISTICS

SEPANG

Location: Forty miles (64 km) from Kuala Lumpur, adjacent to the international airport

Number of laps: 56

First World Championship Grand Prix: 17 October 1999

Number of corners: 15

World Championship Grands Prix staged: 19

Lap record (F1): 1m 34.080s, 131.795 mph (212.104 kph) Sebastian Vettel (Ferrari SF70H). Established 2017

Circuit length:
Original 3.444 miles (5.54 km)
Current 3.444 miles (5.54 km)

Driver with the most wins: Sebastian Vettel (2010, 2011, 2013, 2015)

THAILAND

MALAYSIA

INDONESIA

Indian
Ocean

Indianapolis Motor Speedway 2000

Indianapolis Motor Speedway

 UNITED STATES OF AMERICA

Used part of the famous banked oval and a new purpose-built infield section. Indy tried hard to make it work. F1 finally seemed to have found a permanent home in the USA but a farcical Grand Prix in 2005 and disagreement over terms ended the relationship after eight races.

In theory, the Indianapolis Motor Speedway (IMS) did have F1 history, the famous Indy 500 counting towards the World Championship between 1950 and 1960. Not that many in F1 felt the urge to make the transatlantic trip to take part in a race with such specialised requirements. In any case, Watkins Glen soon assumed the mantle of USGP host, leaving teams such as Lotus to build cars especially for the Indy 500.

The subsequent failure of several tracks to provide a permanent GP home is documented in the preceding pages, the flop at Phoenix igniting the search once more. When Tony George, President of the IMS, showed interest in adapting the speedway to stage a Grand Prix, the idea made sense. Here was a world famous motor sport centre with established facilities. The difficulty would be meeting the specialised demands of F1.

To the dismay of Indy veterans, George undertook a major programme that cut a swathe through the famous past by restructuring the likes of Gasoline Alley in order to accommodate the F1 garages.

As for the F1 track itself, a good start was made by coming off the banked Turn 1 and running in the opposite direction along the vast straight towards the exit of Turn 4. Then came disappointment as the new section swung towards the infield. A couple of reasonable corners and curves led onto a short straight running parallel with the main one before a very tight sequence of corners spat the cars back towards the banking at the exit of Turn 2 on the oval course. Given

the high-speed genesis of the IMS, the final section would scarcely flatter the image of Grand Prix cars, supposedly the best in the world.

As for the rest, however, the IMS organisation and facilities, coupled with a generous welcome, fitted the bill. F1 finally seemed to have found an American home when the first Grand Prix ran without a hitch in September 2000 and more than 220,000 spectators – the largest F1 attendance in the USA by a country mile – turned out to see it.

That feeling appeared to be cemented in an emotional way in 2001 when the Grand Prix was scheduled for 30 September. This would be the first major international event within the US boundaries since the terrorist attacks of 9-11. The Americans embraced the occasion as a means of reacting to the atrocities and showing as best they could that it was business as usual.

Four years later, the accord and acceptance created by F1 would be blown apart by a disgraceful episode when, due to a dispute that rapidly became political, only six cars took part in the Grand Prix following a worrying tyre failure during practice. Michelin, the company found to be at fault, went some way towards making amends by offering refunds, the fans responding by returning in surprising numbers for 2006.

Meanwhile, in the background, an all-too-familiar disagreement over fees would ensure that Grand Prix racing was finished after just 8 years at the IMS, George turning his attention to MotoGP and modifying the road course to accommodate the bikes.

The good and the bad of F1 at Indianapolis. (Top) Fans express their gratitude in 2001 for the Grand Prix teams showing faith and putting on a race two weeks after the terrorist attacks on September 11. (Bottom) Feelings were not so charitable four years later when a dispute over safety led to a farce as just six cars took the start.

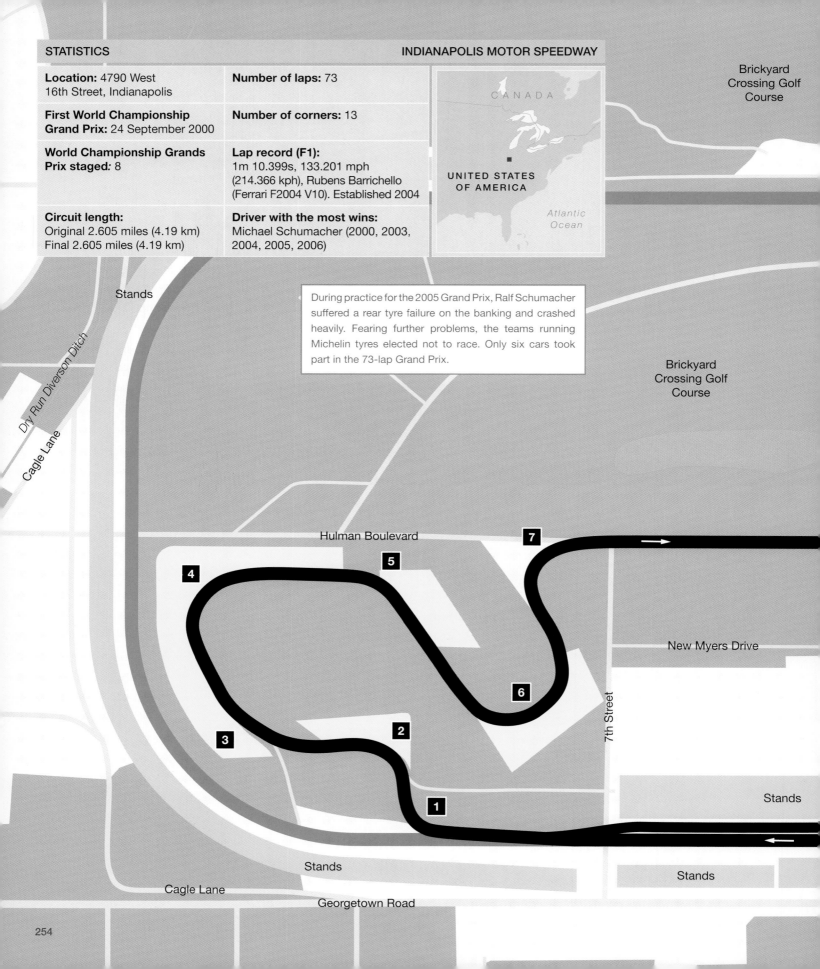

STATISTICS

INDIANAPOLIS MOTOR SPEEDWAY

Location: 4790 West
16th Street, Indianapolis

**First World Championship
Grand Prix:** 24 September 2000

**World Championship Grands
Prix staged:** 8

Circuit length:
Original 2.605 miles (4.19 km)
Final 2.605 miles (4.19 km)

Number of laps: 73

Number of corners: 13

Lap record (F1):
1m 10.399s, 133.201 mph
(214.366 kph), Rubens Barrichello
(Ferrari F2004 V10). Established 2004

Driver with the most wins:
Michael Schumacher (2000, 2003,
2004, 2005, 2006)

CANADA

UNITED STATES
OF AMERICA

Atlantic
Ocean

During practice for the 2005 Grand Prix, Ralf Schumacher
suffered a rear tyre failure on the banking and crashed
heavily. Fearing further problems, the teams running
Michelin tyres elected not to race. Only six cars took
part in the 73-lap Grand Prix.

Brickyard
Crossing Golf
Course

Brickyard
Crossing Golf
Course

Stands

Dry Run Diverson Ditch

Cagle Lane

Hulman Boulevard

New Myers Drive

7th Street

Stands

Stands

Stands

Cagle Lane

Georgetown Road

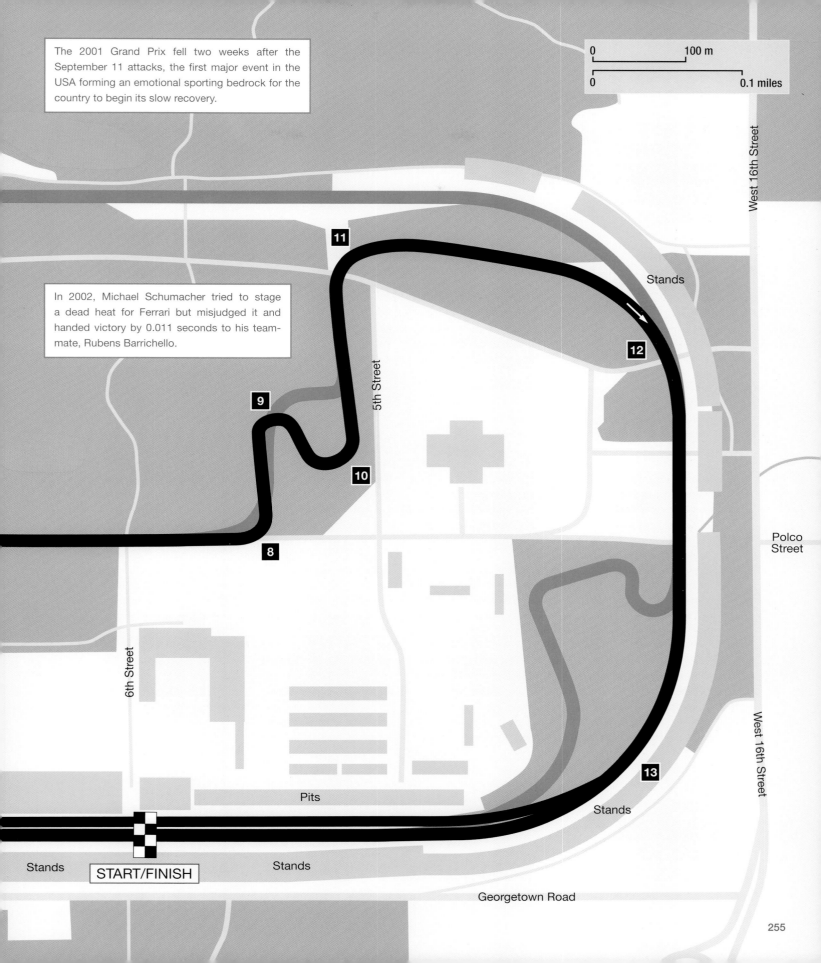

The 2001 Grand Prix fell two weeks after the September 11 attacks, the first major event in the USA forming an emotional sporting bedrock for the country to begin its slow recovery.

In 2002, Michael Schumacher tried to stage a dead heat for Ferrari but misjudged it and handed victory by 0.011 seconds to his team-mate, Rubens Barrichello.

0 100 m

0 0.1 miles

West 16th Street

Stands

11

12

5th Street

9

10

8

Polco Street

6th Street

13

Pits

Stands

START/FINISH

Stands Stands

Georgetown Road

West 16th Street

Bahrain 2004

Bahrain International Circuit, Sakhir

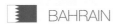 BAHRAIN

Brand new facility in the desert. Immaculate facilities that gradually matured over the years. A tricky layout, undulating in parts, provides a tough test in the heat and occasional good racing. Held two championship races during Covid-ravaged 2020, an outer loop staging the Sakhir Grand Prix.

The blossoming global profile of F1 was certain to catch the eye of wealthy Middle East countries, keen to use the sport to gain international credibility. Bahrain won the race to stage the first Grand Prix in 2004, race being the operative word when F1's Bernie Ecclestone unhelpfully moved the date forward by six months.

The Bahrainis, encouraged and led by motor sport enthusiast Crown Prince Sheikh Salman bin Hamad Al Khalifa, rose to the challenge magnificently, completing the work in 18 months to produce an immaculate venue that conformed precisely to Ecclestone's wishes. Which is to say the paddock and facilities were pristine but, as a result, initially looked like a spotless blue-chip industrial complex rather than a centre of world-class motor sporting endeavour.

Faced with little to work on, designer Hermann Tilke chose to make the pits and main grandstand an 'oasis' area, with the rest of the circuit described as the 'desert' sector. In truth, he had little option given the barren location on the site of a former camel farm, 20 miles (32 km) from the capital, Manama.

Tilke cleverly used what little gradient there was to have the track rise and fall in places, the blind curving descent to a hairpin being made even trickier by a slightly off camber profile. Three reasonable straights were connected by medium and slow speed sections, the specially imported track surface offering a surprising amount of grip despite the dusty surroundings. The trick, as ever, was to find a good rhythm.

Apart from a main grandstand with the striking appearance of a tented roof, the most noticeable feature of Sakhir (so-called after the local area) is a 10-storey circular VIP tower designed in a distinctive Arabic style and offering commanding views of much of the circuit. Occupants of the grandstand have to make do with the main straight and pits, this being the only place to watch while shaded from the torrid sun, a situation later side-stepped by the introduction of a night race.

Despite the absence of a motor sport heritage leading to a thinly populated grandstand when the first Grand Prix was staged on 4 April 2004, Bahrain worked hard to continually improve the quality and approval rating. Staging the season's opening race in 2008 and 2010 brought added cache but the addition of a loop at Turn 4 was a backward step. Any additional overtaking – such as it was – was out of sight of the grandstand and the cars were appearing less often. The idea was dropped after one race in 2010.

The opening sections of the lap, with plenty of run-off, provided the setting for a superb wheel-to-wheel contest between the Mercedes of Lewis Hamilton and Nico Rosberg in 2014. Three years previously, however, the race organisers had serious concerns when rioting in the streets caused the cancellation of the race, F1 finding itself caught in the middle of a political cauldron. The 2014 race was held under lights, which would become the norm. When Covid-19 forced last-minute revisions to the 2020 calendar, Bahrain hosted two races, the Sakhir Grand Prix using an outer loop one week after the Bahrain Grand Prix had been staged on the usual track.

Top: Bahrain broke new ground in every sense in 2004 by building a circuit in the desert to host the first Grand Prix in the Middle East.

Bottom: Lewis Hamilton became a regular winner in Bahrain, starting in 2014 when the Grand Prix became a night race.

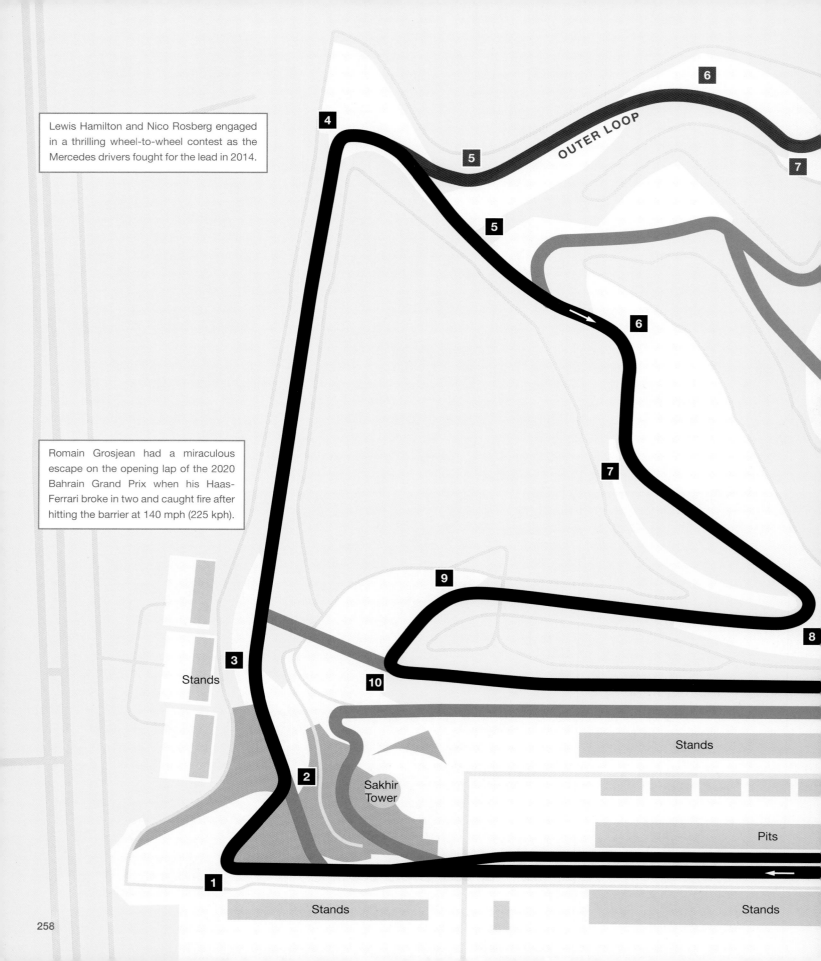

Lewis Hamilton and Nico Rosberg engaged in a thrilling wheel-to-wheel contest as the Mercedes drivers fought for the lead in 2014.

Romain Grosjean had a miraculous escape on the opening lap of the 2020 Bahrain Grand Prix when his Haas-Ferrari broke in two and caught fire after hitting the barrier at 140 mph (225 kph).

OUTER LOOP

Stands

Sakhir Tower

Stands

Pits

Stands

Stands

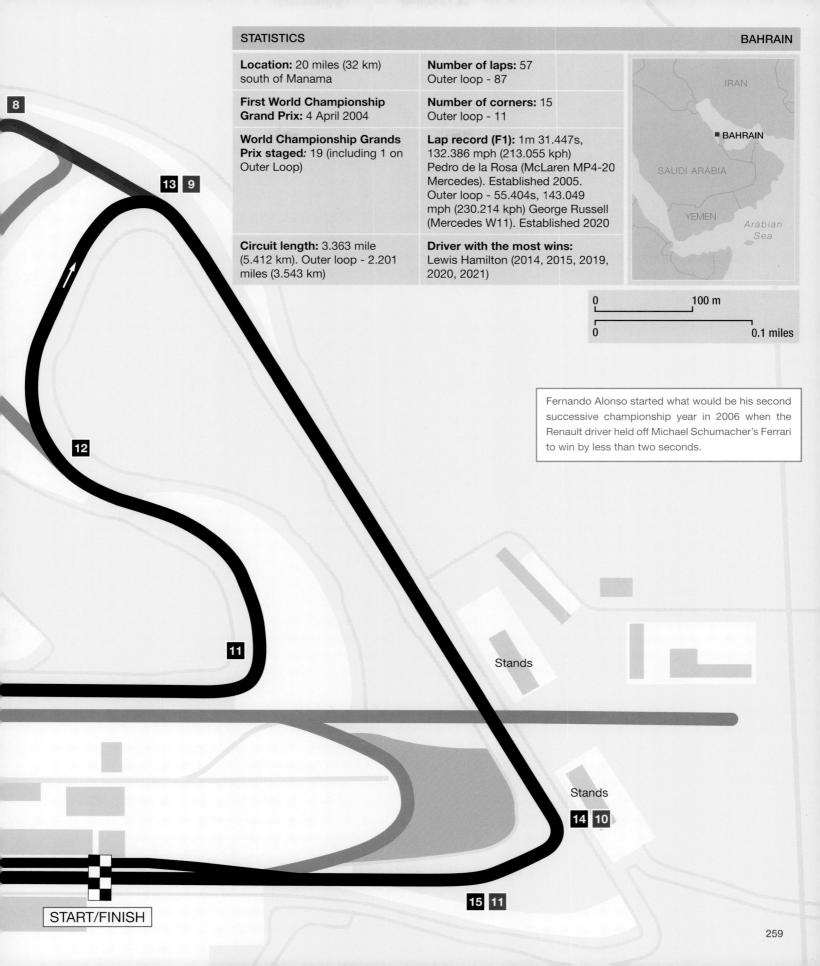

Location: 20 miles (32 km) south of Manama

First World Championship Grand Prix: 4 April 2004

World Championship Grands Prix staged: 19 (including 1 on Outer Loop)

Circuit length: 3.363 mile (5.412 km). Outer loop - 2.201 miles (3.543 km)

Number of laps: 57
Outer loop - 87

Number of corners: 15
Outer loop - 11

Lap record (F1): 1m 31.447s, 132.386 mph (213.055 kph) Pedro de la Rosa (McLaren MP4-20 Mercedes). Established 2005. Outer loop - 55.404s, 143.049 mph (230.214 kph) George Russell (Mercedes W11). Established 2020

Driver with the most wins: Lewis Hamilton (2014, 2015, 2019, 2020, 2021)

IRAN

BAHRAIN

SAUDI ARABIA

YEMEN

Arabian Sea

0 100 m

0 0.1 miles

Fernando Alonso started what would be his second successive championship year in 2006 when the Renault driver held off Michael Schumacher's Ferrari to win by less than two seconds.

8

13 9

12

11

Stands

Stands

14 10

15 11

START/FINISH

259

Shanghai 2004

Shanghai International Circuit

 CHINA

Government-funded race track some distance from central Shanghai. An engineering feat, built in 18 months on swamp land. Interesting layout with a few tricky versions of standard corners. Majority of grandstands remain empty. Team offices on stilts within inventive but vast paddock lacking atmosphere.

As a means of asserting itself as China's 'Go To' metropolis, and in the face of Beijing securing the 2008 Olympic Games, Shanghai focused on attracting a Grand Prix for 2004. The first hurdle – providing a race track to F1's stringent standards – was met with vigour, the Chinese government supporting a joint-venture company in raising 2.6 billion Yuan (£250 million). To make life really difficult, they chose a swamp on which to construct the facility in the Jiading District, northwest of the city, and completed the lavish project in 18 months; a remarkable feat on many levels.

The track layout was inspired by Chinese culture and the 'Shang' symbol, the first character in the name of the city of Shanghai and meaning 'above' or 'ascend'. It seemed to matter little that the circuit was almost flat, apart from a drop at a never-ending first corner that turned in on itself before twisting in the opposite direction. A wide and extremely long back straight had the familiar 'overtaking' stamp of a hairpin at the end of it. Inbetween, a mix of medium and slow speed corners; in essence a typical contemporary track that was technical rather than taxing.

A grandstand capable of seating 30,000 spectators was linked with the lavish pit buildings opposite by two wing-like structures crossing the track at either end of the start/finish straight. Most striking, however, was a collection of team pavilions on stilts in a lake designed to resemble the ancient Yuyuan Garden in Shanghai. According to the promotional blurb, this was intended to create 'an island of peace and meditation for the fast world of Formula 1'. If anything, this worked in a negative way, the wide expanse of concrete between the lake and the garages lacking the usual sight of people hanging around, chatting and generating atmosphere.

The main talking point of the first race weekend was Michael Schumacher spinning at the first corner during qualifying and starting from the pit lane. The Ferrari driver failed to finish on the podium for only the second time that season.

The organisers claimed 260,000 had attended throughout the weekend. Doubt would be shed on that figure when letters in the Shanghai press complained about having to spend almost a month's salary for a ticket plus the extras required for a day out. This, coupled with a lack of motor sport tradition in China (and the absence of a local driver), would contribute to declining attendances and empty grandstands hidden beneath advertising banners.

If the race was uneventful – quite often the case – the same could not be said for the return journey to central Shanghai. Speeding motorists changed lane with such ferocity it was always likely to make even the liveliest Grand Prix seem tame. The same could be said for the nightlife in such a buzzing cosmopolitan city, which at least helped make China a welcome addition to the calendar.

Shanghai International Circuit: an exceptional feat of engineering on marsh land. The 26 team offices on stilts in the lake at the rear of the pit and paddock complex add to the novelty, if not the atmosphere.

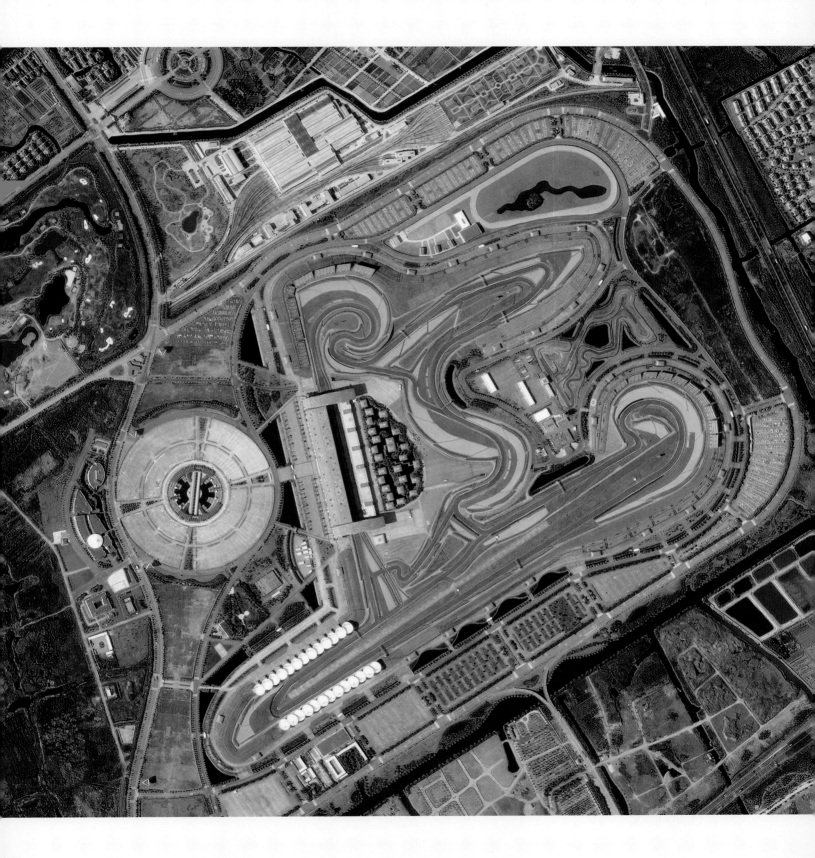

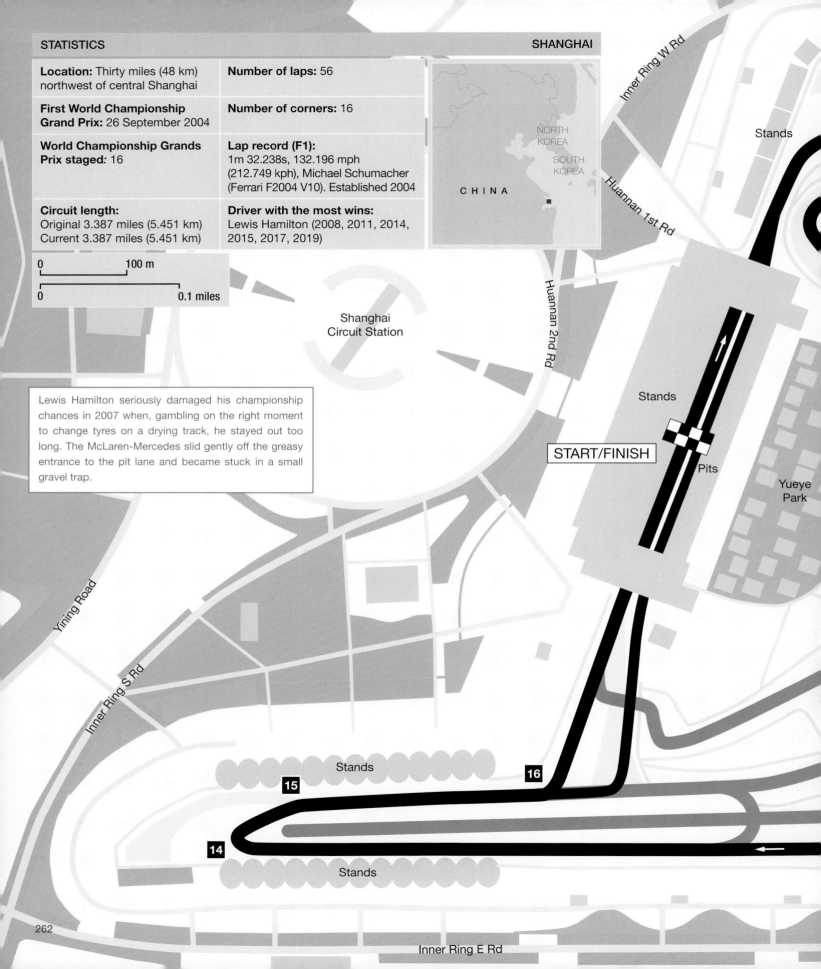

STATISTICS

Location: Thirty miles (48 km) northwest of central Shanghai

First World Championship Grand Prix: 26 September 2004

World Championship Grands Prix staged: 16

Circuit length:
Original 3.387 miles (5.451 km)
Current 3.387 miles (5.451 km)

Number of laps: 56

Number of corners: 16

Lap record (F1):
1m 32.238s, 132.196 mph (212.749 kph), Michael Schumacher (Ferrari F2004 V10). Established 2004

Driver with the most wins:
Lewis Hamilton (2008, 2011, 2014, 2015, 2017, 2019)

NORTH KOREA

SOUTH KOREA

CHINA

0 100 m

0 0.1 miles

Shanghai
Circuit Station

Lewis Hamilton seriously damaged his championship chances in 2007 when, gambling on the right moment to change tyres on a drying track, he stayed out too long. The McLaren-Mercedes slid gently off the greasy entrance to the pit lane and became stuck in a small gravel trap.

Inner Ring W Rd

Stands

Huannan 1st Rd

Huannan 2nd Rd

Stands

START/FINISH

Pits

Yueye Park

Yining Road

Inner Ring S Rd

Stands

15

14

Stands

16

Inner Ring E Rd

Stands

1

3

Outer Ring N Rd

Inner Ring W Rd

Inner Ring W Rd

Inner Ring W Rd

2

5

Stands

4

6

Jenson Button scored a classy win to head the championship in 2010 (China had moved from the end to the beginning of the season) after making the right tyre choice for his McLaren-Mercedes during another race of changing conditions.

7

2005 was not a great race for Michael Schumacher, the out-going World Champion colliding with the Minardi-Cosworth of Christijan Albers while heading to the grid (necessitating a pit lane start for both with spare cars) and then spinning into retirement when running behind the Safety Car.

Shanghai International Kart World

Inner Ring N Rd

8

9

12

Stands

10

11

13

Istanbul 2005

Istanbul Park

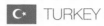 TURKEY

Best by a long way of the modern permanent circuits. Reasonable straights, variety of corners and good use of gradients helped produce close racing. Triple-apex Turn 8 a particular challenge. Lack of motor sport culture and paying spectators spelt the end after seven Grands Prix, only for the race to be revived in 2020.

Another government backed project, Istanbul park was welcomed by F1 as it brought Grand Prix racing into new territory once more. The name Istanbul Park (or Istanbul Otodrom as it was known initially) was a misnomer because the site was across the Bosporus, in the Asian part of the country and a two-hour drive from the capital. But such details mattered little once the circuit was eventually located near Akfirat village, 30 miles east of Istanbul.

Designed by Hermann Tilke, this was considered to be an outstanding race track of the modern era, making full use of elevation changes, some of which were bulldozed into place. The original plan was to run the race in a clockwise direction but, as the work neared completion, Tilke realised the track would be even more challenging if it became one of just three (at the time) run anti-clockwise.

Drivers would feel the strain on neck muscles immediately as the track turned left, into a corkscrew downhill right, heading towards further tight corners before plunging downhill once more. A tight right at the circuit's lowest point was the prelude to a climb with a blind approach to Turn 8, a very long left that was quickly to become notorious for its triple apex with a bump about one third of the way through. Downhill again to a left and a right before powering along the back straight towards an overtaking opportunity leading to further neck muscle-sapping tight turns before the start/finish straight.

It almost went without saying that the pits and 25,000-seat main grandstand would be of the expected high standard. Seven-storey towers at either end of the pit lane would form part of extensive accommodation for 5,000 VIP guests, additional grandstand seating at various points around the circuit's 3.3-mile (5.3-km) length bringing total capacity to the region of 155,000. Reaching those numbers would become an enduring problem for Istanbul Park.

The first Grand Prix in August 2005 would attract a large crowd to witness Kimi Räikkönen win for McLaren-Mercedes and throw the championship wide open with five races to run. When Felipe Massa won the next three Turkish Grands Prix, it was no surprise to hear the Ferrari driver praise Istanbul Park, particularly as this was the track that had provided his first F1 win and turned his career around.

Ferrari would celebrate their 800th Grand Prix in Turkey in 2010 but the Grand Prix would also be remembered for a controversial collision between Mark Webber and Sebastian Vettel as the Red Bull drivers fought for the lead.

When it came to an eventful race from start to finish, it would be difficult to beat the 2011 Grand Prix with more that 80 scheduled pit stops and the resulting plethora of overtaking moves.

And yet, such exceptional track action would not save Istanbul Park from heading into decline thanks to a lack of interest from spectators who did not feel strongly enough about F1 to pay at the gate. The absence of an ingrained motor sport tradition within Turkey also affected the success of this venture from the start.

It said much for the potential of Istanbul Park, however, when Bernie Ecclestone declared a financial interest and claimed to have secured the race's future. But not even the de facto leader of F1 could halt the spread of empty grandstand seats that looked bad on television. Despite occasional talk of the race being revived, the 2011 Turkish Grand Prix would be the last for the time being.

With a new airport for low-cost airlines just seven miles away and pleasant places to stay along the Sea of Marmara coast, this was considered a sad loss for reasons other than an excellent race track. The Turkish Grand Prix returned to the calendar during the Covid-affected 2020 season.

Top: One of the best of the new generation of F1 tracks deserved a better future.

Bottom: A landmark win for Ferrari's Felipe Massa in 2006.

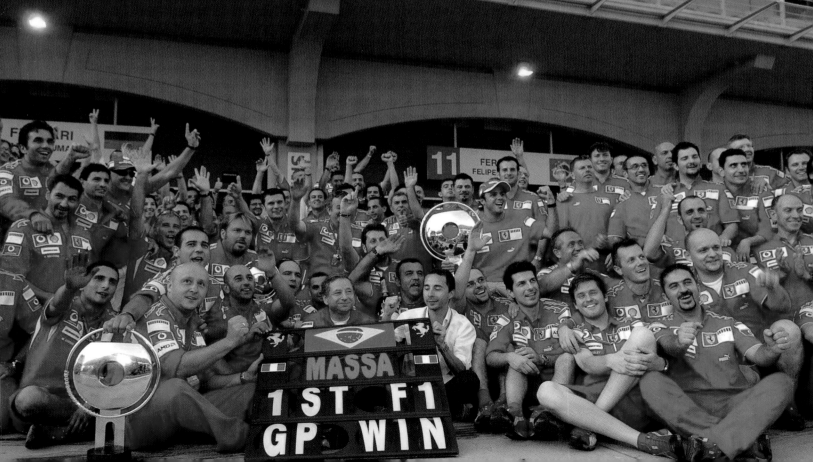

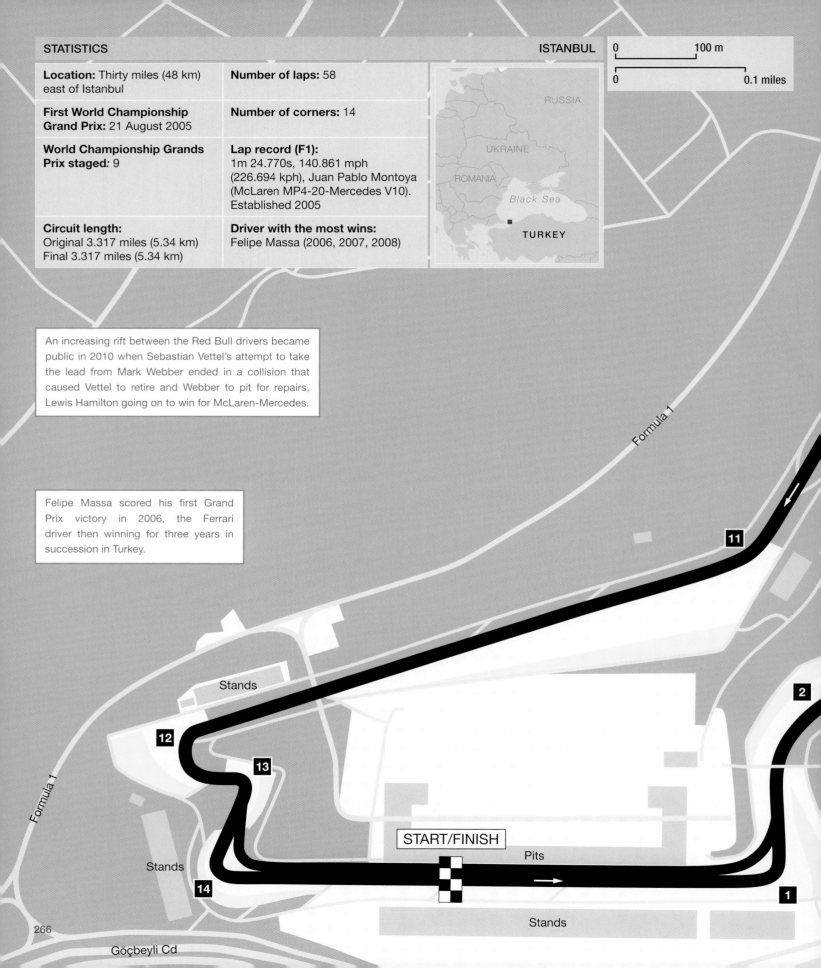

STATISTICS

ISTANBUL

Location: Thirty miles (48 km) east of Istanbul

First World Championship Grand Prix: 21 August 2005

World Championship Grands Prix staged: 9

Circuit length:
Original 3.317 miles (5.34 km)
Final 3.317 miles (5.34 km)

Number of laps: 58

Number of corners: 14

Lap record (F1):
1m 24.770s, 140.861 mph (226.694 kph), Juan Pablo Montoya (McLaren MP4-20-Mercedes V10). Established 2005

Driver with the most wins:
Felipe Massa (2006, 2007, 2008)

RUSSIA

UKRAINE

ROMANIA

Black Sea

TURKEY

0 100 m

0 0.1 miles

An increasing rift between the Red Bull drivers became public in 2010 when Sebastian Vettel's attempt to take the lead from Mark Webber ended in a collision that caused Vettel to retire and Webber to pit for repairs, Lewis Hamilton going on to win for McLaren-Mercedes.

Felipe Massa scored his first Grand Prix victory in 2006, the Ferrari driver then winning for three years in succession in Turkey.

Formula 1

11

Stands

12

2

13

Formula 1

Stands

14

START/FINISH

Pits

Stands

1

Göçbeyli Cd

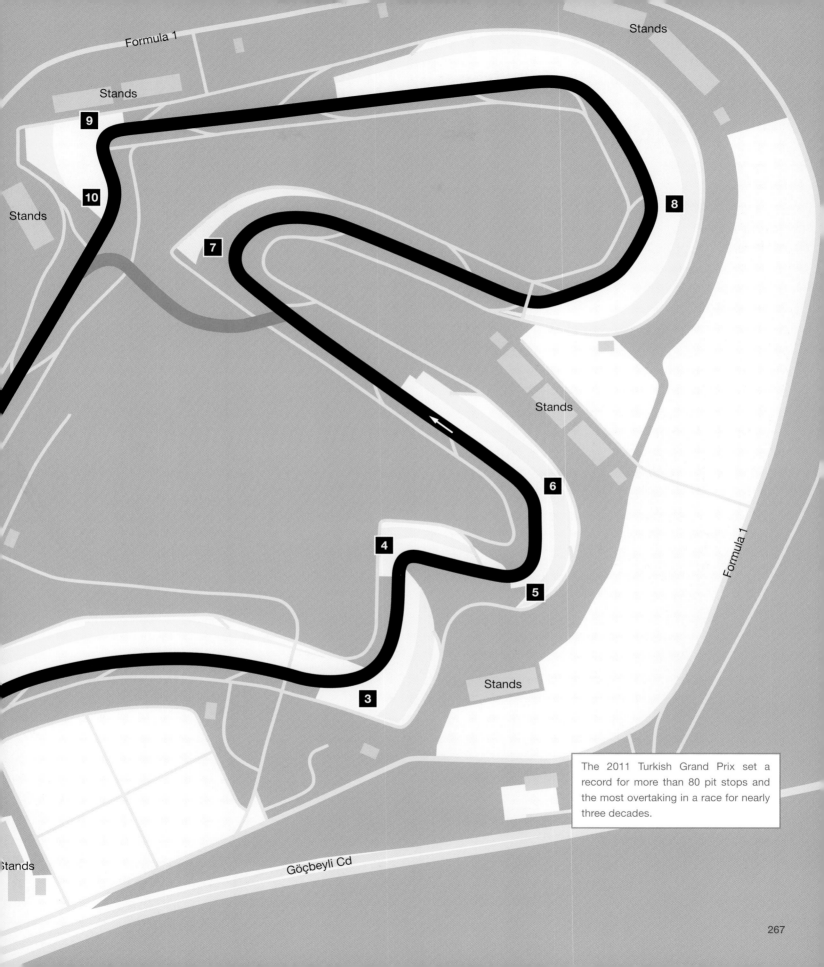

Formula 1

Stands

9

10

Stands

Stands

7

8

Stands

Formula 1

6

4

5

3

Stands

The 2011 Turkish Grand Prix set a record for more than 80 pit stops and the most overtaking in a race for nearly three decades.

Stands

Göçbeyli Cd

267

Valencia 2008

Valencia Street Circuit

 SPAIN

Introduced in 2008, using roads around part of Valencia's port and the former America's Cup yachting base. Interesting collection of corners and obstacles – including crossing a swing bridge – that didn't quite work. Plans to alternate the Grand Prix with Barcelona fell through in 2013.

The future of any Spanish F1 race outside Barcelona in the 2000s was always going to be tricky given Montmeló's permenancy, not only as a track but also as a regular part of the calendar. Nonetheless, knowing the European Grand Prix title was usually available, and given Bernie Ecclestone's willingness to do a deal if the terms were right, the Valmor Sport group pressed ahead with plans to stage a Grand Prix in Valencia's port district.

It was an adventurous project consisting of a mix of 25 corners linked in places by reasonable straights allowing a top speed approaching 200 mph (322 kph). The most impressive part was the backdrop of towering hangers once used by the America's Cup yachting squads and a loop around a large harbour, linked at the entrance by a swing bridge. Novel use had been made of a former warehouse for the pits but, in the event, the garages turned out to be too hot and cramped.

In some ways, that disappointment summed up initial reaction to a track that, on paper, should have worked very well. Certain parts, such as the curving run to Turn 17, were described by disgruntled spectators as featureless and drab thanks to abandoned buildings, concrete barriers and not much else to look at. The drivers were also less than thrilled since the layout provided very few opportunities for overtaking and sectors that could not even remotely be described as challenging. Added to which the blazing August sun brought little comfort.

To be fair to the track however, a dull first race in 2008 was caused just as much by cars and refuelling regulations that did little to encourage attempts to overtake, Felipe Massa's Ferrari leading for 50 of the 57 laps. If anything, the only activity of note had been in the pit lane when Massa almost collided with another car and a mechanic was injured when Kimi Räikkönen's Ferrari was released prematurely.

Rubens Barrichello won for Brawn-Mercedes in 2009 although his opportunist drive from third on the grid did not disguise another dreary race. Reacting to comments that one part of the track looked very much like another on television, the organisers applied much green paint to brighten the edges and they also gave names to two corners, Turn 8 becoming Curva Marca Leyenda and Turn 25 named Curva Boluda. These cosmetic changes made little difference as such but it so happened that the 2010 European Grand Prix would be memorable for the wrong reasons.

Mark Webber, making up lost ground after a slow pit stop, collided with the Lotus-Cosworth of Heikki Kovalainen, Webber's Red Bull flipping through the air before landing on its wheels and crashing into a tyre barrier at the end of the straight. Webber, remarkably, was unhurt.

The accident prompted the Safety Car and much confusion over its position on the race track as Lewis Hamilton appeared to overtake it illegally and received a controversial drive-through penalty. The race was won by Red Bull's Sebastian Vettel, who repeated victory in 2011. Vettel would retire from the lead a year later, handing victory to the Ferrari of Fernando Alonso.

It was appropriate that a Spaniard should win what would be the last European Grand Prix in Valencia, a deal to alternate the Spanish Grand Prix with Barcelona Montmeló falling through. Valencia had failed to deliver, starting with a lack of promotion and the strange phenomenon of being within a mile of the track and having no clue that a Grand Prix was taking place.

Top: Despite the attractive backdrop, the Valencia street circuit failed to click.

Bottom: The novel swing bridge in the foreground with the America's Cup boat houses on the upper right of the harbour.

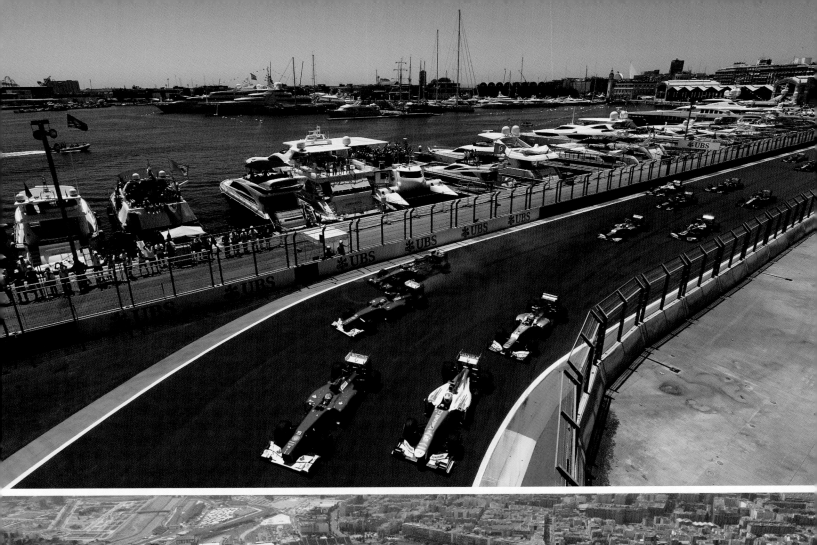
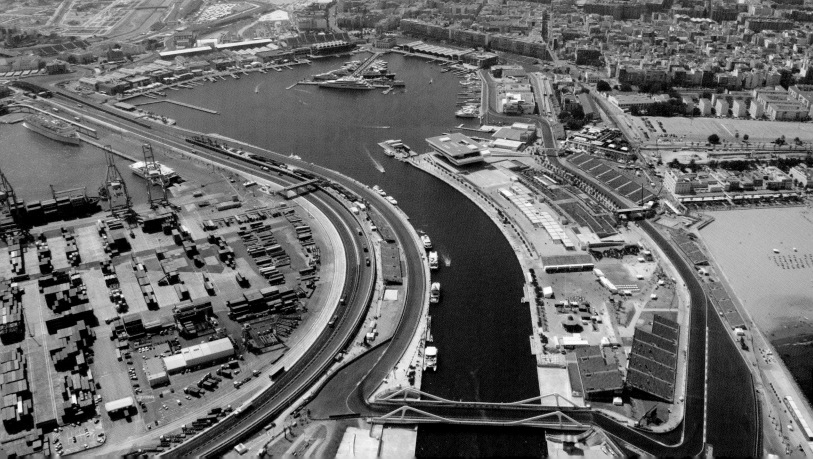

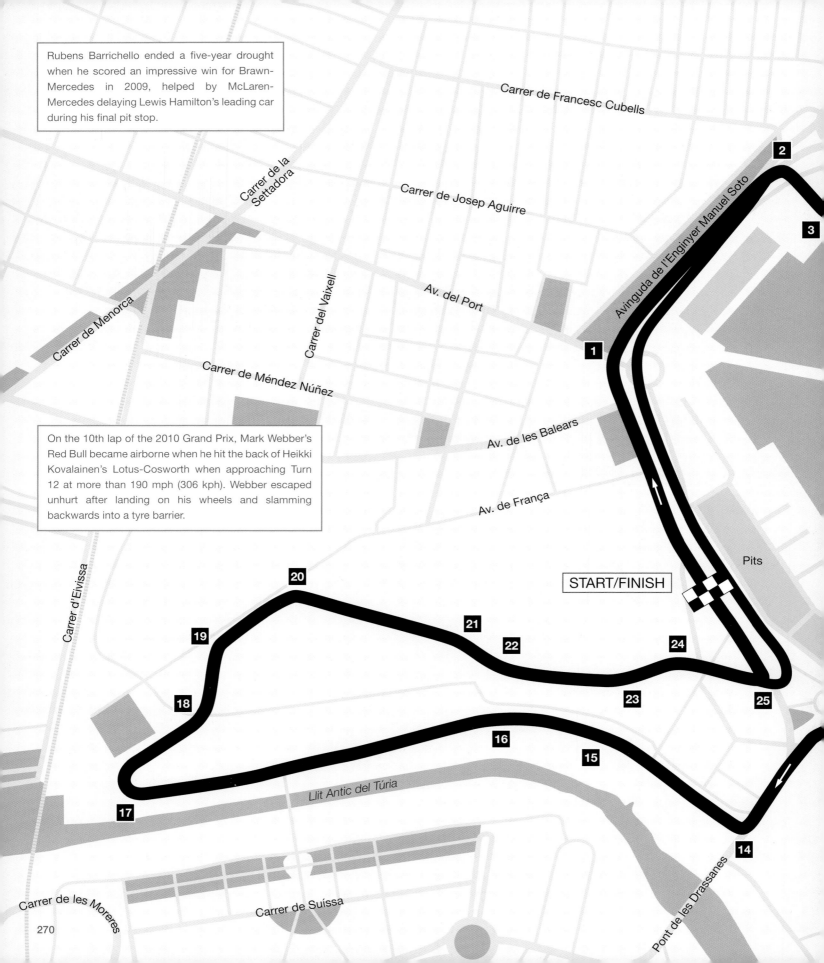

Rubens Barrichello ended a five-year drought when he scored an impressive win for Brawn-Mercedes in 2009, helped by McLaren-Mercedes delaying Lewis Hamilton's leading car during his final pit stop.

On the 10th lap of the 2010 Grand Prix, Mark Webber's Red Bull became airborne when he hit the back of Heikki Kovalainen's Lotus-Cosworth when approaching Turn 12 at more than 190 mph (306 kph). Webber escaped unhurt after landing on his wheels and slamming backwards into a tyre barrier.

Carrer de Francesc Cubells

Carrer de la Settadora

Carrer de Josep Aguirre

Avinguda de l'Enginyer Manuel Soto

2

3

Carrer del Vaixell

Av. del Port

1

Carrer de Menorca

Carrer de Méndez Núñez

Av. de les Balears

Av. de França

Pits

START/FINISH

Carrer d'Eivissa

20

21

22

24

19

23

25

18

16

15

17

Llit Antic del Túria

14

Pont de les Drassanes

Carrer de les Moreres

Carrer de Suïssa

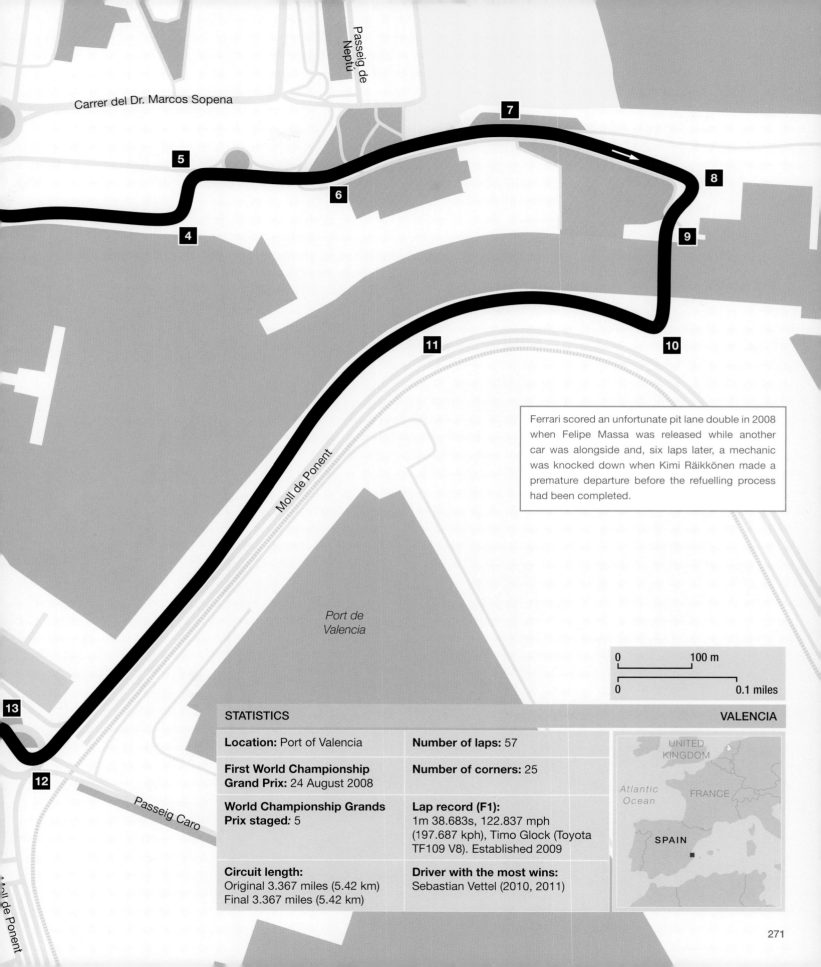

Passeig de Neptú

Carrer del Dr. Marcos Sopena

7

5

6

4

8

9

11

10

Moll de Ponent

Ferrari scored an unfortunate pit lane double in 2008 when Felipe Massa was released while another car was alongside and, six laps later, a mechanic was knocked down when Kimi Räikkönen made a premature departure before the refuelling process had been completed.

Port de Valencia

0		100 m
0		0.1 miles

13

STATISTICS

VALENCIA

12

Passeig Caro

Moll de Ponent

Location: Port of Valencia	**Number of laps:** 57
First World Championship Grand Prix: 24 August 2008	**Number of corners:** 25
World Championship Grands Prix staged: 5	**Lap record (F1):** 1m 38.683s, 122.837 mph (197.687 kph), Timo Glock (Toyota TF109 V8). Established 2009
Circuit length: Original 3.367 miles (5.42 km) Final 3.367 miles (5.42 km)	**Driver with the most wins:** Sebastian Vettel (2010, 2011)

UNITED KINGDOM

Atlantic Ocean

FRANCE

SPAIN

Singapore 2008

Marina Bay Circuit

 SINGAPORE

Adventurous project on streets of business district and alongside Marina Bay. Introduced in 2008: the first Grand Prix to be run at night. Paid off handsomely. Rapidly became one of the most popular – and different – Grands Prix on the calendar. Bumpy surface, angular corners and humidity make it a tough test.

A five-year deal between F1, the Singapore Tourism Board and entrepreneur Mr. Ong Beng Seng brought F1 to the streets of this business-orientated city-state in 2008. It may have been a new concept – particularly with the brave venture of running a round of the F1 World Championship at night – but motor sport was not new in the region.

There had been major races on the Thompson Road Circuit to the north of the city, the early events known as the Malaysian Grand Prix prior to Singapore gaining independence in 1965. By 1973, the 3-mile (4.8-km) circuit was considered to be too dangerous and difficult to manage in the light of rising speeds, the final Singapore Grand Prix of the era being won by Vern Schuppan in a March F2 car.

Plans to build a permanent circuit never got beyond discussion and the thought of a Singapore Grand Prix was not raised until F1 began to cast its eye towards the Far East. Even then, the proposal to convert busy streets adjacent to the downtown business centre seemed an ambitious one, particularly when it was suggested the race should be run under floodlights.

But once the local authorities got behind the idea, any obstacles, both physical and moral, were quickly dealt with. The question of where to place the necessary pits, paddock and administration centre was overcome by erecting a permanent building and main straight on a plot of land close by the Singapore Flyer giant Ferris wheel and overlooking Marina Bay. The majority of the track used boulevards and highways as it crossed the ancient Anderson Bridge and passed iconic landmarks such as the City Hall

and the hallowed cricket ground. Around the 3.1-mile (4.99-km) length, powerful overhead lights would replicate daylight conditions, the benefit of running at night being the dovetailing of the race into sociable hours for the television audience in Europe.

Viewers of the inaugural Grand Prix on Marina Bay Circuit witnessed a hugely successful event as corporate and hospitality packages cashed in on F1's first night race, an event that ran without a hitch. Or so it seemed.

Fernando Alonso scored a surprise victory after starting from 15th on the grid. It also seemed a lucky win after the Renault driver had been able to make the most of a fortuitous pit stop which came just before his team-mate, Nelson Piquet Junior, crashed and prompted a Safety Car that allowed Alonso to move to the front of the field. A year later, it emerged that Piquet's crash had been deliberate. The 2008 Singapore Grand Prix would become infamous – but with no negative reflection on the organisers.

Indeed, the race would go from strength to strength; drivers coping with the physical demands of humidity and a bumpy track lined by concrete walls; spectators enjoying the unique atmosphere and surroundings. From lessons learned in the first year, the pit lane entrance was altered, Turns 1 and 2 adjusted to aid overtaking and high kerbs removed from a chicane at Turn 10. The latter corner continued to present difficulties until the chicane was removed altogether and a regular corner substituted for 2013. Otherwise, the Marina Bay Circuit remained a delightful and unusual addition to the calendar, the contract with F1 extended until 2028.

F1's first night race worked perfectly, the floodlights enhancing a captivating setting with its majestic buildings and waterfront, the track itself presenting variety and unique challenges.

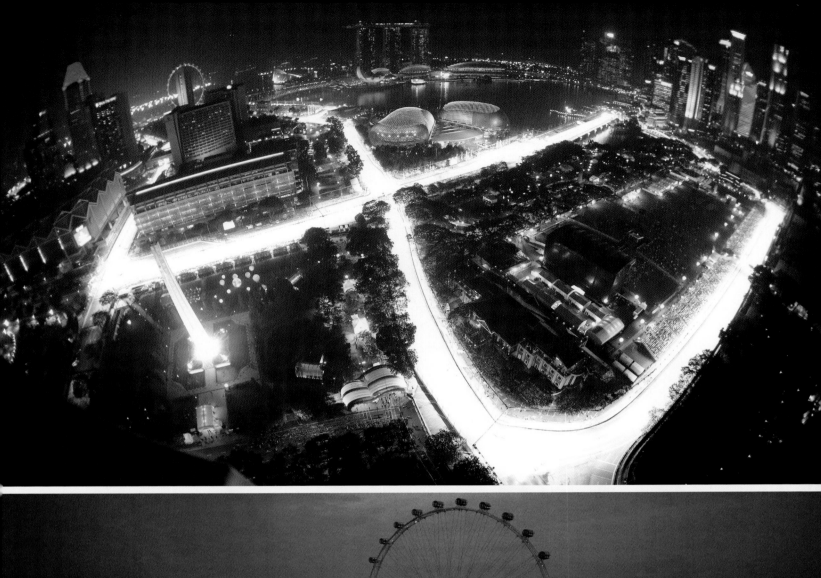
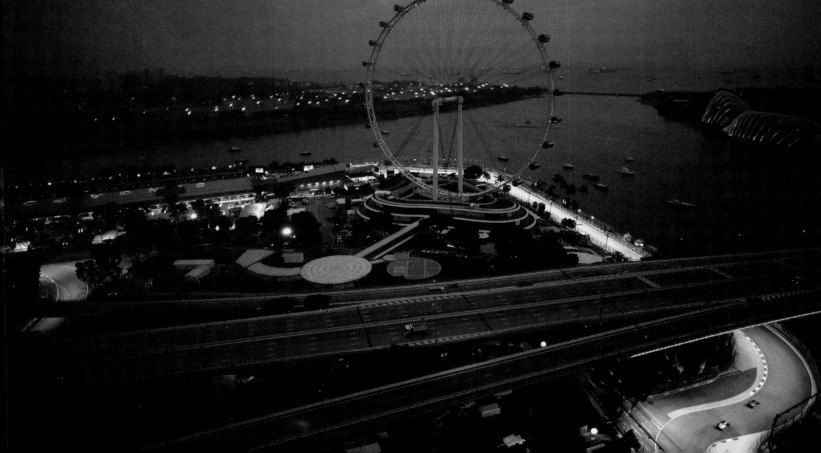

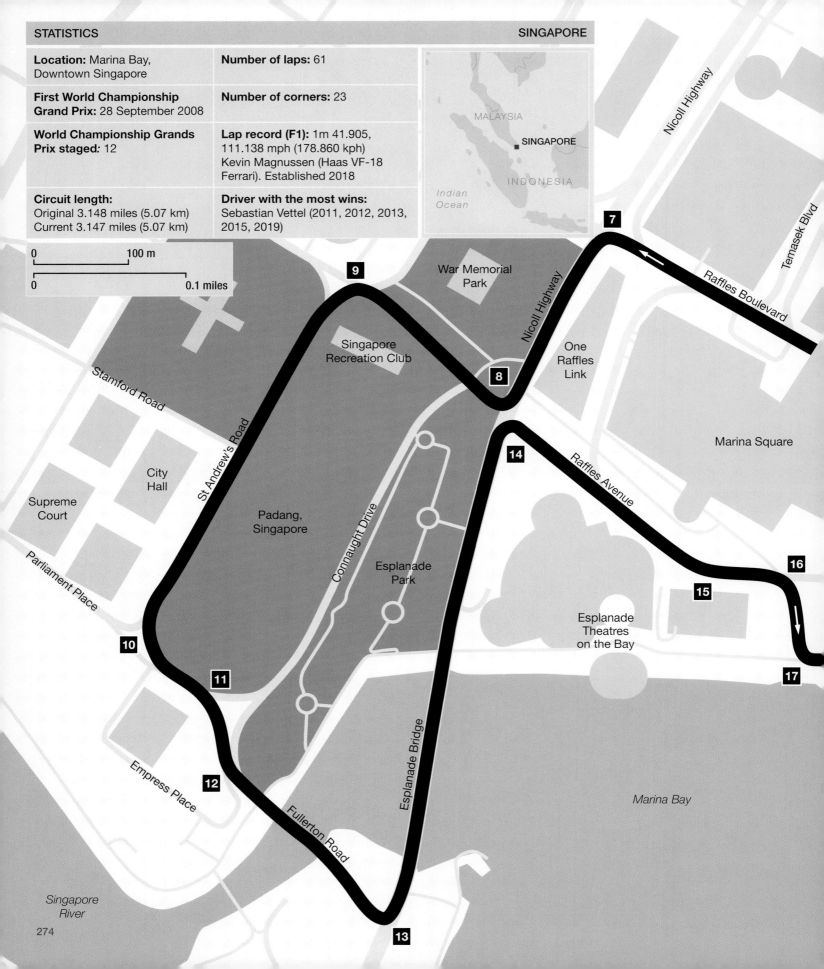

Location: Marina Bay,
Downtown Singapore

**First World Championship
Grand Prix:** 28 September 2008

**World Championship Grands
Prix staged:** 12

Circuit length:
Original 3.148 miles (5.07 km)
Current 3.147 miles (5.07 km)

Number of laps: 61

Number of corners: 23

Lap record (F1): 1m 41.905,
111.138 mph (178.860 kph)
Kevin Magnussen (Haas VF-18
Ferrari). Established 2018

Driver with the most wins:
Sebastian Vettel (2011, 2012, 2013,
2015, 2019)

MALAYSIA

SINGAPORE

INDONESIA

Indian
Ocean

0 100 m

0 0.1 miles

Nicoll Highway

Temasek Blvd

Raffles Boulevard

7

9

War Memorial
Park

Nicoll Highway

One
Raffles
Link

8

Marina Square

Stamford Road

Singapore
Recreation Club

St Andrew's Road

City
Hall

14

Raffles Avenue

Supreme
Court

Padang,
Singapore

Connaught Drive

Esplanade
Park

16

15

Esplanade
Theatres
on the Bay

Parliament Place

10

11

Esplanade Bridge

17

Empress Place

12

Fullerton Road

Marina Bay

Singapore
River

13

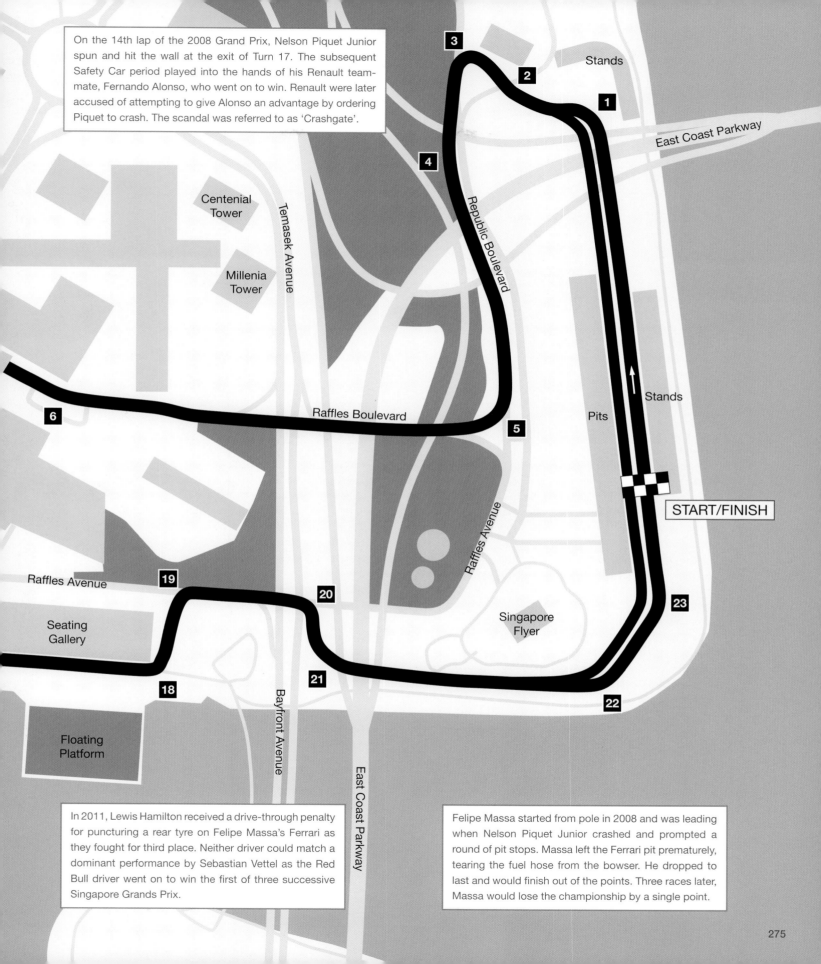

On the 14th lap of the 2008 Grand Prix, Nelson Piquet Junior spun and hit the wall at the exit of Turn 17. The subsequent Safety Car period played into the hands of his Renault team-mate, Fernando Alonso, who went on to win. Renault were later accused of attempting to give Alonso an advantage by ordering Piquet to crash. The scandal was referred to as 'Crashgate'.

Stands

3

2

1

East Coast Parkway

4

Centenial Tower

Temasek Avenue

Millenia Tower

Republic Boulevard

Raffles Boulevard

5

Stands

Pits

6

Raffles Avenue

START/FINISH

Raffles Avenue

19

Raffles Avenue

20

Seating Gallery

Singapore Flyer

23

18

21

22

Bayfront Avenue

Floating Platform

East Coast Parkway

In 2011, Lewis Hamilton received a drive-through penalty for puncturing a rear tyre on Felipe Massa's Ferrari as they fought for third place. Neither driver could match a dominant performance by Sebastian Vettel as the Red Bull driver went on to win the first of three successive Singapore Grands Prix.

Felipe Massa started from pole in 2008 and was leading when Nelson Piquet Junior crashed and prompted a round of pit stops. Massa left the Ferrari pit prematurely, tearing the fuel hose from the bowser. He dropped to last and would finish out of the points. Three races later, Massa would lose the championship by a single point.

Abu Dhabi 2009

Yas Marina Circuit

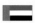 UNITED ARAB EMIRATES

Built at huge cost on an island, close to Abu Dhabi airport. Facilities second to none but track layout disappointing. Racing from dusk into darkness added to atmosphere and marina back-drop. Settled the championship more than once since introduction in 2009, the final lap in 2021 being hugely contentious.

Noting the move by Bahrain to stage a Grand Prix in 2004, the Abu Dhabi government instigated a wide-ranging scheme based on the emirate's reputation for careful planning and husbandry. That said, this would be something on the grand scale, $1 billion allegedly being spent on the construction of a race track on Yas Island not far from the international airport.

Known as the Yas Marina Circuit, this would be part of a vast complex including a drag strip, concert venue, hotels, shopping mall, a links golf course and a theme park incorporating a massive red canopy covering Ferrari World. Straddling part of the track would be the Yas Hotel (now the Yas Viceroy) with a futuristic roof that would change colour at night. The five main grandstands were covered to provide shade.

It almost went without saying that circuit facilities were second to none, the team headquarters facing onto a marina that was quickly filled with exotic craft – once the water had been pumped in. The paddock was neat and compact, providing a perfect atmosphere in the reasonably mild (for Abu Dhabi) November climate. When the hard-to-please teams could not find fault within the 40 air-conditioned garages, it was evidence of Abu Dhabi's clever move in hiring CEO Richard Cregan, the former Toyota team manager who understood the specialised requirements of F1 and gathered a capable support team drawn from European racing.

There was just one shortcoming; the track itself. Much had been made of a novel pit exit, where cars would run under the track in order to make a safe return beyond the first corner. There was a very long straight and a number of tricky adverse camber corners calling for precision but, apart from a rising curve after Turn 1, there was little to get the adrenalin going.

It was a technical circuit to challenge drivers and engineers when setting up their cars. Despite starting from scratch, however, Abu Dhabi had somehow missed a trick by failing to provide a track that would allow wheel-to-wheel racing.

That would be proved in the most painful manner in 2010 when a bungled pit strategy by Ferrari saw Fernando Alonso emerge some way down the order and become trapped behind a Renault, by rights slower than the Ferrari but, crucially, not planning to stop and allow Alonso a clear track. For 37 laps Alonso tried all he could to move higher than seventh, his frustration made worse by seeing the championship slip into the hands of Sebastian Vettel in the leading Red Bull.

Staging the final round of the championship had added to the atmosphere created by uniquely starting at dusk and racing into the warm evening. A first class floodlight system was backed up by the ever-changing LED lights on the cascading roof of the hotel. There was no question that, as an event, the Abu Dhabi Grand Prix was a worthwhile addition to the calendar. In 2021, however, Yas Marina would achieve notoriety when a controversial decision by the race director saw the championship change hands on the final lap of a 22-race season.

Top: The ever-changing lights on the roof of the Yas Hotel adds to the atmosphere of a race starting at dusk.

Bottom: The pit lane made a unique exit beneath the main straight.

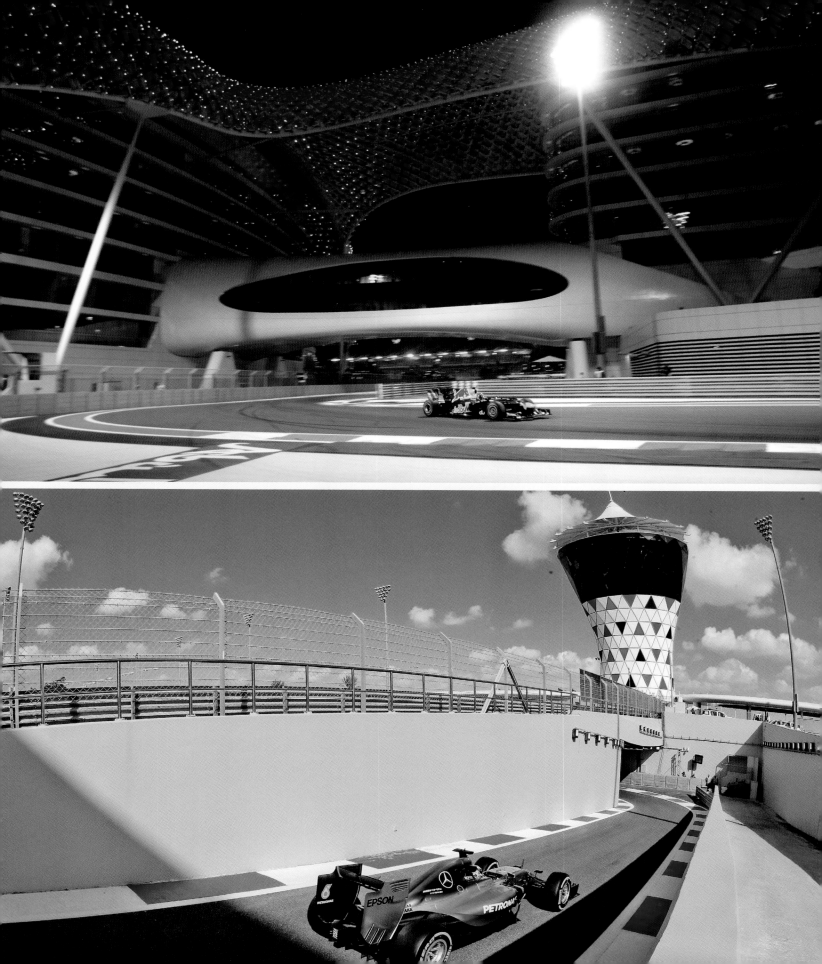

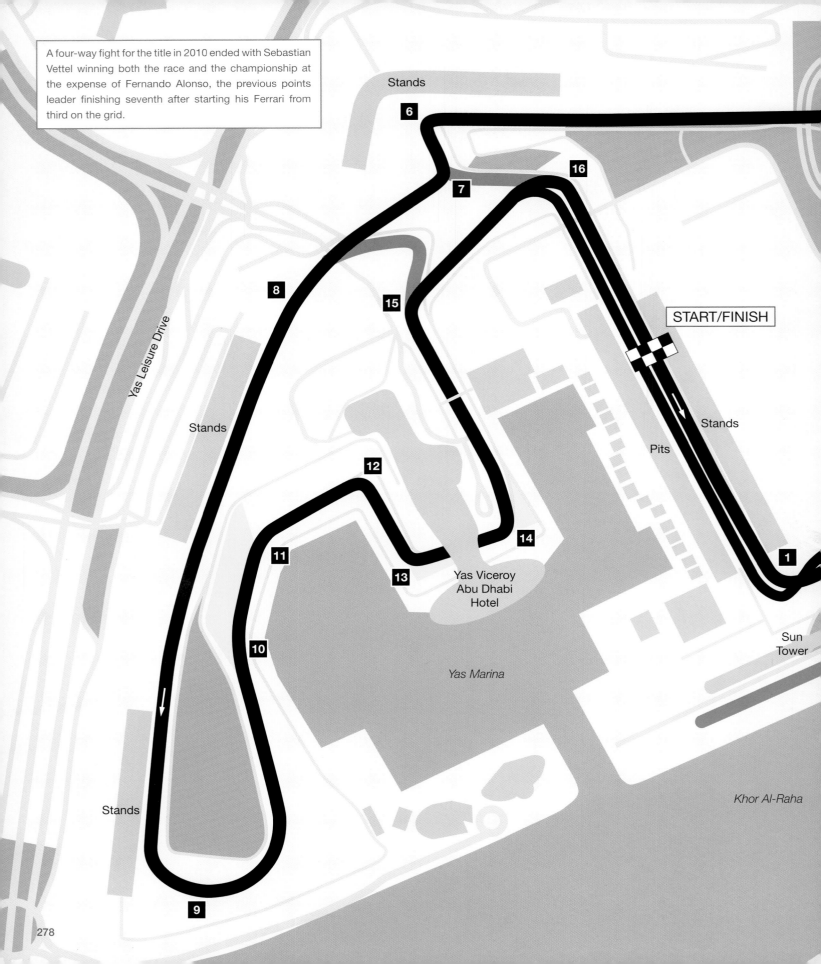

A four-way fight for the title in 2010 ended with Sebastian Vettel winning both the race and the championship at the expense of Fernando Alonso, the previous points leader finishing seventh after starting his Ferrari from third on the grid.

Stands

6

16

7

8

15

START/FINISH

Yas Leisure Drive

Stands

Stands

Pits

12

14

11

13

Yas Viceroy
Abu Dhabi
Hotel

1

10

Sun
Tower

Yas Marina

Stands

Khor Al-Raha

9

Stands

Ferrari
World –
Abu Dhabi

5

3

Stands

4

2

Yas Drag Racing Circuit

The 2011 Grand Prix took a dramatic turn within seconds of the start when a sudden puncture caused Sebastian Vettel's pole position Red Bull to spin as he turned into the second corner.

A tense battle between the Mercedes drivers in 2014 ended when Lewis Hamilton won the race to beat Nico Rosberg to the title.

STATISTICS

ABU DHABI

Location: Yas Island, 15 miles (24 km) east of central Abu Dhabi

Number of laps: 58

First World Championship Grand Prix: 1 November 2009

Number of corners: 16

World Championship Grands Prix staged: 13

Lap record (F1):
1m 26.103s, 137.199 mph (220.800 kph), Max Verstappen (Red Bull RB16B-Honda V6) Established 2021

Circuit length:
3.281 miles (5.281 km)

Driver with the most wins:
Lewis Hamilton (2011, 2014, 2016, 2018, 2019)

0 100 m

0 0.1 miles

IRAN

U.A.E.

SAUDI ARABIA

YEMEN

Korea 2010

Korea International Circuit, Yeongam

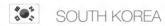 SOUTH KOREA

In immediate trouble with late completion in 2010. A flat circuit with an interesting mix of corners and reasonably tricky sections. Located on reclaimed land and was supposed to be part of a far-reaching urban plan that didn't come off. A change of local government and lack of interest from Korean spectators spelt a short life for a track in an uninspiring remote area.

This was an ambitious project – at least on paper. When the Korea Auto Valley Operation, a joint-venture involving the regional government in South Jeolla, agreed to build a track to host a Korean Grand Prix, the original plan was to incorporate this as part of a community of hotels, shops, restaurants and luxury housing alongside a marina.

They chose to do this on reclaimed land at Yeongam, 250 miles (402 km) south of Seoul, near the fishing port of Mokpo. The $250 million project envisaged holding a Grand Prix for at least seven years. For a while, it seemed they would be lucky to stage just one.

Construction work in the winter of 2009–10 was delayed by the sort of unpleasant weather that frequently visits this corner of South Korea. That should have been an omen, particularly when circuit inspections were delayed several times, the final check being carried out less than two weeks before the scheduled race date in October 2010.

The F1 teams arrived from Japan for the 17th race of the season to find work on-going in the midst of furious activity and an aroma of drying paint. Being positive, drivers exploring the 3.5-mile (5.6-km) track on foot were impressed by the potential. The layout may have been completely flat and exposed to a strong breeze coming off a waterway leading to the South China Sea, but there was a variety of corners with long straights. A sweeping section preceded a number of 'street circuit' tight turns through what would be a planned marina on the harbour side. The fact that the only thing nautical to be seen was the profile of distant cranes in the

Mokpo shipyard strengthened concern about the venture's future. Added to which, not many race fans seemed willing to make the trip from Seoul and those that stayed at home were probably glad they did so as rain lashed the inaugural Grand Prix.

Of more immediate concern had been the pit lane entry and exit, both of which were on the racing line. For 2011, the circuit bosses moved the wall at the quick Turn 17 to allow drivers a better view of anyone slowing and heading for the pits. The pit exit had been re-routed around the outside of Turn 1 for 2013, by which time the drivers and teams had become disenchanted with the venue.

Apart from an increasingly bumpy surface (a product of settlement on the reclaimed land), it was noted that F1's arrival each year seemed to mark the first time the track had been used since the previous Grand Prix – which was usually true. It was as if someone had come along with the key to the circuit gates and allowed teams to venture inside and discover no one had cleared up since their last visit twelve months before. For a facility that was reasonably new, it had the appearance of an abandoned race track as weeds poked through the paddock paving and the hastily applied paint had started to peel.

Despite the venue's potential it was no surprise when, in the face of a change of local government and the absence of necessary on-going financial support, the Korea International Circuit was seen to be dying on its feet. The 2013 Grand Prix would be the last for the time being.

Despite the best intentions, extensive plans for developing the area around a good race track came to nothing.

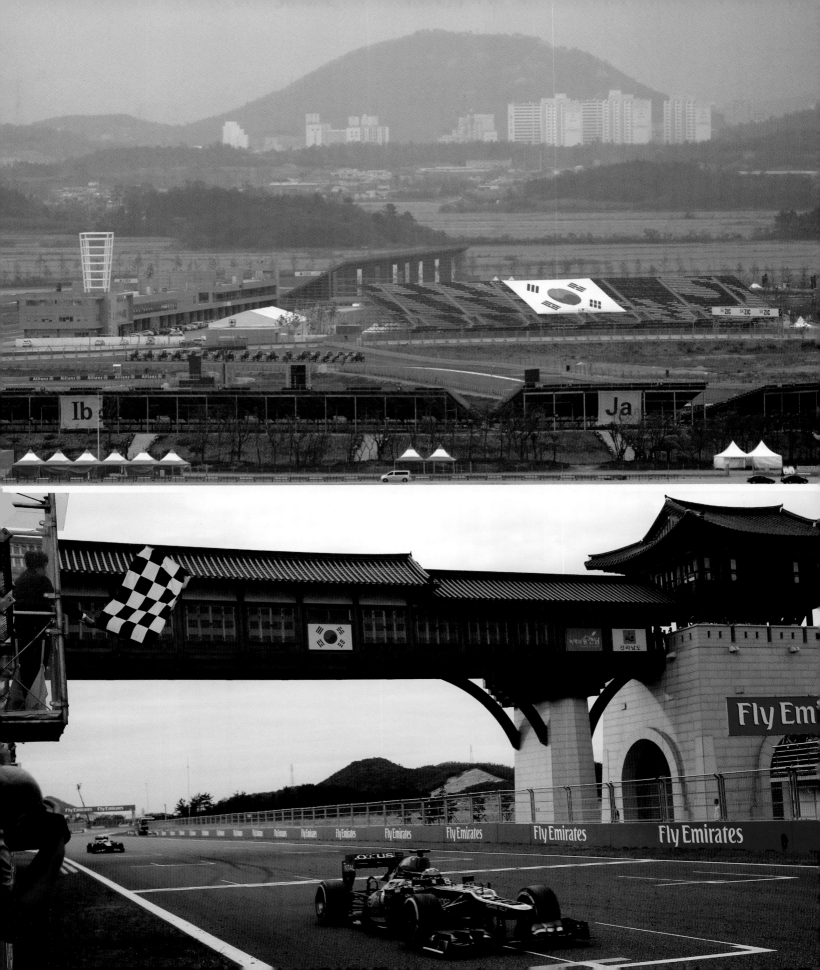

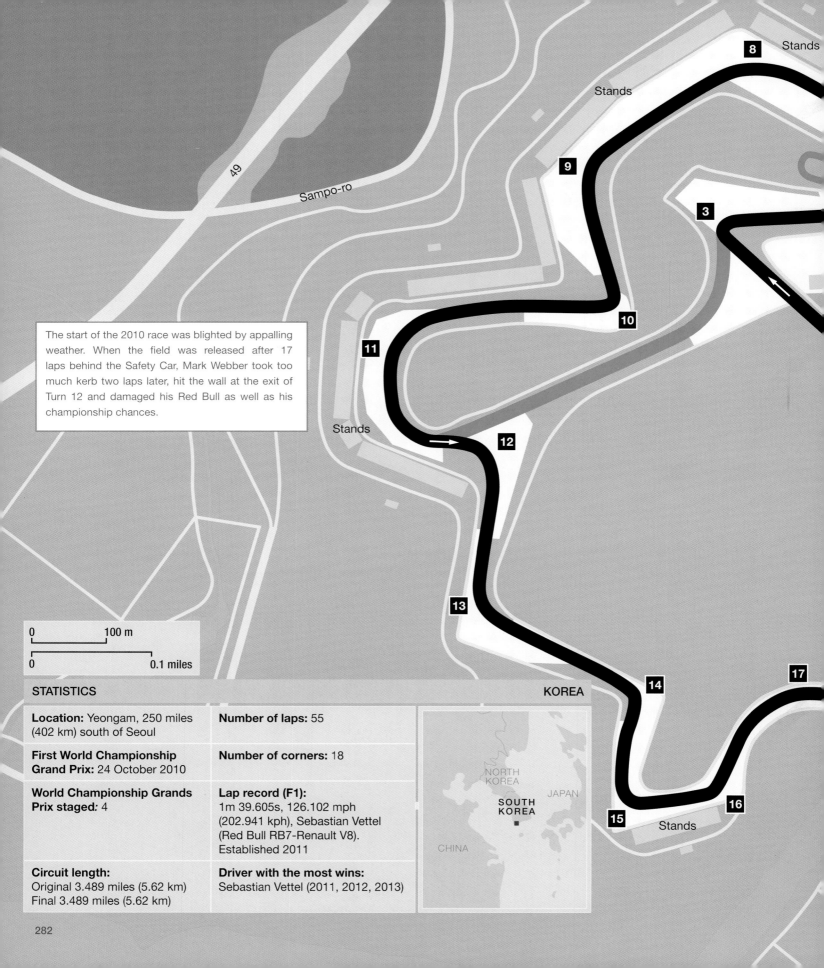

The start of the 2010 race was blighted by appalling weather. When the field was released after 17 laps behind the Safety Car, Mark Webber took too much kerb two laps later, hit the wall at the exit of Turn 12 and damaged his Red Bull as well as his championship chances.

STATISTICS

Location: Yeongam, 250 miles (402 km) south of Seoul	**Number of laps:** 55
First World Championship Grand Prix: 24 October 2010	**Number of corners:** 18
World Championship Grands Prix staged: 4	**Lap record (F1):** 1m 39.605s, 126.102 mph (202.941 kph), Sebastian Vettel (Red Bull RB7-Renault V8). Established 2011
Circuit length: Original 3.489 miles (5.62 km) Final 3.489 miles (5.62 km)	**Driver with the most wins:** Sebastian Vettel (2011, 2012, 2013)

KOREA

NORTH KOREA

SOUTH KOREA

JAPAN

CHINA

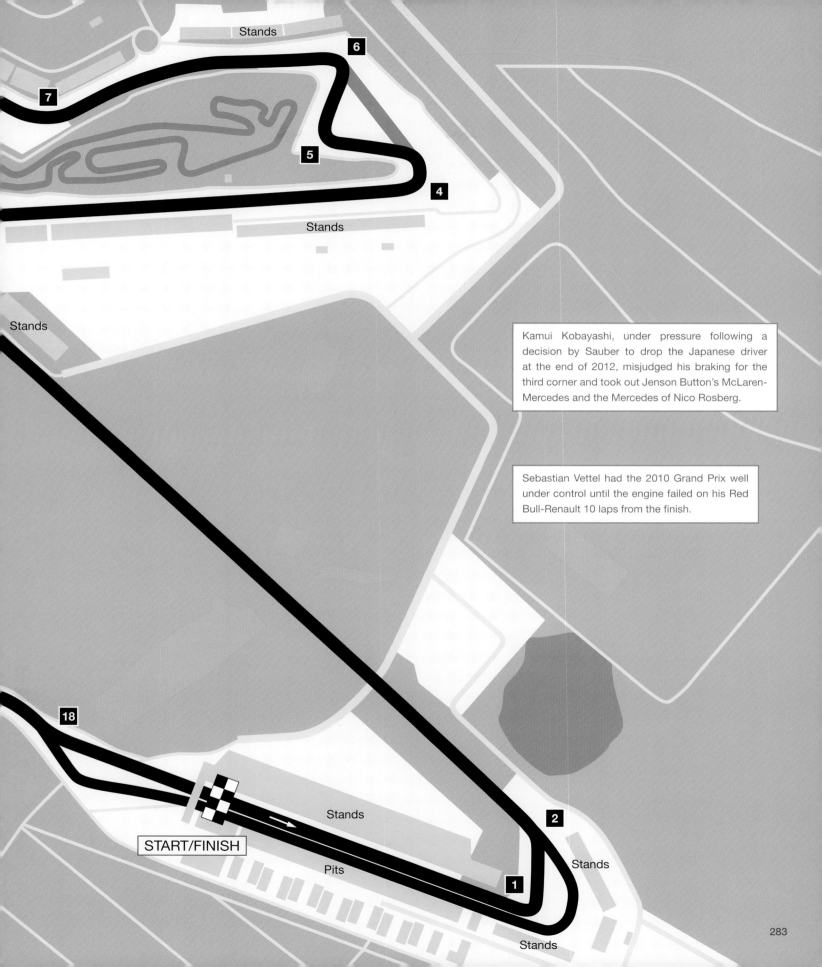

Stands

6

7

5

4

Stands

Stands

Kamui Kobayashi, under pressure following a decision by Sauber to drop the Japanese driver at the end of 2012, misjudged his braking for the third corner and took out Jenson Button's McLaren-Mercedes and the Mercedes of Nico Rosberg.

Sebastian Vettel had the 2010 Grand Prix well under control until the engine failed on his Red Bull-Renault 10 laps from the finish.

18

Stands

START/FINISH

Pits

2

Stands

1

Stands

India 2011

Buddh International Circuit

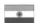 INDIA

Hosted India's first Grand Prix in 2011. The undulating permanent track with a good mix of high-speed and tricky corners received drivers' warm approval. Political and financial difficulties stalled plans to be a regular part of the F1 calendar.

Unlike some of the more recent arrivals on the Grand Prix calendar, India had long been a possibility, given the country's enthusiasm for motor sport and a potentially lucrative market for sponsors. Grands Prix had been televised since the 1990s and the arrival of Indian sponsors, not to mention the Force India team, cranked up further interest.

Permanent tracks were already in existence, albeit deemed unsuitable for F1, when the idea was first mooted in the 1990s. A site in Hyderabad was considered before the political emphasis swung the idea towards Mumbai, although neither got off the ground. There was further prevarication over proposed sites elsewhere until 2007 when the focus shifted to Greater Noida, near New Delhi. A scheme for the Buddh International Circuit, backed by private enterprise, was approved with the first Grand Prix finally scheduled for October 2011. Construction was completed barely weeks before the F1 teams arrived.

The end-product, spread over 874 acres at a cost in excess of $400 million, was considered to be worth waiting for. Designer Hermann Tilke had called for considerable groundwork to provide the rise and fall that would make the 3.2-mile (5.15-km) track more testing than some of his earlier creations.

The moving of four million cubic tons of earth laid the foundation for sweeping corners that drivers compared favourably with parts of Spa-Francorchamps. The opening sector was composed of long straights, mild changes of gradient and wide corner entries to encourage overtaking. A long looping right-hander in full view of a large grandstand was the key feature of the final sector. At the start/finish straight, a huge curved awning covered the 13,000-seat grandstand to compliment the world-class pit and paddock area. Buddh International had its individual stamp to accompany the cultural differences enjoyed by the teams in this teeming city with quirky traditions, at least by European standards.

There would be a trio of Grands Prix initially, all three won by Sebastian Vettel and Red Bull. Despite the first in 2011 being a dull affair, reports were positive and the enthusiastic response of 100,000 fans matched the initial feelings of the participants. The India Grand Prix seemed set to continue until a switch from the end of the season to the beginning led to the 2014 race being postponed for a year. And then indefinitely thanks to disputes about operations charges and taxes. The losers were the passionate race fans and F1 itself.

Top: The Buddh International Circuit was well-received by drivers and race fans but politics and finance would come into play.

Bottom: Sebastian Vettel won all three Grands Prix, the Red Bull-Renault driver celebrating his fourth championship in 2013.

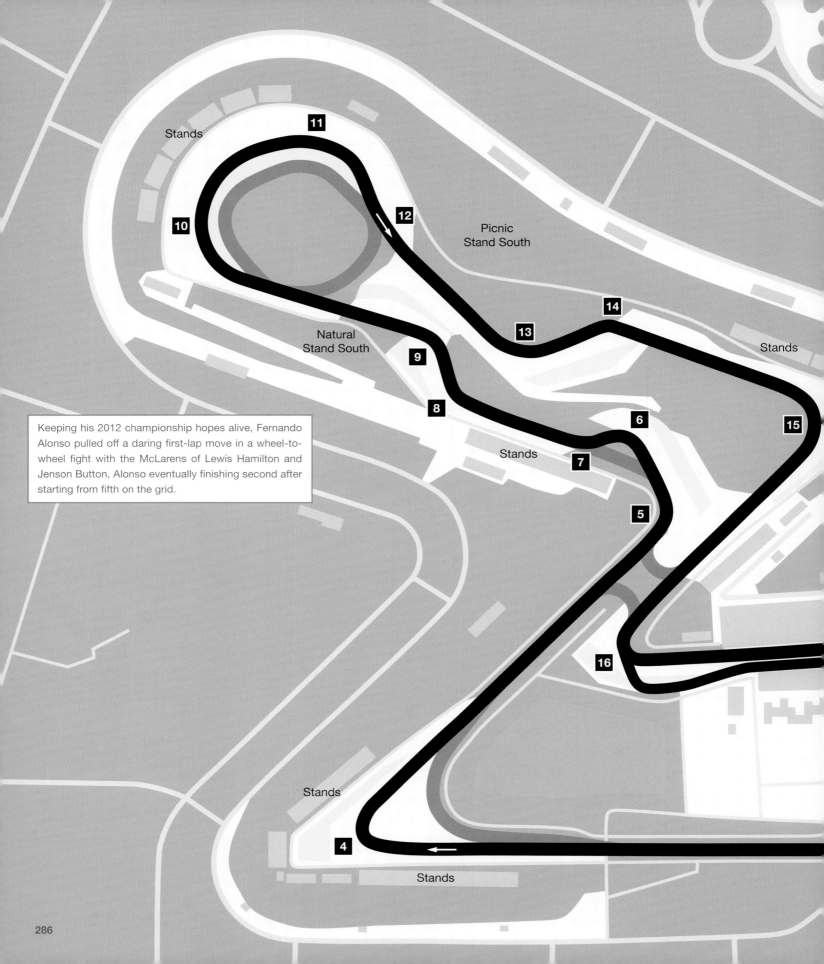

Keeping his 2012 championship hopes alive, Fernando Alonso pulled off a daring first-lap move in a wheel-to-wheel fight with the McLarens of Lewis Hamilton and Jenson Button, Alonso eventually finishing second after starting from fifth on the grid.

Stands

11

10

Stands

12

Picnic
Stand South

14

13

Natural
Stand South

9

Stands

8

6

15

Stands

7

5

16

4

Stands

Stands

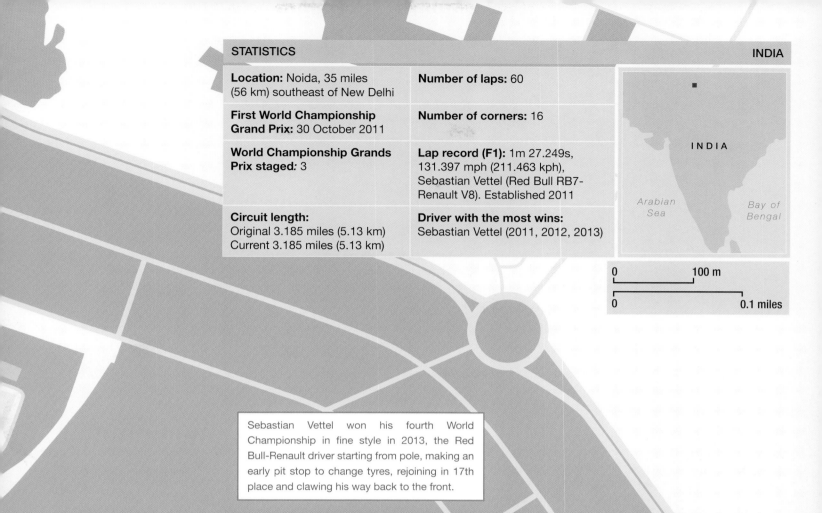

STATISTICS

Location: Noida, 35 miles (56 km) southeast of New Delhi

First World Championship Grand Prix: 30 October 2011

World Championship Grands Prix staged: 3

Circuit length:
Original 3.185 miles (5.13 km)
Current 3.185 miles (5.13 km)

Number of laps: 60

Number of corners: 16

Lap record (F1): 1m 27.249s, 131.397 mph (211.463 kph), Sebastian Vettel (Red Bull RB7-Renault V8). Established 2011

Driver with the most wins: Sebastian Vettel (2011, 2012, 2013)

INDIA

Arabian Sea

Bay of Bengal

0	100 m
0	0.1 miles

Sebastian Vettel won his fourth World Championship in fine style in 2013, the Red Bull-Renault driver starting from pole, making an early pit stop to change tyres, rejoining in 17th place and clawing his way back to the front.

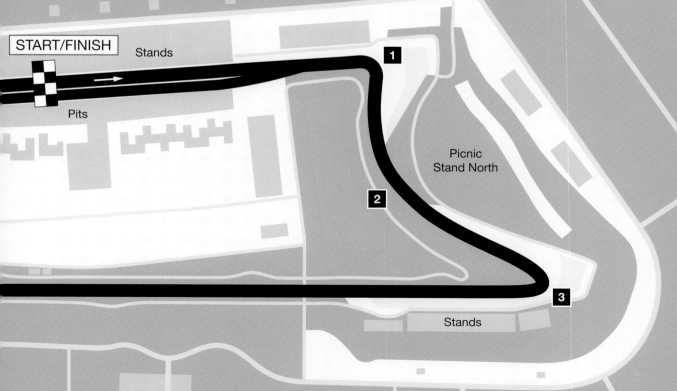

START/FINISH

Stands

Pits

1

2

3

Picnic Stand North

Stands

Austin 2012

Circuit of the Americas

 UNITED STATES OF AMERICA

The USA finally produced a permanent track worthy of inclusion on the F1 schedule in 2012. An excellent combination of corners and sweeps, falling and rising to give good viewing. Well appointed and enjoyed by enthusiastic crowds. The vibrant city of Austin threw itself behind the race from the outset.

The thought of the United States finally having a world class permanent race track seemed doomed not long after building work had commenced on undeveloped land 15 miles southeast of Austin in Texas. A major disagreement between the promoter, Tavo Hellmund, and the management company led to construction being put on hold and the return of the United States Grand Prix put in doubt. Hellmund left the company and threatened to sue but sufficient guarantees were made to have the race reinstated on the 2012 calendar.

Work on the Circuit of the Americas recommenced to the relief of many on both sides of the Atlantic. F1's need for American representation in its World Championship was even greater than the USA's desire to finally provide a secure home. A quick glance on first acquaintance was enough to show that the objective had been reached.

The drive towards gently rolling fields just off Texas State Highway 130 was misleading because, inside the boundary, Hermann Tilke had created a circuit with massive gradients, starting with an uphill charge to the first corner. A wide hairpin left preceded a steep drop into a quick right and on towards a series of fast swerves reminiscent of the Maggotts/Becketts complex at Silverstone. A climb to Turns 9 and 10 brought competitors to another high point, the large grandstand giving excellent views of the return leg along the valley below.

The longest straight fed a final sector filled with a mix of corners, including a very long multi-apex right in the mould of Turn 8 in Turkey. Surrounding this and the run towards the start/finish straight were serried ranks of hospitality units signifying the business aspect of the weekend.

Speaking of which, the so-called Grand Plaza in the centre housed concession stands, restrooms and a landscaped zone, the entire area dominated by a landmark observation tower served by either an elevator (high-speed, of course) or 428 steps for those not in a hurry. From the top, it was possible to see downtown Austin, the renegade city that embraced the Grand Prix in generous style. Although much larger in size than Adelaide, comparisons were readily drawn with the welcome generated by the first home for the Australian Grand Prix.

The willingness to make this venue work eased initial gripes that the team hospitality areas were basic (in contrast with, say, the stainless steel splendour of the kitchens in Bahrain), a shortcoming that mattered even less when the mild climate allowed team members to sit outside and enjoy the buzz of a compact and homely paddock. The soulless concrete expanse of Shanghai this most certainly was not.

On race day, 117,429 spectators – a massive figure by United States standards (Indianapolis notwithstanding) – turned out in the sunshine to enjoy a race that held its interest thanks to Lewis Hamilton's McLaren-Mercedes taking the lead from the Red Bull of Sebastian Vettel 14 laps from the end. Mario Andretti, the 1978 World Champion and natural choice as circuit ambassador, carried out the podium interviews, the happy image of the day completed by Pirelli arranging for each of the three drivers to wear black Texan Stetsons instead of the usual peaked caps. No question, the United States Grand Prix was back.

Top: Clever marketing had Lewis Hamilton, Sebastian Vettel and Fernando Alonso wearing Pirelli Stetsons instead of caps on the podium after the first race in 2012.

Bottom: The United States Grand Prix appeared to have finally found a permanent home with an excellent race track backed by the enthusiastic city of Austin.

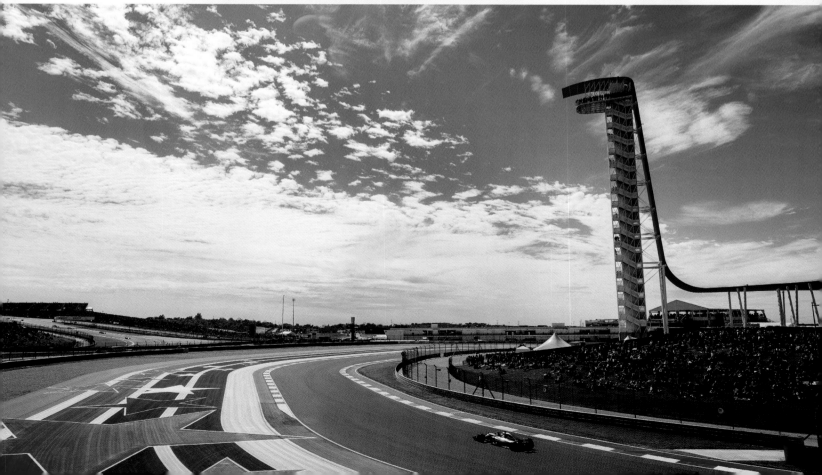

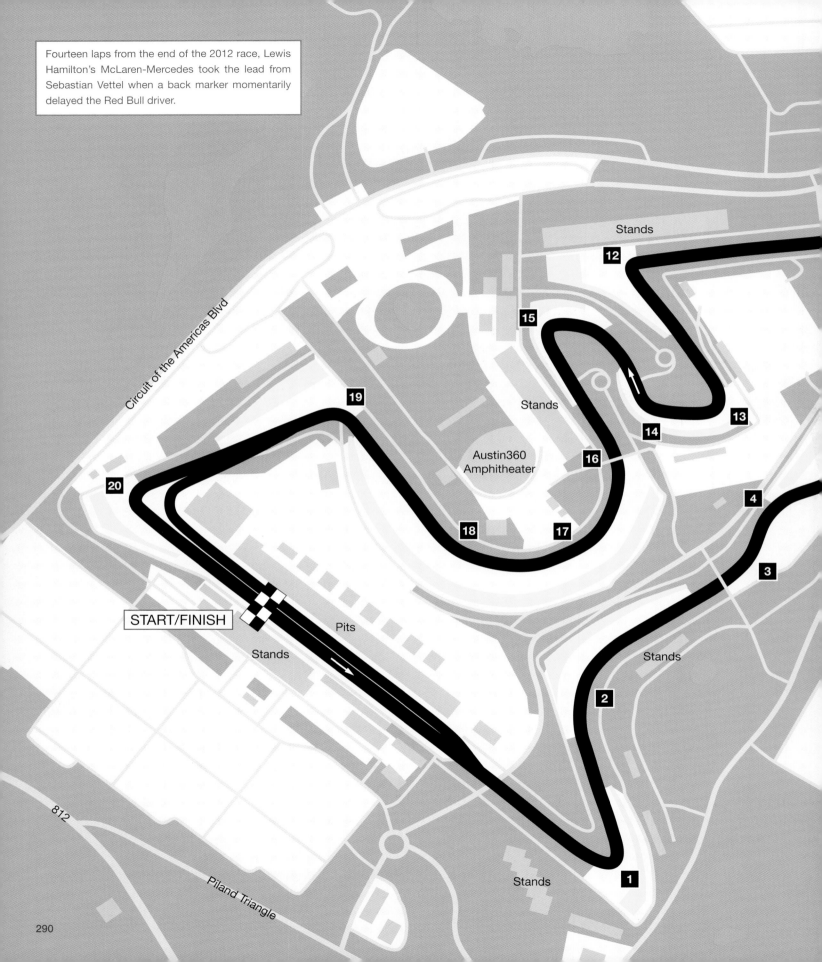

Fourteen laps from the end of the 2012 race, Lewis Hamilton's McLaren-Mercedes took the lead from Sebastian Vettel when a back marker momentarily delayed the Red Bull driver.

Stands

12

15

Circuit of the Americas Blvd

19

Stands

14

13

20

Austin360 Amphitheater

16

4

18

17

START/FINISH

Pits

3

Stands

Stands

2

812

Stands

1

Piland Triangle

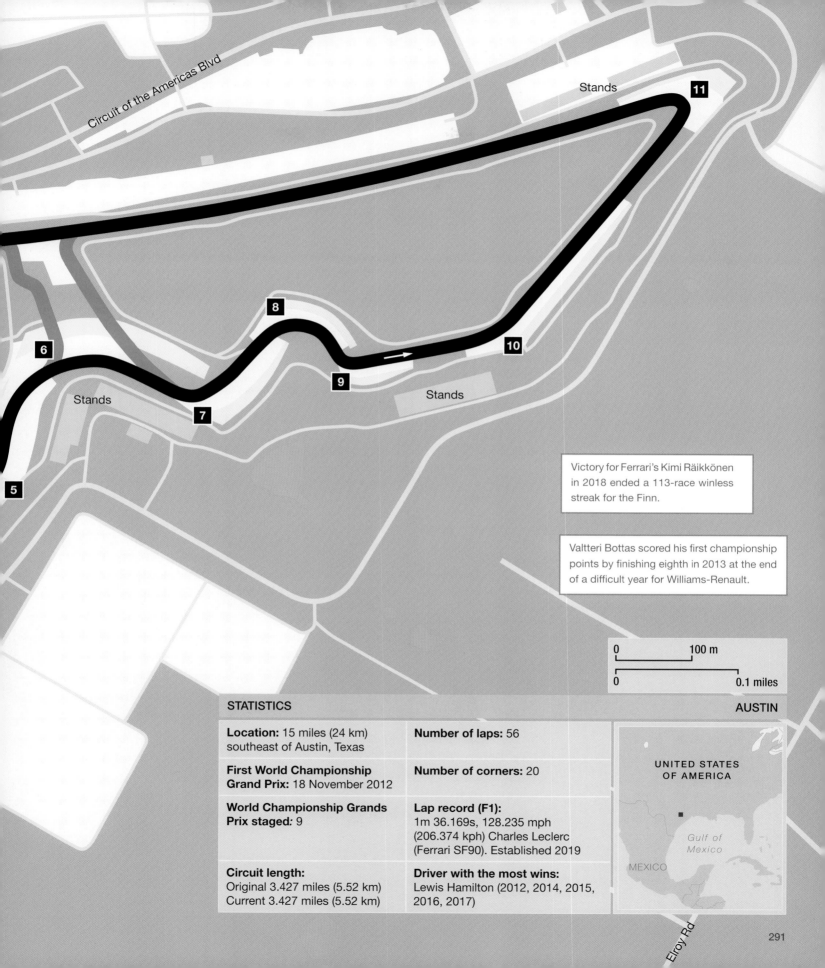

Circuit of the Americas Blvd

Stands

11

8

6

10

Stands

9

7

Stands

5

Victory for Ferrari's Kimi Räikkönen in 2018 ended a 113-race winless streak for the Finn.

Valtteri Bottas scored his first championship points by finishing eighth in 2013 at the end of a difficult year for Williams-Renault.

0	100 m
0	0.1 miles

AUSTIN

STATISTICS

Location: 15 miles (24 km) southeast of Austin, Texas	**Number of laps:** 56
First World Championship Grand Prix: 18 November 2012	**Number of corners:** 20
World Championship Grands Prix staged: 9	**Lap record (F1):** 1m 36.169s, 128.235 mph (206.374 kph) Charles Leclerc (Ferrari SF90). Established 2019
Circuit length: Original 3.427 miles (5.52 km) Current 3.427 miles (5.52 km)	**Driver with the most wins:** Lewis Hamilton (2012, 2014, 2015, 2016, 2017)

UNITED STATES OF AMERICA

Gulf of Mexico

MEXICO

Elroy Rd

Sochi 2014

Sochi Autodrome

 RUSSIA

After many false starts elsewhere, Sochi became the first Grand Prix in Russia. Built off the back of the 2014 Winter Olympics, using the same site with permanent pit and paddock facilities. Government backing ensured the race's presence despite a growing lack of enthusiasm within F1. The political situation in Ukraine in 2022 ensured the immediate end of the Russian Grand Prix.

Plans for a Russian Grand Prix – much coveted by Bernie Ecclestone – had been on-going since the turn of the Millennium. Various projects – the Pulkovskoe Ring and Nagatino Island – had been discussed but came to nothing. However, a track at the town of Fedyukino in Moscow Province was built to a standard high enough to stage rounds of the Formula Renault Series, as well as the FIA GT and Superbike World Championships. A planned F1 Grand Prix did not materialise but, in the meantime, agreement was reached to construct a track in the resort city of Sochi, where a vast amount to work was being done to stage the 2014 Winter Olympics.

Part of the track, including the pits and paddock, would be permanent, the remainder utilising service roads serving Olympic venues. The constricted location limited Hermann Tilke's scope but the designer came up with a reasonable mix, starting with a very long 180-degree left-hander circling the former 'Medals Plaza' and skirting the Bolshoy Ice Dome before heading north along the edge of the Olympic Park, past the skating and curling centres. A series of angular American street-style 90 degree corners brought competitors to the end of the third-longest lap in 2014. A date was set for October of that year.

The initial reaction from the drivers was that the circuit was varied and interesting. The never-ending Turn 3 put a high loading on the right front tyre in a similar manner to Turn 8 at Istanbul, the difference being that tyre wear was not so severe at Sochi. Turn 13 was also considered to be more challenging than expected, first appearances on paper and on race simulators having been deceptive.

A Grand Prix in Russia had its inevitable political nuances, particularly when President Vladimir Putin gave his seal of approval by turning up and watching the race – or some of it – in the company of Bernie Ecclestone. They were joined by 55,000 fans, most of whom had been desperate to have a Formula 1 race on Russian soil. The race may have been processional but they were not let down by what fussy F1 insiders considered to be a well-organised Grand Prix. The invasion of Ukraine in 2022, however, immediately ended all ties between Formula 1 and Russia.

Top: The first Grand Prix in Russia used a street track incorporating many of the facilities put in place for the 2014 Winter Olympics.

Bottom: Local enthusiasm for a Grand Prix in Russia remained high in 2021.

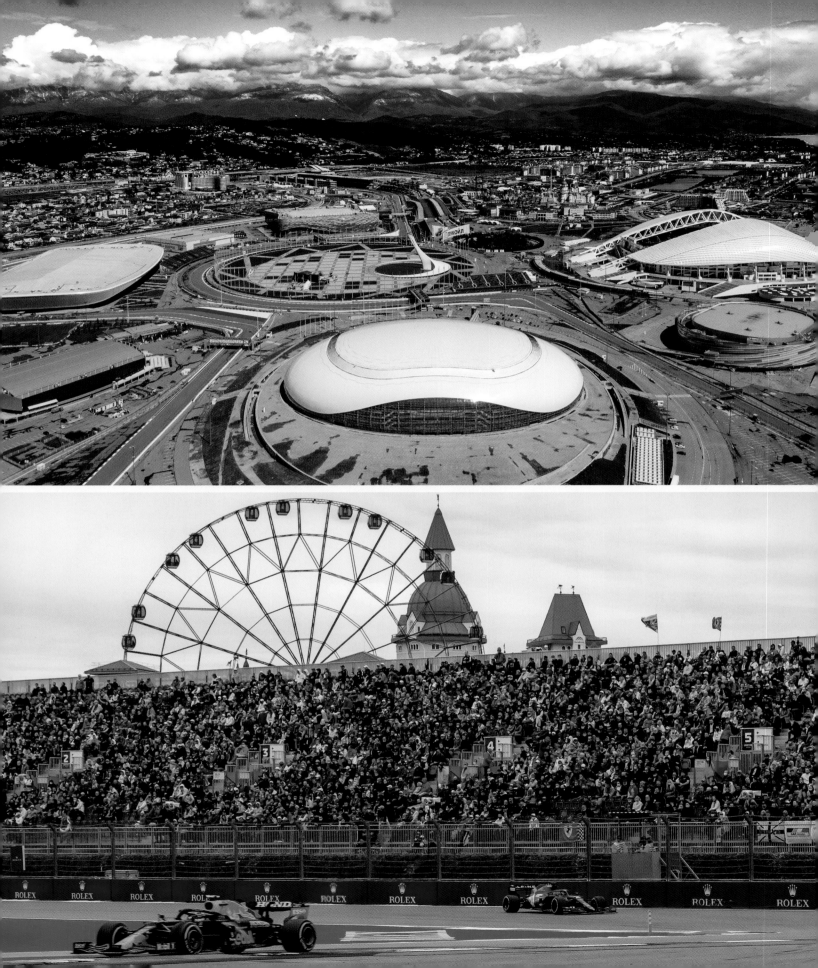

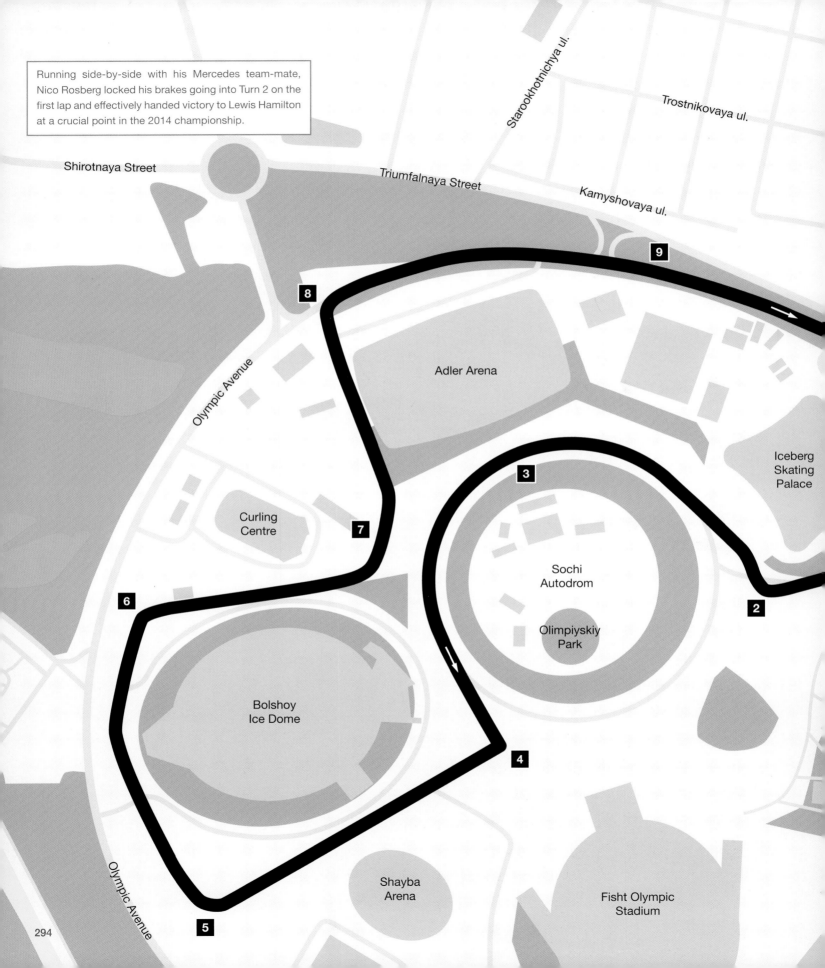

Running side-by-side with his Mercedes team-mate, Nico Rosberg locked his brakes going into Turn 2 on the first lap and effectively handed victory to Lewis Hamilton at a crucial point in the 2014 championship.

Shirotnaya Street

Starookhotnichya ul.

Trostnikovaya ul.

Triumfalnaya Street

Kamyshovaya ul.

9

8

Adler Arena

Olympic Avenue

Iceberg Skating Palace

3

Curling Centre

7

Sochi Autodrom

6

2

Olimpiyskiy Park

Bolshoy Ice Dome

4

Shayba Arena

Fisht Olympic Stadium

Olympic Avenue

5

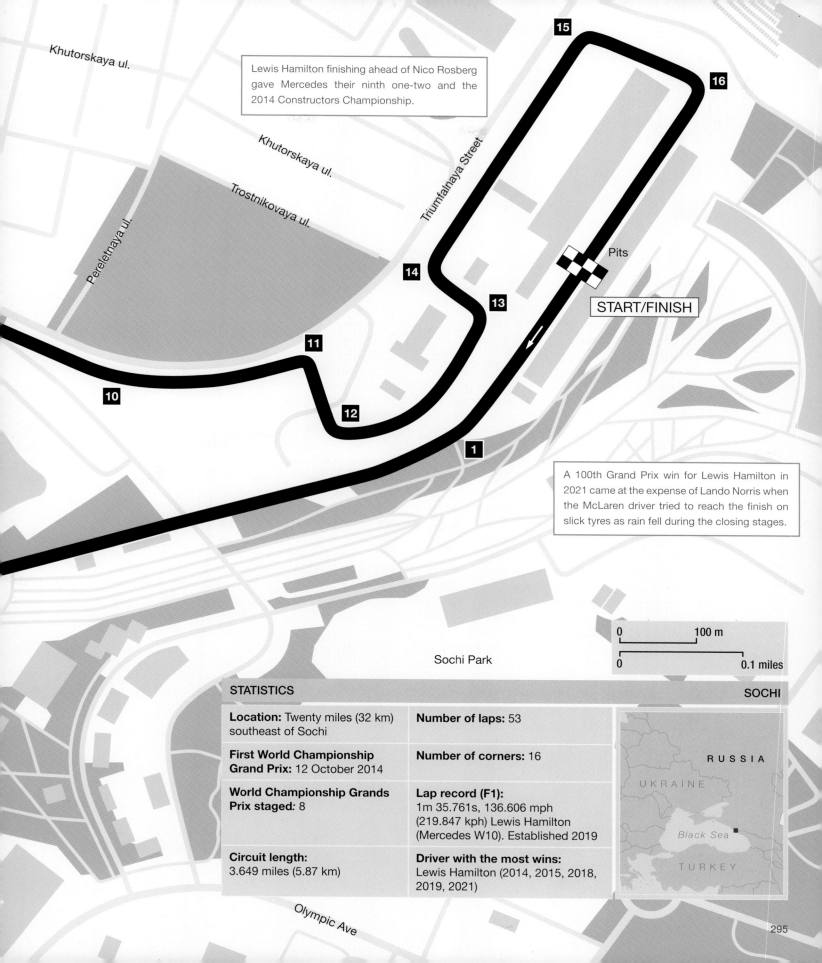

Lewis Hamilton finishing ahead of Nico Rosberg gave Mercedes their ninth one-two and the 2014 Constructors Championship.

A 100th Grand Prix win for Lewis Hamilton in 2021 came at the expense of Lando Norris when the McLaren driver tried to reach the finish on slick tyres as rain fell during the closing stages.

Khutorskaya ul.

Khutorskaya ul.

Trostnikovaya ul.

Pereletnaya ul.

Triumfalnaya Street

Pits

START/FINISH

Sochi Park

0 100 m

0 0.1 miles

SOCHI

STATISTICS

Location: Twenty miles (32 km) southeast of Sochi	**Number of laps:** 53
First World Championship Grand Prix: 12 October 2014	**Number of corners:** 16
World Championship Grands Prix staged: 8	**Lap record (F1):** 1m 35.761s, 136.606 mph (219.847 kph) Lewis Hamilton (Mercedes W10). Established 2019
Circuit length: 3.649 miles (5.87 km)	**Driver with the most wins:** Lewis Hamilton (2014, 2015, 2018, 2019, 2021)

RUSSIA

UKRAINE

Black Sea

TURKEY

Olympic Ave

Baku 2016

Baku City Circuit

 AZERBAIJAN

A Grand Prix with a brief history as spectacular as the circuit. Run through the streets of the Azerbaijani capital, Baku is likened to a combination of Monaco and Monza, the tight sections and super-fast straights producing incidents and dramatic racing.

A Grand Prix on the streets of Baku was first discussed in 2010, with Hermann Tilke commissioned to design a track three years later. The first race, scheduled for June 2016, would be the eighth round of the championship and carry the title European Grand Prix.

Initial doubts about the viability of staging a motor race through parts of a UNESCO World Heritage site were soon dispelled. A series of short straights linking 90-degree corners near government buildings in the city centre led to a section through the historic quarter. The cobbled surface may have been covered in asphalt but the past could not be avoided as a narrow passage – just 25 ft (7.6 metres) wide – remained at a point between an ancient stone turret and an apartment building. Cars emerged from this loop onto the wide, gently curving promenade by the Caspian Sea for a 1.25-mile (2-km) blast towards the finishing line.

From as low as 60 mph (96.56 kph) at one stage during his best lap in 2016, the Williams-Mercedes of Valtteri Bottas went on to reach 234.87 mph (378 kph); at the time, the fastest-ever speed recorded during an official practice/qualifying session. This unique combination presented a test for drivers and engineers as they dealt with a mix of technical sections and high-speed stretches. With the walls being in close proximity, mistakes would be punished.

The first Grand Prix weekend experienced the anticipated teething problems (insecure artificial kerbs and a drain cover coming loose during practice) but, overall, Baku was impressive. An eventful race, won by the Mercedes of Nico Rosberg, had been run without any contentious incidents.

The same could not be said the following year. Now known as the Azerbaijan Grand Prix, the race, as would become the norm, had its fair share of safety car periods. During one, the Ferrari of Sebastian Vettel ran into the back of Lewis Hamilton's Mercedes. Claiming Hamilton had given him a brake test, Vettel drew alongside and swerved into the Mercedes. Vettel was penalised for dangerous driving.

Contact with the walls – and between cars – became commonplace. In 2018, the Red Bulls of Max Verstappen and Daniel Ricciardo collided while disputing fourth place. The Covid-19 pandemic caused the cancellation of the Grand Prix in 2020 and the following year's race to be run behind closed doors.

That did not dilute the drama as Verstappen lost a comfortable lead when, with five laps remaining, his Red Bull suffered a tyre failure at 200 mph (322 kph) on the main straight. Verstappen was able to step from the wreckage but the race was red flagged. At the restart, Hamilton came close to taking other drivers out when he locked his brakes and went straight on at the first corner.

These incidents, and the efficient method of dealing with them on a spectacular circuit, would contribute to the Grand Prix at Baku becoming highly regarded during a comparatively short space of time.

A unique mix of fast and slow sections through contemporary areas of Baku and the old town.

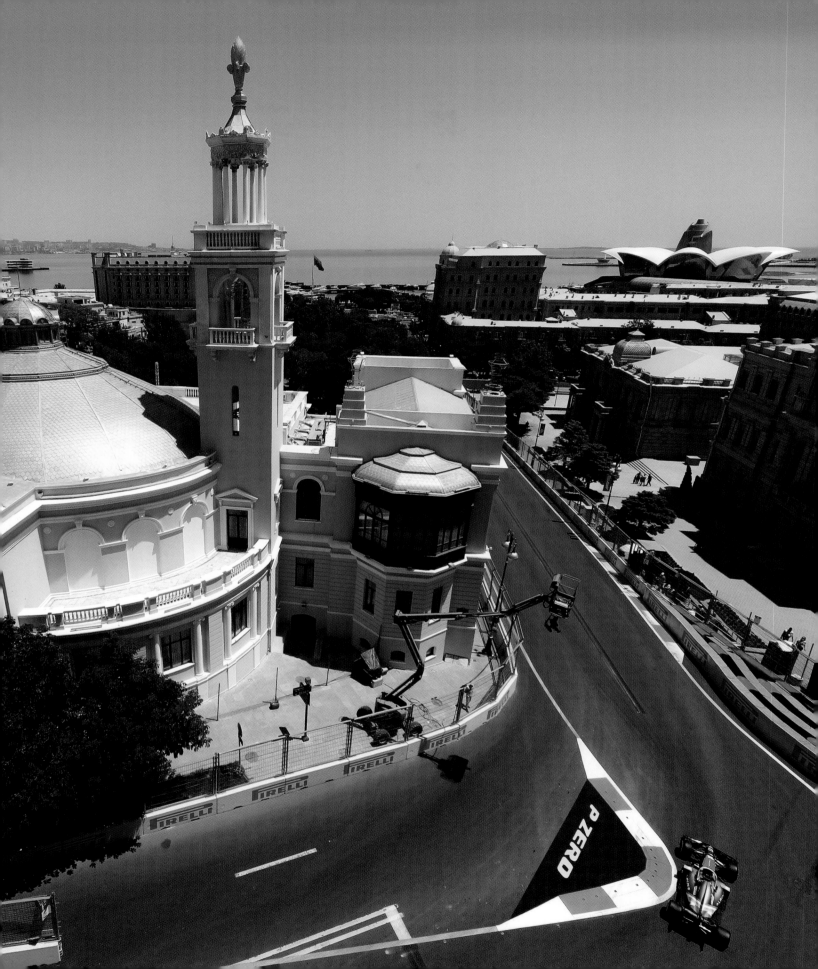

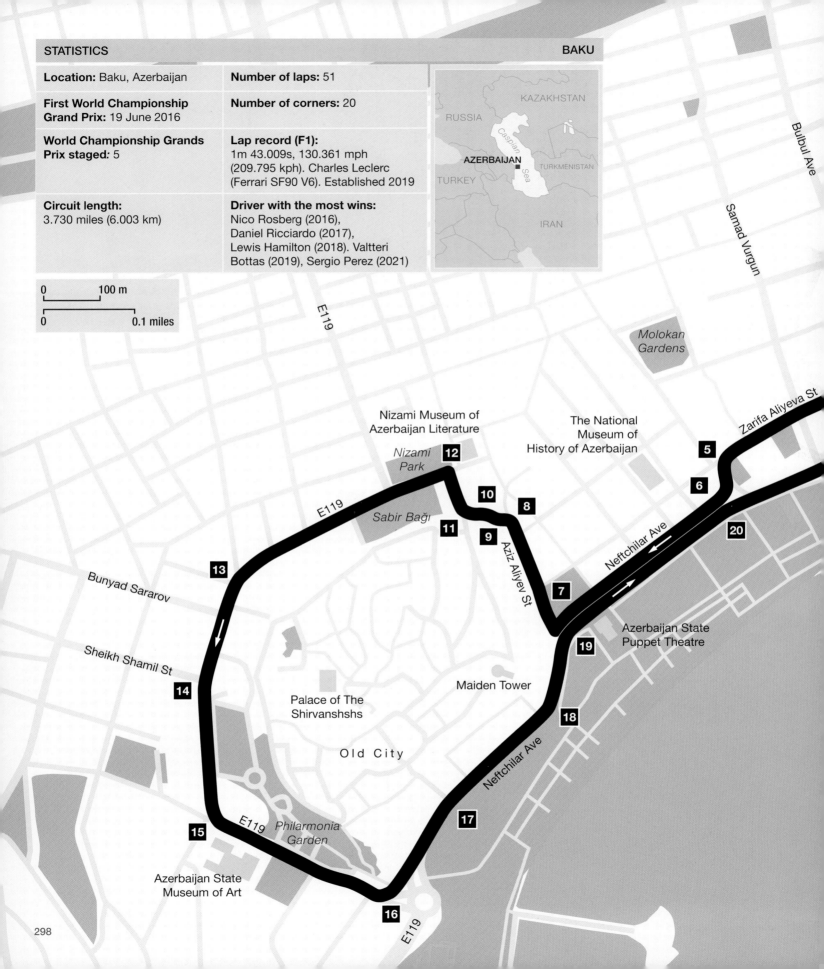

Location: Baku, Azerbaijan

First World Championship Grand Prix: 19 June 2016

World Championship Grands Prix staged: 5

Circuit length: 3.730 miles (6.003 km)

Number of laps: 51

Number of corners: 20

Lap record (F1): 1m 43.009s, 130.361 mph (209.795 kph). Charles Leclerc (Ferrari SF90 V6). Established 2019

Driver with the most wins: Nico Rosberg (2016), Daniel Ricciardo (2017), Lewis Hamilton (2018). Valtteri Bottas (2019), Sergio Perez (2021)

KAZAKHSTAN

RUSSIA

Caspian Sea

AZERBAIJAN

TURKMENISTAN

TURKEY

IRAN

0 100 m

0 0.1 miles

E119

Bulbul Ave

Samad Vurgun

Molokan Gardens

Zarifa Aliyeva St

Nizami Museum of Azerbaijan Literature

The National Museum of History of Azerbaijan

Nizami Park

12

5

10

6

8

E119

Sabir Bağı

11

9

7

20

Neftchilar Ave

Aziz Aliyev St

13

Bunyad Sararov

19

Sheikh Shamil St

Azerbaijan State Puppet Theatre

14

Maiden Tower

18

Palace of The Shirvanshshs

Old City

Neftchilar Ave

15

E119

Philarmonia Garden

17

Azerbaijan State Museum of Art

16

E119

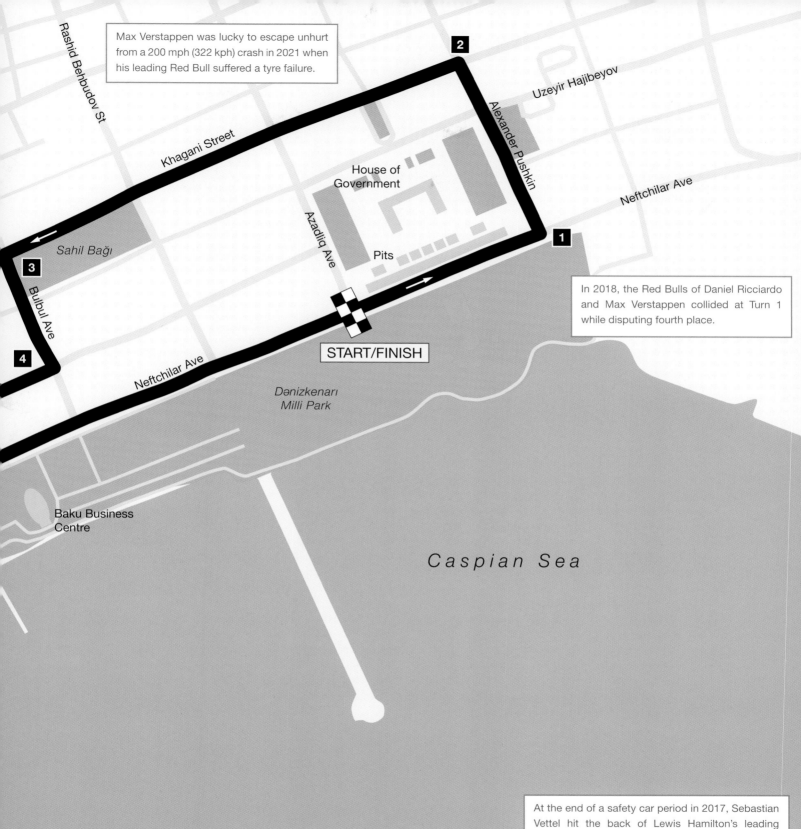

Max Verstappen was lucky to escape unhurt from a 200 mph (322 kph) crash in 2021 when his leading Red Bull suffered a tyre failure.

Rashid Behbudov St

Khagani Street

Uzeyir Hajibeyov

Alexander Pushkin

Neftchilar Ave

House of Government

Azadlıq Ave

Pits

Sahil Bağı

Bulbul Ave

2

1

3

4

In 2018, the Red Bulls of Daniel Ricciardo and Max Verstappen collided at Turn 1 while disputing fourth place.

START/FINISH

Neftchilar Ave

Dənizkenarı Milli Park

Baku Business Centre

Caspian Sea

At the end of a safety car period in 2017, Sebastian Vettel hit the back of Lewis Hamilton's leading Mercedes as they exited Turn 15. Believing Hamilton had reduced speed deliberately, the Ferrari driver drew alongside and swerved into the Mercedes.

Mugello 2020

Autodromo Internazionale del Mugello

 ITALY

A classic, fast and spectacular track in the rolling hills of Tuscany, more famous for motorcycle racing than F1 Grands Prix. Owned by Ferrari and called into use by F1 during the Covid-19 pandemic of 2020, Mugello proved to be a popular stop-gap.

The Mugello area had history as a classic motor sport venue. The Mugello Grand Prix, held on a 41-mile (66.2-km) circuit (using part of the prestigious Mille Miglia route), was part of the World Sportscar Championship in the 1960s. Fatal injuries to spectators in 1970 brought 50 years of racing to a close.

The present circuit, close by part of the original road course in the Tuscan hills near Scarperia e San Piero, was opened in 1974 and, two years later, hosted the first of many rounds of the World Motorcycle Championship.

Extensive renovations and new pit buildings were put in place following Ferrari's purchase of the track as a test facility in 1988. Although considered unsuitable for a Grand Prix, F1 used Mugello for an in-season test in 2012 when all but one of the 12 teams turned up. Romain Grosjean (Lotus-Renault) set an unofficial track record of 1m 21.035s.

Mugello suddenly came into the reckoning in 2020 when the Covid-19 pandemic wrought havoc with the calendar and F1 was urgently searching for suitable venues. The Tuscan Grand Prix, scheduled for 13 September, would be the ninth round of the revised calendar and, coincidentally, the 1000th Grand Prix for Ferrari.

F1 drivers relished the challenge presented by the 3.259-mile (5.245-km) track with 15 corners, most of them fast and sweeping, some with blind crests which added to the need for bravery and commitment. The downhill Turn 7 was flat out in sixth gear. The double Arrabbiata (Turns 8 and 9) was taken as one flat-in-seventh sweep.

With most of the bends being fifth gear and higher, a processional race with little overtaking was anticipated. In fact, there was plenty of passing, helped largely by the final corner (Bucine) being wide enough to allow different lines and slipstreaming onto the main straight. When drivers could then run side-by-side through San Donato (Turn 1), close racing was ensured.

The elevation changes not only enhanced the spectacle and embraced the stunning topography, but they also accentuated the 'old school' nature of Mugello. If a driver made a mistake or had a problem, the accident was likely to be a big one. When Lance Stroll crashed (without injury) in his Racing Point at the exit of the 170 mph (273.588 kph) Arrabbiata, a red flag was necessary to allow repairs to the barrier.

The Grand Prix was considered a success; the pit and paddock facilities more than adequate. With Covid restrictions having limited spectators to around 2000 Ferrari Club members, Mugello had been able to cope. But potential problems created by the limited access roads, and the future Grand Prix calendar being over-subscribed, meant Mugello was unlikely to be considered again despite having provided a spectacular, if potentially hazardous, stand-in.

Mugello and the rolling hills of Tuscany provided a welcome and spectacular venue during a Covid-ravaged season in 2020.

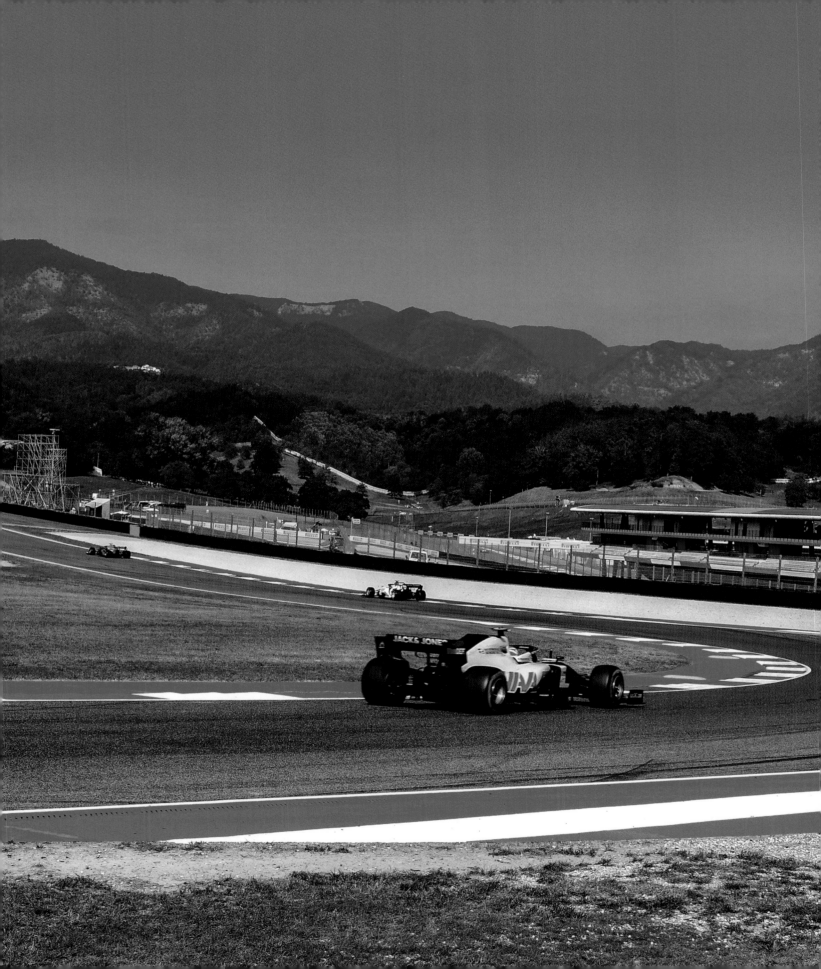

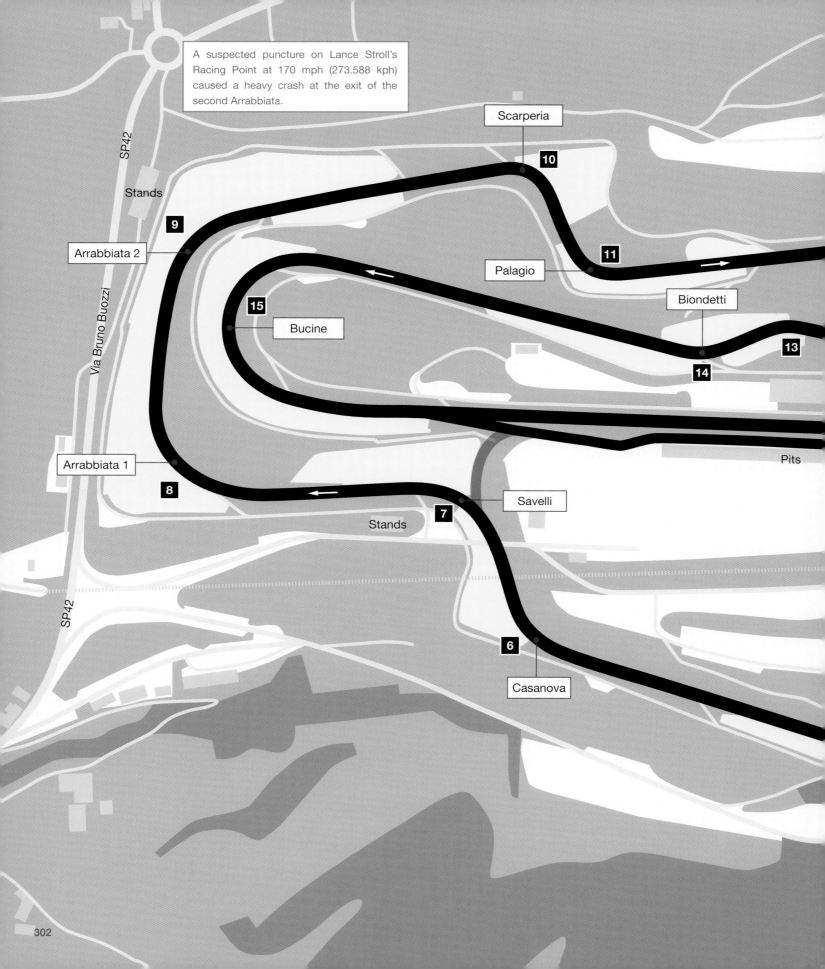

A suspected puncture on Lance Stroll's Racing Point at 170 mph (273.588 kph) caused a heavy crash at the exit of the second Arrabbiata.

Scarperia

10

SP42

Stands

9

Arrabbiata 2

11

Palagio

Biondetti

Via Bruno Buozzi

15

Bucine

13

14

Arrabbiata 1

Pits

8

Savelli

Stands

7

SP42

6

Casanova

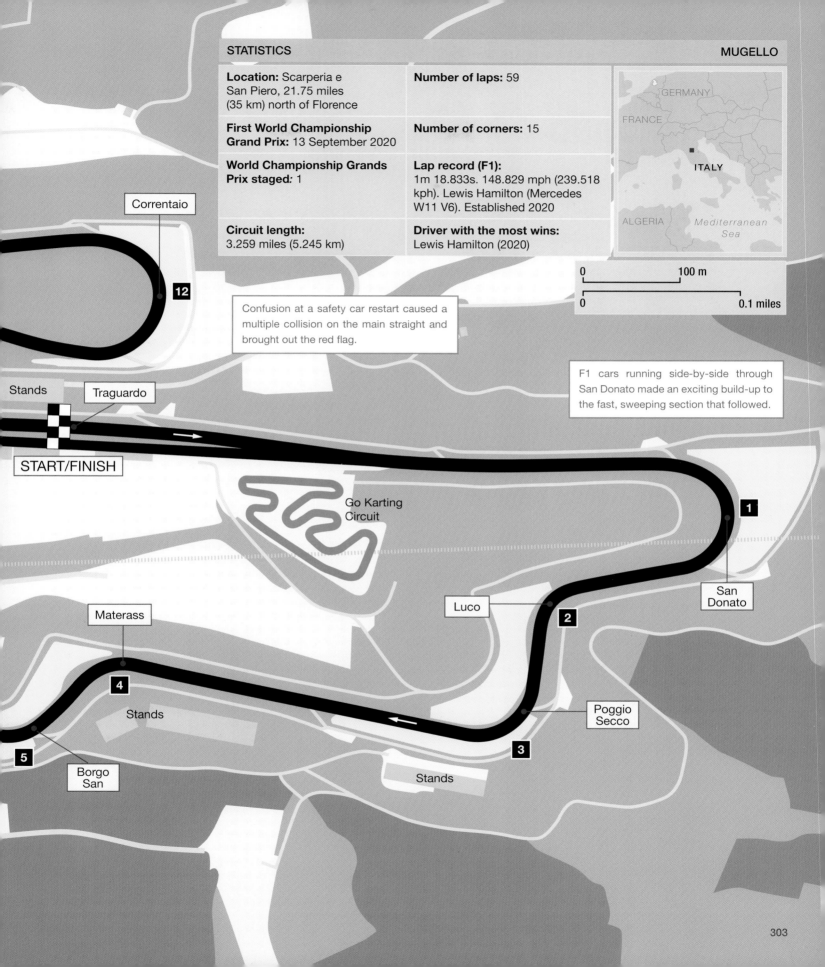

Location: Scarperia e San Piero, 21.75 miles (35 km) north of Florence

First World Championship Grand Prix: 13 September 2020

World Championship Grands Prix staged: 1

Circuit length: 3.259 miles (5.245 km)

Number of laps: 59

Number of corners: 15

Lap record (F1): 1m 18.833s. 148.829 mph (239.518 kph). Lewis Hamilton (Mercedes W11 V6). Established 2020

Driver with the most wins: Lewis Hamilton (2020)

GERMANY

FRANCE

ITALY

ALGERIA Mediterranean Sea

0 100 m

0 0.1 miles

Correntaio

12

Confusion at a safety car restart caused a multiple collision on the main straight and brought out the red flag.

F1 cars running side-by-side through San Donato made an exciting build-up to the fast, sweeping section that followed.

Stands

Traguardo

START/FINISH

Go Karting Circuit

Materass

4

Stands

Luco

2

Poggio Secco

3

1

San Donato

Stands

Borgo San

5

Portimão 2020

Autódromo Internacional do Algarve

 PORTUGAL

Built in 2008, the circuit not far from the Algarve coast was only included on the Grand Prix calendar because of Covid restrictions elsewhere in 2020 and 2021. The return of the Portuguese Grand Prix was enhanced by a challenging track and good facilities.

A new circuit at Portimão was completed in October 2008, 12 years after Estoril, 186.5 miles (300 km) to the north, had fallen from F1 favour. Portimão was well appointed, and the track considered to be challenging and safe, FIA president Max Mosley saying it would make a suitable venue for the return of the Portuguese Grand Prix.

Despite several F1 teams using Portimão for testing in 2009, and the circuit hosting world championship races for superbikes, touring cars and GT categories, agreement was never reached for its inclusion in the F1 World Championship. Like Mugello, Portimão's significance as a Grand Prix venue would become elevated by the disruptive arrival of the Covid-19 pandemic.

Another parallel with the Italian track would be the F1 teams liking what they found. The Portimão circuit, a 30-minute drive inland from the port of the same name, presented another roller-coaster layout thanks to good use of the natural contours. Elevation changes – a 279 ft (85 metre) difference between the highest and lowest points – led to fast, sweeping sections with blind brows and off-camber corners.

Unlike Mugello, however, more recent construction and thinking had allowed for better run-off areas and a generally safer environment as drivers lapped at an average of 135 mph (218 kph) – despite there being two hairpins. Nonetheless, the 2.891-mile (4.653-km) track, made up of 15 corners, offered plenty of challenge and opportunities for overtaking.

The 2020 Portuguese Grand Prix was scheduled for 25 October. The late inclusion and date led to unexpected problems due to cool conditions and track resurfacing that had insufficient time to settle. Drivers struggled to find grip initially on the oily surface with tyres that were not reaching working temperature but, by the third day, the teams' engineers and drivers had learned to cope, thus ensuring a lively race on a track where overtaking was possible. The 66-lap race was run without major incident, Lewis Hamilton dealing with the changing tyre performance better than most.

With Covid continuing to affect the choice of venue, Portimão was included in the 2021 calendar although, this time, a date in May brought improved ambient temperature – if not better grip on a still-slippery surface. Hamilton won in Portugal for a second time, his Mercedes less averse than some to the effect of crosswind on an exposed track, just 9.32 miles (15 km) from the coast.

The comparatively remote location would contribute to a potential lack of sponsorship and spectator support when it came bidding for a place on future F1 calendars. Because of Covid, both Portuguese Grands Prix had been run behind closed doors. The race, despite a willingness of the Portuguese promoters, was not included in the 2022 World Championship.

Top: The return of the Portuguese Grand Prix, and the introduction of the Portimão track, was well received in 2020.

Bottom: Lewis Hamilton's Mercedes leads the charge to the first corner in 2021.

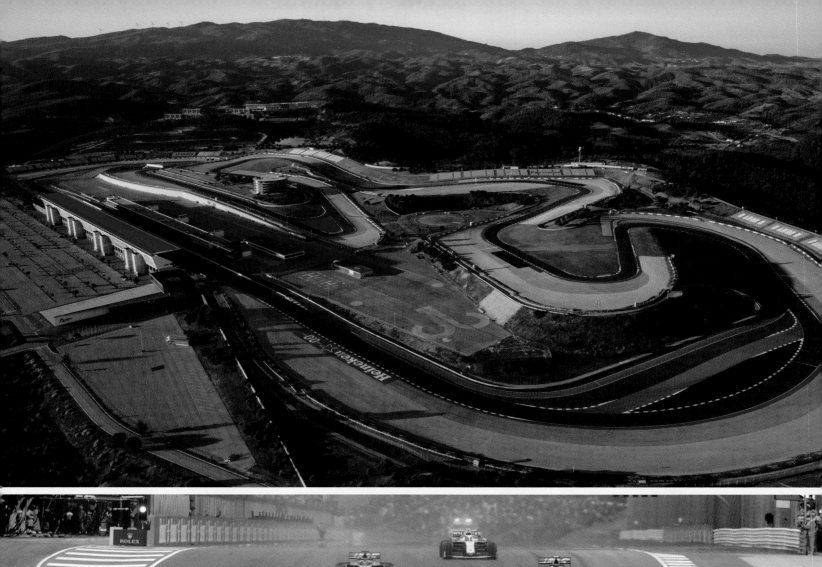
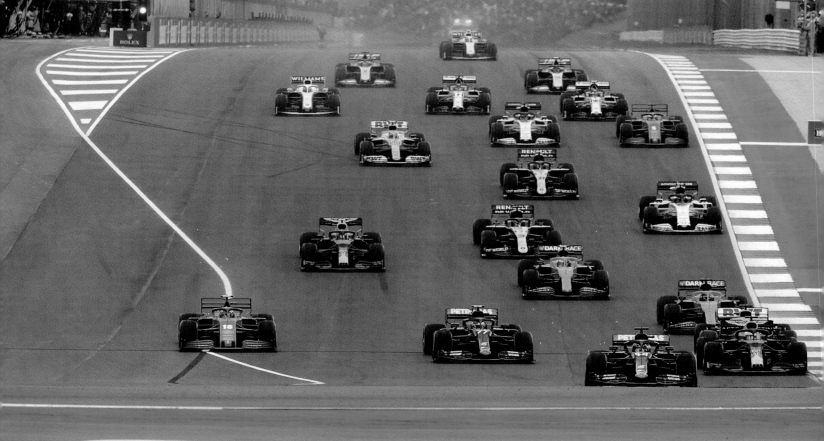

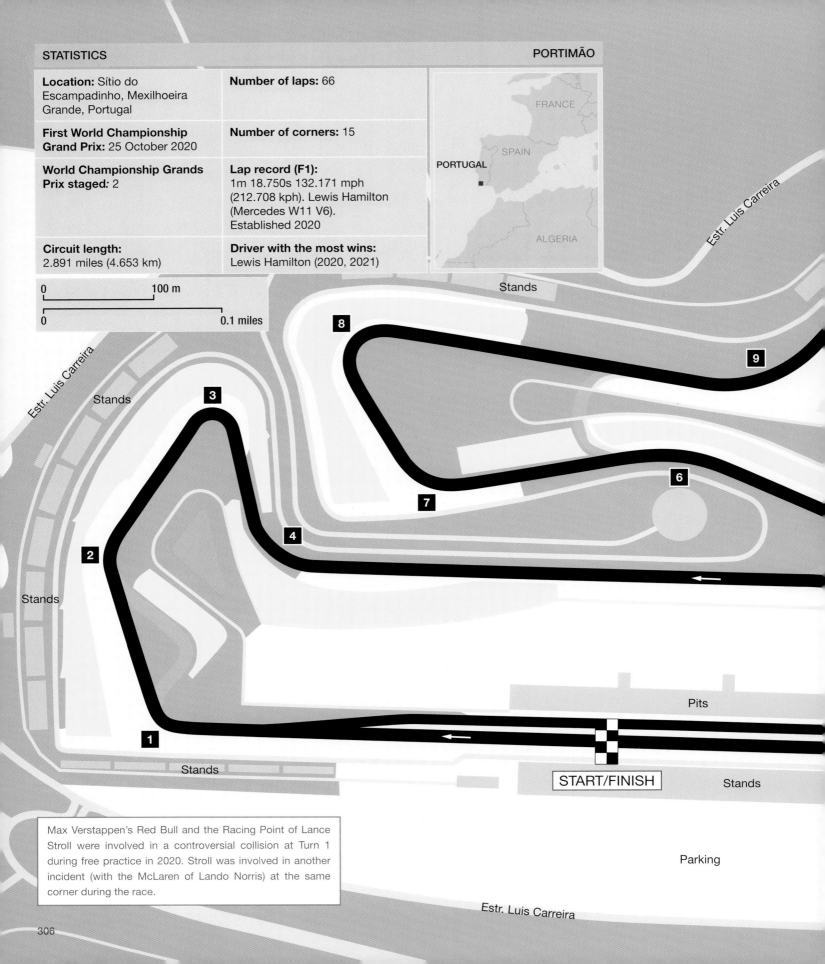

Location: Sítio do Escampadinho, Mexilhoeira Grande, Portugal

First World Championship Grand Prix: 25 October 2020

World Championship Grands Prix staged: 2

Circuit length: 2.891 miles (4.653 km)

Number of laps: 66

Number of corners: 15

Lap record (F1): 1m 18.750s 132.171 mph (212.708 kph). Lewis Hamilton (Mercedes W11 V6). Established 2020

Driver with the most wins: Lewis Hamilton (2020, 2021)

FRANCE

SPAIN

PORTUGAL

ALGERIA

0 100 m

0 0.1 miles

Estr. Luis Carreira

Stands

9

Stands

Estr. Luis Carreira

8

3

7

6

Stands

4

2

Stands

1

Pits

Stands

START/FINISH

Stands

Max Verstappen's Red Bull and the Racing Point of Lance Stroll were involved in a controversial collision at Turn 1 during free practice in 2020. Stroll was involved in another incident (with the McLaren of Lando Norris) at the same corner during the race.

Parking

Estr. Luis Carreira

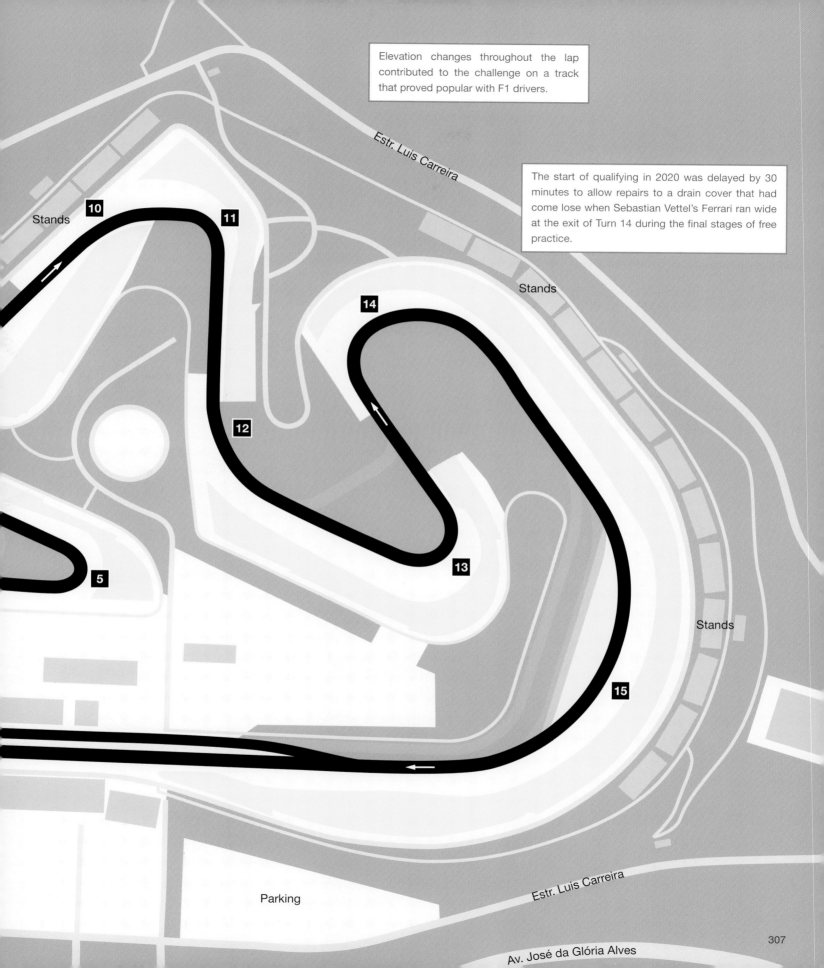

Elevation changes throughout the lap contributed to the challenge on a track that proved popular with F1 drivers.

The start of qualifying in 2020 was delayed by 30 minutes to allow repairs to a drain cover that had come lose when Sebastian Vettel's Ferrari ran wide at the exit of Turn 14 during the final stages of free practice.

Estr. Luis Carreira

Stands

10

11

14

Stands

12

5

13

Stands

15

Estr. Luis Carreira

Parking

Av. José da Glória Alves

Lossail 2021

Lusail International Circuit

 QATAR

A Covid-19 inspired substitute, normally used for motorcycle racing but perfectly adequate to fill out the 2021 F1 calendar. A long straight and a testing mix of fast sweeping curves. Flat kerbs, favoured by motorbikes, caused havoc in the heat with F1 tyres. The 57-lap race signalled the start of a long-term F1 contract elsewhere in Qatar.

Constructed in little over a year at a cost of $58m, the circuit near Lusail, north of Doha, was made ready for the 2004 Qatar motorcycle Grand Prix. Although used occasionally for touring cars and various single seaters, the only permanent race track in Qatar mainly hosted motorbike racing. The installation of trackside lighting allowed Losail to become the largest lit permanent venue in the world (later claimed by Yas Marina Circuit in Abu Dhabi) and stage the first night race in MotoGP history in 2008.

F1 was never on the agenda until the far-reaching effect of the coronavirus pandemic on world events made Losail a viable option. Adjustments were made to the pit lane entry and, in certain places, crash barriers were upgraded. It was announced there would be a Qatar Grand Prix on 21 November 2021, making the fourth full night race on the F1 calendar.

The Grand Prix teams found a comparatively narrow 3.343-mile (5.380-km) circuit with a 0.664-mile (1.068-km) straight. Although there were a few slow corners among the 16 in total, the majority were fast and flowing, one section requiring commitment and accuracy at the start in order not to lose time all the way through the interconnecting curves that followed.

F1 teams also discovered the effect of Losail's predominant motorcycle heritage and its need for flat (rather than raised) kerbs. When drivers used the kerbs to the full at high speed, the effect of rough and ridged surfaces damaged tyres more than expected. In high ambient temperatures, at least four drivers suffered failures on their front-left tyre, which took most of the longitudinal and lateral punishment in the high-speed sections.

Tyre conservation played a major part in a 57-lap race, which turned out to be largely uneventful. Despite its fairly remote desert location (similar to Bahrain) and rather down-at-heel state (compared to other F1 venues), Losail more than served its purpose. Staging a Grand Prix in Qatar worked both ways. The Gulf state demonstrated a latent interest in motor sport and F1 was able to prove its value as a sport and a shop window in the global market for this small nation.

Qatar signed a 10-year contract with F1, with the proviso that 2022 would not be included on the calendar as the country devoted all its energy to staging the FIFA World Cup. For commercial reasons, the track at Losail would in future be marketed as Lusail International Circuit in recognition of the major new city constructed for the football tournament. Meanwhile, a F1 street race was planned for Doha, the nation's capital. There was also talk of a new permanent venue. Losail appeared to have had its day in every sense.

A night race at Lossail in 2021 helped fill out the calendar and cement relationships between Qatar and F1.

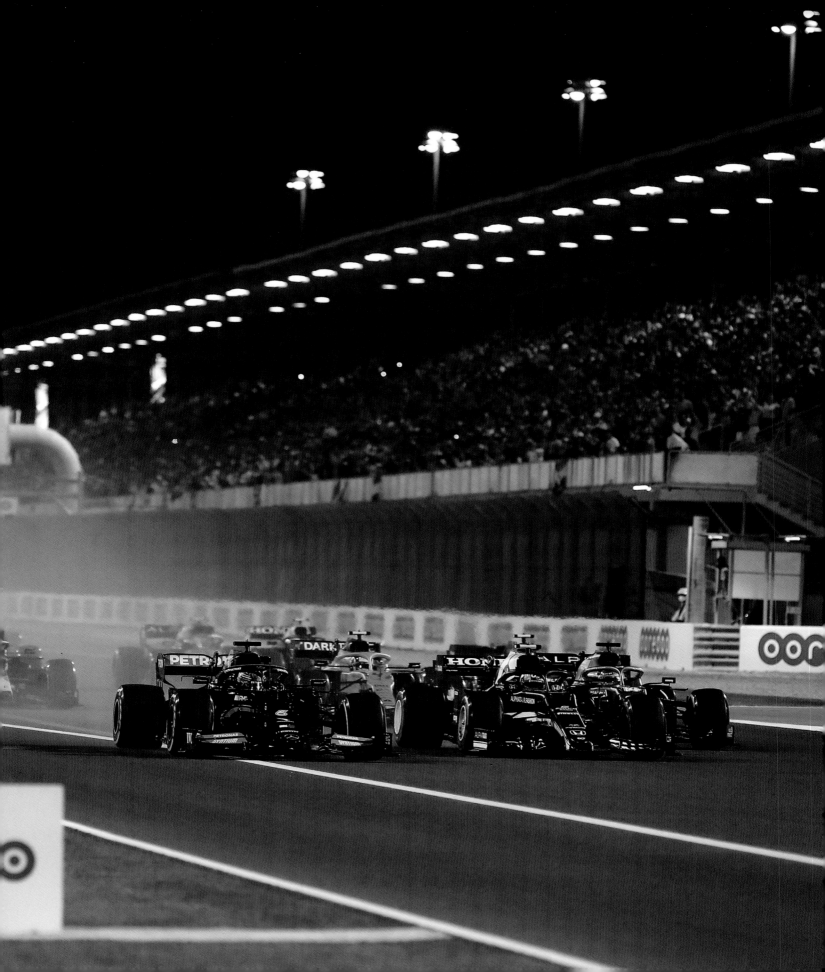

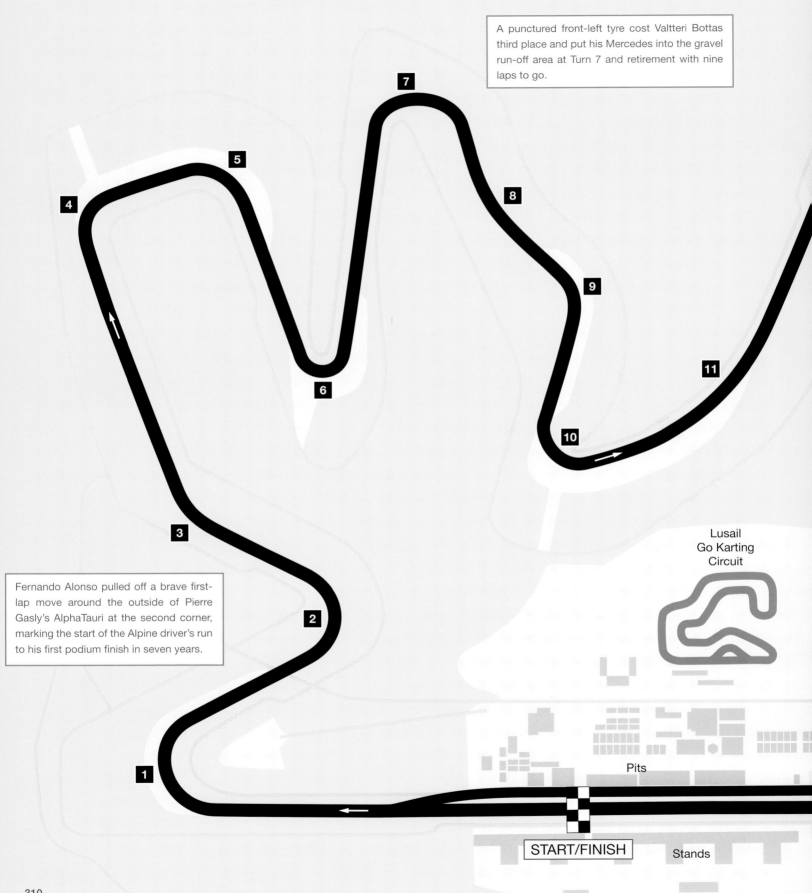

Street 1705

A punctured front-left tyre cost Valtteri Bottas third place and put his Mercedes into the gravel run-off area at Turn 7 and retirement with nine laps to go.

Fernando Alonso pulled off a brave first-lap move around the outside of Pierre Gasly's AlphaTauri at the second corner, marking the start of the Alpine driver's run to his first podium finish in seven years.

Lusail
Go Karting
Circuit

Pits

START/FINISH

Stands

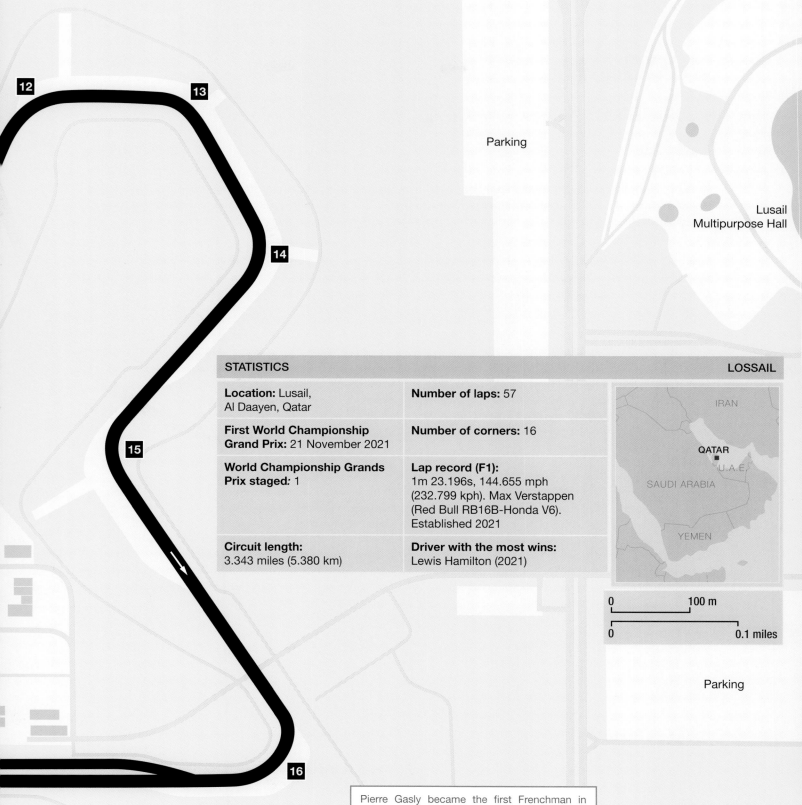

12

13

14

Parking

15

Lusail
Multipurpose Hall

STATISTICS

LOSSAIL

Location: Lusail,
Al Daayen, Qatar

**First World Championship
Grand Prix:** 21 November 2021

**World Championship Grands
Prix staged:** 1

Circuit length:
3.343 miles (5.380 km)

Number of laps: 57

Number of corners: 16

Lap record (F1):
1m 23.196s, 144.655 mph
(232.799 kph). Max Verstappen
(Red Bull RB16B-Honda V6).
Established 2021

Driver with the most wins:
Lewis Hamilton (2021)

IRAN

QATAR
U.A.E.

SAUDI ARABIA

YEMEN

0 100 m

0 0.1 miles

16

Parking

Pierre Gasly became the first Frenchman in
nine years to qualify on the front row when he
put his AlphaTauri alongside the pole position
Mercedes of Lewis Hamilton.

Jeddah 2021

Jeddah Corniche Circuit

 SAUDI ARABIA

A spectacular street circuit by the Red Sea, lined by concrete walls and noted for high speeds. The first Saudi Arabian Grand Prix, the penultimate round of the 2021 championship, was tense and controversial, the walls continuing to add to the drama when the Grand Prix returned in March 2022.

When the Kingdom of Saudi Arabia followed the Middle East trend established by Bahrain and Abu Dhabi, the initial preference for a Grand Prix track was a very fast combination of roads in the city of Jeddah. Planned by Carsten Tilke, son of circuit designer Hermann Tilke, the circuit featured an elongated series of curves created from existing roads linked by new sections of asphalt. Located on the Jeddah Corniche adjoining the Red Sea, at 3.836 miles (6.174 km), this would be the second longest track (behind Spa-Francorchamps) on the F1 calendar. With a lap average of 155 mph (250 kph) through 27 corners, it would also be very fast. The first Saudi Arabian Grand Prix – a night race - was scheduled for 5 December, the 21st round of the 2021 F1 World Championship.

From the outset, drivers enjoyed the challenge presented by the quick curves. But there were reservations, the main one being that the close proximity of concrete walls hid potential hazards. In the event of an incident or a slow car, there would be minimal warning, even allowing for the efficiency of flag marshals.

Adding to the drama in 2021, this race would be the penultimate round of an increasingly fractious championship battle between Max Verstappen and Lewis Hamilton and their respective teams, Red Bull and Mercedes. The tension was racked up even more towards the close of qualifying when Verstappen, going for pole, hit the wall at the exit of the final corner.

This set the scene for a Grand Prix noted more for incidents than actual racing, one of the most contentious being a collision between the championship rivals during a safety car period. The race was interrupted by two red flags and several safety car phases.

Drivers' safety concerns had been noted as the Jeddah circuit was prepared for a return just 16 weeks later. But the time and space restraints meant little could be done, apart from moving the walls back a limited amount in certain places.

The Grand Prix itself was put in doubt when, on 25 March (the first day of practice), a large fire was triggered by a missile strike on an oil depot 10 miles (16 km) from the circuit. The race weekend went ahead following government reassurances about security.

There were several incidents involving cars hitting the walls, the worst occurring during the second part of qualifying when Mick Schumacher lost control on a kerb and smashed into the wall. The Haas driver was released from hospital after a routine check-up. Unlike the race in 2021, the second Grand Prix was notable for a clean wheel-to-wheel fight for the lead between the Ferrari of Charles Leclerc and the ultimately victorious Red Bull of Verstappen.

The future of the Jeddah Corniche Circuit was put in doubt by plans to build a permanent track at Qiddiya, a vast entertainment complex 28 miles (45 km) southwest of the capital, Riyadh.

Top: The lap launched into tricky left and right corners not long after the start.

Bottom: While drivers loved the challenge presented by fast, sweeping curves, there were concerns about the concrete walls restricting visibility.

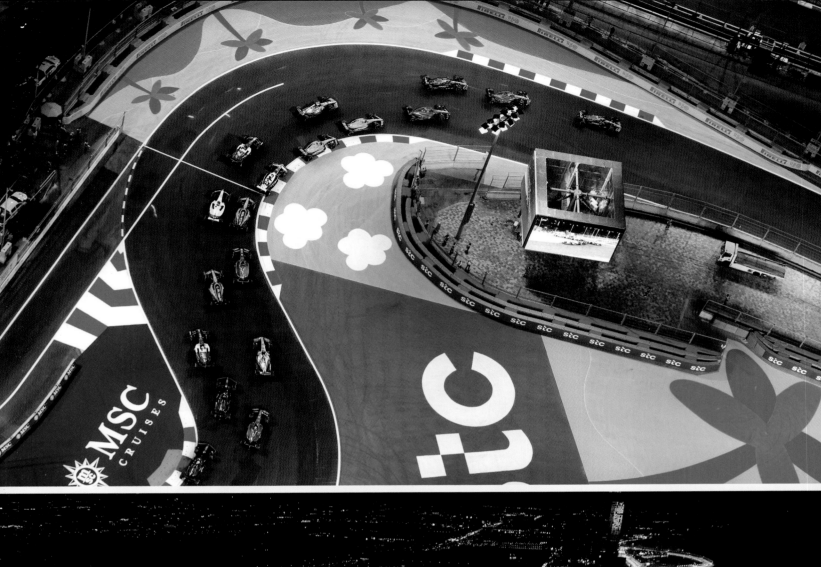

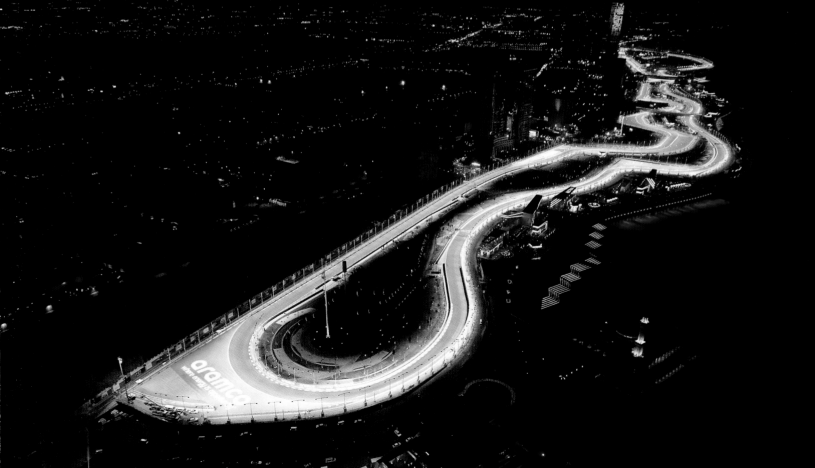

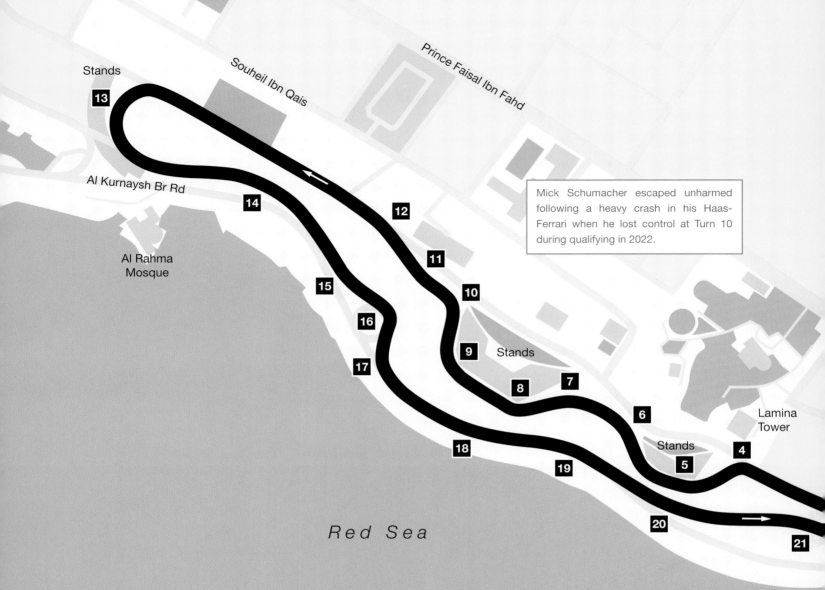

Stands

13

Souheil Ibn Qais

Prince Faisal Ibn Fahd

Al Kurnaysh Br Rd

14

12

Mick Schumacher escaped unharmed following a heavy crash in his Haas-Ferrari when he lost control at Turn 10 during qualifying in 2022.

11

Al Rahma Mosque

15

10

16

9 Stands

17

8 7

6 Lamina Tower

18 Stands

5 4

19

Red Sea

20

21

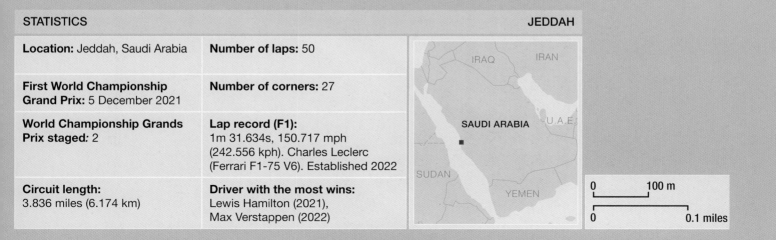

STATISTICS

JEDDAH

Location: Jeddah, Saudi Arabia	**Number of laps:** 50
First World Championship Grand Prix: 5 December 2021	**Number of corners:** 27
World Championship Grands Prix staged: 2	**Lap record (F1):** 1m 31.634s, 150.717 mph (242.556 kph). Charles Leclerc (Ferrari F1-75 V6). Established 2022
Circuit length: 3.836 miles (6.174 km)	**Driver with the most wins:** Lewis Hamilton (2021), Max Verstappen (2022)

IRAQ IRAN

SAUDI ARABIA U.A.E.

SUDAN

YEMEN

0 100 m

0 0.1 miles

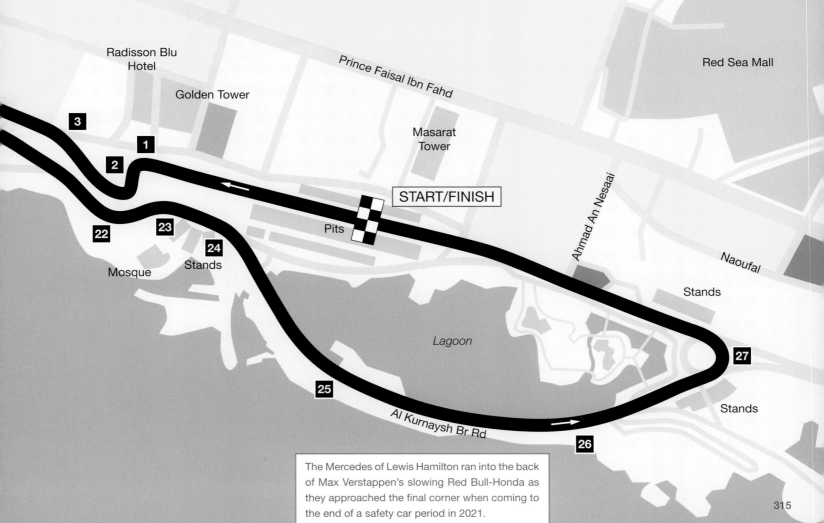

Criminal Court

King Abdul Aziz Rd

Red Sea Mall

A multiple collision coming out of Turn 2 following a restart in 2021 brought a second red flag.

Radisson Blu Hotel

Prince Faisal Ibn Fahd

Golden Tower

Masarat Tower

3

1

2

START/FINISH

Pits

Ahmad An Nesaai

Naoufal

22

23

24

Mosque

Stands

Stands

Lagoon

27

25

Al Kurnaysh Br Rd

Stands

26

The Mercedes of Lewis Hamilton ran into the back of Max Verstappen's slowing Red Bull-Honda as they approached the final corner when coming to the end of a safety car period in 2021.

Miami 2022

Miami International Autodrome

 UNITED STATES OF AMERICA

After failed attempts to stage a Grand Prix on the streets of downtown Miami, the area around the Hard Rock Stadium to the north of the city provided the setting for the fifth round of the 2022 Formula 1 World Championship and a sell-out crowd. A physically demanding and varied track received a mixed reaction.

A Grand Prix in Miami was high on Liberty Media's wish list from the moment the American mass media company bought the Formula One Group in late 2016. A proposal to adopt a track around Bayfront Bay and Biscayne Bay seemed a logical choice, particularly as the downtown street circuit had been used for the CART IndyCar series and Formula E. But the prospect of F1 proved too much for vehement locals who eventually had their way despite the proposed circuit being revised three times – although, in truth, none of the suggested layouts matched F1's true expectations.

Stephen M Ross, a local real estate magnate and philanthropist, had been the driving force behind the project. Undaunted, Ross turned his attention to a property he already owned; the Hard Rock Stadium, home to the Miami Dolphins NFL team – which also belonged to Ross. The stadium may have been in Miami Gardens, a 30-minute drive north of downtown, but the advantages offered were too good to ignore.

Apart from the permanent facilities within the stadium complex, the vast car parks would lend themselves to a track layout that would also incorporate NW 203rd Street on the north side of the stadium. The proposal was not without its detractors, one group saying the event was racially discriminatory, while other objectors claimed the noise would risk permanent hearing damage for the locals. Both cases were dismissed in court. A change of mayor in the City of Miami Gardens – plus the creation of a $5 million community fund – helped seal approval for the race.

The effects of Covid-19 had not helped progress in 2020 and 2021 but Ross overcame this and other obstacles by forming a new company, South Florida Motorsports (SFM), with Tom Garfinkel, an experienced sports organiser, as managing partner. The appointment of Richard Cregan as CEO was another shrewd move, the former Toyota F1 team manager having successfully directed the F1 circuit projects in Abu Dhabi and Sochi.

When the Hard Rock Stadium was first mooted and mention made of car parks as suitable areas for the track, memories were evoked of the unimaginative layout at the back of Caesars Palace Hotel in 1981 and 1982. It soon became apparent that Miami was far-removed in every sense from the Las Vegas venue.

Consultation with F1 MD, Ross Brawn, made clear the sport's hopes when establishing a track to promote close racing. Despite difficulties overcoming issues with going beneath freeways and adopting local roads, SFM eventually laid down a 3.362-mile (5.412-km) track with a variety of corners and 200-mph (322-kph) straights; a tricky combination designed to challenge drivers and their engineers.

Meanwhile, the promotors had been hard at work, ensuring a sell-out long before the first F1 car turned a wheel during free practice on 6 May 2022. While the track itself had points in need of improvement, it was physically demanding and the vibrant atmosphere provided evidence of how a Grand Prix in Miami was being received.

Top: An artificial marina inside Turn 7 was one of many talking points.

Bottom: Red Bull's Max Verstappen, Ferrari's Charles Leclerc (left) and Carlos Sainz (right) endured a physically demanding maiden Grand Prix at Miami in 2022.

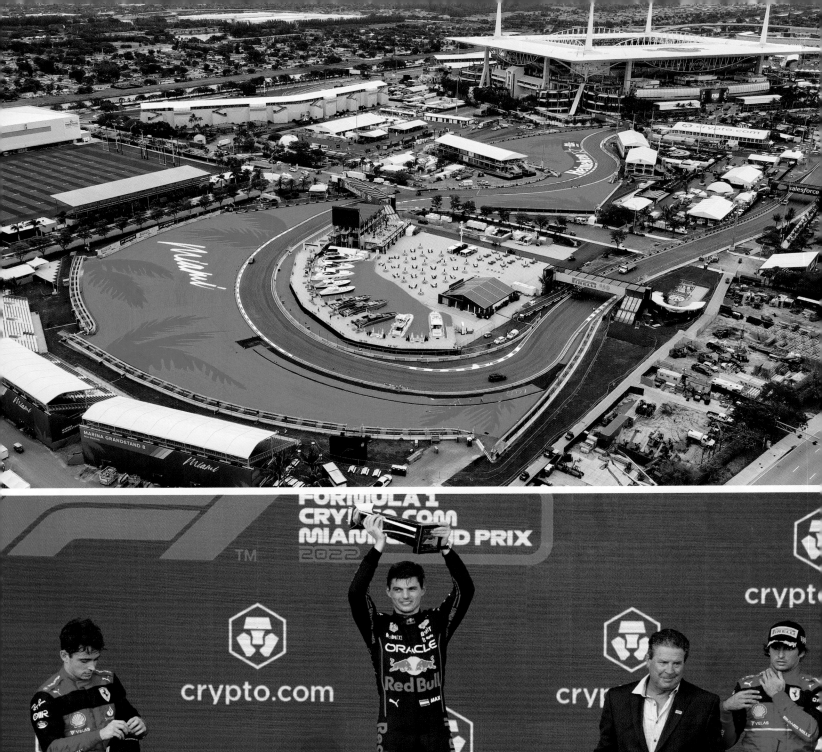
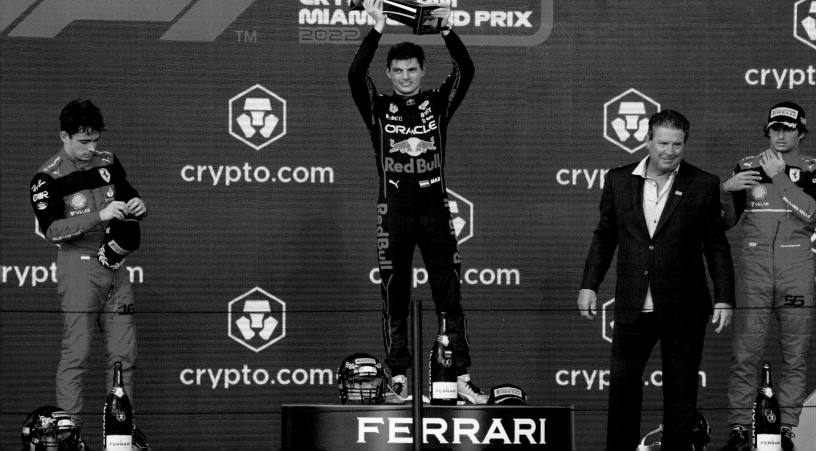

The facilities in and around the Hard Rock Stadium offered an ideal focal point for the Grand Prix.

NW 203rd St

17

19

Stands

18

Stands

Carl F Barger Blvd

Miami Dolphins Training Complex

Parking

Real boats in a fake marina provided a major social talking point for the first Grand Prix in 2022.

Pits

START/FINISH

Hard Rock Stadium

6

4

Stands

7

5

8

9

The advent of a safety car, following a collision between the McLaren of Lando Norris and Pierre Gasly's AlphaTauri, brought life to the 2022 race.

Miami Open Grandstand Stadium

NW 199th St

Mall

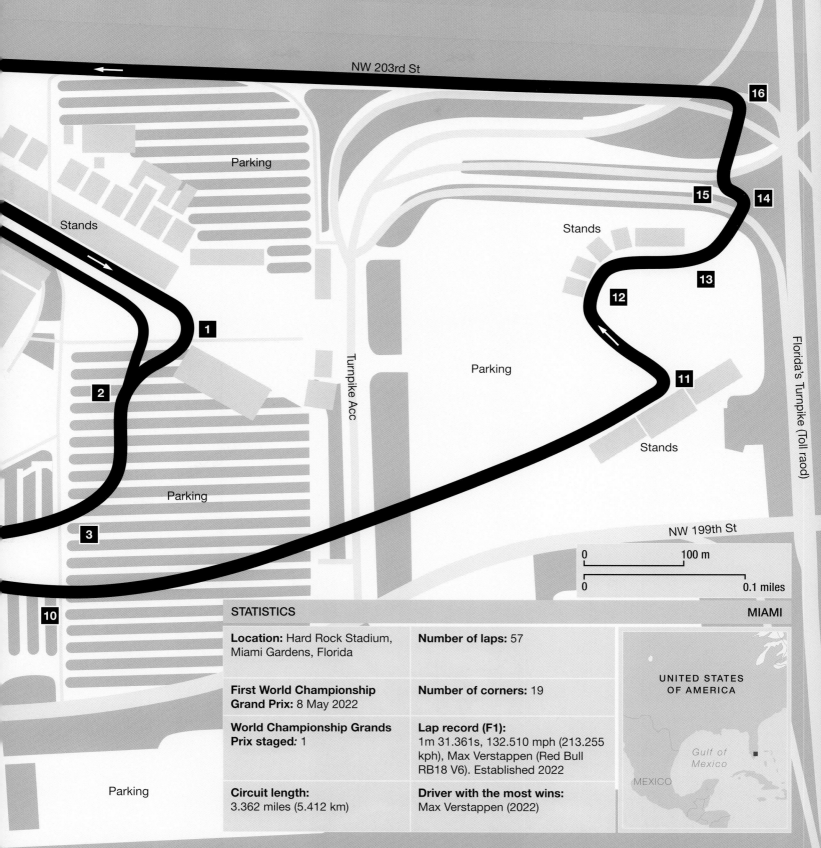

NW 203rd St

16

15 **14**

Parking

Stands

13

Stands

12

11

Florida's Turnpike (Toll raod)

Turnpike Acc

Parking

1

2

Parking

3

NW 199th St

0		100 m

0		0.1 miles

10

Parking

STATISTICS

MIAMI

Location: Hard Rock Stadium, Miami Gardens, Florida	**Number of laps:** 57
First World Championship Grand Prix: 8 May 2022	**Number of corners:** 19
World Championship Grands Prix staged: 1	**Lap record (F1):** 1m 31.361s, 132.510 mph (213.255 kph), Max Verstappen (Red Bull RB18 V6). Established 2022
Circuit length: 3.362 miles (5.412 km)	**Driver with the most wins:** Max Verstappen (2022)

UNITED STATES
OF AMERICA

Gulf of
Mexico

MEXICO

Index by country

NETHERLANDS

Zandvoort 52

PORTUGAL

Estoril 208
Monsanto 80
Portimao 304
Porto 68

QATAR

Lossail 308

RUSSIA

Sochi 292

SAUDI ARABIA

Jeddah 312

SINGAPORE

Singapore 272

SOUTH AFRICA

East London 96
Kyalami 116

SOUTH KOREA

Korea 280

SPAIN

Barcelona Montjuïc 136
Barcelona Montmeló 236
Barcelona Pedralbes 44
Jarama 128
Jerez 216
Valencia 268

SWEDEN

Anderstorp 164

SWITZERLAND

Berne 40

TURKEY

Istanbul 264

UNITED ARAB EMIRATES

Abu Dhabi 276

UNITED STATES OF AMERICA

Austin 288
Caesars Palace 192
Dallas 200
Detroit 196
Indianapolis Motor
 Speedway 252
Long Beach 172
Miami 316
Phoenix 228
Riverside 88
Sebring 84
Watkins Glen 92

Index

Bold page numbers refer to maps
and images

Monza 6, 8, 9, 12, **12**, **14–15**, 76,
 92, 188, 296
 tragedies at 12, **14–15**, 164
Morocco, Casablanca 72, **72**, **74–5**
Mosley, Max 304
Mosport 124, **124**, **126–7**, 132, 184
Moss, Stirling **24**, **31**, **56**, **59**, **66–7**
 Aintree 60, **60**, **62–3**
 Casablanca 72, **72**, **74–5**
 East London 96, **98**
 Melbourne 244
 Monsanto 80, **82**, **83**
 Mosport 124
 Pescara 64, **64**
 Porto 68, **70–1**
 Riverside 88, **90**
 Sebring 84
MotoGP 120, 216, 252, 308
'Motor Sport' magazine 132
Mugello 300, **300**, **302–3**, 304
 San Donato 300, **303**
 tragedies at 300
Mugello Grand Prix 300
Muizon 28
Mulino 64, **66**
Musso, Luigi **31**, **56**, 64, **66**

N
Nagatino Island 292
Natal Grand Prix, Westmead 96
Népliget 220
Netherlands, Zandvoort 52, **52**,
 54–5, 88, **88**, 128, 152, 224
Netherlands Grand Prix 52
New Nürburgring 20, 204, **204**,
 206–7
New York State 92
Nilsson, Gunnar 164

Nissan 240
Nivelles 152, **152**, **154–5**, 160
Nordschleife 204
Norris, Lando **295**, **318**
Nürburg *see* New Nürburgring
Nürburgring Nordschleife 6, 20, **20**,
 22–3, 112, 140, 232
 tragedies at **23**
Nuvolari, Tazio 220

O
Ocon, Esteban 220
O'Gorman, Bill 212
Okayama Prefecture 240
Olivier, Jackie 128
Olympic Games 180, 184, 236,
 260, 292, **292**
Omloop Terlaemen Zolder *see*
 Zolder
Ontario 132
Oporto 208
Osella 160, 184
Österreichring 108, 144, **144**,
 146–7
 Hella Licht Curve 144, **146**
 tragedies at 144, **146**
Oulton Park 132

P
Pace, Carlos 156
pace cars 124, **127**
Pacific Grand Prix 240, **243**
Paletti, Ricardo 184
Palmers de Terlaemen, Antoine 160
Patrese, Riccardo **183**, **191**, **211**
Paul Ricard 148, **148**, **150–1**, 168,
 232

Mistral Straight 148, **148**
Signes 148, **148**, **151**
tragedies at 148, **150**
Pedralbes Circuit *see* Barcelona
 Pedralbes
Penske team 144
Penske-Ford 144
Penya Rhin Grand Prix 44
Perez, Sergio **251**, **298**
Perón, Juan 56
Pescara 64, **64**, **66–7**
Peterson, Ronnie 12, **14**, 36, **118**,
 139, 164, **166**, **171**, 176, 188
Phoenix 228, **228**, **230–1**, 252
Piquet, Nelson **39**, 116, **116**, 168,
 174, 180, **182–3**, 184, **187**, 192,
 192, **195**, **199**
Piquet, Nelson, Jr. 273, **275**
Pirelli **44**, 288, **288**
Pironi, Didier **131**, 140, 184, 188
Pook, Chris 172
Pornace 64
Porsche 76, **79**, 96
Portimão 304, **304**, **306–7**
Porto 68, **68**, **70–1**
Portugal 88
 Estoril 208, **208**, **210–11**, 304
 Monsanto 80, **80**, **82–3**, 208
 Portimão 304, **304**, **306–7**
 Porto 68, **68**, **70–1**
Portuguese Grand Prix 208, 304
Prenois 168
Prince George Circuit *see* East
 London
Pringle, Marvin A 228
Prost, Alain **118**, 140, **192**, **215**,
 218
 Dallas 200, **200**
 Dijon 168, **171**

Bibliography

Books

Adelaide Alive! The Grand Prix Years (Adelaide GP Office)

40 Anos de Historia Del Montjuïc, Javier Del Arco

Grand Prix of Canada, Gerald Donaldson (Avon Books)

Motor Racing Circuits of Europe, Louis Klemantaski and Michael Frostick (Batsford)

The German Grand Prix, Cyril Posthumus (Temple Press)

The French Grand Prix, David Hodges (Temple Press)

The Last Road Race, Richard Williams (Weidenfeld & Nicholson)

The Monaco Grand Prix, David Hodges (Temple Press)

The World Atlas of Motor Car Racing, Joe Saward (Hamlyn)

Magazines

Autocourse, Autosport, F1 Racing, Grand Prix International, Motor Racing, Motor Sport

Newspapers

The Guardian, The Independent, The Observer

Acknowledgements

Publisher: Jethro Lennox and Harley Griffiths
Project manager: Craig Balfour
Designer: Kevin Robbins
Maps and layout: Gordon MacGilp
Editorial: Lisa Footit, Ruth Hall, Louise Robb, Lauren Reid and Sheena Shanks

Images

Front Cover	© Klemantaski Collection/Getty
Front Cover	© motorsports Photographer/Shutterstock
Back Cover	© Hasan Bratic/SIPA/Shutterstock
End paper	© Klemantaski Collection/Getty
End paper	© Hasan Bratic/SIPA/Shutterstock
P4	© Ev. Safronov/Shutterstock
P7	© 2005 Getty Images
P13	© Heritage Image Partnership Ltd /Alamy
P17a	© Bernard Cahier/Getty Images
P17b	© Jerome Delay/AP/Shutterstock
P21a	© ULLSTEIN BILD/Getty Images
P21b	© Bernard Cahier/Getty Images
P25	© KLEMANTASKI COLLECTION/Getty Images
P29a	© KLEMANTASKI COLLECTION/Getty Images
P29b	© KLEMANTASKI COLLECTION/Getty Images
P33a	© Paul-Henri Cahier/Getty Images
P33b	© PASCAL PAVANI/Getty Images
P37a	© Daily Mail/Shutterstock
P37b	© Handout/Getty Images
P41	© KLEMANTASKI COLLECTION/Getty Images
P45	© KLEMANTASKI COLLECTION/Getty Images
P49	© KLEMANTASKI COLLECTION/Getty Images
P53a	© HERITAGE IMAGES/Getty Images
P53b	© motorsports Photographer/Shutterstock
P57	© Keystone/Getty Images
P61a	© HERITAGE IMAGES/Getty Images
P61b	© KLEMANTASKI COLLECTION/Getty Images
P65	© KLEMANTASKI COLLECTION/Getty Images
P69	© KLEMANTASKI COLLECTION/Getty Images
P73	© KLEMANTASKI COLLECTION/Getty Images
P77a	© Popperfoto/Getty Images
P77b	© Heinrich Sanden Jr/AP/Shutterstock
P81	© LAT Photographic
P85	© RacingOne/Getty Images
P89	© Bernard Cahier/Getty Images
P93	© Anonymous/AP/Shutterstock
P97	© Popperfoto/Getty Images
P101	© Florent Gooden/LiveMedia/Shutterstock
P105a	© Bentley Archive/Popperfoto/Getty Images
P105b	© RacingOne/Getty Images
P109	© Motoring Picture Library/Alamy Stock Photo
P113a	© Bernard Cahier/Getty Images
P113b	© Bob Thomas/Popperfoto/Getty Images
P117	© Bernard Cahier/Getty Images
P120a	© Bernard Cahier/Getty Images
P125a	© Ts/Keystone USA/Shutterstock
P125b	© Boris Spremo/Getty Images
P129a	© Heritage Image Partnership Ltd /Alamy Stock Photo
P133	© GP Library Limited/Alamy Stock Photo
P137a	© Bernard Cahier/Getty Images
P141a	© GP Library Limited/Alamy Stock Photo
P141b	© DPPI Media/Alamy Stock Photo
P145a	© GP Library Limited/Alamy Stock Photo
P145b	© cristiano barni/Shutterstock
P149a	© aerial-photos.com/Alamy Stock Photo
P149b	© Paul-Henri Cahier/Getty Images
P153	© Bernard Cahier/Getty Images
P157a	© Bernard Cahier/Getty Images
P157b	© Paul-Henri Cahier/Getty Images
P161	© Bernard Cahier/Getty Images
P165a	© GP Library Limited/Alamy Stock Photo
P165b	© GP Library Limited/Alamy Stock Photo
P169a	© Roque/AP/Shutterstock
P169b	© Hoch Zwei/Getty Images
P173	© KLEMANTASKI COLLECTION/Getty Images
P177a	© Grand Prix Photo/Getty Images
P177b	© 2006 Shutterstock.
P181a	© Simon Bruty/Getty Images
P181b	© Paul-Henri Cahier/Getty Images
P185	© Klemantaski Collection/Getty Images
P189a	© Paul-Henri Cahier/Getty Images
P189b	© cristiano barni/Shutterstock
P193a	© Bernard Cahier/Getty Images
P193b	© Bob Thomas/Getty Images
P197	© GP Library Limited/Alamy Stock Photo
P201	© Paul-Henri Cahier/Getty Images
P205a	© Hans Blossey/Alamy Stock Photo
P205b	© Bongarts/Getty Images
P209a	© Paul-Henri Cahier/Getty Images
P209b	© Paul-Henri Cahier/Getty Images
P213	© Mike Hewitt/Getty Images
P217a	© PASCAL RONDEAU/Getty Images
P221a	© Geza Kurka Photo Video/Shutterstock
P221b	© Leonhard Foeger/AP/Shutterstock
P225	© Clive Rose/Getty Images
P229	© PASCAL RONDEAU/Getty Images
P233a	© MARTIN BUREAU/Getty Images
P233b	© Oliver Multhaup/EPA/Shutterstock
P237	© Paul-Henri Cahier/Getty Images
P241a	© PASCAL RONDEAU/Getty Images
P241b	© Jean-Marc LOUBAT/Getty Images
P245	© Antonin Vincent/DPPI/LiveMedia/Shutterstock
P249a	© Shahjehan/Shutterstock
P249b	© Mark Thompson/Getty Images
P253a	© JOHN RUTHROFF/Getty Images
P253b	© Vladimir Rys/Getty Images
P257a	© Digital Globe/Getty Images
P257b	© Lars Baron/AP/Shutterstock
P261	© Digital Globe/Getty Images
P265a	© MUSTAFA OZER/Getty Images
P265b	© Sipa/Shutterstock
P269a	© Paul Gilham/Getty Images
P269b	© Pool/Getty Images
P273a	© Clive Mason/Getty Images
P273b	© Mark Thompson/Getty Images
P277a	© KARIM SAHIB/Getty Images
P277b	© Srdjan Suki/EPA/Shutterstock
P281a	© ROSLAN RAHMAN/Getty Images
P281b	© Mark Thompson/Getty Images
P285a	© Digital Globe/Getty Images
P285b	© Paul Gilham/Getty Images
P289a	© JIM WATSON/Getty Images
P289b	© Peter J Fox/Getty Images
P293a	© Dmitriy Kandinskiy/Shutterstock
P293b	© motorsports Photographer/Shutterstock
P297	© TOLGA BOZOGLU/EPA-EFE/Shutterstock
P301	© Jennifer Lorenzini/Pool/EPA-EFE/Shutterstock
P305a	© Miguel Couto/Shutterstock
P305b	© Action Press/Shutterstock
P309	© Dppi/LiveMedia/Shutterstock
P313a	© Xinhua/Shutterstock
P313b	© Hasan Bratic/SIPA/Shutterstock
P317a	© YES Market Media/Shutterstock
P317b	© Eleanor Hoad/Shutterstock
P320	© motorsports Photographer/Shutterstock

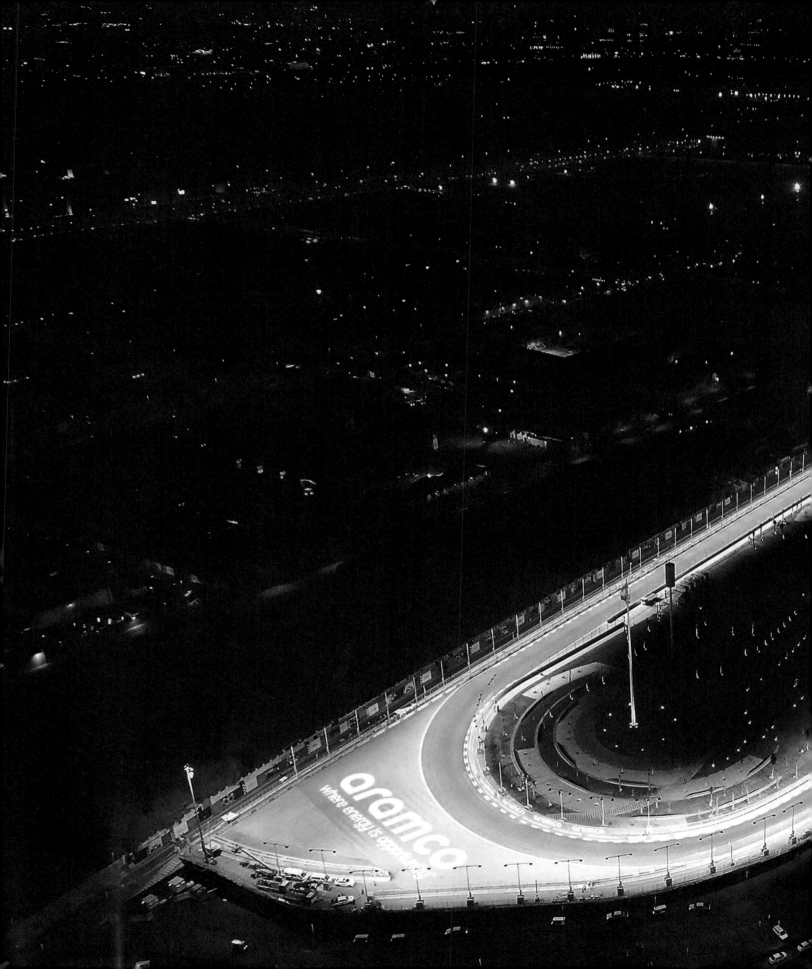